GATEWAY CITY

COVINGTON
KENTUCKY

1815–2015

CLERISY PRESS

Gateway City: Covington, Kentucky 1815–2015
© 2015 by Paul A. Tenkotte, James C. Claypool, and David E. Schroeder

For further information, contact the publisher at

Clerisy Press
306 Greenup Street
Covington, KY 41011
clerisypress.com

ISBN: 978-1-57860-567-5

Cover and interior designed by Stephen Sullivan
Project editors: Amber Kaye Henderson and Richard Hunt
Copy editor: Kerry Smith
Proofreader: Kate McWhorter Johnson
Index: Ann Cassar

FRONT COVER: © Dave Ivory
BACK COVER: TOP ROW, LEFT TO RIGHT: General Leonard Covington, courtesy of Kenton County Public Library, Covington; Licking River Suspension Bridge, *Ballou's Pictorial Drawing-Room Companion* 11, no. 25 (20 Dec. 1856); painter Johann Schmitt, courtesy of Sharon Cahill. SECOND ROW, LEFT TO RIGHT: Cathedral Basilica of the Assumption, © Raymond E. Hadorn, courtesy of Paul A. Tenkotte; Sister Francis Schervier, courtesy of St. Elizabeth Healthcare Collection, Kenton County Public Library, Covington; US Representative Brent Spence, courtesy of Kenton County Public Library, Covington; 1980 Oktoberfest in the MainStrasse district, courtesy of Kenton County Public Library, Covington. THIRD ROW, LEFT TO RIGHT: Eilerman's Men's and Boys' Wear, courtesy of Kenton County Public Library, Covington; Notre Dame Academy, © Raymond E. Hadorn, courtesy of Paul A. Tenkotte. BOTTOM ROW, LEFT TO RIGHT: Motch Jewelers, © Dave Ivory; city commission member James Simpson Jr., courtesy of Kenton County Public Library, Covington; Mayor Sherry Carran, courtesy of Sherry Carran; Kenton County Public Library, © Dave Ivory.

GATEWAY CITY

COVINGTON
KENTUCKY

1815–2015

GATEWAY CITY
COVINGTON, KENTUCKY
1815–2015

EDITORS

Paul A. Tenkotte, PhD

James C. Claypool, PhD

David E. Schroeder

AUTHORS

Roger Auge II

John H. Boh

Victor J. Canfield

Don Clare

James C. Claypool, PhD

Luke Groeschen

Brian L. Hackett, PhD

Rob Haney

Theodore H. H. Harris

Joseph Hinds

Marc F. Hult

Katie Hushebeck-Schneider

Beth Johnson

Matthew J. Kelley

Chuck and Ruth Korzenborn

Deborah Kohl Kremer

Elaine M. Kuhn

Karl J. Lietzenmayer

Nathan McGee

Janice Mueller

James Ott

John Schlipp

David E. Schroeder

John T. Spence

Bill Stolz

Paul A. Tenkotte, PhD

Robert D. Webster

TABLE OF CONTENTS

PUBLISHER'S NOTE

PUBLISHERS OPERATE in anonymity, an invisible existence that lets us do our best work in relative quiet. Being perpetually unnoticed also allows us to focus on (1) making great books and (2) shining the spotlight on our authors. If we do our job well, when an interested reader walks into a bookstore, he or she will recollect three things, in order of importance: the title, the author's last name, and the subject of the book. No one, rightly or otherwise, really has any reason to remember the publisher. The world is in balance when we serve a supporting role.

Gateway City: Covington, Kentucky 1815–2015 provides us with a rare reason to step out from behind the curtain. Because the subject of this book and our address are one and the same, we're taking this opportunity to spill a bit about why we love Covington, a city with a rich history (as this book wonderfully attests) and the promise of renaissance as one of the best places to live and work in the United States.

First and foremost, it has been a pleasure and an honor to work with Paul Tenkotte, Jim Claypool, and David Schroeder on this book (and by extension, the other fine contributors they enlisted). We learned a lot about Covington through the publication process of this volume, which deepens our sense of connection to the community. In Kentucky parlance, it's like hitting a trifecta: working with splendid authors, gaining knowledge about a subject, and being of service to the readers. Our sincere thanks to them and the Cov200 committee for including us in the bicentennial celebration in a way that we can gladly, and best, contribute.

The goals of a publisher include literacy, devotion to free speech, and respect for everyone. We've been doubly lucky in the last few years to add "bookstore" to the shingle of "independent publisher." Our value to and role within this community are a promise made tangible when someone picks up one of our books. A city needs a bookstore, and a publisher, like a body, needs a heart and a mind.

Especially during quiet times, we reflect on the role we hope to play in this community and the lives of those who grace us with their company. Every time we put one of our favorite books in someone's hands as a recommended read, we're reminded of why this pursuit means so much to us: sharing words of insight and purpose. We're committed to giving the people in Covington a place they can call their own and, with this book, a published record of how we got here.

Actually, *community* in the previous paragraph should be *communities*, as there are many groups that we gladly embrace and support and reach out to: readers, neighbors, authors, social advocacy organizations, not-for-profit ventures, visitors, Covington in specific, Northern Kentucky and Cincinnati at large, the cosmos, and on and on.

For this opportunity, we have to first thank two people in particular who provided us this place and permission to operate. In the words of Gertrude Stein, "there is no there there" without Marilyn and Martin Wade. They've generously allowed us to operate in a building that once was home to John Roebling's office when the suspension bridge was being built. We're grateful for the chance to be a bridge between centuries as well as the connector between eager readers and appreciative authors. Because

of the Wades' support, we in turn can help grassroots groups who need a place to meet and plan (and occasionally celebrate) and individuals who need time to reflect and refresh and maybe heal, and we continually serve to further free expression by opening our doors for readers every day.

Being a publisher has allowed me the pleasure of silently reaching out to thousands of people with our authors' insightful histories and other stories. Fascinating, fortifying folks who constantly rekindle our faith in the human spirit. Through the five different imprints within our publishing house, we have almost 150 years of experience . . . which makes us just about as long-standing as Covington. On our shelves are, collectively, centuries of authorial insight and worldly achievements. All of this comes together to remind me daily how much there is that I still don't know. It can be overwhelming, it certainly is humbling, and yet it inspires me to share books and ideas and words of wise authors so that our culture might grow collectively. Which makes me inestimably and infinitely appreciative for all those who yearn for this same en masse enlightenment.

Here's the essence of what we seek: that every individual—regardless of race, age, gender, income, birthplace, political and religious persuasion, sexual orientation, or personal aspiration—be granted a chance to succeed. I believe the human condition is improved by acknowledging that every person on this planet has the same hopes and dreams, and that by reading and reasoning and reflecting, we will lift one another up. Our golden future lies not at the end of a yellow brick road. Instead, it's a path paved by books, described by dreamers and those who dare, and our job is to protect and promote those whose words light the way for us all. We'll do our share by making great books, promoting great authors, and putting their books in readers' hands every time we get the chance. We are so grateful that this path has taken us over the river and through this 'hood, because the many neighborhoods of Covington have become our hearth, our home, and the place where our hearts reside.

—Richard Hunt,
Clerisy Press

ACKNOWLEDGMENTS

No project encompassing a comprehensive 200-year history such as this would be possible without the help of countless individuals and entities. This five-year-long project has utilized a vast array of individual talents. At the forefront are the tireless and selfless contributions made by Norm Desmarais, who, over the last two years, has guided the project with great administrative skills and loving care. Along the way, he has been aided by the fine administrative work of both Amanda Greenwell and Kate Esarey. The project's Executive Committee has also been tireless in meeting to help guide the project toward success. Likewise, Covington Mayor Sherry Carran and the Covington City Commission have lent both their moral and their financial support. Special thanks for all of the assistance from the Kenton County Public Library. Thanks also to all those who contributed photos, and to Jeff Blakemore and Dave Ivory for their splendid photography. A special thanks to Tom DiBello, the executive director of the Center for Great Neighborhoods, for allowing his agency to serve as Cov200's financial clearinghouse and for hosting so many of the Executive Committee's monthly meetings. The editors wish to thank all of the event volunteers for contributing their time and all those who have made financial contributions in support of the project.

OUR GREAT APPRECIATION TO:

Steve Arlinghaus
Roger Auge II
Mike Averdick
Linda Bailey
Baker Hunt Art & Cultural Center
Chris Banks
Tom and Kim Banta
Casey Barach
Jay and Cate Becker
Behringer-Crawford Museum
Adrian Belew
Pete Berard
Jeff Blakemore
BLDG
John Boh
Denny Bowman
Walter Bowman
Shannan Boyer
Mark Braunwart
Joseph Brennan
Trisha Brundage
Emily Brunemann
Steve Brunson
Trisha Brush
Justine Burchell
Bill and Sue Butler
Butch Callery
Campbell County Clerk's Office
Vic Canfield
The Carnegie (Covington)
Sherry Carran
Steve and Meg Casper
The Center for Great Neighborhoods
 of Covington
Chase Law Library, Northern Kentucky
 University
Cincinnati History Library and Archives at
 the Cincinnati Museum Center
City of Covington City Commissioners
City of Covington City Manager's Office
City of Covington Fire Department
City of Covington Mayor's Office
City of Covington Police Department
Don Clare
James Claypool
Sharon Claypool
Clerisy Press
Brent Cooper
Corporex
Covington 200 Committees
Covington 200 Executive Committee
Covington Catholic High School,
 Athletic Department
Covington Independent Public Schools
Beth Coyle
Cathy Darpel
Tracy Denham
Normand and Lisa Desmarais
Cassandra, Katie, and Brianna Desmarais
Rita DiBello
Tom DiBello
Corey Druschal
Duke Energy
Cierra Earl
Chuck Eileerman
Greg Engelman
Mitch English
Kate Esarey

Mark Exterkamp
Oakley and Eva Farris
Leslee Garner
Gateway Community and Technical College
Dennis Gordon
Niki Gordon
Anna Gospodinovich
Amanda Greenwell
Olivia and Aidan Greenwell
Luke Groeschen
Dan Groneck
Brian Hackett
George Hagan
Mike Hammons
Rob Haney
Robert Hans
Ted Harris
Hebrew Union College, American
 Jewish Archives
Tom Hedges
Maggie Heran
Jan Hillard
Joseph Hinds
Mike Holliday
Holmes High School Hall of Fame
Tiffany Hoppenjans
Jennifer Huebscher
Ed and Sarah Hughes
Marc Hult
Richard Hunt
Katie Hushebeck-Schneider
Dave Ivory
Beth Johnson
Spike Jones
Keen Communications
Matt Kelley
Cullen Kennison
Ryan Kent
Kenton County Clerk's Office
Kenton County Fiscal Court
Kenton County Historical Society
Kenton County Public Library
Kenton County School District
Kentucky Department for Libraries
 and Archives
Kentucky Department of Highways
Kentucky Historical Society
Virginia Kerst
Stephen Kidd
Charles King
Paul Kleier
Larry Klein
Dan Knecht
Chuck and Ruth Korzenborn
Mark Kreimborg
Deborah Kohl Kremer
Elaine Kuhn
Gretchen Landrum
The LBJ Presidential Library
Library of Congress
Karl Lietzenmayer
Lloyd Library and Museum
Louisiana State Museum
Jennifer Lovelace
Danny Lovell
Diane Mallstrom
Dan Mathew
Nate McGee

Molly Merkle
Debra Meyers
Minnesota Historical Society
Michael Monks
Janice Mueller
Mark Neikirk
Northern Kentucky Convention and
 Visitors Bureau
Northern Kentucky University, Office of
 Research, Grants, and Contracts Office
Notre Dame Academy, Athletic Department
Margaret Nyhan
Steve Oldfield
Wayne Onkst
Jim Ott
Dan Petronio
Planning and Development Services of
 Kenton County (formerly Northern
 Kentucky Area Planning Commission)
Kevin Proffitt
Public Library of Cincinnati and Hamilton
 County: Genealogy/Local History/
 Cincinnati Room
Carol Rekow
Laurie Risch
River City News
Wendy Rush
Don Sanders
Becky Schaffer
Mark Schaffer
Chuck and Julie Scheper
Bill Scheyer
Karen Schlipf
John Schlipp
Dave Schroeder
Mike and Jeanne Schroer
Zell Schulman
Carolee Schwartz
Scooter Media
Dorothy Siegel
Kaira Simmons
Erin Smith
Jack Snodgrass
J. T. Spence
Spotted Yeti
Bill Stolz
Eric Summe
Gabrielle Summe
Paul Tenkotte
Will Terwort
Jerod Theobold
Sean Thomas
Thomas More College
TiER1 Performance Solutions
John and Sue Topits
Vision 2015
Greg Von Hoene
Jamie Wagner
Jim Wallace
Robert Webster
Kari Wethington
W. Frank Steely Library, Northern Kentucky
 University
Michael Whiteman
Kara Clark Williams
Nancy Wood
Creighton and Carolyn Wright
Phil Yannarella

IN MEMORY OF RON EINHAUS

FOREWORD

In preparation for Covington's 200th anniversary, we have learned much about our city's history, its people, and its spirit. We are in the midst of technological and social transformations. The increased popularity of social media has translated into a major shift in personal interactions (or the lack thereof). With President Obama, we now have our first African American president, who is redefining communication using blogs, Facebook, and Twitter. Our society has adopted a general attitude of increased tolerance as same-sex marriage is gaining support and more fathers are staying home to raise children. The current millennial generation is confident, self-expressive, liberal, upbeat, and open to change.

Since our sesquicentennial (150th) anniversary in 1965, much has changed in Covington. The interstate highway system has made it easier to get to once-remote locations. Manufacturing has shifted to a global focus, and much of the population has moved out of the cities and into the suburbs, where they live in significantly larger homes. Large, centrally located shopping malls replaced most downtown retailers, who either moved or went out of business. From the 1960s to the 1990s, Covington searched for its new niche.

However, in the past two decades, Covington has adapted and evolved into a unique destination, with a diverse population, a spirit of tolerance, and 19 neighborhoods still maintaining their pride. People are rediscovering the beauty this city has in architecture, affordability, diversity, and a helping-hand attitude. Covington is once again united, unique, adaptive, meaningful, and resourceful.

It is this reinvigorated spirit that acts as our inspiration for the bicentennial committee. We see this as the bicentennial that exposes Covington's uniqueness, while giving back by collaborating and lending a hand. In the digital age, we plan to bring people together to celebrate in the analog world, while promoting in the digital world. We are confident that our hard work and plans will assist Covington in its journey for continued growth.

—Normand G. Desmarais and Amanda Everhart Greenwell,
Chair and Vice Chair, Covington200 Project

INTRODUCTION

COVINGTON, KENTUCKY, lies along the southern shore of the Ohio River, directly opposite the city of Cincinnati, Ohio. With a 2013 population of 40,956 people, Covington is part of the 15-county Cincinnati-Hamilton, OH-KY-IN CMSA (Consolidated Metropolitan Statistical Area) of 2.1 million people. Lying at nearly the halfway point of the Ohio River—mile 470 of 981 meandering miles—Cincinnati and Covington are both "children of the river." Their founding, growth, and prosperity have largely paralleled the river's fortunes. Today, they are returning to their rich roots, rebuilding their riverfronts for residences, businesses, and leisure activities. And here, in the midst of a prosperous Ohio River region, Cincinnati and Covington share a common destiny as a transition area. They are vital parts of a border region that acts as a geological, climatological, historical, and cultural gateway.

Geologically, the Ohio River region is a transition area. During the Pleistocene Epoch of the Quaternary Period, some 200,000–250,000 years ago, the Illinoian Glacier scoured the land of present-day Ohio. Like a gigantic bulldozer, it plowed down the surface features. Forming an ice dam along the ancient Deep Stage Ohio River lying to the north of modern Cincinnati, the glacier forced the river southward. The modern Ohio River assumed a new course, running between what is now Lunken Airport toward present-day Lawrenceburg, Indiana. In turn, this new Ohio River channel deflected the ancient Deep Stage Licking River also southward. The Point—the name given to the confluence of the Licking River with the modern Ohio River, what we call Covington—was born.

Climatologically, the Ohio River region is also a transition area. Lying between two major climate zones, Humid Continental to the north and Humid Subtropical to the south, residents of Cincinnati and Covington are accustomed to wild weather shifts. Prevailing westerly winds bring surprises year-round, but especially in the winter and spring seasons. Temperatures can drop or rise precipitously within a 24-hour period. A sunny, mild winter day can turn ugly within hours, bringing sleet, snow, and below-freezing temperatures. Along a crooked horizontal line traced by meteorologists across Hamilton County north of Cincinnati, a noticeable transition between the numbers of frost-free days occurs. As pundits claim, if you don't like the weather in the region, just wait a day or so, and it will change, perhaps to your liking.

Historically, the Ohio River region is likewise a transition zone. Virginia, one of the 13 original colonies, claimed and settled Kentucky. As a result, wealthy aristocratic families from Virginia vied for land grants along the fertile Ohio River Valley of Northern Kentucky. Surveyors used the relatively crude instruments of their era, and based land boundaries on natural markers like rivers, streams, trees, and rocks. Not surprisingly, land claims sometimes overlapped, assuming a shingled-over effect. Land became shrouded in controversy and court battles. Lawyers immigrated to the young state of Kentucky, availing themselves of opportunities to build their legal practices. Quickly, Kentucky became a gentrified society, complete with the institution of slavery. Meanwhile, to the north of the Ohio River, the Northwest Territory forbade slavery. Once again, the Ohio River region became a legal battleground, this time between the adherents of slavery and those who wished to end it. At the heart of the Underground Railroad to free the slaves, the region holds an important place in our nation's greatest historical crisis.

As a transition area, Covington and the Ohio Valley region also serve as a cultural gateway. Border regions often have a flavor of their own, influenced by forces from all directions. Gateways lie at geographically significant national crossroads. There, political, social, religious, and cultural issues sometimes arise earlier than elsewhere and often seem more contentious. At other times, as cultural intersections, gateway areas can adopt, promote, and market innovative ideas. For example, the John A. Roebling Suspension Bridge between Cincinnati and Covington remains a testimony to the innovation of this region, as well as a symbol of its gateway status.

This bicentennial history of Covington, Kentucky, seeks to present an overview of an important gateway city in our national history, one situated at a national crossroads. At times, this gateway has pointed in different directions, and, at other times, it has vacillated between innovation and complacency. As in other transition or gateway regions, the residents of Covington have sought their fortunes with the prevailing winds of change. Initially, Covington served as a Gateway to the West, then as a Gateway between the North and the South, subsequently as a Gateway to the North, and most recently as a Gateway to Progress. Using these themes, we trace the history of Covington and its residents as they alternately adopted, stimulated, and/or resisted national changes that shaped their regional identity.

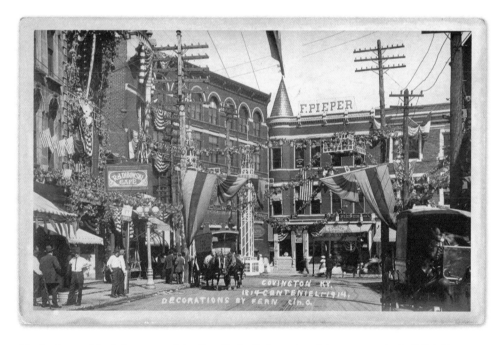

Covington residents began celebrating their city's centennial a year early, in 1914. Here, we see a splendidly regaled Pike Street, looking toward Madison Avenue. On the left is Dibowski's Cafe, grand-prize winner of the best-decorated business for the centennial. Courtesy of the Kenton County Public Library.

CHAPTER

GATEWAY TO THE WEST 1763-1830

by Paul A. Tenkotte, PhD

IN the 21st century, it may seem strange—even preposterous—to consider that Covington was once a Gateway to the West. Of course, before the Louisiana Purchase of 1803, the Ohio River valley was the nation's West. Settlers from the East worked their way to Redstone (Brownsville), Pennsylvania, on the Monongahela River, boarding flatboats down the Ohio River for points west.

Brownsville, like Covington, is one of the nation's historic gateways. Located at a crossable ford in the Monongahela River, Brownsville is also situated at the intersection of an important mountain pass, tying the Monongahela River to the Potomac River. And in the 1700s, travel over the Allegheny Mountains (part of the Appalachian Mountain chain) was extraordinarily arduous. France claimed the Ohio River valley, but the British and Colonial Virginians cast longing eyes at it. In 1749 the British crown gave the Ohio Company of Virginia the right to settle up to 500,000 acres of land in the Ohio River valley between the Monongahela and Kanawha Rivers. In the following year, the Ohio Company hired Christopher Gist to survey much of the area. By 1752, the company had opened a crude road stretching from what is now Cumberland, Maryland (on the Potomac River), to Brownsville. Conflicting land claims to the entire area between France and Great Britain proved vexing, however, leading to the French and Indian War in 1754.

THE FRENCH AND INDIAN WAR

The French and Indian War, pitting Great Britain against France, evolved into one of the most significant world wars in history. Called the Seven Years' War (1756–1763), it ended in one of the largest land transfers of all time. By the Treaty of Paris of 1763, the French lost all of their territory east of the Mississippi River, except for New Orleans. Great Britain, now in control of Canada, Florida, and the Ohio River valley, celebrated its success. Ironically, the annexation of such a large territory would prove to be a mixed blessing for Great Britain, for two reasons. First, facing the expensive need to defend this vastly enlarged territory, the British Parliament increased Colonial taxation. The American colonists, accustomed to the salutary neglect of British oversight before this time, vehemently opposed the centralization of British control. Second, some colonists, impatient to expand westward beyond the Appalachian Mountains, found themselves perturbed by Britain's tightening imperial reins. In both cases, disappointed colonists fanned the flames of revolution that tore asunder the newly won territory of British North America.

In truth, Great Britain was not yet ready to settle or defend the Ohio River valley. Consequently, King George III (1760–1820) declared the Royal Proclamation of 1763 on October 7. This proclamation established a line along the Appalachian Mountains, temporarily forbidding white settlement to its west. Intended to be temporary, the line was viewed as an opportunity for Great Britain to regulate the settlement of the new western territory and to allow it the time and resources to deal with the American Indians residing there. Already unhappy with the outcome of the French

1

and Indian War/Seven Years' War, the American Indians had mounted a vast confederation of tribes against the British in May 1763. Pontiac's Rebellion (1763–66) was the result. Among the many tribes involved were the Shawnee and Miami Indians, both of whom had substantial presences in the Ohio River valley.

THE SHAWNEE AND MIAMI INDIANS

By the late 1700s, the Shawnees occupied the watershed of the Scioto River westward to two other bodies of water—the Little Miami and Great Miami Rivers. Tributaries of the Ohio, the Little Miami River lies upriver from Covington, and the Great Miami, downriver. The Shawnees' main town was located near the mouth of the Scioto River at present-day Portsmouth, Ohio, about 114 miles upriver from Cincinnati, Ohio. Likewise, the Miami Indians made their home between the Great Miami and Little Miami Rivers, but principally lived farther north and west, along the Maumee, Wabash, and Illinois Rivers, in present-day Ohio, Indiana, and Illinois. These tribes occasionally ventured south to hunt in Northern Kentucky, particularly to follow the buffalo trails to the great animal salt licks at Big Bone and Blue Licks in Northern Kentucky.

In 1768 King George III's Indian commissioner, Sir William Johnson, concluded a pact with the Six Nations of the Iroquois at Fort Stanwix in New York. This treaty recognized British claims to the lands south of the Ohio River, including Northern Kentucky, continuing southeast to the mouth of the Tennessee River and east to the Susquehanna Valley of Pennsylvania. The Iroquois claim to this vast area, while recognized by the British as legitimate, was in reality extremely tenuous. It was based upon a military conquest of this area many years before, one that was no longer enforced or recognized. For instance, the Shawnees, who were represented among the 3,200 American Indians at the Fort Stanwix conference, disputed the claims of the Iroquois, and argued that the territory belonged to the tribes living there, not the Iroquois. Nevertheless, the Shawnees were denied any voice in the matter.

While not officially recognized by the Shawnees, the Treaty of Fort Stanwix became the basis for the British Crown's claim to much of Kentucky. The colony of Virginia, on the other hand, continued to argue that its 1609 charter entitled it to nearly all of the lands west of the Alleghenies and north of the 34th parallel. Not agreeing to the terms of the Treaty of Fort Stanwix, the Shawnees were soon embroiled in Lord Dunmore's War with the colonists. In 1774, the Shawnees signed the Treaty of Camp Charlotte, agreeing to stay north of the Ohio River. Subsequently, a 1775 treaty with the Cherokee Indians transferred the balance of pioneer Kentucky to the Transylvania Company of Virginia.

THE AMERICAN REVOLUTION

Originally part of Fincastle County, Virginia, Kentucky became a separate county in 1776 during the course of the American Revolutionary War. General George Rogers Clark (1752–1818) led the Kentucky County militia in attacks against British forts at Kaskaskia (now Illinois), Cahokia (Illinois), and Vincennes (Indiana), designed to relieve stress on the Kentucky settlements. In 1779, the war came to Northern Kentucky, near what is now Dayton, Kentucky. There, about 65 Americans were caught in an ambush called Rogers's Defeat. In spring 1780, British captain Henry Bird (Byrd), with an army of 1,000 British troops and their American Indian allies, decided to attack the Kentucky settlements. He crossed the Point (the site of Covington, where the Licking joins the Ohio River). In reprisal, Clark assembled a 1,000-troop army at the Point in July 1780 against the British's Shawnee Indian allies. In August 1781 American Colonel Archibald Lochry and more than 100 troops were ambushed near the mouth of the Great Miami River, downriver from Covington. Although the British surrendered at Yorktown in October 1781, the war raged on in Kentucky. During the summer of 1782, Clark built a 73-foot boat to patrol the area around the Point. It was armed with a cannon and 100 men. Nevertheless, in August 1782, Kentuckians suffered a major defeat at the Battle of Blue Licks in Northern Kentucky, which some call the last battle of the American Revolution but others consider one of the first battles of the American Indian skirmishes thereafter. As a counteroffensive to Blue Licks, Clark assembled 1,000 troops at the Point in November 1782 in a military expedition against the American Indians. By the Peace of Paris

of 1783, ending the American Revolution, the United States gained title to the trans-Appalachian West, with the exception of British Canada and the Spanish possessions of Florida, West Florida, and New Orleans.

Subsequently, a dispute ensued between the Continental Congress and the state of Virginia over ownership of the western lands. In the end, Virginia surrendered its claims to Kentucky and to part of Ohio (excepting the Virginia Military District between the Little Miami and Scioto Rivers). The commonwealth of Kentucky was established as the 15th state of the union in June 1792. Five years earlier, in 1787, the US Congress established the Northwest Territory, north of the Ohio River.

The establishment of the Northwest Territory, of course, followed the ratification of further treaties with the American Indians. Of local significance was the treaty negotiated between the Shawnees and Generals George Rogers Clark, Richard Butler, and Samuel H. Parsons in January 1786, at Fort Finney at the mouth of the Great Miami River, opposite Northern Kentucky. By the terms of this treaty, the Shawnees agreed to limit themselves to a much-restricted area between the Great Miami and Wabash Rivers.

Of course, treaties were of little use unless they were enforced. In the interest of protecting the early settlers of New Jersey Judge John Symmes's Miami Purchase in southwestern Ohio, United States Secretary of War Henry Knox (1785–95) pledged his support in garrisoning federal troops at Fort Finney. In the winter of 1788–89, Captain Kearsey and 45 troops traveled downriver for this purpose but, arriving during a flood, discovered Fort Finney submerged. Unprepared to build a new fort at this time, they left immediately for the Falls of the Ohio at Louisville. From there, in the following spring, Ensign Luce and 18 men journeyed to North Bend, a settlement founded by Symmes 7 miles downriver from Cincinnati. They erected a temporary blockhouse there, but soon removed to Cincinnati, a location they deemed more fitting for the construction of a fort. Joined by additional federal troops, they built Fort Washington.

The presence of Fort Washington, in the pioneer settlement of Cincinnati, contributed to the region's security and growth. At this fort, settlers in Northern Kentucky sought refuge during American Indian raids. And, around this fort, a town of sizable proportions grew. Other factors, in addition to Fort Washington, further catapulted Cincinnati ahead of its Northern Kentucky neighbors.

THE ADVANTAGES OF CINCINNATI

The topography of Cincinnati proved more conducive than that of later Covington to the development of an extensive late 18th- and early 19th-century "walking city." As described by historians, "walking cities" were common before the invention of electric streetcars and other modes of urban transport in the late 19th century. In a walking city, residents walked to work, school, church, shopping, and other places. Large, flat basin areas, like that of Cincinnati, furnished many possibilities for the building of a large city. Further, the rich alluvial plains of the Cincinnati basin area on the north shore of the Ohio River conveniently consisted of two separate stages—a low-lying narrow strip along the shore of the Ohio River, well suited for use as a public landing, and a more extensive plateau immediately behind, generally above the flood plain of the Ohio. On the other hand, the basin area of Covington was much less extensive, and was more hemmed in by the surrounding amphitheater of hills. Stated succinctly by Daniel Drake (1810) in his *Notices Concerning Cincinnati*, "On the southern, or Kentucky side of the Ohio, the land is hilly, and the interval grounds narrow; on this side [Cincinnati] the land is more level, and the interval spaces wider."

Further, Cincinnati's alluvial basin area was defined, rather than interrupted, by Deer Creek to the east and Mill Creek to the west. On the other hand, Northern Kentucky's smaller basin area was bisected by the Licking River, leading to the development of two separate cities: Covington on its western shore and Newport on its eastern bank. As Charles Theodore Greve (1904) related in his *Centennial History of Cincinnati and Representative Citizens*, Covington and Newport, like Cincinnati, occupied "a similar, [but] smaller half-basin intersected by the Licking River and semi-circled by hills."

Geographically, Cincinnati was further favored by the navigable channel of the Ohio River, which, in the immediate vicinity of Cincinnati, swept along the northern shore. Coupled with the fact that the Licking River, as it

emptied into the Ohio River between Covington and Newport, deposited silt on the Kentucky shoreline, this meant that Cincinnati had deeper year-round harbor facilities than Northern Kentucky. In addition, the Covington channel was further impeded by a limestone rock formation that began on the Covington side and extended "nearly half way across the river" ("The Bridge Question," *Daily Cincinnati Chronicle,* 19 Feb. 1846). During times of low water, this bedrock obstruction proved vexing to ferry operators, and as the editor of the *Daily Cincinnati Chronicle* noted, "Over that limestone rock, steam-boats, even when the water is high very rarely venture. The channel, as used by steam-boats, is on the Cincinnati shore." This, of course, proved an important advantage for Cincinnati in attracting and sustaining the steamboat trade that mushroomed along the Ohio River by the second decade of the 19th century. By 1831 Cincinnatians could rightfully boast that "we have the channel of the river sweeping our shore.—This last advantage must forever exclude our less favored neighbors, during a great part of the year, from the benefit of a harbour, and constitute Cincinnati their place of deposit" ("Bridge Over the Ohio," *Cincinnati Daily Gazette,* 12 July 1831).

Human action reinforced the geographical advantages of Cincinnati. In 1788, years before the invention of the steamboat, Israel Ludlow, acting as surveyor for a partnership of three, platted the town of Cincinnati. In his plan for the city, he made a two-block-long area, fronting the Ohio River between Main and Broadway Streets, "a common or public ground forever, reserving the privilege to the proprietors of a ferry, within those limits" (Cist 1859, 15). This area later became the public wharf of Cincinnati, where steamboats landed to load and unload goods. On the other hand, the original town of Covington, platted in 1815, did not have a public wharf. Indeed, the limits of the city did not even extend all the way to the river's shore. Rather, in the typical shingled-over surveying fashion of Virginia, a tiny strip of land, separately owned, lay between the river and the town of Covington.

While explorers and pioneers had pushed into the central, Bluegrass region of Kentucky by the 1770s, colonization of Northern Kentucky awaited the establishment and subsequent development of the Northwest Territory, north of the Ohio River. Northern Kentucky, located along the southern shore of the Ohio River, was at the very edge of the frontier. Understandably, the precariousness of the area did not initially prove attractive to early settlers. Although not a permanent home to American Indians, it was nonetheless an important hunting ground of the Shawnees and of the Indians of the Miami Confederacy.

In addition to its more arable land and its gentler topography, the northern shore of the Ohio River was further promoted by specific features of the Northwest Ordinance of 1787. In particular, two provisions of the ordinance advanced settlement along the lines of New England. The first of these established a linear system of surveying and sale of lands in the territory, in accordance with the township model. Each township was to be 36 square miles, divided into 36 individual sections of 1 square mile. Further, section number 16 of each township was set aside for later resale, the proceeds of which benefited the local school district.

In contrast, Kentucky, as part of the state of Virginia, subscribed to the irregular, haphazard method of surveying common in the Old Dominion. Throughout Northern Kentucky, land was surveyed and granted either to veterans who had served in the British Colonial forces against France and its American Indian allies or to soldiers who had served in the Virginia lines during the American Revolution. Regardless, these grants were located and surveyed by a number of individuals, and over an extended period of time. The result was a topographical and legal jigsaw, where shingled-over claims led to years of litigation. Further, under this system, little if any land was initially set aside for later resale to benefit school systems. And finally, since most of the military land grants were of substantial size—for instance Prettyman Merry's 2,000 acres or Raleigh Colston's 5,000 acres—Northern Kentucky contained larger land tracts and fewer landowners. Stated Nathaniel Southgate Shaler (1841–1906), the scion of a pioneer family of Northern Kentucky: "Under this patent system there grew up a form of proprietorship where the land was held by relatively few men, who let it to tenants." The result, he claimed, was a difference in ideology. "Kentucky inherited from Virginia," Shaler maintained, "the mediaeval [*sic*] theory of a landed aristocracy resting upon a tenantry. North of the river . . . the conception of the relation of the people to the land was that of the free man working acres which he owned" (Shaler 1909, 32–33).

Further, the Northwest Ordinance prohibited slavery in the newly created territory north of the Ohio River. In Kentucky, of course, the institution of slavery existed from the beginning, making the area attractive to certain types of labor-intensive agricultural pursuits like the cultivation of tobacco. And as many Northern Kentuckians and Southerners themselves noted in the first half of the 19th century, slavery was a mixed blessing, for it contributed to the backwardness of Kentucky by reinforcing the remoteness and isolation of its plantation system, by discouraging immigration and the growth of manufacturing, by depreciating the work ethic, and by encouraging inferior productivity (for, they claimed, slave labor was always less productive than free labor).

The absence of slavery in the Northwest Territory attracted a number of migrants opposed to the institution, namely Quakers. In addition, other resemblances to the New England and Mid-Atlantic states, such as the system of surveying and the existence of townships, drew immigrants from those areas. As a result, at least in its early days, Cincinnati allured settlers from places like Connecticut and New Jersey.

Slavery also proved a drawback in that it perpetuated ideas and customs increasingly out of character with the advances of the 19th century. As Shaler professed, "institutionally" Ohio and Kentucky were "widely parted," where "one represented the motives of the nineteenth century, the other of the sixteenth" (Shaler 1909, 32). Slavery and the tenant system, he thought, deepened and solidified an aristocracy incompatible with democracy. Even in farming techniques, Shaler theorized that large landowners and their tenants were fixed upon older, more conservative methods. Crop rotation was generally disregarded, he noted, and coupled with the cultivation of tobacco, the soil was rapidly exhausted. Within "the first sixty years of this atrocious process nearly one half of the arable soil of the northern counties of Kentucky, where most of the surface steeply inclined, became unremunerative [*sic*] to plough tillage" (Shaler 1909, 35).

LAND GRANTS AND EARLY SETTLERS

Despite the geographical and political differences between Cincinnati and Northern Kentucky, the social ties were inextricable. Settlers in both Southern Ohio and Northern Kentucky resembled more than differed from each other, and both actively promoted urbanization. Among the foremost of these early pioneers was James Taylor Jr. (1769–1848), who was born in Caroline County, Virginia. A child during the American Revolution, he came of age during the postrevolutionary years, in time to settle a portion of a 1,500-acre tract of land his father purchased from Colonel George Muse, a soldier of the Colonial lines in the French and Indian War. This land was situated at the confluence of the Licking and Ohio Rivers, on the eastern shore. In 1780, James's older brother, Hubbard Taylor (1760–1840), became deputy surveyor for the county of Kentucky, Virginia. In April he surveyed the 1,500-acre tract for his father, and in 1788, he purchased 500 acres of land for himself, east of Lexington. In 1790, Hubbard Taylor removed to Kentucky with his family and his eldest sister, Lucy Eubank; her husband, James; and their family. Then, in autumn 1791, Hubbard accompanied the Kentucky militia from Lexington to Fort Washington to join General St. Clair's expedition against the American Indians. At that time, he laid out some lots at the mouth of the Licking and called the place New Port.

One year later, in 1792, Hubbard's younger brother, James, who had been promised the bulk of the 1,500-acre estate by his father, first visited Kentucky. James Taylor traveled overland to Redstone (now Brownsville), Pennsylvania, on the Monongahela River, where he and a number of westward-bound settlers directed the building and launching of 25 flatboats. In April 1792 he and his personal slave, Adam, set sail with a large company down the Monongahela to the Ohio River. On May 1 the party arrived at Limestone (now Maysville), Kentucky. James journeyed onward to his brother Hubbard's estate about

General James Taylor Jr. Courtesy of the Kenton County Public Library, Covington.

12 miles east of Lexington, Kentucky, and from there, he visited Lexington, where he stayed with Thomas Carneal, the father of Thomas D. Carneal, who later became one of the founders of Covington. Leaving Lexington, James Taylor proceeded along the Dry Ridge Trace, "a mean horse path" to Cincinnati. He visited with the officers at Fort Washington and crossed the Ohio River to view his family's property. He examined the site thoroughly and determined to build his home upon a "beautiful ridge," some 400 yards from the Ohio River and "about 600 yards from the Licking," a site he later called Belle Vue, for it commanded an exquisite view. James noted that the Cincinnati and Northern Kentucky areas were still sparsely settled. Indeed, he related that "at this time, June 1792, there were only about 150 souls in Cincinnati, independent of the Military. The American Indians were so troublesome there were but few settlements beyond Cincinnati, and they in and about the stockade forts." (Dickoré [1970s?], 44)

Returning to Virginia from his 1792 trip to Kentucky, James Taylor made immediate preparations to migrate to Northern Kentucky. In April 1793—along with his sister, Alice; her husband, Washington Berry; the Berrys' 9-month-old son; two black slaves and one white servant of James'; and two single men, John Berry (Washington Berry's brother) and John W. Buckner—James embarked on his journey. At Redstone (now Brownsville), Pennsylvania, on the Monongahela River, the party boarded flatboats for Kentucky. Proceeding downriver, they arrived at Limestone (now Maysville), Kentucky, where Washington and Alice Berry decided to disembark and to travel southward, settling instead near Hubbard Taylor's estate at Lexington. James adhered to his original plans, continued downriver and landed above the mouth of the Licking on May 3, 1793. In November 1794 he journeyed to Frankfort, Kentucky, to establish the new county of Campbell, which was created from parts of Mason, Scott, and Harrison Counties by act of the Kentucky General Assembly on December 17, 1794. The act became effective on May 10, 1795.

In 1803, probably owing to Taylor's connections to his first cousin once removed, James Madison, then secretary of state under Thomas Jefferson, Taylor received a letter from the secretary of war, Henry Dearborn, informing him that the United States Congress had passed a law calling for the erection of a western arsenal. Governor Garrard of Kentucky and General Charles Scott, a distant relative of Taylor's father-in-law, Major Hugh Moss, had been appointed to inspect possible sites. Although Garrard later supported locating the arsenal in Frankfort, Kentucky, Scott remained steadfast in his resolve to see it at Newport. Taylor offered to donate 5–6 acres of ground "immediately at the mouth of the Licking" (Dickoré [1970s?], 63) for the arsenal, and the government accepted his terms and appointed him supervisor of the construction. Begun in 1803 and completed in the following year, the Newport Barracks, with additions over the years, became the chief army arsenal in the then-West, important in the War of 1812, the Mexican-American War, and the Civil War.

Opposite Newport, Kentucky, and on the western shore of the Licking River where Covington now lies, the land was sparsely settled. Francis Kennedy came to Cincinnati in 1789 and established a ferry across the Ohio River to present-day Covington. Shortly thereafter, his brother, Thomas Kennedy (1741–1821), moved to Cincinnati from Pennsylvania and either rented or made arrangements to purchase 200 acres at the confluence of the Ohio and Licking Rivers in Northern Kentucky from James Welch, assignee and patentee of a military warrant surveyed for Colonel Stephen Trigg (who died at the Battle of Blue Licks). Originally, the land was patented in 1780 to George Muse, a soldier of the French and Indian War and an acquaintance of Colonel James Taylor of Virginia, then assigned to Colonel James Taylor, given to Stephen Trigg, sold to John Todd (who later died at the Battle of Blue Licks), and, finally, assigned to James Welch. After moving to this area, Thomas Kennedy assumed control of the Kentucky side of Francis Kennedy's ferry, and in 1791 obtained a ferry license for himself from Woodford County, Virginia, to operate a ferry between Cincinnati and Northern Kentucky. In 1801 Thomas Kennedy legally purchased the 200 acres from Welch, the reason for the delay of the record of the sale until that time being unknown. He eventually built a stone house, located on the present site of George Rogers Clark Park on Covington's Riverside Drive.

Besides the Taylors and the Kennedys, another prominent pioneer family of Northern Kentucky was the

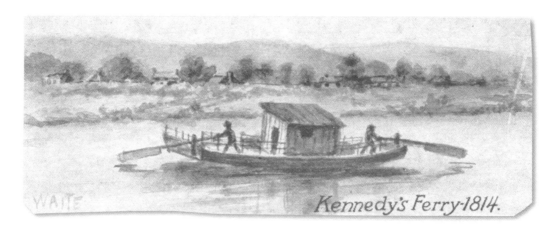

Kennedy's Ferry. Source: St. Mary, Franklin J., and James W. Brown, comp. *Covington Centennial: Official Book and Program.* Covington, KY: Semple & Schram, 1914.

Colstons. Raleigh Colston (1747–1823), the scion of an old Virginia family that had immigrated to America about the middle of the 17th century, was born to affluence at Exeter Lodge in Northumberland County, Virginia, in 1747. Shortly after the death of his mother, Raleigh moved with his family to Hornby's Manor, Virginia, on the Rappahannock River. Hornby's manor had been willed to Raleigh and his brother, William, by their great uncle by marriage, Daniel Hornby. In 1752 or 1753, Raleigh's father died, so Raleigh and William were sent to live with a guardian, Mr. Beall, who employed a private tutor for the boys. Raleigh recalled this teacher many

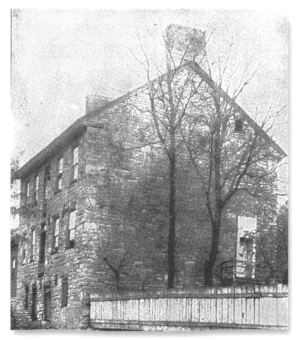

Thomas Kennedy's home on Riverside Drive (demolished). Source: St. Mary, Franklin J., and James W. Brown, comp. *Covington Centennial: Official Book and Program.* Covington, KY: Semple & Schram, 1914.

years later with particular affection, claiming he taught him "to read & write & carried me as far as Eutropius in Latin" (Edward Colston Papers). In addition, Raleigh noted that the tutor "was very attentive to my moral conduct and impressed me with religious sentiments which I have never forgotten" (Edward Colston Papers). Another guardian and relative, Major Traverse Tarpley, apprenticed Raleigh at the age of 14 to the mercantile house of Tarpley, Thompson, and Company in Williamsburg, Virginia. There, Raleigh stayed for two or three years, and lived a somewhat extravagant, prodigal life. "My principal associates," he recollected years later, "were the students of William & Mary College, & most of whom were at that time much more celebrated for their vices than their literary arguments. I frequently fell into the dissipated practices of my companions. I read none, my mind was a blank, and no inquiry was made into the conduct of my guardian" (Edward Colston Papers). Following the death of Tarpley and the dissolution of his mercantile house, Raleigh returned home to his former guardian, who was "very indulgent," furnishing him "with a good horse" so that he "went and came when and where" he pleased. Stated Raleigh, "After pursuing this idle dissipated life for 12 or 18 months [additional] I became perfectly disgusted with an idle life and determined to apply myself" (Edward Colston Papers).

Boarding with a respectable gentleman in the area, Raleigh Colston studied and read for 12 or 15 months, before deciding to enter law. Honorable John Taylor and Presley Thornton, longtime friends of Raleigh's father, then introduced him to a Williamsburg lawyer, George Wythe (1726–1806), under whom Raleigh studied law. Wythe was one of the great patriots and intellectuals of his era. He married Elizabeth Taliaferro (of a well-known Virginia

and, later, Northern Kentucky, family), signed the Declaration of Independence, was a delegate to the Constitutional Convention in 1787, and taught law to Thomas Jefferson, James Monroe, John Marshall, Henry Clay, John Breckinridge, and many other notables. Embarking upon a practice of his own in Richmond and Northumberland County, Virginia, Colston soon became bored by the profession, sold his father's estate, and made plans to enter the ranks of the American revolutionaries. He received an "appointment of commercial agent, for the purpose of collecting military stores from abroad," and subsequently, he "settled at Cape Francois in St. Domingo and was connected with a house in Curacoa" (Edward Colston Papers). After the war, in June 1784, he returned to the United States a wealthy man. He moved to Richmond, Virginia, married Elizabeth Marshall, the sister of Chief Justice John Marshall, and in 1785 retired to the life of a gentleman farmer in Frederick County, Virginia. With his brother-in-law John Marshall, he invested in lands in "what was then the far West, now the Valley of Virginia and West Virginia" (Edward Colston Papers). In 1801 he removed to a new estate, Honeywood, in Berkeley County, Virginia, along the Potomac River, where he died in 1823.

Raleigh Colston speculated in land in Northern Kentucky as early as the 1780s, in conjunction with his half-sister's husband, Colonel William Peachy. Peachy, a veteran of Virginia's American Revolutionary troops, was entitled, by a 1779 Virginia act, to military bounty lands in the west. Therefore, in April 1780, Peachy entered a formal request for land with the registrar of the Virginia Land Office and was issued several land warrants. After the war, he hired two surveyors, Thomas Marshall, the surveyor of Fayette County, and Robert Johnson, the deputy surveyor, to locate lands for him in Northern Kentucky, then Fayette County, Virginia. On March 10, 1784, the two men surveyed a 5,000-acre tract for Peachy in Northern Kentucky, now comprising part of Covington and many of its suburbs to the west. Three days later, they marked out another 5,000 acres for Peachy not far distant from the first tract. Soon after, Raleigh Colston purchased Peachy's rights to the first plot of land. In technical terms, then, Colston became the assignee to one of Peachy's military warrants.

It was logical that Peachy and Colston located their lands in Northern Kentucky, for that is where their Virginia friends and family had chosen to speculate. James Taylor's father had been a childhood friend of Raleigh Colston's father, and the Colstons were related by marriage to the Beall family, early settlers of Northern Kentucky. In addition, the Colstons, the Brockenbroughs, and the Stevensons seem to have been Virginian acquaintances. The second wife of Raleigh Colston's son, Edward, was Sarah Jane Brockenbrough, the first cousin of John White Stevenson. Stevenson was the son of Andrew Stevenson (1784–1857), a US representative (1821–34); Speaker of the House (1827–34); minister to Great Britain (1836–41); and an acquaintance of Thomas Jefferson, James Madison, and John Marshall, who, of course, was tied by marriage to the Colston family. John White Stevenson moved to Covington in 1841 and became a US representative (1857–61), governor of Kentucky (1867–71), and a United States senator (1871–77).

Covington Land Grants

Mapping late 18th-century land grants—and superimposing them on detailed modern maps—is a cumbersome and inexact process. In the 1700s, surveying was very basic. Two men, standing with poles attached by a chain of 16.5 feet, would measure out land, using creeks, trees, stones, and other natural phenomena as their markers. Since the trees and other markers have long since disappeared, and the rivers and creeks have changed course, the puzzle pieces are incomplete. For example, Robert Johnson surveyed a 2,000-acre tract of land for Prettyman Merry on March 10, 1784. One of the corners of the property was formed by "two Beeches at the mouth of a branch about one Mile below the mouth of Licking" ("Prettyman Merry"). The beech trees are long gone, but the creek 1 mile below the Licking was undoubtedly the Willow Run, which has since been piped underground and displaced by I-75/I-71. Its mouth was in the vicinity of today's Brent Spence Bridge. The survey further references neighboring

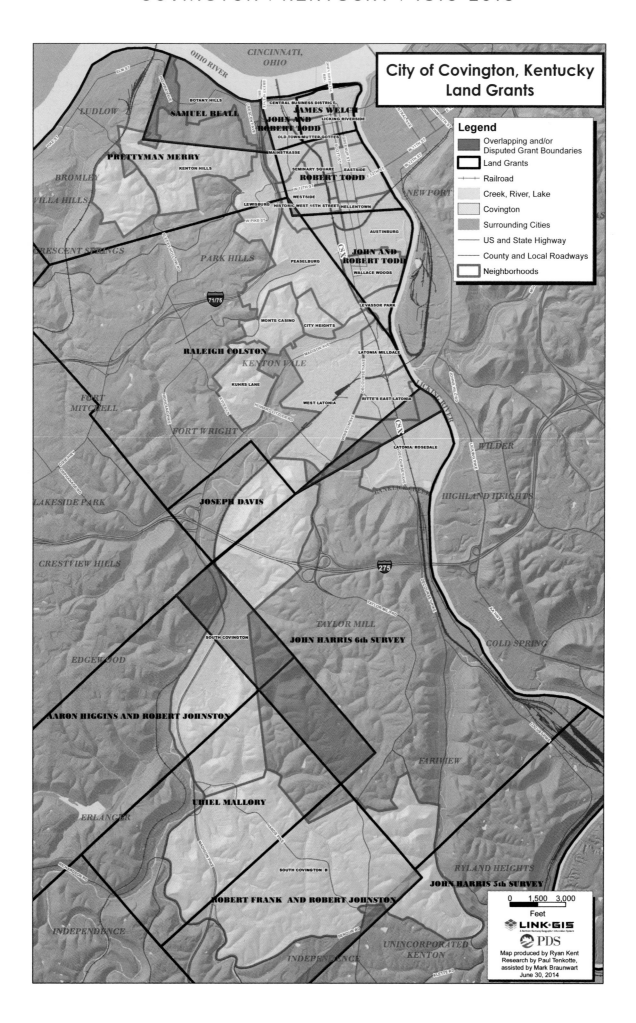

City of Covington, Kentucky
Land Grants

Legend
- Overlapping and/or Disputed Grant Boundaries
- Land Grants
- Railroad
- Creek, River, Lake
- Covington
- Surrounding Cities
- US and State Highway
- County and Local Roadways
- Neighborhoods

Map produced by Ryan Kent
Research by Paul Tenkotte,
assisted by Mark Braunwart
June 30, 2014

"Peachy's line." William Peachy assigned his adjoining patent to his brother-in-law, Rawleigh (Raleigh), for whom Robert Johnson surveyed 5,000 acres (also on March 10, 1784). Colston's survey, in turn, refers to a "branch of Dry Creek" ("William Peachy"). And so, piece by piece—inaccurate by perhaps dozens or even hundreds of feet—a map emerges. For example, an 1815 resurvey of Colston's land grant, for a court case, found that the property was actually 5,760 acres, not 5,000 acres! Fortunately, later sales of land and the development of 19th- and 20th-century landmarks, like farms, cemeteries, and subdivisions, provide a few scattered clues.

Prettyman Merry (1742–1817) received a 2,000-acre land grant, which encompasses part of the Main-Strasse, Lewisburg, and Kenton Hills neighborhoods of Covington, as well as part of Devou Park. In the late 1790s, he and his son, John, cleared bottomland in the parcel and perhaps built a still-surviving stone house in what is now Bromley, Kentucky, although this could have been built later. In January 1797 Prettyman Merry agreed to divide his 2,000-acre land grant in half with General Thomas Sandford (1762–1808), the purchase price to be determined thereafter. A native of Westmoreland County, Virginia, Sandford served in the American Revolution, moved to Kentucky circa 1792, and later was a general in the Kentucky militia. He was a member of the Kentucky General Assembly, and served two terms in the United States House of Representatives (1803–07). After the death of his first wife, he married Margaret Bell in 1805. Thomas Sandford drowned in the Ohio River in 1808.

Since the land surveying process was basic, and the legal claiming of land in Virginia was complex—requiring four steps: a warrant, an entry, a survey, and a patent—it was not uncommon for land grants to be overlapping, or shingled over. In the case of Prettyman Merry's 2,000 acres, the title was clouded much more than usual. Samuel Beall claimed that he was the assignee of James Mercer, who received 1,000 acres, basically contained within Merry's original survey (see land grant map). Beall's surveyor was not Robert Johnson, who was Merry's surveyor. The resultant litigation required 10 years to unravel, 1809–19, and resulted in Beall obtaining title to 546.75 acres (for a very thorough description of the court case, see Kreinbrink and VonStrohe 2014).

Robert Johnston/Johnson was a very skilled surveyor and one of the earliest pioneers of Kentucky. He and his brother, Cave Johnson, were early settlers of Bryan's (Bryant's) Station in central Kentucky in 1779. Robert Johnson was a member of the first and second constitutional conventions of the new state of Kentucky, and with other surveyors established the official boundary line between Kentucky and Virginia. Founder of Big Crossing (also called Great Crossing) near present-day Georgetown, Kentucky, Robert served as a Kentucky state representative and senator. His first wife, Jemima Suggett, and his second spouse, Fanny Bledsoe, came from old Virginia families with Northern Kentucky ties. Robert and Jemima's son, Richard Mentor Johnson, was a hero of the War of 1812 and served as vice president of the United States from 1837 until 1841. Robert Johnson surveyed land for his brother, Cave, who settled in Boone County, Kentucky, along the Ohio River in 1796. Today, the Cave Johnson Home still stands on Kentucky State Route 8.

Prettyman Merry and Robert Johnson married Thomas Sandford's cousins, respectively, the sisters Catherine and Jemima Suggett. Further, these marriages made Prettyman Merry and Robert Johnson brothers-in-law. Northern Kentucky, including the land that became Covington, boasted some of the most highly coveted land sought by Virginia's aristocracy. Robert Johnson, realizing the importance of the Ohio River, surveyed much of Northern Kentucky for his family and friends. They, in turn, sent younger sons either to settle or to buy and sell the land for profit.

Robert Johnson shared two land grants in what later became South Covington, one with Aaron Higgins and the other with Robert Frank. Aaron Higgins was an ensign in Captain Bush's Company of Kentucky Militia. The Kentuckians served under General Josiah Harmar in his autumn 1790 expedition against a confederacy of Northwest Territory Indians, composed of Miami, Shawnee, and Delaware tribes. A part of the Northwest Indian War (sometimes called Little Turtle's War, after the war chief of the Miami tribe), the expedition resulted in a major defeat for US troops. Aaron Higgins died in battle on October 22, 1790. Less is known about Robert Frank, who was probably from the wealthy and influential Frank family of Westmoreland County, Virginia, in the Northern Neck (peninsula) between the Potomac and Rappahannock Rivers.

The Todd family received three land grants encompassing what are now historic neighborhoods of Covington, west and south of the original town limits. A 90-acre survey, as well as a 300-acre parcel, was assigned to Reverend John Todd and Robert Todd. Reverend John Todd of Virginia was the uncle of John (1750–1782), Levi (1756–1807), and Robert (circa 1757–1814) Todd. The three brothers were early settlers of the Bluegrass area of Kentucky. The oldest brother, John, died at the Battle of Blue Licks in 1782, and hence was not the John Todd of the Covington land grants. The middle brother, Levi, was the grandfather of Mary Todd Lincoln (1818–82), wife of President Abraham Lincoln. The Todds never settled in Northern Kentucky but sold their land to others who did.

One of the major landholders of Kentucky was Colonel John Jordan Harris (1732–1800) of Virginia. Part of the South Covington neighborhood is contained within two of his immense land grants. The northern one, called John Harris 6th Survey, contained 5,000 acres, and to its south the John Harris 5th Survey encompassed another 5,000 acres. Unfortunately, Robert Johnson was not Harris's surveyor, and so the two land grants lack his accuracy. Instead, the John Harris land grants (as re-created in this land grant map) overlapped land surveyed by Robert Johnson on behalf of his clients Raleigh Colston, Robert Frank, Aaron Higgins, and Uriel Mallory.

The shingled-over land grants of Raleigh Colston and the John Harris 6th Survey, in an area south of Ritte's corner in the present-day Latonia/Rosedale neighborhood of Covington, proved particularly contentious. John Jordan Harris lived in Cumberland County, Virginia, and was a member of that county's Committee of Safety during the American Revolution. He was involved in the building of the James River and Kanawha Canal, which had been surveyed by George Washington. In 1754, John Jordan Harris married Anne Obedience Turpin (1734–1800), the first cousin of President Thomas Jefferson (1743–1826). John and Anne's daughter, Judith Harris (1765–1813) married Major John Crittenden (1754–1809), an American Revolutionary soldier and friend of Judith's brother, John Harris (1738–1821). In the late 1790s, John Crittenden assumed possession of his father-in-law's 5,000-acre 6th Survey (minus 200 acres that had already been sold to William DeCoursey). Crittenden's son, John Jordan Crittenden (1787–1863), was a governor of Kentucky, a US representative and senator, and US attorney general under Presidents William Henry Harrison and Millard Fillmore, as well as the architect of the Crittenden Compromise that attempted to avert the Civil War.

The Colston-Harris/Crittenden land dispute took decades to unravel. General James Taylor of Newport, Kentucky, resolved the difficulties, essentially by buying large tracts of land from both Colston and Crittenden. Taylor purchased what became known as Taylor's Mill on Banklick Creek, a grist and saw mill whose location was "on the north side of the creek at about the place where Riedlin Road intersects Grand Avenue" (Hammons 1988). Hence, much of present-day Latonia became Taylor family property. Some 1,200 acres of his Latonia-area property were included in Taylor's 1844 will to his four children, James Taylor III, Keturah L. Harris, Ann Taylor Tibbatts, and Jane Taylor Williamson.

Uriel Mallory Sr. (1737–38 to 1824) received 2,320.75 acres in what is now the South Covington neighborhood. Mallory, of Orange County, Virginia, served as a captain in the Virginia lines of the American Revolution. He and his wife, Hannah Cave, had many children. Two of their daughters married into the Welch family: Mary married Nathaniel Welch, and Elizabeth married Oliver Welch. Two other daughters married into the Terrell/Terrill family: Susannah to Oliver Terrill, and Nancy Ann to Robert Terrill. Their son, Uriel Mallory Jr., married Melinda Welch. Perhaps the Welches were related to James Welch, the grantee of the original 200 acres that comprised Covington. It is also possible that the Terrells were related to the family of the same name who settled in Northern Kentucky. Most important, Uriel Mallory Sr. was the uncle by marriage of Robert Johnson, the well-known surveyor of the property. Robert Johnson's mother was Elizabeth Cave, sister of Hannah Cave, the wife of Uriel Mallory Sr. In addition, Robert and Cave Johnson's sister, Hannah Johnson, married Thomas Montague. The Montague family settled in Northern Kentucky, particularly a large part of what is now Devou Park. Montague Road is named for them.

Joseph Davis/Daveiss (1745–95) received 600 acres in what is now part of the South Covington neighborhood. Daveiss, of Bedford County, Virginia, served as a second lieutenant in the Virginia lines of the American Revolution. He and his wife, Jean Hamilton (1746–86), moved to the area of what is now

Danville, Kentucky, circa 1779. Their son, Joseph Hamilton Daveiss, was a well-known Kentucky lawyer, married to Anne Marshall, the sister of US Chief Justice John Marshall. Joseph Hamilton Daveiss was the first attorney from the western states to argue a case before the US Supreme Court. He died at the Battle of Tippecanoe in 1811.

Raleigh Colston's son, Edward (1786–1851), attended to his family's Northern Kentucky property. In an 1829 letter to his brother, Dr. Raleigh T. Colston of Paris, France, Edward chided his brother for not acknowledging a communication he had sent him the prior spring, in which he had mentioned his "intention of taking up a temporary abode in this western country [around Cincinnati], for the purpose of attending to our interests here." Edward noted that he had first visited Cincinnati in 1812, and it is possible that he did so during the War of 1812, of which he was a veteran. The growth and prosperity of the city impressed him greatly. Edward stated that he had "determined to locate myself near" Cincinnati "during my stay here, on account of its easy intercourse with all the country below where our lands lie," and that he was having a house built in Covington for his family. He hoped to move into his Covington residence by May of the same year. According to the 1830 census schedule, he, his wife, their two daughters, six slaves, and one free colored servant lived in Covington. They were listed between two other prominent Covingtonians, Thomas D. Carneal and James G. Arnold. Edward's son, Edward Colston II (1844–1928), became a well-known Cincinnatian, marrying into the famous Stevenson family. Edward II's first wife was Sally Coles Stevenson, daughter of later Kentucky Governor John White Stevenson. When Sally died, Edward married her sister, Mary White Stevenson. (Edward Colston Papers, box 1, folder 1, letter #4)

Thomas Davis Carneal (1786–1860), born in Virginia, came to Kentucky with his family "about the year 1792." In 1806 Carneal moved to Cincinnati; in 1812, "he engaged in military affairs with General James Taylor"; and in 1814 he entered into a partnership titled the Covington Company, with John Stites Gano of Cincinnati, Richard M. Gano of Georgetown, Kentucky, and James Bryson (*Short Sketch* [1915?], 2). The four partners made arrangements to purchase, in August 1814, 200 acres of land at the mouth of the Ohio and Licking Rivers from Thomas Kennedy. In February 1815 Carneal married Sally Stanley, the widow of Major William Stanley, daughter of Major Silas Howell of Morristown, New Jersey, and the sister of the first Mrs. Nicholas Longworth. The marriage placed Carneal in an even higher social standing. By May of the same year, Carneal sold his interest in the newly platted town of Covington, excepting a 9.5-acre reserve, and by 1820 he purchased a 968-acre estate in present-day Ludlow, Kentucky, and erected a palatial home there. In 1831 he moved to Cincinnati.

The Covington Company, of which Carneal was an original partner, obtained a charter from the Kentucky General Assembly in February 1815, incorporating the town of Covington. Its provisions named five trustees, who acted on behalf of the proprietors in the sale of the lots and in the governance of the town. In late August 1815, the plat of the town of Covington, occupying 150 of the company's 200 acres, was officially recorded. A total of 299 lots were platted on a linear grid, the first three of which were reserved for the ferry, for the operation of which John S. Gano and Thomas D. Carneal obtained a county license in February 1816. Four lots were reserved for the public square and were later used for that purpose, but were never formally dedicated as such.

The Covington Company featured a number of lot auctions to promote its town. The first of these was held on March 20, 1815; notice was given in *The Western Spy,* a Cincinnati newspaper, in late February. The announcement proclaimed that Covington, "a new town," occupied a "commanding & beautiful position" that was "generally known throughout the Western country." It lay at a number of important crossroads, namely the confluence of the Licking and Ohio Rivers, as well as along "the main road from Lexington Ky. to Cincinnati, Dayton, and western parts of the state of Ohio." Further, "opposite to the flourishing town of Cincinnati," it was "convenient to a good Market, Steam Mill, and a variety of Factories, the facility with which all kinds of building materials can be procured." In short, then, the proprietors of Covington promoted their town as a possible rival of Cincinnati—a location sufficiently important in itself to attain,

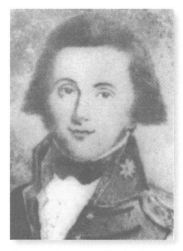

General Leonard Covington, of Maryland, who died at the Battle of Chrysler's Field in 1813, a hero of the War of 1812. Courtesy of the Kenton County Public Library, Covington.

eventually, a certain degree of independence and self-sufficiency. Until it had advanced to such a point, however, they were pragmatic enough to avail themselves of the marketable advantages offered by its proximity to Cincinnati. Nowhere in this or in other early notices of the town are there references to its possibilities as a quiet, pastoral suburban village. Instead, the owners advanced the city as ideal for the "enterprising merchant, mechanic, manufacturer & men of business of every description."

Securing factories for the young town of Covington was, indeed, an important priority of its early boosters. For example, in 1828 Thomas D. Carneal, although he had by then sold his interest in the Covington Company, gave seven of his personal lots to four individuals interested in building a cotton factory in Covington. Apparently, Carneal's offer of a site proved more attractive than incentives presented by the citizens of Newport, Kentucky, and the manufacturers informed Carneal that they would accept his gift, provided the city trustees allow the company to close off an alley. The trustees obliged, and the Covington Cotton Manufacturing Company, Covington's first major factory, began operations shortly thereafter.

The efforts of Taylor, Colston, Carneal, and other urban boosters earned substantial dividends for Northern Kentucky in the early 1800s. By 1830 Covington and Newport stood head-to-head in population, at 743 and 715 people respectively. The decades of the 1830s and 1840s witnessed even more spectacular growth, as the population of Covington leaped to 9,408 by 1850 and that of Newport to 5,895. Upon the foundations firmly set by Taylor and others, Northern Kentuckians promoted the construction of bridges, turnpikes, and railroads with increasing vigor from 1830 onward. Their urban ambitions, as reflected in both the contemplated and the completed works of internal improvement, marked the emergence of Covington as an important Kentucky city.

Early Settlers and Subdivisions

The recipients of early land grants in Covington regarded their land as investments. They looked for attractive opportunities to sell or develop their property. The Todd family sold their 90-acre parcel to Joel Craig in 1804. In early maps of Covington, Craig's Road was the name of present-day Craig Street, which at one time ran all the way to the shore of the Ohio River. Later, Craig sold parts of his land to James Riddle, who operated a ferry across the Ohio River, at the foot of Main Street (once called Ferry Street). At one time, Riddle Street was the name of what is now West Ninth Street. In 1825, the Bank of the United States (BUS) foreclosed on Riddle's extensive properties. Later, the BUS subdivided the land, naming Philadelphia Street after the city of its headquarters.

The Todd family sold their 400-acre tract of land, south of the original town of Covington, to a number of early settlers and buyers, including Jacob Fowler (1764–1849), Robert Kyle (whose house stood near the corner of present-day Pike Street and Madison Avenue), Pressley Peake/Peek (see photo), Oner (Onerias)

The Gano-Southgate House, also known as the Carneal House, is located on East Second Street. It was the first brick house built in the city, probably with bricks from Thomas D. Carneal's own Covington brickyard. The Buckner Family Papers at the Filson Club Historical Society in Louisville, Kentucky, contain a February 8, 1816, agreement between Thomas D. Carneal on the one hand and Thomas Catlett Buckner (1793–1844) and George Buckner on the other. The Buckner brothers were contracted to do the joiners' work (that is, the carpentry finish work) on Carneal's house. In payment, they were to receive 70,000 bricks from Thomas Carneal's brickyard. This newly found document settles longtime debates about the date of this house and some of its possible builders. Photo by Dave Ivory.

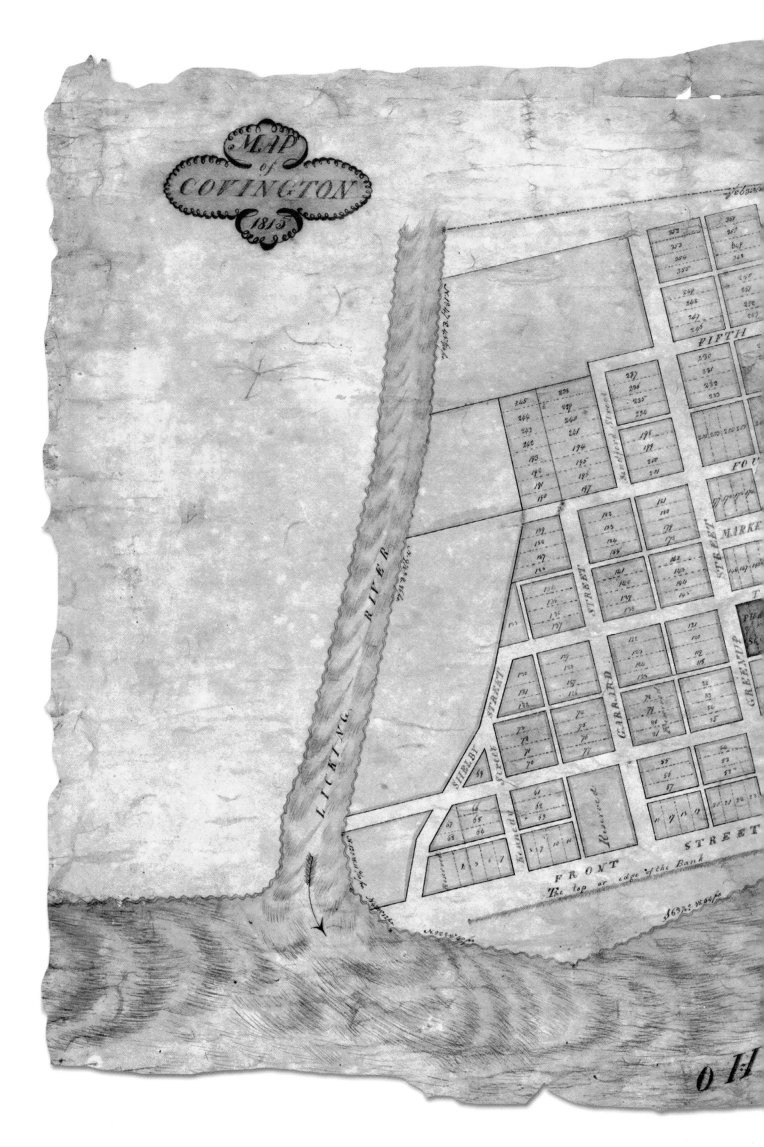

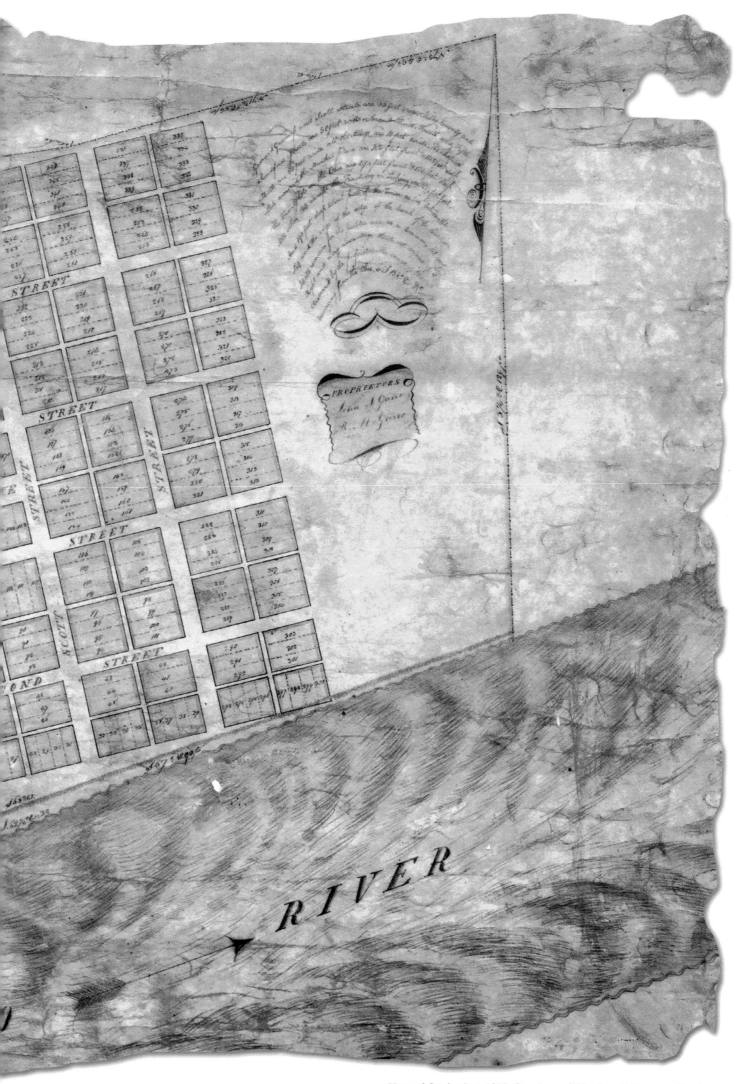

Map of Covington, 1815. Courtesy of Cincinnati Museum Center.

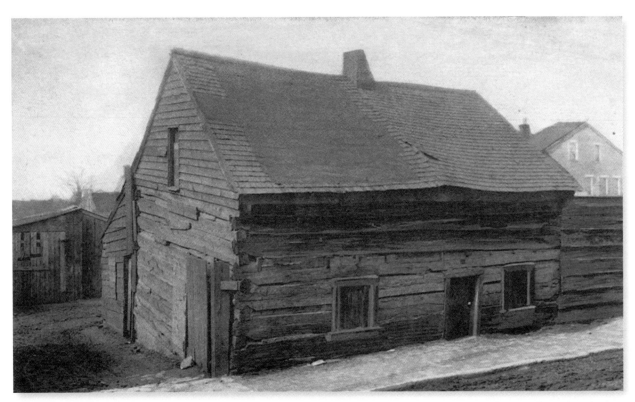

The first house built in what became the city limits of Covington, this log dwelling constructed circa 1792 was located on West Ninth Street, between Russell and Banklick Streets. Various stories of its origins exist, but the most likely is that it was built by the early settler Pressley Peake (also spelled Peek). Courtesy of Paul A. Tenkotte.

Powell (1771–1863), and the Western Baptist Theological Institute (which later divided its property into almost 700 building lots). Major Jacob Fowler was one of the pioneer settlers of Northern Kentucky, building the first cabin in Newport, Kentucky, helping to survey the first road from Newport to Lexington, operating a ferry across the Licking River, and participating in the founding of the Newport Academy in 1798–99. As a soldier, Major Fowler served in expeditions of the Northwest Indian Wars, including Harmar's Defeat in 1789 and Wayne's victory at Fallen Timbers in 1794. A skilled surveyor, he participated in the US government's survey of the Great Plains and the foothills of the Rocky Mountains. Guide of the noted Fowler-Glenn Expedition of 1821–22, which pioneered the Old Taos Trail into New Mexico, Fowler kept a detailed journal of the expedition that was later edited and published by the renowned American scientist Elliott Coues as *The Journal of Jacob Fowler*. Fowler's Covington home stood at West 11th and Banklick Streets.

In the 19th century, when Onerias Powell or the Western Baptist Theological Institute officially filed courthouse plats subdividing their property into small lots, they did so in a fashion different from the later 20th century. So-called subdivisions in 19th-century cities like Covington were simply divisions of property into building lots, streets, and alleys. Individual buyers would purchase a lot or lots, and then would either build their house/houses themselves or hire house builders, bricklayers, carpenters, and so on to oversee the construction. Tract development as we know it today, whereby large companies develop subdivisions and build houses, was largely unknown.

The Todd family assigned their 300-acre land grant to Humphrey Marshall (1760–1841), brother-in-law of US Supreme Court Justice John Marshall, a US senator, author of *History of Kentucky* (1812), and one of Kentucky's largest landowners. In 1811, Marshall sold the 300-acre parcel to Joseph Robinson, who settled there and built a house that stood on Banklick Street, south of what later became West 15th Street. Robinson, in turn, sold 134 acres to Onerias Powell (Powell Street—now 15th Street—was once named for him). Eventually, within the original 300-acre Todd land grant, other subdivisions developed, including Austinburg (developed by Seneca Austin), Holmesdale (Daniel Holmes), Levassor Park (named for Eugene Levassor), and Wallace Woods (developed by Robert Wallace Jr. and his wife, Jane Eliza Sterrett).

Raleigh Colston's massive 5,000-acre land grant encompassed many later neighborhoods and subdivisions of Covington, including most of Latonia (later purchased by General James Taylor), Peaselburg, City Heights, Monte Casino, Kuhr's Lane, and the southern part of Lewisburg.

Prettyman Merry's 2,000-acre land grant (including the legal settlement to Samuel Beall) encompassed much of Devou Park, as well as the neighborhoods of Kenton Hills, Botany Hills (West Covington), and most of Lewisburg.

South Covington lies in parts of what was once a series of land grants to Joseph Davis, Robert Frank and Robert Johnson, John Harris, Aaron Higgins and Robert Johnson, and Uriel Mallory.

Other early settlers of Covington, according to Richard H. Collins (1882), included Edmond Rittenhouse, and John Martin, after whose family Martin Street is named. There is probably no truth to the claim that the Revolutionary War heroine Molly Pitcher settled in Covington, as many areas of the United States have such legends about her.

SELECTED BIBLIOGRAPHY

Burns, John E. *A History of Covington, Kentucky, through 1865*. Covington, KY: Kenton County Historical Society, 2012.

Campbell County Kentucky History and Genealogy. Falmouth, KY: Falmouth Outlook, 1978.

Cist, Charles. *Sketches and Statistics of Cincinnati in 1851*. Cincinnati, OH: Wm. H. Moore & Co., 1851.

———. *Sketches and Statistics of Cincinnati in 1859*. Cincinnati, OH: n.p., 1859.

Collins, Richard H. *History of Kentucky*. 2 vols. Covington, KY: Collins & Company, 1882.

Dickoré, Marie, comp. *General James Taylor's Narrative*. N.p. [1970s?]. Available from Kenton County Public Library in Covington, KY, and Campbell County Historical and Genealogical Society in Alexandria, KY.

Donnelly, Col. Joseph, M.D. *Newport Barracks—Kentucky's Forgotten Military Installation*. Covington, KY: Kenton County Historical Society, 1999.

Drake, Daniel. *Notices Concerning Cincinnati*. Cincinnati, OH: John W. Browne & Co., 1810.

Edward Colston Papers. Cincinnati Historical Society Library, Cincinnati Museum Center, Cincinnati, OH.

Gastright, Joseph F. *Gentleman Farmers to City Folks: A Study of Wallace Woods, Covington, Kentucky*. Cincinnati, OH: Cincinnati Historical Society, 1980.

Greve, Charles Theodore. *Centennial History of Cincinnati and Representative Citizens*. 2 vols. Chicago: Biographical Publishing Company, 1904.

Hammons, Michael J. *History of Taylor Mill, Kentucky*. Covington, KY: Sandy Cohen, 1988.

Johnson, Robert. "Survey of 2,000 acres for Prettyman Merry," Virginia Patent #0997.0, apps.sos.ky.gov/land/nonmilitary/patentseries/vaandokpatents/Default.aspx.

———. "Survey of 5,000 acres for William Peachy (assignee Raleigh Colston)," Virginia Patent #6676.0, apps.sos.ky.gov/land/nonmilitary/patentseries/vaandokpatents/Default.aspx.

Kreinbrink, Jeannine, and Doug VonStrohe. "Devou Park: Beginnings." *Northern Kentucky Heritage* 21 (2) (2014): 18–28.

Meehan, Eleanor Childs. *An Octogenarian's Personal Recollections of a Beloved Old Kentucky Town, "Old Covington."* Cincinnati, OH: Telegraph Press, 1924.

Northern Kentucky Newspaper Index. Covington, KY: Kenton County Public Library.

Shaler, Nathaniel Southgate. *The Autobiography of Nathaniel Southgate Shaler: With a Supplementary Memoir by His Wife*. Boston: Houghton Mifflin, 1909.

A Short Sketch of Thomas D. Carneal. Covington, KY: Pioneers' Association of Kenton County [1915?].

Smith, Allen Webb. *Beginning at "the Point," a Documented History of Northern Kentucky and Environs, the Town of Covington in Particular, 1751–1834*. Park Hills, KY: self-published, 1977.

St. Mary, Franklin J., and James W. Brown, comp. *Covington Centennial: Official Book and Program*. Covington, KY: Semple & Schram, 1914.

Tenkotte, Paul A. "Rival Cities to Suburbs: Covington and Newport, Kentucky, 1790–1890." PhD diss., University of Cincinnati, 1989.

Tenkotte, Paul A., and James C. Claypool, eds. *The Encyclopedia of Northern Kentucky*. Lexington, KY: University Press of Kentucky, 2009.

CHAPTER

GATEWAY BETWEEN THE NORTH AND THE SOUTH 1830-66

by Paul A. Tenkotte, PhD

BEFORE the Civil War, Covington was engaged in a two-tiered "urban sweepstakes." First, it considered itself a veritable rival of Cincinnati, Ohio, in a localized contest for municipal dominance. Second, Covington vied for statewide leverage in Kentucky against three strong competitors, Louisville, Lexington, and Maysville. By the late 1840s, however, the first tier of this dual urban sweepstakes dissipated, as the residents of Covington realized that they would never overtake Cincinnati in size or importance. Perhaps more important, Cincinnati no longer regarded Covington as a viable threat, although faint echoes of the rivalry would continue until the 1850s. Still, the second tier continued well beyond 1850, the year that Covington surpassed both Lexington and Maysville in population, becoming the second-largest city in Kentucky. It continued its struggle throughout the 1850s against Louisville for statewide dominance.

Throughout the latter part of the 18th and the first half of the 19th centuries, Covington devoted its civic energies to the development and pursuit of strategies aimed at winning the urban sweepstakes. Toward this end, leading citizens framed a four-point program that would strengthen Covington's position as a Gateway between the North and the South. First, they crusaded for the building of bridges, linking Covington and Newport, Kentucky, and more important, Covington and Cincinnati. Second, they completed plans for a macadamized turnpike between Covington and Lexington. Third, they built a railroad south. And fourth, they clamored for the extension of navigation on the Licking River, to be achieved through the construction of a network of locks and dams.

BRIDGING THE OHIO, ACT ONE

The earliest known source to propose the building of a bridge across the Ohio River from Cincinnati to Kentucky was Daniel Drake's *Natural and Statistical View, or Picture of Cincinnati and the Miami Country* (1815). In this account, Drake noted that "some enthusiastic persons already speak of a bridge across the Ohio at Cincinnati; but the period at which this great project can be executed, is certainly remote." Among the early advocates of a bridge linking Cincinnati to Northern Kentucky were Benjamin Drake and E. D. Mansfield. Benjamin Drake was the younger brother of the author mentioned above, Dr. Daniel Drake. Coming to Cincinnati in 1814 to join his brother, Benjamin studied law, established his own legal practice, and, in addition, served for many years as editor of the *Cincinnati Chronicle*. E. D. Mansfield was a graduate of West Point, an attorney, and, later, editor of the *Cincinnati Chronicle* from 1836 to 1848 and of the *Chronicle and Atlas* from 1849 to 1852.

In 1827 Benjamin Drake and E. D. Mansfield published a historic and statistical account of the Cincinnati area titled *Cincinnati in 1826*. In this volume, they reported that proposals to build a bridge over the Ohio River at Cincinnati had been a subject "of much speculation for several years past." The two men claimed that the

construction of a Y-shaped bridge, linking Cincinnati, Covington, and Newport, was entirely practical from an engineering standpoint. Indeed, they stated that "an architect who has superintended the construction of several bridges in the Miami Country [Ohio]" had considered the Y-bridge plan and estimated its cost at $150,000. In late 1827, an anonymous group of Northern Kentucky leaders drafted a petition calling for the incorporation of an Ohio River bridge company by the Kentucky General Assembly. As evidence of the need for a bridge, the petitioners held that the trade between Ohio and Kentucky had grown to such an extent as to warrant a "permanent bridge across the Ohio river [*sic*], so as to keep up communications between Cincinnati, Newport, and Covington" ("Bridge across the Ohio," *Liberty Hall and Cincinnati Gazette*, 6 Dec. 1827).

As stated by the petitioners, "the growing and rising importance of this section of the country, by the introduction of steam boat navigation on the Ohio river [*sic*], has drawn to this point not only travelers from East and West, but has concentrated a great portion of trade, from both Kentucky and Ohio." Further, the western routes of commerce were slowly changing and developing, as a new north-to-south trade began during the 1820s with the completion of the Erie Canal in New York. Claimed the Northern Kentuckians, "all the central part of Kentucky, north of the Kentucky river [*sic*]" would benefit from the bridge, for it would keep "open this communication direct to the lake. Indeed, it has already been announced, that merchants as far *South* as Nashville, in Tennessee, are beginning to order their goods by way of the New York Canal, and the lake. In the winter season, on snow, or when the ground is hard frozen, the communication from Cincinnati to the lake, will be kept open by means of *stages*, wagons, sleighs, or sledges, longer than in the spring or summer seasons."

The proposed bridge was, therefore, seen as a vital link in the Lake Erie–Ohio River commercial network. In July 1825 construction began on the Miami Canal, linking Dayton, Ohio, to Cincinnati. Practically coinciding with the petition for a bridge charter, the first canalboats arrived in Cincinnati on March 20, 1828. It was a joyous occasion marked by celebrations, cannon fire, speeches, and toasts, as "many thousands" of Cincinnati's residents "lined the banks of the canal for nearly a mile" ("Arrival of the Canal Boats," *Liberty Hall and Cincinnati Gazette*, 20 Mar. 1828). The Miami Canal extended Cincinnati's hinterland at least to Dayton, Ohio. Goods were transported from New York City and the east coast via the Erie Canal to Lake Erie and Cleveland, Ohio, and thence either overland to Cincinnati, or by way of the Ohio Canal to Portsmouth (along the Ohio River), and finally to Cincinnati, Covington, and points south. In later years, a more direct route was opened as the Miami Canal was extended to Toledo, and became known as the Miami and Erie Canal.

The bridge was needed for other reasons. In winter, the Ohio River was "frequently obstructed by ice," compelling ferryboat operators to suspend operations until conditions cleared ("Bridge across the Ohio," *Liberty Hall and Cincinnati Gazette*, 6 Dec. 1827). The ferries interrupted their services not only when ice formed a solid bridge from shore to shore but also when ice floes proved too dangerous. Indeed, the traffic between Cincinnati and Kentucky did, at times, come to a complete standstill for weeks on end. The cessation of trade by river ice, and during times of equally treacherous floodwaters, proved a hardship for residents of both shores, but particularly for Cincinnatians, who grew to depend on Kentucky supplies of fuel and food. Shortages of these necessities led to temporary price increases in Cincinnati that, in turn, bore heavily on the city's poor.

A bridge would also permit continuous traffic between Cincinnati and Kentucky, day and night, and there would be no delays occasioned by waiting for a ferryboat to take on passengers and to cross to the opposite shore. Obviously, a major drawback of the ferries was their abbreviated hours of operation. Generally, they shut down early in the evening, a situation that prevented many residents of Covington from attending the nightly theater and entertainments of Cincinnati.

The Kentucky General Assembly did not pass a bridge charter when it met in 1827–28. Nevertheless, during its next sitting, in 1828–29, the legislature approved the incorporation of the Kentucky and Ohio Bridge Company. The latter was the handiwork of 32 prominent residents of Covington, Newport, and Cincinnati. The charter, passed on January 29, 1829, authorized the company to build a bridge "from the towns of New-port [*sic*]

and Covington, or either of them" to Cincinnati, provided that the Ohio General Assembly ratify the act, and further, "that the consent of the Congress of the United States . . . be obtained before the said corporation shall commence the erection of the bridge" (Ky. Acts 119 1828–29).

The Kentucky and Ohio Bridge Company was capitalized at $300,000, issuable in 6,000 shares of stock at $50 each. The towns of Covington and Newport were permitted to subscribe to a maximum of 250 shares each, the state of Kentucky 1,000 shares, and the city of Cincinnati 500. The act additionally stipulated that the bridge was not to impede navigation in any way: "That the said permanent bridge shall be erected so as to permit the passage of ships, schooners, sloops and steam vessels, of the largest size and height, at the highest stage of water in the river, and shall have over the channel of the river a span or arch not less than two hundred feet wide, and the other spans or arches, not less than one hundred and fifty feet each." Further, the company was held liable for the loss of runaway slaves passing over the bridge.

The terms and conditions of the charter satisfied neither those who feared "the obstruction to the navigation of the Ohio," nor those Cincinnatians who felt assured that a bridge would develop the rival cities of Covington and Newport, at the expense of the Queen City ("From the Covington Farmers' Record," *Cincinnati Daily Gazette*, 24 June 1831). Many real estate owners in Cincinnati believed that property values would increase considerably in Northern Kentucky with the construction of a bridge, while those in Cincinnati would fall, or at least would not increase at former rates. A correspondent to the *Covington Farmers' Record*, in a letter signed "One of the People," disagreed with this position, stating that "the cure for commercial competition *on this side of the river* [the Kentucky shore], is prompt, cheap, and regular communication throughout the year with the markets of Cincinnati." The writer further claimed that the navigable channel of the river favored the Ohio shore at Cincinnati, thus affording the Queen City better and deeper harbor facilities than could ever be matched by Covington or Newport. And since the "channel of the river" and the "location of capital and business" were "already established on the Ohio side," the writer argued, Covington and Newport would "ever remain as Brooklyns to play a subordinate part in ministering to the distinction of the Western Emporium, and as auxiliary appendages in this particular" ("From the Covington Farmers' Record," *Cincinnati Daily Gazette*, 24 June 1831).

Notwithstanding the persuasiveness of the arguments advanced in favor of the bridge proposal, some Cincinnatians still viewed it with suspicion. "A Cincinnatian," in a letter addressed to the editor of the *Cincinnati Daily Gazette*, stated that the "first effect to be produced by the proposed connexion [*sic*], will be the transfer of a portion, more or less, of the population, capital and business of Cincinnati to the opposite side of the river" ("Communicated. Bridge over the Ohio," 4 July 1831). To claim that such a migration would not have a detrimental effect on Cincinnati, the writer claimed, was a gross inaccuracy. It would be, he maintained, an irredeemable loss "that might as well go to Lexington as to Covington; for, as soon as it passes the river, it becomes the capital of another corporation, and of another state. It will be taxed for their benefit, and not for ours. It will contribute nothing to sustain the improvements of this city or that of the state, and consequently, it will be so much capital lost to both." With easier access to Covington and Newport, he argued, future emigrants would settle there instead of Cincinnati. Likewise, the removal of population and business to Kentucky would reduce the value of that remaining in Cincinnati—and so the vicious cycle would continue. Not convinced by the arguments of the bridge advocates, "A Cincinnatian" replied poignantly: "I do not understand that system of arithmetic, which makes a part equal to, or more valuable than the whole. . . . The inference is plain, that in proportion as Covington gains, Cincinnati must lose, for the simple reason, that a part is less than the whole" ("Communicated. Bridge over the Ohio," *Cincinnati Daily Gazette*, 4 July 1831).

Citizens moving to Covington or Newport, "A Cincinnatian" claimed, not only would no longer contribute to the tax base of the Queen City and to the state of Ohio, but they would also become voters of the state of Kentucky, thus reducing the relative size and influence of Cincinnati's electorate, both statewide and

nationwide. Further, the writer questioned the validity of the argument that claimed that Northern Kentucky would continue to remain dependent upon Cincinnati for supplies and warehousing. Rather, Covington and Newport, he said, would develop their own infrastructures, and then compete with Cincinnati much "as Pittsburgh has . . . applying, in the same manner, all the profits of their industry, to their own advantage, and for their own aggrandizement."

The views of "A Cincinnatian" and of other opponents of the bridge held sway in the 1830s. The Ohio General Assembly did not pass a charter for the bridge company, nor is it known whether the matter was even presented to its attention by any Cincinnati interests. Accordingly, the bridge proposal quietly died. And by the terms of its own charter, which specified that construction had to begin within four years after the passage of the act, the bridge company ceased to exist. Nevertheless, the bridge topic was resurrected by the press on a sporadic basis in the mid-1830s. For instance, E. S. Thomas, editor of the *Daily Evening Post* of Cincinnati, remarked, in conjunction with the news that Louisville was planning to build a bridge across the Ohio River to Jeffersonville, Indiana, that Cincinnati would be wise to do the same to Covington and Newport. In Thomas's eyes, it was not difficult to "anticipate the time" when the "three [Cincinnati, Covington, and Newport] will be one." Such a union, he claimed, "would add to the prosperity of each. Pittsburgh found her advantage in taking Allegheny-town to wife . . . and we think Cincinnati, had better forthwith marry Newport and Covington,—never mind the *bigamy* of the matter. A city may wed two brides . . . think what a thriving progeny may be the result" ("Louisville Bridge Co.," *Daily Evening Post* [Cincinnati], 18 June 1835).

Market and Square, Covington, Kentucky. Source: *Ballou's Pictorial Drawing-Room Companion* 11, no. 25 (20 Dec. 1856).

COVINGTON AND LEXINGTON TURNPIKE

The bridge project languished until 1839, when proposals for a bridge across the Ohio River at Cincinnati reappeared. Then, a group of Lexington, Kentucky, citizens provided the impetus for the movement. Meeting at the courthouse of that city on March 11, 1839, to "take into consideration the importance of a speedy completion of the 'Covington and Lexington Turnpike Road,'" the Lexingtonians adopted an additional resolution calling for the construction of a bridge across the Ohio River at Covington ("Turnpike Meeting," *Covington Free Press*, 23 Mar. 1839). The proceedings of this meeting were then forwarded to Covington, where they were read to a group of public-spirited residents on March 16. Two days later, the Covingtonians again met and responded favorably to the Lexington proposals. Adopting a similar set of resolutions, calling for the completion of the Covington and Lexington Turnpike and the building of a bridge over the Ohio River at Covington, they sent copies of the same to the mayors and city councils of Newport, Georgetown, and Lexington, in an effort to solicit their support. Finally, they formed a committee, consisting of some of the most influential residents and manufacturers of the city, to make arrangements for the reception and entertainment of the Lexington delegation, which proposed a visit to Cincinnati.

On March 23, 1839, Cincinnati followed suit, and held a public meeting at the city council chambers to make preparations for the planned visit of the Lexington contingent, as well as to discuss the proposed bridge. The mayor of Cincinnati presided over the assembly, which appointed a committee of 15 "to receive and confer, and co-operate with the committees appointed by the citizens of Lexington and Covington, for the purpose of procuring the erection of a bridge across the Ohio river, from Cincinnati to Covington" ("Public Meeting," *Cincinnati Daily Gazette*, 26 Mar. 1839).

The Covington and Lexington delegations traveled to Cincinnati, where they were the guests of honor at a public meeting held at the College Hall on Friday evening, April 5, 1839. Apparently, the participants chose to defer the bridge proposal entirely, and instead, concentrated on plans to complete the macadamized turnpike to Lexington. In any case, the Cincinnatians appointed a committee of 10, whose sole function was to cooperate with the Kentucky groups "for the purpose of obtaining subscriptions from the citizens of Cincinnati" for the stock of the turnpike company.

The decision to finish the turnpike and to shelve, temporarily, the plans for a bridge, was a realistic one. Cincinnati depended vitally upon the Bluegrass region for the sustenance of its pork-packing industry. According to one correspondent, Kentuckians provided "about one-half of the hogs packed in Cincinnati and Covington" in the winter of 1838–39 (*Cincinnati Daily Gazette*, 11 Apr. 1839). In all, this amounted to some 70,000 hogs, purchased at an average cost of $12 per head, amounting to a direct payment of some $840,000 a year to Kentucky farmers. Further, it was estimated that some 10,000 cows were obtained yearly from Kentucky, which, at $40 per head, represented an additional $400,000 in cash payments. Had the residents of the Bluegrass region surrounding Lexington exchanged a good portion of these earnings for Cincinnati merchandise, the score would have been more evenly settled. However, Bluegrass farmers generally purchased goods from Maysville and Louisville merchants, for fine macadamized turnpikes connected Lexington with the latter two cities. In contrast, the Covington and Lexington Turnpike was, for the most part, a notoriously bad road in 1839. With the turnpike only partially completed, the improved, macadamized sections of the road lay near each terminus—10 miles outside of Covington and 12 miles from Lexington to Georgetown. The intervening 63 miles stretched through a sparsely settled, remote area of Kentucky called the Eagle Hills and the Dry Ridge, both spurs of the Cumberland Mountain chain.

The prominent role Kentucky farmers played in the pork-packing and beef industries of Cincinnati and Covington underscored the area's need to finish the Covington and Lexington Turnpike. Expressed succinctly in 1844 by a group of stockholders, the convenience of the farmers and drovers demanded a better and cheaper route to Northern Kentucky and Cincinnati, for they often experienced difficulty in "getting the stock to market in good condition, particularly in the winter season, when the prices are highest—which is illustrated by the fact that for

the want of a good road, cattle and hogs have been driven fifty miles on the Maysville and Lexington road, to Maysville, and thence shipped to the Cincinnati market, at a great expense to the owner" (*Licking Valley Register*, 20 Jan. 1844).

Kentuckians, meanwhile, viewed the turnpike as more than just a feeder line for Cincinnati's and Covington's pork-packing and beef industries. As the stockholders further remarked in 1844, the completed road would open new possibilities for the Kentucky farmers to transport their products directly to the east coast, via the Miami and Erie Canals. Indeed, they observed, this network was "destined shortly to be the great thoroughfare which will give transit to the beef, pork, bacon, flour, hemp, tobacco, and all the varied products of Kentucky agriculture, to its best market, the cities of New York, Boston, and the various manufacturing towns of the North and East" (*Licking Valley Register*, 20 Jan. 1844). In addition, Kentuckians would gain new access to alternative sources of manufactured goods from these same places.

In 1839 the road to Lexington did not lend itself to these visions. It still followed, for the most part, an old pioneer trail called the Dry Ridge Trace, which hugged the ridges of the hills north of Georgetown and south of Covington. The Dry Ridge divided the tributaries that flowed into the Licking River to the east from those flowing into the Kentucky River on the west. Part of the route followed an old buffalo trail that linked salt licks at Big Bone Lick and the Lower Blue Licks, and was used by American Indians and early settlers. By 1819 its condition was so poor as to warrant a special act of the Kentucky General Assembly, which made the route, for the first time, a turnpike. Noting that "the road leading from Georgetown to Cincinnati, through the counties of Scott, Pendleton, Boone, and Campbell, passes through a tract of country so thinly inhabited, that a large portion of it cannot be kept in repair, without great oppression to individuals," the state legislature appointed commissioners to oversee the leasing of the road, or portions thereof, to anyone who could keep it in good repair. In exchange for the improvement and upkeep of the road, the lessees were permitted to erect two tollgates, one at either end of the section of road they maintained.

The 1819 act applied only to the road between Scott County and Gaines's Tavern, a noted 19th-century inn at Gaines's Crossing (now Walton, Kentucky), 20 miles south of Cincinnati. A regularly scheduled stagecoach, owned by the inn's proprietor, Abner Gaines, and carrying the United States mail, was based at the tavern and operated between Cincinnati and Lexington from at least 1818.

As of 1819, the Covington and Lexington Turnpike began at Banklick Street in Covington (near Linden Grove Cemetery), passed over the Willow Run Creek, and climbed a steep hill southwest of the present Big Bend. It is not surprising that wagons and stages had a difficult time climbing this hill, for the steep grade there was far beyond anything imaginable.

In an effort to improve the road to Lexington, the Kentucky General Assembly chartered the Covington and Lexington Turnpike Road Company in February 1834. Capitalized at $300,000, this public stock corporation was largely the creation of Covington interests. The charter called for the construction of an "artificial road" of "stone, gravel, wood or other suitable materials" from Covington to Lexington, of a grade not to exceed five degrees, and empowered the company to "locate the said road, on the line on which it can be constructed with the least expense to the company, and which shall be the most direct" (Mackoy [1890?]). The state's growing interest in public improvements at this time was reflected by other broad-based powers given the turnpike corporation—the right "to survey, lay out and make their road, through any improved or unimproved lands," as well as the right to "take from the land occupied by said road . . . or from any lands in the vicinity thereof, any stone, gravel, timber or other materials, necessary to construct a good, secure and substantial road." In addition, the governor could subscribe to, on behalf of the state, up to $50,000 worth of stock, provided a like sum had been raised from private sources. Further, the general assembly actually decreed that the governor must, once $20,000 had been expended in construction of the road between Lexington and Georgetown, purchase $10,000 in stock from the company.

Construction of the macadamized Covington and Lexington Turnpike proceeded slowly. Considering, though,

the geographical obstacles that faced the company, particularly in grading the road over the steep hills southwest of Covington and in financing the route through the sparsely settled area of the Eagle Hills, the company fared well. Apparently, Covington and Lexington residents, convinced of the turnpike's importance to the successful outcome of their own urban agendas, subscribed liberally to the stock of the company. According to a report by the Board of Internal Improvement of the State of Kentucky in 1840, the 10-mile section completed and adjoining the city of Covington was, at an average construction cost of $7,800 per mile, the most expensive road-building project in the entire state. The construction included a rerouting of the road from Covington, which now began on Pike Street and proceeded—over a gentler slope—through the neighborhood of Lewisburg and around a new "Big Bend," as it ascended the hills west of Covington (Morehead 1839–40).

By 1849 a substantial portion of the Covington and Lexington Turnpike was completed. Of the 37 miles between Covington and Williamstown, 31 were finished and the other 6 were "graded and under contract." From Williamstown to Georgetown, the most sparsely settled section of the road, 18 miles were completed and "the remainder, in part, graded." The Board of Internal Improvement of the state considered the completion of this section of great importance and recommended to the legislature that they appropriate an additional $30,000 to this purpose. The final 12 miles of the turnpike, between Georgetown and Lexington, passed through an area of rich farmland, and had been finished for quite some time ("Annual Report of the Board," 1848–49, 502). The state of Kentucky contributed heavily to the improvement of the Covington and Lexington Turnpike. By 1848, it had spent $170,135.77 on the road, presumably in subscription to its stock, and that figure increased to $200,405.77 in 1849.

Covington promoted the road as crucial to its urban development. The city itself owned 100 shares in the turnpike, and, in addition, many of its citizens bought stock. By December 1849 the *Covington Journal* reported that the Covington to Williamstown section of the turnpike had been completed, and in June 1851, the same newspaper remarked that "all of the unfinished portion of the Covington and Lexington Turnpike road is now under contract" ("Covington and Lexington Turnpike," 16 Nov. 1849).

By the early 1850s, then, the newly macadamized Covington and Lexington Turnpike stood completed, tangible evidence of Northern Kentucky's interest in internal improvement projects that would sustain and advance the "rival city" status of Covington. To enable the project to reach fruition, however, another important component of Northern Kentucky's urban agenda lay temporarily postponed—the building of a bridge across the Ohio River. In the interim, yet another related proposal, the construction of a railroad from Cincinnati to Charleston, South Carolina, engrossed the attention of area residents in their attempt to win the urban sweepstakes.

A RAILROAD TO THE SOUTH, ACT ONE

In addition to their promotion of a bridge to Cincinnati and a turnpike to Lexington, residents of Covington and Newport, joined by a handful of Cincinnatians, advocated a railroad to Charleston, South Carolina, in the 1820s and the 1830s. An ambitious project of generally gargantuan proportions, particularly considering the newness of rail travel in that period, the Cincinnati and Charleston Railroad was nonetheless a serious, workable proposal. It was not a mere passing fancy. Indeed, the ability of Covington and Newport eventually to finance and construct an abridged version of the line, to Lexington, Kentucky, was proof of the two cities' sincerity and determination. Even more remarkable was the fact that they succeeded in building the latter route, and at the same time, underwrote a host of other expensive internal improvements, including bridges to Cincinnati and Covington, and a turnpike to Lexington. Had Cincinnati interests supported the Charleston Railroad proposal, its future might have been secured. That they did not demonstrated that they entertained serious doubts about the advantages the railroad would confer to Covington versus Cincinnati. And these doubts were exacerbated by fears that Covington and Newport, as "rival cities" rather than suitors of Cincinnati, might use the railroad to gain the upper hand in the local urban sweepstakes. The Cincinnati and Charleston Railroad might then become, some thought, the Trojan horse that Cincinnati unwittingly allowed to pass through the city's gate.

It was by way of the Covington and Lexington Turnpike that the president and several directors of the Charleston Railroad traveled to Cincinnati on August 31, 1838. Stopping at Gaines's Tavern for a dinner prepared for them by the proprietor, Abner Gaines, they proceeded toward Covington, and "from Florence, rolled swiftly over a fine Mackadamized [*sic*] road, and through a wild and romantic country, as it seemed by moonlight, some ten or fifteen miles, to Covington" (Thomas 1840, 94). The traveling party included General Robert Y. Hayne, a former United States senator and governor of South Carolina and then president of the Charleston Railroad; General James Taylor, a director of the railroad, founder of Newport, Kentucky, and the city's most prominent resident; and Richard Yeadon Jr., editor of the *Charleston Courier*.

Arriving in Covington, the group took the ferry to Cincinnati and spent the night at the Broadway Hotel. The next day, they were wined and dined by the most influential men of Cincinnati, Covington, and Newport, among them Joseph Bonsall, John Casey, Dr. Daniel Drake, General William Henry Harrison, Nicholas Longworth, Alexander McGrew, William Wright Southgate, and E. S. Thomas.

E. S. Thomas had been a resident of Charleston, South Carolina, during the War of 1812. There, he had been proprietor and editor of the daily *City Gazette* and of the weekly *Carolina Gazette*. During the war, he, like many other Charleston residents, had experienced firsthand the tremendous shortages, and accompanying inflation, occasioned by the curtailment of the Atlantic trade. In the absence of that commerce, Charleston became dependent upon supplies shipped by wagon from cities like Baltimore, Boston, New York, Philadelphia, and Richmond. The additional transportation costs proved considerable, and Thomas proposed that a horse tramway of wooden rails be constructed along the Atlantic coast. Relaying his idea to the "late governor, Charles Pinckney" and to some select friends, his proposal "met the fate of most projects that are new in their nature, and gigantic in their extent: it was laughed at, as being, if at all practicable, a hundred years too soon to be thought of." Later moving to Baltimore, Maryland, Thomas gave himself "no farther trouble, or thought about that, or any other Railroad, until the Baltimore and Ohio Railroad was projected." Then, ruined in business, he left for the West, and in the autumn of 1827, traveled down the Ohio River as far as Louisville. Returning upriver, he stopped at Cincinnati for two weeks, whereupon the idea first struck him "of a Railroad from this city to Charleston, and the superior advantages it would have over all others, from the circumstance of its being north to south, and thus bringing together people who are strangers to each other, and whose products are so admirably calculated for a beneficial exchange" (Thomas 1840).

In December 1827 Thomas conveyed his idea to Joseph Walker, a longtime resident of Cincinnati. The suggestion made little import at that time. In the interim, Thomas established the *Commercial Daily Advertiser*. The railroad proposal languished until January 1830, when the Kentucky General Assembly chartered the Lexington and Ohio Rail Road. The creation of a group of Lexingtonians, the Lexington and Ohio was empowered to build a railroad "from the town of Lexington to some one or more suitable points on the Ohio river" (Ky. Acts 132 1829–30). Obviously, the largest contenders for the Ohio River terminus, or possibly termini, of the line would be Louisville, Covington, and Maysville. The *Cincinnati Chronicle and Literary Gazette* lost no time in recommending Covington, maintaining that "in fixing upon the point of termination on the Ohio [River], no fears are entertained that Covington will be lost sight of by the company. So far as regards the northern market, about to be laid open by the Ohio canals, this point has decided advantages over Louisville, inasmuch as the ascending river navigation of one hundred and fifty miles is saved" ("Lexington and Ohio Rail Road," 6 Feb. 1830).

The subject disappeared as quickly from the Cincinnati newspapers as it came, and was not reawakened until December 1830. At that time, Thomas and other Cincinnati editors noted in the Louisville papers that the Falls City had grown lukewarm to the idea of the railroad, indeed that the citizens of Louisville had "decided in town meeting, that the Directors of this contemplated improvement shall not run it through that city" ("Lexington and Cincinnati," *Cincinnati Daily Gazette,* 1 Dec. 1830).

The board of directors of the Lexington and Ohio Rail Road subsequently suggested that a route between Covington and Lexington be examined.

Thomas, meanwhile, called for a town meeting on the subject, procured the signatures of 47 of the most prominent men of Cincinnati, and requested the citizenry to attend an open forum at the council chambers on December 4. At that assembly, a committee of 15 was appointed to consider the subject, and of this body, 3 men, William C. Anderson, William Greene, and E. S. Thomas, composed a subcommittee charged with corresponding with the directors of the Lexington and Ohio Rail Road. Then, another subcommittee of 2, William Greene and Major Gwynn, were delegated to travel to Lexington and to speak with the directors of the company.

Considering the very novelty of railroads in 1830, the interest expressed by Cincinnatians, Northern Kentuckians, and the Kentucky General Assembly in the Lexington and Ohio Rail Road demands closer examination. Only five years had passed since the world's first successful steam railroad, the Stockton and Darlington in Britain, was opened. Moreover, just more than a year had elapsed since the October 1829 railroad trials at Rainhill, England, introduced the first practical steam locomotive. In America, the Baltimore and Ohio Railroad had broken ground on July 4, 1828, but even this pioneering line experimented with horse cars, sail cars, and various other methods until it formally adopted steam in 1831. In fact, the first scheduled steam railroad train to be operated in America did not run until Christmas Day 1830, on the line of the Charleston and Hamburg Railroad. The Charleston and Hamburg Railroad had been chartered by the South Carolina legislature in 1829, to connect the seaport of Charleston to the city of Hamburg, South Carolina, on the Savannah River, opposite Augusta, Georgia. By 1833 the entire 136-mile-long railway was finished to Hamburg.

In 1830, the same year the Lexington and Ohio Rail Road was chartered, there were only 23 miles of railroad in operation in the United States. Like the cities of Baltimore and Charleston, both of which chartered westward-bound railroads in the hope of recapturing lost trade, landlocked Lexington, Kentucky, sought to extend its own arms northward to the Ohio River, where steamboats plied the waters and reigned supreme. The Kentucky General Assembly granted a liberal charter to the Lexington and Ohio Rail Road Company, exempting "the shares of the capital stock, and all the estate, real and personal" of the company from "the imposition of taxes by the Commonwealth of Kentucky, for the term and space of twenty years from the passage" of the charter in 1830 (Ky. Acts 136 1829–30).

The political party most interested in extending transportation networks was the Whigs. Shortly before the railroad meeting at Cincinnati city council chambers, Whig supporters of Henry Clay's American System, which embodied a higher tariff, government support of internal improvements, and a national bank, met in Newport on November 23, 1830. The attendees at this meeting included some of the wealthiest and most influential men of Covington and Newport. Whether or not E. S. Thomas had become a Whig by this time is unknown. By 1832, though, Thomas had abandoned the Democratic Party for the Whigs and through the voice of his newspaper supported Henry Clay for the presidency. This reversal in political allegiance probably stemmed, at least in part, from Thomas's friendship with Robert Y. Hayne, a supporter of the estranged Jacksonian John C. Calhoun. Hayne was the senatorial spokesperson for states' rights in the national Webster-Hayne Debates of January 1830, and, later, was governor of South Carolina during the nullification crisis of 1832–33. In 1836 Hayne became president of the Cincinnati and Charleston Rail Road. In the interim, Thomas sold the *Commercial Daily Advertiser* and, in May 1835, began publication of the *Daily Evening Post*. In the presidential election of 1836, he endorsed William Henry Harrison, a Whig, for the presidency.

The directors of the Lexington and Ohio Rail Road Company ultimately selected the Louisville route over the Cincinnati one, but construction of the line had proceeded very slowly by late 1835. Indeed, by September 1835, the railroad only extended "from Lexington, to within one mile of Frankfort" ("Lexington and Ohio Rail Road," *Kentucky Gazette*, 25 Sept. 1835). Paris, Kentucky, itself a rival of Lexington, was irate that the Lexington and Ohio Rail Road had bypassed it and was determined to build a line of its own. In fall 1835, residents of Paris met in public assembly, proposed the construction of a railroad to Covington, and requested that Cincinnatians hold a meeting to ascertain their own citizens' reaction to the proposal. The Cincinnati meeting was held on August

10, 1835. Dr. Daniel Drake, one of many who attended, suggested that this proposed line be extended to connect with the Charleston and Hamburg Railroad. The result would be a railroad of mammoth proportions—nearly 700 miles in length—at a time when the railroad mileage in the United States totaled only 1,098 miles. A committee was appointed to investigate the matter, with Drake as its head and John S. Williams and Thomas W. Bakewell (of Covington) as members.

Actually a restatement of an earlier proposal by E. S. Thomas, Drake's scheme attracted the attention of Cincinnatians and Northern Kentuckians alike. In 1835, in an effort to arouse further enthusiasm for the project, Drake published a tract titled *Rail-road from the Banks of the Ohio River to the Tide Waters of the Carolinas and Georgia*. According to Drake, the railroad would foster development of sparsely settled areas in Kentucky, Tennessee, and the Carolinas, and would provide a year-round communication network, facilitating the exchange of the products of "the corn states, from Kentucky to Michigan" with "the tropical productions of the north-east of Cuba and of East Florida—their spices, sugar, oranges, lemons, and figs—and the indigo, rice and cotton of Georgia and Carolina." The latter would "penetrate, in a few days, the interior of the continent, and spread among the consumers, even to the shores of Lake Superior."

Like the advocates of a bridge across the Ohio at Cincinnati, Drake also thought that the railroad would contribute to a better understanding between Northerners and Southerners. He predicted that the people of the North and South "would, in summer, meet in the intervening mountain region of North Carolina and Tennessee, one of the most delightful climates in the United States." There, they would "exchange their opinions, compare their sentiments, and blend their feelings—the north and the south would, in fact, shake hands with each other, yield up their social and political hostility, pledge themselves to common national interests, and part as friends and brethren." Drake's report received a favorable response in Charleston. The proceedings of the August 10 Cincinnati meeting were forwarded to the Charleston Chamber of Commerce, who, in turn, referred it to "a special Committee of that body to consider and report thereon" ("Cincinnati and Charleston Rail Road," *Daily Evening Post* [Cincinnati], 11 Nov. 1835). On October 16, the Charleston committee issued its own report, recommending the construction of the line. This communication received an enthusiastic reception from the attendants, and its resolutions were unanimously adopted. The Charleston Chamber of Commerce pledged itself to procure a charter for the railroad from the next session of the South Carolina legislature. Eclipsed by New Orleans in a struggle for Southern commercial hegemony, Charleston embraced the proposed railroad as an opportunity to regain its former commercial status.

As additional railroad meetings were held to discuss the project, the proposed venture grew in magnitude and importance. At a Columbia, South Carolina, forum, Colonel Abram Blanding reported that he had corresponded with Mr. Williams, a civil engineer of Cincinnati, and had been told by him that a railroad was being constructed between Sandusky, on Lake Erie, to Springfield, Ohio. With great enthusiasm, Blanding predicted that a 1,000-mile-long railroad might eventually connect Columbia, Charleston, Cincinnati, and Lake Erie. As did the participants at the Charleston meeting, those at the Columbia assembly pledged themselves to approach their state legislature for a railroad charter and appointed an 11-member committee to gather petitions not only to the South Carolina legislature but also to the state assemblies of North Carolina, Tennessee, and Kentucky, through which the road would pass. Their purpose, of course, was to obtain a uniform charter from each.

At a Cincinnati meeting on November 26, 1835, Drake took the initiative in recommending several important resolutions, which were approved by the assembly. These essentially were an attempt to forestall opposition by the various state legislatures in granting a uniform charter to the railroad. In other words, the resolutions were both recognition of, and a concession to, the existence of urban rivalries. So, while Drake remained steadfast in arguing that the main route of the railroad should run between Cincinnati and Charleston, he suggested a number of possible branch lines to Fayetteville, North Carolina; Athens, Georgia; and Louisville and Maysville, Kentucky. In Kentucky, the request for a charter sparked anew the urban rivalries between Covington, Louisville, and Maysville.

Louisville newspaper writers shuddered at the thought of Cincinnati completing a railroad south, possibly even before they began construction of their portion of the Lexington and Ohio Rail Road, the route to Frankfort. Louisville's worst premonitions seemed to unfold before its very eyes, as Lexington interests were seduced by the Cincinnati and Charleston Rail Road. Drake's proposal to extend the railroad south to Charleston was an ingenious stroke, for Lexington soon wanted to be involved. It did not take Louisville long to counter the Cincinnati railroad proposal with one of its own. Reporting on the proceedings of a public meeting held in Charleston, South Carolina, supportive of the Drake plan, the *Louisville Public Advertiser* stated that it would make greater sense for the road to terminate in Louisville.

Meanwhile, the citizens of Charleston and Columbia, South Carolina, engaged the services of Colonel Abram Blanding to secure the passage of state charters for the enterprise. In early January 1836, Blanding traveled to Frankfort, Kentucky, where the state legislature was in session, and lobbied, with committees from Charleston and Cincinnati, on behalf of a charter. The mayor and city council of Louisville drafted a memorial to the general assembly, objecting to Cincinnati (that is, to Covington or Newport) as a terminus. The *Louisville Public Advertiser* concurred with Louisville's city council, claiming that the proposal was nothing more than a veiled attempt to increase the trade of Cincinnati at the expense of Louisville. The editor refused to recognize the cities of Covington and Newport as anything more than pawns in the hands of Cincinnati and beseeched them to quit deluding themselves into believing that "they will become, so soon as the Cincinnati and Charleston Rail Road may be completed, very considerable marts" ("Cincinnati and Charleston Rail Road," *Louisville Public Advertiser*, 7 Jan. 1836).

The original bill to charter the railroad, as passed by the legislature of South Carolina, was presented to the Kentucky General Assembly by Colonel Blanding. It included a single route through Kentucky, linking Charleston to Cincinnati. Submitted to the Committee of Internal Improvements of the Kentucky General Assembly, Mr. Marshall of Louisville moved to strike out Cincinnati as the terminus and, in its place, to insert Louisville in the bill. The committee did not adopt this measure, but instead agreed to a compromise, whereby the main route would lead to Cincinnati, and a branch line would be constructed to Louisville. This amendment to the charter was formally accepted, and was presented to the Kentucky House on January 18.

During the opening day of deliberations, Representative Robert Wickliffe of Lexington proposed an amendment to the company's charter, substituting Maysville for Cincinnati. Furthermore, Wickliffe moved that the Louisville branch should run south of the Kentucky River, thus preventing the railroad from merely purchasing the Lexington and Ohio route to Frankfort. Rather, it would be forced to build two separate lines from some as-yet-undetermined point northwest of the Cumberland Gap, where the road would enter Kentucky. Apparently, Wickliffe and some of the other representatives of Lexington joined forces with Louisville and Maysville, persuaded by the Louisville argument that two trunk lines, one to Cincinnati and the other to Louisville, would be ruinous to Lexington merchants. Nevertheless, the governor, the Speaker of the House, and the chairman of the Board of Internal Improvement were all soundly behind the Cincinnati interests, as were the representatives from the northern counties of Boone, Grant, Harrison, and Pendleton.

The Speaker of the House, Mr. Helm, a friend to the Cincinnati route, deferred consideration of Wickliffe's amendment to the charter until the whole act was polished. The debate on Wickliffe's motion resumed in the Kentucky House on January 23, and Mr. Davis of Bourbon County (the county seat of which was Paris) declared his support for the Covington or Newport terminus over that of Maysville. Again, the *Louisville Public Advertiser* ridiculed the notion that "the termination of the rail road at Covington or Newport will cause both of these places to rival Cincinnati, by which they were long since overshadowed" ("From a Gentleman at Frankfort," *Louisville Public Advertiser*, 23 Jan. 1836). The debate continued in the Kentucky House on Monday, January 25, on the motion to "strike out Cincinnati and insert Maysville" in the railroad charter.

On February 3, the bill to charter the railroad was read for the third time in the Kentucky House, and on the next day, that body passed it by a vote of 71 to 26. As enacted, the charter provided for three branches in

Kentucky—one to Cincinnati through Lexington and Georgetown, bypassing Paris; another running south of the Kentucky River to Louisville; and a third passing from Lexington, through Paris, to Maysville. The Maysville branch was added as an amendment earlier in the day to assuage the urban ambitions of that Ohio River city.

In a letter dated February 8 and addressed to the Committee of Internal Improvement of the senate of Kentucky, Colonel Blanding stated that the three branch lines in Kentucky, to Cincinnati, Louisville, and Maysville, met his "approbation," and that "if it passes the Senate in that shape," he would "return to the South determined" to convince others that the charter had "assumed its best form" (*Louisville Public Advertiser*, 11 Feb. 1836). As the principal lobbyist for the railroad, Blanding obviously realized that, considering the intense urban rivalries existing between Cincinnati, Covington, Newport, Louisville, Lexington, and Maysville, the bill indeed had probably "assumed its best form."

On February 29, 1836, the Kentucky General Assembly approved the charter incorporating the Louisville, Cincinnati, and Charleston Rail Road Company. It was the last of four states to do so, the other three being North Carolina, South Carolina, and Tennessee. The charter authorized the company to open subscription books for sale of 60,000 shares of its capital stock, valued at $100 each, beginning on Monday, October 17, 1836, and continuing for six days thereafter. Shares were to be sold at cities and towns throughout the four states, through which the route was proposed, as well as at Cincinnati and at Lawrenceburg, Indiana. Once 40,000 shares had been taken, the company would be officially recognized as formed within the four states. It was then instructed to call a general meeting of the stockholders, to be held at Knoxville, Tennessee, for the election of officers and for the inauguration of the company's basic operation and the drafting of its general bylaws.

The Kentucky charter, which stipulated several additional provisions that the other three states did not demand, became immediately binding upon the whole company. Paralyzed by a political stalemate that pitted Louisville, Covington, Newport, Lexington, and Maysville interests against one another, the Kentucky legislature embraced a compromise that assured passage of the charter but ultimately crippled and preordained the failure of the enterprise. Saddled with the financing and construction of two additional branch lines, one to Louisville and the other to Maysville, the company reeled under the heavy burden. The extra routes would have been onerous enough, but the Kentucky General Assembly also enjoined the company to build both the Louisville and the Cincinnati routes (according to the charter, the railroad was to terminate in either Covington or Newport) simultaneously. Likewise, the act specified that from Lexington, the lines to Covington or Newport and to Maysville were also to be "constructed simultaneously" ("Cincinnati and Charleston Rail Road," *Daily Evening Post* [Cincinnati], 14 Dec. 1836).

The additional branch lines in Kentucky placed a heavy financial burden on the company. On July 4, 1836, nearly 400 delegates from nine states gathered in Knoxville, Tennessee, for a convention marking the official establishment of the Louisville, Cincinnati, and Charleston Rail Road Company. At that assembly, it was reported that the entire railroad, with all of its branches, could be built for an estimated sum of $10,814,046. Of this amount, the projected cost of the route to Maysville was $729,720 and that to Louisville of $990,000, making a total of $1,719,720. In Kentucky, only the citizens of Covington, Newport, and Lexington subscribed to the stock liberally enough to save the effort from being a total embarrassment.

By late November 1836, the *Daily Evening Post* of Cincinnati reported that the Louisville, Cincinnati, and Charleston Rail Road Company had met its stipulated goal to organize as a corporation; that is, it had sold 40,000 shares. An early report of the breakdown of 38,000 of these shares demonstrated that more than 31,000 had been purchased by South Carolinians; more than 1,000 by North Carolinians; more than 3,500 by Tennesseans; 122 by Cincinnatians; and 1,871 by Kentuckians. Covington reported a total of 602 shares sold, Newport 150, and Lexington 1,021 (1,000 of which were purchased by the city of Lexington itself). No shares were reported as being sold in either Louisville or Maysville. Some four or five individuals in Covington and one man in Newport (presumably James Taylor) had subscribed to 50 or more shares each, making them eligible to be elected directors of the company.

Dissatisfied with the performance of Cincinnati and Kentucky, the South Carolina interests in the railroad hoped to amend the charter in Kentucky, removing the objectionable branch lines to Louisville and Maysville. Some Carolinians even recommended that the railroad terminate at Muscle Shoals, Alabama, and not enter Kentucky. In early January of 1837, the *Louisville Public Advertiser* disclosed that in December, the South Carolina legislature had passed new amendments to the charter of the company, stipulating a single route to Lexington, Kentucky, and specifying no northern terminus for the line. In one simple stroke, then, the latest provisions revoked the routes to Cincinnati, Louisville, and Maysville, until a new charter could be obtained from Kentucky. The news arrived too late for Cincinnati, whose residents, "by a vote of nearly four to one," approved the city's borrowing of $600,000 to subscribe to the "Charleston Rail Road, the White Water Canal, and the Cleveland Rail Road" (*Louisville Public Advertiser,* 13 Jan. 1837).

The Louisville, Cincinnati, and Charleston Rail Road Company sent the draft of the new South Carolina amendments to the Kentucky legislature, calling for drastic changes in the company's charter. Most important, the proposed amendments rejected the branches to Louisville and Maysville, as well as the main line from Lexington to Cincinnati, authorizing only a route to Lexington. The company stated that should Kentucky not approve the new conditions, the railroad company would remain "a body public and corporate" in the other three states, but not in Kentucky, and it would no longer be obliged "to construct any road in the State of Kentucky" (*Louisville Public Advertiser,* 16 Jan. 1837).

In late January, Blanding again journeyed to Frankfort to encourage the general assembly to approve the new provisions of the charter. In addition, he asked the Kentucky legislature to follow the example of South Carolina, which approved an act giving the company banking privileges. Moreover, he urged Kentucky to consider a state subscription to the line, similar to South Carolina, which had pledged $1 million in state money to the venture. The renascent railroad debate in Frankfort rekindled the fires of urban rivalry in Kentucky, and elicited from the *Advertiser* a host of invidious statements that questioned the motivations of Cincinnati and rejected the urban ambitions of Covington. From the time that the Cincinnati and Charleston Rail Road was first proposed, claimed the editor of the *Louisville Public Advertiser,* Cincinnati acted out of selfish interests. Covington, the Louisville newspaper argued, was "overshadowed by Cincinnati, and so she must remain." Northern Kentucky was merely an appendage of Cincinnati, it claimed. The Queen City "controls and partly owns Newport and Covington. It has literally *colonized* them; and not only absorbs their manufactures and the profits arising from their business, but makes them do battle for her in the Legislative Halls of Kentucky." In conclusion, the editor noted scathingly, "We are sorry Newport and Covington cannot become important points. They are too far behind Cincinnati to authorize a hope that they can ever overtake her" ("Louisville, Covington, & c.," *Louisville Public Advertiser,* 26 Jan. 1837).

As Lexington joined hands with Northern Kentucky in supporting the new provisions to the charter, Louisville interests became increasingly envious of the new relationship, as well as distressed by the threat posed by Cincinnati. It was obvious, asserted the editor of the *Louisville Public Advertiser,* that Cincinnati was rapacious and desired to control the trade and commerce of Northern Kentucky, and he added, matter-of-factly: "If we have seemed to neglect Covington in the above remarks, it is simply because we view it as one of the suburbs of Cincinnati" ("Lexington—Cincinnati—Louisville," *Louisville Public Advertiser,* 2 Feb. 1837).

The *North Kentuckian* of Covington hurled its own invectives back to Louisville. It maintained that the Falls City was animated by its own selfish interests, and that it ignored the rest of the state:

> *The rank, unmitigated selfishness of her [Louisville's] policy, her unjust, aye, and unwise attempt to check every improvement which does not throw treasure into her lap, to prevent any other portion of the State from acquiring new advantages, and even to filch those it may already possess, are characteristics it were well for the people to understand. The philosopher in Rasselas, who fancied that the earth and all the heavenly bodies were regulated in their motions and held in their orbits by his power, differed but in degree from our swollen*

sister. If we regard her acts, we must conclude that she believes, or wishes others to believe, that our legislators
are assembled for no other purpose than to minister to her vanity and to puff her importance. ("Covington"
[as quoted from North Kentuckian*], Louisville Public Advertiser, 3 Feb. 1837)*

In answer to Covington's indictment of Louisville, the editor of the *Louisville Public Advertiser* scoffed at Covington's own pretensions to greatness and referred to it disparagingly as an "infant *City*," "laboring to remove Lexington to Cincinnati," her citizens "pliant subjects" promising fealty and obedience to "'the Queen.'" "Now there are some men in Covington who would be vastly improved by studying the fable of 'the frog and the ox;' and others that might be materially edified by reading the story of the fly perched on a coach wheel, exclaiming as the vehicle dashed onward, "Gods! What a dust I make!" ("Covington," *Louisville Public Advertiser*, 3 Feb. 1837).

The debate over the provisions of the charter became increasingly heated. On February 10, 1837, the *Louisville Public Advertiser* reported that the bill amending the charter of the Louisville, Cincinnati, and Charleston Rail Road had been passed by the Kentucky House of Representatives. This act essentially acceded to the recent demands of the company to allow it to build a single route in Kentucky, to Lexington, which then assumed the status of northern terminus of the line. In addition, the act provided that, should the company later desire to pursue construction of the route north to Cincinnati, it would have to build, simultaneously, the branch lines to Louisville and Maysville. The likelihood of this occurring, of course, was nil. In essence, this feature of the amendment was designed to garner the votes of Louisville and Maysville representatives in support of the measure. For, if the line were extended to Cincinnati, it would probably be financed and built by Cincinnati, Covington, Newport, and Paris interests, who, in turn, would incorporate their own independent company for this purpose. Thus, they would not be obligated to construct the branches to Louisville and Maysville, since they would be a separate operation from the Cincinnati and Charleston Rail Road Company. The *Louisville Public Advertiser* called the legislation a "trick" and accused Lexington of attempting to control the construction of railroads in the state, including both the Lexington and Ohio Rail Road and the Louisville, Cincinnati and Charleston, in such a way as to ensure that through trains on both would have to break shipment in Lexington ("The Trick," 11 Feb. 1837). The Lexington press was not amused, accusing Louisville of a "determination to grasp and monopolize every thing [*sic*] over which the Commonwealth has control." Louisville, the editor of *Lexington Intelligencer* said, was a "dog in the manger," and a present-day "Sparta," obsessed in its "arrogance" to destroy the "Athens of the West" ("Lexington for Lexington" [as quoted from *Lexington Intelligencer*], *Louisville Public Advertiser*, 3 Mar. 1837). On February 16, the Kentucky Senate passed the railroad charter, a political coup on the part of Lexington and Northern Kentucky that left the Louisville press fuming and indignant.

Further discussion of the Paris railroad and of the Louisville, Cincinnati, and Charleston faded from the newspapers. Presumably, the onset of the 1837 depression played its part in bringing about the demise of one of the nation's earliest railroad proposals. Nonetheless, Northern Kentucky and Lexington interests had displayed, throughout the lobbying efforts associated with the enterprise, their overall political strength and clout. They would repeat this successful performance in the late 1840s, when proposals for a southern railroad were resurrected.

BRIDGING THE OHIO: SUCCESS

The Kentucky and Ohio Bridge Company's Charter expired by 1839, in accordance with its articles of incorporation, which specified that the company had to complete a bridge within 10 years or forfeit its rights. So, in early 1845, a group of Covington citizens again approached the Kentucky legislature for a new Ohio River bridge charter. Presented too late for consideration at that session, the bill was laid on the table. By November 1845, though, the editor of the *Licking Valley Register* noted renewed interest in the bridge proposal and extolled his readers "that such a work would be the 'making' of Covington" ("Bridge across the Ohio," 29 Nov. 1845).

Soon after, on Monday evening, December 8, 1845, a public meeting of the citizens of Covington was convened at the mayor's office to consider the necessary steps to secure a bridge charter from the Kentucky General

Assembly. A committee of 10 was appointed to collect signatures of Kentuckians in support of the bridge charter, and a committee of 5 was chosen to lobby both the Kentucky and the Ohio legislatures for articles of incorporation. The committee of 10 was further charged with the task of enlisting the support of Cincinnatians in this effort. Moreover, the citizens unanimously passed resolutions expressing their belief that a bridge could be built without obstructing navigation.

The bridge bill was subsequently introduced in the Kentucky General Assembly, where it passed the House in early 1846. Reported to the Senate on January 31, it encountered resistance from Pierce Butler of Jefferson County (Louisville) and Colonel Key of Mason County (Maysville). The *Licking Valley Register*'s Frankfort correspondent suspected that the opposition of each was based upon selfish motives. Colonel Key, he stated, worried that the bridge would act "as a public highway for runaway slaves." In a sarcastic tone, the correspondent added that Key "fears that his negroes would run all the way from Mason to cross into Ohio over the bridge!" ("Correspondence of the Register," 7 Feb. 1846).

On February 7, 1846, the Kentucky Senate enacted the charter, but after adding two amendments—one that guaranteed freedom of navigation on the Ohio, and the other that gave "slaveholders indemnity for slaves escaping by the Bridge with the wilful [*sic*] knowledge of the Company or its Agents" ("Correspondence of the Cincinnati Gazette, From Frankfort, February 7th, 1846," *Daily Cincinnati Gazette,* 10 Feb. 1846). The House reconsidered the bill with its new amendments, and passed the charter the same day. The bill was then forwarded to the Ohio General Assembly at Columbus for consideration.

The *Licking Valley Register* rejoiced at the news, but availed itself of one last opportunity to blast Louisville for having opposed the measure. "Jealousies against Cincinnati," the Frankfort correspondent claimed, "have no doubt been sedulously inflamed by Louisville, whose citizens have the sagacity to see that the trade of Kentucky, once solely their own, is rapidly tending toward the Queen City, and that with increased facilities of trade between Kentucky and Cincinnati, the time will soon arrive when this point [Covington] will become the great market for the surplus productions of this state" ("The Bridge Again," *Licking Valley Register,* 14 Feb. 1846).

On the other hand, the Cincinnati newspapers reacted to the passage of the charter with ambivalence. A letter to the editor of the *Daily Morning Atlas,* signed "Commerce," asserted:

> *I trust our Representatives will give this proposed scheme to injure our harbor the reception it deserves. They should consider that however high the flooring of the Bridge may be above high water mark, the piers will ever be a serious obstruction to navigation. They will be in the way of steamboats when rounding to or coming into port, and when turning to go out. They will act as barriers to prevent driftwood and ice from being carried off by the current, so that in times of high water we shall have our harbor dammed up with logs and trees, and in winter gorged with ice. ("For the Atlas. The Proposed Bridge," 12 Feb. 1846)*

Cincinnati City Council joined the disparaging chorus on Wednesday evening, February 6, when it passed a resolution objecting to the bridge. Then, it ordered the same to be forwarded to the Ohio General Assembly. Like other opponents, the city council feared that the bridge would impede navigation on the Ohio, but in the same sentence expressed perhaps its truer feelings by maintaining that "the construction of such a bridge would involve great injury to Real Estate lying within this city" ("Proceedings in Council. Wednesday Evening, Feb. 6th, 1846," *Daily Cincinnati Gazette,* 13 Feb. 1846).

At least one Cincinnati newspaper, the *Daily Cincinnati Chronicle* supported the bridge proposal, agreeing with the *Licking Valley Register* that a bridge could be built that did not obstruct navigation. Indeed, the *Chronicle* joined those forces that urged the construction of a suspension bridge, with no channel piers whatsoever.

As the newspaper debate on the subject of the bridge continued, a new item appeared—concern over the amendment in the company's charter, which made it liable to the owners of runaway slaves who might pass to

freedom across the bridge. The *Daily Cincinnati Chronicle* faulted the *Atlas* for its resistance to the charter based on the slavery clause. Claimed the *Chronicle*'s editor, the bridge company's liability for runaway slaves did not differ from that of the ferryboat operators, or for that matter, from that of any individual man "if he aids slaves to escape" ("The Bridge Question," *Daily Cincinnati Chronicle,* 19 Feb. 1846).

On February 19, 1846, the Standing Committee on Federal Relations of the Ohio General Assembly recommended to the state Senate that the bill to charter the Covington and Cincinnati Bridge Company be deferred for consideration until December 1846. In its report, the committee voiced its concern that the bridge would "to some extent at least have the effect to make Cincinnati, Covington and Newport, for most business purposes, one city. If this apprehension be well founded, part, at least, of the wealth and population that would otherwise locate themselves in Cincinnati, will be transferred to the opposite side of the river, and thus be lost to the State of Ohio, resulting in a partial depreciation of the price of real property in Cincinnati" ("Bridge and Report Thereupon," *Daily Cincinnati Gazette*, 24 Feb. 1846). Moreover, the committee lacked confidence in the company's ability to build a bridge that would not be an impediment to navigation.

The *Daily Cincinnati Chronicle* reacted in horror to the committee's report. Regarding the bridge as an opportunity to bind together North and South, indeed to cement the Union at a time when "there are parties, sects, cliques, and special interest enough in this country," it remarked that "here, in a Report of the Ohio Legislature, we have the idea thrown out, that we should *fence up* Cincinnati, if possible, lest its 'wealth and population' should flow over the river, and its real estate depreciate!!!" Noting that there were "factions who would destroy the Union to put down slavery," the editor added that Cincinnati had nothing to fear—that it had, in effect, no rival in Covington or Newport. These Northern Kentucky towns were in a slave state, while Cincinnati was in a "great, fertile, rapidly increasing free State" ("The Bridge and the Legislature—Freedom," *Daily Cincinnati Chronicle*, 25 Feb. 1846). To the editor of the *Daily Cincinnati Chronicle*, the cities of Covington and Newport were no longer "rival cities" capable of overtaking Cincinnati. To some residents of Cincinnati, though, and to the Ohio legislature, the two Northern Kentucky cities were still potential rivals.

In January 1847 the Cincinnati newspapers reported that the bridge charter was scheduled to be reconsidered by the Ohio General Assembly. Again, certain individuals, principally owners of "large tracts of land in the Mill Creek Bottoms, along Deer Creek, and along the slopes of the hills adjacent to Cincinnati," opposed the charter, on the grounds that a bridge to Covington would make real estate more valuable there, to the detriment of their own holdings ("For the Cincinnati Gazette. To the Public," *Daily Cincinnati Gazette,* 6 Jan. 1847). Nevertheless, the opponents of the measure obtained only about 300 names for their petition, while the promoters of the bridge collected more than 1,500 signatures in Cincinnati. This overwhelming support for the bridge failed to convince the Ohio Senate, though, and that body defeated the bridge charter by a vote of 25 to 8.

A renewed effort to obtain a charter for the Covington and Cincinnati Bridge Company was made in early 1849. By February 20 the *Daily Atlas* reported that the bill had passed the Ohio House and probably would pass the Senate. The intervening two years were occasioned by a vast change in outlook, not only among the legislators, but also among newspapermen. The *Atlas*, formerly an adamant opponent of the bridge, now stated rather matter-of-factly: "If it [a suspension bridge] does not interfere with navigation, there can be no reasonable objection to the construction of such a Bridge. We hope, therefore, the Bill may be passed and a trial made of the utility of such construction. At some time not far distant, there must be many Bridges over the Ohio—and now is a good time to begin" ("Suspension Bridge on the Ohio," *Daily Atlas,* 20 Feb. 1849).

Likewise, by 1849, the discussion of Covington as rival assumed a slightly different course. Covington, and also Newport, came to be viewed by some not as rival cities, but as rival suburbs, contenders to Cincinnati's own outlying suburban communities. One reader of the *Daily Cincinnati Gazette* wrote, "Cincinnati is growing rapidly, and must continue to do so for years to come. The question is, shall Cincinnati grow in the direction of the suburbs of Covington, in another State, or in the direction of her own suburbs in our own State? The way to turn the

current of improvements from Ohio to Kentucky is to build a bridge by which it will be made easier to get to Covington, than to get to our own suburbs" ("For the Cincinnati Gazette. Cincinnati and Covington Bridge," *Daily Cincinnati Gazette,* 2 Mar. 1849). The same writer argued that the suburbs of Cincinnati could one day apply for annexation, while Covington would forever remain a separate city.

A writer to the *Daily Cincinnati Gazette,* who penned himself "Cincinnati Merchant," welcomed the idea of a bridge to Covington and regarded that city's growing suburban status as a boon to Cincinnati, not a detriment. Noting that five ferry companies operated between Cincinnati and Northern Kentucky, the correspondent claimed that "many of the Cincinnati merchants and mechanics do now live with their families on the other side of the River, and many more will continue to do so, whether the Bridge is built or not—for the reason that our city is becoming so densely populated, that men of moderate means cannot procure residences within a reasonable distance from their businesses, without the payment of enormous and onerous rents" ("For the Cincinnati Daily Gazette. Cincinnati Bridge," *Daily Cincinnati Gazette,* 6 Mar. 1849). Like other Cincinnatians of his day, a "Cincinnati Merchant" was convinced that the bridge would not curtail the growth or importance of the Queen City, which he believed was destined to advance. Declaring that contemporary estimates of the annual immigration to Cincinnati placed the number of arrivals at 15,000, he felt assured that "the efforts to confine such a population as we shall have very soon, within the present prescribed limits of Cincinnati will be in vain. Men whose business calls them to that point of the city—now considered the centre of trade—will not go to Cummingsville [*sic*] or over Mount Auburn to sleep. It is already much more convenient to cross over to Covington or Newport" ("For the Cincinnati Daily Gazette. Cincinnati Bridge," *Daily Cincinnati Gazette,* 6 Mar. 1849).

The Ohio General Assembly gave its assent to the Covington and Cincinnati Bridge Company's charter, with the addition of six amendments, in March 1849. One amendment clearly stated that no Ohio state court was to accept any cases dealing with runaway slaves who passed over the bridge. Another clause specified that the Ohio General Assembly's acceptance of the bridge charter was to be in no way construed as to imply that Ohio yielded in its Ohio River boundary dispute with Kentucky. Rather, Ohio still claimed half the river.

In consequence of the bill's passage, the *Daily Atlas* [Cincinnati] reported on March 19 that property values were already beginning to rise in Covington and Newport. Further, it paid a rare compliment to the two Northern Kentucky cities, stating, "Our smart neighbors over the river will grow fast enough, bridge or no bridge. There are no towns in America of their size growing faster" ("Things About Town," 19 Mar. 1849).

That real estate speculators availed themselves of the prospects of the bridge was certain. On March 19, an advertisement in the *Cincinnati Enquirer* announced the auction of 200 building lots on the Howell Property, just south of Covington, and "within 20 minutes walk of the ferry landing opposite the city of Cincinnati." The auctioneer noted that the contemplated bridges to Cincinnati and Newport would "bring this place so near to the great business mart of Cincinnati, as to make it a part and parcel of the great Queen City of the West." Likewise, the area was attractive from yet another standpoint: "the taxes on the property are three fourths less than the taxes on the same amount of property within the limits of Covington, and not one-eighth as high as the taxes on the same amount of property in Cincinnati" (advertisement, *Cincinnati Enquirer,* 19 Mar. 1850).

At its own session the following year, 1850, the Kentucky General Assembly expressed its disapproval of the Ohio legislature's amendments to the bridge company's charter. At one point, the discussion at Frankfort became so heated that one state senator moved to repeal the charter. For the moment, the question was referred to a committee, but it reappeared in a day or so on the floors of both the House and the Senate. There, the legislators voted to repeal the company's charter, unless the Ohio General Assembly repealed its two clauses, namely that barring runaway slave suits in Ohio state courts and the other claiming jurisdiction to the midpoint of the river. Meanwhile, a delegation of Covington businessmen journeyed to Frankfort to lobby on behalf of the bridge. Their efforts achieved results, and the 1846 articles of incorporation remained intact.

The slavery issue caused disquieting new concerns in the Ohio General Assembly as well. There, on March 9,

1850, the state legislature passed an amendment to the bridge company's charter, prohibiting it from entering any "of the lands now used for public travel upon Vine, Race, Elm and Plum streets" (*Annual Report of the President and Directors* 1867, 106). Because this amendment also stipulated that the bridge had to be built between Walnut Street and Western Row, and because the four aforementioned streets were the only north–south arteries within that area, this meant that the bridge company would have to purchase private property for its abutments and ramps in Cincinnati. Indeed, the amendment granted the company the right to acquire such real estate, and moreover, to pursue condemnation of lands for this purpose, using, of course, the proper channels of the Hamilton County Court of Common Pleas. What the amendment really accomplished, then, was this: it forbade the bridge company, a corporation composed largely of Kentucky interests and with a charter protecting the rights of slave owners, from using any public right-of-way in Ohio. In other words, the amendment removed Cincinnati's responsibility for runaway slaves who might cross the bridge and first set foot on a public street. There was a moral dimension, as the amendment was probably a direct response to reluctance or reservations upon the part of some to dedicate a public right-of-way in a free state to the use of a company based in a slave state, and sympathetic to the institution of slavery. Indeed, the *Daily Cincinnati Gazette* implied that even this amendment was opposed by some of "the Free Soil gentry, who seem bitter with the notion that associated humanity must necessarily be tyrannical, unjust and oppressive, while individual humanity is ever weak, powerless and unprotected. With them, if there is to be taxation—it turns some poor man out of his homestead, deprives his wife of a home, and beggars his children; if land is to be taken for a public purpose, and paid for, it is the land of some poor widow or fatherless orphan, whose wrongs scream to Heaven through their lungs, calling down vengeance upon that civilization and progress, whose demands are exorbitant" ("Correspondence of the Cincinnati Gazette. From Columbus," 12 Mar. 1850).

A RAILROAD SOUTH, SUCCESS

On behalf of farmers from the Bluegrass, drovers led hogs by foot over the Covington and Lexington Turnpike to pork-packing houses in Covington and Cincinnati. The journey from as far as Lexington, however, proved cumbersome, expensive, and time-consuming, taking as long as three weeks to a month. Along the way, the hogs had to be fed, and many of them died. The result was that it cost an average of about $1 per head to transport hogs to Cincinnati from the Bluegrass, but if a railroad were built to Covington, the hogs "could probably be carried in the course of a few hours, without loss" for about "25 to 30 cents the head" ("From the Lexington Atlas. A Railroad from Lexington to Covington," *Covington Journal*, 6 Oct. 1848).

Of course, the *Atlas*'s proposal for a railroad to Lexington was the resurrection of a much older idea, dating back to the time of the Cincinnati and Charleston Rail Road. On March 1, 1847, the Kentucky General Assembly passed an act incorporating the Licking and Lexington Rail Road Company, with a southern terminus at Lexington, and a northern terminus at either Newport or Covington. The citizens of Covington assembled at a public meeting in late March and passed a series of resolutions in support of the railroad, advocating Covington as the northern terminus. Such a railroad would, one of the resolutions stated, contribute to the growth of Covington: "Covington possessing already the elements of prosperity, will become in commerce, in manufactures, and in all that adorns and elevates society, the leading city and pride of this Commonwealth, and Northern Kentucky eminently prosperous, great and powerful" (*Licking Valley Register*, 3 Apr. 1847). Further, the residents urged the City Council to submit to the voters of the city a proposal whereby the city would subscribe $50,000 to the railroad.

Despite the public's initial excitement, they remained disillusioned by the ambiguity of the charter concerning the northern terminus. As a result, they supported the railroad verbally, but not financially. Books for subscription to the stock of the company were opened in Covington on May 10, 1847, and remained open on Tuesday and Wednesday of that week. By Friday, May 14, the *Licking Valley Register* sadly reported that only "20 shares of stock were taken, and they all by one individual!" Meanwhile, the citizens of Lexington, Kentucky, already involved in

financing the Lexington and Frankfort Rail Road, could ill afford to assume another costly financial undertaking. Excitement concerning the proposed railroad abated and did not resurface until 1849.

On February 27, 1849, the Kentucky General Assembly passed an act more amenable to Covingtonians. This new act amended the original charter of the Licking and Lexington Rail Road Company and officially renamed it the Covington and Lexington Railroad Company, expressive of the fact that its northern terminus was now set at Covington. A further provision of the new act established a board of directors, to consist of seven stockholders. Most important of all, though, was section eight of the 1849 amendment, enabling the cities of Covington and Lexington, and the counties of Kenton, Pendleton, Grant, Harrison, Scott, Bourbon, and Fayette (through which the railroad would pass) to subscribe up to $100,000 each to the stock of the company, provided that a majority of property holders approved.

Maysville interests regarded the new act as a clever device on the part of Cincinnatians to "drain all the trade of the rich garden land of Kentucky into the hands of Ohio capitalists." In an article reprinted in the *Covington Journal*, the publisher of the *Maysville Eagle* attested that the effort to secure a charter for the Covington and Lexington Railroad was orchestrated by Cincinnati, whose "cormorant appetite" necessitated "pouring immense wealth into her over grown maw," goading "little Miss Covington" to request a railroad charter. The *Covington Journal* countered this accusation as attributable to "jealousy." "Little Miss Covington," the Covington editor voiced, "considers herself of age and has set up for herself. She alone is responsible and accountable for all that has been done for the Railroad. Her 'overgrown' neighbor has not yet assisted her to the amount of—one cent!" (*Covington Journal*, 19 Jan. 1850).

The new railroad was considered vital to the interests of Covington and Northern Kentucky. The *Covington Journal* warned that Louisville was proceeding with the construction of a railroad, and, as such, Covington should not delay, for "Louisville is . . . our natural rival." Besides contributing to the growth of Covington as a rival city of Louisville, the railroad would benefit the entire Northern Kentucky area in its suburban status to Cincinnati. Property values would increase as "farms will become gardens, corn and oats will give way to market vegetables; dairymen and poultries will daily bring their produce into the market here" and "residences for those doing business here and in Cincinnati will be erected for miles out from the city" ("Tax in Favor of the Railroad," *Covington Journal*, 23 Mar. 1850). The railroad would contribute, in other words, to a symbiotic relationship between Covington and Cincinnati, a prospect that frightened the editor of the *Maysville Eagle*, whose own hometown boosterism led him to assert that Covington was "only a lodging place for Cincinnati," and a "mere channel through which the Queen City" was furnished Kentucky "beef-steaks" ("Maysville and the Maysville Eagle—Covington," *Covington Journal*, 23 Nov. 1850).

The new provisions of the 1849 act and of a new 1851 act helped to ensure the railroad's success. On Saturday, April 28, 1849, the voters of Covington overwhelmingly approved, 292 to 10, a cash subscription of $100,000 to the stock of the Covington and Lexington Railroad Company. A further statute of the Kentucky General Assembly, dated March 3, 1851, enabled the city of Covington to issue an additional $200,000 in bonds, which could then be subscribed to the railroad. Once again, the voters of Covington enthusiastically expressed their support for this new measure in the election of Monday, August 4, 1851, as 991 ballots were entered for the proposal and only 88 against.

Meanwhile, the city council of Cincinnati requested its citizens to vote on a proposal whereby a total of $1,000,000 would be loaned to four railroads. The Covington and Lexington Railroad, one of the four recipients, would receive $100,000 of the sum. In the annual municipal elections held on Tuesday, October 8, 1850, the measure passed overwhelmingly. Unlike Covington's direct subscription to the stock of the company, however, Cincinnati's contribution was in the form of a collateral loan, offered to the company as soon as a matching amount had been spent toward construction of the road.

In addition to Covington's subscription to $300,000 worth of the railroad's stock and Cincinnati's loan of $100,000, Fayette County (Lexington) purchased $200,000 in stock; Bourbon County (Paris), $100,000; and Pendleton County, $50,000. In the spring of 1850, the residents of Kenton County voted an increase in taxation,

KENTUCKY CENTRAL RAILROAD DEPOT.

The Covington and Lexington Railroad's terminal at Pike and Washington Streets. The C&L was generally known as the Kentucky Central Railroad. Source: Kenny, D. J. *Illustrated Cincinnati*. Cincinnati, OH: Geo. E. Stevens & Co., 1875.

the proceeds of which were to be applied toward stock in the railroad, but the justices of the Kenton County Court refused to sanction the tax, and the issue was subsequently dropped. Private individuals in Covington purchased nearly $84,000 of stock; residents of Bourbon County bought $159,000; those of Harrison County, $116,000; Cincinnatians, $22,000; and various other Kentuckians, about $14,000. In all, individuals invested $395,400 in stock of the railroad, of which $297,682.50 was realized by 1855 (*Fifth Annual Report* 1855, 8).

With much of its financing secured, the company could begin construction of the route. Sylvester Welch, an engineer, began surveying on April 10, 1850. He suggested a route along the valley of the Licking River as the most practical. The board of overseers accepted his recommendations on June 11, 1850, and the route was set. Beginning at Covington, it proceeded through the Kentucky counties of Kenton, Pendleton, Harrison, Bourbon, and Fayette, terminating in the city of Lexington, a distance of some 96 meandering miles.

Nearly four months after the June board meeting, in October 1850, a $210,000 contract was signed for "the grading and the masonry for the bridges on eighteen and a half miles" of the road (*Annual Reports of the President*, 1850, 4). In January 1851, 7.8 miles of the remaining route to Falmouth were contracted for, and in May of the same year, work was let for the grading of most of the roadbed between Falmouth and Paris, Kentucky. Construction advanced steadily, the *Covington Journal* reporting on June 28, 1851, that "almost 1000 hands are now actively at work on the Covington and Lexington Railroad." Finally, in October 1851, the last northern stretch of the railroad, between South Covington and the 7th and Washington Streets depot (the railroad's terminus) was placed under contract. Construction along this section was postponed until acquisition problems along the proposed right-of-way were resolved.

Eventually, the backbreaking work of as many as 2,300 laborers began to take shape. On April 10, 1852, Grant's Bend Tunnel, about 9½ miles from the railroad's northern terminus in Covington, was completed. Nearly 2,150 feet long, this tunnel was the most extensive one on the route. On October 17, 1853, the railroad was finished to Falmouth; in May 1854, it was completed to Cynthiana in Harrison County; and on September 26, 1854, it was opened to Paris, Kentucky.

The final link of the railroad, from Paris to Lexington, was built by the Maysville and Lexington Railroad Company, and was jointly used by them and the Covington and Lexington Railroad Company. In December 1854 the Covington and Lexington Company finalized these arrangements, signing an 18-month lease with the Maysville corporation. This short-term leasing arrangement was later formalized and extended in November 1856, when a new lease of 10 years' duration was negotiated. Thus, by late December 1854, the entire route of the Covington and Lexington Railroad was fully operational.

ECONOMIC CHANGES

The Covington and Lexington Railroad bolstered existing trade patterns and fostered new ones. To the Cincinnati business community, the completion of the Covington and Lexington Railroad signaled a new era, the culmination of years of dreaming and planning. Cincinnati merchants and manufacturers had longed to increase their already considerable trade with the South, particularly with Lexington and the Bluegrass region. Ties between the two areas had deep historical and commercial roots. Two of the principal founders of Cincinnati, John Filson and Colonel Robert Patterson, had been residents of Lexington. In addition, the proximity of Cincinnati to Lexington

enhanced trade between the two cities, so much so that Lexington actually preferred the Cincinnati market to that of Louisville. As expected, the exportation of hogs and wheat to Cincinnati from Kentucky increased upon completion of the railroad, as did the sale of Cincinnati merchandise south.

The most striking effect of the Covington and Lexington Railroad was its stimulation of wheat production among the farmers of central Kentucky. Enterprising farmers in the Bluegrass, realizing the advantages offered by their improved access to the markets of Covington and Cincinnati, increasingly turned to the production of white Kentucky wheat for export to these cities and, eventually, to others beyond.

The Covington and Lexington Railroad carried 284,941 bushels of wheat to Covington in 1855. A large portion of this undoubtedly made its way to Cincinnati, which, according to a chamber of commerce report, imported 437,412 bushels of wheat, by all means of transportation, in the same year. Likewise, the C&L hauled 329,127 bushels of wheat in 1857, while Cincinnati imported 737,723 bushels that year.

As in the case of wheat, a large number of hogs were transported aboard the cars of the Covington and Lexington. Many of these were, in turn, ferried across the river to Cincinnati, or when the river was frozen over, driven directly across the ice. Covington's own pork packing industry was substantial by the 1840s, and most certainly by the 1850s. For instance, Ashbrook and Hughes of Covington in 1845–46 slaughtered 12,736 hogs. Also of importance was the firm of Milward and Oldershaw, located on the Licking River in Covington, reputedly one of the largest packers in the nation. It apparently specialized, by 1850, in preparing pork for the English market. During the 1849–50 marketing season, this firm packed 25,000 hogs, and a total of 23,531 hogs during the 1851–52 season, making it the third-largest packer in the Cincinnati area that year. Impressively, this latter figure did not include a total of 18,131 hogs slaughtered in Covington that season and shipped to Cincinnati for packing. Overall, the Covington and Lexington Railroad caused a decrease in Covington pork packing and a corresponding increase in Cincinnati packing. For instance, while in 1851–52, 18,131 hogs had been slaughtered in Covington, this number decreased to 15,046 in 1852–53 and only 8,246 in 1853–54. In contrast, as the Covington and Lexington Railroad neared completion, with a number of sections opening throughout the 1853–54 hog season, the receipts of Kentucky hogs at Cincinnati demonstrated a "large increase," numbering "106,855 head against 72,287" the season prior ("Hogs Packed in Cincinnati," *Cincinnati Price-Current*, 15 Feb. 1854). Covington and Lexington Railroad figures for later years for Covington were unavailable; however, evidence appears to support this conclusion. Notably, a November 1863 issue of the *Cincinnati Daily Enquirer* mentioned that "large numbers of hogs are driven through our [Covington's] streets daily to the Cincinnati slaughtering houses. We understand that the firm of Ashbrook and Wilson, the only pork packers in Covington will not kill any hogs this season" ("Covington News," 17 Nov. 1863). While the number of hogs packed in Cincinnati fluctuated during the decade of the 1850s, a large portion of these arrived via the Covington and Lexington Railroad. In 1855, for instance, the C&L transported 57,222 hogs to Covington, and Cincinnati packed a total of 355,786 hogs that year. In 1857, the Covington and Lexington Railroad hauled 119,974 hogs, and Cincinnati packers processed a total of 344,542.

Just as it benefited Cincinnati industry, the Covington and Lexington Railroad promoted suburbanization in Northern Kentucky. On July 24, 1858, for instance, an advertisement appearing in the *Covington Journal* announced the sale of 50 acres of ground 7 miles from Covington, at Culbertson's Station, "where persons can get on the cars twice every day and be in Covington or Cincinnati in 15 minutes." The suburban property was planted in 40 acres of orchard land and 10 acres of woodland, affording a pastoral setting to the buyer. Such bucolic surroundings, at healthy distances from the city, were the rage of the day. An earlier notice, for example, highlighted the rural flavor of an estate located 1 mile west of Covington upon another transportation route, the Covington and Lexington Turnpike. This "suburban residence . . . being within a few minutes ride of the city, and commanding a fine view of Cincinnati, Covington and Newport, and the beautiful valleys and hills adjacent," the advertisement proclaimed, recommended it as a "healthy and pleasant suburban retreat" (advertisement, *Covington Journal*, 22 Mar. 1856).

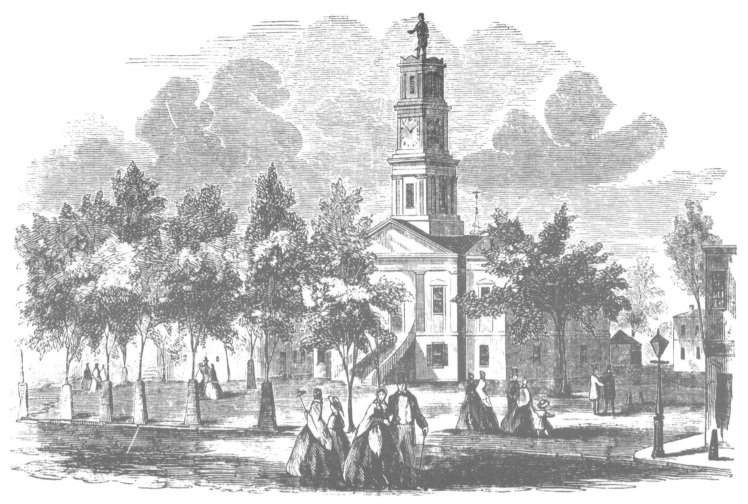

City Hall, Covington, Kentucky. Source: *Ballou's Pictorial Drawing-Room Companion* 11, no. 25 (20 Dec. 1856).

A NEW COUNTY AND BRIDGING THE LICKING RIVER

On January 27, 1830, the Kentucky General Assembly passed an act incorporating the Licking Bridge Company, a corporation vested with the power of building a bridge across the Licking River, to connect the towns of Newport and Covington. The incorporators included the most prominent Covington residents of the time, numbering among them Thomas D. Carneal, Edward Colston, Samuel Kennedy, Richard and William Wright Southgate, and others. Capitalized at $15,000, to be divided into a total of 3,000 shares, the company was to advertise the opening of stock subscriptions within six months of the passage of the act. Further, the act's provisions stipulated that, upon the sale of 2,000 shares, the corporation could officially organize. Moreover, the charter specified that "in case the bridge . . . shall not have been begun within two years after the passage of this act, and completed within six years," then the company would, in essence, be dissolved (An Act to incorporate a company to erect a Bridge across Licking river 1830, 115). Nothing further is known about the Licking Bridge Company. Presumably, the organizers did not succeed in raising sufficient funds to meet the criteria of the charter.

As plans for the Licking Bridge languished, a subrivalry between Covington and Newport emerged with new vigor. In December 1838 a letter to the editor of the *Covington Free Press*, simply signed "A Citizen," noted the need for a new Campbell County courthouse and jail. Those public buildings, as they existed in Newport, he claimed, were in a "dilapidated state" and were an embarrassment to the residents. He suggested that some residents of Covington were willing to donate ground for a new courthouse and jail, as well as contribute $3,000–$4,000 for the construction of new public buildings "if the people will permit the court house to be removed" to Covington ("New Court House and Jail," *Covington Free Press*, 8 Dec. 1838).

This underlying rivalry between Covington and Newport changed course somewhat by late 1839. Rather

than removing the county seat to Covington, a new movement emerged calling for the establishment of a separate county west of the Licking River. By late August 1839, some 600 signatures had been obtained for a petition requesting this action on the part of the upcoming legislature. As of October, these had increased to 1,200, and the final petition counted some 1,304 voters, a clear majority of the electorate of Campbell County. Consequently, the Kentucky General Assembly passed an act creating the new county of Kenton and appointed commissioners to choose a central location for a county seat.

In contrast to the popular will, however, a number of the leading citizens of Covington, including James M. Clarkson and William Wright Southgate, opposed the measure creating the new county of Kenton. At a public meeting held at the Methodist church in Covington on January 20, 1840, they and other opponents of the act passed a series of resolutions requesting the legislature to modify the act, whereby the issue would be presented to the voters at the next August election. In addition, they suggested leaving the location of the county seat to the voters, not to appointed commissioners. Finally, they nominated a committee of delegates "to repair immediately to Frankfort for the purpose of using their best efforts to carry into effect the object" of their resolutions ("To the Editor," *Western Globe,* 22 Jan. 1840). A week later, prominent residents of an area west of Covington, including Washington and James Cleveland, Major Bartlett Graves, and Major T. Timberlake, met and, in agreement with a resolution of the Covington assembly, preferred that the choice of a county seat be submitted to the voters of the new county (*Western Globe,* 29 Jan. 1840).

The opponents of the act, generally described as "citizens of Covington and the lower end of the county," were averse to the provision appointing commissioners to choose a central location for the county seat. Indeed, this condition clearly removed Covington from the list of eligible sites, as it lay along the northeastern boundary of the new county. The friends of Covington subsequently succeeded in obtaining the passage of an amendment in the Kentucky Senate favorable to their position. In turn, a number of citizens gathered at an assembly on February 14, 1840, protesting the passage of the senate amendment and agreeing to send a "remonstrance" to the Kentucky General Assembly, as well as a delegate to Frankfort, to oppose the amendment's passage in the House. The amendment, this assembly stated, was counter to the will of the majority, and as proof of their position, they hurriedly gathered 633 signatures, "notwithstanding the bad roads and inclemency of the weather," in opposition to it ("Public Meeting," *Western Globe,* 4 Mar. 1840). Apparently, the amendment failed in the house, and the county seat was located at Independence, 13 miles southwest of Covington.

With the contests between Covington and Newport, and later, between Covington and the rest of the new county of Kenton largely settled, attentions once again focused on the construction of a Licking River bridge. In February 1844 the Covington-based *Licking Valley Register* published an article describing the economy and efficacy of an iron suspension bridge just completed over the Miami Canal at Race Street in Cincinnati. Noting that it was the first such bridge built "west of the mountains," it further referenced the success of a similar suspension bridge, designed by Charles Ellet, and erected over the Schuylkill River at Fairmount near Philadelphia, Pennsylvania. Moreover, the article, as reprinted from the *Cincinnati Atlas,* stated that Northern Kentuckians had recently secured a new charter for a bridge across the Licking and were "discussing the propriety of erecting a wire suspension bridge." The *Atlas* encouraged the project, claiming that the "high banks of the Licking are exceedingly favorable for the erection of such a bridge, (without piers) so high above the water as not to impede the navigation of steamboats" ("From the Cincinnati Atlas. Wire Bridge," *Licking Valley Register,* 24 Feb. 1844).

By mid-August 1844, the *Licking Valley Register* reported that the town of Newport and nearly 80 individuals had subscribed to the stock of the bridge company. With already 2,000 shares sold, the company was officially organized, and it held its first meeting at Newport on Saturday, August 31, 1844. By November the *Licking Valley Register* confirmed that "hundreds of perch of stone are already on the ground," and that pine timber from the Allegheny River would arrive with the "early spring freshets." Construction was expected to be completed by October 1, 1845 ("The Licking Bridge," *Licking Valley Register,* 16 Nov. 1844). By the first week of April 1845, the east, or Newport shore,

pier was begun, with promises that the Covington abutment was to be begun the following week. Unfortunately, the work slowed, so much so that by September 1846, it apparently had been halted for lack of funds.

The Licking River bridge proposal was resurrected in 1849, at which time only a single pier, on the Newport shore, stood in testimony of the earlier efforts of the 1844 company. Under terms of the original 1830 charter, Charles Ellet, the noted suspension bridge designer, traveled to Northern Kentucky in late February or early March of 1849 and made arrangements to build a suspension bridge between Covington and Newport. He was to begin construction on April 1, and he projected completion by December 1. Although the exact circumstances are unknown, Ellet's proposal never reached fruition.

In January 1852 the Kentucky General Assembly chartered the Newport and Covington Bridge Company, a corporation of prominent Covington and Newport residents. The act provided that the cities of Covington and Newport could subscribe for stock in the span, and within 10 years, both cities or either had the option of purchasing the bridge for the cost of construction, plus 6% interest. By June 1853 the *Covington Journal* reported that construction of the company's suspension bridge, at the end of Fourth Street in Covington, was proceeding quickly under the superintendence of George C. Tarvin. The contractor was, apparently, John Gray of Pittsburgh, Pennsylvania, and the cost of construction was originally pegged at $62,500. On Wednesday, December 28, 1853, Tarvin, joined by Mayor Foley of Covington, made the first vehicular passage across the bridge.

On Monday evening, January 16, 1854, while two men and 18 head of cattle were crossing the bridge, it suddenly collapsed into the river. Its stonework left completely intact, rebuilding began immediately. There were no human fatalities. Damage amounted to about $14,000, and with other additional expenses, it was estimated that the final cost of the bridge would be some $81,000. Reopened in May 1854, the bridge was further strengthened and improved in 1867 by Washington Roebling, son of John Roebling, designer of the Covington and Cincinnati Suspension Bridge.

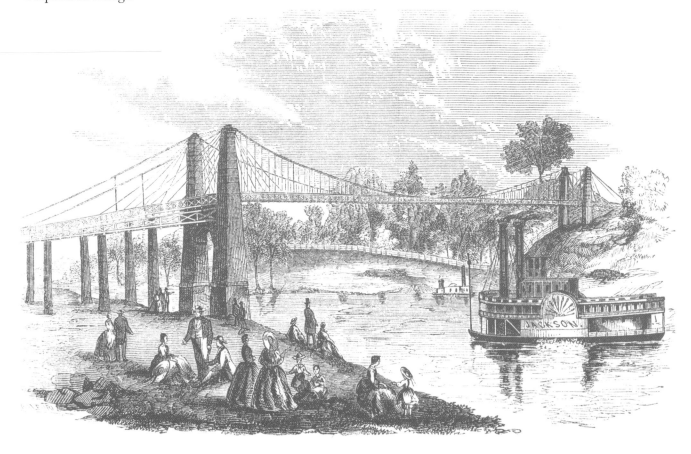

The Licking River Suspension Bridge between Covington and Newport.
Source: *Ballou's Pictorial Drawing-Room Companion* 11, no. 25 (20 Dec. 1856).

LOCKS AND DAMS ON THE LICKING RIVER

For many years, residents along the shores of the Licking River had entertained hopes of extending steamboat navigation on the river. The improvement of the Licking River, through the construction of a series of locks and dams, was officially begun by the state of Kentucky's Board of Internal Improvement with inauguration of surveys in 1836. In October 1837 contracts were made for the first five locks and dams. In its annual report for 1839, issued in January 1840, the Board disclosed that work was progressing on the first five of the projected 21 locks and dams of the Licking River slack water navigation plan. The initial phase of the project was to consist of eight locks and dams, the eighth at Claysville, Kentucky, ensuring a passable channel for some 90 miles from the mouth of the Licking. Also in 1839, proposals were received for locks and dams six, seven, and eight, but contracts were let for only two of these. The total cost of the first phase of the project, for eight locks and dams, was estimated at $871,460, of which $97,689.64 had been expended by December 20, 1839. It was estimated that the entire project of slack water navigation for the Licking, extending from its mouth 231 miles to West Liberty, Kentucky, would cost $2,036,000. Construction was slow that year, however, and the board blamed delays on both a failure to locate and retain contractors with the financial wherewithal to undertake the project, and to a lack of state funds. Hampered by insufficient means, the state concentrated on older, more advanced projects on the Kentucky and Green Rivers.

The year 1840 witnessed minimal progress in the construction of the Licking River improvements. By November 30, 1840, a total of $182,727.05 had been spent on the Licking River slack water navigation, a fraction of the sum paid for that on the Kentucky River, nearly $620,000, and for the Green and Barren Rivers improvement, $663,000. The first five Licking River locks were still under construction, but none of the dams had been started. Locks six through eight, after minimal settlements with the contractors, were apparently abandoned for lack of funds. The state, financially strapped for appropriations for its internal improvements overall, hoped to complete at least the first five locks and dams, thus securing navigation to Falmouth, about 51 miles above the mouth of the Licking. The total estimated cost of these first five locks and dams was increased to $573,445.

Facing financial problems of mammoth proportions, the state suspended work on the Licking River slack water navigation project from November 1840 until the middle of April 1841. This further delayed construction the following spring, since the contractors for the first three locks depended upon late-winter and early-spring freshets, generally occurring on the Licking in February, March, and April, to float their stone (quarried from a location near Portsmouth, Ohio) to the construction sites. Nevertheless, by December 1841, the Board of Internal Improvement reported that a total of $303,197.76 had been expended on the Licking River slack water navigation plan since its beginnings, leaving an estimated $270,247.24 worth of work still remaining to complete the first five locks and dams. In 1842, under severe financial constraints, the Board of Internal Improvements suspended, until further notice, the completion of the Licking River slack water navigation project, devoting its funds to the finishing of the Kentucky and Green River locks and dams, which were closer to completion and in which more had been invested. The movable timber, iron, and other materials of the Licking River project were either sold or used elsewhere, and the uncompleted lock walls stood as visible reminders of a vast, unfinished project. Final revised figures stated that a sum of $372,520.70 had been spent on the Licking River slack water navigation plan.

The failure of the slack water navigation project of the Licking River was a loss to both Northern Kentucky and Cincinnati. As early as 1841, Cincinnatian Charles Cist had noted in his book, *Cincinnati in 1841,* that the improvement was of great importance to the Queen City. Besides enabling the movement of agricultural products, the system of locks and dams would connect Cincinnati with the valuable minerals and natural resources of the upper Licking. Some 140 miles from the mouth, for instance, in Kentucky in Bath and Fleming Counties, there were deposits of iron ore, and at 200 miles, coal.

Delayed by what they regarded as a temporary setback, Northern Kentuckians refused to accept defeat and continued to agitate for the completion of the locks and dams on the Licking. In early November 1845,

a convention of citizens from Bath, Bourbon, Boone, Campbell, Fleming, Harrison, Kenton, Montgomery, Nicholas, and Pendleton Counties met in Covington. They resolved to petition the state to complete the project, or, if it was unable, to allow a private company to undertake the task.

The state of Kentucky did not resume the slack water navigation project on the Licking River. A bill to appropriate $20,000 for the completion of the second lock and dam, and to make provisions for the counties of Campbell, Kenton, and Pendleton to apply certain of their own revenues to finishing the first five locks and dams, was introduced in the Kentucky Senate in early February 1846, but it failed passage. The inaction on the part of the legislature was "another instance," the *Daily Cincinnati Chronicle* claimed, "of foolish jealousy and rivalry." "Louisville, Maysville and Covington," it asserted, "are each striving for the Kentucky Trade. The consequence is, each defeats the other" ("Licking Navigation," 21 Feb. 1846).

In 1851 a bill was presented to the Kentucky General Assembly to authorize an individual to complete locks one and two on the Licking River. The bill would give the investor the right to use all of the state's land, stone, and materials on the two sites. In addition, it would grant him the right to charge tolls to ascending boats, as well as the exclusive use of all water rights connected with the project. The bill passed the Kentucky House, but was defeated in the Senate by a Northern Kentuckian, Captain J. W. Leathers. Leathers supported the project, but declined to grant such a vast enterprise to a single individual. Leathers, an advocate of the Licking River navigation projects, proposed a substitute bill, which created a joint stock company of $750,000 with the same privileges offered the individual. This law passed both houses. Leathers hoped that this corporation could achieve even greater results than an individual. Indeed, he conceived of an even more colossal plan, whereby the first lock, at the mouth of the Licking, would be built wide enough to permit the passage of the largest boats, and its dam high enough to create a deep pool to the second lock. Dry docks and shipyards could then be built along the shores of Covington and Newport. The second lock and dam, 6 miles upriver, could be 45 feet high, furnishing power for Covington, Newport, and Cincinnati.

Leathers's scheme did not attract any investors, principally because the resources of Northern Kentuckians were already being diverted to the Covington and Lexington Railroad, then under construction. In 1857, though, there was renewed interest in completing the navigation of the Licking River, and, accordingly, a public meeting was planned for Saturday, May 30, to consider the matter. Again, nothing further developed. Some of the Licking River locks were subsequently dismantled by the Covington and Cincinnati Bridge Company, which purchased the stone for use in the piers of their suspension bridge over the Ohio River at Covington.

COVINGTON AS SUBURB

By 1850 Covington was the second-largest city in Kentucky, with a population of 9,408. However, it was clearly eclipsed by Cincinnati, then the nation's sixth-largest city, with a population of 115,435. Increasingly, Covington was becoming a "suburb" of Cincinnati, a rather pleasant and affordable place to live and to raise a family. This suburban perception of Covington was echoed by the 1857 edition of *Appletons' Illustrated Hand-book of American Travel.* This guide described Covington in a manner typical of how its residents then viewed it—as a suburban city. That is, Covington was a suburb of Cincinnati, but at the same time, it was an important Kentucky city. The guidebook portrayed Covington as "one of the principal cities of Kentucky, with a population of about 14,000," but further, as "built upon a broad and beautiful plain, very much after the topography of the great Ohio city opposite, to which, indeed, it may be regarded as suburban."

Although suburban, Covington was also a major manufacturing center. By 1851 Covington's Licking Rolling Mill employed 120 workers and, according to Charles Cist in his *Cincinnati in 1851*, was "in steady operation throughout the year, day and night, Sundays excepted." The building housing the works was an immense structure, 180 feet by 155 feet.

The Licking Rolling Mill was a small establishment in comparison with Milward and Oldershaw, a Covington pork and beef packing plant, erected in 1848. It was a huge structure, 360 feet by 160 feet, occupying an area of 2 acres. According to Charles Cist, Milward and Oldershaw packed 11,746 hogs and some 3,000 beef cattle in 1851.

Many contemporary observers of the 1830s and the 1840s described Covington as a bustling city of phenomenal growth. Population statistics easily verify this view. The decade 1830–1840 witnessed the second-largest percentage increase in Covington's population history, a leap of nearly 173%, as the city grew from 743 inhabitants to 2,026. Covington's rate of growth more than doubled in the following decade, 1840–50, to more than 364%, the largest percentage increase in Covington's history, as the city's population jumped from 2,026 to 9,408.

The year 1846 witnessed a phenomenal expansion of Covington. A reporter for the *Cincinnati Chronicle*, quoted in the *Licking Valley Register* in October 1846, maintained that Covington's commercial business had more than doubled within the prior 12 months. Likewise, the writer disclosed that the number of buildings "just completed" or in the course of erection was greater "than in any previous year" ("Covington," *Licking Valley Register,* 3 Oct. 1846). The *Licking Valley Register* corroborated this claim when it estimated in May 1847 that 250 buildings were constructed in Covington in 1846.

Notwithstanding the extensive construction of new residences, the demand for houses in Covington still outpaced the supply. The *Covington Journal* reported in October 1848 that the shortage of residences was such that it heartily recommended the construction of "dwelling houses" in the city as a safe and secure investment for capitalists ("Improvements in Our City," 6 Oct. 1848). The lack was understandable, considering the restless stride of the city. In fact, the *Daily Atlas* of Cincinnati asserted that Covington "increased more rapidly" in 1848 "than in any one year since its commencement" ("Things About Town," 20 Jan. 1849). City assessor records substantiated this claim. According to the latter, the population of the city increased 1,405, or 30%, from 1848 to 1849. Likewise, the value of real estate grew from $2,238,956 in 1848 to $2,759,837 in 1849, representing a gain of 23%. Thus, the statistics confirm the impression that the population was increasing more rapidly than the resources to contain it ("Statistics of Covington," *Covington Journal*, 13 Apr. 1849).

The headlong advance of Covington even lent itself to hyperbole. In an article reprinted in the *Covington Journal*, a reporter for the *Lexington Atlas* recounted some tall tales related to him by a friend from Covington, whom he had asked for information on Covington's progress. The friend stated that he had heard of a man who moved his family to Covington, and then returned to his former home to finalize some remaining business transactions. When he returned to his family in Covington, the city "had built up so fast around him that he did not know the house he lived in." So, he inquired of passersby in the general direction where he thought he lived, but none knew because they too were all "new comers." Finally, he passed the door of his own house, and one of his children "came running out, and cried out 'O father! Why don't you come in and see us all?'" ("How They Do Grow!" *Covington Journal*, 1 Dec. 1848).

Much of the growth of Covington was attributable to a surge in immigration. Irish and German immigrants especially gravitated to Covington, as they did to Cincinnati and Newport. They built an entire network of social and cultural institutions, including churches, schools, and businesses. By 1860, available US census figures revealed that 28% of Kenton County's population was foreign-born. By 1870, when the first separate Covington figures are available, the city was 28.8% foreign-born. (See also "Chapter 9, From Language to Legacy: Immigration and Migration in Covington.")

FERRIES

As the Covington and Cincinnati Suspension Bridge was not officially opened until 1867, Covington residents relied upon ferries across the Ohio River. The original ferry that operated between Covington and Cincinnati had passed into the hands of Pliny Bliss. In March 1835 Bliss's lease expired, and Samuel Wiggins and John P. Garniss of Cincinnati secured the right of operation. At the same time, by agreement with the city of Cincinnati, the ferry's north landing was moved from Cincinnati's public landing to the foot of Walnut Street in Cincinnati, to facilitate the arrival and departure of steamboats at the wharf. Then, by 1846, as Cincinnati and Covington began to reexamine their relationship with one another, moving toward a redefinition of Covington as suburb, the Ohio Senate passed a resolution requesting the attorney general of Ohio, Henry Stanberry, to investigate certain facets of the ferry. In particular, the Senate desired to

know "by whom said ferry is licensed—the tolls charged—the amount of money invested—and the net annual income of the same," as well as if "the tolls of said ferry can be regulated by the General Assembly; and, also, whether additional ferries might be licensed at or near the place from whence" the ferry operated (*Documents, Including Messages*, 1847, 526).

The attorney general of Ohio responded that the granting of a ferry license was the responsibility of a city or of a county court of common pleas, and since a ferry was a "public convenience," the proper authorities could license additional ferries: "The license to keep a ferry is no more exclusive," Stanberry wrote, "than the license to keep a tavern. If the public convenience requires more than one ferry at one place . . . it is the duty of the public authorities to license the requisite number." Of course, Stanberry noted, in this instance, the state of Kentucky would also have to approve additional ferry licenses.

Wiggins and Garniss provided, at the attorney general's request, a report of their receipts. From the time that they assumed operation of the ferry, March 6, 1835, to December 1, 1846, they earned a net profit of $37,703.34, averaging, over these 11 years, a net annual income for each proprietor of $1,615.72. Further, the owners claimed that the tolls, which were regulated by the city council were "actually less than those authorized by law" ("Ferry Receipts and Expenditures," *Covington Journal*, 25 Oct. 1851).

By 1849, the amount of commuting between Cincinnati, Covington, and Newport had become great enough to warrant the attention of the *Daily Atlas* of Cincinnati, which noted, in an impressive tone, "There are now four Ferry boats plying between this city and Covington and Newport. Five years ago, there were but two. This shows an increase in the business across the river" ("Things about Town," 30 Jan. 1849). On one ferry alone, the Covington Ferry, it was estimated in 1851 that an average of 2,300 persons used that ferry daily, "many of whom" crossed "four to eight times" per day. To accommodate such commuters, the Covington Ferry had adopted a fare policy allowing families, "no matter how numerous," to cross for 50¢ per month, averaging "less than *one cent* per passenger, at the end of the year" ("Ferry Receipts and Expenditures," *Covington Journal*, 25 Oct. 1851).

Meanwhile, in 1850, as the growth of Covington and Cincinnati continued unabated, the Covington Ferry was again moved, one block downriver from Walnut Street to the foot of Vine Street in Cincinnati, and, likewise, in Covington, from the foot of Greenup Street to Scott Street. This latest arrangement was a reflection of the expansion of both cities. Cincinnati needed the extra block of public landing for steamboats, and as Covington stretched westward, the new terminus of the ferry was brought "nearer the center of travel" ("Town Facts and Fancies," *Cincinnati Enquirer*, 8 Mar. 1850).

GAS

Transportation, of course, was not the sole component or measure of a city's prosperity. The procurement of gas for the city of Covington was yet another vital ingredient of its agenda to develop and enhance the city. On October 28, 1852, the city council of Covington signed a contract with James Southgate and associates to provide gas for the city. The ordinance granted the gas franchise for a period of 50 years and specified that the city itself would be entitled to receive gas, at half price, for public street lamps. Further, the city established prices that the gas company could charge private users and, in addition, reserved the right of the city to purchase "all the pipe, buildings, privileges and apparatus, constituting the gas works," contingent upon a year's advance notice, on or after January 1, 1869. Should the city decide not to purchase the gas works at that time, it could reconsider the matter every five years thereafter ("An Ordinance to Provide for Lighting with Gas the City of Covington, Ky.," *Covington Journal*, 6 Nov. 1852).

By March 1853 the *Covington Journal* reported that the gas company had begun laying gas pipes throughout the city and had chosen a site for the gas works, where the gas was to be manufactured, on East Ninth Street. The work was proceeding as scheduled, and it was hoped that before long, Covington would be lighted with gas. By September, the *Journal* disclosed that the buildings of the gas works were nearly completed.

Building Civil War defense south of Covington. Source: *Frank Leslie's Illustrated Newspaper*, 4 Oct. 1862.

THE CIVIL WAR

By 1860 Covington's population had increased to 16,471. A prosperous commercial center, the city depended upon a vast network of trade between the North and the South. Not surprisingly, the residents of Covington—whether or not they supported states' rights—were reluctant to see the Union torn apart. Further, by 1860, slavery was a dying institution in Covington. In 1850, the US census counted 281 slaves in the city versus 197 in 1860, a decrease of nearly 30% in 10 years. Many of these remaining slaves were domestic household servants, so slavery played a very minimal role in Covington's overall economy by the time of the Civil War. In addition, Covington—along with Newport and Cincinnati—had been centers of the Underground Railroad, that is, of the long network of stations aiding the flight of African Americans to freedom. (See "Chapter 5, From Fettered to Freedom: African Americans in Covington.")

The 1860 presidential election in Covington was a further barometer of the city's support for maintaining the Union. More than 89% of the city's total votes went to candidates supporting the maintenance of the Union, John Bell of the Constitutional Union Party, Stephen Douglas of the Northern Democrats, or Abraham Lincoln of the Republican Party. Less than 11% supported Kentuckian John J. Breckinridge of the Southern Democrats. Regardless of where they stood politically, Covington's residents did not desire war, nor did those of Kentucky overall. Kentucky remained one of the neutral "border states" during the Civil War, along with Delaware, Maryland, and Missouri (and West Virginia, which became a state in 1863).

Of course, once the Civil War started, some Covington residents supported the Confederate States of America, including the influential Bruce and Withers families. Covington residents joined the Union and Confederate armies alike. A large but unknown number of the city's Germans supported the Union and joined German-speaking regiments in Ohio and Indiana, including the famous *Turnverein* (Turners) regiment, the Ninth Ohio Volunteer Infantry.

The Licking River is seen to the far left, along with the tents of Camp King. In the center of the photo is the Kentucky Central Railroad (C&L) leaving Covington southbound. In the foreground is Battery Anderson, protecting the valley. Source: *New-York Illustrated News*, 25 Nov. 1861.

Covington's most anxious moments during the Civil War occurred in late summer 1862, when 8,000 Confederate forces under General Henry Heth advanced northward toward Northern Kentucky, intending to lay siege to Cincinnati. In reality, the Confederate forces never would have been able to hold a city the size of Cincinnati, but they could have emptied its warehouses of needed supplies and even demanded a ransom from its residents. Neither occurred, however, as Union forces quickly went into action. Union General Lew Wallace assumed command. Thousands of troops crossed a pontoon bridge across the Ohio River to construct an 8-mile-long series of fortifications along the hillsides of Kenton and Campbell Counties to protect the region from invasion. (See the illustrations, "Chapter 13, From Packet Boats to Pollution: The Ohio and Licking Rivers.") The Cincinnati Black Brigade, one of the first uses of black soldiers by the Union, assisted in the building of the defensive line. Union gunboats patrolled the Ohio River, and martial law was declared in Covington, Cincinnati, and Newport. The Confederates withdrew, and the three cities only sporadically worried about rebel raiders, like John Hunt Morgan, thereafter. Rebel uprooting of railroad tracks, the burning of trestles, and the cutting of telegraph lines along the Kentucky Central (the Covington and Lexington) Railroad proved particularly annoying and expensive, leading to the detachment of Union troops to guard this important supply line.

During the course of the Civil War, Covington and Newport must have seemed like armed camps. Across the Licking River from Covington was Newport Barracks, a major Union army installation. South of the Covington city limits, Camp King mustered in Union soldiers along the Licking River (in the area of present Meinken Field), and kept a regiment posted for maintenance of the city's defensive line. In 1862, near 20th and Greenup Streets, the Union Army opened Covington Barracks, composed of 41 frame structures, with the capacity to house up to 2,000 troops temporarily. In the same year, the government built three large stables on Banklick Pike south of the city, capable of holding as many as 4,500 horses and mules. Untold thousands of Union soldiers passed through the city, arriving and

departing at the Kentucky Central Railroad terminal at Pike and Washington Streets. Trains laden with army provisions regularly left the city, and Covington's industries, stores, and bakeries worked to supply the army's needs. For instance, Covington's Busch and Jordan Rolling Mill manufactured axles for government wagons.

Meanwhile, runaway slaves, as well as refugees from the South, especially those from eastern Tennessee, passed through Covington. So too did newly released Confederate prisoners of war on their way home. And newly captured Confederate prisoners of war were housed temporarily at the Odd Fellows Hall, and later at a new prison near Covington Barracks. A hotel on Main Street in Covington, formerly called the Elliston House, became Covington's largest Union army hospital, with 402 beds. So too did the former Western Baptist Theological Institute on West 11th Street, with 218, and the old Bridge Hotel at Front and Greenup Streets. At times, steamboats filled with hundreds of casualties arrived in Covington. Without a doubt, the city was one of the major national centers to receive and treat wounded soldiers. Sadly, its funeral directors also supplied untold numbers of caskets for those who died.

In the presidential election of 1864, Abraham Lincoln garnered 55.5% of the vote of Kenton County. In April 1865, with the end of hostilities, war-weary residents of Covington celebrated with the ringing of church bells, the firing of cannon, and bonfires at night. The Covington fire department joined a celebratory parade in Cincinnati, proudly displaying its fire engine called the *U.S. Grant*. After Lincoln's assassination, Covington businesses closed on the day of his funeral (April 19, 1865), bells tolled, and residents attended church services in his memory.

The Civil War was the nation's worst disaster. Too often it has been romanticized in history books and in films, but the ugly truth was that 620,000 people—North and South—died as the result of the nation's bloodiest war, two-thirds of them from disease. Medicine was still primitive, the germ theory of disease had not yet been discovered, and sanitary conditions were poor. Yet, the war lived on for years afterward, in the memories of those who lived through it, and in the lives of widows and orphans who never saw their loved ones again. Before the

The Jesse Root Grant House, Greenup Street, Covington. During part of the Civil War, Julia (the wife of General Ulysses S. Grant) and their children stayed at this house of General Grant's father and mother. Source: *Harper's Weekly*, 11 Nov. 1865.

war, Covington's Catholic bishop, George Carrell, formerly president of Xavier College in Cincinnati and always a proponent of education, had established St. Stanislaus Seminary in White Sulphur, in Kentucky's Bluegrass region. During the war, it closed, and after the war it became an orphanage for boys. Likewise, in 1868, the bishop sold his short-lived St. Aloysius Seminary, located several miles south of Covington, to the St. John Orphan Society.

SELECTED BIBLIOGRAPHY

An Act to incorporate a company to erect a Bridge across Licking river, between the towns of Newport and Covington. *Acts Passed at the First Session of the Thirty-Eighth General Assembly for the Commonwealth of Kentucky*. Frankfort, KY: J. G. Dana and A. G. Hodges, 1830, 109–115.

"Annual Report of the Board of Internal Improvements." *Reports Communicated to Both Branches of the Legislature of Kentucky, at the December Session, 1848*. 2 vols. Frankfort, KY: A. G. Hodges & Co., 1848–49.

Annual Report of the President and Directors to the Stockholders of the Covington & Cincinnati Bridge Company, for the Year Ending Feb. 28th, 1867. Trenton, NJ: Murphy & Bechtel, 1867.

Annual Reports of the President and Engineer of the Covington and Lexington Railroad, December, 1850. Covington, KY: Journal Office, 1850.

Burns, John E. *A History of Covington, Kentucky, through 1865*. Covington, KY: Kenton County Historical Society, 2012.

Documents, Including Messages and Other Communications Made to the Forty-Fifth General Assembly of the State of Ohio. Vol. 11. Columbus, OH: C. Scott's Steam Press, 1847.

Drake, Benjamin, and E. D. Mansfield. *Cincinnati in 1826*. Cincinnati, OH: Morgan, Lodge, and Fisher, 1827.

Drake, Daniel. *Natural and Statistical View, or Picture of Cincinnati and the Miami Country*. Cincinnati, OH: Looker and Wallace, 1815.

Fifth Annual Report to the Stockholders of the Covington and Lexington Railroad. Covington, KY: Covington Journal Office, 1855.

Geaslen, Chester F. *Our Moment of Glory in the Civil War: When Cincinnati was Defended from the Hills of Northern Kentucky*. Newport, KY: Otto Printing, 1972.

Mackoy, W. H., comp. *Charter and By-Laws of the Covington and Lexington Turnpike Road Co*. [Cincinnati, OH: W.B. Carpenter, 1890?].

Morehead, J. T. "Annual Report of the Board of Internal Improvement of the State of Kentucky." *Appendix to the House of Representatives' Journal* (1839–40): 1.

Northern Kentucky Newspaper Index. Covington, KY: Kenton County Public Library.

Ramage, James A. "Panic In Cincinnati." *Blue & Gray* 3 (1986): 12–15.

———. *Rebel Raider: The Life of General John Hunt Morgan*. Lexington, KY: University Press of Kentucky, 1986.

Richards, T. Addison. *Appletons' Illustrated Hand-book of American Travel*. New York: D. Appleton & Co., 1857.

Tenkotte, Paul A. "The 'Chronic Want' of Cincinnati: A Southern Railroad." *NKH* 6 (1) (1998): 24–33.

———. "A Note on Regional Allegiances During the Civil War: Kenton County, Kentucky, As a Test Case." *Register of the Kentucky Historical Society* 79 (3) (1981): 211–18.

———. "Rival Cities to Suburbs: Covington and Newport, Kentucky, 1790–1890." PhD diss., University of Cincinnati, 1989.

———. "The 'Chronic Want' of Cincinnati: A Southern Railroad." *NKH* 6 (1) (1998): 24–33.

Tenkotte, Paul A., and James C. Claypool, eds. *The Encyclopedia of Northern Kentucky*. Lexington, KY: University Press of Kentucky, 2009.

Thomas, E. S. *Reminiscences of the Last Sixty-Five Years, Commencing with the Battle of Lexington. Also Sketches of His Own Life and Times*. 2 vols. Hartford, CT: Case, Tiffany, and Burnham, 1840.

Wimberg, Robert J. *Cincinnati and the Civil War: Off to Battle*. Cincinnati, OH: Ohio Book Store, 1992.

———. *Cincinnati and the Civil War: Under Attack*. Cincinnati, OH: Ohio Book Store, 1999.

———. *Cincinnati and the Civil War: 1863*. Cincinnati, OH: Ohio Book Store, 2006.

CHAPTER

GATEWAY TO THE NORTH 1867–99

by Paul A. Tenkotte, PhD

THE COVINGTON AND CINCINNATI SUSPENSION BRIDGE (JOHN A. ROEBLING SUSPENSION BRIDGE)

On January 1, 1867, the Ohio River at Cincinnati was frozen, occasioning the interruption of ferry service between Northern Kentucky and Cincinnati, Ohio. In response, the directors of the Covington and Cincinnati Bridge Company opened their still-uncompleted span to vehicular traffic, a move that was initially expected to delay the workmen's finishing touches to the bridge. The decision was a magnanimous gesture, declared the *Cincinnati Daily Gazette,* for "the present condition of the river shows the importance of the bridge; and the managers are doing their best to accommodate the public, even to the detriment of their own interests" ("Covington. Opening of the Bridge for Vehicles," 1 Jan. 1867).

The bridge opening was marked by enthusiasm in Covington and Cincinnati. At 11 a.m., a procession of carriages, carrying the officers, directors, and engineers of the bridge company, followed by members of the city council of Covington, horsemen, and citizens of Covington, left Covington and proceeded over the bridge. Reaching Cincinnati, they were met by "a much larger procession" and the two "thus united marched back over the bridge to the music of Menter's and Heidel's bands, and amid the shouts of the thousands who lined both shores of the river" ("Covington. Opening of the Bridge for Vehicles Yesterday," *Cincinnati Daily Gazette,* 2 Jan. 1867). During the span's first day of operation, an estimated 45,000–50,000 people crossed the bridge.

The opening of the Covington and Cincinnati Suspension Bridge reduced, to some extent, the volume of ferry traffic between Covington and Cincinnati. For instance, the Covington and Cincinnati Ferry Company announced that it would cease operations on the last day of March 1867. This closure proved to be a temporary hiatus. On August 5, 1867, the Scott Street Ferry Company, the successor to the Covington and Cincinnati Ferry Company, reopened the ferry. The Scott Street Ferry deliberately set their tolls "below those charged by the bridge," charging for pedestrians, 1¢ for "each crossing" if tickets were purchased in commuter packages ("Covington. Opposition," *Cincinnati Daily Gazette*, 2 Aug. 1867).

The competition must have proved too fierce for the Main Street Ferry, though, which operated between Main Street in Covington and Central Avenue in Cincinnati, for the latter ceased operations in September 1867. The closing of the Main Street Ferry proved a hardship to many workingmen of Covington who had relied upon it for daily commuting to Cincinnati. The *Cincinnati Daily Gazette* outlined the situation in detail:

> *The people residing in that part of the city lying west of Main street, have been put to great inconvenience by the suspension of ferry communication with Cincinnati, at Main street. A large number of persons living in that section of the city work in the foundries, machine shops, furniture factories, & c., below Plum street, in*

Cincinnati, and they have always crossed at the Main street ferry; but now that the boat at that point has stopped running, they are compelled to go up to the bridge or the Scott street ferry, making the additional distance they have to walk, in going and returning from work, fully a mile and a half. ("The Main Street Ferry," 8 Oct. 1867)

At a meeting on Saturday, October 12, at the Sixth Street Market House in Covington, Westside residents clamored for the resumption of the Main Street Ferry. The assembly appointed a committee of three to collect signatures of Westside residents for a petition requesting Covington City Council to condemn a 100-foot strip of land below Main Street for the use of a ferry. By the end of the month, James P. Patton, a Covington councilman

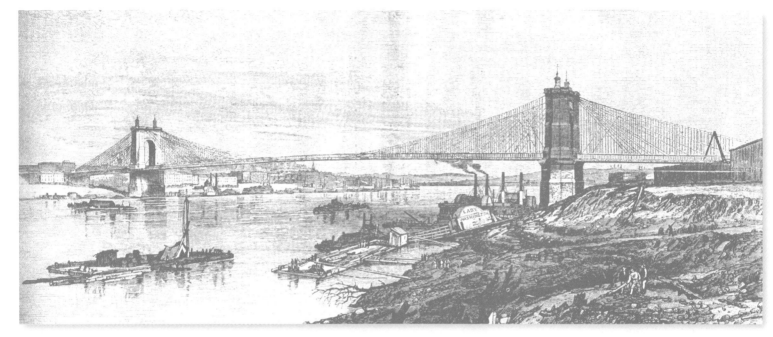

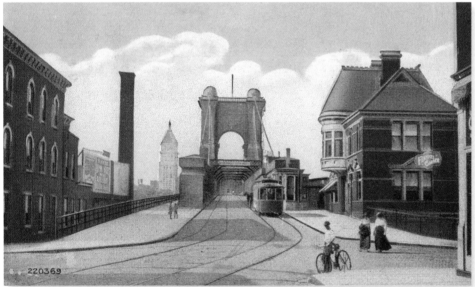

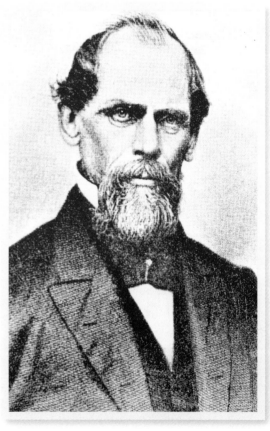

TOP: The Covington and Cincinnati Suspension Bridge, now called the John A. Roebling Suspension Bridge. Source: *Frank Leslie's Illustrated Newspaper,* 17 Aug. 1867. ABOVE: The Covington side of the John A. Roebling Suspension Bridge, circa 1920, looking toward Cincinnati. Courtesy of Paul A. Tenkotte. RIGHT: John Augustus Roebling (1806–69), chief engineer of the Covington and Cincinnati Suspension Bridge. In 1983 the Kentucky Transportation Cabinet renamed the bridge in his memory. John Roebling and his son, Washington Roebling (1837–1926), designed the world-famous Brooklyn Bridge. Courtesy of the Kenton County Public Library, Covington.

from the seventh ward in Westside, informed the public that he intended to "apply at the November term of the Kenton County Court for [a] license to run a ferryboat from the foot of Main street, Covington, to the foot of Central Avenue, Cincinnati" ("The Main Street Ferry," *Cincinnati Daily Gazette,* 31 Oct. 1867).

In November Patton filed suit against the Covington and Cincinnati Ferry Company, the former operators of the Main Street Ferry, for its failure to fulfill its license in running a ferryboat from the foot of Main Street. Patton's suit, "to recover $25" in damages, was actually more ominous than it sounded, for the ferry company was "liable to be sued by every person who goes down to the foot of Main street for the purpose of crossing the river, and is prevented by the Company not running a boat, as required by the license which they hold" ("Covington. Suit Against a Ferry Company," *Cincinnati Daily Gazette,* 6 Nov. 1867). In light of this fact, perhaps, the company agreed to resume the Main Street Ferry in late November 1867. By early December the ferry suspended operations for the second time, and James P. Patton continued to fight for a ferry franchise.

In January 1868 the *Cincinnati Daily Gazette* reported that the Covington and Cincinnati Ferry Company had sold "their boats, floats, franchise, & c." to the Louisville and Cincinnati Mail Line Company, a major operator of steamboats along the Ohio River. The terms of sale were finalized in February, and the Louisville and Cincinnati Mail Line Company discontinued the Scott Street–Vine Street Ferry and instead berthed its packets at the old ferry landing at the foot of Vine Street in Cincinnati. The Mail Line was expected to continue to run the Main Street–Central Avenue Ferry. In 1869, the Mail Line sold the Main Street Ferry to the Covington and Cincinnati Bridge Company, giving the latter a monopoly over daily commutes between Covington and Cincinnati.

By the late 1860s, the heyday of the Covington and Newport ferries had ended. The gross receipts of the two ferries of the Covington and Cincinnati Ferry Company for the year 1867 paled in comparison to the tolls taken by the Suspension Bridge: $18,815.75 to $115,774.37. A somewhat nostalgic yet forward-looking editor of the *Covington Journal* remarked on the imminent passing of the Scott Street–Vine Street Ferry with a certain ambivalence, exclaiming "Good-bye to the old Ferry!" in one breath, and in another, stating with a certain relief: "The importance of the Ferry, and of uninterrupted communication with Cincinnati, was fully appreciated, if at no other time, when, as has sometimes happened, the ice so obstructed the river as to prevent the boats from making trips and yet was not compact enough to admit of crossing on it. Then there was nothing to do but to grumble and wait" ("The Scott Street Ferry," 8 Feb. 1868).

While the operators of ferryboats grappled with the new exigencies of bridge competition, the Covington and Cincinnati Bridge Company charted its path finding course. In late January the bridge company began the sale of coupon books, or what might be termed commuter tickets. These books consisted of 25 tickets; one coupon of each was "cut off by the toll gatherer at every crossing of the holder" ("Covington. New Arrangement," *Cincinnati Daily Gazette,* 22 Jan. 1867). Likewise, cooperation between the Newport and Covington Bridge Company and the Covington and Cincinnati Bridge Company enabled pedestrians, by August 1867, to cross both bridges for 2¢ one way, when tickets were "purchased in packages." Similarly, vehicular commuters were offered reduced package rates ("Newport. Newport and Covington Bridge," *Cincinnati Daily Gazette,* 23 Aug. 1867).

AN ERA OF GROWTH

As a reliable, all-season, all-weather link to Cincinnati with special provisions for commuters, the Covington and Cincinnati Suspension Bridge stimulated an era of growth in Covington, which to that time had no parallel. It advanced the suburbanization of the city and generated a new migration of both well-to-do and working class Cincinnatians to Northern Kentucky. Indeed, H. C. White, city assessor of Covington, reported to the city council on Friday, May 3, 1867, that the past year had seen an increase in the population of the city of 2,973, from 18,487 to 21,460. Likewise, the property valuation increased $742,906, from $7,837,409 to $8,580,315.

Commercial and industrial development benefited as well from the bridge. A day after the bridge opening, a new tobacco warehouse in Covington, located within two blocks of the new span, commenced operations amid

a city environment where, according to the *Cincinnati Daily Gazette,* "openings seem to be all the rage at present" ("Covington. Opening of a Tobacco Warehouse," 3 Jan. 1867). The warehouse was a huge complex, two stories tall and 72 feet by 196 feet in size, a visible sign of "the increasing tobacco interest of Northern Kentucky, and Covington in particular."

The residential boom, however, was the one that elicited the most comments. Already, by 1867, there were reports of tenements in Covington. The City Assessor noted, for instance, during his rounds in March of that year that "he found living in one building on Greenup Street, near the City Hall [and the bridge]—the old Franklin House— twenty-seven families, or an aggregate of about 110 persons" ("Covington. A Covington Tenement House," *Cincinnati Daily Gazette,* 21 Mar. 1867).

The real estate boom in Covington lasted for a number of years. One of the most prosperous years for suburban property in Covington was 1868, when the state auditor of Kentucky reported that "the value of town lots in Lexington increased $79,085; in Newport, $616,711; in Covington, $1,943,054" ("Newport," *Cincinnati Daily Gazette,* 15 Mar. 1869). Meanwhile, "in Louisville they decreased $1,376,288," prompting the *Cincinnati Daily Gazette* to ask somewhat triumphantly, "What is the matter with Louisville?"

The following year, 1869, was an equally banner one for Covington, where the skyrocketing costs of lots and residences were recounted in detail by a reporter:

> *Real estate in Covington continues to advance steadily in value, as indicated by the sales which are constantly being made. Ground in the western part of the city, which was held two years ago at $40 per foot, now readily commands $60–$75 per foot. A lot on Greenup street, which was sold two years ago for $3,500, brought $6,500 a few days since. A well-known business man purchased a residence on Madison street less than a year ago for $10,000 and sold it recently for $15,000. A lot, 38 feet front by 96 feet deep, at the northwest corner of Fifteenth and Madison streets, was sold recently for $2,280, or $60 per foot. It could have been bought eighteen months ago for $30 per foot. A little less than two years ago a lot at the corner of Scott and Martin streets sold for $800, and has since changed hands at $2,200. About two years ago a parcel of ground fronting on Scott street, south of Thirteenth, and running back 280 feet, was sold at $55 per foot. It has since been cut up into lots having a depth of 120 feet, and sold at $65 per foot, which indicates an advance of over one hundred per cent. ("Covington,"* Cincinnati Daily Gazette, *4 Mar. 1869)*

Amos Shinkle, a longtime director of the bridge company and its president from 1866 until 1892, was a speculator in this real estate boom. On July 6, 1866, Shinkle, along with Jonathan Barker, Wesley C. Hamilton, Matthew Hart, and Jonathan David Hearne, officially formed a land partnership to develop a tract of land in Covington earlier purchased by the partners for $110,000 from Mrs. Rosina Groesbeck. The land was "bounded on the East by [the] Licking River—on the North by Fourth Street—[and] on the West by Sandford Street." The partners agreed to improve and subdivide the land as Park Place, a rather exclusive neighborhood, the development of which was strictly controlled by deed restrictions, one of the earliest local examples of this. Purchasers of lots on Garrard Street, for instance, were required to "erect upon the land" a "substantial first-class Dwelling House of brick or stone, of not less than two stories high" and "not built nearer than eighteen feet to the front of the lot, or margin of the street." In addition, buyers agreed, for a period of 20 years, not to use their property for anything other than "a Dwelling House, Private Boarding House, or Private Boarding School." If the grantee refused to honor these restrictions, the company, or grantor, could fine the buyer $1,000 for the first year and $2,000 for each year or "part of a year" thereafter, for as long as the restrictions were violated. Further, the fines would act as an official lien against the property (Jonathan David Hearne Papers, Box 2).

The Park Place partnership was an eclectic mix of businessmen. Shinkle was a Covington entrepreneur, banker and, as mentioned, guiding light of the suspension bridge. Wesley C. Hamilton was a Covington distiller. Jonathan

David Hearne, born in Bourbon County, Kentucky, in 1829, had been a dry goods merchant in Paris, Kentucky, but in the early 1860s relocated to Covington, and "soon after, went into the wholesale boot and shoe trade, in Cincinnati" (*Biographical Encyclopaedia of Kentucky* 1878, 196). An associate of Shinkle's in the Union Methodist Church in Covington, Hearne was later elected president of the Covington branch of the Farmers' Bank of Kentucky (1870), served as a Covington city councilman in 1872–73, organized the City National Bank of Covington, and was the president of the Cincinnati and Newport Iron and Pipe Company. In 1882 he resigned his positions with the latter two institutions and became president of the Third National Bank of Cincinnati. Hearne also served as a director of the Covington and Cincinnati Bridge Company from 1902 until 1905. Matthew Hart, meanwhile, was another bridge associate of Shinkle's and a director of the bridge company from 1884 until 1895.

The Park Place development obviously was timed to coincide closely with the opening of the Covington and Cincinnati Suspension Bridge. As Shinkle and his fellow investors hoped, the bridge substantially increased the value of Covington property. Indeed, Covington grew at a rapid pace in the late 1860s. The city assessor's report to Covington City Council in April 1869, for instance, noted that over the prior year, the population of the city had increased from 22,034 to 23,185, an increase of 1,151, and that taxable property had gone from $10,089,654 to $11,128,926, representing an increase of $1,039,272.

With the growth of real estate and population in Covington came an increase in commuter traffic to Cincinnati. The *Cincinnati Daily Gazette* reported on October 22, 1869, that "it is estimated that five thousand people and a thousand vehicles cross and recross the Covington & Cincinnati Bridge daily. The average receipts of the bridge are about $500 per day."

OMNIBUSES AND HORSECARS

The new bridge also enabled Covington to be connected to Cincinnati by horsecar service. Streetcars, in turn, enlarged and, in effect, consummated a commuter relationship between Covington and Cincinnati that had been steadily growing during the 1850s, the consequence of Covington's new assumptive role as a suburban city. The completion of the bridge, then, acted to enhance this process. And it raised the expectations of those who rapidly became accustomed to streetcar service, contributing to an overall sense of the area as an integral metropolitan community composed of many parts.

By 1852 the newly avowed status of Covington as suburb made the establishment of an omnibus line, between Covington and Cincinnati, a feasible venture. In that year, V. T. Perkins inaugurated such a route, at a reasonable fare of 10¢, which included the price of ferriage. The omnibuses operated 6 a.m.–6 p.m. and ran every 45 minutes. The business proved a success, and in 1854 Perkins opened an omnibus service between Covington and Crittenden, Kentucky. In the same year, two partners, Clayton and Grant, established an omnibus line from the terminus of the newly opened Covington and Lexington Railroad in Covington. Six or seven buses shuttled passengers between the railroad and "any part of Covington, Newport or Cincinnati," in "elegant vehicles," driven by "accommodating drivers" ("Clayton and Grant's Omnibus Line," *Covington Journal*, 7 Oct. 1854).

Omnibus service was, however, only the first step in establishing closer commuter ties with Cincinnati. In December 1859 the Covington City Council considered an ordinance proposing the right to build a horsecar street railroad throughout the city to William Ernst, John W. Finnell, James Spilman, and Napoleon B. Stephens. Fares were limited to 5¢, and the franchise was set at 25 years, after which the city had the privilege to purchase the street railroad. In the same month, the Kentucky General Assembly chartered the Street Railway Company of Covington. However, by late December, the street railroad ordinance had been referred to a committee of the whole, where it supposedly died.

In March 1860 the Covington and Cincinnati Bridge Company presented a plea to the Covington City Council, requesting the right to construct a horsecar route through the city. The company designed the petition to make the bridge a more attractive venture for investors, thus providing it with the additional funds necessary to complete

the project. Further, the bridge directors expressed their desire to use their railway to transport passengers and freight between the railhead of the Covington and Lexington Railroad and the city of Cincinnati. In return for a 30-year franchise, the company offered the city the right of purchase at any time.

As advanced by the bridge company, the proposals for a street railroad gained many adherents. Most residents of Covington had, by 1860, concurred in the opinion that the bridge, once completed, would "augment the population and business of Covington, and promote its general prosperity" (*Covington Journal*, 31 Mar. 1860). Still, a few holdouts insisted that the street railroad, facilitating as it would traffic with Cincinnati, would "reduce Covington to a mere flag station, and forever blight the prosperity of the city."

The Covington City Council submitted the bridge company's proposal to a vote of the citizens on Friday, May 11, 1860. A persuasive argument offered in favor of the plan outlined the history of the bridge company and Covington's stake in it. Covington had purchased $100,000 worth of stock in the Covington and Cincinnati Bridge Company by issuing an equal amount in municipal bonds, the interest of which was payable every six months, and the principal in 20 years. Since the bridge was still far from completion at that time, the city's stock in the company was virtually worthless. If the bridge company were granted a street railroad franchise, though, new investors might become interested in the bridge, enabling the company to complete it. Covington citizens attended a variety of meetings to discuss the ordinance. These were held in various locations throughout the city, and generally featured a debate between the supporters and opponents of the measure. Of the advocates of the measure, John W. Finnell and William Ernst proved the most influential, as both were close associates of the guiding light of the suspension bridge, Amos Shinkle. Finnell, born in 1824 in Winchester, Kentucky, was a lawyer, a former newspaper editor, and a member of the Whig party. He was a state representative in Kentucky from Nicholas County in 1845–46, befriending John W. Stevenson of Kenton County. He served as secretary of state of Kentucky from 1849 until 1852, when he moved to Covington and practiced law. Finnell was a director of the Covington and Cincinnati Bridge Company from 1856 to 1860, served as its president from 1860 to 1862, and finally, returned as a director from 1862 to 1863.

William Ernst, born in 1813 in Bucks County, Pennsylvania, moved to Covington in 1838, after receiving an appointment as teller of the Covington branch of the Northern Bank of Kentucky. In 1849, he became cashier of the bank, and in 1867, its president. In addition, Ernst served as president of the Covington and Lexington Turnpike Company, as director and treasurer of the Kentucky Central Railroad (that is, the Covington and Lexington Railroad), and two terms as president of Covington City Council. He also held a position on the board of directors of the Covington and Cincinnati Bridge Company from 1861 until 1863.

The Bridge–Railway Proposition, as it was called, was defeated by a vote of 920 to 641. Its failure spelled the end to a further discussion of street railroads until several years later. In the interim, Clayton's omnibus line improved its services, adding two additional omnibuses in March 1863, and increasing stops to every half hour.

In February 1864 the Kentucky General Assembly chartered the Covington Street Railway Company, granting it the right to construct a street railway in "Covington,

William Ernst. Source: Roe, George Mortimer. *Cincinnati: The Queen City of the West*. Cincinnati, OH: The Cincinnati Times-Star, 1895.

and in the suburbs of said city," as well as proffering to it the privilege of laying its tracks across the Covington and Cincinnati bridge and the Newport and Covington bridge (provided, of course, the owners of both of these spans approved). The incorporators of the Covington Street Railway Company included Mortimer Murray Benton, John F. Fisk, N. C. Morse, J. C. Sayers, Amos Shinkle, and Jesse Wilcox. In November 1864 four of the six founders of the company, John F. Fisk, N. C. Morse, Amos Shinkle, and Jesse Wilcox petitioned the city council of Covington for a horsecar franchise. Like the previous request by the Covington and Cincinnati Bridge Company, this appeal seemed tailored by a close-knit group of bridge investors and supporters. Shinkle and Fisk were close associates in a number of companies and institutions, including the Covington and Cincinnati Bridge Company, the Covington Gas Light Company, the International Order of Odd Fellows, and the First National Bank of Covington. Likewise, Jesse Wilcox was the president of the Covington and Cincinnati Bridge Company in 1864, and Shinkle a director. Not a petitioner, but nevertheless an incorporator, was Mortimer Murray Benton. Benton, born in 1807 in Benton, New York, came to Covington in 1828, where he pursued "merchandizing and trading," teaching, and legal studies. In 1831, he was admitted to the bar, and practiced for a while with Major Jefferson Phelps, a noted Covington resident and lawyer. Soon embarking on a practice of his own, Benton became a distinguished lawyer, and a man of great political prominence. He served as the first mayor of Covington, and later as a state representative. Always an advocate of local public improvements, Benton was instrumental in obtaining state charters for the Cincinnati and Charleston Railroad, as well as the Covington and Lexington Railroad. He held the positions of attorney, director, and later, president of the Covington and Lexington Railroad. Later, from 1872 until 1881, Benton served on the board of directors of the Covington and Cincinnati Bridge Company (*Biographical Encyclopaedia of Kentucky* 1878, 52–55).

This 1864 petition of city council, then, represented a partisan effort of a number of influential Covington residents to establish a street railroad company closely allied with the bridge company. Indeed, along with the 1860 Bridge–Railway Proposition, the 1864 Covington Street Railway Company proposal disclosed a new political and business coalition consisting of Ernst, Finnell, Fisk, and Shinkle.

The Covington Street Railway plan was referred to a select committee of five, which drafted a report favoring the proposal, delivered on December 1 and approved on December 5. A number of people found fault with the hurried process whereby the petition was accepted by council, and a correspondent of the *Cincinnati Daily Enquirer* perhaps expressed these sentiments best when he proclaimed that the Covington Street Railway Company offered nothing to the city in return and that "it really looks, upon examination of the papers, very much like there were too many *city officers* mixed up with the thing" ("Covington News. Street Railroads," 9 Dec. 1864). Accordingly, the committee on law of the city council drafted an ordinance more favorable to the city's interests. The latter was presented to and passed by the city council on December 15, 1864. It stipulated that the company awarded the franchise would be required to pay the city an annual bonus of $250 per year for a period of 25 years.

In the interim, between Shinkle's petition and the passage of the street railroad ordinance, Shinkle and his fellow incorporators transferred their interests in the Covington Street Railway Company to A. D. Bullock, Theodore Cook, Henry Lewis, Malcolm McDowell, C. K. Russell, and Thomas Sherlock. A new proposal on behalf of the Covington Street Railway Company was then submitted by Thomas Sherlock, Malcolm McDowell, and associates. Sherlock was yet another colleague of Ernst, Finnell, Fisk, and Shinkle. He served as a director of the Covington and Cincinnati Bridge Company from 1858 until 1860, and then again, from 1864 until 1867.

The city council approved Sherlock and McDowell's bid and proposals on February 23, 1865. Then, on August 15, 1865, the council finalized its initial agreement with the Covington Street Railway Company. According to the provisions of the contract signed by Sherlock, the company's president, and the city on that date, 2 miles of track were to be laid and the cars running by September 9, 1867. By February 1867 the *Cincinnati Daily Gazette* announced that the company had finished nearly all of the horsecars for the line and that it expected to begin laying track in Covington in May of the same year. In all, the street railway company proposed five different routes for the city, running as far south as 15th Street and as far west as Bullock Street, at the foot of the first great hill west

of the city. Construction of the first line, running along Covington's main thoroughfare, Madison Avenue, began in June 1867 and was completed by July 1867.

By June 1867 the Covington Street Railway Company concluded an agreement with the Covington and Cincinnati Bridge Company, whereby the streetcar corporation was allowed to lay its tracks over the bridge to Cincinnati. At the Cincinnati approach of the bridge, the streetcars were to be met by omnibuses, at least until the city council of Cincinnati granted the Covington Street Railway Company the right to operate a loop route over Vine and Walnut Streets. On Monday, August 5, 1867, the first route of Covington's horsecar system, from the city limits down Madison Avenue to the bridge, inaugurated its operations. Fares to the Covington approach of the bridge were 5¢, and to Cincinnati, 10¢. Anticipated for many years, the first day of operation was a success. By August 8 the *Cincinnati Daily Enquirer* reported that the popularity of the horsecars had ordained the end of the omnibuses, which were discontinued. Recounted some years later by officials of the Covington Street Railway Company, "the press sounded out loudly that now Covington and Cincinnati were one; real estate felt the inspiration; the great bridge and the busy plying cars of the Covington Street Railroad had annihilated space" ("Covington," *Cincinnati Daily Gazette,* 31 July 1869). By July of the following year, 1868, the streetcars were carrying "2,600 passengers per day over the Ohio river suspension bridge," or some 78,000 per month ("Covington," *Cincinnati Daily Gazette,* 18 Aug. 1868).

Meanwhile, Major Malcolm McDowell, one of the owners of the Covington Street Railway Company, began an active campaign to court the favor of Cincinnati's council members in an effort to allow his company to extend its tracks, in a loop, into the downtown area of Cincinnati. On September 16, 1867, McDowell transported Mayor Wilstach of Cincinnati and a number of members of Cincinnati City Council and its board of improvements across the suspension bridge aboard a Covington horsecar "drawn by four horses and decorated with flags." Ostensibly, he was merely offering his hospitality to the Cincinnatians as a civic gesture, to enable them to view a special type of pavement installed on Madison Avenue between Seventh and Eighth Streets. In reality, though, his motivations were quite different, for after examining the new pavement, the "party then re-embarked, and was conveyed to the extensive car-house and stables of the Covington Street Railway Company, at the corner of Twelfth and Madison streets, where Major McDowell spread before his guests a cold collation. A bountiful supply of champagne was also furnished, and a great many toasts were drank [*sic*]" ("Covington. Visit of the City Council and Board of Improvements of Cincinnati to Covington," *Cincinnati Daily Enquirer,* 17 Sept. 1867). The result was a foregone conclusion. The *Cincinnati Daily Enquirer* proclaimed, "The sentiment of every member of the City Council of Cincinnati, who was present, was that the Covington City Railway Company should be granted the privilege of extending the road up Vine and Walnut streets, in Cincinnati, to Fourth or Fifth."

In mid-February 1868, Cincinnati City Council read, for the first and second times, an ordinance establishing a downtown Cincinnati loop to the Covington Street Railway Company's line. This was to run from the Cincinnati end of the suspension bridge, over Front, Walnut, Vine, and Fifth Streets, utilizing the tracks of some Cincinnati routes. The city council's Committee on Public Improvements, Roads, and Canals recommended passage of the ordinance. On April 7, 1868, the Cincinnati Board of Public Improvements granted the franchise for the downtown Cincinnati loop to "a gentleman connected with the Covington Street Railway Company" (*Covington Journal,* 18 Apr. 1868). The latter agreed to charge a fare of 5¢ per ride or $1 for 25 commuter tickets. Construction of the route began in July 1868. In October of the same year, John F. Fisk was elected president of the Covington Street Railway Company, which had, by that date, gained "the consent of a majority of the property owners on Vine and Walnut streets, from Front to Fifth, to lay down their track in those streets" ("Covington," *Cincinnati Daily Gazette,* 8 Oct. 1868). In November 1869 the Covington and Newport streetcars began running to Fourth Street in Cincinnati, and by October 1870, the Covington Street Railway Company concluded an agreement with the owners of the Cincinnati loop, whereby the Covington company began to operate its cars over the route.

The Covington Street Railway Company failed to construct four of its five proposed Covington routes, so the Covington City Council passed an ordinance, in December 1869, permitting another corporation to build two

this location alone. The second inclined plane railway incorporated for Covington was the Covington Inclined Plane and Narrow-Gauge and Elevated Railway Company, chartered in March 1884. This company was authorized to construct a narrow-gauge railway from south of 17th Street in Covington to Milldale (the current neighborhood of Latonia in Covington), as well as to Ludlow, west of the city of Covington. In addition, the company could build an incline on the hills west of the city. The third and final incline company was the Anderson Hill Inclined Plane and Railway Company, incorporated in April 1886 and authorized to build an incline along Anderson Hill, south of Covington, as well as a street railway along the Banklick Turnpike, should its owners consent to such.

SUBURBS, RESORTS, AND HILLS

A number of Cincinnati's wealthier citizens moved to bucolic estates in Northern Kentucky. In the 1830s Robert Wallace Jr., a wholesale grocery man and steamboat owner of Cincinnati, moved to an area south of the then city limits of Covington, which eventually became known as Wallace Woods. In 1836 Wallace's eldest daughter married John Shillito, a Cincinnati department store magnate. The Shillitos apparently lived for a time with the Wallaces, and in the late 1850s built a cottage of their own nearby. Joining Wallace in the neighborhood of Wallace Woods was Eugene Levassor, also a Cincinnati dry goods merchant, who moved to the area about 1850. In turn, a friend of Levassor, Daniel Holmes, owner of Holmes Department Store in New Orleans, Louisiana, purchased property near Levassor and Wallace in the mid-1850s. He built a summer home there, in the more salubrious climate of Northern Kentucky, which functioned further as a convenient stopping point between his business trips to New Orleans and New York City. By the 1850s Holmes established permanent residency in Covington, although he continued to travel extensively on business. After the Civil War, he built a palatial home upon his estate. Meanwhile, both Wallace and Levassor began subdividing their land during the 1850s.

To the weary city dweller, the hills and resorts of Kentucky proved a welcome escape. Cincinnati, Covington, and Newport residents sought recreation in suburban, outlying areas. Many took Sunday rides along the turnpikes, such as the Covington and Dry Creek Turnpike, which led to Ludlow. On the hills overlooking the city, urban residents picnicked. As the Covington correspondent of the *Cincinnati Daily Gazette* reported of the Independence Day weekend of 1869, "nearly everyone left the city on Monday for the woods. There was a large number of picnics, all of which were well attended" ("Covington," *Cincinnati Daily Gazette,* 7 July 1869).

An old and respected resort located 4.5 miles south of Cincinnati, just outside Covington, was Latonian Springs (situated where the United Dairy Farmers is now located, at Highland and 3L Highways in Fort Wright, Kentucky). Opened in the summer of 1829, it embraced four medicinal springs, "the water of each differing in taste and quality," and "valuable in the cure of bilious and cutaneous affections [*sic*] and in diseases of the liver." Located in the pleasant wooded valley of Banklick Creek, a tributary of the Licking, the resort featured a "Mansion House" to accommodate visitors. The latter was "100 feet in front, 3 stories high, and divided into 31 rooms, with two piazzas, each 10 feet wide, running the entire length of the building." The upper veranda was described by contemporaries as "cool and pleasant, affording a fine promenade, and an agreeable view of the surrounding scenery." A stable and a "fine carriage" were kept for the use of visitors. In addition, sportsmen could hunt in the neighboring hills, where there were "deer and turkeys, the valley quail, wood cock and other small game." In adjacent Banklick Creek, fishermen could cast their lines for "bass, sunfish, and a variety of turtle" ("Latonian Springs," *Cincinnati Chronicle and Literary Gazette*, 25 July 1829; for another description of Latonian Springs, see "Communicated. Latonian Springs," *Cincinnati Chronicle and Literary Gazette,* 8 Aug. 1829, and "Medicinal Waters," *Cincinnati Chronicle and Literary Gazette,* 25 July 1829).

The founders and proprietors of Latonian Springs were Letton and Hunter. Ralph Letton was the owner and operator of Letton's Museum at Fourth and Main Streets in Cincinnati, a menagerie of "rare Birds," "Minerals and antiquities," "Mammoth and Elephant teeth," "Wax Figures," and assorted exhibits, typical of the eclectic museums of its day (*Daily Cincinnati Gazette*, 14 Jan. 1828). In 1832 Letton sold the resort to a new proprietor, J. A. Morgan, who,

by 1835, apparently enlarged the hotel to about 50 rooms, renamed the "Mansion House" the "Pavilion," and advertised its ballroom as one "admirably calculated to gratify such as are fond of Dancing" (advertisement for "Latonian Springs," *Covington Enquirer*, 12 Aug. 1835). With additions and alterations throughout the years, Latonia Springs, as it came to be known by 1850, continued in operation. In 1866 it was enlarged and refurnished by Walker and Gibson of the noted Gibson House (hotel) in Cincinnati. After the opening of the Covington and Cincinnati Suspension Bridge, omnibuses operated regularly between the Gibson House in Cincinnati and Latonia Springs. By the late 1870s, however, the former glory of Latonia Springs had passed, the *Daily Commonwealth* stating on July 21, 1879, that "hard times and perhaps mismanagement" transformed what "was at one time one of the most popular summer resorts in the State" to a "dilapidated wreck of former prosperity."

CHURCHES

See also "Chapter 6, From Art to Architecture: The Visual Arts in Covington."

Bucolic suburbs and sylvan resorts constituted one component of Victorian Americans' efforts to improve their quality of life. Equally important was the construction of civic monuments reflective of a city's prosperity and indicative of its cultural tastes. Massive, well-designed architecture, particularly churches and civic buildings, was a measure of a community's spirit. Covingtonians devoted considerable sums to the construction and embellishment of churches. The building of church edifices assumed a competitive flavor, as Protestant and Catholic congregations vied with one another in erecting churches worthy of their stature in the life of the city. For instance, the noted Cincinnati architectural firm of Walter and Stewart (William Walter and William Stewart) was commissioned by the wealthiest congregations of each major denomination in the city to design exquisite churches. The Union Methodist Episcopal Church, whose membership counted the wealthy financier and philanthropist Amos Shinkle, hired Walter and Stewart to design their elegant Victorian Gothic–style church on the southwest corner of Fifth and Greenup Streets. Dedicated in July 1867, it cost nearly $67,000, excluding its organ and furnishings.

The German Catholics of Mother of God Church in Covington next employed the services of the firm of Walter and Stewart in designing an outstanding example of Italian Renaissance Revival architecture. Dedicated in September 1871, Mother of God Church cost nearly $95,000 and was of mammoth dimensions, with a dome reaching 150 feet into the air and twin bell towers rising 200 feet each. In part, the congregation "agitated for a larger and a better house of worship," following the dedication of neighboring St. Aloysius's impressive church building in 1867 (Brungs 1941, 34–35). Built at a cost of $82,000 and designed by another noted regional architect, Louis A. Piket, St. Aloysius Catholic Church sported a spire of 200 feet.

Like the congregations of Union Methodist and Mother of God Churches, the members of Covington's First Baptist Church and of its First Presbyterian Church commissioned Walter and Stewart to design imposing structures. Dedicated in December 1873, First Baptist Church, a large Victorian Gothic edifice, featured an elaborate Kentucky limestone front. First Baptist stood adjacent to First Presbyterian Church, dedicated in January 1873 at a cost (including the lot) of $86,108. Together, the two churches made for an impressive streetscape, the lofty spire of First Presbyterian rising 185 feet into the air.

PUBLIC BUILDINGS

The construction of well-designed public buildings was also important to Victorian Americans. Like many 19th-century civic improvements, Covington's waterworks were attractively designed, with the intention of adding to the beauty of the city. The plans for the waterworks building itself, with a handsome Mansard roof, were also drawn by the architectural firm of Walter and Stewart. In addition, at the front of the waterworks building, a 40-foot by 60-foot emergency reservoir was constructed to "afford a supply of water in case of accident to the machinery in the well, as well as to supply a beautiful fountain, which will be erected in the center" ("Covington Water Works," *Covington Journal*, 22 Oct. 1870).

One of the architectural jewels of the city of Covington was the United States Post Office and Custom House, a mammoth Victorian Gothic structure that stood at the southeast corner of Third Street and Scott Boulevard. The site for the new building was chosen in 1873, and the cornerstone was laid in 1876.

GATEWAY TO THE NORTH

By the 1880s United States government studies adhered to the conception that Cincinnati, Covington, and Newport were, for all intents and purposes, one metropolitan area. For instance, George E. Waring, an agent with the U.S. Department of the Interior's Census Office, described the surrounding area of Covington, "especially the valley portion" as "largely engaged in raising garden-produce for Cincinnati, Covington, and the suburbs around these cities, while the hilly part is used, besides extensive fruit-culture, for common farming and dairying, considerable land being in pasture" (*Report on the Social Statistics of Cities*, 2 parts, 1887, 2:132, 112).

An 1883 correspondent for *Harper's New Monthly Magazine* agreed with the perceptions of government officials when he stated that Covington and Newport were "two large suburban towns," which had "been made substantially part and parcel of Cincinnati's self since the perfection of the bridge communication" ("Cincinnati," *Harper's New Monthly Magazine*, July 1883). Similarly, an 1886 author of *Leading Manufacturers and Merchants of Cincinnati and Environs* proclaimed that Covington was a delightful Cincinnati suburb, containing homes of "elegant styles of architecture," as well as "handsome and well-kept lawns and parterres." Then, in an excellent summation of Covington's relationship to Cincinnati, he related that "the people who have made Covington a beautiful city of homes and a thriving business place as well have welcomed the merchants of Cincinnati to their city, and in mutual accord and for the good of all, this community is advancing the common interests of the people of both Covington and the Queen City, without permitting that jealous spirit to manifest itself which has too often, under like circumstances, worked incalculable injury to one or both cities similarly situated" *(Leading Manufacturers and Merchants* 1886, 233–34).

A WATER SYSTEM AND MUNICIPAL CORRUPTION

A joint water system, to service both Cincinnati and Covington, was another rallying call of the post-1850 generation of local leaders. In 1867, the year that the Covington and Cincinnati Suspension Bridge opened, the city councils of Covington and Cincinnati acted upon a proposal to effect a cooperative arrangement whereby Covington would tie into Cincinnati's water mains. Although the plan's implementation was prevented by a number of complicating factors, including an injunction and an investigation into alleged corruption in the matter, the proposal nonetheless evidenced a growing metropolitan alliance.

Demands for a healthy water system further underscored a related metropolitan theme that was of great significance in the 1860s and 1870s: the quality of life. This quality of life could be assessed in two principal ways. The older method related it to various statistics—for instance, the number of residents, houses, shops, churches, physicians, and so on, that a city had. Indeed, city boosters seemed consumed by the collection of mathematical data during this era and in their passion to determine the rate of growth and development of cities recorded such facts with enthusiasm. A second approach or barometer was the quality of life itself. What did a city have to offer in terms of parks, resorts, civic architecture, and utilities? Did it, for example, have a pure water supply? The answers to these and related questions assumed a growing significance throughout the latter half of the 19th century.

Ironically, Covington's search for a pure water supply involved it in one—if not the first—local example of metropolitan boss rule. Charges of corruption abounded in the matter, and Covington citizens became disenchanted with their city government. Disillusioned by the immorality evidenced by their elected officials, many came to realize that in the pursuit of the quality of life, much had been sacrificed. The quality of life, they felt, should also include moral and ethical behavior by their public officials

In 1857 the *Covington Journal* advocated a waterworks for Covington, to supply pure, plentiful water to domestic and industrial users. Such a system was a necessity, the *Journal* attested, if Covington was to attract further residents

and manufacturers. Water was inextricably tied to the city's future. Ignoring the issue would be the equivalent of "retarding the growth and prosperity of the city" ("Magnificent Project. Immense Water Power—Water Works for Covington," *Covington Journal,* 23 May 1857). Toward this goal, the *Journal* promoted the completion of locks one and two on the Licking River by private interests. In 1851 the Kentucky General Assembly had approved an act authorizing a joint stock company to finish the stalled project, conferring upon it additional privileges concerning the sale of water to users for manufacturing and other purposes. If completed, the dams would provide a steady pool of water in the Licking, which could be diverted for year-round consumption by the citizens of Covington. A public meeting was called for May 30, but as no more was reported about the measure, it is assumed that a sufficient number of investors could not be interested.

In 1858 the editor of the *Covington Journal* renewed his crusade for a pure water supply for Covington, again relating it to the growth of the city. The *Journal* admitted that the Licking River, with its locks and dams still uncompleted, could not provide a reliable supply of water during seasonal droughts. Further, the Ohio River at Covington was so polluted by the direct sewage and waste discharges of Cincinnati, Covington, and Newport, that securing a supply of water from it would prove a health hazard. A possible solution, the editor suggested, was an artesian well, such as that which had been completed in Lafayette, Indiana. Again, the proposal was not acted upon.

In September 1858 the *Covington Journal* noted that the residents of Newport were seeking a water system. It seemed sensible, the editor suggested, that Covington and Newport consider building a consolidated waterworks. This would furnish a solution to the polluted Ohio River at Covington, for the two cities could place their water intakes above Newport, and hence, "above the emptyings of the sewers and gutters of Cincinnati" (*Covington Journal,* 11 Sept. 1858).

In October 1859 some residents proposed supplying Covington with water by tapping into the supply of the Cincinnati waterworks. In return for the public franchise, the investors agreed to provide free water to the city's public buildings and fire cisterns. The Covington City Council rejected the idea and instead passed a resolution requiring any such private interests to build a separate waterworks within the confines of Covington or, at least, of Kenton County.

Not until 1863 did the Covington City Council reactivate the water issue. On October 29 of that year, President Ernst presided over a city council meeting that appointed a committee, consisting of Ernst and Messrs. Carter, Matthews, and Nixon, "to examine and report the most eligible site for the erection of a reservoir" ("Covington News. Council Proceedings," *Cincinnati Daily Enquirer,* 31 Oct. 1863). Then, in November 1863, the *Cincinnati Daily Enquirer* intimated that the Cincinnati Water Works Company was about to "make a proposition to the City Council of Covington" to supply Covington with "water from their reservoir" ("Covington News. A Supply of Water for Covington and Newport," 6 Nov. 1863). It was also suspected that they would propose the same to Newport. Again, the subject languished until October 1864, when the *Enquirer* announced that the city council of Newport had recently presented a formal report on supplying that city with water from the Cincinnati Water Works.

Not until 1867, the year that the Covington and Cincinnati Suspension Bridge was completed, did all of the proposals for supplying Covington and Newport with water begin to materialize. In April of that year, the Covington City Council established a three-member committee to investigate a water supply for the city. By July Covington initiated discussions with the directors of the Cincinnati Water Works to examine the possibility of obtaining water from their mains. The Cincinnatians proposed that they provide water to Covington on the following terms. Cincinnati would construct a water main between its reservoir and Front Street in Covington, the expense of the iron pipe and its installation to be borne by Covington. Covington, in turn, would pay the costs of laying pipes throughout its own city, and would collect all water rents, retaining 50% of the net proceeds after collection expenses, and returning the rest to Cincinnati. Covington's citizens would always be charged the same water rate as Cincinnatians, and the city of Covington would be entitled to free water use for its public buildings and for its fire department. The water contract between the two cities would be exclusive, for a period of 25 years, and renewable thereafter. The city of Cincinnati

further reserved the right to provide Newport with water via the Covington pipe to Front Street and then the use of Covington streets to carry the branch to Newport. The whole proposal, of course, was contingent upon the approval of the Cincinnati and Covington City Councils.

The Cincinnati City Council approved, 23 to 11, the Cincinnati–Covington water contract at its meeting on October 18, 1867. The document included one important amendment, whereby Covington was charged a fixed water rate, 7.5¢ per 1,000 gallons, for all of the water pumped to it through the connecting pipe. This was half the meter rate charged to Cincinnati customers; however, the new provision was, at least partly, more of an attempt by Cincinnati to streamline the collection of water rents than to practice altruism. According to the new regulations, Covington would pay for all of the water sent to it and, in addition, would be responsible for establishing and collecting its own water fees. Thus, Covington would not receive any free water, either for its public buildings or for the use of its fire department. Moreover, the amendment safeguarded the legal interests of Cincinnati. Since there was some question as to whether Cincinnati could legally pipe water to Covington and then sell it, the amendment assured that the water was to be sold to Covington in Cincinnati and then conveyed, by Covington, to the Kentucky shore.

On the following day, Saturday, October 19, the Covington City Council met in a special session and approved the water contract with Cincinnati. The special committee, composed of James Clarkson, Robert Howe, and Vincent Shinkle, was then reappointed to oversee the laying of the part across the Ohio River.

Not all Cincinnatians welcomed the water contract with Covington. The Kleiner Brothers Brewery of Cincinnati filed an injunction in the Court of Common Pleas against the city of Cincinnati and the trustees of the waterworks to prevent them from honoring the agreement with Covington. A judge ruled that the injunction held, for the city of Cincinnati had no right to furnish water to cities outside of the state of Ohio.

Some months later, the *Cincinnati Commercial* imputed that the water contract had passed the Cincinnati City Council under questionable means. In an article titled "How Much Money It Takes to Buy the Cincinnati Council," Murat Halstead, the editor of the *Cincinnati Commercial*, charged that the votes of Cincinnati City Council had been purchased by a "shrewd lawyer of Cincinnati," who was paid $5,000 by Covington to put the "scheme through the Cincinnati Council on the double-quick" ("Local Matters. How Much Money It Takes to Buy the Cincinnati Council," *Cincinnati Commercial*, 18 Jan. 1868).

Following the *Cincinnati Commercial*'s allegations, the city councils of both Covington and Cincinnati appointed special investigative commissions to conduct examinations into the matter. What emerged was not only a major scandal that rocked local politics, but more important, a realization the boss rule had adopted the new metropolitan vision as its own. Indeed, bossism had interjected itself into the life of the communities on both the Ohio and Kentucky shores of the river.

On Thursday, February 6, 1868, a special Covington City Council committee charged with investigating the activities of the Committee on Water Works, presented the results of its labors. Composed of council members George W. Howell, A. P. Rose, and Colonel John Todd, the investigative committee reviewed the facts at their disposal. At a meeting on Tuesday, October 15, 1867, Covington City Council had voted to approve a $500 appropriation to J. M. Clarkson of the Water Works Committee, as a reimbursement for "an amount paid by him to an attorney in Cincinnati, as a retainer's fee, to assist in obtaining [the] Water Works contract." ("Covington News. Regular Session of the City Council. The Cincinnati and Covington Water Contract. Miscellaneous Business," *Cincinnati Daily Gazette*, 7 Feb. 1868). Following a meeting of the Covington City Council two nights later, on Thursday, October 17, the Committee on Water Works received from the city clerk a release upon the city treasurer to issue a check for $4,500. That same evening, President Cushing of the city council signed the check at his home for $4,500. The next evening, Friday, October 18, Cincinnati City Council formally approved the water contract with Covington, and on October 19, the Covington City Council gave its official consent. Two days later, the Covington council again met and reappointed Clarkson, Howe, and Shinkle to a committee assigned to oversee the laying of the water pipe from Cincinnati to Covington. That same day, Clarkson relayed the city's $4,500 check to M. W. Myers, supposedly the

final installment of the $5,000 promised him "to procure the passage of an ordinance [by the Cincinnati City Council] to supply the city of Covington with water" ("Covington. Council Proceedings," *Cincinnati Daily Enquirer*, 7 Feb. 1868). About this same time, the reappointed Committee on Water Works contracted with a company to lay 500 feet of pipe across the river, and on October 24 and 25, surveyors supposedly mapped out the proposed route of the iron pipe between Central Avenue in Cincinnati and Main Street in Covington. A week later, on Thursday, October 31, the Covington City Council appropriated $5,000, in a resolution introduced by council member Vincent Shinkle, "for the purpose of paying bills contracted for making and laying down water pipes under the river so as to procure a supply of water for the city of Covington." The money, according to the Committee on Water Works, was not spent for this latter purpose, but rather, "four thousand five hundred dollars of said amount was paid to M. W. Myers," to secure the Cincinnati City Council's approval of the contract. The remaining $500 was unspent. Further, the "Committee on Water Works were referred to the said M. W. Myers, with the assurance that '*he was the man to put it through*'" ("Covington News. Regular Session of the City Council. The Cincinnati and Covington Water Contract. Miscellaneous Business," *Cincinnati Daily Gazette*, 7 Feb. 1868).

The special investigative committee concluded that although the actions of the Committee on Water Works' members had been "quite irregular," they "were convinced that every member of that committee had the best interests of the city at heart, and honestly considered that they were executing the wishes of the citizens by making the expenditures they did" ("Covington, Council Proceedings," *Cincinnati Daily Enquirer*, 7 Feb. 1868). The report was quickly accepted by the city council, and then Colonel John Todd, a councilman and a member of the special investigating committee, moved that the president appoint a new waterworks committee "to procure such legislation in Ohio and Kentucky as may be necessary to obtain a supply of water for the City of Covington" ("Covington News. Regular Session of the City Council. The Cincinnati and Covington Water Contract. Miscellaneous Business," *Cincinnati Daily Gazette*, 7 Feb. 1868). The proposal sparked a fiery discussion, as Mr. Chambers questioned the rapidity with which the investigative report was accepted. He stated that "he did not approve of the use made of the money referred to in the report," and that Colonel Todd's resolution was, "in his opinion, giving the authority to a new Committee to do exactly what the old one had done." Chambers maintained that Covington had "no authority to create a water works," at least not until the state legislature formally adopted the pertinent amendments to the city's charter, then under consideration at Frankfort. Further, he argued that even if the requisite legislation was secured in Kentucky, the Ohio courts had still ruled Cincinnati's approval of the contract null and void. Finally, he said, Covington had a debt of $605,000, all due within 20 years, and could ill afford increasing it for a waterworks. In a note of biting sarcasm, Mr. Chambers concluded that he was "opposed to appropriating any more money for *pipe laying*" ("Covington News. Regular Session of the City Council. The Cincinnati and Covington Water Contract. Miscellaneous Business," *Cincinnati Daily Gazette*, 7 Feb. 1868).

Objections notwithstanding, a new committee of city council members was named to investigate a water supply for Covington. It consisted of council members James M. Clarkson, George W. Howell, and Colonel John Todd.

On Friday afternoon, February 7, the Cincinnati City Council appointed its own committee to investigate the charges of corruption levied by the *Cincinnati Commercial* regarding the council's waterworks contract with Covington. Its investigations into the alleged corruption of its members began on Thursday, February 13, 1868, beginning with an examination of the Covington water contract. After six days of hearings on the water contract issue, and the calling of 43 witnesses, the Cincinnati investigating committee concluded that "nothing whatever has been adduced to substantiate the charge that bribery and corruption have been resorted to." Professing their belief that "no member of Cincinnati city council received a bribe, nor has any one of them been approached for such an object," the committee held that "the entire matter has resulted from unfounded rumors and the light talk of irresponsible persons" ("The City Council. Special Session Yesterday Afternoon," *Cincinnati Daily Gazette*, 29 Feb. 1868).

The various investigations into the alleged corruption associated with the Cincinnati–Covington water contract essentially shattered the possibility of the two cities pursuing a unified water system, although continued

attempts were made in that direction. Covington did, however, examine the possibility of building a joint water system with neighboring Newport. Meanwhile, on January 25, 1868, the Kentucky General Assembly passed an act allowing "any municipal corporation" in Kentucky, "situated upon the Ohio or Mississippi rivers," to "contract with any other municipal corporation or person, either within or without this Commonwealth, to procure" a "supply of water for its own citizens or other customers" (*Covington Journal*, 18 Apr. 1868).

Meanwhile, the Committee on Water Works of Covington started to examine the Holly water and fire protection system, making arrangements to meet William C. Weir, an engineer with the Holly Manufacturing Company, of Lockport, New York, in June 1869. The Holly Water System was the rage of its day. It utilized Holly rotary pumps that provided a constant and dependable stream of water through the mains of a city, at a uniform water pressure. This differed from a standpipe or pulsation pipe system, where both the quantity and the pressure of the water varied. With a steady water pressure, the Holly plan's fire plugs made steam fire pumping apparatus obsolete, and a reservoir redundant. Further, the Holly system filtered the water, insuring a cleaner and healthier supply.

The Holly system was based upon natural filtration of water. In July 1869 Weir visited Covington and conducted "topographical and geographical" surveys, by which he concluded that within three blocks of the Ohio River, between the suspension bridge and Willow Run Creek, the river water seeped through the neighboring ground. According to an explanation given by Homer Hudson, chairman of Covington's Water Works Committee, this meant that:

> *all that plateau of Covington lying between Third street and the river, rests upon a substratum of sand and gravel, through which the water of the river will percolate freely, thus forming a natural filter sufficient to supply a basin which he [Mr. Weir] proposes to sink fifteen feet wide, with a frontage of sixty feet on the river, and distant therefrom two or three hundred feet, extending below low water mark, and walled up with stone above high water level, and on which foundation the necessary buildings and engines would be erected. . . . The water is [then] taken by the pumps from the basin and forced through all the pipes of the city, keeping a regular pressure of 150 pounds to the square inch. ("Covington. Covington Water Works,"* Cincinnati Daily Gazette, *21 July 1869)*

In August the city of Covington sunk a test well at the foot of Philadelphia Street, along the Ohio River, to determine the depth and quality of the artesian water. On Wednesday, August 11, 1869, a special committee appointed by the Covington City Council to examine the Holly Water Works of Peoria, Illinois, left Covington. They arrived in Peoria on Friday, and made an intensive examination of the water system there, announcing their approval. Then, they traveled to Chicago, Illinois, where they viewed a standpipe system that failed to impress them. On Thursday, August 19, 1869, the Water Works Committee of the Covington City Council reported the findings of the special committee, stating unequivocally that the Holly system seemed best suited to the needs of Covington.

On September 9, 1869, Covington City Council resolved to submit to the voters, at a special election on September 20, a proposal authorizing it to request of the General Assembly the right to issue up to $300,000 in bonds for the construction of a waterworks. The ordinance followed an estimate of the costs of a Holly system, set at $257,082, made by Weir at the council meeting a week prior, on September 2, 1869. In its appeal to the citizens, the council heralded the measure as one integrally related to the future "health and prosperity" of the city. "The continued prosperity of Covington," it claimed, "which already has a population approaching twenty-five thousand, imperiously demands a speedy and abundant supply of pure water" ("Water Works," *Covington Journal*, 11 Sept. 1869).

At the special election held on Monday, September 20, 1868, Covington voters decided, overwhelmingly, to support the $300,000 waterworks bond issue. Some 1,525 people voiced their support for the measure, while only

161 stood opposed to it. The vote, the *Covington Journal* jubilantly stated on September 25, 1869, signaled "a new impetus to the growth and prosperity of Covington."

Having submitted the bond issue to the voters, Covington was now free to proceed with construction of a waterworks. To the embarrassment of the city, though, it was announced at the council meeting on Monday, September 27, 1869, that new legislation authorizing the city to sell an additional $300,000 worth of bonds would not have to be requested, as originally supposed. Due to a supposed oversight, city officials had forgotten that the General Assembly had passed an amendment to Covington's charter in March 1869, permitting it to issue up to $600,000 in municipal bonds "to be used in procuring a supply of water . . . by the construction of a Water Works in connection with the city of Newport, Cincinnati, Ohio, or with both, or on account of said city of Covington alone," contingent upon the approval of the voters of the city. That same evening, Covington City Council named a new standing Committee on Water Works, and appointed Homer Hudson as chairman and James M. Clarkson and Thomas H. Kennedy as members. It then authorized this committee to "investigate any and all schemes that they may deem feasible for supplying our city with water . . . [and] to visit any cities they may desire, in order to procure such information as may be necessary to enable them to make judicious contracts" ("Covington," *Cincinnati Daily Gazette*, 28 Sept. 1869).

The Holly Plan continued to interest Covington's city council, so the city's Water Works Committee traveled, in early October, to examine Holly systems in Dayton, Ohio, and in Lockport, Rochester, Syracuse, Binghampton, and Auburn, New York. Impressed by the demonstrations of the Holly systems that they viewed during their weeklong journey, the committee gave the Holly system high regards when they delivered their report to council on October 14.

Finally, on Monday, January 24, 1870, the Covington City Council voted to sign a contract with the Holly Manufacturing Company. By mid-February, the site of the works, on the northwest corner of Main and Second Streets extending 150 feet to the Ohio River, was chosen, and in March, the city council authorized the sale of the $300,000 worth of waterworks bonds. The Covington Waterworks was completed by February 1871 (fully operative to the public on Monday, February 20), at a cost overrun of some $100,000, an additional bond issue of the same amount being authorized by the legislature. By May 1871 more than 600 families were tied into the water mains. The public response to the water system ranged from satisfactory, with accompanying complaints of the unexpected hardness of the water, to enthusiastic. Even a bit of mischief surfaced, as adults gleefully squirted one another with fire hoses.

The hardness of the Covington water—that is, the presence of other elements in it, principally lime, magnesia, and silica—rendered it palatable for drinking, but less useful for other domestic and industrial uses. In particular, the hard water was not particularly suited to the operation of steam machinery. To correct the situation, the city council moved ahead with a plan to build an intake valve in the channel of the Ohio River. Completed by November 1873, the river water was then mixed with the well water, and the two were pumped together through the water mains of the city. This compromise produced a softer water, albeit one considerably less pure than the well water alone. Unsatisfied with the Holly system, Covington completed an entirely new $1.6 million water system in the late 1880s, with intake pipes along the Ohio River, far above the reach of the Cincinnati area's sewers. The water was then pumped to a new reservoir in Fort Thomas, Kentucky.

MACHINE POLITICS: THE HAWES–SANDFORD RING

Although surviving newspapers from the late 1870s in Covington are scanty, the isolated issues available tell a story, albeit incomplete, of a city administration generally regarded as corrupt and profligate. In early 1876 the city treasurer of Covington, Captain Smith N. Hawes, suddenly disappeared from the city, and it was presumed, from the state as well. Supposedly ruined financially by gambling debts, he left in his wake a $52,000 shortfall in the city treasury (including the school board accounts) and some $5,000 in the county jury fund. The *Covington Journal* alleged that Hawes was "for a time" the "Boss" of the Democratic party in Kenton County and that he "exercised

a large influence over its nominations." "He set up and controlled," the *Journal* accused, "Committees, Ward meetings and County Conventions," and to maintain his position, he relied on the "free use of money." In addition, he served in a variety of political offices, and at one time held simultaneously the positions of "City Treasurer, Treasurer of the City School Fund, Secretary of the Water-Works Board, Trustee of the Jury Fund and School Trustee" ("Covington's Political Boss. The Default of the Late City Treasurer," *Covington Journal*, 5 Feb. 1876). Hawes, according to the editor, gained political control "only by the help of paid bummers." The journalist wrote, "He never cared whether a man was a Republican or a Democrat, so long as he could buy him; and he tried to make the Democratic party a mere machine to carry out his own corrupt purposes" (*Ticket*, 27 Dec. 1876). Hawes was only the ringleader of a larger machine, the *Ticket* professed, which included "W. J. Sandford, George G. Perkins, James Orr, W. L. Grant, and James B. Casey."

The Hawes scandal, subject to a special committee of investigation appointed by the Covington City Council on February 3, 1876, grew larger as time progressed. In March 1876 Thomas F. Leary, who was Hawes's bookkeeper, was arrested on charges of committing forgery. By late June 1876 Hawes wrote a letter to the Covington City Council claiming that the total of his embezzlement was no more than $18,000. While not denying his guilt, he nonetheless blamed his actions during the last 18 months he held office on "too much drink." Moreover, he claimed that two members of the city council's investigating committee were "personal enemies, and that he did not expect at their hands a fair and just examination" (*Covington Journal*, 24 June 1876).

The investigating committee issued its report in June 1876. The special committee was composed of three citizens, D. C. Collins, John J. Maybery, and James Spilman. They were assisted in their task by the financial expertise of former city treasurer George M. Clark. In addition, the three members of city council's Committee on Ways and Means, W. E. Ashbrook, H. R. Deglow, and Robert Howe, signed the Collins

D. C. Collins. Collins was a part owner of the Lovell and Buffington Tobacco Company, and a well-respected banker and reformer. Source: Roe, George Mortimer. *Cincinnati: The Queen City of the West.* Cincinnati, OH: Cincinnati Times-Star, 1895.

committee report. Their final statement, printed in June 1876, was an extensive document, some 43 pages in length. The committee conducted a detailed examination of a number of city offices, in particular that of the city treasurer, Smith N. Hawes, who held that office for two consecutive terms, from January 5, 1872, to February 3, 1876. Hawes's records were found to be in a state of "very great confusion," the lack of organization and disregard of procedures probably committed "to cover up fraudulent transactions and thereby prevent their discovery and exposure" (*Report of Special Committee* 1876, 179).

The Collins investigative committee also found irregularities in the records and procedures of the city clerk, W. J. Sandford. Particularly disconcerting was Sandford's release of one of his appropriation books, which he claimed he had recently ordered rebound "to preserve and keep it together." Upon closer examination and submission to a number of "experienced blank-book makers," it was discovered that the rebound volume had "two kinds of

papers, pagings by two different paging machines, faint line rulings different, as well as the head lines [*sic*] different and differently located." The experts concurred that "with these and other evidences, such as produced by the use of paper in a book much handled, . . . it was extremely improbable, that the book as now found could have been a book of continuous record" (*Report of Special Committee* 1876, 37).

Despite the committee's findings, the city council procrastinated in taking any suggested actions of the investigation, and an enraged citizenry voiced their disapproval of the council's failure at a mass meeting of Covington's residents on Tuesday, July 11, 1876, at Odd Fellows Hall. About 200 people attended the assembly, which was chaired by Judge W. E. Arthur. Arthur presented a report that proclaimed "municipal affairs" to be "in instant need of thorough reform." "For more than four years," he read, "a ring of incompetent and corrupt men have controlled and debouched the parties and elections in this city, and boldly applied the public revenue to perpetuate their power by the corruption of the voter." One citizen, James D. Campbell, declared that he thought the estimate of four years of corruption was conservative. According to the *Covington Journal*, Campbell offered his opinion that frauds "had been perpetrated" for "at least eleven years." Claiming that he had been "employed by the City Council once to ascertain the floating debt of the city," Campbell remarked that he examined the "vouchers and Treasurer's books, and there were things he found wrong long before Smith Hawes became Treasurer" ("Municipal Reform. Arraignment of the City Council. Appointment of a Committee of Safety," *Covington Journal*, 15 July 1876).

The fraudulent situation in city government had become intolerable, Arthur continued. He relayed the shocking incident of a journalist, who, "on a sabbath morning," was "fearfully assaulted" on a public street, forced to the ground and "maltreated" for having written an article denouncing the actions of a public official. Clearly, in Arthur's mind and in the thoughts of those assembled, the exigencies of the problem were apparent. Arthur called for immediate action on the part of the city council "to institute proper civil and criminal proceedings" against the guilty officeholders. Further, he advocated the formation of a 20-member citizens' Committee of Public Safety, to examine "thoroughly" city government periodically and to act as a vigilant guardian of public virtue. To operate solely on the voluntary contributions or subscriptions of its members, the Committee of Public Safety would, as its first task, offer a reward for the return of Smith Hawes. The committee, as chosen that evening, consisted of a number of leading citizens, including Jonathan David Hearne, George W. Howell, Homer Hudson, W. H. Mackoy, and N. B. Stephens.

Judge Arthur's references to the buying of citizens' votes and the assault of the newspaperman evidenced the concern he and his fellow residents placed on the interrelationship between public and private morality. To Arthur and to other late 19th-century reformers, there was a direct causal relationship between public and private morality. The attempt to bribe citizens for their votes on an election day was but one step in a process that would slowly erode and destroy the moral fiber of private citizens. Hawes's embezzling of funds, an issue of public fraud, was also an agent of private immorality. If citizens began taking the law into their own hands—assaulting one another on the streets on the Sabbath—then the very foundations of society were threatened. Both public and private moralities were the inextricable elements of a collateral arrangement. The two were, in many ways, indistinguishable and inseparable.

The corruption gave Covington a bad image. As the *Covington Journal* declared in July 1876, "Covington is getting a bad name abroad. Its officials are spoken of as corrupt; its late Ring compared to the Tweed ring" ("The Facts in the Case," 15 July 1876). In reaction to the popular demand for further action, the city council, acting on the accusation of James Campbell and others at the mass citizens' meeting, chose, at its meeting on Thursday, July 13, 1876, to investigate the matter further. In the effort, it appointed the council's Ways and Means Committee (of council members Blakely, Croninger, Kearny, and Rich) with the examination, and, in addition, appointed two citizens, Charles W. Stewart (cashier of the Farmers' Bank, Covington) and Karl F. Benndorf (secretary of the German Mutual Fire Insurance Company) as members of the committee. The Blakely Committee had authorization to make a "thorough examination" of the witnesses, including James Campbell, and of city documents, dating as far back as 11 years. In their work, they could, if necessary, "employ skilled accountants to assist them" ("Municipal Affairs. More Investigation Demanded," *Covington Journal*, 15 July 1876).

At a city council meeting on Thursday evening, October 19, 1876, the 20-member Committee of Safety, appointed at the mass citizens' meeting, presented a report of their own findings into the corruption, including "abuses" in the "engineer's department." In a move that the *Ticket* regarded as insulting to such leading citizens, the council "received and filed" the report "without action or reference." The "ring" was still operative in Covington, the editor declared, and "Vincent Shinkle knows perfectly well that every decent citizen who has watched his course believes him to be the ally and defender of the ring which has despoiled us." Shinkle, in turn, denounced The Committee of Safety as "composed mainly of disappointed officeseekers." (*Ticket*, 20 Oct. 1876). Shinkle's actions, particularly in criticizing N. B. Stephens, Homer Hudson, W. H. Mackoy, and the other members of the Committee of Safety" were "so vehement" and his speech "so shrill" that the *Ticket* editor humorously remarked on October 23 that "he lost two suspender buttons and cracked several globes in the innocent chandelier."

In its report to council, the Committee of Safety further revealed that the Covington Street Railway Company had never paid the $250 annually required of it to the city treasury, nor the annual $10 license fee per car it operated. The citizens' watchdog committee concluded, then, that the streetcar company owed the city a total of $1,750 plus interest. Likewise, it disclosed that the Covington and Cincinnati Street Railway Company had not paid, as specified by its contract with the city, a $25 annual license fee per car, and owed the city a sum exceeding $300. Moreover, the Covington and Cincinnati Streetcar Company was negligent in paying its portion, as specified by law, of street repairs.

In November 1876 President Shinkle "unexpectedly called up" the matter of the Blakely Committee, which had questioned Sandford and others, and recommended that they make a more definitive report. The editor of the *Ticket* regarded Shinkle's tactic as a ruse, designed to "delay the matter as long as possible with a view to a final whitewash." Shinkle's intentions, the editor thought, were suspicious: "His noise and bullying bluster does not mean that he is earnest and excited. We have seen him put on his war-paint and howl around the Council Chamber too many times to be fooled" (*Ticket*, 11 Nov. 1876).

In December Councilmen Laurie J. Blakely and W. J. Rich issued a minority report of the Blakely Committee in response to Shinkle's request. In it, they seemed to restate their earlier premise that fraud had been committed, but that based on the testimony given them, they did not believe "the Committee the proper body to express an opinion on the truth or falsity of said charges." A confusing statement overall, the report appeared to confirm the committee's prior conclusion that, in the light of the witnesses allowed and the manner in which the committee was confined in its hearings, it was reluctant to issue a definitive statement ("Minority Report in the Sandford Case," *Ticket*, 6 Jan. 1877).

The *Ticket* reiterated the case's importance to society and to overall morality. "The most notorious crimes in the city of Covington and those most damaging to the public have grown out of official corruption," it claimed (21 Nov. 1876). The situation was comparable to the "Tweed ring" of New York City. To make matters worse, Shinkle was supporting James B. Casey for president of the city council in the upcoming election. The move was an unfortunate one, the editor wrote. Going from Shinkle to Casey was no choice at all, he said, unless one "of staying in the frying-pan or falling into the fire" (*Ticket*, 27 Nov. 1876). Nonetheless, the *Ticket* was convinced that the "ring" would achieve its goal, but only if it began "scattering money among the corrupted voters." Sarcastically, it urged the machine to "put money in the hands of all the Hen Linnenmans [Germans] and Bill Sullivans [Irish] in the city." According to the editor of the *Ticket*, the Democratic ring exercised immense power and control in the area. He alleged that Shinkle had been nominated for president of the city council at a meeting convened and presided over by Smith N. Hawes. Likewise, Judge Perkins had been elected to the post of criminal judge, the publisher claimed, by the same ring, who spent money liberally to purchase votes in "Covington and Newport" (*Ticket*, 18 Dec. 1876). Not surprisingly, the editor also noted that, with the support of the ring's friend, commonwealth attorney W. W. Cleary, efforts to seek a grand jury indictment against Sandford and others had failed.

The *Ticket* sounded the cause for reform in the upcoming Covington city elections of January 1877. Interested citizens, both Democrats and Republicans, heeded its call. The names of 94 residents, many of them distinguished, appeared in a *Ticket* article of late December 1876, requesting others interested in reform to join them in a mass meeting to be held at Odd Fellows Hall on Friday evening, December 22, 1876. Their purpose was to nominate a reform slate for "city and ward officers." The advocates of the cause included such prominent Covingtonians as J. H. Buffington, John R. Coppin, J. D. Hearne, George W. Howell, F. A. Laidley, H. L. Lovell, W. H. Mackoy, and Amos Shinkle ("Reform! In the City Government," *Ticket*, 20 Dec. 1876). The *Ticket* applauded their efforts, and in a column adjoining the article, expressed, in poetic sentiments, the pressing need at hand:

Remember that Ring!
And not without cause;
'Twas only a segment
Outrooted with Hawes.
The remnants have patched up
That fracture since Spring,
And now 'tis all solid—
A good working Ring!

Remember that Ring
When you go to the polls;
It promises, threatens,
It bribes and cajoles.
And thus may secure
For itself a new fling;
But still, we implore you,
Remember that Ring!

When your taxes, now high,
Become rapidly higher;
And "Holly," [Holly Waterworks] almost dry
Is infernally dryer;
And our coffers, so low,
Are found empty some morning,
Remember that Ring—
And THE TICKET man's warning!
*("Remember the Ring," *Ticket, *20 Dec. 1876)*

The mass meeting of reformers attracted a crowd of some 500 people. D. C. Collins, a member of the original committee that investigated Hawes and ever since a much-hated enemy of the ring, was one of the prominent figures in the proceedings. He was joined by Samuel Davis, chairman of the meeting; J. D. Shutt, secretary; and P. P. McVeigh and Dr. T. N. Wise, vice presidents. Hearne, Howell, Laidley, and other reformers, including B. M. Piatt and distiller James Walsh, comprised a nominating committee. In the words of D. C. Collins, the assembled were committed to doing everything in their power "to help lift Covington out of the cess-pool of corruption into which it had sunk." As such, they agreed to promote a nonpartisan, citizens' ticket of candidates, as proposed by the nominating committee ("Citizens' Reform Meeting," *Ticket*, 23 Dec. 1876).

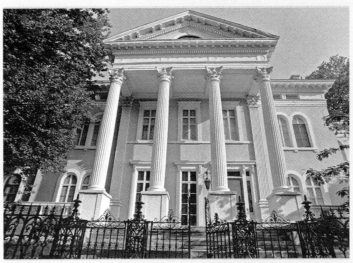

ABOVE: Howell Lewis Lovell was a reformer and business owner. Born in West Virginia, he went to California in 1852 to pan for gold. In 1868, he moved to Covington. Source: Roe, George Mortimer. *Cincinnati: The Queen City of the West.* Cincinnati, OH: The Cincinnati Times-Star, 1895. TOP RIGHT: Howell Lovell lived in this beautiful home that still stands at East Second and Shelby Streets. Courtesy of James C. Claypool. RIGHT: The Lovell and Buffington Tobacco Company, on Scott Boulevard, was one of Howell Lovell's enterprises. Courtesy of Paul A. Tenkotte.

As additional accusations against city clerk W. J. Sandford mounted, Vincent Shinkle succumbed to public pressure. At a city council meeting of Thursday, January 4, 1877, a special committee, composed of W. A. Crawford, William Ernst, and W. J. Rich, was appointed to investigate the latest reports of Sandford's forgeries. Acting quickly, the committee examined a sampling of Sandford's records and the next day issued a report stating that forgeries had been discovered and that these were probably "only specimens of many similar ones, extending through a series of years" ("Report of Committee Appointed to Investigate the City Clerk's Office," *Ticket,* 6 Jan. 1877). Meanwhile, Sandford disappeared from town and was supposedly seen on Thursday evening disembarking from a train in Hamilton, Ohio (*Ticket,* 6 Jan. 1877). In response, the city council, at a special session on Friday evening, January 5, declared the office of city clerk vacant and offered a reward of $600 each for the capture of Hawes and Sandford.

The disappearance of Sandford was the crowning blow to the Democratic ring. The results of the annual city elections of Saturday, January 6, 1877, revealed an overwhelming victory for the citizens' ticket, with a few exceptions. Reformers carried the positions of president of city council and president of the school board, but lost the city assessor and city weigher offices to Democrats. Citizens' ticket candidates also won city council seats in the first, third, sixth, seventh, eighth, and ninth wards, or a majority of six of the nine ward positions. In the city school board elections, reformers carried seats in six of the nine wards—the first, second, third, fourth, eighth, and ninth.

In mid-January 1877, Hawes was arrested by Covington city marshal P. J. Bolan in London, Canada. Detained, he was held for extradition proceedings. D. C. Collins, a reformer and new member of the city council, along with George R. Hartley, traveled to Canada to represent the city in the extradition trial. On the other hand, John G. Carlisle, C. B. Simrall, and Theodore Hallam went to Canada as counsel for Hawes. The Canadian court ruled in favor of the extradition in late January, and it was presumed that Hawes would be "delivered to the Covington authorities, within a few weeks" (*Ticket*, 26 Jan. 1877). In February 1877 Bolan traveled to Washington, D.C., to obtain the extradition papers.

The corruption in Covington garnered some nationwide attention. A rather lengthy article appeared in the *New York Sun*, reprinted in the *Ticket*. The *Sun* article reviewed the entire scenario and noted that the situation was not a total surprise, that "for some years past it has been hinted" that Covington "was run by a Ring" ("Covington's Treasurer and Clerk. A Fine Field for Investigation—Gambling, Embezzlement and Violence," *Ticket*, 2 Feb. 1877).

The editor of the *Ticket* again related the scandal to the overall state of morality, as well as to the reputation of the city, and to the system of justice in particular. In late February 1877 the publisher announced that already rumors were circulating that the family and friends of Hawes, once he was returned to the city, would do everything in their means to prevent his conviction. Such a situation would be a travesty of justice, the journalist implored. Hawes and Sandford, he attested, had "stolen more money than a hundred penitentiary birds" who perhaps "cast on the street in youth" stole a "few dollars" to keep themselves from starvation. To let embezzlers who defrauded the city of thousands of dollars go free while petty criminals wasted away in the penitentiary would make a mockery of the court system and would be a perversion to the name of Covington (*Ticket*, 24 Feb. 1877).

Hawes was returned to the city of Covington on Tuesday, February 27, 1877. The Hawes trial began in Covington by June 1877, when the *Newport Local* reported that it was starting out very slowly, "the object probably being to keep it going until something turns up; the end of the world, for instance" (21 June 1877). Technicalities regarding the extradition of Hawes entered the picture, and Hawes was subsequently released on September 1, 1877, and returned to Canada. In January 1880 Smith Hawes was officially pardoned by Kentucky Governor Luke Pryor Blackburn.

ANNEXATION

The 1880s and the 1890s ushered in a new phase of metropolitan identity. Having witnessed the vagaries of boss rule, in cities like Cincinnati and Covington, many suburbanites began to question the policies of annexation and consolidation. There emerged a new and expanded "balance sheet" mentality among suburban residents that differed significantly from their prior attitudes about the city. In the 1850s, 1860s, and 1870s, those who opposed annexation generally did so not because they felt that the city had nothing to offer, for it did. Rather, the objections of some suburbanites centered on whether, if annexed, their resultant increase in tax rates justified the benefits to be derived. Thus, the advantages of annexation were better services, and the disadvantages, higher taxes. By the 1880s and the 1890s, however, the list of disadvantages had increased significantly, so that a fuller "balance sheet" of items presented itself in the contemporary debates over annexation. Possible detrimental effects of consolidation included certain "fear of association" items. That is, suburbanites worried that the contagion of boss rule, corruption, fiscal irresponsibility, and even city dirt and pollution would envelop and engulf the annexed territories. In its

wake, suburban land values would fall, and the metropolitan area would ultimately suffer. Population and national rank, all part of an older argument that stressed that what was good for the central city was good for its suburbs and the entire metropolitan community, had become unraveled in many people's eyes.

For the most part, the Kentucky General Assembly reflected the public's changing views of annexation. During the early and mid-19th century, the state legislature granted each individual city separate municipal charters, which, in turn, were frequently amended. As platted in 1815, Covington's original town limits extended to about Sixth Street. In 1841, seven years after the town of Covington was chartered as a city, the Kentucky General Assembly approved

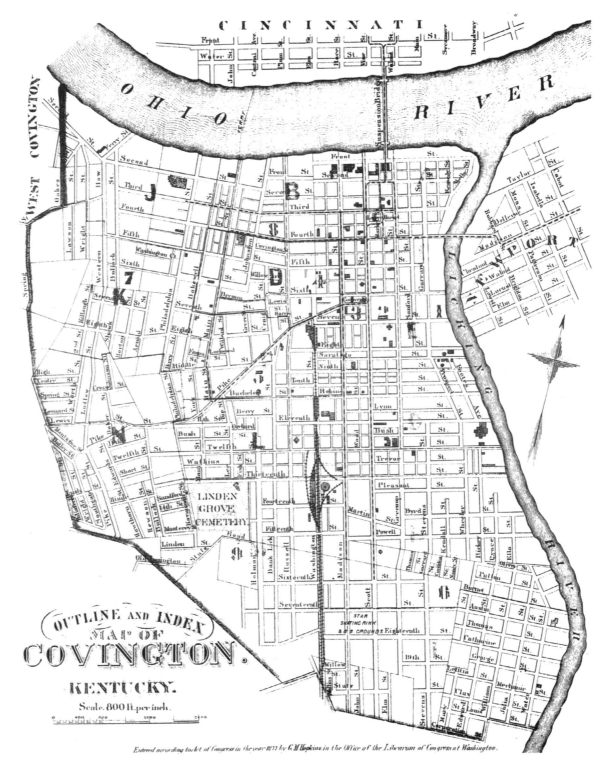

1877 map of the city of Covington. Source: Hopkins, G. M. *City Atlas of Covington, Kentucky*. Philadelphia, PA: G. M. Hopkins, 1877.

the annexation of a large area to Covington. The western boundary moved three blocks west, to the west side of Main Street, and the southern limits extended six blocks farther south, to the south side of 12th Street. Covington's new city charter of March 1850 further extended the city's boundaries to include a massive territory west and south of the city. With a slight addition, approved by the Kentucky General Assembly in March 1860, the city had assumed the limits portrayed in an 1877 map.

The area encompassed by the 1850 annexation included a variety of new subdivisions, Ludlow's on the hillside west of Covington, Casey and Kennedy's in Covington's heavily German neighborhood of Lewisburg, and the recently platted subdivision of Austinburg in the area of 16th and 17th Streets. In addition, the newly annexed territory included about 220 acres of agricultural land belonging to Richard Southgate. Southgate, through his agent or legal counsel, voiced his opposition to the proposed act when it was being considered by the state legislature. Not succeeding, his agent nevertheless managed to achieve a compromise whereby Southgate's land was annexed to the city but was exempted from taxation for a period of two years. Having sold a portion of his tract in the interim, Southgate faced a $676 city tax bill, on his remaining 167 acres, in 1852. He paid the sum, but subsequently brought suit against the city of Covington in Kenton Circuit Court for the recovery of the taxes, claiming that he never approved of the annexation in the first place, and secondly, that he derived no benefits from inclusion within the city limits. The Kenton Circuit Court ruled in his favor, and the city of Covington appealed the decision to the Kentucky Court of Appeals. While not questioning the right of the state legislature to extend the city limits of Covington or of any Kentucky city, the court of appeals ruled that since Southgate's land was devoted to "fields, pasture land and wood land" and not subdivided into lots, the city's taxation of it was essentially a case of appropriating "private property for public use." Thus, while the annexation remained in force, Covington was prohibited from taxing the land until "some portion of it shall be appropriated for lots or buildings indicating that it is used as a part of the city" (*City of Covington v. Southgate,* 15 Monroe 491–99, Ky. Ct. App. 1854).

The court case cited above confirmed the power of the state legislature to extend city limits. Earlier, in 1848, the Kentucky Court of Appeals had ruled, in a similar proceeding, that the General Assembly had the right to establish cities and towns and to extend their boundaries, in the interest of the public good. The chief justice stated that a "municipal government" was a "corporation, or *quasi* corporation," that is, "a mere creature of the law and of the legislative authority." While the "aggregation of people, and the building and inhabiting of houses" constituted the "*material* requisites of a town," he stated, and were the "voluntary acts of individuals," cities and towns nevertheless owed their existence to the state legislature. Indeed, it was the duty of the General Assembly to incorporate a city or to extend its limits if the residents proved remiss in requesting the same. Further, the residents did not necessarily have to approve of the measure, and individual objections could not be considered where the greater public good and its security were at issue. In other words, the public good overrode an individual's disapproval, although the city needed to exercise caution and prudence in the application of taxation to essentially agricultural land (*Cheaney v. Hooser,* 9 Monroe 330–50, Ky. Ct. App. 1848).

By the 1880s and the 1890s, annexation proved much more difficult. In 1882 Covington attempted annexation of the city of Ludlow to its west. On behalf of Covington, State Senator Theodore Hallam attempted to secure the annexation in the Kentucky General Assembly, but was met by the opposition of Ludlow's citizenry. The council of Ludlow passed a resolution against annexation and instructed its state representative to defeat the measure. Subsequently, the annexation bill failed passage.

In January 1894 Alderman John C. Droege presented at a Covington City Council meeting an ordinance to annex "Milldale and other suburbs" ("Annexation. Alderman John C. Droege's New Ordinance Causes Considerable Discussion in Milldale," *Kentucky Post,* 19 Jan. 1894). Immediately, the *Kentucky Post* surveyed a number of residents of Milldale, asking their opinions in regard to the matter, and discovered that "in the majority of cases annexation is looked upon as the readiest and best means of settling the difficulties existing in Milldale." Essentially, the citizens there felt that the benefits of better schools, police and fire protection, and the promise of free

roads, as opposed to the tolls imposed by the Banklick Turnpike, more than outweighed the extra taxation. One of the area's most prominent residents, John B. Coppin, a dry goods merchant in Covington, claimed, "It is an outrage . . . that we should have to pay tolls almost within the city limits. . . . We want Milldale, Central Covington and Covington to be one town assuredly" ("He'll Vote No on the Saloon License Increase." *Kentucky Post,* 20 Jan. 1894). Still, there was some reluctance on the part of residents to make the annexation unconditional. Some believed that there should be special provisions made so that Milldale did not have to assume any of Covington's old city debt. Still others maintained, in sentiments consonant with the new quality of life viewpoint, that they would have to wait until the new Covington charter, being drafted in accordance with the new state constitution, was finished. Presumably, this meant that they hoped that the administrative flaws of the old charter would be corrected. The proposed annexation of Milldale did not become a reality in 1894, but what exactly transpired to block the measure is unknown, for the *Kentucky Post* simply ended its discussion of the matter.

The topic of annexation languished again until March 1896, when Milldale requested the neighboring town of Central Covington to annex it. Milldale hoped to gain a water supply in the move by tying into Central Covington's mains, which, in turn, were fed by Covington's waterworks. The trustees of Central Covington decided against the proposal, arguing that Central Covington would derive no benefits from the move, and that Milldale residents might outvote them in city matters. Political autonomy was a matter of utmost importance in the sustenance of a community's character.

Meanwhile, Kentucky was writing a new state constitution. In December 1890 Bennett H. Young of Louisville, chairman of the state constitutional convention's Committee on Municipalities, presented an initial report, outlining proposals for the establishment of five classes of cities in Kentucky, as well as restrictions upon the incurring of debt and features governing municipal officers and elections. The changes, Chairman Young argued, were necessary, for there were "more than a thousand town and city charters in Kentucky," a situation "creating enormous litigation, and producing uncertain determination of the principles of law." To correct the confusion and to ensure honesty and efficiency in municipal government were the aims of the committee. "Every right-thinking and intelligent patriot" could see, Young claimed, "that there is more extravagance and fraud in the government of the cities than in any other department of our political life, and that, unless these be in some way stayed, the entire fabric of our republican system will inevitably be endangered." The goal of the committee, Young stated succinctly, was to reform the cities, by means of enacting general legislation, thus preventing "slipshod" or "partisan legislation" (*Official Report of the Proceedings* 1890).

William H. Mackoy of Covington, a member of the Committee on Municipalities, was one of the guiding lights of its report. Like Young, Mackoy expressed his belief that the committee's report was designed to accomplish two reforms. First, he said, they attempted to "preserve for cities home rule, in order that they might not be made playthings or footballs for politicians in the Legislature of Kentucky." Such was the case, Mackoy related, in the neighboring state of Ohio, where cities were "made and unmade every day, as one party or the other" gained control. The result was chaotic. The Committee on Municipalities, therefore, sought "stability" for city governments. Second, it recommended "such limitations upon the power of taxing and contracting debts, as would be prudent and safe."

A main feature of its report was a proposal to elect city officers at large, yet still provide for representation at a local or ward level. The advantages of such a plan, Mr. Young offered, were that it removed or at least reduced the influence of ward bosses, and concurrently, that it increased the chances that more "respectable gentlemen" would be elected. "A city," Young concluded, was "a unit. What is best for one particular Ward is good for another Ward, and there can be no clashing. . . . So far as a city government is concerned, it has no politics in it. It is a business corporation, and should be run as a man would conduct his own business affairs."

As signed by the constitutional delegates and as ratified by the voters in August 1891, the new state constitution included most of the reforms recommended by the Committee on Municipalities. There were, for instance, six classes of cities, Louisville being the sole city of the first class, and Covington, Newport, and

Lexington belonging to the second class, defined as cities with a population of at least 20,000 and less than 100,000. Moreover, cities of 15,000 people or more were limited to property tax rates, excluding school taxes, of $1.50 per $100, and were forbidden to incur an indebtedness exceeding 10% of the value of their taxable property. Further, for cities of the first and second class, at-large elections for members of legislative bodies were mandated. Finally, all cities and towns were to surrender their present charters before January 1, 1895, during which time the Kentucky General Assembly was instructed to enact laws relative to the governance of cities, according to the provisions of the new 1891 constitution.

In March 1894 the Kentucky General Assembly passed An Act for the Government of Cities of the Second Class in the Commonwealth of Kentucky. Its provisions included sweeping changes in the manner of annexation of contiguous territory or of neighboring cities or towns. In essence, the annexation legislation of 1894 confirmed the grant of home rule both to unincorporated territories and to incorporated cities, towns, and villages, faced with proposed annexation by a city of the second class. The annexing city was required to subject the voters of any incorporated or unincorporated area to a vote. If four-sevenths of the voters approved the measure, then the annexation became effective. If it passed, however, only that territory "as may be thickly built upon, inhabited and needing municipal government" could be immediately included in the extended boundaries of the second-class city. Lands "occupied and used for agricultural purposes" were exempt. Rather, the city would extend its boundaries as "public necessity" demanded. Since the act further stipulated that a city of the second class could not propose annexation of simply a portion of an incorporated city or town, it is implied that the annexation, once approved, was effective, but that it could be applied in stages (*Acts of the General Assembly* 1894, 240).

From this point forward, annexation would not be a simple matter for cities like Covington. Splintered by political and philosophical barriers, Northern Kentucky slowly assumed a fragmentation that became increasingly entrenched in the 20th century.

THE FIGHT AGAINST TOLLS

The belief that cities, like Covington, could and should construct and operate their own internal improvements and municipal services was a relatively new concept, one perhaps best exemplified by Cincinnati's building of the Cincinnati Southern Railroad in the 1870s. It arose, in part, from the disappointments cities like Covington experienced with corporate control of gas, streetcar, and related franchises, with their attendant bouts of corruption and their inclination toward monopolistic practices. Covingtonians, like many Americans of the era, grew more amenable to public ownership and operation of necessary services, even if recourse to such sometimes sacrificed efficiency. For instance, the municipally constructed Holly Waterworks of Covington was far from a model operation, but virtually no one proposed that Covington grant its water franchise, once Holly was built, to an independent contractor. Tolerating the situation was far preferable to surrendering municipal control to corporate interests.

As the economic climate worsened for many during and after the depression of 1873, corporations, particularly railroads, became the enemy of countless thousands. Reformers, including Covington politicians William Goebel (1856–1900) and Harvey Myers Jr. (1859–1933), convinced that the American dream was being circumscribed by the power and influence of major companies, targeted corporations in their political platforms. And throughout their political careers, they attempted to bridle the power of railway, bridge, and ferry companies that they felt unfairly monopolized the movement of people and goods in a metropolitan area.

Two new railroads came to Northern Kentucky in the 1860s and the 1870s and sparked a debate for the end of tolls. In 1867, two railroad companies—the Lexington and Frankfort, and the Louisville and Frankfort—were cooperating in the construction of a line between LaGrange, Kentucky (east of Louisville), and Cincinnati. Called the Short Line, it was completed under the name of a consolidated company of the two lines, the Louisville, Cincinnati, and Lexington Railroad, or the LC&L. As of 1869, however, the LC&L still had not decided whether

to run the line to Cincinnati via Covington or by way of Newport. Three options were available to it. It could build its lines to the Covington and Cincinnati Suspension Bridge, it could erect a new bridge across the Ohio River at Covington, or it could extend its road to Newport and use the proposed bridge there. The trump card was decided by the Newport City Council, which acted aggressively in pursuit of the railroad. On the other hand, Covington, which already had a bridge, feared that trains on their way to Cincinnati simply would pass through Covington, relegating it to the status of a flag station rather than a terminus ("Newport, Louisville, Cincinnati & Lexington Branch Railroad," *Cincinnati Daily Gazette,* 20 Apr. 1868).

In February 1868 the Kentucky General Assembly chartered the Newport and Cincinnati Bridge Company, a private corporation. Interestingly, one of its provisions stipulated that the bridge's "rates of toll shall at no time exceed the rates authorized to be charged by the Covington and Cincinnati Bridge Company" (Acts of the General Assembly 1868, 438).

In 1869 Covington and Cincinnati Bridge Company raised tolls. The increase sparked a lively response from the citizenry. Some people even clamored for a free bridge between the two cities. In response, Amos Shinkle, the president of the company, offered to sell the suspension bridge at cost, provided that Covington or Cincinnati would purchase it within three months.

Meanwhile, in Covington's Westside, some residents proposed the construction of a free bridge across the Ohio River, tying Main Street in Covington to Central Avenue in Cincinnati. Evidently, by *free* the advocates of the measure meant "free to pedestrians," with nominal tolls for vehicular traffic. The proposal was, therefore, a unique combination of the older and newer viewpoints of internal improvements. On the one hand, it was to be a private venture—with the exception of $300,000 or so, which its proponents thought Cincinnati and Covington could issue in municipal bonds. And on the other hand, it was to be a semipublic or municipal improvement because it would feature a free walkway for pedestrian commuters.

The proposals for a free bridge evidently frightened the directors of the Covington and Cincinnati Bridge Company, for, in early June 1869, they lowered their tolls to pre-increase levels, that is, to 3¢ for "transient crossers, and $1.50 per hundred for commutation tickets" ("Covington," *Cincinnati Daily Gazette*, 9 June 1869). The clamor for a free bridge thereafter dissolved, but reappeared, somewhat appropriately, in conjunction with a Cincinnati-funded internal improvement, the Cincinnati Southern Railroad.

In February 1872 the *Covington Journal* noted that the Cincinnati Southern Railroad, then under construction, would have to cross a bridge into Cincinnati, the site having not yet been chosen. Supporting the location of Covington, the *Journal* suggested that Covington and Cincinnati "arrange with the company building the bridge for the free passage of vehicles and foot passengers" (17 Feb. 1872). In the same issue of that paper, in an adjoining column, it was noted that a mass meeting was held on Wednesday evening, February 14, 1872, at Covington's Arbeiter (German for "workers") Hall to "sustain and approve of the action" of State Representative C. D. Foote in proceeding with legislation aimed at reducing the tolls of the bridge and ferry at Covington. Chaired by E. Clarkson, a Committee of Resolutions was appointed, consisting of E. D. Allnutt, James L. Anspaugh, and Platt Evans Jr. The committee unanimously adopted resolutions in support of Foote, complaining that the Covington and Cincinnati Bridge Company had failed to keep its "golden promises made respecting cheap transit across the Ohio River" ("Public Meeting. Movement for the Reduction of Ferry and Bridge Tolls," *Covington Journal,* 17 Feb. 1872).

On Saturday evening, February 17, 1872, another mass meeting of citizens was held, this time at Covington's city hall, to discuss the movement to reduce bridge and ferry tolls. A resolution was passed "instructing the Senator and Representative in the Legislature from Kenton County to have the bills known as the Bridge and Ferry Bills," which had already passed the Kentucky House, enacted into law. Mortimer M. Benton, a director of the Covington and Cincinnati Bridge Company, responded by addressing the assembly and stating that the bridge company was of "no disposition" to "have any warfare or contest with the people of Covington." Instead, he welcomed the assembled to suggest how a reduction in tolls might be accomplished, and in the effort, suggested they appoint a committee

to examine the "affairs of the Bridge Company, and of the Main Street Ferry, their receipts, expenditures, & c" ("Local Affairs. Bridge and Ferry Tolls. The Reduction Movement," *Covington Journal*, 24 Feb. 1872).

After Benton finished his speech and returned to his seat, Judge Robert Warden, a native of Kentucky but a longtime resident of Cincinnati who had recently moved to Covington, addressed the crowd. Warden's speech was punctuated by loud applause, his stance being corporations were "but necessary evils," "not to be loved, but rather to be dreaded." Legally, Warden explained, corporations were the creations of people, "invisible, intangible, inaudible," existing only in "political and juridical contemplation." They were "made, not born." Further, Warden argued that "it was entirely wrong to allow the Bridge Company to own and control" the Main Street Ferry. In his mind, the ferry existed merely "to advance the interests of the bridge." It seldom operated past nightfall, to the great inconvenience of residents of Covington's Westside. It had, Warden noted to the amusement of the crowd, "a dread of the night air." Further, its daytime operations were slow and inefficient, with its "wheezing" steam ferryboat plying between the two shores. "When is a ferry *not* a ferry?" Warden teased the audience. "When it belongs to the Covington and Cincinnati Bridge Company," he replied sardonically ("The Bridge and the Ferry. Substance of the Speech of Hon. Robert Warden at the City Hall Meeting, Covington, February 17, 1872," *Covington Journal*, 24 Feb. 1872).

The two bills introduced by Representative Foote and passed by the Kentucky House were initially "unanimously rejected by the Senate Judiciary Committee," leading the *Covington Journal* to conclude that the "prospects of a reduction of bridge and ferry tolls this year are not very good" (2 Mar. 1872). The *Journal* proved premature in its judgment. While Foote's attempt to regulate tolls on the Covington and Cincinnati Suspension Bridge failed, his bill to control the ferries operated by the bridge company was approved by the Kentucky General Assembly in late March 1872. This act empowered the county court of Kenton, upon the submission of a petition of five or more citizens of Covington, to conduct an investigation into the rates of ferriage and the hours of operation of the Covington ferry, as conducted by its former owners in a 10-year period preceding its purchase by the bridge company in 1869. After the conclusion of its investigation, the county court could then set a schedule of ferry rates and hours of operation based on their historical findings.

Foote's ferry legislation, although an important first step, did not really address the citizens' widespread appeal for a free bridge. Nor did it contribute to the city fathers' desire to capture the Southern Railroad for Covington. In June 1872, therefore, the Covington City Council passed an ordinance calling for an August plebiscite to determine whether the citizens of Covington wished to subscribe $500,000 "to the capital stock of a company organized to build a railroad and free foot-passenger bridge across the Ohio river, at some point west of Madison street" ("The West-End Bridge," *Covington Journal*, 29 June 1872). The *Journal* admitted that the free footpath provision was only secondary to the real issue at hand, the securing of a railroad bridge for Covington. Without such a bridge, it was predicted that the trains of the Kentucky Central and the Cincinnati Southern, the latter then under construction, would probably cross Newport's LC&L Railroad Bridge. On the other hand, it was clearly evident that the passage of the proposal probably hinged upon the provision for the free footpath.

Meanwhile, in July 1872, the Covington and Cincinnati Bridge Company offered to sell the suspension bridge to the city of Covington for $750,000, plus the assumption of the company's debts, estimated at an additional $1,000,000. The matter was referred by council to the Committee on Railroads and Bridges.

In August 1872 the free bridge plan evidenced its overall popularity in two separate elections. In one of the two, the race for state representative, the "free bridge proposition was made a leading issue in the contest." Following the revelation that one of the candidates for the state house seat, Charles H. Fisk, had voted against the $500,000 subscription, his opponent, Mr. Hermes, garnered additional support and ultimate victory by warmly embracing the cause of a free bridge. "On election day, the friends of Mr. Hermes," the *Covington Journal* related, "prepared a large banner with this inscription: 'If you want a Free Bridge, vote for Hermes.' This banner, with music, was paraded through the District" ("The Free Bridge," 25 Oct. 1873). Meanwhile, Covington's citizens

voted overwhelmingly, 2,486 to 639, in favor of the bridge subscription. Such a victory, however, marked but the first step in a long and somewhat tedious course. Next, the Kentucky General Assembly would have to approve the issue of $500,000 worth of bonds for the city, and, then, the city ordinance for the bridge subscription provided for the levying of "an additional tax of thirty cents on the one hundred dollars" for "the payment and principal" of the bonds ("The West-End Bridge," *Covington Journal*, 29 June 1872). In March 1873 the Kentucky General Assembly passed an amendment to the city's charter, enabling the city to issue up to $500,000 in bonds to any person or company to build a bridge west of Madison Avenue, contingent on the specification that the pedestrian walkway be "free perpetually" and the tolls for "carriage and wagon-ways" not to exceed one-third the rate charged at that time by the Covington and Cincinnati Bridge Company. Further, the act established a nine-member board of bridge commissioners, who were "empowered and authorized," on behalf of the city of Covington, "to contract with any person, persons, incorporated company or companies, agreeing and undertaking" to build such a bridge (*Acts of the General Assembly* 1873, 347–349). The March 1873 enactment marked a temporary postponement of further activity on the city's part. By October 1873 the *Covington Journal* complained of the city council's negligence in the matter, arguing that "nothing" had been "accomplished" in regard to the "free bridge" and fearing that "the opportunity to effect this great object has been forever lost" ("City Affairs," *Covington Journal*, 25 Oct. 1873).

In the following month, November 1873, W. W. Mosher, president of Covington's city council, addressed the bridge issue as part of a larger speech focusing on the present and future status of Covington. Mosher first noted that, although the city had a bonded indebtedness of $1,100,000, he supported increasing it another $2,000,000 to finance necessary improvements to the city, including a public park, a workhouse, and a free bridge. In Mosher's eyes, the latter would not be a railroad bridge, but a municipally constructed and city-operated bridge with a free pedestrian crossway and tolls for "vehicles and stock about one-third the present rate on the suspension bridge." The bridge could be located, Mosher felt, at the foot of Main Street in Covington, and a "good substantial pier bridge" could probably be built for $1,000,000 to $1,500,000 ("Municipal Affairs. Big Ideas. A Review of Municipal Financial Troubles, and a Way to Get out of Them," *Covington Journal*, 8 Nov. 1873).

The proposals for a free bridge, originally tied to plans for a railroad bridge, finally asserted their own independence in the plans of Mosher and other subsequent boosters. Essentially, the newer clamor for a municipally constructed free bridge was related not only to the rejection of Covington by the trustees of the Cincinnati Southern Railroad in February 1874—instead they chose a bridge at Ludlow, Kentucky—but also to a gradual solidification and acceptance of the idea of Cincinnati as a metropolitan community. "We have long since ceased," the editor of the *Covington Journal* declared in June 1875, "to take offence at the oft-repeated remark—intended as a slur—that Covington is merely a sleeping place for business men of Cincinnati." The course ahead of Covington was clearly outlined by the editor: "First of all let us accept the situation; acknowledge that Covington is an adjunct, a suburb, an appendage of Cincinnati; and thus so recognizing the inevitable give up the wild hope of making Covington an independent business place, that is so far as wholesale transactions in dry goods, groceries, &c. are concerned." Instead, the city should concentrate, the editor believed, on attracting more Cincinnatians to live on "the highlands overlooking Covington on the west and south," which could be "mapped with broad avenues and dotted with beautiful residences like those on the high grounds north, east and west of Cincinnati." Tolls were the culprit preventing this from happening, the *Journal* proclaimed. "Covington is pent up by tolls. Tolls on the bridges, tolls on the ferries, tolls on the turnpikes leading into the city." Covington was "so closely identified with Cincinnati by business and social relations" that high tolls made no sense whatsoever. They inhibited progress, dissuading residents and manufacturers from locating in the city. The solution was simple—a bridge with a free pedestrian crossing and "only nominal charges for vehicles" ("A Free Bridge," *Covington Journal*, 26 June 1875).

The *Covington Journal* underscored the overall desire of the majority of the city's residents for a free bridge. While the voters had long since approved the proposition to devote $500,000 to the project, the *Journal* implied that certain influences in the city council, presumably investors or lobbyists of the Covington and Cincinnati

Bridge Company, had prevented the expenditure. The citizens needed to "watch the members of the City Council," the editor suggested, lest the proposal be overlooked. "The people of Covington still want a free bridge," he wrote. "They demand it now as the first great public work which the city undertakes" ("The Free Bridge," 28 Aug. 1875).

At a regular meeting of the Covington City Council on November 26, 1875, the council recognized, in a series of resolutions, that "public opinion" was "strongly in favor of" a free bridge, and that the "extravagant rates of toll charges on all the avenues of ingress or egress to or from the city of Covington" were "detrimental to her [Covington's] present welfare and a serious obstacle to her future prosperity." As such, a committee of five was appointed to examine all sides of the question, including possible locations of the bridge and the legality and possible applicability of the old $500,000 plebiscite. In addition, the committee was charged with the preparation of a "petition to the Legislature of Kentucky and Ohio for a charter for the erection and operation of said bridge" ("The Free Bridge. Proposed Legislation. Action of the Covington City Council," *Covington Journal,* 4 Dec. 1875).

The citizens of Covington, meanwhile, assembled at the Odd Fellows Hall in Covington on Monday evening, December 6, 1875, to discuss the proposals for a free bridge. The assembly, one of the largest in Covington's history, was overwhelmingly in favor of the plan and passed a number of resolutions that eloquently expressed its belief in the sensible and indisputable law of progress that ordained and demanded the measure. According to the drafters of the resolutions, "both nature and progress" were "obstructed by the old-time private monopoly in the form of a toll-bridge," which in "this era of progress" was comparable to "peddling the air we breathe, or tolling the natural impulse of the body." Cincinnati and Covington were tied together by mutual interests in a metropolitan community ("Free Bridge Meting," *Ticket,* 7 Dec. 1875).

The resolutions passed at the citizens' meeting further argued that a free bridge would not be an elitist venture but a truly democratic concern. The bridge would be open to all, and would attract further residents to Covington, thereby increasing the tax base and decreasing the rate of taxation. "Public facilities for personal enterprise," declared the Committee on Resolutions, "foster alike the poor and the rich; the improvement which benefits the whole benefits each part; the gain may be in unequal proportions, but every man has his share in it; the aggregate is the corporate wealth."

The mass meeting, presided over by Jonathan David Hearne, appointed a committee of five to cooperate with the city council's counterpart, "in doing all things necessary for the purpose of giving us a free bridge." The committee members included Judge W. E. Arthur, S. Easton, Charles Eginton, H. W. Schleutker, and Henry Worthington.

On Thursday evening, December 23, 1875, the city council committee charged with investigating the matter of a free bridge recommended that the issue be submitted to the voters. Specifically, it suggested that the voters be asked whether they supported the pursuit of necessary legislation to enable the city to build an $800,000 free bridge. The results of the vote, taken on Saturday, January 1, 1876, marked a victory for the free bridge, as 1,425 voted for the proposition and 679 against it.

The free bridge charter was passed by the Covington City Council on Thursday evening, February 10, 1876, by a vote of 10 to 8, with council president Shinkle counted among the opposition. Indeed, Shinkle called the charter "a fraud" ("Council Proceedings. The Fire Department to be Investigated—The Free Bridge Charter Passed," *Covington Journal,* 12 Feb. 1876). Shinkle, a stockholder in the bridge company, claimed that of the original stock issue of $1,000,000, the stockholders had never received "a cent in the way of dividends" ("The Suspension Bridge—A Free Bridge," *Covington Journal,* 19 Feb. 1876). The preferred shareholders, holding $750,000 in preferred stock, Shinkle attested, never earned more than 4.5% per year. Further, the state of Ohio issued $100,000 in claims for taxes on the bridge. Added to the fact that the Cincinnati Southern Railroad Bridge, once completed at Ludlow, would draw business from the suspension bridge and the probability that the Kentucky Central would gain access over a competing bridge, Shinkle did not see the need for an additional bridge. If Shinkle's statements were correct, the *Covington Journal* countered, it proposed that Covington simply buy the suspension bridge and make the footways free, while reducing the fares of vehicles.

Subsequently, the citizens' committee for the free bridge lobbied on its behalf, spending $186 "in sending parties to Frankfort and Washington in furtherance of the scheme" ("Free Bridge Meeting," *Covington Journal,* 27 May 1876). Their actions bore fruit with the Kentucky General Assembly, which, on February 29, 1876, approved an amendment to Covington's city charter, enabling the city to build the bridge for $800,000. The act authorized the city, upon approval of the voters in an additional election, to approve up to $800,000 worth of bonds, and to levy a property tax to pay the interest on the bonds and to establish a sinking fund to pay the principal. The amendment stipulated that this tax should not exceed 43¢ per $100 valuation during the construction period of the bridge, or more than 23¢ per $100 valuation "on and after the completion of the bridge." If the tax levy passed, the judges of the Kenton circuit and county courts, along with the mayor of the city, would then appoint five persons, none of whom could be concurrently "holding any office of honor, trust, or profit under the city government," to the Trustees of Covington City Bridge board. The latter would oversee construction of the bridge and its operation 12 months after completion. Thereafter, a board of four members, elected by the residents of the city, would direct the bridge. The bridge would be "forever absolutely free from toll to all persons who shall be foot-passengers thereon." Moreover, the board of trustees was obligated to establish "rates of minimum toll for all other uses of the bridge." The sum total of these tolls was, according to a prescribed formula, not to exceed the costs of maintenance and improvements, plus half the "accruing interest on the bonds." Finally, the act provided that the bridge was, in no manner, to be constructed in such a fashion as to "conflict with any act of Congress relating to the free and common navigation of the Ohio river" (*Acts of the General Assembly* 1876, 415).

The last provision of the $800,000 free bridge act referred to legislation passed by the United States Congress on December 17, 1872. This act stipulated that any bridges constructed across the Ohio River, below the Covington and Cincinnati Suspension Bridge, had to have at least one span, allowing a clearance of 400 feet across and measuring 100 feet above low water and 40 feet above the highest-known water stage. In addition, bridges below the suspension bridge had to have a pivot-draw, with two clearances of 160 feet each (An Act to Authorize the Construction of Bridges across the Ohio River, and to Prescribe the Dimensions of the Same, 17 Stat. III, ch. 4 [1873]).

Obviously, a pivot-draw would substantially increase the construction cost of a bridge. The citizens' committee for the free bridge, therefore, sent lobbyists to Washington, D.C., with the intention of influencing Congress to reconsider this provision. In January 1877 Congress considered a bill calling for the repeal of the pivot-draw provision. The attempted repeal was defeated in the House by a vote of 133 to 74. Representatives John H. Reagan of Texas and Milton J. Durham of Kentucky failed in their efforts to convince the House that the bridge did not need a draw, and further, that it would not be an obstruction to river traffic, since steamboats were generally built with the capacity to lower their stacks "in passing under all bridges at high water" ("The Covington Bridge in Congress," *Ticket,* 11 Jan. 1877). Moreover, Mr. Reagan of Texas claimed that the bridge was a necessity, as some 9,000 pedestrians crossed the current suspension bridge daily, on a structure that was controlled by the same company that also held a ferry monopoly at Covington. Reagan and Durham further claimed that the Covington and Cincinnati Bridge Company "was at the bottom of the opposition to this bill," along with the Cincinnati Chamber of Commerce. Despite the setbacks, the Covington City Council decided, in accordance with the provisions of the original General Assembly Act and a subsequent amendment, to present the issue to the taxpayers at an election on Saturday, January 4, 1879. Unlike the *Covington Journal,* the *Daily Commonwealth* of Covington vociferously opposed the measure, claiming, in a table comparing bridge tolls throughout the nation, that the prices exacted by the Covington and Cincinnati Suspension Bridge were lower than those at Wheeling, Saint Louis, Louisville, New York City, Brooklyn, and other cities, excepting Pittsburgh. Voting an increase in taxation, the *Commonwealth* warned, would be an open invitation to more governmental corruption.

The depressed economic climate, recent scandals in the Covington city government, and the opposition of the *Daily Commonwealth* doubtless played a part in defeating the free bridge tax at the elections of Saturday, January 4, 1879. The measure failed by a vote of 2,210 to 1,275.

Advocates of a free bridge persevered in their attempts. In 1881, following an announcement that Collis P. Huntington (1821–1900) of the Chesapeake and Ohio Railroad had acquired the Kentucky Central Railroad (the old Covington and Lexington Railroad) and had proposed plans to build a railway bridge from Covington to Cincinnati, supporters of the free bridge scheme formed a committee to request its directors to dedicate a free public walkway on the bridge. Of particular interest to Westside residents of Covington, the free bridge advocates established a permanent organization to lobby on behalf of the bridge, convening meetings twice monthly at a hall at Sixth and Main Streets in the city's Westside.

Collis Huntington himself, meanwhile, lost no time in courting disciples to his cause. In September 1881 he wrote M. E. Ingalls, the president of the Kentucky Central, who also served as president of the Cincinnati, Indianapolis, Saint Louis, and Chicago Railroad, or the Big Four Railroad. Huntington asked Ingalls to publicize his willingness to cooperate with the residents of Covington in building a railroad bridge "in connection with their desire to have wagon and footways free or at a nominal toll." Further, Huntington relayed that he would be in town on October 15, 1881, and would be "glad to confer with any representative body or a public meeting" ("Important. An Opportunity for a Free Bridge. A Suggestion that Demands Immediate and Favorable Consideration," *Daily Commonwealth*, 23 Sept. 1881). The *Daily Commonwealth* hailed the offer as one which was "in the interest of the masses and against some of the close corporations, whose exorbitant charges have for years been a drawback to the prosperity of Covington." The bridge, if built, would "break the cordon of high tolls which now surrounds the city." In April 1882 civil engineers of the Chesapeake and Ohio Railroad arrived in Covington to begin surveying the route for a bridge, with the possible inclusion of a free footpath.

On Thursday evening, May 25, 1882, the Covington City Council reactivated a Board of Commissioners, which according to the provisions of the 1873 bridge amendment to the city charter, could negotiate with "any person, persons, incorporated company or companies" for the construction of a bridge "for railway and other modes of travel," provided it contained "free passenger-ways" and tolls for carriages and wagons not to exceed "one third the rate" charged by the suspension bridge (*Acts of the General Assembly* 1873, 347–348). As originally constituted, the 1873 Bridge Commissioners included N. Barlett, Platt Evans Jr., J. M. Fisher, Louis Geisbauer, George W. Howell, William M. Leathers, John Marshall, W. W. Mosher, and J. O'Hara Jr. Because Marshall and Fisher had died, and Leathers and Geisbauer had moved from the city, the council appointed in their place Theodore Beuter, Jonathan David Hearne, Alexander Montgomery, and Henry Worthington. At a subsequent meeting of the bridge commissioners on Monday, May 29, 1882, the board elected Hearne as president and Mosher as secretary. Both men had long been instrumental in the free bridge movement.

The proposed Chesapeake and Ohio Railroad bridge was but one of four concurrent schemes being considered in the early 1880s in an attempt to secure a free bridge for Covington. A second plan was for the city of Covington to hold an election on February 23, 1884, to determine whether its citizens would submit to a new property tax, enabling the city to issue $600,000 in municipal bonds to a newly incorporated company called the Covington and Cincinnati Pier Bridge Company. Incorporated in March 1884 by Jonathan David Hearne, Charles B. Pearce, Horace S. Walbridge, Henry Worthington, and Samuel M. Young, the company—in exchange for the issuance of $600,000 in municipal bonds—would make its walkways free to pedestrian traffic and would set its tolls on vehicles to "never exceed one-half" the rates charged by the Covington and Cincinnati Bridge Company, as of January 1, 1884 (*Acts of the General Assembly* 1884, 761).

A third plan was for an unnamed "joint stock company," presumably the Kentucky and Ohio Bridge Company, to erect the bridge and for the city to subscribe for stock in the company and to have a "voice in the management" ("City Affairs. The Free Bridge Question," *Daily Commonwealth*, 24 Apr. 1884). The Kentucky General Assembly chartered the Kentucky and Ohio Bridge Company the month following the *Commonwealth*'s comments, authorizing a $2,000,000 corporation to build a bridge between Covington and Cincinnati. Its incorporators were John C. Benton, A. D. Bullock, Walter Cleary, B. W. Foley, and Henry Hanna.

The fourth and final plan, referred to as "the million dollar bridge" was largely a resurrection of an earlier general assembly act, the 1876 $800,000 bridge act. The Kentucky legislature, in April 1884, approved the "million dollar bridge" act, empowering the city of Covington to build, instead of an $800,000 bridge, a $1,000,000 span. Other than this change and the additional provision that tolls for vehicles on the new bridge could be "at no time greater than one-third the rate charged" by the Covington and Cincinnati Bridge Company, the new act was generally a replica of the old. Moreover, the act specified that the tax issue was to be submitted to the voters of Covington on Saturday, May 31, 1884.

The "million dollar bridge" proposal, by early poll reports issued as of noon, Saturday, May 31, 1884, was suffering a wide margin of defeat, 918 to 141. Final results revealed that the proposition had failed by a vote of 1,749 to 441. The "pier bridge" plan, whereby the city would issue $600,000 in bonds for the construction of a bridge by the Covington and Cincinnati Pier Bridge Company, also foundered. At the municipal election held on Saturday, June 28, 1884, it failed by a vote of 2,648 to 1,177.

Of the four bridge proposals forwarded in the early 1880s, the Chesapeake and Ohio Railroad Bridge was the one that met success, but no provisions were made to make the walkways of this span free to pedestrians. In October 1885 the Covington City Council enacted an ordinance granting the Kentucky Central Railroad, then owned by the Chesapeake and Ohio Railroad, the right to extend its track from its terminus at Pike and Washington Streets to the Ohio River on the Westside. Further, the ordinance stipulated that the company was to construct the extension within 18 months of its passage and, moreover, specified that the railroad should continue to maintain a passenger and freight depot in the city. The Kentucky Central agreed to the terms of the ordinance in November 1885, and subsequently submitted its plans for the improvements to the city clerk. In January 1886, the company officially announced that it

Cincinnati, O. - C. and O. Ry. Bridge - View from Kentucky Side, Ohio River.

The Chesapeake and Ohio (C&O) Railroad Bridge, looking toward Cincinnati, early 1900s. In 1929 a new railroad bridge was built immediately adjoining this bridge to the west. At that time, the old railroad bridge became a highway bridge owned by the state of Kentucky. In 1974, the highway bridge was demolished and was replaced by the Clay Wade Bailey Bridge. The 1929 railroad bridge still serves the CSX system today. Courtesy of Paul A. Tenkotte.

would build a bridge across the Ohio River at Covington, and in September 1886, the city council passed an amend-ment to the 1885 ordinance, detailing the plans of the Kentucky Central to build an extension and a bridge approach, the latter to cross Fifth Street at least "13 feet 5 inches above the surface of the ground" (Wells 1895, 339). Meanwhile, in February 1886, the Kentucky General Assembly issued a new charter to the Covington and Cincinnati Pier Bridge Company. Renamed the Covington and Cincinnati Elevated Railroad and Transfer and Bridge Company, this new limited corporation under the control of Collis P. Huntington built the C&O Bridge at Covington. The terms of the charter specified nothing about free pedestrian pathways, but it did require the company to erect vehicular and pedestrian ways, the toll for which could "at no time exceed the rate charged" by the Covington and Cincinnati Bridge Company on January 1, 1886 (*Acts of the General Assembly* 1886, 344). The C&O Bridge was opened in 1888, with the first train crossing it on Christmas Day of that year.

The opening of the Chesapeake and Ohio Bridge at Covington did not assuage the groundswell of opinion aimed at terminating the collection of what was popularly seen as extravagant rates of toll. Indeed, the Covington and Cincin-nati Bridge Company aroused further suspicions when it failed to issue any reports for a period of 20 years, from 1868 to 1888. Nor did it allow its books to be examined. This conduct was a direct violation of the provisions detailed by the Kentucky General Assembly in the company's original charter. William Goebel, a state senator from Covington, seized this issue and in 1888, introduced a bill into the Kentucky General Assembly calling for a reduction of the tolls charged by the Covington and Cincinnati Suspension Bridge, as well as the Chesapeake and Ohio Railroad Bridge.

Goebel's move underscored two concurrent issues in the arena of local politics. First, he was a reformer, violently opposed to the Old Guard who had long controlled Northern Kentucky. To Goebel, men like Shinkle of the Coving-ton and Cincinnati Bridge Company, and Sanford and his cronies of the Covington and Lexington Turnpike Com-pany, were aristocratic and elitist. They represented an older generation characterized by a certain paternalistic spirit, albeit one that had shaped and overseen the development of Covington and had ushered in a new era of metropolitan consciousness. Now, that very metropolitan vision had become their undoing. Adopted by the working class, it became the banner of Goebel. And in the interim, Shinkle and others became the bête noire of the masses.

The Kentucky General Assembly appointed a special investigating committee to examine the books of the Covington and Cincinnati Bridge Company. One of its four members was Harvey Myers Jr., Speaker of the Ken-tucky House. The committee issued a report on March 10, 1888, which found the financial reports "well kept and convenient in form." It had no reason to suspect any wrongdoing, the committee concluded, although it did scold the company for its failure to issue annual reports. In addition, it faulted the directors for their 1869 purchase and subsequent operation of "the only ferry or ferry franchise between the cities of Covington and Cincinnati, thus controlling and monopolizing the entire traffic between the two cities. The ferry has also been a source of revenue to the company," the committee report asserted, "and has been operated without much regard to the convenience of the people" (*Journal of the Regular Session* 1887–88, 959–70).

The special investigating committee further provided a valuable summary of the volume of traffic crossing both the bridge and the ferry annually. Streetcars made a total of 224 round-trips per day, carrying an average of 8–10 passengers per trip, or more than 1,000,000 riders annually. About 6,700 pedestrians crossed the bridge daily, totaling some 4,445,500 annually, 90% of whom hailed from Covington. The total combined net profits of the bridge for its first 21 years of operation, and for 19 years of the ferry (purchased by the company in 1869), were a healthy $1,900,000.29.

Goebel's bill was introduced in the Kentucky House in late February 1888. In April 1888 the bill was enacted into law. It stipulated that bridges at Covington, clearly the Covington and Cincinnati Suspension Bridge and the C&O Bridge, could not charge greater tolls for the passengers of streetcars or other vehicles than they did for pedestrians. Second, the act required the bridge companies to offer for sale "at all hours, both day and night . . . such coupons or commutation tickets as shall be offered for sale by them at any time." Finally, the act prohibited the bridges from charging the streetcar companies "any toll in addition to that paid for the passengers carried in

its cars" (*Acts of the General Assembly* 1888, 817–818). The latter meant that the Covington and Cincinnati Bridge Company was prohibited from exacting its usual $1.25 per day per streetcar.

Goebel continued his crusade in 1890. As a state senator, he introduced two separate bills, one calling for the reduction of fares on the Covington and Cincinnati Ferry, and the other seeking a decrease in the tolls on the Covington and Cincinnati Suspension Bridge and the Chesapeake and Ohio Bridge. Goebel's ferry bill passed the Kentucky Senate on March 13, 1890. It was enacted into law on March 31, 1890, followed by separate acts reducing the tolls on the Covington and Cincinnati Suspension Bridge and the C&O Bridge, both approved on April 9, 1890. The three acts established uniform rates of tolls on the ferry, which was owned by the Covington and Cincinnati Bridge Company, on the suspension bridge itself, and on the C&O Bridge. Tolls for pedestrians were set at 1¢ per crossing or 25 tickets for 20¢. One-horse vehicles were charged 8¢, or 8 tickets for 50¢, or 16 passes for $1. The fare for two-horse vehicles was 12¢, or 6 tickets for 50¢, or 12 for $1. Rates were set for four-horse vehicles at 18¢, or 8 tickets for $1. Similarly, the rate schedule included maximum prices for three-horse vehicles, livestock, and various other categories. Overall, the legislation produced a drastic reduction of tolls. Two years earlier, in 1888, the Covington and Cincinnati Bridge Company charged, according to a graduated scale, 15¢ to 30¢ per crossing for one-horse to four-horse vehicles, and a discount commuter rate of 13.5¢–27¢ for the same. The 1888 toll for foot passengers was 3¢ cash or 1.5¢ for discount commuter tickets. In most categories, then, Goebel's bill achieved nearly a 50% reduction of tolls. In addition, Goebel's three 1890 bills required the ferry and bridge companies to offer tickets for sale during specified hours of the day. Finally, in an effort to regulate the ferry in accordance with the public interest, the legislature required it to operate from 5:30 a.m. until 7 p.m., and to make crossing at intervals of at least every 20 minutes.

Goebel's successful efforts to reduce the rate of tolls on the Covington and Cincinnati Suspension Bridge, the C&O Bridge, and the Covington and Cincinnati Ferry marked a victory for the suburban residents of Covington. After 1867, espousing a new metropolitan vision of the Cincinnati area, Covington residents could not understand how a community that was one in spirit could be divided by artificial barriers such as tolls. As a result, they actively opposed ferry and bridge monopolies, and they clamored for the building of free bridges. In the long run, their efforts contributed to a deepening understanding of the symbiotic relationship between Cincinnati and Covington.

SELECTED BIBLIOGRAPHY

Acts of the General Assembly of the Commonwealth of Kentucky. Frankfort, KY: John H. Harney, 1868.

———. Frankfort, KY: S. I. M. Major, 1873.

———. Vol. 1. Frankfort, KY: James A. Hodges, 1876.

———. Vol. 1. Frankfort, KY: John D. Woods, 1884.

———. Vol. 2. Frankfort, KY: John D. Woods, 1886.

———. Vol. 2. Frankfort, KY: John D. Woods, 1888.

———. Frankfort, KY: Capital Printing Co., 1894.

Biographical Cyclopedia of the Commonwealth of Kentucky. Chicago, IL: John M. Gresham Company, 1896.

The Biographical Encyclopaedia of Kentucky of the Dead and Living Men of the Nineteenth Century. Cincinnati, OH: J. M. Armstrong & Company, 1878.

Brungs, Sister Mary Carmelite, SND. *The Church of the Mother of God: A Centennial Chronicle.* Covington, KY: Jameson-Rolfes, 1941.

The Cincinnati, Newport, and Covington Railway Company and Constituent Companies. Organization and Franchises. January 1, 1900. Cincinnati, OH: F. W. Freeman, 1900.

Employees' Educational Committee. "A Manual on the Cincinnati, Newport and Covington Railway Company: The Green Line." Cincinnati, OH: Cincinnati, Newport and Covington Railway Company, 1932. Green Line System papers, 1880–1986, 1932–1958 (bulk dates), 1M87M9, Special Collections, University of Kentucky.

Gastright, Joseph F. *Gentleman Farmers to City Folks: A Study of Wallace Woods, Covington, Kentucky.* Cincinnati, OH: Cincinnati Historical Society, 1980.

Geaslen, Chester F. *Strolling Along Memory Lane.* Newport, KY: Otto Printing, 1971–74.

Jonathan David Hearne Papers. Cincinnati Historical Society Library, Cincinnati Museum Center, Cincinnati, OH.

Journal of the Regular Session of the House of Representatives of the Commonwealth of Kentucky. Frankfort, KY: Kentucky State Journal Pub. Co., 1887–88.

Leading Manufacturers and Merchants of Cincinnati and Environs. The Great Railroad Centre of the South and Southwest. An Epitome of the City's History and Descriptive Review of the Industrial Enterprises that are Making Cincinnati the Source of Supply for the New South. New York: International Publishing Co., 1886.

Lehmann, Terry W., and Earl W. Clark Jr. *The Green Line: The Cincinnati, Newport & Covington Railway.* Chicago, IL: Central Electric Railfans' Association, 2000.

Northern Kentucky Newspaper Index. Covington, KY: Kenton County Public Library.

Official Report of the Proceedings and Debates in the Convention Assembled at Frankfort, on the Eighth Day of September, 1890, to Adopt, Amend or Change the Constitution of the State of Kentucky. Frankfort, KY: E. Polk Johnson, 1890.

Report of Special Committee Appointed February 3, 1876, to Investigate the Financial Affairs of the City of Covington, Ky., from January 5, 1872 to February 3, 1876. Covington, KY: Ticket Printing Office, 1876.

Tenkotte, Paul A. "Rival Cities to Suburbs: Covington and Newport, Kentucky, 1790–1890." PhD diss., University of Cincinnati, 1989.

———. "The 'Chronic Want' of Cincinnati: A Southern Railroad." *NKH* 6 (1) (1998): 24–33.

Tenkotte, Paul A., and James C. Claypool, eds. *The Encyclopedia of Northern Kentucky.* Lexington, KY: University Press of Kentucky, 2009.

Tenkotte, Paul A., and Walter E. Langsam. *A Heritage of Art and Faith: Downtown Covington Churches.* Covington, KY: Kenton County Historical Society, 1986.

Tolzmann, Don Heinrich. *Covington's German Heritage.* Bowie, MD: Heritage Books, 1998.

Waring, George E. *Report on the Social Statistics of Cities.* Washington, DC: Government Printing Office, 1887.

Wells, J. C. *A Revision of the Ordinances and Municipal Laws of the City of Covington, Ky., Under the Charter Act of March 19, 1894.* Covington, KY: Jameson Print, 1895.

White, John H. *On the Right Track—Some Historic Cincinnati Railroads.* Cincinnati, OH: Cincinnati Railroad Club, 2003.

CHAPTER

A GATEWAY TO PROGRESS
1900–1915

by Paul A. Tenkotte, PhD,
with contributions by Elaine M. Kuhn

IN his classic study of assassinated Kentucky Governor William Goebel (1856–1900) of Covington, historian James C. Klotter paints a vivid portrait of the morning of February 6, 1900. At the Odd Fellows Hall at Fifth Street and Scott Boulevard (formerly called Scott Street) in Covington, Goebel's body lay in state:

William Goebel. Courtesy of the Library of Congress.

When the hall was opened to the public, the mass of the "common people" passed by; estimates of their numbers reached 100,000. When the casket was closed late that evening thousands more stood waiting outside.

In the darkness of an early morning rainstorm the next day the casket was brought back to the Queen and Crescent [Cincinnati Southern] line train, which moved toward Cincinnati, then south toward Frankfort. The direct route on the Louisville and Nashville tracks would not be taken—a final, bitter rebuff to the line which had so opposed the man now dead. As the train passed through northern Kentucky at every town and hamlet, every village and station, people stood in the rain for a final view of the dead leader. . . .

And so William Goebel became in death a martyr for the Democracy, a "folk hero" to his party, a man honored and remembered, a much-loved symbol. He became in death, then, something he never was in life. (Klotter 1977, 1–2)

Born to German immigrant parents, William Goebel was a hardworking man of great intellect. A graduate of the law school of the University of Cincinnati, Goebel became a very effective and wealthy lawyer, especially in prosecuting cases against large corporations, like the Louisville and Nashville Railroad. Uncomfortable in crowds and certainly not a very good public speaker, he nonetheless excelled in organizational skills. Covington residents John White Stevenson (1812–1886) and John G. Carlisle (1834–1910)—among the most influential men of their day from Kentucky—recognized his genius.

Stevenson & Carlisle

John White Stevenson, a Democrat, served in the state House of Representatives and in the US House of Representatives (1857–61) and became lieutenant governor of Kentucky in 1867. Five days later, Governor John L. Helm died in office, and Stevenson became the first governor of Kentucky from Covington. In 1871 he resigned the governorship and became a US senator, serving one term.

John G. Carlisle, also a Democrat, studied law under John White Stevenson. Carlisle served in the state House (1859–61) and the state Senate (1867–71). He was lieutenant governor (1871–75) under Kentucky Governor Preston H. Leslie. In 1877 he began the first of six terms in the US House of Representatives, where he advanced to Speaker of the House (1883–89). He next served in the US Senate (1890–93), but resigned when President Grover Cleveland appointed him secretary of the treasury during Cleveland's second term (1893–97). Unfortunately, one of the nation's worst economic depressions struck in 1893. Carlisle, a believer in the gold standard, was disliked by Populists, such as William Jennings Bryan, who preferred a "soft money" policy based on bimetallism.

James W. Bryan (1852–1903) studied law under both James J. O'Hara (1825–1900) and John White Stevenson. Also a Democrat, Bryan was a state senator (1885–87). He became the youngest person ever elected lieutenant governor of Kentucky, serving under Governor Simon G. Buckner 1887–91.

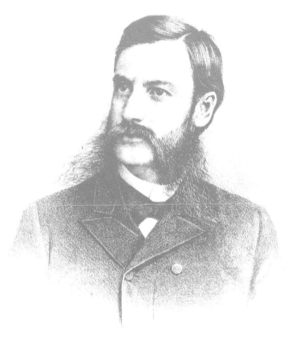

ABOVE: The Boone Block, east side of Scott Boulevard between Fourth and Fifth Streets, still exists today. It once housed the offices of some of Covington's most influential lawyers, including John G. Carlisle, William Goebel, John W. Stevenson, and Orie Ware. Source: *28th Annual Crowning Fest of The Deutsche Schuetzen-Gesellschaft of Covington, Ky.* Cincinnati, OH: Hennegan & Co., 1910. RIGHT: James W. Bryan. Source: Perrin, William Henry, J. H. Battle, and G. C. Kniffin. *Kentucky: A History of the State.* Louisville, KY: F. A. Battey & Company, 1888.

BOSS RULE

William Goebel was Stevenson's law partner, and later, Carlisle's law partner. In 1880, Goebel became the secretary of a local Democratic club, and in 1887, he was elected to the state Senate. As detailed in Chapter 3 ("Gateway to the North, 1867–99"), Goebel was an advocate for the working class, especially in terms of fighting tolls on bridges and turnpikes. He fought for women's rights, African American rights, and labor. In many respects, he was a Populist like his friend, William Jennings Bryan, but with a "machine politics" twist. In Kenton County, Goebel was known as the Kenton King and Boss Bill. Behind the scenes, he largely controlled the Democratic Party machinery. His protégés were Joe Pugh and Joseph Rhinock. As publisher of the *Covington Ledger*, Goebel

PUGH AND RHINOCK.
Will These Bosses Pass?

A caricature of Joe Pugh and Joe Rhinock. Source:
***Cincinnati Commercial Tribune*, 28 Dec. 1900.**

could wield an acerbic pen, calling his opponent John Sandford (sometimes spelled Sanford) "Gon_h_ea [gonorrhea] John." An enraged Sandford cornered Goebel on Madison Avenue on April 11, 1895, and shots rang out. Sandford died, and not knowing who fired first, no jury indicted Goebel.

In 1889, 1893, and 1897, Goebel was reelected to the state Senate, becoming president pro tem in 1894. In 1898 he orchestrated—over the governor's veto—the General Assembly's passage of what became known as the Goebel Election Law. Highly controversial, even among some of his fellow Democrats, the law established a state board of election commissioners, appointed by the General Assembly for four-year terms and composed of only three people. The state election commissioners, in turn, appointed three people annually—in every county of Kentucky—to a county board of election commissioners. The county election commissions, moreover, appointed election officers representing both of the two leading parties to oversee elections at each county's polls. In addition, the county election commissioners would count the votes for each county, certify the election, and send the results to the state election commission. Finally, the county election commissioners would investigate contested elections and decide the winner. Basically, then, whatever political party was in control of the Kentucky General Assembly would control the election process statewide, all the way down to the county level.

The Louisville *Courier-Journal* accused Goebel of engineering the new election law to ensure that he would be elected governor, a rather prescient insight. When state Democrats met at Music Hall in Louisville, Kentucky, in 1899 to choose a candidate for the gubernatorial election, the party eventually nominated Goebel (on the 26th ballot), but some Democrats bolted the party and ran John Young Brown as a third-party candidate. The subsequent campaign was one of Kentucky's most lively gubernatorial races. William Jennings Bryan made a three-day whistle-stop tour of Kentucky on behalf of the Democratic Party in October 1899. On Wednesday evening, October 18, shortly before 8 p.m., Bryan arrived via the C&O Railroad at the Covington station. He was escorted by carriage in a great parade, headed by Covington mayor and Goebel's fellow political boss, Joseph L. Rhinock. At Park Place near city hall and the federal courthouse, more than "15,000 people pushed, shoved, shouted and fought in vain efforts to get near the speaker's stand." The *Kentucky Post* of October 19, 1899, stated that the "oldest residents agreed that it was the largest political gathering that Covington ever had." Bryan's speech was short and succinct, stressing the importance of voting for the Democratic Party.

Fall 1899's gubernatorial election seemed too close to call between Republican candidate William S. Taylor and Democrat Goebel. Goebel contested the election, claiming that illegal ballots had been filed, and the case went to a special legislative committee. On January 30, 1900, Goebel was shot as he approached the state capitol building in Frankfort, Kentucky. As he lay dying, the committee declared Goebel the governor. Taylor, meanwhile, called out the militia, and the state seemed on the verge of civil conflict. On February 3, Goebel died, the only sitting governor in US history whose life was ended by assassination.

In Covington and Kenton County, the assassination of William Goebel left two separate factions vying for power in the Democratic machine. Goebel's younger brothers, Arthur and Justus, whom Goebel had cared for after their parents had died, picked up his shield. The so-called Goebelites, they were joined by Alex (Alexander) Davezac (1859–1923), Joseph L. Elliston (1855–1917), and Daniel L. Gooch (1853–1913). Their opponents included Joe Pugh, a former Goebel ally and chief of police of the city of Covington, and Joseph Rhinock (1863–1926).

Justus and Arthur Goebel

Justus Goebel (1858–1919) was a Cincinnati, Ohio, businessman, who began his career as a salesman at the Cincinnati department stores of the John Shillito Company and, later, of the Alms and Doepke Company. He and his friend, William Lowry, opened a wholesale and retail carpet business in Cincinnati in July 1881. The firm eventually occupied 16 floors of the Lowry and Goebel Building on Cincinnati's Elm Street, in addition to a warehouse. In 1891 his younger brother, Arthur Goebel, became a partner in the business. Arthur was especially devoted to his brother William, and after William's assassination, Arthur spent much time and money seeking justice. Kentucky Governor Augustus E. Willson (1907–11) pardoned two of the principal suspects, Caleb Powers and James Howard, in 1908. Pardons of suspects William Taylor and Charles Finley followed in 1909. In January 1910 Arthur Goebel died. Newspaper accounts stated the cause as a broken heart.

Justus Goebel. Source: Roe, George Mortimer. *Cincinnati: The Queen City of the West.* Cincinnati, OH: Cincinnati Times-Star, 1895.

Arthur Goebel. Source: Roe, George Mortimer. *Cincinnati: The Queen City of the West.* Cincinnati, OH: Cincinnati Times-Star, 1895.

Alexander Davezac was born in France. His parents, Peter and Mary Besson Davezac, immigrated to the United States in 1859. Years later, a *Kentucky Post* article of September 30, 1893, recounted how Alex Davezac had 60¢ in his pocket when he arrived in Cincinnati, and only 57¢ when he stepped foot in Covington, having spent 3¢ to take the ferry. The young boy became a rag collector in Covington, a person who bought rags from residents for recycling into other products, like linen paper for newspapers. Within three months, he bought a horse and wagon to assist in his business, and eventually, he bought old iron from customers as well. He never attended a single day of school in the United States, but learned English "from the newspapers and private conversation here and there," and also "at night a little time was spent on the dictionary and English grammar." In 1872 Davezac established a wholesale liquor business, adding a retail section in 1885. In 1882 his father died at Toulouse, France, while on a visit back home with his wife. His father's funeral was held at Tabas, France, and Alex's mother remained there. Alex Davezac served on the board of commissioners that built Covington's waterworks, was a Covington City Council member for six years, and was a member of the state House (1883–84). In 1893 US President Grover Cleveland appointed him internal revenue collector for the district of Covington. According to the same *Kentucky Post* article, Davezac was an honest man, who "never accepted any money for services rendered his party or friends."

Alexander Davezac. Source: Roe, George Mortimer. *Cincinnati: The Queen City of the West.* Cincinnati, OH: Cincinnati Times-Star, 1895.

The William Goebel-Pugh-Rhinock machine had built a powerful Democratic political base. In 1893 30-year-old Joseph L. Rhinock, a former Covington City Council member, was elected as then the city's youngest mayor. In 1895 Covington's police and fire commissioners chose Joseph W. Pugh as chief of police. At that time, nearly all appointments to the police and fire departments of the city—even for firefighters and police officers—were political. If a new administration were elected, one could expect a new round of firefighters and police officers. Civil service was not practiced, and experience did not really matter (see also "Chapter 15, From Badges to Blazes: Police, Fire, and Paramedics in Covington").

The Covington mayoral race of November 1899 underscored a growing discord between Democrats of the Pugh-Rhinock ring on the one hand and Republicans and fusion Democrats, who had bolted from the Pugh-Rhinock gang, on the other. Although he was officially the Republican mayoral candidate, George Davison was also supported by fusion Democrats on the one hand and the Democrats of the Pugh-Rhinock ring on the other. Although he was officially the Republican mayoral candidate, George Davison was also supported by fusion Democrats. As chief of police, Pugh had winked at the operation of poolrooms in the city, places where off-track betting and other vices took place. Democrats and Republicans alike, who viewed the poolrooms as detrimental to the city and to its moral fabric, were determined to elect Davison and therefore to get rid of Pugh. More than a year after the election, in December 1900, the county election commissioners (Joseph L. Elliston, Henry Kokenge, and William Riedlin) were still trying to unravel the vote counts. Dozens of people testified that police officers, firefighters, election officers, and Democratic Party officials had interfered with the election. In one instance, ballots had been burned, and in other cases, voters had been ejected from the polling places. Then, Circuit Court Judge James P. Tarvin (1859–1907) issued a writ of prohibition against the election commissioners from proceeding with their investigation. In subsequent trials, all of those accused were acquitted. Meanwhile, W. A. Johnson assumed office as mayor.

On December 10, 1900, the *Cincinnati Commercial Tribune,* in an article titled the "Worst Governed City in the United States," claimed that "hardly a man who knows what was going on will attempt to deny the assertion that by a majority of at least 1,500 Davison was chosen. But the gang machinery was put into full play" under the "infamous Goebel election

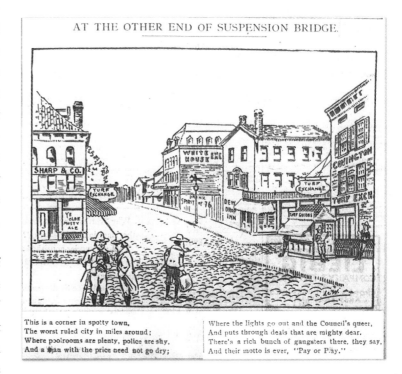

AT THE OTHER END OF SUSPENSION BRIDGE.

This is a corner in spotty town,
The worst ruled city in miles around;
Where poolrooms are plenty, police are shy,
And a man with the price need not go dry;

Where the lights go out and the Council's queer,
And puts through deals that are mighty dear.
There's a rich bunch of gangsters there, they say,
And their motto is ever, "Pay or Play."

This editorial cartoon lampoons Covington, calling it Spotty Town and referring to the gambling and other vices available. Source: *Cincinnati Commercial Tribune,* 19 Dec. 1900.

law" on behalf of the Democratic candidate, W. A. Johnson. Tarvin, the *Cincinnati Commercial Tribune* accused, came "to the rescue," knowing full well that the old Goebel Election Law was being replaced by a new law in January 1901. Basically, Tarvin was buying time, the newspaper surmised, waiting for a new county board of election commissioners to be appointed. In mid-January 1901, Judge Tarvin dismissed the writ of prohibition, and in the text of his decision, blasted the Goebel Election Law, blaming it for the cause of such contested elections in the first place. Although Tarvin questioned the impartiality of county election commissioners in investigating an election that they themselves had overseen, he nonetheless kicked the decision back into the hands of the old county board of election commissioners. They, in turn, ruled on behalf of Johnson, therefore not upsetting his yearlong service as mayor.

Tarvin was well known in Covington circles. A graduate of the law school of the University of Cincinnati, he became a Kenton circuit court judge in 1898. Tarvin and the Covington City Council locked horns on a number of occasions. The background was this—when Kenton County was created in 1840, rural Independence (near the center of the county) was chosen as the county seat. However, in 1858, Covington became a secondary county courthouse for the convenience of much of the population who lived there. From that time on, Covington city hall provided space to the county and was responsible for the building's upkeep. Dedicated in 1844, the city hall was an old building. Not surprisingly, Tarvin found the city council in contempt of court for failing to provide adequate security for court and other important legal documents. Tarvin's concern was real. After all, the Cincinnati Courthouse Riots of 1884 had burned Hamilton County's (Ohio) courthouse to the ground and, with it, important legal records. Losing patience with the city, Tarvin jailed seven city council members for contempt of court in February 1898. They spent a week incarcerated at Independence. William Riedlin, owner of the Bavarian Brewery, provided the jailed council with the comforts of home, including beer and fried chicken. Finally, another judge issued a writ of habeas corpus, releasing them from jail. In 1899, Covington demolished the old city hall and began construction of a new building. Already by 1900, in a situation that sounded much like the case of New York City's city hall, the Covington building was still unfinished, unfurnished, and vacant. There were immense cost overruns, and inflated bids from contractor-friends. When council tried to appropriate funds for the construction normally reserved for sewers and streets, taxpayers sued. Then, when council carried a new bond issue to the ballot in 1900, the voters rejected it. Finally, the new city hall and courthouse was dedicated in January 1902, at a cost of $210,000, a sizable sum for the time.

The area's newspapers found much corruption in Covington at the turn of the 20th century. Although it supported the Democratic Party, the *Kentucky Post* eventually abandoned the Pugh-Rhinock ring. On the other hand, the *Cincinnati Daily Commercial*, a steadfast Republican newspaper, constantly excoriated the Democrats, claiming that Covington was one of the worst governed cities in America, where gambling occurred within sight of the city hall and courthouse. By the late 19th and early 20th centuries, Covington and Kenton County were clearly Democratic strongholds. In the presidential election of 1900, for instance, the county votes tallied 7,245 for William Jennings Bryan (Democrat), and 5,620 for William McKinley (Republican). Likewise, in the city's municipal election for that year, Democrats were swept back into every office, with the exception of three.

In the interim, 1900 was marked by scandals in Covington, and divisions between the bicameral legislature of the city, composed of an upper house called the board of aldermen, and a lower house called the city council. The issue involved the gas franchise. In 1902 the Covington Gas Light Company's (CGLC) 20-year franchise with the city was due to expire. In preparation, the city began accepting bids. The CGLC, headed by Bradford Shinkle, submitted theirs, as did a mysterious company called the Detweiler Company, of Toledo [Ohio]. Pugh and Rhinock supported the Detweiler Company, as did the city council for the most part. On the other hand, the city's board of aldermen preferred the CGLC. Charges of bribery were being tossed around, and then, on Thanksgiving Day in 1900, the Detweiler Company suddenly withdrew its bid. The *Cincinnati Commercial Tribune* and certain concerned citizens saw the Detweiler Company as nothing more than a trick to secure the bid for the CGLC, claiming that the Detweiler firm had sold out to them. The board of aldermen passed a resolution supporting

the CGLC. Concerned citizens made certain that injunctions were filed with the circuit court to prevent the city council from voting on the CGLC proposal. However, it was to no avail. In late December the city council voted for the CGLC's proposal.

Like the properties of gas itself, the gas issue quickly expanded. By early 1901, the North American Company from the eastern coast gained controlling interest in the Covington Gas Light Company, the Newport Gas Company, and the Suburban Electric Light Company of Covington. Subsequently, the merged corporation took the title of the Union Light, Heat, and Power Company (ULH&P). ULH&P's new president was James C. Ernst (1855–1917) of Covington, member of the influential Ernst family. Ernst was the son of William Ernst (1813–1895), longtime president of the Covington branch of the Northern Bank of Kentucky. James Ernst's brother, Richard P. Ernst (1858–1934) of Covington, was an investor in the Cincinnati, Newport, and Covington Railway Company (CN&C, otherwise known as the Green Line). James C. Ernst served as president of both the CN&C and ULH&P.

Meanwhile, already in control of the Cincinnati Edison Light Company, the North American Company next courted the Cincinnati Gas Light and Coke Company (CGLCC). General Andrew Hickenlooper (1837–1904), a hero of the Civil War Battle of Shiloh, was president of the CGLCC. In spring 1901 the merger between the two companies was announced, creating a virtual power company monopoly in the Cincinnati–Northern Kentucky area. Then, in 1902, the North American Company acquired the Cincinnati, Newport, and Covington Railway Company (the Green Line), holding a monopoly over mass transit as well. Columbia Gas and Electric Company (CG&E), in turn, purchased both ULH&P and the Green Line in 1907. By the 1940s the federal government was moving to break up such large monopolies, and in 1944 CG&E sold the Green Line to Allen and Company of New York City.

Richard P. Ernst. Source: Roe, George Mortimer. *Cincinnati: The Queen City of the West*. Cincinnati, OH: Cincinnati Times-Star, 1895.

Politically, the struggle between the Pugh-Rhinock faction and the Goebelites (Arthur and Justus Goebel, Alex Davezac, Joseph Elliston, and Daniel Gooch) was coming to a head in 1900. The Goebelites, with the rallying call "Lest We Forget" (in memory of the assassinated William Goebel), had succeeded in seeing their candidate, Daniel L. Gooch (Democrat), elected to the US House of Representatives for the Sixth District in the fall 1900 election. Now, both factions anxiously awaited a decision by the Democrats' State Central Committee. Who would control the party's County Executive Committee, the Pugh-Rhinock faction or the Goebelite one? Joseph Elliston was the chairman of the county committee, but Pugh was a member of the State Central Committee, as well as the party's Sixth District Committee. The county committee, in turn, controlled the nominations of party members to political offices. The *Cincinnati Commercial Tribune* of December 30, 1900, demonstrated a firm distaste for the Goebelites, proclaiming that Arthur Goebel, a "distinguished Ohio Republican," had "reached across the bridge, picked up the Democratic Party and quietly dropped it in his carpet bag." The humor would not have been lost on the contemporary reader, as Goebel was a successful carpet dealer in Cincinnati.

As chairman of the county party committee, Elliston received a petition from its members requesting the convening of a meeting. He called a meeting for February 6, 1901, in his law office in Covington. Elliston quickly proceeded to push through his reelection as chair and hastily declared the meeting adjourned before the Pugh faction had a chance to voice their dissent. As a result, a fistfight erupted in the street outside between Bud

McInerney, deputy county clerk and a Goebelite, and Ed King, a Covington policeman and Pugh supporter. The two men were pulled off each other, and the meeting reconvened at the city's police courtroom, with a quorum. They proceeded to elect a new chair, Larry Bogenschutz. So by the end of the evening, there were two different committees claiming to represent the Democratic Party in the county. By late February, both were planning on holding separate May primaries. Interestingly, the decision as to which might earn the Democratic emblem on the ballot would possibly be determined by Alex Davezac, then Kenton county clerk.

Both the Pugh-Rhinock and the Goebelite factions had attempted to court Judge Tarvin in the State Central Committee fight. He intelligently declined both, having been stung by both in his attempt to gain the state nomination for governor at the state Democratic convention in Lexington, Kentucky, in 1900. As the *Cincinnati Commercial Tribune* wryly noted, when Tarvin's name was put forth for governor, "Rhinock and Pugh were a mile away, drinking soda water at the Phoenix Hotel." Further, the *Commercial* teased that "naming Tarvin in front of Arthur Goebel and his crowd is like inviting a bull to join you in eating a piece of red handkerchief. There was a roar from Elm Street [Cincinnati]. It shook the Suspension bridge, bumped around the dark streets of Covington and prepared the faithful for what was to come. Covington's population grew just one and Cincinnati lost one in a day or two" (*Cincinnati Commercial Tribune*, 30 Dec. 1900).

The State Central Committee of the Democratic Party had no intention of stepping into the struggle between the Pugh-Rhinock and Goebelite factions, at least not publicly. At a meeting in the police courtroom in Covington on March 14, 1901, Allie Young, chair of the state committee, made his opinion quite clear: "I won't dictate who shall be Chairman of your committee. It's none of my business. I'll tell you one thing, though. You must settle this matter among yourselves tonight. If you don't, I will settle it tomorrow morning myself, and it will be settled for good" ("Joe Pugh Wins Fight in the Kenton Democracy," *Cincinnati Commercial Tribune*, 15 Mar. 1901). The warning was sufficient. The committee elected Larry Bogenschutz (a Pugh man) as chairman, while the Goebelites' proposal to cancel the separate primaries and to hold a single primary was accepted.

The truce between the two factions was temporary. The end result was predictable. In both 1901 and 1902, the divided Democrats suffered in elections in Kenton County and Covington. Clearly, the electorate was upset with the bickering and the corruption. Many Covington residents knew the situation at hand. City positions were being bought and sold. In late June 1901 the Kenton circuit court grand jury reported to Judge Tarvin the initial results of its investigation into municipal corruption in Covington. The court issued an indictment for Justus Goebel, on charges that he secured the position of city auditor for Jerry Kirtley. Kirtley, in turn, agreed to pay Justus Goebel $50 monthly for the office. More indictments were returned against Justus Goebel in July 1901.

By December 1902 Joe Pugh and Justus Goebel reportedly met in Cincinnati and settled their differences. The Goebelite faction had little choice. The following month, January 1903, Allie Young, the state Democratic Party chairman, gave Pugh everything he wanted. Young approved all of Pugh's nominees to both the Covington and Newport Democratic Party committees. The list for Covington included Joseph Elliston and Henry Kokenge. The Goebel-Elliston faction seemed defeated.

The Democratic Party remained divided, however. Joe Pugh supported Theodore Von Hoene as candidate for mayor of Covington in 1903. On the other hand, George Davison also was a candidate for mayor, this time for the Democratic Party and with the support of Frank Tracy (1872–1947), as well as the so-called McInerney-Simmons confederacy ("Pugh versus M'Inerney," *Kentucky Post*, 19 Jan. 1903). Frank Tracy was a graduate of the law school of the University of Cincinnati, was a former member of the Kentucky House, and held the office of Kenton county attorney. Bud McInerney was then sheriff of Kenton County, and Bert Simmons was a Democratic candidate for circuit judge. Meanwhile, the Democratic primary in May was, according to the *Covington Courier* of May 15, 1903, another blatant example of boss rule. "Circulars were freely distributed by poolroom employees and by hangers-on of the Court House ring, giving the names of those candidates for whom the slaves of the ring were expected to cast their ballots. Money was plainly in evidence

Frank Tracy. Source: *Pictorial and Industrial Review of Northern Kentucky*. Newport, KY: Northern Kentucky Review, 1923.

to whomsoever would accept it for their votes." Not surprisingly, Davison lost the Democratic primary, as well as Simmons. The anti-Pugh forces claimed election fraud, but had no place really to turn, as nearly all of the election officers were Pugh appointees.

THE END OF BOSS RULE

Boss rule in Covington, however, was quickly approaching its end. The Republican Party, well organized and represented by Covington's William Riedlin Republican Club, included capable leaders such as George T. Beach, Maurice L. Galvin, William McD. Shaw, and John G. Weaver. In the November 1903 election, Shaw, a former city solicitor and also a county attorney, was running against Tarvin for Kenton circuit judge, while Beach was facing off against Von Hoene for mayor. By October 22, 1903, the *Kentucky Post* featured a front-page story titled, "The Republican Ticket Represents Anti-Pugh." On October 31, nearly 1,500 voters met at Covington's Turners Hall in Lewisburg to hear the Republican candidates speak. The crowd included many Democrats "tired of the Democratic misrule" ("Republicans Close Campaign," *Cincinnati Commercial Tribune,* 1 Nov. 1903).

For all intents and purposes, the November 1903 municipal and county elections spelled the end to boss rule in Covington. George Beach, Republican candidate for mayor, carried the election, 4,776 votes to Von Hoene's 3,984. Republican John J. Craig defeated George H. Kruse for city clerk, and Republicans John J. Beltzer and J. F. Thompson won the city treasurer and city assessor offices. At the county level, the Republicans swept the voting. Shaw defeated Tarvin for Kenton circuit court judge, Maurice L. Galvin won the office of commonwealth attorney, and John G. Weaver secured the race for Kenton circuit court clerk.

On November 12, 1903, the *Kentucky Post* (reprinting an article from the *Cincinnati Post*) jubilantly celebrated the end of boss rule in Covington. In print, it clearly and unequivocally stated what everyone already knew: There was indeed a connection between the notorious Republican boss of Cincinnati, George B. Cox (1853–1916), and Covington's Democratic Pugh-Rhinock ring. "Anti-Pugh people, both Democrats and Republicans, declare that there is no secret of the arrangement for the exchange of floaters between the Cox organization in Cincinnati and the Pugh organization in Covington. At the recent primary elections it is said that Rud K. Hynicka [a Cox organization man] was as active in the Kentucky fight as almost any resident on that side of the river." The *Post* continued, "An evidence of the thorough understanding between the two gangs, frequently mentioned in Covington, is that while the leaders of the Republican organization in Cincinnati were celebrating the great Republican victory in Ohio they openly expressed the deepest regret that the same party had been successful in Covington, and that the Pugh Democratic faction had been defeated."

Joe Pugh continued to rule the Democratic Party in Kenton County, but having lost Covington, his path was nearing an end. In November 1907 Republican candidate John J. Craig Sr. (1873–1930) won the election for mayor of Covington, succeeding Republican George Beach. Craig would serve as mayor from 1908 until 1911, and then again from 1916 until 1920. Meanwhile, in June 1911, the Democratic Party's Sixth District

George T. Beach. Courtesy of the Kenton County Public Library, Covington.

committee completely ignored Pugh. Instead, the anti-Pugh faction elected J. A. Donaldson of Carroll County as their representative on the party's State Central Committee, although Joseph Rhinock, then a member of the US House of Representatives, secured a position for his old ally Pugh on the state committee as an at-large candidate. Subsequently, Donaldson shifted control of the Kenton County committee to the anti-Pugh faction. And by 1908 Pugh and Alex Davezac—both fading stars—ended their feud. Finally, in October 1919, Pugh died on his way home after attending game one of the World Series between the Cincinnati Reds and the Chicago White Sox (the year of the famous Black Sox Scandal).

Goebel Park
BY ELAINE M. KUHN

Covington residents have long cherished their green spaces and places for recreation. But making public parks a reality within the city took a great deal of time and effort. As early as 1853, Covington residents expressed their desire to obtain public park space for the enjoyment of present and future citizens. Acknowledging the rapid growth of their city, concerns were noted that delaying land purchase would put worthy properties out of financial reach for the city. In a show of support for the cause, Jacob Ellinger wrote to the editor of the *Covington Journal* in 1854, announcing that he had deposited $50 into the Kentucky Trust Company Bank for the purpose of purchasing land for a city park.

During the latter half of the 19th century, however, plans for public parks languished. It was not until the turn of the 20th century, when interest in public playgrounds also grew in popularity, that the Covington City Council took formal steps toward developing properties for public recreational use. Receiving pressure from various civic organizations and the local media, the city purchased and improved a playground area on the north side of Second Street. The playground was officially opened on July 27, 1901.

One of the individual driving forces behind making public parks a reality in Covington was Frank Woodall, a traveling salesman who used his own money to publish two pamphlets meant to foster public support for financing and building a public park in downtown Covington. One of the local newspapers ran an abbreviated version of Woodall's first pamphlet article, which included a detailed plan for borrowing the money to purchase the necessary plots of land. Accompanying the article were illustrations of the new city park layout, which encompassed land between Second Street on the north, Fourth Street on the south, Sandford Alley on the east, and to a proposed alley between Scott Boulevard and Madison Avenue on the west.

Though local business owners and community philanthropists had formed a group to raise funds and acquire properties for parks development, it became apparent that local government would require the means by which monies could be raised and properties acquired. In 1906 with the passage of legislation permitting mayors of "cities of the second class" to appoint boards of park commissioners, Covington Mayor George Beach (1904–1907) wasted little time in forming such a group. Due in great part to his in-depth research and advocacy for public parks and playgrounds, Frank Woodall was named president of the first Park Commission. For his tireless efforts in supporting parks development, when Woodall died in 1916 he was remembered as "the father of the Covington parks."

In 1909, after months of negotiations, Covington agreed to purchase approximately 15 acres of land located at Fifth and Philadelphia Streets from brothers Arthur and Justus Goebel for $25,000. The brothers asked for one stipulation in the purchase, that the park be named William Goebel Park in honor of their brother.

The city soon began improving the land, eventually adding wading pools and shelters. But as with many park areas, upkeep had its challenges, and at various times in its history, Goebel Park, as it became known, showed signs of neglect and vandalism. However, with the creation of MainStrasse Village directly to the east of Goebel Park, increased attention brought the plight of the park to the foreground. Improvements and cleanup ensued, and with the addition of the Carroll Chimes clock tower in 1978, the park began its revival. Named for Kentucky Governor Julian M. Carroll (1974–1979), who assisted the MainStrasse area with obtaining funds for the project, the Carroll Chimes boasts a 43-bell carillon, manufactured in Cincinnati by the Verdin Company, and a glockenspiel by Petit and Fritsen of Aarle-Rixtel, Netherlands.

Goebel Park is also home to two Kentucky historical markers, one dedicated to actress Una Merkel (1903–1986), and the other to songwriter Haven Gillespie (1888–1975) who penned the popular song, "Santa Claus is Comin' to Town." Both women were Covington natives. Today's Goebel Park sports a gazebo, picnic shelters, a public pool, basketball and tennis courts, and public parking.

LEFT: Goebel Park shelterhouse, looking southwest. Photo by Cyril Von Hoene, courtesy of Greg Von Hoene. RIGHT: Carroll Chimes, Goebel Park, 2014. Photo by Dave Ivory.

FLOODS AND A TORNADO

Located along the Ohio and Licking Rivers, Covington was always prone to flooding. Floods had occurred fairly regularly, with two of the worst being in February 1883 (66.3 feet) and February 1884 (71.1 feet). In 1907, the community was hit with two floods: In January 1907 the Ohio River crested at 65.2 feet, and in March, at 62.1 feet. With no floodwalls or levees, and with backwaters flowing up the Willow Run and Banklick Creeks, these early 20th-century floods were worse than a comparable flood of today. The January 1907 flood inundated about 300 homes in Covington. Typically, the lowest-lying areas included where West Third Street crossed the Willow Run Creek, Turkey Foot Bottom near the Licking River's C&O Railroad Bridge, and neighborhoods along the Licking River, including parts of Austinburg.

In April 1913 the Ohio River rose to 69.9 feet. The flood proved especially disastrous for cities north of Cincinnati along the Great Miami River, including Dayton and Hamilton, Ohio. In Covington, the 1913 flood led to the area's first proposals to build a floodwall. In March 1915 the West End Welfare Association (WEWA) of Covington, whose secretary, Peter J. Gil, was an engineer, presented plans for a 30-foot wall, stretching along the Ohio River from the Licking River to Western Avenue. The association hoped that the floodwall would be eligible for some of the $18 million appropriated by the US Congress for improvements along the Ohio. Arthur Rouse (1874–1956), US representative for Kentucky's Sixth District (1911–1927) presented the proposal to the US Army Corps of Engineers, who were surveying the Ohio River Valley and planned to meet with the WEWA. Unfortunately, the floodwall was not built at that time.

On July 7, 1915, a tornado swept through the Ohio River Valley, causing devastating damage to Erlanger, Kentucky; the Lagoon Amusement Park in Ludlow, Kentucky; Cincinnati's West End; and Campbell County in Kentucky. The twister hit Covington at 9:26 p.m., moving in a southeasterly direction and doing the most damage in the vicinity of 12th and Greenup Streets. There, it toppled the spire of St. Joseph Catholic Church. The steeple, with its clock stopping at 9:26, landed on Donovan's Tavern across the street. At 14th Street and Madison Avenue,

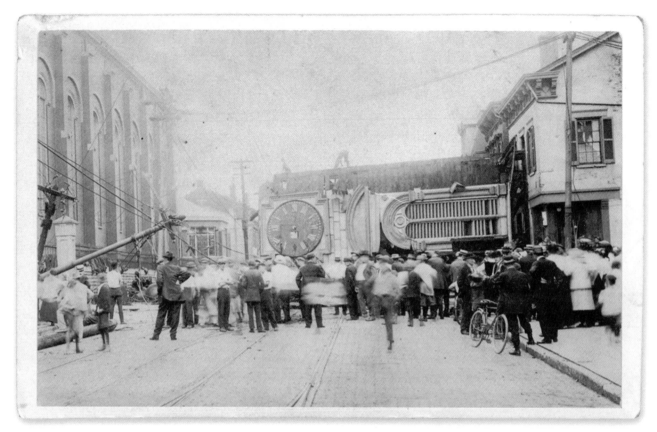

The toppled bell tower of St. Joseph Catholic Church, 1915 tornado. Courtesy of Paul A. Tenkotte.

the C&O Railroad offices and roundhouse suffered extensive damage. The roof blew off the city jail, and the jailer quickly swore in two deputies. Latonia Race Track also received damage, as did numerous businesses and homes throughout the city. Fortunately, there were no fatalities in Covington.

WORLD WAR I

The coming of World War I found the residents of Covington involved in American patriotic activities. Covington's German American Catholic churches proudly supported the United States cause. At St. Joseph Catholic Church in Covington, a program featuring the raising of a new outdoor American flag—donated by the St. Joseph Commandery of the Knights of St. John—began the parish's efforts in May 1917. During the course of the war, 150 of the parish's men served in the United States forces, two of them dying in Europe. The Young Ladies' Red Cross Unit of the church "in the first half year alone" gave "4,000 compresses and packings" to the Red Cross, "while the Married Ladies' Sewing Circle" donated "hundreds of blankets, woolen underwear, jackets, stockings, etc." Meanwhile, during 1918 alone, members of St. Joseph in Covington purchased "$17,561.25 worth of War Savings and Thrift stamps" (*Souvenir Diamond Jubilee* 1934, 24).

The patriotic activities of German Americans did not, however, dissuade the bigotry of reactionaries. Indeed, anti-German sentiments during World War I in Northern Kentucky raged at a fever pitch. Shortly after the April 1917 Congressional declaration of war against Germany, President Woodrow Wilson (1913–21) "issued a proclamation requiring all 'alien enemies' (Germans) residing in the United States to turn over their firearms or be arrested." In February 1918 Wilson issued a new proclamation requiring all male aliens (from Germany or the Austro-Hungarian Empire) to register with local police, be fingerprinted, have their photographs taken, and be issued special identification cards "to be carried with them at all times." In June 1918 this provision was extended to female aliens (Stamm 1989, 6).

The German language and German culture soon came under attack, as well. The public schools in Covington banned German language instruction. Covington even changed German street names—for example, Bremen to

Pershing. Private businesses followed suit as the German National Bank of Covington changed its official name to the Liberty National Bank of Covington.

By June 1918 anti-German sentiments in Northern Kentucky turned to violence, at the hands of a vigilante group called the Citizens' Patriotic League of Covington, founded in 1917 and claiming more than 1,000 members by 1919. On Wednesday, June 5, 1918, 200 members of the Citizens' Patriotic League of Covington traveled in "forty automobiles" from Covington to Erlanger and back again. The assembly stopped at St. John Catholic Church in Covington's heavily German American neighborhood of Lewisburg and harassed its pastor, Reverend Anthony Goebel. In an article titled "Seditious Hun Skunks" published in the newsletter *Comment "One Hundred Per Cent America,"* the vigilantes admitted forcing Reverend Goebel to come out of the rectory onto his porch, during a thunderstorm, where they proudly noted that "he cowed and trembled and pleaded." An attorney, John B. O'Neal, "confronting the priest in the center of a surging throng of outraged Americans," accused him in these words: "You are a traitor to your country. You have been guilty of acts of pro-Germanism. This must stop. You are being warned that the Americans of this community will not permit any further evidences of disloyalty on your part." Nothing, of course, could be further from the truth. St. John's Parish, under Reverend Goebel, was involved in patriotic American activities, including the purchase of war bonds and assistance to the American Red Cross.

In suburban Erlanger, the Citizens' Patriotic League took Joseph Merk from his home to "Schaeffer's saloon," where he was "compelled to deliver up the books of the German Pioneer Society." In addition, Stephens L. Blakely, Kenton County Commonwealth Attorney, "instructed" Mr. Merk "to move to Cincinnati within five days." Returning to Covington, the league proceeded to harass two saloon owners and then went to the grocery store of Simon Schollmeyer, where they "surged up the narrow stairs" to his residence, and despite hearing the "voice of a woman, behind a locked door," broke their way into his quarters and dragged him out to the sidewalk. At Frank Rowekamp's saloon, the league forced Rowekamp and Joe Grote, a Covington merchant, to "stand side by side upon a table that the crowd might view them," slapping them in the "face several times," while Stephens Blakely verbally accosted them ("An Open Reply" 1921, 5–8).

On June 24, 1918, the Citizens' Patriotic League repeated its harassing activities. Led by Stephens Blakely, Harvey Myers Jr., and a Mr. O'Neal, the crowd traveled out Madison Pike in Kenton County to the farm of Paul W. Flynn. There, they kicked old Mr. Flynn, dragging him across the field, blindfolded him, threatened to hang him, fired shots at him, stripped him naked, and horsewhipped him until the blood ran down into his boots. Next, Blakely and the lawless mob went to the Schneider farm, where they hit 24-year-old John Schneider, stripped him, and whipped him with the horse whips taken from Flynn's ("An Open Reply" 1921, 5–8).

These two nights of anti-German harassment, called later "The Reign of Terror," found their way into court. Joseph C. Grote pursued litigation against Stephens L. Blakely and others in the Kenton circuit court in Covington. The testimony, taken from both the perpetrators and the victims, painted an ugly picture of hatred and total disregard for human life. Reverend Goebel testified of his mistreatment: "I saw that I was up against a group,—a crowd. I tried to prevent being shoved out, I had in my right hand the door knob, in the left hand I pressed against the door post. They beat me on my knuckles, and shoved me out. . . . They tore my shirt to pieces, they shoved me out to the porch. . . . Abusive language was used against me, called me 'pro-German', 'Traitor' and other vile epithets." The crowd then struck and kicked him, threatening to hang him. On further examination, Reverend Goebel testified that he had actively supported the American cause in the war, that his parish had a "ladies Red Cross society," and that he had personally subscribed to Liberty Bonds ("An Open Reply" 1921, 11–15).

The Citizens' Patriotic League of Covington also engaged in collecting incriminating information sufficient to indict German Americans under the federal Espionage Act of 1917 and its 1918 amendment. For instance, in early 1918, the League secured the services of a "detective agency to install a dictograph" behind a wall clock in the Latonia shoe store of C. B. Schoberg at Ritte's Corner. Every day, private investigators eavesdropped on conversations in the store from the basement of the bank building in which it was located. When enough evidence was collected,

it was turned over to federal authorities, and eight men were arrested, including Schoberg; J. Henry Kruse, former secretary and treasurer of the Bavarian Brewery; and Matt Feltman, a "wealthy tobacco dealer." The seditious statements included Schoberg's comment that "Germans as a rule are successful in business enterprises. Where would this country be without its German population?" Feltman, meanwhile, supposedly commented, "Don't you worry; the worst and the very worst that Germany can get out of it [the war] is a draw or an even break." Even singing could be considered seditious, as Schoberg was accused "of regularly singing two German songs, 'Fatherland' and 'Lorelei'" (Stamm 1989, 27–29). The court was not swayed by defendants' attorneys who argued for freedom of speech. Even though all three men had patriotically purchased war bonds, including Feltman who bought $45,000 worth, the men were convicted. An appeal to the federal Sixth Circuit Court of Appeals failed to overturn the convictions. The US Supreme Court declined to hear the case. All three men spent about six months in prison, and then were pardoned.

THE GREAT DEPRESSION AND THE FLOOD OF 1937

In fall 1929 the US stock market crashed, ushering in a long economic downfall, called the Great Depression. Through the implementation of government programs like the WPA (Works Progress Administration; renamed the Works Projects Administration in 1939), President Roosevelt's New Deal attempted to put the unemployed to work on public projects. Covington, and its neighboring suburbs, took advantage of the opportunity to fund municipal improvements for streets, sewers, parks, waterworks, and even the building of schools. The WPA program was a matching grant program, whereby the city would fund part of each construction project. In Covington, in addition to streets and sewers, and improvements to Devou Park, the city upgraded its water filtration plant in Fort Thomas, Kentucky. Other large projects included a new auditorium for the Sixth District School, new school buildings for the First, Third, and Fourth District Schools, and a school board administration building on East Seventh Street. The new Memorial Bridge at Fourth Street, between Covington and Newport, was also a WPA project.

In conjunction with the United States Housing Authority (USHA), the city established the Covington Municipal Housing Commission during the late 1930s to build and operate low-cost public housing. The USHA loaned $1.7 million to Covington, which the city matched at 10% by bonds. The housing units, therefore, were to be owned and operated by the city itself. Typical of the time, two segregated projects were completed, Jacob Price Homes for blacks in the city's Eastside, and Latonia Terrace for whites in Latonia. Both housing projects were under construction in late 1939 and had units open for inspection in January 1941. In the 1950s another public housing project was built in the Monte Casino neighborhood, called Ida Spence Homes (named after the wife of US Congressman Brent Spence). Today, it is known as City Heights.

In January 1937 the Ohio River, following excessive precipitation in the form of melting snow and rains, swelled beyond its banks like nothing in recorded history. Historian David Welky calls

IDA SPENCE HOMES

Covington, Kentucky —
Two-story row houses

Maintenance problems resulting from common stair halls, stairs, and entrances in apartment buildings were eliminated when the Covington Municipal Housing Commission decided upon row houses for this project. Looking forward to the time when its tenants will be home owners, the housing commission views its tenant maintenance program, possible in row house buildings, as a training ground for home ownership.

Moreover, the smaller ground areas required for row house units made them a logical selection for a hilltop site without the sacrifice of courts or service yards.

BUILDINGS—SITE

Two-story row houses—340 dwellings
Three-story row houses combined with two-story row houses—32 dwellings
One-bedroom flats in two-story row houses—28 dwellings
Total dwellings—400
Room ratio—4.8 for 1,920 rooms
Density—20.2 families per net acre
Land coverage—23.23 per cent
Bid opening date—March 12, 1952
Foundations—concrete walls on concrete footings; partial basements
Walls—brick veneer
Floors—concrete slab on 4-inch gravel; wood
Roofs—pitched, wood trusses, asphalt shingles
Heat—group plants, gas-fired forced hot water

COSTS

Per dwelling:
Overhead, interest, initial operating deficit, and planning—$813
Site acquisition (vacant)—$77
Site improvement—$2,293
Dwelling construction and equipment —$8,156
Nondwelling construction and equipment—$204
Total development—$11,658*

Per room:
Dwelling construction and equipment —$1,716*
Total project—$4,663,279*

*Includes contingency

Ida Spence Homes. Courtesy of Paul A. Tenkotte.

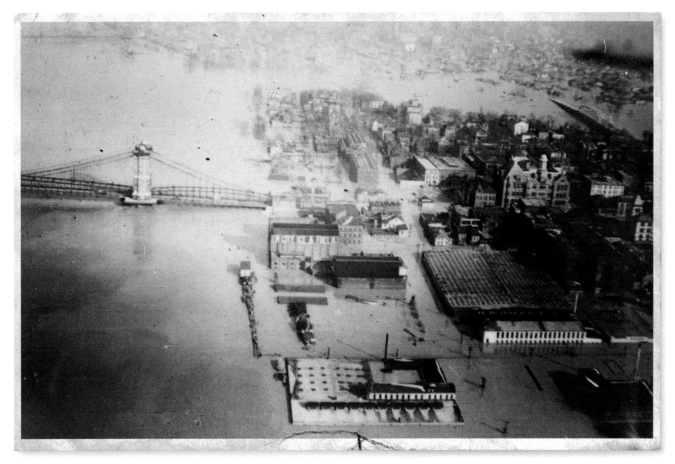

Aerial view of the Point, at the confluence of the Licking and Ohio Rivers, 1937 flood. Courtesy of Jim Resing and Paul A. Tenkotte.

the disaster, in his book title of the same name, *The Thousand-Year Flood*. By January 25, with the Ohio River climbing toward an unprecedented 79 feet, the *Kentucky Post* reported that 20,000 people in Covington had evacuated their homes, and that 40% of the city's land area was flooded in some form. Booth Hospital on East Second Street, with a flooded basement, was without heat, but tried to keep patients warm. St. Elizabeth Hospital on East 20th Street was surrounded by water, but pumped steam from two steamrollers into its heating system. Emergency traffic only was allowed over the suspension bridge between

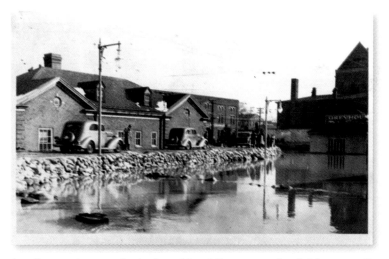

Sandbagged ramp, Covington side of the suspension bridge over the Ohio River, 1937 flood. Courtesy of Paul A. Tenkotte.

Covington and Cincinnati (now called the John A. Roebling Suspension Bridge), protected by WPA-built sandbags on its Covington ramp. Emergency egress to the suburbs west of Covington was possible only by way of 16th Street, Jefferson Avenue, and Highland Avenue. Access to Latonia was cut off, and south of Latonia, 25 feet of water blocked Winston Avenue over Banklick Creek. Decoursey Avenue, as well, was cut off from the floodwaters of Banklick Creek. All over the city, homes collapsed and floated off their foundations. Augmented by artesian wells, Covington rationed water through the city's remaining water mains, from 6 to 8 a.m., and then from 4 to 6 p.m. All residents were advised to boil the water before using it. Kentucky National Guard troops were called in to help.

At its crest on January 26, the 1937 flood at Cincinnati hit 79.99 feet, although records today give 80 feet as the official mark. Cleanup was time consuming, and by February 4 involved 175 city employees and 500 WPA workers in clearing mud and debris from Covington's streets. Ed Reinke, the city's building inspector, and Dr. Theodore Sallee, its health officer, trained a group of 10 workers to inspect each house for health reasons and structural stability before allowing residents to return. The Green Line, with damage to its streetcar power plant and to the streetcars themselves, purchased a number of independent bus lines in the area. On February 1, a 100-foot by 200-foot section of land on the west side of Philadelphia Street, between Eighth and Ninth Streets, literally sank into the undermining backwaters of Willow Run Creek. On February 4, Kentucky Governor A. B. Chandler inspected the damage in Covington and the surrounding cities, promising to meet with President Franklin Roosevelt to request all available aid. The American Red Cross was also busy working in the area to assist the destitute homeless.

On Saturday, February 6, Harry Hopkins, FDR's director of the WPA and chair of the President's Flood Relief Committee, met with area leaders in Cincinnati. There, Covington and other city officials suggested that their most flood-prone areas be demolished and turned into parks and playgrounds. The people displaced would be moved to low-cost housing on the surrounding hills. Covington City Manager Theodore Kluemper (1866–1946; city manager, 1934–40) recommended that the city seek federal grants, or if necessary, federal loans, to acquire properties in flood-prone areas, encompassing as many as 24 city blocks. Kluemper proposed

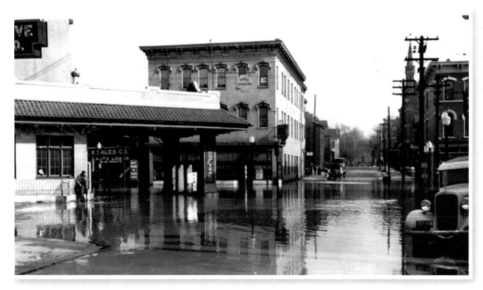

Fifth Street and Scotts Boulevard, 1937 flood. Courtesy of Paul A. Tenkotte.

that the area stretch north of Third Street from Madison Avenue to Crescent Avenue, as well as along the Licking River between 16th and 18th Streets and east of Oakland Avenue. Meanwhile, in Washington, D.C., US Representative Brent Spence introduced a flood control bill. And on February 16, Governor Chandler and US Senator Alben Barkley led a delegation from Kentucky to Washington, D.C., to confer with Harry Hopkins. Hopkins promised the continued support of the WPA, even in helping to clean private homes that were declared health risks. In addition, the federal Home Owners' Loan Corporation would advance loans to homeowners. A week later, federal officials announced that a new Disaster Loan Corporation was accepting applications. By late February, the US Army Corps of Engineers was already recommending a multimillion-dollar floodwall and levee project for Northern Kentucky, stretching from Dayton, Kentucky, to Bromley, Kentucky, and including the city of Covington.

Covington and Kenton County suffered an estimated $9 million in damages from the 1937 flood, a number equivalent to about $150 million in 2014. The psychological damage was immeasurable, though. People who could afford to do so moved from the flood-prone areas to higher city neighborhoods or even to outlying suburbs. With proposals floating around to demolish housing for parks or floodwalls, the poor were left behind to await the next flood. Homeowners and landlords alike in flood-prone areas had little incentive to improve their properties. So, the spiral of ghettoization of some neighborhoods continued downward.

Floods are never convenient, of course, but the 1937 flood could not have hit at a worse time. The United States was in the throes of the Great Depression. As the United States inched toward war in Europe, flood control would

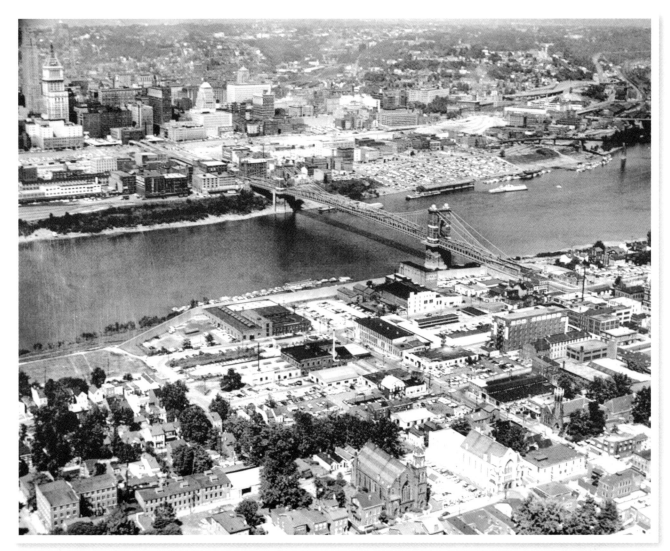

Aerial view, late 1950s, after completion of the new floodwall along the Ohio River. First Presbyterian and First Baptist Churches can be seen on West Fourth Street, and to the left of them, the area later demolished for urban renewal and the construction of the one-floor IRS Center. The large building on the left is Kelley-Koett, manufacturers of X-ray equipment. Photo by Raymond E. Hadorn, in the collection of Paul A. Tenkotte.

be put on the back burner. Construction of Covington's system of levees, concrete floodwalls, and pumping stations began in 1948. Finished in 1955, these cost $8.9 million. Homeowners along Riverside Drive, determined not to sacrifice their view of Cincinnati, opted out of a floodwall. Otherwise, the flood control system of Covington protects the entire city from a flood of 1937 proportions.

WORLD WAR II

On December 7, 1941, Japanese forces attacked Pearl Harbor in Honolulu, Hawaii. The United States entered World War II, the bloodiest conflict in world history. Covington men volunteered for the armed forces, and some women joined the WACS (Women's Army Corps) and the WAVES (Women Accepted for Volunteer Emergency Service). In May 1943 the WACS held a rally at the Covington Public Library. The fact that the grade and pay scales for WACS was the same as in the army was an unheard-of advance.

With many men off to war in the European and Pacific theaters of operation, women were needed as laborers in manufacturing facilities. The War Production Board (WPB) oversaw the nation's industrial mobilization, as factories switched from domestic production to the manufacture of munitions and supplies to win the war. The WPB also allocated raw materials, such as oil, paper, steel, and aluminum. And in 1942 the Office of Price Administration (OPA) began the rationing of butter, coffee, gasoline, meat, sugar, and tires for domestic consumption.

Americans were issued ration books, using the stamps contained therein to purchase rationed items. Meanwhile, recycling of rubber, steel, and newspapers became widespread. By early November 1942, in fact, Kenton County residents had collected more than 5.2 million pounds of scrap metal. Eighth District School led the scrap drive for Covington Independent Schools, collecting more than 44,000 pounds of scrap metal by late October 1942, or an average of 150.7 pounds per student. Catholic school students throughout the Covington diocese were also involved in numerous activities for the war, including scrap drives. Catholic high schools began to establish Victory Corps, in an effort "to direct the class work and extracurricular activities of high school students to a fuller participation in the war effort, both while the pupil is in school and outside of school hours as well." La Salette Academy in Covington, for instance, established a Victory Corps in November 1942 that featured "home nursing classes, Red Cross work, classes in nutrition, a physical fitness program, the Inter-American Correspondence Club, the Radio Communications Service Club, and the sale of war bonds and stamps." Following a talk at La Salette by Reverend Gerard Kuhn, CSSR, the chaplain at the US Army's installation at nearby Fort Thomas, the students examined a jeep in the courtyard and hoped to sell war bonds equivalent to its cost (*Messenger*, 19 Nov. 1942).

With the encouragement of the Covington Kiwanis Club, Covington residents planted victory gardens at home to supplement their supply of fruits and vegetables. Civilians enrolled in first aid courses and donated blood for the soldiers abroad. Building construction was highly regulated by the federal government in order to save scarce resources for the war effort. In the interim, the OPA placed the metropolitan area, including Covington, under rent controls in an effort to manage inflation.

In the Greater Cincinnati metropolitan area, Brigadier General Dan T. Merrill oversaw civilian defense. On Monday evening, July 13, 1942, at 10:30 p.m., Kenton County held its first countywide blackout. During mandatory blackouts, sirens sounded the alert, and all homes and businesses were required to turn off their lights. All traffic was stopped, all vehicles turned off their headlights, and residents were expected to move indoors. Air wardens patrolled the street looking for violators. First aid and casualty stations were manned. Civil Air Patrol planes flew over the county, observing whether the test drill was successful in concealing the area "in the event enemy planes visit the Ohio Valley territory" ("4000 Workers Set for Kenton Dim-out," *Kentucky Post*, 9 July 1942).

Brigadier General Merrill supervised the coordination of a two-county blackout (Kenton and Campbell) on Friday, September 11, 1942. No one escaped the order. Even four football games in the area were required to turn off their lights, with the spectators remaining quietly in their seats. Merrill instructed residents to "select the safest place in your house for general blackout purposes. Be prepared to blanket windows or cover the glass with opaque protective materials. Be sure that no lights can be seen from the outside. Keep your blackout material ready for instant use" ("Stage Set for Black-out Friday," *Kentucky Post*, 9 Sept. 1942).

The Green Line expanded its hours of operation on many routes to facilitate a steady supply of laborers working night shifts at factories. Factories operated on Saturdays and even national holidays. Government orders kept assembly lines humming at Covington factories, including Avey Drilling Machine Company, Michaels Art Bronze Company, Sebastian Lathe Company, Stewart Iron Works Company, and the Wadsworth Electric Manufacturing Company.

Hardworking Covington residents took time to enjoy themselves, attending summer concerts in Devou Park. Year-round, they went to movie theaters, not only to see the latest films but especially to view the newsreels beforehand, telling them the latest news of the war. In addition, they stayed glued to their radios and read daily newspapers.

On May 8, 1945, Covington residents celebrated V-E (Victory in Europe) Day. Businesses and city offices closed, and many attended local church services. Still, the war raged on in the Pacific until the Japanese surrendered in August 1945. In June 1946 the War Department issued its Honor List of Dead and Missing, which included 225 people from Kenton County.

World War II, resulting in the deaths of 60 million soldiers and civilians worldwide, also led to the displacement of 30 million European refugees. The joy of victory was tempered by the necessity of feeding the hungry and of rebuilding. By Christmas 1945, Reverend Edward G. Klosterman, pastor of Mother of God Catholic Church

in Covington and diocesan director of Catholic Charities, supervised a diocesan canned-food drive for "victims of starvation in war-torn countries, in conjunction with the National Catholic Welfare Conference" (*Messenger*, January 1946).

There were many local heroes. Among them were Reverend Henry Bernard Stober (1901–1945) and Dr. Alvin C. Poweleit (1908–1997). Stober, a priest of the Roman Catholic Diocese of Covington, volunteered for service as a chaplain in the US Army in 1940. Ordained by Bishop Francis Howard in 1931, Reverend Stober had served at a number of posts, including St. John Catholic Church in Covington, St. Agnes Chapel in suburban Park Hills, and for a short time as Bishop Howard's secretary. In 1941 the Army deployed Reverend Stober to the Philippine Islands to serve the men of the 14th Engineer and the 57th Infantry Regiments. On Good Friday, April 3, 1942, the Japanese forces "pressed the attack for the final assault on the troops defending the lower peninsula of Bataan" (Mahoney 2001, 15). Three chaplains, including Reverend Stober, offered religious services for men who real-ized that the situation was desperate. Six days later, the American mainland forces in the Philippines surrendered to the Japanese. The Japanese subsequently subjected the American and Filipino POWs to the brutal "Bataan Death March." Recipient posthumously of both the Bronze Star and the Purple Heart, Reverend Stober performed heroic acts of charity during the Death March. Once, while attending to a dying American soldier, Stober was bayoneted by a Japanese sentry. Bleeding, he continued on the march, eventually reaching the prison base, Camp O'Donnell.

**Reverend Henry Bernard Stober.
Courtesy of Paul A. Tenkotte.**

At Camp O'Donnell, Dr. Alvin C. Poweleit (see also "Chapter 11, From Leeches to Lasers: Medicine and Senior Housing in Covington"), a POW, survivor of the Bataan Death March, and later noted physician of Cov-ington, wrote in his detailed diary that Reverend Stober arrived at the camp on April 17, 1942:

> As I looked at this motley group of men, I thought I recognized a man I used to know, a priest from my home town, Newport, Kentucky. He looked as if he were on his last leg. He was thin, his eyes sunk in, practically devoid of flesh and muscle. After the guards left, I went over to him and asked if he were Reverend Stober from Newport, Kentucky. He looked at me and said, "You are Alvin Poweleit. I didn't know you were here." He had malaria, dysentery, beriberi, malnutrition and was covered with sores and defecation. I took him over to the medics and we cleaned him up as best we could. I gave him some sulfapyridine and some guava tea which we made for diarrhea. I also gave him some atabrine for his malaria. (Poweleit 1975, 63)

Reverend Stober remained at Camp O'Donnell until September 29, 1942, when he volunteered for work detail on the island of Mindanao. He remained imprisoned there, at the Davao Penal Colony, where he ministered to Christians and Jews alike. In June 1944 he sailed aboard a prison ship to Manila and was subsequently sent to a prisoner-of-war camp at Cabanatuan. In December 1944 the Japanese loaded Reverend Stober and more than 1,600 other POWs aboard the *Oryoku Maru*, one of the "hell ships" bound for slave labor in Japan. American air-planes bombed the Japanese ship, which subsequently sank. Stober and other survivors swam to safety and were transferred to the ship *Enoura Maru*, on which he died in early January 1945 en route to Formosa (Taiwan).

THE POSTWAR ERA, THE FLIGHT TO THE SUBURBS, AND THE EXPRESSWAY

In 1946 the United States witnessed a profound spike in the number of births, a phenomenon that would last through 1964. Called the baby boom, 77 million babies were born during this period. At the same time, housing was scarce. Returning veterans were starting families, but the Great Depression and World War II had slowed, and then halted, the construction of homes. Pent-up demand for consumer goods was also high as factories retooled

from military production to the manufacture of household appliances and automobiles. Americans, more than ever, fell in love with the automobile. A federal highway act paved the way for interstate highways to link the nation. Americans' love of the auto became wedded to their desire for the wide-open spaces of the suburbs, away from the pollution, crime, and crowding of the older cities. The GI Bill (Serviceman's Readjustment Act, 1944), meanwhile, focused on the need to ease returning veterans back into the workforce, without causing massive unemployment and inflation. Its provisions enabled veterans to complete college degrees and to buy homes on affordable terms. All of these factors combined to lead to the largest migration in US history—the movement to the suburbs.

Urban sprawl in Northern Kentucky, like elsewhere nationwide, was largely a consequence of the popularity of automobiles and principally evidenced itself in the post–World War II era. Before then, outlying suburbs were well served by mass transportation. In the case of Erlanger and Crescent Springs, Kentucky, the Cincinnati Southern Railroad operated daily commuter trains. Other suburbs, like Park Hills, Lookout Heights, Fort Mitchell, and South Fort Mitchell, Kentucky, lay along the streetcar line. The Cincinnati, Newport & Covington Railway, commonly known as the Green Line, extended its electric streetcar line to Highland and St. Mary Cemeteries in Fort Mitchell by 1903 and to its final terminus across from the intersection of Dixie Highway and Orphanage Road in old South Fort Mitchell in 1910. At the terminus, buses of the Dixie Traction Company transported passengers along the Dixie Highway in Kentucky to the southwestern suburbs of Lakeside Park, Crestview Hills, Edgewood, Erlanger, and Florence. The Fort Mitchell streetcar route discontinued operations in 1950. Although Green Line buses replaced the streetcars, the era of the automobile was clearly replacing mass transportation.

Road construction fed the growing appetite for the independence and convenience of automobiles. The Dixie Highway (US 25 and 42), serving the suburban corridor from Park Hills to Florence, was widened to four lanes in 1933. From the 1940s onward, various proposals for an additional access road from Covington to Florence were forwarded, largely a consequence of the need to serve better the newly opened Boone County Airport (renamed the Greater Cincinnati Airport, and now known as the Cincinnati/Northern Kentucky International Airport).

By 1948 turnpike fever gripped the nation, following on the heels of the popularity of the pioneering Pennsylvania Turnpike. The Kentucky General Assembly considered a proposal to build a limited-access turnpike between Covington and the Tennessee line. The toll road would feature a speed limit of 70 miles per hour and would connect to a larger proposed Great Lakes–to–Atlanta turnpike system. Passed by the Kentucky Senate but killed by a house committee, the turnpike idea was resurrected in new form in 1949. By then, local leaders and state officials scaled down the plans. The new proposal called for an access highway, or expressway, to connect Covington to the airport. Alben Barkley, a US Senator from Kentucky, felt certain that the road proposal should be advanced to the federal government for potential funding. In February, the state highway department released its preferred route for the road, stretching from the C&O highway bridge in Covington to Donaldson Highway and then to Florence. The path would utilize the soon-to-be-abandoned streetcar route through Park Hills and Fort Mitchell, cutting the two residential communities in half. The cost of construction, estimated at $5,200,000, would be shared one-third each by federal, state, and local governments. Residents of Fort Mitchell and Park Hills, however, opposed the road, not wishing to see it cut their cities in half. The Covington–Kenton County Chamber of Commerce continued to promote the idea of an access road in 1950, but suburban opposition continued.

By 1954 interest in the building of highways was steadily growing once again, partly as a response to nuclear threats posed by the Cold War. An interstate highway system could be used for national defense efforts in times of emergency. President Dwight Eisenhower's (1953–61) administration was carefully considering proposals. By October of that year, private groups began to campaign for a national turnpike linking Lake Erie to the Gulf of Mexico. Northern Kentucky leaders embraced the idea, undoubtedly viewing it as an opportunity to wed a Covington-to-Florence access highway to a larger vision. The Covington–Kenton Chamber of Commerce, for example, enthusiastically expressed its support, underscoring the importance of such a route to "civil, national, and continental defense" ("Turnpike Gets Local Support," *Kentucky Post*, 12 Oct. 1954).

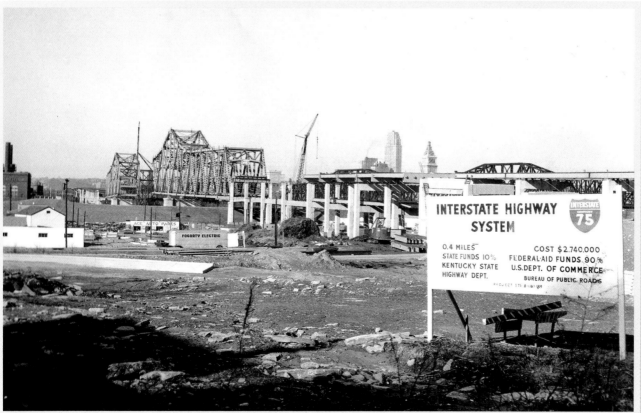

TOP: Aerial view of Lewisburg neighborhood before the construction of I-75 bisected it. Courtesy of Paul A. Tenkotte. ABOVE: Construction of I-75 and the Brent Spence Bridge. Photo by Raymond E. Hadorn, in the collection of Paul A. Tenkotte.

Cincinnati, meanwhile, was planning an access road on its side of the Ohio River, later to become the Mill-creek Expressway (I-75). The state of Kentucky had agreed to build a bridge to connect to the Cincinnati access road, provided it would be located in the vicinity of the Willow Run Creek in Covington, a stream running south to north through the Westside and Lewisburg neighborhoods of that city. The Willow Run Creek was considered an expendable piece of property, flood-prone, bisected by a large sewer, and used solely for baseball fields and a dump. By February 1955, Covington's city commission approved the Willow Run Creek route of the proposed $8 million access highway. The new plan had totally abandoned the streetcar line path. Instead, it settled upon the Willow Run–"Cut-of-the-Hill" route from Covington, an option that would displace fewer homes in Covington and that would largely be elevated throughout the city. For all intents and purposes, the highway's planned path through Kenton County would change little from a revision in June 1955 until its completion as I-75 through the county in 1962.

In August 1955 voters of Kenton County approved a $1 million bond issue—11,090 votes to 5,633—to fund some of the right-of-way purchases for the highway. In the initial cost-sharing plan, the federal and state governments would provide an additional $10 for every $1 raised locally. The evolution of federal financing proved somewhat complicated. The 1952 Federal Aid Highway had placed the federal match at 50%, while a new 1954 Federal Aid Highway Act stipulated a 60% federal contribution. In the bond issue that passed, therefore, the federal government apparently would provide 60% of the costs, the state 30%, and the county the remaining 10%. In addition to the route itself, a new Ohio River bridge would connect the Covington–Florence and Cincinnati access highways. With the passage of the Interstate Highway Act by the US Congress in 1956 (providing a 90% federal match), the separate access highways on each side of the Ohio River morphed into I-75. The route opened from Covington to Florence in September 1962. In November 1963 Brent Spence Bridge opened, providing a new commuter route into Cincinnati.

GAMBLING AND THE BEGINNING OF NORTHERN KENTUCKY AS "STEPCHILD"

Municipal reforms notwithstanding, the continued existence of gambling in Covington and in Northern Kentucky was difficult to combat. Even reformers were involved in gambling. For instance, in late 1909, Alex Davezac, then owner of the White House, a tavern and restaurant on Court Street in Covington, pleaded guilty to allowing gambling, paying a $500 fine. In January 1910, Frank Tracy, recently elected circuit court judge and an emerging leader of the Democratic Party, undertook a grand jury investigation into gambling and other problems in Covington. Like most Kenton grand jury investigations, there was a lot of puff but little action. As the famous Kefauver Committee (officially the Special Committee to Investigate Organized Crime in Interstate Commerce, United States Senate) stated in its 1951 report *Organized Crime in Interstate Commerce:* "It appears that Kentucky has a quaint custom under which all gambling ceases during the three periods of the year when the grand jury is in session. The grand juries purport to investigate gambling and find none taking place. Grand juries are in session for a total of about 27 days each year and the rest of the time gambling continues unhindered."

Likewise, gambling interests—in particular the so-called Cleveland Syndicate—were so entrenched in Covington and Northern Kentucky that it made little difference which reform styles of government were adopted. For example, Covington inaugurated the Progressive-model commission form of government in 1914 and the city manager form in 1930 (see also "Chapter 14, From City Council to City Manager: Government in Covington"). Neither threatened the gambling empire. In fact, John J. Maloney, a Covington city commissioner and later mayor of Covington, testified to the Kefauver Committee that he was approached many times "to participate in a 'profit-sharing plan' conducted by the gambling interests for high appointive or elective officials." He refused their overtures, and, in turn, received death threats for his lack of cooperation.

The Kenton County sheriff's office, with only nine full-time deputies in 1951—six of whom were assigned to collect taxes—had little time to devote to trying to control gambling. According to the Kefauver Committee,

Covington's administration and its police force were also receiving payments "if they would not interfere with gambling." There would be occasional raids and calls for enforcement, but more for public show than for actual law enforcement. When police officers did attempt to enforce the law, they were sometimes suspended. Further, tip-offs about impending raids were commonplace. Clubs would hide slot machines in cellars, suspend games of chance, and clear out bookmaking operations until the raids had passed.

The Kefauver Committee sent investigators to visit gambling establishments in both Campbell and Kenton Counties. Their investigations were eye-opening: "the gambling operations in both counties, especially Campbell, were so open that the casual visitor would gain the impression that gambling is legal in Kentucky." In Covington, and Kenton County, the investigators commented that "the establishments were smaller and operated more surreptitiously. Those in operation were the Lookout House [Lookout Heights, now Fort Wright, Kentucky], the Kentucky Club [27 East Pike Street], the 514 Club [514 Madison Avenue], the Kenton Club, the Press Club [79 Scott Street], the Gold Horseshoe, and the Turf Club [10 West Southern Avenue]." A number of these places also operated bookmaking operations; that is, with the installation of many telephone lines, they could take bets from throughout the nation.

Covington and Kenton County were also plastered with slot machines in small grocery stores and corner taverns, in full view of children. In fact, older citizens still recount how they played them as youngsters. At one time, it was estimated that there were 1,500 slot machines in Kenton County.

Brent Spence, shown here circa 1940, was one of the most influential Northern Kentucky members of the US House of Representatives, serving for 32 years. He secured important projects for Northern Kentucky, including the IRS Center in Covington, the Greater Cincinnati Airport (now the Cincinnati/ Northern Kentucky International Airport), floodwalls, and public housing projects. He was chairman of the Committee on Banking and Currency of the US House, and was instrumental in the Bretton Woods Agreement. Courtesy of the Kenton County Public Library, Covington.

The Kenton County Protestant Association was appalled by the openness and lawlessness of the gambling operations. They attempted, on many occasions, to effect change, but experienced limited success. Covington's

Construction of the IRS Center in Covington, early 1960s. Photo by Raymond E. Hadorn, in the collection of Paul A. Tenkotte.

cleanup would follow on the heels of that of neighboring Newport and Campbell County in the 1960s, when united citizen efforts succeeded in what seemed impossible, the decision of the Cleveland Syndicate to move elsewhere.

Unfortunately, boss rule and the corruption occasioned by gambling contributed to Covington's (and Northern Kentucky's) self-imposed stepchild image. For example, the Kenton County Protestant Association testified to the Kefauver Committee that "two large industrial concerns that would have employed hundreds of persons refused to locate plants in or around Covington merely because of the community's reputation as a center of wide-open gambling." Likewise, to Kentucky's conservative Bible Belt, Northern Kentucky was a den of iniquity. To many Cincinnatians, it was a playground, where all types of vice were available. Before Prohibition, Covington and Northern Kentucky produced state, regional, and federal leaders. Covington was not a stepchild before 1900—it was a respected leader. After Prohibition and the gradual incursion of the Cleveland Syndicate, Covington and Northern Kentucky lost much of their credibility. A few leaders remained, like Republican Richard P. Ernst of Covington, who served in the US Senate from 1921 to 1927. And there was New Deal Democrat Brent Spence (1874–1967) of Newport, who served in the US House of Representatives, for the Sixth District, from 1931 until 1963. But overall, Covington and Northern Kentucky became stepchildren of the state because that is what they asked for—they did not want state police or any other state body to interfere in the prosperity of their vice industries.

ANNEXATION

The proliferation of small suburbs nationwide in post–World War II, and their overwhelming steadfast opposition to annexation, marked a new chapter in American urban history. In the 19th and early 20th centuries, annexation was the typical manner that cities used to increase their territory, tax base, and population. The process was viewed rather organically. Indeed, there were few regulations governing municipalities. Then, the new Kentucky Constitution of 1890–91 adopted a municipal classification system based upon population. Louisville was the only city of the first class. Covington, Newport, and Lexington were cities of the second class.

ANNEXATION OF CENTRAL COVINGTON

Through much of the 20th century, from 1906 through 1980, the city leaders of Covington pursued a systematic course of annexations. Some of these proved successful and others resulted in protracted lawsuits, ill feelings, and a heightened sense of fragmentation in Kenton County. Basic issues underlay most of these annexation attempts. The first dealt with city services. Put simply, what benefits did annexation to Covington promise? Was the territory proposed for annexation satisfied with its level of services, or did it desire more? The second issue, closely related to the first, hinged on economics. Would the benefits of expanded city services warrant the economic costs? Finally, the third point focused on perceptions or "image." Was annexation to Covington seen as enhancing or detracting from an area's image? And related to this issue, how did the image of Covington change from the early years of the 20th century to the later decades?

In 1906 the town of Central Covington faced financial exigencies. Located in the area of today's Peaselburg neighborhood, Central Covington was heavily in debt and was no longer able to borrow money to make needed repairs to its sewers or to complete a main-trunk sewer line along Willow Run Creek. Willow Run Creek, now displaced by I-75 through Covington, emptied into the Ohio River near what is now the Brent Spence Bridge. In the summer of 1906, heavy rains caused flooding in Central Covington. Covington city officials and business leaders alike advocated annexation. Appealing to the voters of Central Covington in an upcoming November 1906 election, proponents of annexation extolled its virtues. The city of Covington would assume the debts of Central Covington and would complete the Willow Run Creek main-trunk sewer. In addition, Covington's fire and police protection would reduce residents' insurance rates. Central Covington children would have access to Covington's fine public schools, and Covington would reduce water rates.

Favorable annexation legislation, passed by the Kentucky General Assembly during its 1906 session, further supported Covington's goal of annexing Central Covington. This new legislation made annexation by second-class

cities like Covington much easier than the earlier 1894 law. In 1894, the Kentucky General Assembly had approved legislation titled An Act for the Government of Cities of the Second Class in the Commonwealth of Kentucky. According to this act, second-class cities, which then included Covington, Newport, and Lexington, could annex either incorporated or unincorporated territory, provided that four-sevenths of those voting in the proposed area to be annexed approved the move. In 1906, the Kentucky General Assembly passed more liberal provisions for annexation by second-class cities. As its model, the legislature considered a recently approved Ohio act, which had enabled Cincinnati to annex a number of its suburbs. The 1906 Kentucky act established three separate categories of annexation: of unincorporated territory; of all or parts of cities of the fifth and sixth classes; and of the entirety of cities of the second, third, and fourth classes.

Concerning unincorporated territory, the 1906 Kentucky legislation specified that the general council of a second-class city could enact an ordinance of proposed annexation. Subsequently, it would publish the ordinance in at least 10 issues of the city's newspaper of record. Residents of the affected area had 30 days to oppose the move by filing a petition with the county circuit court. If no petition was filed, the city council could enact an official ordinance annexing the unincorporated territory. If a petition was filed, the circuit court would decide the matter. If the court was satisfied that fewer than 75% of the property owners of the proposed area disapproved, then the annexation would become effective.

In regard to annexation of all or part of fifth- and sixth-class cities, the 1906 legislation provided that at least one-fourth (25%) of those voting in the proposed area needed to approve the annexation. In effect, then, a small minority could accede to annexation of their city while the majority disapproved. The same principle held for annexation of third- and fourth-class cities, as well as other second-class cities, with two exceptions. First, a second-class city could not propose annexation of a part or parts of second-, third-, and fourth-class cities. Annexation of the entire city was the only option. Second, a vote of two-fifths in the proposed area was necessary for annexation to occur.

The Covington Business Men's Club, a firm supporter of annexation, used its influence in Frankfort to ensure that liberal annexation provisions passed. In fact, the club's members chartered a special train to Frankfort to appear in person. In a communication to the chairman of the Senate Committee on Municipalities, the club members argued that passage of the bill would allow Covington "to become a city of 75,000 people, and enable it to become a city in truth of some importance" ("Annexation Is Wanted," *Kentucky Post*, 31 Jan. 1906).

In the case of Central Covington, the one-fourth rule applied. About 34% of the voters of Central Covington, or 140 of a total of 408 cast, favored annexation in the election of November 6. On November 17, 1906, Mayor George T. Beach of Covington officially signed Covington Council Ordinance No. 2951, annexing Central Covington.

ANNEXATION OF LATONIA

In early 1907 the Covington Business Men's Club appointed a committee of three to pursue the annexation of Latonia, a fourth-class city bordering Covington to its immediate south. Among the steadfast supporters of the proposition was John R. Coppin, president of the Covington Business Men's Club and owner of Covington's largest department store. The committee's duty was to meet with Covington City Council and to endorse the measure. Shortly thereafter, on February 18, 1907, Covington City Council approved a resolution calling for a plebiscite of Latonia voters regarding annexation in November 1907. Mayor J. T. Earle of Latonia strongly opposed the measure, claiming that Latonia had only been a fourth-class city for two years, and was largely free of debt. Clearly, he saw no advantages of annexation. Opponents of annexation stated that street and sewer construction in the city was a high priority and feared that if Covington annexed them, these construction projects would be delayed. Some opponents even favored issuing as many bonds as Latonia's charter allowed, thus hoping to dissuade Covington from annexing them. The city council of Latonia passed its own resolutions, calling for Covington's city council to postpone a vote of annexation until a majority of Latonia residents favored the issue. The council of Latonia argued

that the annexation legislation, requiring only two-fifths approval of the voters of a fourth-class city, was unfair.

Nevertheless, Covington officials relentlessly pursued the annexation of Latonia. In September Mayor George T. Beach notified the county clerk to include the annexation vote in the upcoming November election. Of particular concern to Covington was the enhancement of its own image. This was perhaps best expressed by an article in the *Kentucky Post,* which stated that "if the issue passes it will increase the population of Covington by more than 5,000, and the boundary of the city will then extend from the Ohio River, on the north, to the corporation line of Latonia, on the south, a distance of seven miles, and from the Licking River, on the east, to the line of Covington, on the west, a distance of three miles" ("Annexation of Latonia Is Wanted," 10 Sept. 1907).

Pro-annexation forces outlined the benefits of annexation. Latonia's inadequate and unhealthy sewers, emptying into open ravines, would be improved. So would efficiency in the construction of streets. A circular claimed that brick streets in Covington cost an average of $2.91 per foot to construct while macadam streets in Latonia "cost from $2.95 to $3.75 per foot" ("Sewers Have Outlet in Ravines," *Kentucky Post,* 4 Oct. 1907). In addition, water rates would be reduced. Obviously unconvinced, the Taxpayers' Association of Latonia held an October meeting to oppose the measure.

A Boosters' Club in Latonia promoted annexation to Covington, as did the *Kentucky Post.* Both extolled the benefits of annexation: better sewers, improved fire and police protection, reduced insurance and water

James T. Earle. Courtesy of the Kenton County Public Library, Covington.

rates, access to better schools, removal of tollgates outside the city, free home mail delivery, and the abolition of a Latonia vehicle license. Covington City Council increased the stakes at its meeting in late October, reading a resolution claiming that the city was providing water to Latonia residents at a cheaper cost than to its own citizens. Further, the resolution recommended that Covington refuse to renew the water contract, should Latonia residents vote against annexation. Threats notwithstanding, the citizens of Latonia overwhelmingly rejected annexation during the November 1907 election by a vote of 599 to 173.

In 1908 the Kentucky General Assembly convened, and Mayor Earle of Latonia appeared before them, successfully arguing for legislation that made annexation of second-, third-, and fourth-class cities more difficult. Two years prior, the legislature had liberalized provisions from its 1894 four-sevenths ratio to only two-fifths approval. The new 1908 legislation required at least a majority of voters in the affected area to approve annexation.

Perhaps the new legislation played a role in prompting Mayor Earle to reverse his earlier position and in July 1908 to state publicly his support of Latonia's annexation to Covington. In fact, Earle presented a consistent stance throughout the annexation controversy, not opposing annexation in principle, simply the timing of it. For instance, a *Kentucky Post* article of February 28, 1907, quoted Earle as stating of annexation: "The time is not ripe, as we have been a fourth-class city but two years, and not until then did we have an opportunity to build streets on the bond-issue plan. . . . What we want to do is to build more streets

and be in good condition when we vote to go into Covington, so we will not have to depend on getting what we need." Less than a year later, in the *Kentucky Post* of July 18, 1908, Earle echoed these thoughts: "I was opposed to annexation last year for various reasons. In the first place, we needed streets and cement sidewalks, something we would have to wait for were we in Covington. Now that we are in nice shape, I, for one, favor going into Covington, as the time is ripe."

In mid-September, Mayor Earle began circulating a petition to Latonia residents, calling for annexation to Covington. In late September, he presented the petition, signed by more than 100 property owners, to the Covington City Council. A newly formed Latonia Progressive League extolled the benefits of annexation, reiterating the argument for better and more efficient services. They were countered by the Taxpayers' Association, which had opposed annexation the year before. The latter group mounted a renewed defensive, claiming that conditions had not changed substantially in one year to warrant annexation. There were no benefits, they maintained, in joining Covington. Like Latonia, Covington was also borrowing money, and was experiencing difficulty in completing a new school building in one of its neighborhoods. Further, the association held that Covington's taxes were "almost twice as much as those of Latonia." Finally, the Taxpayers' Association accused owners of Latonia saloons of favoring annexation, claiming that the liquor license was $100 less expensive in Covington, and that they hoped to evade blue laws on Sundays, which they intimated were not as heavily enforced in Covington ("Latonia People to Fight Annexation," *Kentucky Post*, 29 Sept. 1908). In the November 1908 election, the residents of Latonia approved annexation to Covington. Five years later, in 1913, the city of Covington annexed the nearly 217-acre Parks' Estate adjacent to Latonia. In 1916 Covington annexed more than 525 acres of land bordering 27th Street and the lands of the old Monte Casino Monastery.

Rosedale Park

BY ELAINE M. KUHN

Rosedale Park had its beginnings as a summer retreat and recreational area. Situated at the end of the former Rosedale streetcar line, it featured rental cottages and dancing, dining, and sporting activities throughout the summer season. A swimming pool was first installed in 1925 at a cost of $35,000 to further enhance the appeal of the facilities. The city of Covington purchased the pool from John and Mary Weisenberger after John passed away in 1974. The Weisenbergers had owned the Rosedale Pool since 1951.

Major flooding in March 1997 caused severe damage to Rosedale Park's pool, and several months later, the city closed the pool. Unfortunately, though the pool was closed in 1997, it was not until after the accidental drowning of a 6-year-old boy in August 2000 that the Rosedale Pool was filled in permanently. In 2002 negotiations between Holy Cross High School and the city of Covington regarding the use and maintenance of Rosedale Park resulted in an agreement that allowed the school's athletic teams to use the park grounds for practice and games. Funds were acquired to build new facilities in the park from various sources, including a donation from local philanthropist Oakley Farris. As a result, Rosedale Park is now known as the Eva G. Farris Sports Complex.

Covington Parks Today

Covington is currently home to 24 individual parks located throughout the city. Many of the parks are named in honor of former residents such as Annie Hargraves, a teacher at the Lincoln-Grant School, and famed artist Henry Farny. Ranging from pocket parks to ball fields to the now 704-acre Devou Park, Covington residents can enjoy myriad recreational, sporting, and leisure activities in the areas set aside for their enjoyment.

ANNEXATION OF WEST COVINGTON

Contemporary to the annexation of Latonia, the editorial pages of the *Kentucky Post* began to press for the annexation of West Covington. Incorporated many years prior as the town of Economy, this small hamlet of workingmen's homes hugged the hillsides west of the city. It was without water and gas services, and also lacked "adequate police" and fire protection. By 1907 gambling interests hoped to open "a poolroom and a poker-faro-roulette room" in West Covington. To the editor of the *Kentucky Post*, the solution seemed annexation. After all, the residents of West Covington "do not want their little girls and boys to come in contact with the thieves and thugs who hang about such establishments. They do not want their grown sons to be enticed into these places, which count their ruined victims by the score." Meanwhile, Covington's reformist mayor, George Beach, was trying to oust poolrooms from Covington. The Covington Business Men's Club joined the chorus for annexation at its October 1907 meeting, adopting a resolution urging the city to annex West Covington. Almost as quickly as it appeared, the West Covington annexation issue disappeared from the newspapers.

In 1909 the issue of annexing West Covington resurfaced. Joseph Moser, mayor of the small city, supported the measure, arguing that the suburb had no fire protection, only one marshal to patrol the town, and a large bonded indebtedness. The citizens of West Covington who opposed annexation, however, actively collected petitions and supposedly had a majority against the measure. Failure to make the deadline to file for a November plebiscite ended the matter for that year.

In 1910 the Devou family presented 500 acres of their family estate, neighboring West Covington, to the city of Covington for a park. The following year, in 1911, the former mayor of West Covington, Joseph Moser, and other prominent citizens again requested annexation by Covington. A citizens' group of the suburb of 1,751 residents opposed the measure, seeing no benefit, as West Covington had gas lines, schools, and a water line under construction. The Covington Industrial Club supported annexation of both West Covington and Ludlow. Covington City Council, realizing the large number of West Covington residents who were opposed to the petition, voted seven to four to reject the measure. Covington's board of aldermen, however, supported the annexation petition without a single dissenting vote, sending it back to the city council. The city council, in turn, passed the annexation ordinance in late August 1911, enabling it to be placed upon the ballot of West Covington in November. Since West Covington was a fifth-class city, Covington only needed 25% of that suburb's voters to approve the measure. City officials of West Covington filed suit in Kenton Circuit Court, claiming that a majority vote of the citizens should be required, especially since the annexation would disrupt the finances of a new public school that West Covington had built with the aid of a neighboring unincorporated area. In November 1911 the annexation proposal was soundly defeated.

Devou Park
BY ELAINE M. KUHN

In 1910 brothers William P. (1855–1937) and Charles P. Devou (1858–1922) approached the Covington Park Commission with an offer to donate more than 500 acres to the city in honor of their parents, William P. and Sarah Ogden Devou. There were requirements to the donation, including a promise that the city spend at least $100,000 within the first six years of the donation on the upkeep and improvement of the park; that the Devou homestead, located almost directly in the middle of the property, be set aside for Charles Devou and his wife until their deaths; and a reversion clause should the city fail to keep their end of the bargain.

The Devou Homestead, circa early 1920s, is now part of the Behringer-Crawford Museum. Courtesy of the Kenton County Public Library, Covington.

Devou Park, circa 1920. Courtesy of Paul A. Tenkotte.

The offer was accepted by the park commission, and improvements to the park soon commenced. Roads were commissioned and built, linking Western Avenue in Covington to Ludlow, and Amsterdam Road to Covington. In 1916, a quarry was established in the park. City prisoners performed most of the quarry labor, but several soon discovered that quarry duty offered a fairly easy means of escape. The quarry was closed in the 1920s. Water eventually filled the quarry, and the site came to be known as Prisoners' Lake.

Other improvements to the park included a nine-hole municipal golf course, which was officially opened in May 1928. In 1925 five tennis courts were opened. During the Great Depression, Devou Park received improvements through the Works Progress Administration, which included the construction of the Devou Park Band Shell. The Band Shell was completed in 1939.

In 1950 the William Behringer Memorial Museum was established in the old Devou home. Ellis Crawford (1905–72), a local archaeologist, was hired to lead the museum and its collection that included several mounted animals and artifacts gathered during Behringer's world travels. In 1980, after several structural improvements, the museum reopened under its present name as the Behringer-Crawford Museum. In 2007, the museum completed a major addition and renovation.

Drees Pavilion in Devou Park, 2014. Photo by Dave Ivory.

Recent improvements to Devou Park saw the expansion of the golf course and the construction of the Drees Pavilion, a large reception and banquet facility, which took the place of the aging Memorial Building, constructed in 1958. Like the building it replaced, the Drees Pavilion offers stunning panoramic views of Covington and Cincinnati.

In 1916 the proposal to annex West Covington resurfaced. Also in 1916, Covington City Council attempted to annex the part of Latonia Race Track not yet within the city limits, Amsterdam and the area neighboring the Stonewall House (currently, the site of the Fort Mitchell Garage in Park Hills) along the Dixie Highway, and the Ohio River to the low-water mark on the Ohio side. The latter was intended to allow the city to tax the owners of the C&O and the Covington and Cincinnati Suspension Bridges. In August the Latonia Agricultural Association, owner of the Latonia Race Track, filed suit in Kenton Circuit Court seeking an injunction to stop the proposed annexation of the racecourse. Eventually, the racetrack and the city settled out of court. In the same month, other plaintiffs filed suit in Kenton Circuit Court against the annexation of the Amsterdam–Stonewall House vicinity, claiming that the territory would not be beneficial for Covington. Meanwhile, pro- and anti-annexation forces began to hold rallies in West Covington. Those opposing annexation cited the usual economic arguments, but also added a new one—the fear of losing their community's individuality. At the November election, more than 25% of the voters in West Covington approved the annexation, a victory for Covington. On the heels of its annexation of West Covington, the Covington City Council urged the annexation of neighboring Ludlow in 1917. Citizens there saw no advantages to being annexed by Covington, particularly as their taxes would be raised. Not surprisingly, Ludlow voters defeated the annexation by a vote of 700 to 96 in the November 1917 election. Likewise, the Amsterdam and Ohio River annexations failed.

GAMBLING, CORRUPTION, AND IMAGE PROBLEMS

That gambling and the municipal corruption it brought adversely affected Covington's image was even recognized by city officials themselves. For example, Covington City Commissioner John J. Moloney perhaps best summarized the situation when he spoke before the Covington Kiwanis Club at the Covington–Kenton County Chamber of Commerce in November 1950. Moloney stated that suburban residents were opposed to annexation principally on two points. The first was an economic reason, which, he felt, would eventually "be overcome as the smaller cities see the cost of replacing established conveniences as they deteriorate through natural causes." The "second objection" was "based on a distrust caused by the apparent influence of subversive and illegal interests on various levels of our government." Larger cities like Covington needed to enforce their laws, so that action could be taken "toward unification of the community." Moloney noted that the census of 1950 revealed that "while Americans are moving from the farms to the cities, the trend from the cities to the suburbs is much greater." Hemmed in by the suburbs, cities like Covington could not expand their tax bases. The suburbs' "water supply, one of the most indelible stamps of urban life, comes from the parent city. Their sewage systems, or lack of same, either drain into Covington sewers or are inadequate and create a menace to public health. The bulk of the burden, and expense of the ever increasing traffic problem, falls upon Covington and is continually met by demands for further sacrifices of the rights and privileges of our citizens to the advantage of the suburbanites." Making matters worse, the Kentucky Constitution at that time made no provisions for city–county government, making annexation "the only solution" ("Moloney Sees Annexation as 'Only Solution,'" *Kentucky Post*, 16 Nov. 1950).

SUBURBAN EXTENSION OF WATER LINES, AND COVINGTON'S LOST DECADES OF THE 1920S AND 1930S

Moloney's 1950 comments had the benefit of hindsight, at least in regard to Covington's extension of water lines to the suburbs and its failure to pursue aggressively annexations through the decades of the 1920s and the 1930s. The economic prosperity of the early to mid-1920s brought further suburban development to Northern Kentucky. The "streetcar suburb" of Park Hills was developed by D. Collins Lee, who, in 1924, obtained permission to tie into Covington's water mains, to extend them at his own cost to Park Hills, and to allow its residents to purchase water. From the vantage point of Covington city officials, its western suburbs were simply too underpopulated and lacked too much infrastructure to warrant annexing them. In fact, residents of Fort Mitchell had suggested that they be annexed in order to obtain city water. Instead, in 1925, Covington agreed to allow the Dixie Highway

Water Company to tie into its water mains, to extend them along the Dixie Highway, and to invite suburban residents to buy water. Meanwhile, these small suburban communities built their own sewage plants, at least until the construction of the Sanitation District's own centralized water and sewage facility. Some residents of Park Hills, impressed by Covington's adoption of the city-manager form of government, examined the possibility of annexation to Covington in the early 1930s; however, the issue was not pursued for various reasons, namely the fear of higher taxes. Nevertheless, the editor of the *Kentucky Post* advocated that Covington pursue an active annexation plan of hilltop suburbs to its southwest. An innovative voice for Northern Kentucky, the *Post* editor promoted municipal consolidation throughout the 1930s, and even broached the topic of a state constitutional change to enable county-manager government. The *Kentucky Post* editor's foresighted plans largely fell on deaf ears, with a few exceptions. By the late 1930s Covington began providing fire protection to the tiny subdivision of Kenton Hills (completely surrounded by Devou Park), and initiated discussions about its possible annexation. Likewise, by 1939, the Covington City Commission investigated the possibility of annexing Ann's Lane near Peaselburg, Kenton Hills, and South Hills (now part of Fort Wright), but nothing came to fruition at that time.

The decades of the 1920s and 1930s became important for the growing professionalization of city planning efforts, as well as the establishment of zoning regulations. In 1916 New York City became the first major US municipality to enact a comprehensive zoning ordinance. Ten years later, in 1926, the United States Supreme Court upheld the constitutionality of zoning. Meanwhile, in 1922, the Kentucky General Assembly enacted The City Planning and Zoning Act, permitting cities of the first and second class to create planning and zoning commissions. These commissions had the authority to approve proposed developments both within a city's limits as well as 3 miles beyond its incorporation line. In 1928 Covington hired noted city planner Ladislas Segoe to prepare a comprehensive city plan for Covington and its immediate environs. Approved by the city commission of Covington in 1931 and by the fiscal court of Kenton County in 1931, the plan became a major model for city planning nationwide.

In 1929 the stock market crashed, and the Great Depression ensued. Housing construction slowed. In an effort to jump-start the economy, the Roosevelt administration enacted a number of New Deal programs, including the PWA and the WPA, designed to increase employment through the construction of public works. Typically, local governments provided a certain amount of cost sharing with the federal government for projects ranging from sidewalks to sewers to schools to city buildings. Covington's neighboring suburbs enjoyed an infrastructural boom, at a fraction of what such improvements would have cost them. For example, South Fort Mitchell used WPA funds to build a new Beechwood School, as well as a city building, sidewalks, and sewers. Coupled with the establishment of volunteer fire departments and a host of other civic organizations, South Fort Mitchell and other suburbs kept property taxes low. Not surprisingly, by the end of World War II, Covington's suburban residents could see no benefits to annexation. They had the infrastructure that they needed, and their citizens enjoyed their roles as council members, volunteer firefighters, and civic activists.

In many ways, then, the 1920s and the 1930s were lost decades for Covington. Its leaders could never have fathomed that New Deal programs of the 1930s would furnish suburban communities with an infrastructure that would have only been possible by raising taxes or by pursuing annexation to Covington. Meanwhile, annexation legislation tightened during the Great Depression. In 1932, the Kentucky General Assembly passed a new annexation law. If 50% of the property owners in any proposed area opposed annexation, then the burden of proof shifted to the annexing city to prove that "failure to annex" the area would "materially retard the prosperity" of both the city and the annexed area.

ANNEXATION EFFORTS IN THE 1940S

In 1941 Covington announced a major plan of annexation. The plan was to include the subdivisions of Mt. Allen (now Park Hills), South Hills and Fort Wright (both now Fort Wright), and Kenton Hills bordering Covington's

Devou Park. Residents of South Hills and Fort Wright responded immediately, holding meetings to resist the attempt and to incorporate as a sixth-class city called Fort Wright. Meetings soon revealed, however, that incorporation of both South Hills and Fort Wright as one city might prove problematic from a legal standpoint. Fort Wright operated its own sewage system, whereas South Hills's sewage system connected to that of Covington. Consequently, Fort Wright pursued incorporation by itself. Covington's annexation attempts languished until the following year, when the Kentucky Municipal League attempted to loosen annexation legislation in the Kentucky General Assembly. The bill, introduced in the house by Representative Sylvester J. Wagner of Covington, failed. Nevertheless, Covington proceeded with small-scale annexation attempts of unincorporated territory, including land near 16th and Monroe Streets, Ann's Lane, and the Mt. Allen and Kenton Hills subdivisions. Residents of the areas opposed the move, and Covington City Commissioner R. E. Culbertson declared his frustration: "Covington has been the big brother for the rest of the little towns around here for many years," he stated. "The City of Covington has paid the bill while furnishing to other communities the services that would cost those communities a large amount of money if the services were furnished by themselves" ("Firm Annexation Stand Taken," *Kentucky Post,* 14 May 1942). Cities like Park Hills perhaps viewed things differently, as they were in a precarious situation, operating on a month-to-month basis with Covington for supply of its water.

Covington's earlier attempts to annex South Hills were renewed in 1949. This time, residents of South Hills pursued incorporation as a sixth-class city. The *Kentucky Post* opined that Covington needed to "do an expert selling job on what it has to offer smaller communities.... School taxes are about on par, outside and inside the city. Utility rates are higher outside the city. Better fire and police protection, waste collection, street lighting, street and sewer maintenance, and other services could be had for some increase in taxes the city would need" ("Maybe a Selling Job Would Help," 18 May 1949). Once again, the annexation plans fell through.

THE 30 YEARS WAR: COVINGTON VS. THE SUBURBS, 1950–1980

In 1950 Covington City Commission pursued a new policy regarding the suburbs. For small suburban communities buying fire protection from Covington, including Kenton Hills (unincorporated until 1962), Kenton Vale, Forest Hills (unincorporated), and Winston Park, it announced that rates would increase May 1 from 35¢ per $100 valuation to $1 per $100 valuation of property. Citing the fact that Covington was losing money by providing fire protection to outlying communities, the commissioners offered another alternative to increased rates—annexation. In addition, the city would no longer agree to extend its water and sewer lines to other unincorporated areas outside the city limits, except in exchange for annexation. Sixth-class cities, like tiny Kenton Vale with 43 homes, were caught in a bind, because the state limited their tax assessment costs to 65¢ per $100 valuation. In order to pay the increased costs of fire protection beyond 65¢ per $100, a sixth-class city like Kenton Vale would need to establish a civic association capable of raising the money. It would seem that Covington had the upper hand in this contest. The tenacity of post–World War II suburbanites, however, proved extraordinarily strong.

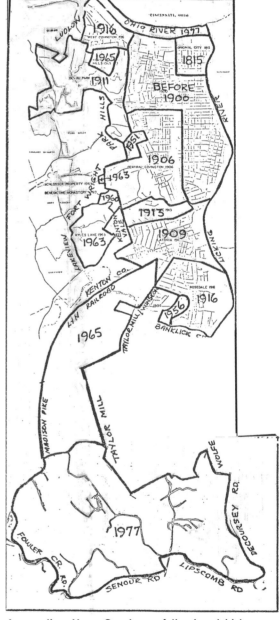

Annexation Map. Courtesy of the local history files, Kenton County Public Library, Covington.

Much to the surprise of Covington officials, suburban residents were not ready to bow to what they regarded as an ultimatum. For example, when polled, only five or six residents of Kenton Vale supported annexation. Residents of the other threatened communities likewise rejected annexation. When Covington cut off their fire protection, suburbanites rallied together and formed their own volunteer fire departments, as in Winston Park. Kenton Hills, an upper-class community, formed its own civic association and continued to pay for fire protection from Covington.

Meanwhile, Covington proceeded with efforts to pass ordinances proposing annexation of unincorporated areas, including a vast tract of land that once housed the Monte Casino winery. The Monte Casino area of 330 acres was "bounded on the north by South Hills, on the south by Madison Pike and Kenton Vale, on the west by Kyles Lane and on the east by the present Covington limits" ("Annexation Move before Board: Area to East of Kyles Lane is Affected," *Kentucky Post,* 16 Nov. 1950). Residents opposed to the measure argued that they would have nothing to gain from annexation and that their "farmland and forested hills" would "never lend itself to housing development" ("Voice Protest on Annexation by Covington," *Kentucky Post,* 4 Dec. 1950). Not true, claimed the *Kentucky Post* in an editorial, for Covington's past "shortsightedness" in "annexing then open territory around the city" was responsible for "its being hemmed in by small independent communities" ("Opponents of Annexation Speak Up," 5 Dec. 1950). When 80% of the residents of the area voiced their opposition to annexation and threatened to sue, Covington commissioners withdrew the annexation ordinance.

SUCCESSES AND FAILURES OF THE 30 YEARS WAR OVER ANNEXATION

For the next 30 years, from 1950 until 1980, a war raged between Covington and its suburbs. Successes and failures were marked by both sides. Covington's annexation successes included the following:

- small tract of land neighboring Devou Park and Park Hills (Garden of Hope/Ann's Lane tract; 1950-51)
- small tract of land bordering Latonia on the southwest (landfill, 1956)
- Monte Casino (47.75 acres; old Benedictine Monastery and Monte Casino Winery property, 1960)
- 4.7 unincorporated acres along Highland Avenue known as the Schlosser property (1963)
- an unincorporated area of 240 acres along Kyles Lane (where St. Charles Care Center and NorthKey Community Care are now located; approved by Kenton Circuit Court in 1963; upheld by the Kentucky Court of Appeals, 1965)
- Kenton Hills, a small sixth-class city, completely surrounded by Devou Park (approved by Kenton Circuit Court in 1965)
- 1,620 unincorporated acres (including the 170-acre Sohio Refinery property that was formerly the home of part of the holdings of the Latonia Race Track) along Winston Avenue and bounded by Taylor Mill Road, Sandman Drive, the boundary of Taylor Mill, Wayman Branch Road, Hands Pike, Madison Pike (KY 17) and the L&N Railroad (approved by Kenton Circuit Court in 1965; upheld by the Kentucky attorney general in 1966; upheld by the Kentucky Court of Appeals in 1967)
- an unincorporated area of nearly 2,415 acres bounded by Madison Pike (KY 17), Fowler Creek Road, Senour Road, the city limits of Latonia Lakes, Lipscomb Road, Old and New Decoursey Pikes, Wolf Road, and the city limits of Taylor Mill (approved by the Kentucky Supreme Court in 1976).

THE HOTTEST ANNEXATION BATTLES

Covington's attempt to annex other areas failed. This included a large portion of what later became the city of Taylor Mill, as well as a narrow strip of Licking River land south of Covington along the railroad tracks (the L&N, later known as the Chessie System) and Decoursey and Rich Roads. By far, the ugliest annexation battles involved Edgewood and

Fort Wright. In February 1962 Covington proposed the annexation of 4,074 acres of unincorporated land, stretching from Covington's western boundary at Mother of God Cemetery, following the L&N Railroad to Madison Pike (KY 17) to Bullock Pen Road, Dudley Pike, Turkeyfoot Road, Horsebranch Road, and Orphanage Road, including the unincorporated subdivisions along Dudley Pike, namely St. Pius Heights, Summit Hills Heights, and Dudley Acres. In July 1962 Covington passed another annexation ordinance for an unincorporated area of 1,423 acres bordering the western boundaries of Devou Park, and bounded by Sleepy Hollow Road, Amsterdam Road, Bromley–Crescent Springs Road, Highwater Road, and Collins Road. For the next 17 years, these two annexations were tied up in litigation. In the interim, areas within these two formerly unincorporated territories incorporated, merged, and annexed.

In 1978 Senate Bill 173 passed the Kentucky General Assembly, allowing cities that had been reclassified as second- through fourth-class cities to hold a referendum on whether they approved annexation. In essence, this meant that the areas that had been unincorporated when Covington filed an annexation ordinance, and that had later been incorporated, were now allowed to hold annexation referendums as if they had always been incorporated. In 1979, the Kentucky Court of Appeals ruled that Senate Bill 173 was unconstitutional on the basis of it being special legislation. The ruling cleared the way for Covington to proceed with its annexation of thousands of residents of parts of the cities of Edgewood, Erlanger, Lakeside Park, Crestview Hills, and Fort Mitchell, and also of the Fort Henry Subdivision in Fort Wright and the prestigious Country Squire Estates in Crescent Springs. The case was subsequently appealed to the Kentucky Supreme Court that, in 1979, refused to take up the decision of the court of appeals, allowing the case to be brought back to the Kenton Circuit Court. Covington proceeded to serve the annexed area in Fort Wright and Crescent Springs in October 1979, claiming that a fire pumper from the city's Ninth and Main Streets station could reach the Fort Henry subdivision in less than four minutes. Residents of the annexed areas began a new opposition organization called Concerned Citizens of Kenton County. Its chairman voiced his intention to fight an all-out war, appearing as a costumed American Indian warrior at a Covington City Commission meeting. Residents began proposing boycotts of Covington businesses and even of undermining the city financially by voting in blocks to reduce taxes to unsustainable levels. At a meeting of the group at St. Pius X School in Edgewood, however, a familiar theme emerged. As the *Cincinnati Enquirer* editors noted, "The people at the meeting expressed the conviction that big government, by definition, is bad government. They see big government nothing more than a vehicle for bureaucratic growth and all the intrusion that goes with it, for spending more money than the taxpayers want spent, for serving its own purposes with little care for future consequences" ("Annexation: A Real Problem Came up Tuesday at St. Pius X," Kentucky ed., 2 Dec. 1979).

At the same meeting of the Concerned Citizens of Kenton County at St. Pius X School, residents were "alarmed at what they" viewed as "the first stirrings of metro government in Northern Kentucky." Indeed, Covington's mayor-elect in 1979, Bernard "Bernie" Moorman, had won election on a platform that included advocating for metro government. Further, the nonprofit group Community Unity Inc., composed of a number of Northern Kentucky's prominent business, education, and government leaders, had just released a 20-page "Plan of Action," promoting consolidation of Kenton County's then-34 governments into one entity.

In January 1980 Edgewood and Covington brought their case over the contested 4,074 acres back to Kenton Circuit Court, where the issue of the 19th-century versus 20th-century route of Bullock Pen Road became of central concern. In February 1980 special judge Frederick Warren ruled against Covington's claim to the entire 4,074 acres. Covington intended to appeal the decision, but the tide was quickly turning in the suburbanites' favor. In 1980, the Kentucky General Assembly passed a de-annexation bill, allowing portions of cities to de-annex themselves. The same de-annexation legislature provided that the de-annexed area compensate the annexing city for losses. In November 1980 residents of the affected areas voted overwhelmingly against annexation to Covington: 3,571 to 39 in the 4,074-acre Edgewood section; 998 to 33 in Fort Wright; and 124 to 10 in Crescent Springs. Bernie Moorman, mayor of Covington, and Thomas Litzler, mayor of Fort Wright, began meetings in late November to negotiate a financial settlement. Shortly thereafter, meetings between Moorman and Crescent Springs's mayor, George Neack, started. By December Moorman proclaimed that Covington had "no further annexation

ambitions." He heralded the end of the years of litigation, admitting the fact that "it took a lot of time and effort—too much time and effort. Now we have time to concentrate on other problems that still exist" ("Covington and Suburbs are at Peace," *Kentucky Post,* 31 Dec. 1980).

From the first volleys fired in 1950 until resolution of the annexation battles in 1980, the intervening 30 years deepened the divide between Covington and its suburbs. Behind the economic objections to annexation often cited by suburbanites was a larger sociological issue, reflecting the post–World War II/Cold War era itself. People distrusted big government and the bureaucracies it engendered. In a series on the pros and cons of annexation, the *Cincinnati Enquirer* summarized the objections of the suburbanites as "big is bad, small is good." "In addition," the *Enquirer* reported, "there's the corollary—big means a loss of personal contact while staying small retains it." The newspaper quoted Wayne K. Allen, one of the leaders opposing Covington's annexation of 2,415 acres near Taylor Mill: "They say these small communities don't work right and they cost too much. . . . I don't care what people say, in small communities you know your councilman. Maybe he lives two doors away and you can go to him and talk over things with a cup of coffee" ("Opponents Feel Big is Bad, Small is Good," *Cincinnati Enquirer,* Kentucky ed., 6 Jan. 1980). The very design of the new suburban communities of the post–World War II era underscored and intensified such arguments. Wide building lots on winding streets, miles from commuters' workplaces in Covington and Cincinnati, proved both a product of, and a magnifier for, this "small is better" philosophy. First, suburbanites viewed their return-home commute as an escape from the pollution, traffic, and crowds of the central cities. Their homes were a bucolic retreat from the larger problems facing metropolitan regions. Second, this sense of retreat led to further efforts to isolate themselves from "big city" and/or regional politics and economics, and to embrace the neighborliness of small communities. Third, the generation that had fought the Second World and Korean Wars were intensely civic minded, at least on a small-community scale. They cheerfully established and joined suburban civic associations, swim clubs, garden clubs, and volunteer fire departments. Finally, having experienced the Great Depression, this generation of suburbanites were intensely frugal, resisting any and all increases in taxation, including annexation efforts that might raise their taxes without a parallel return in benefits.

Although Covington gained territory in the 30-year annexation struggle, it did so at some level of peril to itself. Its image was tarnished. Second, numerous lawsuits and appeals sapped Covington of financial and psychological resources that might have been better spent in rebuilding the city. And as the *Kentucky Post* so eloquently stated in a 1982 editorial, "The fight brought hostility to just about every aspect of governmental activity and made co-operation impossible. It further splintered an already fragmented area" ("Annexation Wounds Pierced by Partisan Politics," 10 Nov. 1982).

While legal battles made cooperation unlikely in fragmented Northern Kentucky, increasing costs and expectations of what local governments should or must provide forced at least some level of shared services and consolidation. Federal and state mandates regarding water pollution, planning, transportation, education, and revenue sharing underlay many of the regional organizations formed. These included Sanitation District #1 (1946), Northern Kentucky Industrial Foundation (1950s), Northern Kentucky Area Planning Commission (1961), NorthKey Community Care (1966), Northern Kentucky Port Authority (1968), Northern Kentucky Chamber of Commerce (1969), Northern Kentucky Convention and Visitors Bureau (1970s), Northern Kentucky Area Development District (1971), Northern Kentucky Health Department (1981), and Northern Kentucky Water District (1997).

The Children's Home of Northern Kentucky

In the late 1800s the cities of Cincinnati and neighboring Covington, Kentucky, looked like many urban areas of their day. Living conditions for the poor and working classes were crowded and dreary, and coal soot from furnaces, factories, and locomotives polluted the environment. Medical knowledge was limited, and the development and use of antibiotics were decades away. Mortality was high, and epidemics regularly swept the nation. As a consequence, there were many orphans—children whose parents had both

died, often rather suddenly. In addition, like modern times, there were homeless, neglected, and abused children, as well as single parents who had no financial means and nowhere to turn for help raising their children. There was no Social Security, no Workmen's Compensation, no Medicaid, and no food stamps. A work accident, an economic recession, an illness, or a death could plunge poor and working class people into financial ruin.

Amos Shinkle (1818–92) was a devout Methodist who practiced works of charity and philanthropy throughout the region. Emotionally moved by the needs of poor children who lived in shanty boats along the rivers, Shinkle began to work for the establishment of an institution whose 1880 charter stated it would care "for the friendless, homeless, unprotected children or orphans." In an era when denominational differences held great importance, Shinkle was especially concerned for Protestant children, as two Catholic orphanages already existed in Northern Kentucky. The Covington Protestant Children's Home (CPCH),

The old Covington Protestant Children's Home, Madison Avenue. Courtesy of Paul A. Tenkotte.

which opened in 1882, was the result of his vision and of his generosity. Designed by the noted architect Samuel Hannaford, the CPCH at 14th Street and Madison Avenue was a state-of-the-art facility. Shinkle spared no expense in making certain that the facility was inviting, that the furnishings were up to date, and that the care provided was "kind and humane."

The Children's Home outgrew its first building by the early years of the 20th century, but World War I delayed planning for a new facility. In May 1925 the home conducted a massive 10-day fundraising campaign that raised more than $225,000 for a new building. Designed by the architectural firm of Hannaford and Sons, the new Colonial Revival facility was situated on 26 acres adjoining Covington's hilltop Devou Park, with sweeping views of Cincinnati. In 1935 a new junior board, composed of dedicated women, was established to assist with fundraising. In that same year, the junior board began its successful Charity Ball, which has been held annually ever since, with the exception of 1937 (the year of the devastating Ohio River flood).

After World War II, as medical advances contributed to lower mortality rates nationwide, there were very few true orphans. In addition, new federal programs like Social Security provided unemployment benefits, as well as Aid to Dependent Children. Third, decades of social service and psychological research cast increasing doubts upon dormitory-style children's homes, as well as institutionalization of children. Foster care became the norm for most children. Finally, for those children in need of the more specialized emotional and behavioral services offered by an institution, a new model prevailed. Smaller freestanding cottages, replicating family life with "parents" and "siblings," became the preferred method. The new 1920s facility of CPCH, only a couple of decades old in the post–World War II period, perhaps delayed the building of cottages. However, other changes were fast approaching. In the 1960s the nursery was closed,

as the home began to focus on children over the age of 6. By the late 1970s the home transitioned to caring for boys only, ages 9–17, in a specialized residential treatment program open to residents of the entire state of Kentucky, "without regard to race, creed, or religious affiliation." In addition, it established programs specializing in foster care, assisting families in the adoption process, providing after-school care for at-risk children, and providing professional assistance for families at risk. In 1990, the Covington Protestant Children's Home changed its name to the Children's Home of Northern Kentucky, and during the 1990s, it constructed its first cottages.

Today, the Children's Home of Northern Kentucky is a bridge to the future for hundreds of people annually who benefit from its specialized treatment programs. It continues to fulfill the mission established by its founder, Amos Shinkle, the bridge builder who recognized a need and took action. And the home continues to invest in the state's most important but often most neglected resource—children.

NOT SUBURBIA BUT INSTEAD URBAN RENAISSANCE

The end of the annexation battles enabled Covington to focus on its present and its future. Before 1980 much time had been wasted in attempting to mimic the suburbs. Urban renewal efforts concentrated on demolishing Covington historic structures to make way for new, suburban-like structures, like the IRS Center in Covington. Likewise, plans had been developed to demolish the historic homes along Riverside Drive in 1968, but were squelched by residents. By the 1980s and 1990s, Covington's historic preservation efforts were beginning to take root (see also "Chapter 14, From City Council to City Manager: Government in Covington").

From the height of its population per the 1930 US Census (65,252), Covington lost residents every decade thereafter. Some of the population decline was due to urban renewal, and part was due to smaller family sizes nationwide. But, by far, the migration to the suburbs was the largest element. In this respect, Covington was no different from any other US city. Nationwide, inner cities declined in population and in commercial activity. By 2010 Covington had a population of 40,640. The city, like many nationwide, began slowly to rebound thereafter, reaching an estimated population of 40,956 in 2013.

Covington realized that its future would lie in four principal directions. First, its unique historic and architectural infrastructure was a boon, not a bane. Increasingly, both young and old rediscovered the city's rich architectural past. Restoration efforts proceeded on, as did the listing of districts on the National Register of Historic Places. Second, the city discovered that its walkability was an attribute, not a detriment.

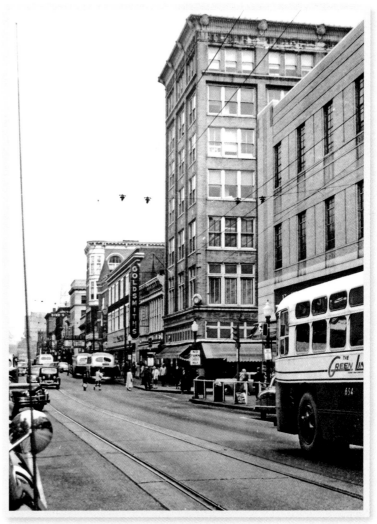

Madison Avenue looking north, Downtown Covington, circa 1940s. The taller building is Coppin's Department Store, and the three-story building on the right is F. W. Woolworth five-and-dime store. Courtesy of the Kenton County Public Library, Covington.

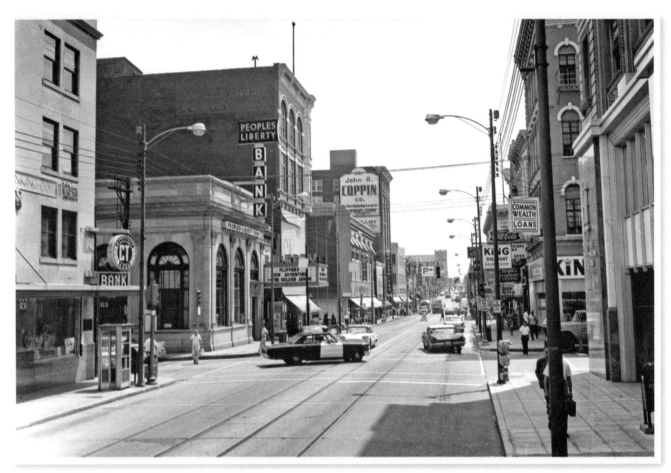

Madison Avenue looking south, Downtown Covington, circa 1960s. Photo by Raymond E. Hadorn, in the collection of Paul A. Tenkotte.

For people tired of sitting in snarled traffic on their daily commutes between Cincinnati and their homes in the suburbs along I-75/I-71, the ability to live in Covington and walk the bridges to Cincinnati was enticing. Third, the city realized that it was more heterogeneous than its suburbs, with rich, middle class, and poor scattered throughout the city. In addition to its economic diversity, the city was racially and culturally mixed. Covington's embrace of its diversity expressed itself in legislation in 2003 affording protections to the gay and lesbian community. Fourth, Covington realized that its downtown would never recapture its former ranking as Northern Kentucky's dominant retail center. The opening of Florence Mall in Florence, Kentucky, in 1976 shifted retail patterns. Sears, Coppin's, and JCPenney had all closed their downtown Covington department stores by 1984. Nevertheless, downtown Covington, along with MainStrasse, has experienced a resurgence for start-up businesses, small shops, restaurants, artists, and entertainment venues. In addition, led by the nonprofit UpTech (a business incubator), the Catalytic Fund, and a host of innovative tech and biotech firms (including Biologic, C-Forward Information Technologies, Great Here, and TiER1 Performance Solutions), Covington is leading the way to the development of innovative 21st-century workforces. The city is still home (in 2014) to more than 26,000 people working in its businesses and nonprofit organizations. The two largest employers, with more than 4,000 employees each, are the Internal Revenue Center and Fidelity Investments. In addition, Covington is headquarters to the Fortune 500 Company Ashland Inc.

Since 1990 downtown Covington has witnessed an urban renaissance that has transformed its core. The city now has a unique skyline, anchored by RiverCenter I (1990), Gateway Center (1993), RiverCenter II (1997–98), the Kenton County Justice Center (1999), the Marriott Hotel (1999), Gateway Center West (2001), Madison Place (2000-01), and the Ascent at Roebling's Bridge (2007). Covington is also home to the Northern Kentucky Convention Center (1998). Some of the many major downtown restoration projects since 1990 have included the Northern Bank of Kentucky Building (1999), the Madison (1990-91), Madison Theater (2001), the Madison South (2002), the Covington Ice House (2003), Odd Fellows Hall (2005), and the Wedding Mall (2006).

As of 2014, Covington's first female mayor, Sherry Carran, sees much progress underway. Construction in downtown Covington includes the renovation of several buildings for Gateway Community and Technical College's new campus, as well as Orleans Development's restoration of the Covington Mutual Fire Insurance Building (Pike Street and Madison Avenue), and its retail–apartment renovations called Pike Star (phase one, 108-112 West Pike Street and phase two, 114 West Pike Street). In July 2014 Kentucky Governor Steve Beshear conducted the ceremonial signing of a new state "angel investor" bill at UpTech in Covington. The bill promises to make Kentucky one of the most progressive states in the nation for business start-up opportunities. Meanwhile, the city's plans for the old Covington Landing are proceeding with the relocation of Jeff Ruby's Waterfront restaurant, and Orleans Development is planning a restoration of the old Doctor's Building at Seventh Street and Scott Boulevard. And brewing will return to Covington once again, with the opening of the Braxton Brewing Company.

IN RETROSPECT

Through 200 years, the residents of Covington have met many challenges. They built turnpikes; railroads; bridges; streetcar lines; telephone lines; and gas, water, and sewer systems. They established fire, police, and paramedic services. They fought against high tolls in the late 19th century, and opposed corrupt machine politicians in the early 20th century. Courageous citizens advocated for the rights of African Americans and women during the 20th century and for gays and lesbians in the 21st century. They founded schools, newspapers, radio and television stations, a library, a museum, and arts and cultural institutions to ensure that truth and beauty could be seen, heard, and cherished above the clamor of everyday distractions. Caring for their fellow citizens, Covington residents built an orphanage, hospitals, churches, parks, soup kitchens, homeless shelters, cold shelters, and retirement and nursing homes. They successfully prevented a Confederate invasion during the Civil War, fought valiantly in the two World Wars, mourned the 23 Kenton County residents killed in the Korean War, grieved for 44 of their county citizens who never returned from the Vietnam War, and feel loss when their young heroes and heroines face death in today's tragic age of terrorism. They buried their dead with honor and dignity in their cemeteries. Covington residents braved floods, storms, epidemics, and economic depressions. They held their heads high, even when they did not have the strength to do so. They wrote books, acted, painted, sculpted, played sports, wrote music, sang, danced, laughed, loved, and prayed. And they worked—lots of work, opening factories, running businesses, banking, baking, brewing, bartering, and always building and rebuilding. They continue to build, seeking progress in all that they do, from rebuilding their downtown and neighborhoods, to combating drug addiction in the larger community, to discovering their niche in a quickly changing global economy.

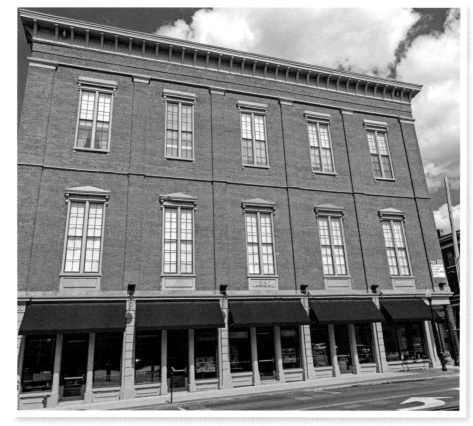

Odd Fellows Hall, Madison Avenue and Fifth Street, 2014. Photo by Dave Ivory.

No generation has it easy. All generations face new hardships and challenges. History judges communities by how they meet those challenges. Covington residents have always opened their doors to others, first as a Gateway to the West, next as a Gateway between the North and the South, and then as a Gateway to the North. Today,

when the Internet and modern communications break down barriers worldwide, Covington residents are called to do the same—to break down artificial barriers to economic, physical, social, and cultural change in the entire Cincinnati metropolitan region of 2.1 million people. History is the study of change over time. With no change, there is no history, just continuous monotony. If we consider that, and also that nearly every barrier we imagine is man-made, then the challenge of following in the footsteps of our Gateway ancestors becomes less intimidating. In our communities, and in our individual lives, we become the gateways to helping others advance. Progress is both a verb and a noun. We ensure that all of us progress together as a community, in a progress that carries the future on its shoulders.

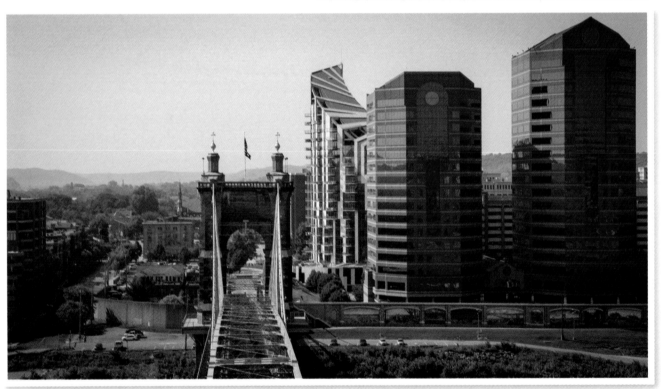

TOP: The restoration of the old Marx Furniture Building on Madison Avenue into one of the buildings of the downtown Gateway Community and Technical College, 2014. Photo by Dave Ivory. ABOVE: The skyline of Covington, as seen from the north pier of the John A. Roebling Suspension Bridge, 2014. Photo by Dave Ivory.

Special thanks to Mark Neikirk for allowing us to reprint part of Paul Tenkotte's annexation chapter (Kenton County Government Study Group 2013).

SELECTED BIBLIOGRAPHY

Gastright, Joseph F. "Parks for the People–The Park Movement in Northern Kentucky. Part One." *Northern Kentucky Heritage* 2 (2) (1995): 63–68.

———. "Parks for the People–The Park Movement in Northern Kentucky. Part Two." *Northern Kentucky Heritage* 3 (2) (1996): 57–67.

The Kenton County Government Study Group. *Kenton County Together: A Call to Action*. Highland Heights, KY: Scripps Howard Center for Civic Engagement of Northern Kentucky University, 2013.

Klotter, James C. *William Goebel: The Politics of Wrath*. Lexington, KY: University Press of Kentucky, 1977.

Mahoney, A. Joseph. *The Chaplain: Henry Bernard Stober Story, Captain United States Army, 1901–1945*. Lake San Marcos, CA: S. Joseph Maloney, 2001.

Northern Kentucky Newspaper Index. Kenton County Public Library, Covington, KY.

"An Open Reply to John Richmond, President Blakely Club, Covington, Ky. Concerning Patriotic Activities." Covington, KY: Alban Wolff, 1921.

Poweleit, Alvin C. *USAFFE: The Loyal Americans and Faithful Filipinos: A Saga of Atrocities Perpetrated During the Fall of the Philippines, the Bataan Death March, and Japanese Imprisonment and Survival*. Covington, KY: Self-published, 1975.

Poweleit, Alvin C. and James C. Claypool. *Kentucky's Patriot Doctor: The Life and Times of Alvin C. Poweleit*. Fort Mitchell, KY: T. I. Hayes, 1996.

Pranger, Arthur B. *Travelling through WWII*. Bloomington, IN: AuthorHouse, 2007.

Souvenir Diamond Jubilee, St. Joseph Parish, Covington, Kentucky, 1859–1934. Covington, KY: Acorn Press, 1934.

Spence, J. T. "Mayoral Power and Governmental Evolution in Covington, Kentucky." *Northern Kentucky Heritage* 6 (1) (1998): 34–38.

Stamm, Lisa A. "The German-American Population of Northern Kentucky during the First World War: The Victimization of an Ethnic Group and its Culture." Senior thesis, Northern Kentucky University, 1989.

Tapp, Hambleton, and James C. Klotter. *Kentucky: Decades of Discord, 1865–1900*. Frankfort, KY: Kentucky Historical Society, 1977.

Tenkotte, Paul A. "Adaptation to the Automobile and Imitation of the Suburb: Covington, Kentucky's 1932 Plan as a Test Case of City Planning." *The Journal of Kentucky Studies* 1 (1984): 155–70.

———. "Rival Cities to Suburbs: Covington and Newport, Kentucky, 1790–1890." PhD diss., University of Cincinnati, 1989.

Tenkotte, Paul A., and James C. Claypool, eds. *The Encyclopedia of Northern Kentucky*. Lexington, KY: University Press of Kentucky, 2009.

Welky, David. *The Thousand-Year Flood: The Ohio-Mississippi Disaster of 1937*. Chicago, IL: The University of Chicago Press, 2011.

Williams, Geoff. *Washed Away: How the Great Flood of 1913, America's Most Widespread Natural Disaster, Terrorized a Nation and Changed It Forever*. New York, NY: Pegasus Books, 2013.

Woodall, Frank. *A Further Plea for Parks in Covington: By the Same Man*. Covington, KY: Self-published, 1903.

Woodson, Urey. *The First New Dealer, William Goebel*. Louisville, KY: Standard Press, 1939.

CHAPTER

5

FROM FETTERED TO FREEDOM: AFRICAN AMERICANS IN COVINGTON

by Theodore H. H. Harris

AFRICAN Americans arrived in Kentucky while accompanying the various explorers and settlers. As a gateway to the West, Covington, Kentucky, had an African American population from earliest times. While never numbering more than 200 people in the very early years of the 19th century, African Americans nevertheless played a vital role in the city's history. Covington's geographical location, at the confluence of two rivers, the Licking and the Ohio, had a bearing on various aspects of residents' lives. Northern Kentucky was active in the slave trading market, with slave markets in both Maysville and Washington, Kentucky. Not surprisingly, Covington's commerce depended upon enslaved African Americans' labor.

The Carneal (Gano-Southgate) House, like many of the homes lining the Ohio and Licking Rivers, played an important role in African American history during the antebellum period. Palatial residences like the Carneal House often had underground service tunnels leading to the rivers, built to enable supplies to be delivered from boats directly into basement storehouses. However, when the opportunity presented itself, those enslaved could use the passages to aid in their escape to freedom. These escapes often occurred during the winter months, when many of the wealthy owners were enjoying balmier weather in the Southern states. Some trusted slaves enjoyed a certain degree of freedom that had its advantages, and at times, disadvantages as well. Dick, an aged enslaved African American, lived behind the main Carneal house. His responsibilities entailed a certain amount of free movement, resembling that of a free man. In addition, he was a minister of the gospel in his community. In 1842 Dick was murdered and robbed for a sum of $1 at the Carneal House. Following his murder, questions surfaced as to the real reason for the crime. Was he affiliated with the Underground Railroad? Was he using the Carneal House tunnel to assist slaves to freedom? His master offered a reward of $400 for the capture of the three men associated with his murder, but they were never found.

Jane, also enslaved, lived in Covington. She was a house slave working as a nanny. Upon the master's death, Jane was given to his oldest son, but she soon discovered that she would be sold and sent to the Deep South. Jane knew it was time to gain her freedom. She immediately contacted a person to help with her escape, someone who was in contact with people who had knowledge of the Underground Railroad. Jane, along with her daughter Beatrice, used the Carneal House tunnel to reach a skiff waiting on the Licking River for her trip across the river to Cincinnati, Ohio. She was assisted by Levi Coffin and eventually found her way to Amherstburg, Canada.

John W. Stevenson moved to Covington in 1841, later becoming governor of Kentucky and a US Senator after the Civil War. His stately Covington home on Garrard Street had a tunnel leading to the Licking River. Stevenson was also

a slave owner, and one of his slaves escaped in January 1856 with a party of slaves from Boone County, Kentucky, that included Margaret Garner. Underground Railroad conductors arranged a rendezvous of Stevenson's slave with Margaret Garner's party at the foot of Covington's Main Street on the Ohio River. She and some of the other slaves were captured at a relative's house in Cincinnati. The case received national newspaper attention when it was discovered that, facing capture, Margaret had killed her youngest child and attempted to kill her other children, stating that death was a better choice than slavery. The heartrending drama of the story galvanized those already opposed to slavery, and converted others not yet committed to the antislavery cause. Toni Morrison based her novel *Beloved* on the events of the Margaret Garner case. In 2005 the Cincinnati Opera Company commissioned *Margaret Garner: A New American Opera.*

With the arrival of settlers in Covington, organized churches were being established, especially Methodist and Baptist congregations. Slavery was the principal cause for the split of the Methodist Church into Northern and Southern components. In addition, antebellum disagreements between proslavery and antislavery factions spelled the end to Covington's Western Baptist Theological Institute, the first Baptist seminary west of the Alleghenies. In 1864, Reverend George W. Dupree, an African American evangelist and cleric from Georgetown, Kentucky, assembled 22 African Americans and organized the First Baptist Church (African American) in Covington. Reverend Jacob Price (1839–1923), the church's first pastor, was a free man who lived on Bremen Street (later renamed Pershing Street) in Covington. It was rumored that Price used his home as a stop on the Underground Railroad.

The antebellum period for those African Americans not enslaved was restricted to employment or business opportunities that did not threaten white businessmen. One of the first African Americans to own a business in Covington was Jonathan Singer, a free man who moved there in 1836 from Virginia. Singer placed an ad (1845) in a local newspaper identifying himself as a "Fashionable Barber and Hair Dresser." The location of the barbershop was on Green Street, opposite the Bates Hotel, later moving to 404 Scott Boulevard (formerly called Scott Street). He lived at 52 East Fourth Street. Reverend Jacob Price married Mary Singer, daughter of Jonathan Singer, and resided with the Singer family. Price was a minister of the gospel and a teamster working for the H. H. Bruns Company. The Prices later moved to 61 Bremen Street, home of Bremen Street Church. A short time later, Price opened a lumberyard at 412 Madison Avenue.

Headquarters for Lumber

JACOB PRICE,

DEALER IN ALL KINDS OF

ROUGH and DRESSED LUMBER,

Shingles, Lath, Locust and Cedar Posts,

No. 412 Madison St.,

Bet. Fourth and Fifth, COVINGTON, KY.

Advertisement for Jacob Price's lumber business. *Daily Commonwealth*, 24 Jan. 1883.

Good roads, such as the Covington and Lexington Turnpike, were developed to move goods to markets in Covington and Cincinnati. African American families provided much of the labor, both as drivers and stevedores. The free African American population in Covington in 1850 was 36, with 281 enslaved persons. They lived along Willow Run Creek, the Licking and Ohio Rivers, and May, Pike, Main, and Greenup Streets. As these roads were improved, the volume of slave escapes increased. By 1860 Covington's African American population consisted of 76 free people and 197 slaves. Again, their residential locations were largely dictated by the location of the slave owners.

The conflict between the states witnessed an influx of African Americans. During the Civil War, two US Army installations were located in Covington: Camp King and Covington Barracks. Camp King was located at the site of Meinken Field, along the Licking River between current-day Wallace Woods and Latonia. Covington Barracks was located at the head of Greenup Street in Wallace Woods. The 72nd Colored Infantry and the 117th Colored Infantry Regiments were formed and served at the two installations. As was the custom, family members of African American soldiers found living arrangements close to the facilities. The Johnson, Wells, and Pate families located nearby, living in the vicinity of the later 500 block of East 20th Street, remaining until the 1950s.

African Americans began living in small clusters near the Western Baptist Theological Institute on West 11th Street, used as a US Army hospital during the Civil War. The military hospital closed in 1865, and became the second location of St. Elizabeth Hospital in 1868. Another Union military hospital was located on Main Street,

near the Sixth Street Market site. African Americans lived nearby, along Bremen Street, which connected to Main Street. At the conclusion of the Civil War, it is estimated that roughly 1,503 African American soldiers had been mustered into the Union army from Covington. In 1870 the US census recorded 755 African Americans living in small clusters throughout the city. Following the Civil War, the Methodist Episcopal (ME) Church South assisted African Americans in organizing their own church, the Third Street ME Church (1866).

After the Civil War, the Covington and Cincinnati Suspension Bridge opened, making travel northward more convenient. Further, with emancipation and Reconstruction, African Americans from the South moved northward, some to Covington. The demise of the hemp industry in Lexington and the Bluegrass region of Kentucky contributed to the migration of many African Americans. Freed slaves gravitated to cities like Covington, joining German and Irish immigrants. In cities, newly arrived migrants and immigrants competed for jobs in iron mills, slaughterhouses, livery stables, and tobacco warehouses. Finding themselves at the bottom of the economic ladder, African Americans also competed for housing. Efforts were made to avoid housing along the unhealthy areas of Willow Run Creek, as well as too close to the Licking River. With the housing stock in limited supply, blacks found homes near railroad tracks and along the city's alleys, namely Wenzel's Hall, Stewart, and Watkins Alleys.

The last half of the 19th century witnessed growth and maturation of the African American community in Covington. A number of prominent businessmen, educators, and ministers emerged as leaders. They included Wallace A. Gaines (1865–1940), an African American businessman, who was also involved in politics, business, and civic projects. He was born in Dayton, Ohio, in April 1865, coming to Covington with his parents about 1875. Gaines began working for his uncle in Ottoway Burton's barbershop at 706 Washington Street, shining shoes. The barbershop was located in a pocket containing several other African American–owned businesses. Sometime later, Gaines became involved in the furniture and feathers businesses. This enterprise lasted until he was appointed a United States storekeeper. By 1880 he was president of the "colored" Garfield First Voters Club. This organization supported James Garfield of Ohio, who was elected president of the United States in 1880 on the Republican ticket. Later, when the Republican Party was voted out of power, Gaines became a hauling contractor, handling most of the grain and whiskey of the city's distilleries, until the Republicans returned to power. A few years later, he joined the United Brothers of Friendship. By 1890 this organization became the largest African American civic association in the country. Gaines rose through that organization's ranks, and by 1897, was the Grand Supreme Master. In May 1898 he was appointed a federal court bailiff, but resigned that same day after it was determined that the job would interfere with his support of the renomination of his personal friend, Republican Congressman Walter Evans.

While performing his job as a special revenue agent for the United States Treasury Department, in 1904, Gaines discovered that the wholesale whiskey house of Crigler & Crigler, located on Pike Street, was moving untaxed whiskey barrels. He reported this to the tax collector and revenue agent, which led to a case against the company in United States district court. In private life, Gaines was one of the founding members, as well as president and director, of the Progressive Building and Loan Association, created for the African American community of Covington. The association was located at the corner of Seventh Street and Scott Boulevard adjacent to the W. A. Gaines funeral home, the city's first African American mortuary.

In the 1890s African American physicians and attorneys became prominent in Covington. By 1894 Dr. Simon J. Watkins became the first African American doctor to practice in the city. His office was located at 429 Scott Boulevard. He later moved to 113 East Ninth Street, where he remained until his retirement in 1946. Dr. Adam D. Kelly was the city's second African American doctor, with a practice located at 56 East Third Street. By 1920 Kelly moved his practice to 514 Scott Boulevard, in what was then considered the heart of the African American business district. Along Scott Boulevard, African American businessmen and professionals included the C. E. Jones Funeral Home at 633–635 Scott Boulevard (which Charles Edward Jones purchased from Wallace Gaines in 1913); the Progressive Building and Loan Association at Seventh Street and Scott Boulevard; and Isaac E. Black, Covington's first African American attorney, who was encouraged by John G. Carlisle and resided in the Boone Block at Fourth and Scott Boulevard.

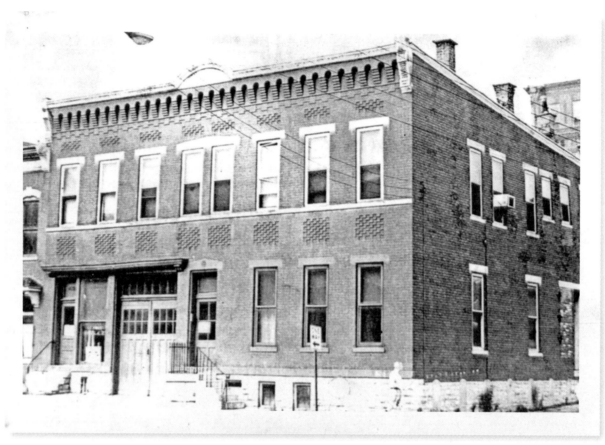

Jones-Simpson Funeral Home, 633–35 Scott Boulevard. Courtesy of Theodore H. H. Harris.

African American Doctors

- J. Bryant, MD, a 1908 graduate of Meharry Medical School in Nashville, Tennessee, practiced in Covington until 1920.
- Albert B. Snowden, MD, was born in Lexington, Kentucky, and graduated from the Lexington Normal School and from Meharry Medical School in 1916. He practiced in Covington from 1916 until the time of his death in 1923.
- Harry P. Taylor, MD, graduated from Meharry Medical School in 1903. He practiced in Flemingsburg, Kentucky, until 1905, when he married and moved to Versailles, Kentucky, practicing there until 1925. He then moved to Covington, where he practiced until his death in 1960.
- Earl Beam, MD, graduated from the National Medical College in Louisville, Kentucky, in 1908. He practiced in Covington from 1909 until the early 1930s.
- Horace S. Brannon, MD, graduated from the National Medical College in Louisville in 1907 and practiced in Covington from 1907 until his retirement in 1965. He moved from 1404 Russell Street in Covington to 953 Church Hill Avenue in Cincinnati. He served in the Army during World War I, and was a first lieutenant.
- Norman Earl Duham, MD, graduated from Meharry Medical College in 1921 and in 1922 came to Covington. Dr. Duham took his premed training at Fisk University in Nashville; he lived at 1222 Russell Street in Covington.
- James E. Randolph, MD, graduated from Meharry Medical College in 1917 and came to Covington in 1922. He served in the US Army Medical Reserve Corps during World War I. Dr. Randolph practiced in Covington until his retirement in 1979.

By the late 19th and early 20th centuries, African Americans were largely concentrated in one area, the city's Eastside. The Eastside, like many city neighborhoods, has rather amorphous and artificial boundaries. It is bounded by 15th Street (Austinburg) on the south, Eighth Street (Licking Riverside) on the north, Madison Avenue (the central business district) on the west, and the Licking River on the east. Historically, the neighborhood was racially mixed and economically diverse. It included churches, a synagogue, schools, playgrounds, and many small businesses. The racial makeup consisted of Irish, Germans, and African Americans. All three ethnic groups began arriving in large numbers in Covington about the same time. Further, the Eastside featured a religious mix of Protestants, Catholics, and Jews.

Just west of the Eastside is Russell Street, which, along with neighboring Banklick Street, has historically been an integrated community. Local factories, like Klaene Foundry and Precision Casting Company, were within walking distance. The community also included railroad workers, educators, and doctors.

Other neighborhoods of Covington had African American residential pockets. For example, the May Street area on the city's Westside included a small number of African American families as late as 1960. Near the city's historic Linden Grove Cemetery, May Street was also close to the Willow Run Creek, generally viewed as unhealthy due to its susceptibility to backwater flooding from the Ohio River and also to the widespread prevalence of sewers and dumps.

Peaselburg is a German and Irish neighborhood in central Covington. The African American community there consisted of not more than 25 families living on Jefferson, Centre, and Franklin Streets. By the turn of the century (circa 1890), employment opportunities for blacks in the Peaselburg neighborhood included railroad, construction, day laborers, and hospital staff. As late as 1959, African American children attended Lincoln Grant School on Greenup Street, although Fifth and Seventh District schools were only a few blocks away. The community remained intact, until Covington adopted an urban renewal project that displaced African Americans, who subsequently moved to the city's Eastside. In their place, Glenn O. Swing School (1969) was constructed at 19th and Jefferson Streets, and in the late 20th and early 21st centuries, Benton Street Homes.

Latonia was once known as Milldale. The community developed at the intersection of Decoursey Pike and Taylor's Mill Pike and was later annexed by Covington (1909). The African American community in Latonia was small, generally employed by the railroad and thoroughbred horse racing industry, including the Latonia Race Track on Winston Avenue. Lincoln School (1909), a small facility located at 30th Street and Decoursey Avenue, educated African American children. For many years, the school's sole teacher was Robert P. Johnson. African Americans who lived in Latonia were permitted to attend the local movie theaters, but blacks residing outside the neighborhood were not. African American families lived on East 33rd Street, East 35th Street, Frazier Street, and Union Street well into the 21st century.

By 1913 some of the most prominent African Americans in the city of Covington created the Colored Citizens Protective League (CCPL). The league's executive committee included a cross section of the community: W. M. Auxier, James Bratten, Stephen Brookins, Dr. W. H. Bryant, Levi Cox, Wood Davis, George Hunter, Albert Johnson, Dr. A. D. Kelly, Reverend F. C. Locust, John H. Smith, Reverend Scott Ward, and Dr. S. J. Watkins. The league demanded greater access for blacks to city government jobs. With African Americans comprising one-fourth of the city's registered Republican voters, the CCPL believed that the request was logical. Indeed, city politicians regularly rewarded voters with patronage jobs, ranging from street workers to police officers. In 1919 a Covington branch of the National Association for the Advancement of Colored People (NAACP) was established. Over the years, the Covington NAACP waxed and waned, and was reorganized as the Covington-Newport branch in 1959.

By the 1920s African Americans lived and worked throughout the city of Covington. They enjoyed integrated public transportation, including the Green Line streetcars, where, unlike many cities throughout the nation, blacks

were permitted to sit anywhere they liked. Likewise, from the day that it opened in 1904, the Covington Public Library was an integrated facility located in the heart of the Eastside, at Robbins and Scott Boulevard. In fact, it was one of the first racially integrated public libraries in the South. African Americans resided on integrated streets throughout the city, including Bush, Banklick, and Russell Streets. Likewise, they resided on smaller, side streets such as Berry, off of Banklick, and along Stewart Alley and Johnson Street, poor areas within shouting distance of the city's then-fashionable West Fourth Street. African American civic organizations held their meetings openly in locations downtown. The Covington Ball Park, located near West Seventh Street next to Willow Run Creek, was an integrated field commonly used circa 1948 by an African American semipro baseball team, the Twenty Counts. Both poor blacks and whites also shared integrated communities, such as Oklahoma, located east of the city's Austinburg neighborhood and adjacent to the Licking River near East 16th Street. There, black and white families sometimes lived in adjoining rooms in the same buildings.

Of course, integration only went so far. Schools were segregated, movie theaters commonly confined black patrons to balconies, certain businesses had separate drinking fountains, and black children were not allowed to swim at white-only pools. The only swimming hole for African American children was located at a place called little Hatchet Lake. This lake was a small receiving pond fed by a larger pay-fishing lake called big Hatchet Lake. Both lakes were drained and replaced by the construction of I-71 and I-75. In later years, the city of Covington provided a small swimming pool at 12th and Maryland Avenue, supervised by an African American woman, Ruth Baker.

B. F. Howard. Courtesy of Theodore H. H. Harris.

With integration, the African American community witnessed a change. As the number of black businessmen and professionals increased, a different housing pattern began to take root. Blacks established stability in the community, and many moved to Russell Street. Still, businessmen, professionals, educators, and workers belonged to the same fraternal orders and churches. Lincoln-Grant School was the pride of the African American community. First Baptist, Ninth Street ME, and St. James AME Churches were the congregations of choice.

B. F. Howard

Benjamin Franklin Howard (1860–1918) grew up in Covington. He became familiar with a white-only fraternal organization called the Elks. When the state of Kentucky refused to charter a black Elks lodge, Howard established the first African American Elks lodge—the Improved Benevolent and Protective Order of Elks of the World (IBPOW)—located in Cincinnati. Other lodges were founded nationwide, and in 1889, he was elected Grand Exalted Ruler, serving in that role until 1910. In 1916 he established Ira Lodge No. 37 in Covington. He died in Covington in 1918 and was buried in Linden Grove Cemetery.

Delaney Funeral Home

John W. Delaney Sr. and Elizabeth B. Delaney founded the E. B. Delaney and Son Funeral Home. Their family lived for a number of years at 117 East 41st Street, in what was then Rosedale, later Latonia. They moved to 30 West 15th Street in 1919. After the death of John Sr., Mrs. Delaney continued to operate the business and found time to earn a degree in business administration. Her civic activities included helping to organize the Kenton County chapters of the Order of Eastern Stars, Sisters of the Mystic Ten, and Household Ruth. John W. Delaney Jr. became a practicing attorney and judge pro tem under Kenton County Judge Probate Dressman.

The new Lincoln-Grant School, located at East Ninth and Greenup Streets, was dedicated on March 31, 1932, the last in a succession of public African American schools. At the dedication, Henry R. Merry, incoming principal,

Lincoln-Grant School. Photo by David Ivory, 2014.

was the speaker of record, with former principal Robert L. Yancey extending his greetings. Other prominent educators and citizens participated in the two-day ceremony. Werlie J. Richardson represented the African American fraternal organizations of Covington. The new building housed the Lincoln-Grant Elementary School, as well as the William Grant High School.

Paul L. Redden came to William Grant High School in 1927 to teach physical education. He also coached both football and basketball until the football team was dissolved when the school moved into its new facilities in 1932, as the Covington Board of Education did not provide the school space for outdoor athletics. Redden continued to coach basketball until becoming head football coach at Knoxville (Tennessee) College in 1952. He started a winning tradition in athletics that would extend into the mid-1960s with James Brock. Redden's football teams were undefeated and won the African American Kentucky state football championships in 1929 and 1932.

The faculty of the new Lincoln-Grant facility worked hard to introduce students to a wide range of artistic and cultural activities. Teachers stressed the importance of having a well-rounded education and, to keep students in school, stressed the need for extracurricular activities. In November 1938 Dr. Clarence Cameron White, a world-renowned African American opera composer and director, visited Lincoln-Grant. He conducted several institutes on music at the school. To keep the community involved, a training session was held in the evenings at Ninth Street Baptist Church and at the First Baptist Church. The training period resulted in a public concert where African American spirituals were featured.

Throughout the history of Lincoln-Grant School, the Parent-Teacher Association (PTA) played an important role. On February 7, 1940, the PTA held its annual Fathers' Night Program at the school. A special invitation was extended to all the fathers who had children in the school. Academically, the involvement of the PTA prompted the students to far exceed expectations. The Lincoln-Grant School faculty's qualifications were considered Grade A within the state. All faculty members had, at a minimum, a bachelor's degree, and most held a master's degree or were continuing their education through graduate study at leading universities. After 1932 the school faculty continued to improve, as did the graduation rate and number of students matriculating to college. In the 1950s William Grant's five high-school faculty members held four master's or double master's degrees, and one had a PhD. The school always received high marks from the Southern Association of Colleges and Schools.

Throughout the 20th century, the African American community had many dedicated music teachers, both vocal and instrumental, available at school and through private lessons. Students studied spirituals as well as traditional, gospel, and jazz musical forms. School vocal teachers in the 20th century included, chronologically, Miss Elizabeth Gooch, Miss Witherspoon, Mrs. Ruth Brown-Phillips, and Mr. William Martin; additional instructions were given in church choirs. Musical instruments and sheet music were taught at school by R. Hayes Strider, Conrad Hutchinson, and Robert Crowder. Private piano lessons were given by Mrs. Amanda Snowden, Mrs. H. R. Merry, and Mrs. Bessie Brean. Many of their students continued playing in local or college bands. For example, Nelson Burton played in the Lincoln-Grant School band and continued in the Kentucky State College band.

African American civic clubs held meetings downtown at the Wenzel Hall (1902) located in the alley between East Fourth Street, East Fifth Street, Scott Boulevard, and Madison Avenue. The hall housed various African American fraternal organizations, including weekly and monthly meetings and even temporary housing needs since no hotels in Covington accepted blacks. Participating organizations included the Grand United Order of Odd Fellows; the Grand Army of the Republic; the Knights of Pythias, Covington No. 6; and the Masonic Lodge Kenton No. 16. Entertainment and social clubs were a result of these fraternal organizations. When organizations like the Masonic lodge moved to 1010 Russell Street, the building was large enough to house a social club as well.

In 1935 the ugliness of segregation reared its head in Covington. In that year, the John Pete Montjoy case drew the attention of the entire state of Kentucky. Montjoy was charged with the rape of a married white woman, a charge that potentially carried a penalty of death by hanging. The case was appealed all the way up to the United States Supreme Court, and finally landed on the desk of Kentucky Governor A. B. Chandler, who refused a stay of execution. Montjoy became the first man executed for a crime in 20th-century Covington, and only the third man ever to be publicly executed in the city. As an African American, he was the first person in Covington's history to be hanged for a crime, upon the conviction of a Kenton County jury. William Wehrman Sr. was Montjoy's lead defense attorney. Theodore Berry, a lawyer from the NAACP legal defense fund, and two American Civil Liberties Union lawyers from Cincinnati also defended Montjoy, who maintained his innocence. Defense lawyers contended that Montjoy knew the woman in question, and socialized with her, but did not rape her. Wehrman appealed the case to the US Supreme Court on the grounds that there were no African Americans on the jury, but the high court refused to hear it. Montjoy was hanged on December 17, 1937, at 8:05 a.m. in the courtyard of the courthouse, one of the last public hangings in the state of Kentucky. To onlookers, he stated that they were hanging an innocent man. For years after, the African American community considered the hanging a severe miscarriage of justice.

While racism remained a contentious problem, a number of businesses slowly began to recognize the possible economic advantages of integration. As unbelievable as it may seem today, many white businesses simply refused to sell to black customers, fearing that white customers would not shop in integrated stores. In other cases, large white-owned businesses, like Coppin's Department Store in downtown Covington, welcomed black customers but retained elements of segregation. For example, black customers were not allowed to try on hats or clothes at Coppin's, nor were they allowed to use white restrooms. The store also had separate white and black drinking fountains. Likewise, many restaurants would not serve blacks, or would only allow them to buy carryout food from their back doors.

In more integrated neighborhoods, such instances of segregation slowly began to make little sense economically. The Great Atlantic & Pacific Tea Company (usually known simply as A&P) was an up-and-coming national supermarket chain. Originally located at 1056 Greenup Street, it opened a brand-new store at 1026 Madison Avenue in Covington in 1932. A&P welcomed black and white customers alike. Ironically, to small African American business owners, like Eugene and Bessie Lacy, the arrival of larger integrated chain stores could be unsettling. The Lacys owned Gene and Bess's Grocery Store at 205 Robbins Avenue in Covington. Lacy, who allowed customers to buy on credit—a particularly important fact during the height of the Great Depression—was rightfully concerned that small African American businesses like his would be unable to match the prices of large national chains.

Fermon Knox (1923–2001) served as president of the Northern Kentucky branch of the NAACP and was instrumental in the desegregation of Covington's public schools. Courtesy of Wendy Rush.

Nonetheless, Lacy's store, known for its customer service, remained open until the 1960s. In fact, Lacy owned another grocery store in Cincinnati's predominantly black West End.

Integration of Covington's Holmes High School took place in 1957, when Jessie Moore became the first African American student to enroll. Her initial attempt to register was denied by the superintendent. A complaint was filed on her behalf by Mrs. Alice Shimfessel, the president of the local chapter of the National Association for the Advancement of Colored People (NAACP). Moore's stay at Holmes lasted only a few weeks, due to overwhelming racial harassment from white students. The action taken by Jessie Moore and her community supporters initiated additional desegregation efforts by the Covington Board of Education. In 1958 two female students from William Grant High School enrolled at Holmes High School, becoming the first African Americans to graduate there in 1959.

James Simpson Jr. Courtesy of the Kenton County Public Library, Covington.

Also in 1959, black students in Peaselburg began attending their neighborhood's Seventh District School, followed by similar moves throughout the city's neighborhoods in 1961. The school board closed William Grant High School at the end of the 1964–65 school year, but Lincoln-Grant's elementary school continued and was soon after renamed Twelfth District School. Still, by 1975, Covington's Independent Schools failed to meet desegregation standards, as outlined in Title VI of the Civil Rights Act of 1964. As a consequence, the US Department of Health, Education, and Welfare (HEW) demanded compliance. With the closing of the Eleventh and Twelfth District Schools in the late 1970s, and redistricting, racial integration was finally achieved.

Meanwhile, in the 1960s, changes began to take place in the African American community. Local branches of the NAACP and of CORE (the Congress of Racial Equality) lobbied for an end to segregation in housing, education, and employment. Covington resident Fermon Knox (1923–2001), as president of the local NAACP during the height of the Civil Rights movement, was at the forefront of desegregation efforts. In addition, Knox served as the first executive director of the Northern Kentucky Community Action Commission.

Nationwide, fair housing eventually became the law of the land. Jobs at corporations like Ford, General Electric, GM, and P&G became available. In addition, the African American community slowly secured political offices and municipal government positions. The victories were long awaited. African Americans began voting in Covington during the 1870 elections. It took more than a century—until 1971—for blacks to have representation on the city commission when James Simpson Jr. (1928–99) was elected, serving a full term and later completing an unexpired term (1991). Likewise, as early as 1913, the Colored Citizens Protective League began a decades-long attempt to have representation in

Arnold Simpson. Courtesy of the Kenton County Public Library, Covington.

municipal positions, especially the police department. Victory finally came in 1967 with the hiring of the city's first African American police officer, Willie Joseph Stewart. In 1973 the city hired its first African American firefighter, Arthur Sheffield. In 1986 Arnold Simpson became the first African American to serve as Covington's city manager, and in 1994 he became the first African American to become a state representative from Northern Kentucky (serving Kentucky's 65th District).

In 1988 Pamela E. Mullins became the first African American woman elected to the Covington Board of Education. She served until 1996. While still serving on the school board, Mullins won election to the city commission. Holding both positions was a violation of Kentucky state law, so the Kentucky attorney general removed her from the school board. That same year, Hensley B. Jemmott was appointed to the Covington Board of Education. In 2007 Paul Mullins (Pam Mullins's son) was elected to the school board. Seated in January 2008, he was removed from office because he worked as a school bus driver for the school district. In both the Pamela and Paul Mullins cases, Kentucky state law was challenged before the Kentucky Supreme Court and was reversed.

In 2009 Jerry Avery was appointed to the school board, winning election to the same in 2011. In 2012 Michelle Williams was elected to the city commission. And in 2013 Alvin L. Garrison was appointed superintendent of Covington Independent Schools, the first African American to hold that position in the city's history. In 1991 Tracey Butler Ross, DMD, became the first female African American dentist in Northern Kentucky.

In the 21st century, the African American community celebrated a small victory, the conaming of 12th Street as Martin Luther King Boulevard (2007), but mourned the loss of four pillars: the Northern Kentucky Community Center; Jacob Price Homes; Ninth Street Methodist Episcopal Church, and St. Paul AME-Zion Church. With integration and the closing of the old Lincoln-Grant (later Twelfth District) School, the school building was purchased by the Northern Kentucky Community Council and renamed the William H. Martin Community Center. In 2013, the Lincoln-Grant building was listed on the National Register of Historic Places. In the same year, the city of Covington sold Lincoln-Grant to the Northern Kentucky Community Action Commission. Proposals for the building include a Lincoln-Grant Scholar House, that is, affordable housing for single parents who are pursuing higher education.

William Martin III (left) and Reverend Edgar Mack, 1973. William "Bill" Martin III was the son of noted Covington businessman William Henry Martin Jr. and the longtime director of the Northern Kentucky Community Center. Reverend Edgar Mack (1930–91) was an African Methodist Episcopal Church (AME) minister and cochairman of the Northern Kentucky committee for the Frankfort, Kentucky, Freedom March (March 1964), featuring Reverend Martin Luther King Jr. Courtesy of the Kenton County Public Library, Covington.

Ninth Street Methodist Episcopal Church closed its doors in 2006. It was the second-oldest congregation serving the African American community in Covington. Over the years, the church's members worked tirelessly for the betterment of African American children through education and for voter education for the newly enfranchised.

St. Paul African Methodist Episcopal-Zion Church (AME-Zion) was organized out of St. James AME Church in 1922 and closed its doors in August 2009. The church's first location in Covington was 238 East Robbins Street. With the need for more space, they constructed a larger building on the same site in the 1940s. During an eight-year period, seven members of the congregation attended the College of Mount St. Joseph in Cincinnati, obtaining

Jacob Price Homes. Photo by Paul A. Tenkotte.

various college degrees. In one case, a student had to change buses six times to reach the college. Another received a Duke Energy ministerial grant. This effort attracted the attention of Covington Mayor Denny Bowman, who formally recognized the accomplishment.

Jacob Price Homes, constructed in the period 1939–41, provided quality public housing. The housing project was named in honor of Jacob Price, an African American businessman who was involved in educational and civil rights, was a minister of the gospel, and was a church organizer. The housing project was demolished in 2010 and replaced in 2014 by a new mixed-income housing complex named River's Edge at Eastside Pointe.

Alice Thornton Shimfessel (1901–83) was the first secretary of the Jacob Price Homes. A Civil Rights leader, she led protests against segregation. Shimfessel served as president of the L. B. Fouse Civic League in Covington for many years. Courtesy of Theodore H. H. Harris.

First Baptist Church, the oldest African American church in Covington (1864), celebrated its sesquicentennial in 2014. Reverend Jacob Price established the church on Bremen Street. It later moved to Third Street, and finally, to East Ninth Street. The church was the home of early educational efforts for African American children in the city. During the Civil War, after the 72nd Colored Infantry and 117th Colored Infantry Regiments were organized in Covington, it was common for regiment members (such as John Richardson) to worship at First Baptist Church. The church served as a beacon during Reconstruction and the early Civil Rights period. The congregation consisted of laymen, educators, and professionals alike. Members provided leadership for organizations like the NAACP and CORE. It was at the forefront when Alice Shimfessel joined Reverend Dr. Martin Luther King with

First Baptist Church (African American). Courtesy of Theodore H. H. Harris.

the civil rights march on Frankfort (1964). The church, along with Lincoln-Grant School, is a source of pride to the community. This 150th celebration witnessed a new pastor, Adam P. Crews Sr.

Over two centuries, Covington's African American community successfully attained its freedom, opened businesses, secured voting rights, and fought against the oppression of segregation. African Americans entered the ranks of Covington's police and fire departments, its city commission, and its civil service. The community founded churches, schools, and civic institutions that contributed to the educational and cultural achievements of Covington.

The Richardson Family

John Richardson was born in 1835 in New Bern, Virginia. By the time of the Civil War, he was an enslaved farmer and was mustered into the US Army as a substitute from Bracken County, Kentucky. He was assigned to Company B, 117th Regiment US Colored Infantry on July 22, 1864, in Covington. Richardson was discharged in May 1866; when the regiment was disbanded following service in Texas, he moved to Covington.

Lucy Hawkins was born in Kentucky in 1837. By 1867, she was living in Crittenden in Grant County, Kentucky. Four years later, in 1871, she moved to Covington, seeking employment. There, she met and married John Richardson. By 1880, the couple lived on Pike Street, opposite Philadelphia Street. They were members of First Baptist Church (African American) during the pastorate of Reverend William Blackburn. John and Lucy's children included a daughter, Frankie (born in 1875), and a son, Werlie J. (born in 1879). Werlie lived for a number of years at 222 Greenup Street. He worked as a janitor for about 50 years at the First National Bank & Trust Company building at Sixth Street and Madison Avenue in Covington, and served as the Exalted Ruler, Ira Lodge No. 37, IBPOEW (Improved Benevolent Protective Order of Elks of the World), Covington, Kentucky, from 1924 to 1925. He was a member of the Masonic Lodge Kenton No. 16 and of First Baptist Church until the time of his death in December 1951. In 1947 Werlie Richardson's nephew, Nathaniel Harris, was also working at the First National Bank Building in Covington. Orie S. Ware (1882–1974), an attorney who had a law office in the building, suggested that Nathaniel contact the postmaster of Covington for employment opportunities at the post office. As a result, Nathaniel Harris became the first African American employee at the Covington branch of the US Postal Service.

In 1892 Frankie Richardson married Professor George Collins (of the British West Indies) in the presence of her parents, John and Lucy Richardson; the wedding was conducted by Reverend Jacob Price. A short time later, the couple left Covington for Institute, West Virginia, where Professor Collins was employed as a teacher at West Virginia State College. John and Lucy Richardson's extended family included grandchildren Grace (born 1888) and Harry (born 1892), the children of Eliza, Frankie's sister. In a complicated arrangement with other family members, Grace and Harry lived with their father and paternal grandmother until their deaths. Grace graduated from William Grant High School (1908) in Covington. Harry, who was five years younger than Grace, moved to West Virginia to live with Frankie. Grace graduated from West Virginia State (1910) with a two-year teacher's degree and returned to Covington. Harry remained in West Virginia and graduated from college while teaching. Grace married but never taught, as during those times teaching was reserved almost exclusively for men and for single women. She raised five children, four of whom graduated from William Grant High School and the fifth of whom served in the Navy Reserve for more than 30 years while working for the postal service.

SELECTED BIBLIOGRAPHY

Brunings, Ruth Wade Cox. "Slavery and the Tragic Story of Two Families—Gaines and Garner." *Northern Kentucky Heritage* 12 (1) (2004): 37–45.

Cooper, Richard, and Eric R. Jackson. *Cincinnati's Underground Railroad*. Charleston, SC: Arcadia Publishing, 2014.

Hampton, Jeffrey. *Leaving Children Behind: Black Education in Covington, Kentucky*. Covington, KY: Kenton County Historical Society, 2011.

Harris, Theodore H. H. "African American Boy Scout Troops in Northern Kentucky during the Early 1940s." *Northern Kentucky Heritage* 19 (2) (2012): 34–35.

———. "The Carneal House and the Underground Railroad: A Covington Family Escapes from Slavery." *Northern Kentucky Heritage* 6 (2) (1999): 35–38.

———. "Creating Windows of Opportunity: Isaac E. Black and the African American Experience in Kentucky, 1848–1914." *Register of the Kentucky Historical Society* 98 (2) (2000): 155–177.

———. "The History of Afro-American Elkdom and Benjamin Franklin (B. F.) Howard in Covington, Kentucky, 1889–1918." *Northern Kentucky Heritage* 1 (2) (1994): 43–44.

Jackson, Eric. *Black America Series: Northern Kentucky*. Charleston, SC: Arcadia Publishing, 2005.

Northern Kentucky Newspaper Index. Kenton County Public Library, Covington, KY.

Prichard, Vicki. "Separate but Unequal NKY: Segregation Remembered." *Sunday Challenger* (Covington, KY), 22 Aug. 2004.

Sartwell, Melinda. "Pioneers of Progress: The Southgate Family in Northern Kentucky." *Northern Kentucky Heritage* 19 (2) (2012): 3–9.

Tenkotte, Paul A., and James C. Claypool, eds. *The Encyclopedia of Northern Kentucky*. Lexington, KY: University Press of Kentucky, 2009.

Walton, Joseph M. *The Life and Legacy of Lincoln-Grant School, Covington, Kentucky, 1866–1976*. Milford, OH: Little Miami Publishing, 2010.

Wright, George C. *Racial Violence in Kentucky, 1865–1940: Lynchings, Mob Rule, and "Legal Lynchings."* Baton Rouge, LA: Louisiana State University Press, 1990.

CHAPTER

FROM ART TO ARCHITECTURE: THE VISUAL ARTS IN COVINGTON

by James Ott and Beth Johnson, with contributions by Bill Stolz, Paul A. Tenkotte, PhD, and David E. Schroeder

THE creation and appreciation of art has long occupied and enriched the lives of Covington residents. The city has three prominent institutions, the Covington Art Club (1877), the Baker Hunt Art and Cultural Center (1922), and the Carnegie (1972), which help drive interest in the skilled production of art. The Covington Art Club, one of the oldest women's clubs in Greater Cincinnati, promotes all of the arts, as does Baker Hunt. These historic organizations occupy adjacent quarters in onetime first-family residences on Greenup Street in the Licking Riverside National Register Historic District. In addition to teaching the arts, the Baker Hunt features

a house museum dedicated to the history of the Baker and Hunt families. The collection includes many items representing the fine arts and decorative arts movements of Greater Cincinnati during the 19th and early 20th centuries. The Carnegie, headquartered in Covington's exquisite old Carnegie library building from 1904, offers a full range of visual arts experiences. The beautifully restored Otto M. Budig Theatre at the Carnegie features an annual theater series, while the main building hosts art exhibits. The Carnegie is fully engaged in integrating the arts into school curricula.

The city has served as home base for many artists, several of whom have achieved international fame. Frank Duveneck (1848–1919), painter and teacher, became the leading exponent of the Munich school of painting and a foundational figure in art schooling in America. The work of sculptor Clement John Barnhorn (1857–1935) won recognition from Paris salons. Henry Farny (1847–1916), the colorful chronicler of American Indians and famed magazine illustrator, and Dixie Selden (1868–1935), a Duveneck student and a portrait and landscape painter of note, had studios in the city. Today, Covington hosts an array of contemporary artists who have extended the sphere of art to ceramics, pottery, and ironworking.

Covington Art Club, Greenup Street. Photo by Dave Ivory, 2014.

ABOVE: The Carnegie, Scott Boulevard. Photo by Dave Ivory, 2014. RIGHT: Baker Hunt Art and Cultural Center, Greenup Street. Photo by Dave Ivory, 2014.

The famous ornithologist and bird illustrator John James Audubon (1785–1851) and his wife, Lucy Green Bakewell, lived only briefly in Covington around 1808. However, Audubon began his unique career by painting cliff swallows living in the Licking River valley in 1819, while serving as a taxidermist with the Daniel Drake Western Museum in Cincinnati, Ohio. His nature studies and tales of his frontier adventures brought Audubon international fame.

COVINGTON ARTISTS

Among artists who visited towns and left portraits in well-to-do 19th-century homes was John Wesley Venable (1822–1908), one of the founders of Trinity Episcopal Church in Covington and later an ordained minister. Before his ordination, he painted portraits of gentry residing in Covington. He also helped mold the skull of Thomas S. Noble (1835–1907),

Reverend John Wesley Venable, circa 1872. Courtesy of Michael R. Averdick.

the first director of the McMicken School of Design in Cincinnati, whose graphic portraits of slaves brought Noble considerable fame. Covington's native connections with art began with the painter James Henry Beard (1814–93), whose work often contained a political message. He gained renown before the Civil War with an oil painting, *Carolina Emigrants*, which sold in New York City for the then-outstanding figure of $750. The painting, now on display in the Cincinnati Art Museum, depicts a poor white refugee family on the road from the South. The narrative in the painting implies that slavery had skewed the economy and denied poor whites an adequate living in a planter-dominated society.

In 1861 Beard was commissioned an officer in the Union army. That year he also acquired a residence in Covington at 322 East Third Street, which became a meeting place for the artistically and literarily inclined officer corps serving under General Lew Wallace, commander of Union forces defending Cincinnati and author of the novel *Ben-Hur*. Another visitor of note was Union officer Thomas Buchanan Read (1822–72). Read, a poet and painter, later based one of his most famous paintings, *Sheridan's Ride* (1871), on a Civil War poem he wrote by the same title. As for Beard, he was already an established painter who continued painting long after the war ended in 1865. His many paintings include *The Night Before the Battle*, reputedly a rendering of old Fort Mitchell, as well as portraits of John Quincy Adams, Lyman Beecher, Henry Clay, William Henry Harrison, William Tecumseh Sherman, and Zachary Taylor.

The Beard residence is also linked to his son, Daniel Carter Beard, founder of the Sons of Daniel Boone, who merged his organization with the Boy Scouts of America in 1910. In addition, Frank Duveneck's mother, Katherine Siemers Duveneck, was employed as a domestic in the Beard household.

James Beard home, East Third Street. Photo by Dave Ivory, 2014.

Frank Duveneck (1848–1919) is a strong contender for the title of Covington's most famous son. He was baptized Frank Decker at Mother of God Church, son of Bernard Decker and Katherine Siemers Decker, immigrants from the German Duchy of Oldenburg. The cholera epidemic took Bernard's life in 1849. The 1850 US census lists Katherine as a 20-year-old woman with a 1-year-old son. Shortly thereafter, she married Joseph Duveneck, known as Squire. They lived at 1232 Greenup Street in the Helentown neighborhood of Covington, where Joseph Squire operated a beer garden. Frank, known from then on as Frank Duveneck, had a knack for artistic expression. He modeled figures from Licking River mud to form toys for his siblings and friends. He also painted signs for the beer garden and a butcher shop.

The Duvenecks were members of St. Joseph Church at 12th and Greenup Streets, and young Frank was taught in the parish school by laymen recruited by the Benedictine order of priests and by religious men and women. St. Joseph became the host parish for an art studio, under Brother Cosmas Wolf, OSB (1822–94), called the Covington Altar Building Stock Company. This company's mission was the construction of altars and the decoration of churches springing up in the Midwest and northeastern United

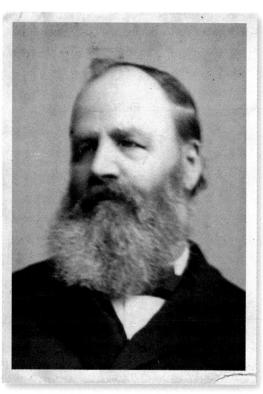

Johann Schmitt. Courtesy of Sharon Cahill.

States. Then a young teenager, Duveneck was apprenticed in the medieval tradition to Brother Wolf and Johann Schmitt (1825–98), painters who had studied art in Germany. Later, Munich-trained Wilhelm Lamprecht (1838–1906) guided young Frank. Duveneck traced what critics called his preternatural capability for creating lifelike eyes to Lamprecht's rigorous discipline, which required the young man to paint two to three eyes each day before breakfast. At 15 years of age, Duveneck produced *Our Lady of the Immaculate Conception* (1864), part of the permanent collection at the St. Vincent Archabbey in Latrobe, Pennsylvania, and later, a *Madonna and Child* oil on canvas for the Benedictine sisters in Covington. The latter painting hangs in St. Walburg's Convent in Villa Hills, Kentucky.

A Full-Blown Art Studio

The Covington Altar Stock Building Company produced more than altars. A glass department created church windows, and woodworking facilities developed furnishings, including altars, which were painted white and gilded similarly to altars in parts of Germany. The studio, in a wood-frame building on Bush Street in Covington, had metalworking capability, as attested by the archives for the company at the Benedictine

Archabbey of St. Vincent in Latrobe, Pennsylvania, which contains sketches of croziers, candlesticks, crucifixes, and at least one chalice. The company operated for a decade, and its artists and craftsman worked on dozens of churches in Kentucky, Ohio, Indiana, Pennsylvania, and New Jersey, as well as the church of Saint-Romuald in Lévis, Québec, designated a treasure by that province's cultural minister.

Although Mother of God Church on West Sixth Street was embellished in the late 19th century, after the Covington Altar Building Stock Company moved, it features the artwork of three of the company's premier artists, Johann Schmitt, Wilhelm Lamprecht, and Wenceslaus Thien (1838–1912). Schmitt and Thein continued their artistic professions in the Cincinnati–Covington area, while Lamprecht eventually moved back to Germany. Source: 1891 lithograph of the interior of Mother of God Church, in the collection of Paul A. Tenkotte.

Duveneck's artist friends interceded for him with his family and helped arrange his admission to the Royal Academy of Art in Munich. He studied there from 1870 to 1873 and so swept awards with an array of skilled portraits that he was granted a studio of his own. An outbreak of cholera and a shortage of money forced his return to the United States. He won his first real acclaim in America in 1875 in reviews of his portraits exhibited at the Boston Art Club by the author and art critic Henry James. Duveneck returned to Europe and lived for a time in Venice, where he produced a series of etchings that won high praise. He became the leading exponent of the Munich school of realism and established a painting school in Munich. He moved the school to Florence, Italy, where he and his students, "the Duveneck Boys," were fictionalized as the Inglehart Boys in William Dean Howells's novel of Florentine life, *Indian Summer*.

Then a rising artist and teacher, Duveneck married Elizabeth Otis Lyman Boott (1846–88), an expatriate artist and a New England textile heiress. They had one son, Frank Jr., before she died from pneumonia in Paris, France, as they prepared works that the 1888 Paris Salon accepted and displayed. Duveneck won honorable mention for a painting of his wife and similar recognition from the 1895 Paris Salon for an effigy of his then-deceased wife. This bronze effigy stands above her grave in the Allori cemetery in Florence, Italy. The original cast of the work in clay is a feature of the Duveneck Room at the Cincinnati Art Museum. Later, Duveneck produced the effigy in marble for the Boston Museum of Fine Arts. Another version, in gold leaf, is exhibited at the New York Metropolitan Museum of Art.

The decade of the 1880s represented a turning point for Duveneck. Under the influence of his wife and sunny Italy, Duveneck lightened his painting style and smoothed out his brushwork. Some of these paintings were featured in a 2012 exhibit, "Americans in Florence," in the Palazzo Strozzi, along with the work of his American colleague John Singer Sargent (1856–1925). It was Sargent who, at an evening affair in London, referred to Duveneck as "the greatest brush of our generation." After the death of his wife, Duveneck returned to Cincinnati where he worked on her effigy with the help of sculptor Clement Barnhorn. He continued to do portraiture in the 1890s. Duveneck's subjects included his family in Covington, but his production of art slowed. Critics have attributed this decline to a period of demoralization after the loss of his wife.

The turn of the century marked other changes for Duveneck. He began teaching at the Cincinnati Art Academy, where he became a legendary figure among his students. His teaching methodology stressed fundamentals and encouraged qualified students to seek their individual approaches to art. He introduced life drawing to Cincinnati both as a working artist and as a teacher. His nude paintings, meditations on the beauty of the female figure, portray subjects with pearl-like skin tones. In this

Frank and Elizabeth Boott Duveneck. Courtesy of the Kenton County Public Library, Covington.

Henry Farny worked as an illustrator for many national magazines and publications, including *Harper's Weekly*. Here, he depicted spectators on the Covington and Cincinnati Suspension Bridge (now the John A. Roebling Suspension Bridge) watching the devastation of the 1883 flood. Source: *Harper's Weekly*, 3 Mar. 1883.

period, Duveneck started spending summers in the seaside village of Gloucester, Massachusetts, where critics say he launched into a new and final artistic period influenced by Impressionism. More than 60 canvases have been located that reflect the region's boating culture, fisher folk, and wave-lashed coves. He is regarded as a pivotal figure in the establishment of the still-thriving art colony in Cape Ann.

Barnhorn, a friend and Duveneck colleague at the Art Academy, coached Duveneck in creating a statue of a seated Ralph Waldo Emerson, which is displayed at Emerson Hall at Harvard University, and a bust of Charles Eliot, Harvard's president. From 1905 to 1910, Duveneck worked on four panels of murals for the Blessed Sacrament Chapel in the Cathedral Basilica of the Assumption in Covington. A triptych of panels, dedicated to his mother, features the practice of sacrifice under the Old Law, the Crucifixion, and its equivalent under the New Law of Christianity. A final one, high on the west wall, touches on another sacramental theme, titled *Christ at Emmaus*.

Often recognized for his works, Duveneck received a specially struck gold medal for his contribution to art and art education by a group of international jurors at the 1915 Panama-Pacific Exhibition in San Francisco, California.

Legions of mourners from here and abroad saluted him and his works at his passing in 1919. He is buried in Covington's Mother of God Cemetery under a tomb constructed by his friend Barnhorn.

Henry F. Farny (1847–1916), born in France, immigrated to America as a youngster with his parents. In 1859 the family came down the Ohio River in a 28-foot-long raft to Cincinnati. He worked as a decorator for Gibson Greeting Cards Inc. and drew sketches of Civil War scenes that landed him a position with *Harper's Weekly,* where he worked periodically for 35 years. After the war, he studied in Rome under Thomas Buchanan Read (1822–72), and in Germany, where he met the western American landscape artist Albert Bierstadt (1830–1902). During his studies in Munich, Farny became friends with Frank Duveneck. After Farny and Duveneck returned to Cincinnati in 1874, they worked on a large oil painting of Joan of Arc titled *Prayer on a Battlefield.* In 1875 Farny traveled to Europe with Duveneck and other artists but returned to America and worked as an illustrator for *McGuffey Readers, Harper's* magazine, and *Century* magazine. In the 1890s he moved to Covington to a duplex at 1029 Banklick Street and worked in a studio at 1031 Banklick Street. During the 1890s, he began spending time in the West, where he painted, collected Indian artifacts, and was adopted by the Sioux. His most famous paintings, depicting what Farny saw in the West, are *Song of the Talking Wire, Coming of the White Man, The Last Vigil, Tellers of the Plain,* and *Hiawatha.*

Two sculptors, Clement Barnhorn (1857–1935) and John C. Meyenberg (1860–1936), each had strong Covington connections. Though born in Cincinnati, Barnhorn sculpted the *Madonna and Child* in Bedford limestone, which occupies the niche in the front of the Cathedral Basilica, and a tympanum, the *Assumption of Mary,* in the arch area above the main door. He created the impressive *Crucifixion Group* in bronze situated near the Duveneck memorial in Mother of God Cemetery. Duveneck's closest friend in his later years, Barnhorn taught at the Cincinnati Art Academy and worked in a studio adjacent to Duveneck's. In the 1890s, his studies had taken him to Paris, where he learned from such greats as William-Adolphe Bouguereau (1825–1905). He won honorable mention from the Paris Salon of 1895 for his sculpture *Magdalen* and a silver medal from the 1900 Paris Exhibition for another *Magdalen.* In America his works were recognized by the Pan-American Exposition in Buffalo, New York, in 1901 and by the 1904 Louisiana Purchase Exhibition in St. Louis, Missouri. His sculptures adorn numerous buildings and churches, including a series of military figures that stretch across the frieze of the Hamilton County Memorial Building, maenads at the Queen City Club in Cincinnati, and bas-reliefs embedded in the Wilson Memorial Building at the University of Cincinnati.

John Meyenberg (1860–1936), born in Tell City, Indiana, to Anthony and Catherine Meyenberg, immigrants from Switzerland, lived most of his life in Covington. He attended the Cincinnati Art Academy and the École des Beaux Arts in Paris. He designed a plaque memorial and bas-relief of General Henry Clay Egbert at the base of the water tower that marks the main entrance to the former US Army post at Fort Thomas, Kentucky. The plaque commemorates Egbert's battle death in the Philippines, where he commanded the Twenty-Second Infantry Regiment. Meyenberg completed a bust of politician Theodore F. Hallam, who coined the term "yaller dog Democrat," which was installed in the old Kenton County Courthouse, and a sculpture of Nancy Hanks Lincoln for Lincoln Park in Indiana. He was listed in *Who's Who in American Art* in 1905. Meyenberg lived at 127 East Third Street in Covington, and died of pneumonia on December 16, 1936, at the Kenton County Infirmary.

Dixie Selden (1868–1935) moved with her parents from Cincinnati to Covington when she was an infant. For most of her life, she lived and worked in Covington, frequently departing for lengthy periods of study and later for adventurous and productive trips to Europe and the Far East. Henry Farny and Frank Duveneck took interest in her work and encouraged her in the vanguard of American women artists. In 1890 she exhibited paintings at the Covington Art Club. She studied with Duveneck that year and later with William Merritt Chase (1849–1916) in Venice, Italy, and in Britain with landscape and marine artist Henry Snell (1858–1943). Her portraits and landscapes, reflecting the Impressionist style, were exhibited in New York City, Philadelphia, and Chicago. Active in art and club circles, she painted portraits of leading figures in Greater Cincinnati, including philanthropist Mary

M. Emery. Her last portrait was of a youthful John Whitley Menzies of Fort Mitchell, Kentucky, who later worked as an editor for the *Cincinnati Enquirer*.

The ceramic tile artist and lithographer Charles J. Dibowski (1875–1923) moved to Covington as a child and studied at the Cincinnati Art Academy. He worked at Rookwood Pottery, two other Ohio potteries, and Donaldson Lithographing Company in Newport, Kentucky. Charles J. McLaughlin (1888–1964) studied under Frank Duveneck and became a multitalented artist and architect. He painted portraits, animals, and scenes of everyday life. After continuing his education at the Sorbonne in Paris, France, McLaughlin worked for Rookwood Pottery. He designed and built the family home at 321 Riverside Drive in Covington. Mary M. Nourse (1870–1959), a niece of the internationally known artist Elizabeth Nourse, attended the Cincinnati Art Academy and worked at Rockwood Pottery. She learned wood carving from Ben Pitman, an uncle by marriage, and taught jewelry making. She lived for years on East Fourth Street in Covington and was a member of the Covington Art Club for 55 years. Mary Bruce Sharon (1878–1961) led a privileged

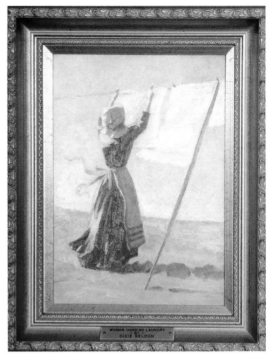

Woman Hanging Laundry by Dixie Selden. Courtesy of the Kenton County Public Library, Covington.

life as a granddaughter of Covington's Colonel Henry Bruce Jr., a Confederate sympathizer and businessman. She married Fredrick Sharon, a real estate broker, and later lived in New York City and Connecticut before taking up painting at age 71. Her childhood in Kentucky highly influenced her primitive (childlike) works, including *Christmas Dinner in Covington*.

Another Duveneck student, Aileen McCarthy (1886–1982) of Covington, owed her academic work in art to Duveneck's generosity. He paid her tuition so that she could continue studying with him at the Cincinnati Art Academy. One of her best-known portraits was of Duveneck. She also studied with Clement Barnhorn, artist George Elmer Browne (1871–1946), and landscape artist Emile Gruppé (1896–1978) of Gloucester, Massachusetts. Her early training came as a student of Sister Josina Whitehead of the Sisters of Charity of Nazareth at La Salette Academy at Seventh and Greenup Streets in Covington. After graduating from La Salette in 1905 and completing studies at the art academy, she taught at La Salette from 1915 to 1923 and opened her own studio at her home at 321 West 21st Street. Among her students was Covington-born Bernard L. Schmidt Jr. (1937–2013), a painter and sculptor, who became chairman of the art departments at Thomas More College in Crestview Hills, Kentucky, and at Xavier University in Cincinnati. She continued to draw in her retirement and died at age 96 in St. Charles Care Center in Covington.

Aileen McCarthy, circa 1970. Courtesy of the Kenton County Public Library, Covington.

Bernard L. Schmidt Jr. (1937–2013), born in Covington, was so good at drawing that as a second grader he took private lessons

from Aileen McCarthy. He performed well in academics, earning his bachelor's degree from Thomas More College (then called Villa Madonna College) and his master of arts from Notre Dame University and master of fine arts from Ohio State University. To family, friends, and colleagues, Schmidt was "the artist," a burly yet peaceful man who spoke his mind and possessed a unique vision that was reflected in his works. He painted and sculpted, including ironworking, and took an interest in creating coins and medallions. His commissioned sculptures include one of St. Thomas More at the Crestview Hills campus of Thomas More College and of St. Francis Xavier, which marks an entrance at Xavier University (XU) in Cincinnati. Schmidt taught at Thomas More College and served as chairman of the art department at XU. The son of Bernard and Rosemary Decker Schmidt of Covington, the artist and his family have traced Rosemary's lineage to a possible link with Frank Duveneck, born Frank Decker.

David Brean (1925–2004), the son of Reverend William L. and Bessie E. Brean, was a 1943 graduate of the African American William Grant High School in Covington. His art career began as a senior high school student when he fashioned a piece that became part of an exhibit at the Cincinnati Art Museum. After serving in the US Army during World War II, Brean earned degrees from the University of Cincinnati and a master of fine arts from Columbia University in New York City. He was one of 51 students to receive a John Hay Whitney Foundation Scholarship. Later, he became director of the visual arts department at the Harlem School of Arts in New York City and was a teacher there. Brean's works have been exhibited in Cincinnati and in New York City.

Darrell Brothers (1931–1993), a widely respected painter, served as chairman of the art department at Thomas More College. Previously he taught at Taft High School in Cincinnati and at the University of Kentucky's Northern Community College. Brothers studied at Herron School of Art in Indianapolis, Indiana, and earned degrees from Ball State University and Indiana University, Bloomington. Though he specialized in painting, Brothers was also respected for his printmaking and drawing. His works are exhibited in museums in Alabama, Indiana, Iowa, Kentucky, Ohio, and Virginia as part of various university collections.

Mike Maydak, a 2004 bachelor of fine arts graduate of Northern Kentucky University, adapts his art talents to mingling the painting technique of impasto impressionism with his flair for creating graphic comics. His subject matter is varied, from pop culture figures to the classics. Maydak sells his original paintings and prints at comic book and pop culture conventions throughout the United States. He illustrated a comic book, *The Blackbeard Legacy,* and has more recently researched Kentucky's pioneer history, resulting in *1782: The Year of Blood.* For his drawings, the Kentucky Arts Council awarded Maydak the Al Smith Individual Artist Fellowship in 2007. He operates a studio at 111 West 11th Street in Covington and a studio shop on Monmouth Street in Newport, Kentucky. His work was featured in the July/August 2013 edition of *Artist's and Graphic Designer's Market* magazine.

Covington-born David Rice trained as a commercial pilot at Eastern Kentucky University, with a minor in philosophy, and has taken up art with a passion. He lives in Covington and combines his love of art with his work at a company he founded, Nuts & Bolts, which fuses his carpentry and restoration skills with art. He often works in mixed media, and he has completed projects of stained glass and works containing computer parts. He was the chief artist for the Henry Farny Sculpture Park at Banklick and Robbins Streets in Covington and produced the metal circle and centered dot that marked many of Farny's paintings.

Rick Hoffman, a graduate of William & Mary College in 1984, operates Covington Clay at 16 West Pike Street, where he has conducted pottery classes since 2008. His work is, he says, "mostly known for brightly colored vintage images fired into pots, often with snarly comments." Potter Janet Tobler, originally from New England and apprenticed in Oslo, Norway, has a studio in Covington at 1111 Lee Street. She specializes in decorative tiles and sells them at art fairs. Jackie Sloan, a self-taught specialist in mosaics, operates the Left Bank coffee shop at Seventh and Greenup Streets in Covington. She worked with Rosemary Topie, a graphic designer educated at Northern Kentucky University, on the public arts project in Covington that features mosaic benches and signs. Topie's work was accepted by the Society of American Mosaic Artists show in 2008. Mark Kohlhas operates a pottery store, in connection with Mind and Matter Studio, in Covington at 11 West Pike Street.

Michaels Art Bronze Company

Michaels Art Bronze Company moved to 230 Scott Boulevard in Covington in 1914 from Cincinnati. In its heyday, it produced everything from parking meters, signs, post office equipment, and pinball machine parts to fine works of art in bronze, aluminum, and stainless steel. The company later moved to Kenton Lands Road in Erlanger. In 1958, the firm produced a 250-ton sheath of gleaming stainless steel that encased Chicago's Inland Steel building and won national attention. Michaels Architectural Inc., a successor corporation, was acquired in 1991 by Crescent Designed Metals and transferred to Philadelphia, Pennsylvania.

Outdoor Art
COMPILED BY PAUL A. TENKOTTE

ARTIST	OUTDOOR ART	DATES AND NOTES
Clement Barnhorn	Crucifixion statue grouping, Mother of God Cemetery, Latonia	1915
Clement Barnhorn	Frank Duveneck tomb, Mother of God Cemetery, Latonia	ca. 1923–25
Clement Barnhorn	Assumption of Mary sculpture in tympanum above front entrance; Madonna and Child statue in niche at front entrance, Cathedral Basilica of the Assumption, 12th St. and Madison Ave.	1914 (Assumption of Mary); 1912 (Madonna and Child)
Ken Bradford	Daniel Carter Beard and Boy Scout statue, E. 3rd St.	1988
Carl Brothers (stonemasons Joseph and John Carl)	Gargoyles and acroteria atop the Cathedral Basilica of the Assumption, 12th St. and Madison Ave.	1908–10
Morris Coers	Re-creation of Holy Land landmarks, including the tomb where Jesus was laid; Garden of Hope, 599 Edgecliff Dr.	1958
Robert Dafford	Roebling Murals, Covington Ohio River floodwall	2002–08
George Danhires	James Bradley statue, Riverside Dr.	1988
Eleftherios Karkadoulias	Goose Girl Fountain, 6th and Main Sts.	1980

Robert C. Koepnick	Chief Little Turtle statue, Riverside Dr.	1988
Robert C. Koepnick	Simon Kenton statue, Riverside Dr.	1988 Donors: Mr. & Mrs. R. C. Durr
Matt Langford	General Leonard Covington statue, E. 11th St,	Donors: Oakley and Eva Farris
Matt Langford	Frank Duveneck statue, 7th, Pike, and Washington Sts.	2006 Donors: Oakley and Eva Farris
Matt Langford	Korean War Memorial, Linden Grove Cemetery	2013 Donors: Oakley and Eva Farris in honor of Sgt. Clofus O. Farris
Matt Langford	Abraham Lincoln statue, Kenton County Public Library, 5th and Scott Blvd.	2004 Donors: Oakley and Eva Farris
Franz Mayer Studio, Munich, Germany	Statues of Saints Peter and Paul, and two mythological lions, Mother of God Church, W. 6th St.	1922–23
John C. Meyenberg	Pediment of Minerva above door, Carnegie Visual and Performing Arts Center, Scott Blvd. and Robbins St.	1904
Richard Miller	John Augustus Roebling statue, Riverside Dr.	1988 Donors: Matthias Toebben and family
Petit and Fritsen (Aarle-Rixtel, Netherlands)	Glockenspiel, Carroll Chimes, Goebel Park	1979
Michael Price	Mary B. Greene statue, Riverside Dr.	1988
Carl Ludwig Schmitz	Frieze sculptures depicting horse breeding and tobacco, US Post Office, 7th St. and Scott Blvd.	1940–41
Elliot and Ivan Schwartz, Studio Eis	John James Audubon statue, Riverside Dr.	1988

ARCHITECTURE

The very first houses in Covington were vernacular-style, simple wood-frame structures and log cabins, as the first residents were just settling and finding a way of life on the land. As Covington was established and the first lots near the river were sold for development, more substantial buildings were built and the story of Covington, as told through its buildings, began.

The first few substantial buildings at the Point, in what is today the Licking Riverside neighborhood in Covington, took on the Federal style, a popular architectural design of the Colonial east coast, where many of the settlers came from. Built circa 1815, the Carneal House (also called the Gano-Southgate House) on East Second Street, is the oldest standing house in Covington. It showcases the classic simple ornamentation so definitive of the Federal style. The symmetrical home has a beautiful two-story portico entry with fanlights and ornate bracketed cornices that were popular in the Federal style.

As immigrants started arriving in Covington, the residential area grew outward through the 1840s, and a small commercial area became established in what is today Roebling Point. The Greek Revival style became the prominent mode of domestic architecture in Covington, as well as the rest of the nation, between 1820 and 1860. Greek Revival construction invoked thoughts of the new democracy of the United States by modeling buildings after the temples of the classical Greeks, the original founders of democracy. This style spread with the use of pattern books that showed plans and construction details. It made its appearance most prominently in two-story, brick row houses with simple dentil molding at the cornices, and a templelike front, with either classical columns or pilasters marking the entrance.

With the booming development of steamboats and railroads in the 19th century, more materials, craftsmen, and money came into the area. Elaborate Greek Revival homes were built using the granite, marble, and stone that were imported along these routes. These stately homes can be seen along Covington's Riverside Drive, and one of the most impressive, the Rugby, is a little bit south on Sanford Street. The Rugby is a picture-perfect example of

The Rugby, Sanford Street. Photo by Dave Ivory, 2014.

an elegant and grand Greek Revival–style building that boasts symmetry and simple, somewhat austere details. This period also brought mass immigration from Europe; residential and commercial construction boomed. The technological advancements of the day were provided by local foundries that enriched the area with mass-produced cast-iron, wrought-iron, and pressed-tin ornamentation.

The Rugby
BY BILL STOLZ

Since its construction in the 1840s, 622 Sanford Street, better known as the Rugby, has served as both a place of learning and a private residence. The structure originally housed Reverend William Orr's Covington Female Seminary. Henry Bruce Jr., a Covington businessman, purchased the property in 1853. John Roebling was invited to stay with the Bruce family in 1856. During the Civil War, the Withers family, prominent tobacco merchants, acquired the home, and Sallie Withers Bruce Morris, widow of Confederate financier Eli Bruce, retained ownership until 1907. On April 16, 1868, the remains of Confederate General John Hunt Morgan lay here in repose. The Rugby name was bestowed on the house when the Rugby School moved there in 1898. The school closed in 1906, and the property was sold shortly thereafter. For much of the 20th century, the building served as apartments. It has since been fully restored as condominiums.

Starting in the 1860s, the influence of new technology, coupled with a growing population of German craftsmen familiar with European architectural forms, caused the Italianate style to become the most popular building style in both Covington's residential and commercial buildings. Covington grew quickly, expanding westward (toward what we now know as the Mutter Gottes and MainStrasse neighborhoods), and southward, along Madison Avenue (the Eastside, Helentown, and Austinburg neighborhoods), to accommodate the growing population. Neighborhood streets were lined with block after block of brick Italianates. Usually two- or three-story structures, with low-pitched roofs supported by decorative brackets, most Italianate-style buildings were designed on a symmetrical square or rectangular floor plan, although asymmetrical examples are not uncommon. Stylistically in Covington, most Italianate buildings are tall and narrow, with tall, narrow one-over-one or two-over-two sash windows. Arched hoods often decorate windows and doors. Simple, one-story porches are common features, and may cover only the entrance or stretch across the primary façade. In Covington, Italianates often also took on a form that came to be known as the Covington Townhouse. The Covington Townhouse featured a main entrance on the side of the house, located near the central staircase. This provided for a two-bay standard form, where the front room would be the entire width of the house, increasing the usable space of the building.

Other Victorian architectural styles, such as Second Empire and Queen Anne, started becoming popular in the mid- and late-19th century respectively. These styles also took advantage of the Covington Townhouse form to maximize space in the house in very

This home on Greer Street exemplifies the Covington Townhouse form. Photo by Dave Ivory, 2014.

dense urban neighborhoods that were continuing to be developed at a rapid pace. While not as popular as the Italianate, these other two subsets of Victorian architecture are also well represented throughout the urban core of Covington. Second Empire structures are defined by a mansard roof, which is a double-pitched roof designed to provide more room and light in the attic space. As the century came to a close, a more organic and ornate style known as Queen Anne emerged. This style, which is the stereotypical image of Victorian architecture, is asymmetrical both in plan and elevation. Usually at least two stories tall, Queen Anne–style houses are distinguished by a steeply pitched roof, large elaborate porches, a variety of sidings, elaborate gingerbread spindle work, patterned slate roofs, textured walls, rich paint colors, and stained glass windows. Not every Queen Anne exhibits all of these elements— many more-restrained versions are seen throughout Covington's residential areas, especially in neighborhoods like

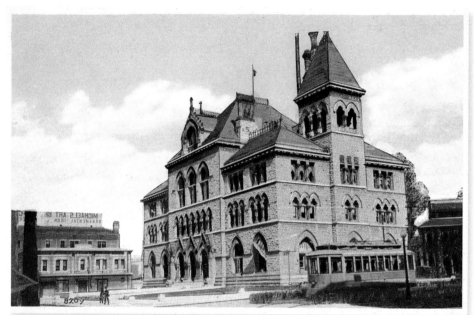

Peaselburg, Austinburg, Wallace Woods, Levassor Park, and Latonia.

As the 19th century came to a close, the Queen Anne style slowly started to wane. By the early 20th century, there was a reaction against the ornateness of the Victorian styles. A simpler style, modeled after colonial sensibilities, took front stage. The Colonial Revival syle was often much more ornate, grandiose, and larger than its historic counterparts, while

ABOVE: Covington's Victorian Gothic–style US Post Office and Federal Building was located on the block between Third Street, Scott Boulevard, and Park and Court Streets. It was designed by William Appleton Potter, supervising architect of the US Treasury, with M. P. Smith acting as the local superintendent of the project. Dedicated in 1876, it was demolished in 1968, and a new county high-rise courthouse was built in its place. RIGHT: These stately Shingle-style homes are on Greenup Street. Photo by Dave Ivory, 2014.

still retaining restrained and symmetrical elements, such as fanlights and centered, columned entrances associated with colonial architecture. It was especially favored for residential construction in Covington.

Contemporary with the Colonial Revival, the neoclassical style also heavily used classical elements, as seen in many of the bank and commercial buildings in Downtown Covington. Older, smaller buildings were razed in downtown to make room for larger more substantial neoclassical buildings, such as Coppin's Department Store.

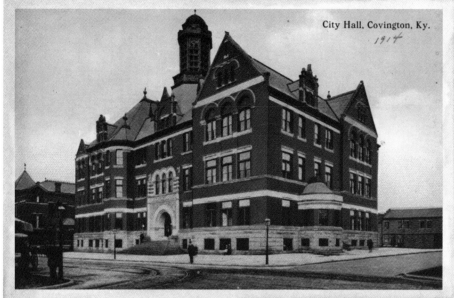

City Hall, Covington, Ky.
1914

ABOVE: Kenton County Courthouse and Covington City Hall, Third and Court Streets. Designed by the architectural firm of Dittoe and Wisenall, it was dedicated in 1902 and demolished in 1970. RIGHT: Louis E. Dittoe and Bernard T. Wisenall, of Dittoe and Wisenall, architects of the old Kenton County Courthouse and Covington City Hall. Source: LaBree, Benjamin, ed. *Notable Men of Cincinnati at the Beginning of the 20th Century (1903)*. Louisville, KY: Geo. G. Fetter Company, 1904. BELOW: First National Bank, northwest corner of Sixth Street and Madison Avenue, designed by Harry Hake with Lyman Walker and George Schofield. Courtesy of the Kenton County Public Library, Covington.

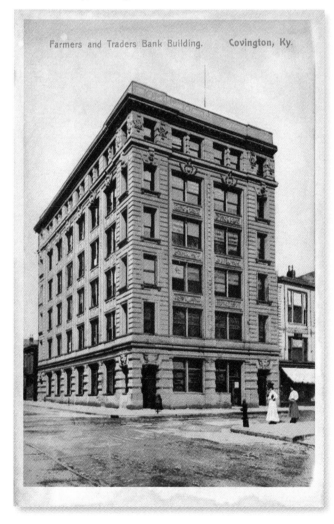

Farmers and Traders Bank Building. Covington, Ky.

A form that was also popularized during this early 20th-century period was the American Foursquare. This style created very livable homes with larger footprints. Their first floors were divided into quadrants—hence many simply call them Foursquares. The Foursquare gained much popularity through mail-order catalogs and pattern books, which standardized design and construction.

The mail-order system also popularized the Craftsman Bungalow and Tudor Revival styles of the 1910s to the 1940s. Concentrated in areas such as Botany Hills, Peaselburg, and Latonia, these architectural types were also early infill styles (that is, new construction on older lots in established neighborhoods) and can be spotted in MainStrasse and Licking Riverside. The Craftsman style is typically a one- to two-story building with a low-pitched, gabled roof with wide, unenclosed eave overhangs, exposed roof rafters, and large porches. The Tudor Revival featured one- to two-story buildings, with steep roofs and a "heart" or "shield" that was prominent on the front façade. The main hallmark of both of these

styles was the transition to smaller, less formal homes, simple in detail but with a nod toward handcrafted elements.

As the 20th century progressed and the population of Covington stabilized, the building boom slowed. The Monte Casino and the Kenton Hills areas of Covington were two exceptions, as the midcentury modern style of the 1950s and 1960s is exemplified in many homes (especially one-story ranch homes) here. As the building industry became more standardized, a vernacular approach to design became more popular, and the ornateness and detail that was seen in the 19th century and the beginning of the 20th century gave way to sleek and simple designs that were mechanized in production.

With the completion of I-75/I-71 in the early 1960s, cutting through the Lewisburg neighborhood of Covington, the building industry moved out to the suburbs, concentrating on new tract development. However, starting in the 1980s, a new concentration of development began along the riverfront of Covington. This development has witnessed the construction of RiverCenter, hotels, the Northern Kentucky Convention Cen-

The Ascent at Roebling's Bridge, by internationally renowned architect Daniel Libeskind. Photo by Dave Ivory, 2014.

ter, and other office and residential developments. It uses large steel construction with contemporary architecture, focusing on modern materials. The most recognized and acclaimed piece of this new development has been the blue and white modern condominium development, the Ascent at Roebling's Bridge, designed by world-renowned architect Daniel Libeskind.

As Covington has developed over two centuries, many beautiful residential and commercial buildings have dotted the landscape. Residents and visitors alike remain awed by the historic and diverse skyline of Covington, with its spires, crosses, and towers. Mostly built in the Gothic, Romanesque, or Italian Renaissance architectural styles, these churches are the centerpieces of the neighborhoods that surround them. They have beautiful artwork in their stained glass windows and are living testimonies to the craftsmanship and attention to detail within their interiors. The two most recognizable churches in the skyline are Mother of God Catholic Church and the Cathedral Basilica of the Assumption. Mother of God, completed in 1871, is a prime example of the Italian Renaissance Revival style. It has curved Roman arches and a symmetrical façade, with twin towers. While ornate, with fabulous artwork on the interior, the exterior has an austere simplicity in its symmetry and simple details. In contrast is the Gothic Revival style that is seen in the Cathedral Basilica of the Assumption. Construction on the cathedral started in 1894 and was finished in 1915; however, the originally planned towers are still lacking to this day. Even with the plans not fully executed, the building stands as an example of the Continental Gothic Revival style, with flying buttresses that reach toward the heavens. There are large Gothic or pointed arches on the ornate and highly decorated front façade, as well as throughout the large stained glass windows on the sides of the building.

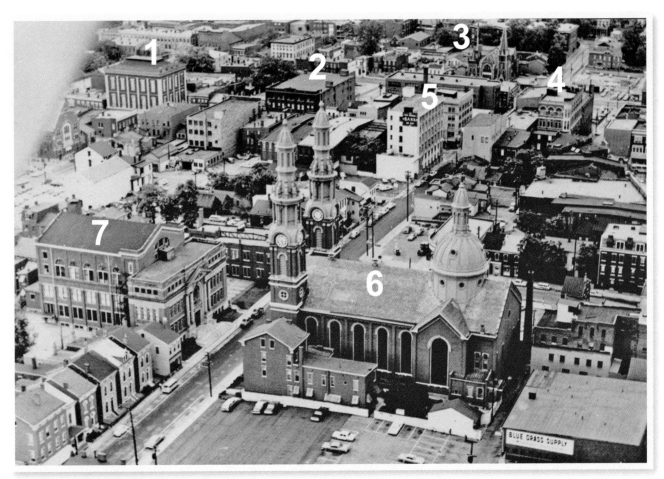

ABOVE: Aerial view of Mother of God Church and Downtown Covington, circa 1960s, showing 1) Odd Fellows Hall; 2) Marx Building; 3) Scott Street Methodist Church (since demolished); 4) Eilerman Building; 5) First National Bank; 6) Mother of God Catholic Church; and 7) Mother of God School (since demolished). Photo courtesy of Paul A. Tenkotte.

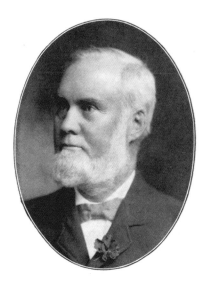

ABOVE, LEFT: Samuel Hannaford, architect of many important buildings in Covington. Source: LaBree, Benjamin, ed. *Notable Men of Cincinnati at the Beginning of the 20th Century (1903)*. Louisville, KY: Geo. G. Fetter Company, 1904. ABOVE, CENTER AND RIGHT: George Selves Werner and John Scudder Adkins, architects of the Arthur Apartments, Sixth and Greenup Streets. Source: LaBree, Benjamin, ed. *Notable Men of Cincinnati at the Beginning of the 20th Century (1903)*. Louisville, KY: Geo. G. Fetter Company, 1904.

Aerial view of the Eastside, circa 1960s, showing 1) Wadsworth Electric Manufacturing Co.; 2) Madison Avenue Baptist Church; 3) Columbus Hall, Villa Madonna College—VMC (former Knights of Columbus Hall; VMC moved to Crestview Hills, Kentucky, in 1968 and was renamed Thomas More College); 4) Covington Latin School; 5) Cathedral Basilica of the Assumption; 6) Citizens Telephone Company; 7) Bishop Howard School; 8) Villa Madonna College (since demolished); and 9) St. Joseph Catholic Church (since demolished). Photo by Raymond E. Hadorn, courtesy of Paul A. Tenkotte.

Starting with simple vernacular buildings along the river, Covington has developed over its two centuries into a city filled with architectural gems. There are famous architectural masterpieces—historic ones such as Mother of God and the Cathedral—as well as more modern buildings like the Ascent. However, many of the buildings in Covington are historic gems of residential and smaller commercial buildings that tell the story of the development of Covington, from the river all the way to the southern edges of the city.

The Architects of Our Heritage
COMPILED BY PAUL A. TENKOTTE AND DAVID E. SCHROEDER

ARCHITECTS	BUILDING	CONSTRUCTION DATES / NOTES
Carl Bankemper	Glenn O. Swing Elementary School	unknown
Carl Bankemper	Golden Tower, W. 11th St.	1972
Carl Bankemper	Internal Revenue Service Center, W. 4th St.	1967

Carl Bankemper	Kenton County Building, 3rd St. and Scott Blvd.	1969-70
Carl Bankemper	Latonia Elementary School	1973
Carl Bankemper	Panorama Apartments, W. 4th St. (Brent Spence Square)	Panorama East, 1967; Panorama West, 1972
Carl Bankemper	Rosedale Manor, new 1992 building	1992
John H. Boll	Fifth District School, 18th and Holman Sts.	1902
Boll and Taylor	Covington Public Library, Robbins St. and Scott Blvd.	1902-04; currently The Carnegie
Boll and Taylor	Woodford Apartment Building, Greenup St.	1897
Thomas J. Collopy	Knights of Columbus, Madison Ave.	1923; currently Senior Services of Northern Kentucky
Leon Coquard	Cathedral Basilica of the Assumption, Madison Ave.	1894-1901
Crapsey and Brown	Madison Avenue Presbyterian Church, Madison Ave.	1886; demolished 1963
Crapsey and Brown	Scott Street Methodist Church South, Scott Blvd.	1895-96; demolished ca. 1970
Crapsey and Brown	St. John Episcopal Church, Scott Blvd.	1890
Alfred B. Daily	Doctor's Building, southeast corner of 7th St. and Scott Blvd.	1929
David Davis	west façade of the Cathedral Basilica of the Assumption, Madison Ave.	west façade, 1908-10
David Davis	addition and new front elevation to the rectory of the Cathedral Basilica of the Assumption, 12th St. and Madison Ave.	1912
David Davis	Kenton County Infirmary (old Rosedale Manor), Latonia	1907; demolished
David Davis	Latonia Christian Church, Decoursey Ave.	1923
David Davis	St. Augustine Catholic Church, W. 19th and Euclid Sts.	1914
David Davis	St. Patrick School, Philadelphia St.	1913; demolished
Chester Disque	Covington Board of Education Building, E. 7th St.	1938

Chester Disque	1931 addition to the Eleventh District School, West Covington	1931 addition; converted into apartments
Chester Disque	Fourth District School, Scott Blvd. and 15th St.	opened in 1940; converted into apartments
Chester Disque	old Latonia firehouse, Southern Ave. and Tibbatts St.	1938
Dittoe and Wisenall	Kenton County Courthouse and Covington City Hall, 3rd and Court Sts.	dedicated in January 1902; demolished in 1970
Dittoe and Wisenall	First Christian Church, W. 5th St.	1893–94
Dittoe and Wisenall	Kentucky Post Building, Madison Ave.	1901
Dittoe and Wisenall	New Shinkle Row, commercial buildings, 11–17 Pike St.	1895
Thomas Harlan Ellett, consulting architect and winner of national competition; Louis A. Simon, supervising architect	Federal Post Office, Scott Blvd. and 7th St.	1940–41
James Gilmore	Coppin's Department Store, northeast corner of 7th St. and Madison Ave.	1907–10; built by the Ferro Concrete Construction Company
Isaac Graveson, builder	Odd Fellows Hall, northeast corner of 5th St. and Scott Blvd.	1857; reconstruction after 2002 fire
Harry Hake with Lyman Walker and George Schofield	Farmers' and Traders' National Bank, northwest corner of 6th St. and Madison Ave.	1904; currently Republic Bank
Harry Hake	Citizens Telephone Building, southeast corner of 11th St. and Scott Blvd.	1923
Harry Hake	Liberty Theater, Madison Ave.	1923; demolished
Harry Hake	Liberty National Bank, southeast corner of 6th St. and Madison Ave.	1923; currently US Bank
Harry Hake	Stewart Home, 117 Wallace Ave.	1909
Samuel Hannaford	Covington Protestant Children's Home, 14th St. and Madison Ave.	1881–82; demolished
Samuel Hannaford & Sons	Children's Home of Northern Kentucky, Devou Park	1925–26
Samuel Hannaford & Sons	Mother of God School, W. 6th St.	1905–06; demolished 1971

Samuel Hannaford & Sons	St. Joseph Church (bell tower), 12th St.	1916 (following 1915 tornado); demolished 1970
Samuel Hannaford & Sons	St. Benedict Catholic Church, E. 17th St.	1908
Samuel Hannaford & Sons	St. Elizabeth Hospital, E. 20th St.	1914
Samuel Hannaford & Sons	Emery Row, 810–828 Scott Blvd.	ca. 1880
Samuel Hannaford & Sons	Mother of God Catholic Church, W. 6th St., new pediment between bell towers	1915 (following tornado)
Samuel Hannaford & Sons	Mutual Fire Insurance Building, Pike St. and Madison Ave.	1917
Samuel Hannaford & Sons	Citizens' Telephone Company South Exchange Building, 4th and Courts Sts.	1903–04
Robert Ehmet Hayes and Associates	Kenton County Public Library, 5th St. and Scott Blvd.	1971–74; reconstruction 2011–13 by DesignGroup, Columbus, OH
Robert Ehmet Hayes and Associates	St. Charles Lodge and Village, 500 Farrell Dr.	Village, 1985; Lodge, 1991
Charles L. Hildreth	Adam Grossman Home, 408 Wallace Ave.	ca. 1914
Charles L. Hildreth	Immanuel Baptist Church, southeast corner of 20th and Greenup Sts.	1915
Charles L. Hildreth	St. Ann School, Highway Ave.	1957
Anthony Kunz Jr.	Holy Cross Church, Church St.	1908
Kunz and Beck	St. Joseph School, Scott Blvd.	1928; later became Bishop Howard School; currently James Biggs Early Childhood Learning Center
E. C. Landberg	Scottish Rite Masonic Temple, Madison Ave.	1954–55
E. C. and G. T. Landberg	Lincoln-Grant School, Greenup St.	1931
Daniel Libeskind	The Ascent at Roebling's Bridge	2007–08
George Lubrecht	Wadsworth Electric Company, 20 W. 11th St.	1923
Frank Ludewig and Henry Dreisoerner	St. John the Evangelist Catholic Church, Pike St.	1923–34
Howard McClory	Holy Cross School, Church St.	1915
Howard McClory	St. Augustine School, W. 19th St.	1916

Howard McClory	Latonia Baptist Church, Church St.	1917
James W. McLaughlin	Motch Jewelers, 613 Madison Ave.	1871
James W. McLaughlin	Ninth St. United Methodist Church, E. 9th St.	ca. 1860s; closed
Neil A. Meehan	St. Ann Catholic Church, Parkway Ave.	1932
Seneca Palmer	Western Baptist Theological Institute, W. 11th St.	ca. 1840; demolished
Anton and Louis Piket	Anton Piket Home, 715 Bakewell St.	ca. late 1860s
Anton and Louis Piket	St. Joseph Catholic Church, E. 12th and Greenup Sts.	1854–59; demolished 1970
Louis Piket	St. Aloysius Catholic Church, W. 7th and Bakewell Sts.	1866–67; fire 1985; demolished 1985
Louis Piket	St. Patrick Catholic Church, Philadelphia and Elm Sts.	1870–72; demolished 1968
Louis Piket	Trinity Episcopal, 4th St. and Madison Ave.: Guild Hall and bell tower, baptistery, and west façade	Guild Hall, 1886; bell tower, baptistery, and west façade, 1888
Lucian Plympton	home, northeast corner of 7th and Greenup Sts.	unknown
William Appleton Potter, supervising architect; M. P. Smith, local superintendent	US Post Office and Federal Building, 3rd St. and Scott Blvd.	1876; demolished 1968
Richards, McCarty, and Bulford; 1931 addition by Chester Disque	11th District School, Parkway, West Covington	1920–22; converted into apartments
John A. Roebling	Covington–Cincinnati Bridge	1866–67; later renamed the John A. Roebling Suspension Bridge
George Roth	additions to St. Elizabeth Hospital, E. 20th St.	date unknown; currently Providence Pavilion
George Schofield	Temple Israel, 7th St.	1915; demolished 1938
George Schofield	First Baptist Church (African American), E. 9th St.	1915
Daniel Seger	Covington Fire Station No. 1, W. 6th and Washington Sts.	1898–99
Daniel Seger	Eilerman & Sons Building, northeast corner of Pike St. and Madison Ave.	1896

Daniel Seger	Daniel Seger Home, 1553 Holman St.	1893
Daniel Seger	Holy Cross Catholic Church rectory	1892; demolished
Daniel Seger	Phoenix Furniture Factory, W. 4th and Russell Sts.	ca. 1890; demolished
Daniel Seger	Pieper Block, southeast corner of Pike St. and Madison Ave.	1896
Daniel Seger	St. Aloysius Catholic Church rectory, 716 Bakewell St.	1890
J. F. Sheblessey	St. John School, Pike St.	1914; currently Prince of Peace School
Henry E. Siter	German National Bank, Madison Ave. near Pike St. (attributed to Siter)	ca. 1890
Willis P. Tharp	Kentucky Central Railroad Shops, Madison Ave. near 12th St.	1881–82
Lyman Walker	Dan Cohen Building, 22–26 W. Pike St.	1910–11; later became JCPenney Company; currently Covington City Hall
Lyman Walker	Seventh District School, 21st and Center Sts.	1910
Lyman Walker	Sixth District School, E. 19th St. and Maryland Ave.	1907
Lyman Walker	St. Stephen's Episcopal Church, Latonia	1910–11
Lyman Walker	Western German Savings Bank, 9th and Pike Sts.	1908; currently Covington Independent Schools
Lyman Walker with George Schofield	YMCA Building, southeast corner Pike St. and Madison Ave.	1913
Weber Brothers	Covington Trust Bank, northeast corner of 6th St. and Madison Ave.	date unknown; currently Huntington Bank
Weber Brothers	Holmes High School	1919
Weber Brothers	Louis Marx Furniture, Madison Ave.	1923; currently Gateway College
Weber Brothers	Madison Ave. Christian Church, Madison Ave.	1912–13
Walter and Stewart	Amos Shinkle mansion, E. 2nd St.	1860s; demolished 1920s
Walter and Stewart	Covington City waterworks (old Holly waterworks, Ohio River)	date unknown; demolished

Walter and Stewart	Covington High School, 12th and Russell Sts.	1872–73; demolished
Walter and Stewart	First Baptist Church, W. 4th St.	1871–73
Walter and Stewart	First Presbyterian Church, W. 4th St.	1871–73; demolished 1963
Walter and Stewart	First United Methodist Church, 5th and Greenup Sts.	1866–67
Walter and Stewart	Mother of God Catholic Church, W. 6th St.	1870–71
Walter and Stewart	Arthur Apartments, 6th and Greenup Sts.	1904
Bernard Wisenall	Ben Adams Insurance Building, northwest corner, 5th St. and Madison Ave.	1924
Bernard Wisenall	Trinity Episcopal: Girls Friendly Building, E. 4th St.	1927; demolished
Bernard Wisenall and Chester Disque	Old John G. Carlisle School, 9th and Holman Sts.	1937; demolished
Bernard Wisenall and Chester Disque	Third District School, W. 3rd and Philadelphia Sts.	1940; renovated with a completely new façade as an office building

SELECTED BIBLIOGRAPHY

Alexander, Mary. "Their Lives were Closely Knit." *Cincinnati Enquirer,* 14 Jan. 1934.

Bardazzi, Francesca, and Carlo Sisi, eds. *Americans in Florence: Sargent and the American Impressionists.* Florence, Italy: Marsilio, 2012.

Carter, Denny. *Henry Farny.* New York, NY: Watson-Guptill, 1978.

Cochran, Nathan. *Br. Cosmas Wolf, O.S.B.: Monk, Architect, Sculptor, Designer.* Latrobe, PA: St. Vincent Gallery, 2013.

Duveneck, Josephine W. *Frank Duveneck, Painter-Teacher.* San Francisco, CA: John Howell-Books, 1970.

Konicki, Leah. "A Look at Sears Houses in Northern Kentucky." *Northern Kentucky Heritage* 11 (2) (1995): 35–49.

Langsam, Walter E. *Biographical Dictionary of Cincinnati Architects, 1788–1940.* Cincinnati, OH: Architectural Foundation of Cincinnati, 2008. oldsite.architecturecincy.org/dictionary (accessed June 2014).

———. *Great Houses of the Queen City.* Cincinnati, OH: Cincinnati Historical Society, 1997.

McLean, Genetta. *Dixie Selden: An American Impressionist from Cincinnati, 1868–1935.* Cincinnati, OH: Cincinnati Art Galleries, 2001.

Northern Kentucky Newspaper Index. Kenton County Public Library, Covington, KY.

Tenkotte, Paul A., and James C. Claypool, eds. *The Encyclopedia of Northern Kentucky.* Lexington, KY: University Press of Kentucky, 2009.

Tenkotte, Paul A., and Walter E. Langsam. *A Heritage of Art and Faith: Downtown Covington Churches.* Covington, KY: Kenton County Historical Society, 1986.

Weldon, Alexandra Kornilowicz. "Urban Row Houses in Northern Kentucky." *Northern Kentucky Heritage* 9 (1) (2001): 39–46.

CHAPTER

7

FROM INVENTORIES TO INVENTIONS: BUSINESS AND COMMERCE IN COVINGTON

by John H. Boh and John Schlipp

EARLY BUSINESS AND COMMERCE

Covington's earliest businesses and commercial establishments relied upon transportation and trade. Thomas and Francis Kennedy's ferry transported much-needed militia and military supplies during US campaigns against American Indian forces in the early 1790s and during the War of 1812. In 1814 Kennedy sold his local land holdings to the Covington Company, which announced its first sale of town lots for March 1815. In the early years, the town's economy was largely devoid of paper money; Benjamin Leathers's general store even scripted promissory notes, in effect running a temporary bank from 1818 to 1821. Alexander Connelly, who operated a tavern on the northwest corner of Second and Garrard Streets, accommodated travelers and even welcomed General Lafayette in 1825. In 1822 copying Virginia practice, Kentucky instituted tobacco inspection. Well-known merchants at Covington's Market Space included tobacconists John B. Casey, Frederick Gedge, and C. A. Withers.

EARLY COMMERCIAL DEVELOPMENTS

After the Revolutionary War and the final removal of Indian dangers from the Ohio territory, entrepreneurs and developers increased activities in the Ohio River valley. Pennsylvanian Robert Buchanan (1797–1879) involved himself in all kinds of enterprises in Ohio before he, Charles McAllister, and others developed the Covington Cotton Factory. Buchanan also leased and operated the Covington Rolling Mill and Nail Factory, and as a commission merchant, he marketed "Covington iron, nails, and cotton yarns." Virginia-born Thomas Davis Carneal (1786–1860) involved himself in Cincinnati, Ohio, civic affairs and partnered in business with brother-in-law James Breckinridge in Louisville, Kentucky. He and wife Sarah sold lots for $5 to the cotton mill investors and land tracts for $6,200 to the rolling mill developer, John J. McNickle, of Pittsburgh, Pennsylvania.

The establishment of these two large factories was a major step in Covington's growth. The Covington Cotton Factory, east of Scott Boulevard (formerly Scott Street), operated 2,288 spindles and produced 4,000 pounds of cotton yarn and 2,000 yards of cloth daily. In 1844, with a 40-horsepower steam engine, it employed 70–100 workers, three-fourths of whom were women being paid $1.50 to $3.25 weekly. That same year, the Covington Rolling Mill and Nail Factory, between Madison Avenue and Scott Boulevard, smelted 10 tons of iron into sheet, nail, and bar iron, and produced 75 hundred-pound kegs of nails daily. In 1869, with 160 employees, total production was valued at $350,000. The plant sold 550 tons of iron in 1871, at $80 per ton, to the Maysville & Lexington Railroad.

RIVER TRADE DEVELOPS

In 1835 the Kentucky General Assembly chartered the Northern Bank of Kentucky. The Covington branch of the bank opened on the northwest corner of Third Street and Scott Boulevard in a Greek Revival edifice, which is still standing. By 1840 Covington had 2,000 inhabitants and a bank capitalized at $350,000.

Textile manufacturing underpinned economic advancement. For trading with Southern cotton producers, the English-born Thomas Woodhouse Bakewell built a factory at Third and Philadelphia Streets that manufactured hemp bags and ropes used to package cotton into 400-pound bales. He learned the river trade from his uncle Benjamin Bakewell, "the Father of flint glass making," at Pittsburgh, and from a brother-in-law who owned a sugar plantation and an interest in a mercantile house at Natchez, Mississippi.

Great quantities of agricultural products in Kentucky were driven or hauled overland and exported downriver. Among pork processors, the huge Milward & Oldershaw meatpacking plant, north of 11th Street on the Licking River, specialized in the overseas English market. In 1851–52, it packed 23,231 hogs, making it the third-largest producer in the Cincinnati area. The Lewisburg neighborhood of Covington had slaughterhouses, too, including those of Charlie Hais, Charlie Kraus & Sons, and Conrad Walz. Farmers drove thousands of head of livestock through the unpaved streets to Covington pork-packing plants.

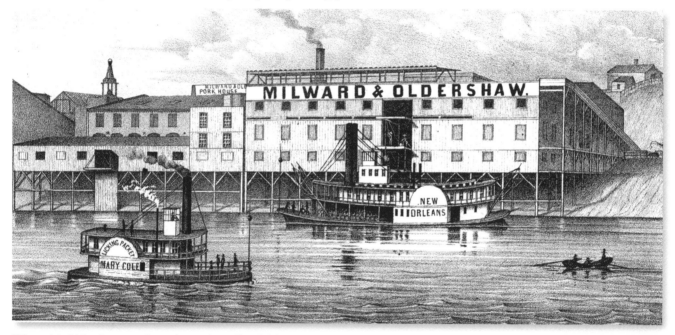

Milward & Oldershaw, pork packers, along the Licking River. Hogs were driven up the incline on the right of the building to the roof, where they were slaughtered. Then they were put on hooks and traveled by gravity down a conveyorlike system to different levels of the building for processing. Finally, the finished pork was loaded onto steamboats. Source: Cist, Charles. *Sketches and Statistics of Cincinnati in 1851.* Cincinnati, OH: Wm. H. Moore & Co., 1851.

Coal, pig iron, and other materials arrived on barges from as far away as Pittsburgh. By 1851, the Licking Rolling Mill, along the Licking River at 11th Street, was consuming 175,000 bushels of coal annually, and producing 3,000 tons of pig iron, as well as 1,000 tons of raw-metal-producing iron bars, sheets, and more. The proprietors in 1878 were Mason County, Kentucky, native Henry Worthington and German-born Ignatius Droege, whose father had owned a Ruhr River iron mill in Germany. It was the Droege family who would operate the mill into the 20th century. Another signature company was the Hemingray Glass Works, started in Cincinnati by Ralph Gray and Robert Hemingray of Pittsburgh. By 1853 they had relocated production to Second Street and Madison Avenue in Covington. Their glass works manufactured a wide variety of glass and flatware, bottles, and jars, and by 1871 it produced its own patented glass telegraph-pole insulators (US patent 122,015).

Covington was also home to breweries and distilleries. In 1844 the Scott Street Brewery was producing 190 barrels of beer per month. To quench the regional thirst in 1886, the Covington Lager Beer Brewery, at 601–629 Scott

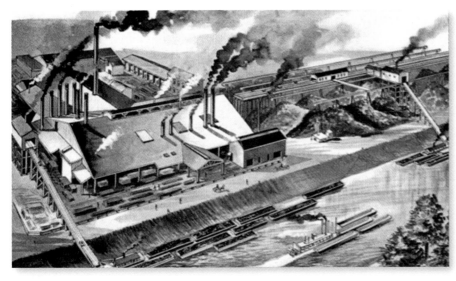

Licking Rolling Mill. Source: Engelhardt, George W. *Cincinnati: The Queen City.* Cincinnati, OH: George W. Engelhardt Co., 1901.

Boulevard, claimed a 30,000-barrel capacity. It had 30-horsepower and 60-horsepower steam engines and had installed a Linde refrigeration machine. With the coming of Prohibition, new owner Philipp Jung closed the Scott Boulevard brewery in 1918. An Irish immigrant, James N. Walsh, started the Walsh Distillery during the 1870s. Located next to the John A. Roebling Suspension Bridge in Covington, the Walsh plant was state of the art, possibly the largest of its kind in the world for both distilling spirits and redistilling (rectifying) liquor from other distillers. By 1915 Covington had 15 distillers and 14 liquor wholesalers. The New England Distillery, known for its Red Star Straight Rum label, survived Prohibition by providing rum flavoring for cigarettes and rum spirits for medicinal purposes. Its 80 years of continuous operation at 115 Pike Street ended in the 1960s.

In Covington's Lewisburg neighborhood, Julius Deglow and Charles Best started a brewery in the mid-1860s, which later was renamed Bavarian; it became Covington's largest beer maker. In 1893 this brewery had a 34-ton refrigeration plant capable of producing 100 tons of ice per week, providing ice to the saloonkeepers who sold its brand. By 1914, Bavarian beer production reached 216,000 barrels annually. With Prohibition, Bavarian turned to producing soft drinks. In 1925 the owners sold the icehouse to Frederick Ruh and others, who incorporated it as the Kenton Ice Company. In 1934 Lawrence Brueggemann founded and incorporated the "Bavarian Trucking Company," which was housed in a leased portion of the Bavarian Brewery, from which it took its name. Bavarian Trucking later become one of Northern Kentucky's largest waste services firms. With the end of Prohibition, local investors opened the Heidelberg Brewing Company on West Fourth Street in the city's Westside. Bavarian Brewery reopened in 1935, and acquired the Heidlelberg Brewery in 1949, but closed in 1966.

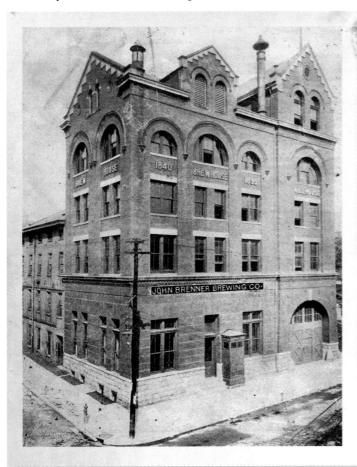

Covington's location north of the tobacco-rich Bluegrass region and its ties to railroad lines made it and Cincinnati major tobacco markets

John Brenner Brewing Company, Scott Boulevard. Source: *28th Annual Crowning Fest of the Deutsche Schuetzen-Gesellschaft of Covington, Ky.* Cincinnati, OH: Hennegan & Co., 1910.

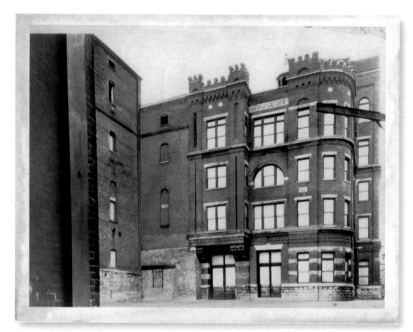

following the Civil War. At one time, Covington had 24 tobacco manufacturers. The J. Shelley Hudson Tobacco Company had a brand name called White Swan, "made of the finest White Burley filler," with a "wrapper" of "selected Virginia stock." The Lovell & Buffington Tobacco Company became the largest Covington tobacco manufacturer. By the 1950s major tobacco trading ended in Covington with the closing of the Kenton Loose Leaf Tobacco Warehouse, once a prominent tobacco auction center.

ABOVE: Bavarian Brewery. Courtesy of the Kenton County Public Library, Covington. RIGHT: Offices of the Bavarian Brewery. This building now houses Glier's Goetta. Courtesy of the Kenton County Public Library, Covington.

MADISON AND PIKE STREETS

To build a roundhouse and its repair shops, the Covington & Lexington (C&L) Railroad filled in a ravine south of 12th Street. Thereafter, Madison Avenue, for 26 blocks, became the city's most convenient and popular thoroughfare. Soon the new railroad terminal attracted five lumber dealers to the immediate area. By 1894 the James A. Brownfield Com-

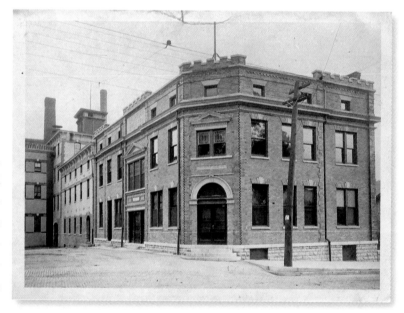

pany, a lumber mill works, had moved into its new building at 31–35 West Eighth Street. Meanwhile, the corner of Sixth Street and Madison Avenue became Northern Kentucky's banking intersection, while Pike Street and Madison Avenue became the retail hub. On Pike Street, farmers and other wagons were parked in rows. John Perkins & Company made saddles, harnesses, and trunks, and Jessie Grant sold leather.

NEIGHBORHOOD BUSINESSES

The diverse neighborhood churches, schools, civic centers, shops, and factories made Covington cosmopolitan and urban. Family life often revolved around mills and businesses, even when these businesses were short-lived. Coal, sand, and gravel barges once unloaded regularly from the Licking River on the Eastside for well-known coal suppliers and coal distributors, like Blick & Phillips and the Hatfield Company, and for local mills and factories, including the Covington Gas Works on Eighth Street. At 633 Scott Boulevard, in the heart of the African American business district, the C. E. Jones Funeral Home became the meeting place in the 1920s for Covington's African-American Businessmen's Association.

Homemakers could walk to nearby butcher shops and bakeries. Ice wagons, meat wagons, milk wagons (before dawn), craftsmen sharpening knives and scissors, and rag collectors made daily runs. By 1876 Covington had 120

Lovell & Buffington Tobacco Company, Scott Boulevard. Source: *You'll Like Covington: Covington, Kentucky, Seen through the Camera.* Covington, KY: Industrial Club of Covington, Kentucky [1912?].

LOVELL & BUFFINGTON TOBACCO COMPANY

Oldest and Largest Independent Tobacco Factory in the United States

MANUFACTURERS OF

FOUNTAIN FINE CUT BULL DOG CUT PLUG

BULL DOG TWIST WHITE SEAL LONG CUT

And Other Brands

saloons, which sometimes provided first- or second-floor space for trade unions, insurance associations, and building and loan associations. By 1956 the city's Westside had about one restaurant, lunchroom, or café per block of Main Street, all the way from the Ohio River, stretching to Ninth Street. At Sixth and Main Streets, Irishman Kern Aylward's saloon operated on one street corner and Pieck's Drug Store on another.

The Westside was also home to major industries, including the short-lived Covington Locomotive & Manufacturing Works at Philadelphia Street near the Ohio River. In the late 1850s, it produced the following locomotives: the *Covington, Cynthiana, Paris, Lexington, M. M. Benton,* and *Sam J.*

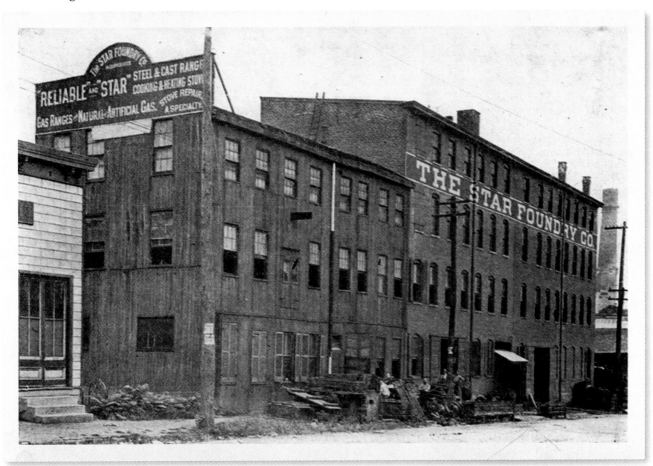

Star Foundry. Source: *You'll Like Covington: Covington, Kentucky, Seen through the Camera.* Covington, KY: Industrial Club of Covington, Kentucky [1912?].

Walker—but the company did not survive economic downturn and competition. The Mitchell & Tranter Rolling Mill was started by John Mitchell and the English-born James Tranter, said to be a pioneer in molding. In the 1880s, its 300 workers went on strike. New owners Republic Iron and Steel closed the plant around 1900, and this "mill neighborhood" lost many jobs. By 1892 the Houston-Stanwood-Gamble Company on Philadelphia Street was manufacturing steam engines and boilers for power mills. Flood levy construction after World War II closed off the river to the Montgomery Coal Company, but associates of this firm established the Doc Rusk Heating and Air Conditioning Company on West Third Street.

Around Main Street, south of the river, several foundries operated. G. W. Ball made stoves and hollowware in 1854 as the Covington Foundry, and during the 1860s as the Kentucky Stove Works. German-born George H. Klaene helped organize the Star Foundry Company, making all types and styles of stoves and ranges for Ohio, Indiana, and Kentucky markets. In 1880, the Kenton Iron Foundry & Railing Works cast grate bars and stove linings. Later known as the Martin Foundry, it forged gray iron and items like steel sewer lids. Machine shops like Sebastian Lathe also employed area residents.

In Covington's Austinburg neighborhood, George Phillips and Ignatius Droege operated the Kentucky Foundry on Burnet Street (now 16th Street) near the Licking River. Droege manufactured stoves popular in the West and the South. He cast most anything in iron, including the columns for buildings like those for the new Mother of God Church in Covington. Having joined Droege in 1867, fellow German immigrant Charles Bogenshutz bought the business in 1877, but eventually Droege's son reacquired the foundry. Nearby, boosted by World War I orders, the C. Rice Packing Company became a thriving small meatpacker on Patton Street and Eastern Avenue.

In Covington's Peaselburg neighborhood, Reverend Joseph Goebbels, a German immigrant assigned as pastor at St. Augustine Church, helped organize the American Wire & Screw Nail Company. Using techniques from Germany, the company made modern nails. It became the American Wire Nail Company on the east side of Washington between 15th and 16th Streets, but it was closed by 1894. By 1931–32 the Klaene family operated another foundry at 16th and Russell Streets. In 1948 it manufactured gray iron castings; the Precision Casting Company, at the same address, produced aluminum alloy. In 1955 a Molders and Foundry Workers Union strike hit the Martin, Star, and

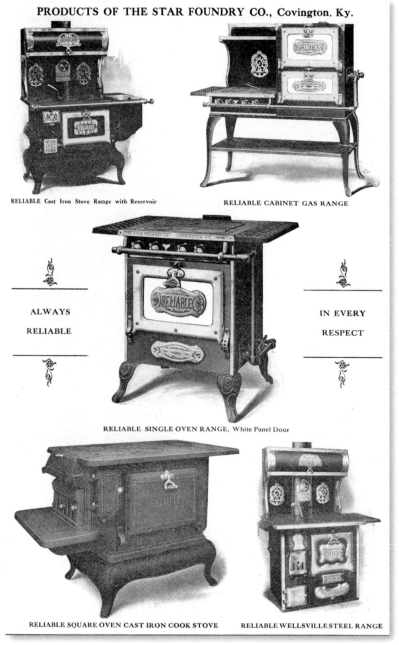

PRODUCTS OF THE STAR FOUNDRY CO., Covington, Ky.

RELIABLE Cast Iron Stove Range with Reservoir

RELIABLE CABINET GAS RANGE

ALWAYS RELIABLE

IN EVERY RESPECT

RELIABLE SINGLE OVEN RANGE, White Panel Door

RELIABLE SQUARE OVEN CAST IRON COOK STOVE

RELIABLE WELLSVILLE STEEL RANGE

Stoves produced by Star Foundry Company. Source: St. Mary, Franklin J., and James W. Brown, comp. *Covington Centennial: Official Book and Program.* Covington, KY: Semple & Schram, 1914.

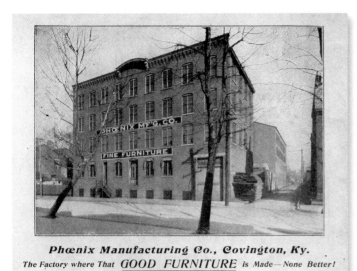

Phœnix Manufacturing Co., Covington, Ky.
The Factory where That GOOD FURNITURE is Made— None Better!

The Phoenix Furniture Company. Source: *You'll Like Covington: Covington, Kentucky, Seen through the Camera. Covington, KY: Industrial Club of Covington, Kentucky* [1912?].

Klaene foundries. Twenty years later, in 1975, a $1 million fire completely destroyed the Klaene foundry.

Rows of tall, cone-shaped kilns of the Cambridge Tile Manufacturing Company, south of 16th Street, once outlined the skyline of Peaselburg. Heinrich Binz, a German immigrant, produced samples of his experimental "glazing face brick and tile," leading to incorporation in 1889 of the Cambridge Tile Works. In 1899 the company donated 35 art tiles to the Smithsonian Institution. According to some sources, Cambridge was once the second-largest tile maker in the United States, with distribution throughout the Unites States, Puerto Rico, Mexico, and South America. Squeezed by limited space at its Peaselburg location, it moved to Norwood, Ohio. Mass producers of building brick in Peaselburg included Benhoff & Samping, Joseph J. Busse, H. H. Heidecker, Bernard Heving, Clemens Schweinefuss, Joseph Wieghaus, and T. W. Spinks, whose firm was located at 1512 Russell Street. Spinks invested $50,000–$75,000 in a large building and the so-called Scott system of brick making. In 1909 Spinks filled an order for 9 million bricks from the city of Cincinnati and another for 3 million from the Ohio Mechanics Institute.

In Covington's Latonia neighborhood, new railroads, the Latonia Race Track, and electric streetcar service attracted businesses and fostered residential neighborhoods, boardinghouses, and saloons. Stores and businesses lined streets emanating from the hub of Latonia, Ritte's Corner. Customers of the Latonia Hay & Grain Company, on Caroline Street, included residential chicken farmers. The Latonia Ice & Fuel Company took up an entire block selling uniquely both ice and coal, and it once kept a "steaming pile of horse manure" free of charge for fertilizing gardens. Latonia businesses have included Rosedale Savings & Loan, First National Bank of Latonia, Johnny's Toys, B&W Paints, Schulte Drug, and a number of auto dealerships.

Covington's funeral homes are among the oldest institutions still in business in the city. As early as 1839, the city directory listed Abraham Rose as a mortician. He also made coffins for his clients. Eventually, his business developed into the present-day Allison and Rose Funeral Home. Other established local funeral businesses operating today, and originating in Covington, include Linnemann Funeral Homes, Middendorf Funeral Home, Middendorf-Bullock Funeral Homes, and Swinder & Currin Funeral Homes.

Locally owned and operated neighborhood drugstores were essential to Covington citizens, as each pharmacist often knew the personal health conditions of the neighborhood's residents. It was not uncommon for a person to visit the local druggist first for common illnesses,

10 Ritte's Corner, Latonia, the Bird Building, circa 1920. Courtesy of the Kenton County Public Library, Covington.

even before contacting the doctor, who made house calls. Early pharmacists from the 19th century were educated by an apprenticeship to an experienced pharmacist. The first pharmacy school west of the Appalachians opened in Cincinnati in 1850. Pharmacists were predominantly male, but often the pharmacist's family provided a store's

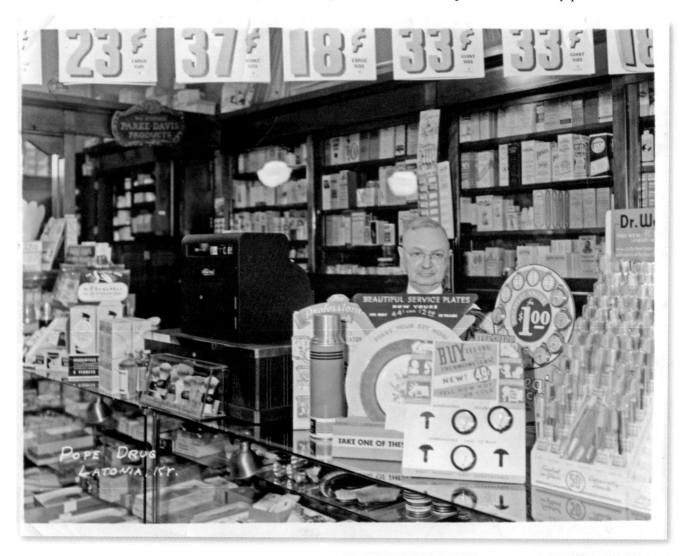

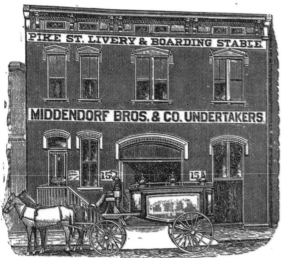

TOP: F. A. Pope Drug Store, Ritte's Corner, Latonia, pre-1941. Courtesy of the Kenton County Public Library, Covington. **ABOVE LEFT:** Middendorf Brothers & Co. Undertakers. Source: *Leading Manufacturers and Merchants of Cincinnati and Environs.* New York, NY: International Publishing Co., 1886. **ABOVE RIGHT:** Henry Morwessel, 1910, Morwessel's Pharmacy. Courtesy of Paul A. Tenkotte.

support staff. Henry Morwessel (an 1883 graduate of the Cincinnati College of Pharmacy) operated his practice at various Covington sites, the final location being near Mother of God Church on the southwest corner of West Sixth and Russell Streets. In business since 1933, Blank's Pharmacy, at 272 Pike Street, is one of the few remaining independently operated drugstores in Covington, as is Ruwe Family Pharmacy at 434 Scott Boulevard and 3712 Winton Avenue in Latonia. In the past several decades, national chains such as Walgreens, CVS, and Kroger have filled the prescription needs of many Covington residents.

THE HEYDAY OF MANUFACTURING CORPORATIONS

Covington's well-connected business community, coupled with waves of ambitious and skilled immigrants and a location along major transportation corridors (bridges, railroads, and roads), attracted and facilitated the establishment and growth of industrial corporations. Most developed national and international customer bases.

The Stewart Iron Works was a legendary corporate giant in its field. In 1908, the sons of Richard Claiborne Stewart merged their fence, bridge, and jail branches as the Stewart Iron Works, valued at $1 million. In 1913 Covington Mayor John Craig (1873–1930) was able to purchase one of the first trucks off the company's assembly line, a product of the company's most recent branch, the United States Motor Truck Company. Stewart sold 100 trucks to the US military, before ceasing truck operations in 1928. Stewart's jail works were installed at Alcatraz, Sing-Sing, Rikers Island, and many other prisons. During World War II, the company made machine-gun mountings, tank parts, Bailey bridges, and landing strip mats. Stewart fencing was sold nationally and in Europe, and continues to be designed, sold, and installed at national sites and elsewhere.

ABOVE: Stewart Iron Works. Source: *You'll Like Covington: Covington, Kentucky, Seen through the Camera.* Covington, KY: Industrial Club of Covington, Kentucky [1912?]. RIGHT: Stewart Iron Works, fences. Source: US Patent 789,242.

The Kelley-Koett X-Ray Company, one of America's earliest large X-ray equipment manufacturers, also became a model corporate marketing firm. Virginia-born J. Robert Kelley and a German-born craftsman, Albert Koett, developed an innovative model Grosse Flamme X-ray coil. It was introduced at an American Roentgen Ray Society meeting in Niagara Falls, New York; appeared in the first issue of the *American Quarterly of Roentgenology* (October 1906); and has been displayed by the Smithsonian. The company donated $1,000 worth of X-ray equipment for the new St. Elizabeth Hospital building in Covington in the early 20th century. J. Robert Kelley secured the famed Mayo Clinic

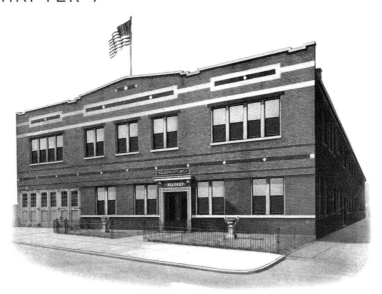

Kelley-Koett company. Source: *Pictorial and Industrial Review of Northern Kentucky.* Newport, KY: Northern Kentucky Review, 1923.

to test models and purchase exclusively, and he provided Covington with a unique slogan: "X-ray City." In 1917, visiting army officials and company technicians planned a mobile table unit for the battlefields. In 1925 Kelley-Koett claimed service branches in 37 cities and, in 1928, $2.5 million in sales. During World War II, Kelley-Koett expanded hours; hired more workers, including women; and set up production lines elsewhere in Covington. For detecting imperfections in structural welding, the casting of propellers, moisture proofing for underground cables, and other special (and secret) orders, the company installed industrial units at production sites elsewhere and in its factory on West Fourth Street. Technicians filled orders for underwater fluoroscopes, used when demining for Kaiser ships. In 1948 the company included 60 salesmen plus independent dealers, but by then it was no match for larger corporations. Kelley-Koett X-Ray Company and its engineers were granted several patents for improvements in X-radiation technology.

The R. A. Jones Company greatly affected American assembly line production. Inventor Ruel Anderson Jones of Lexington, Kentucky, patented advertising soap with the label embedded in wax. After moving to Covington, Jones and plant superintendent Harry Struewing devised, in 1912, an original soap press increasing the rate of production tenfold. Soon Jones built a new factory on East 15th Street at Garrard Street. More innovation followed. R. A. Jones started marketing a mechanical packaging machine. In 1921 Procter & Gamble bought an original machine for its soap manufacturing. Numerous mass producers of consumer products have used R. A. Jones machines. In 1966 the company moved to suburban Crescent Springs, Kentucky.

The Wadsworth Electric Company at 22 West 11th Street (founded by George B. and Harry Wadsworth in 1904) figured prominently in the developing electrical industry. It's earliest recorded patent application from 1916

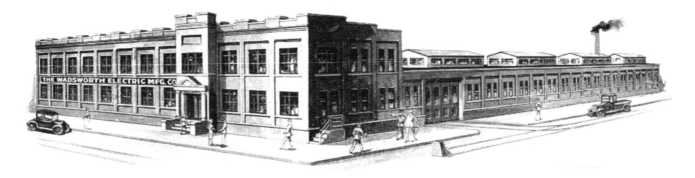

Wadsworth Electric Company. Source: *Pictorial and Industrial Review of Northern Kentucky.* Newport, KY: Northern Kentucky Review, 1923.

was granted in 1922 (US patent 1,403,659). It was a safety box for electrical installation for use where service lines enter buildings, also making it possible for owners to replace fuses. Wadsworth became an exclusive supplier in 1922 to cities such as Boston, Massachusetts. The firm's annual domestic and export market reached about $10 million between 1922 and 1925. It also became a leading manufacturer of circuit breakers.

In 1949 the Moeschl-Edwards Corrugating Company of Covington was one of the nation's largest manufacturers of rolling steel doors. Back in the early 1900s, it manufactured iron and steel roofing, sidings and ceilings, eaves troughs, downspouts, metal shingles, and both fireproof rolling and overhead doors at 812 Russell Street. It even made ballot boxes.

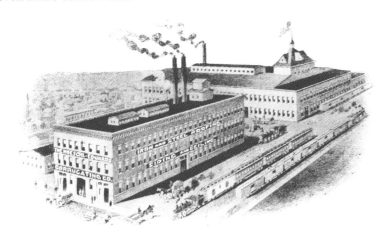

THE MOESCHL-EDWARDS CORRUGATING CO.

Eighth to Ninth Streets, C. & O. and L. & N. Railroads

Covington, Kentucky

MANUFACTURERS OF

Iron and Steel Roofing, Sidings and Ceilings

Eaves Trough, Conductor Pipe and
Metal Shingles

Moeschl-Edwards Corrugating Company. Source: *You'll Like Covington: Covington, Kentucky, Seen through the Camera.* Covington, KY: Industrial Club of Covington, Kentucky [1912?].

The Michaels Art Bronze Company became prominent by outfitting public buildings with bronze work, and later manufactured parking meters. In early 1931 Michaels Art Bronze had a $225,000 contract for First National Bank of Oklahoma City, Oklahoma, and another large contract for the New York State Roosevelt Memorial. The company also produced a bronze tablet for Covington's Baker-Hunt Foundation. In 1940 Michaels Art Bronze had orders for many Federal buildings, including Covington's new post office. During the late 1940s, the company was making and installing parking meters nationally. Relocated to Erlanger, Kentucky, in 1958, it became one of the nation's largest producers of parking meters, with sales to hundreds of cities.

Local companies provided vital components and devices for other manufacturers. The Avey Drilling Machines Company at Third Street, between Scott Boulevard and Madison Avenue, reached a zenith in 1956, employing 157 and selling machine tools worldwide, including clients like Ford, Pratt and Whitney, Westinghouse, International Business Machines, Chrysler, and General Motors. Later, the plant became a division of the Motch & Merryweather Company of Cleveland, Ohio, making special transfer and indexing machines and drilling, reaming, and tapping tools. The plant operated in Covington from 1910 to 1983.

The Reliance Dyeing and Finishing Corporation of Covington dyed and finished fabric and components for carpet, vacuum cleaner, furniture, and car manufacturers nationwide. It acquired cotton and modern synthetics from the South and overseas, and dyes from Cincinnati, Germany, and elsewhere.

The Ohio Scroll & Lumber Company was a very significant Covington company. It once carved adornments for the private railroad cars of the John Robinson Circus, the *Island Queen,* and opulent public and private buildings nationally and in Europe. It turned and embossed furniture and made wood components for World War II armaments. It ordered hardwood lumber from Eastern Kentucky and elsewhere, and mahogany and gum from the South, keeping a lumberyard off Russell Street north of Fourth Street. The Donaldson Art Sign Company on 22nd Street was built in 1914. It made colorful posters for traveling circus groups and outdoor billboards.

Covington had many dairies, including the Hanneken Dairy at 624 Scott Boulevard, the Trenkamp's Dairy on West 11th Street, and the Summe and Ratermann Dairy at 224 East 20th Street. These dairies operated milk wagons—and later milk trucks—delivering dairy products to residents door-to-door. During the 1960s, the Clover

Leaf Dairy began purchasing some of these dairies, as well as their milk routes. By the 1970s, the ever-present milk box on residential front porches and stoops began to disappear from the landscape, as customers began purchasing dairy products at convenience stores or large supermarkets.

AUTOMOBILE RETAILERS

Around 1908, the Covington Automobile Company was operating at 409 Madison Avenue. The Seiler Motor Company, incorporated in 1918 and located at 1324 Madison Avenue, was one of Covington's largest automobile retailers. By 1960 the dealership's name was Robke Chevrolet. Seiler and Robke family members also managed Rockcastle Motors in Covington as Oldsmobile and Cadillac dealers. In April 1933 the Covington Buick Company opened a used car sales lot at 620 Scott Boulevard illuminated at night, a modern innovation. In 1938 hardware store owner Charles Zimmer started Zimmer Motors at 559 Pike Street. Managed by Edgar J. Zimmer, it sold the new, cheaper DeSoto and Plymouth brands. After World War II, the Monarch Auto Supply operated at 722 Scott Boulevard, then in 1960 at 234 Scott Boulevard in a very large building where it sold auto supplies, and also operated a machine shop service. Kentucky Motors, which later became the interstate KOI regional auto parts chain, operated at 325 Scott Boulevard, then at 235 Scott Boulevard until the 1990s.

Summe and Ratermann Dairy, East 20th Street, circa 1929. The Summe family, and their cousins the Ratermanns, operated this major dairy until its closure in 1965. The Summes concentrated on the East 20th Street processing plant, while the Ratermanns focused on the Latonia Springs dairy farm on Three-L Highway (now Madison Pike) that once included more than 100 cows, that required milking twice daily. Summe and Ratermann also operated milk delivery routes to homes and businesses. Courtesy of Eric Summe.

Covington Industrial Club

In 1909 the *Kentucky Post* reported a major loss of manufacturers in Covington since 1890. The census bureau reported that the number of manufacturers in the city had dropped more than 69%, from 1,808 firms in 1890 to 403 in 1900. In response, on March 23, 1911, 10 organizers of the Covington Industrial Club met in Cody's Restaurant at Third Street and Scott Boulevard and established a plan to sign up a maximum of 100 members. Richard Coleman Stewart (1857–1937), of Stewart Iron Works, announced a matching donation of the dues new members were to be charged. The new Covington Industrial Club remodeled the old Kearns mansion at Eighth Street and Madison Avenue for an office, restaurant, and meeting space. The articles of incorporation were filed in May 1911. Stewart became its first president. At the election meeting, Stewart reaffirmed that the purpose of the club was to "boost the town" and to draw industry. In 1916, J. Robert Kelley recommended acquiring a more spacious meeting space. By 1919 the Club had relocated to the southwest corner of Pike Street and Madison Avenue in a modern, new building with office, meeting, and banquet space, plus a first-floor storefront for retail businesses.

Doll and Baseball Manufacturing

An entrepreneurial story of two Jewish immigrant businessmen begins with Wolf Fletcher's doll manufacturing shop, in operation by 1873 in Covington at 714 Madison Avenue. A trade magazine claimed in 1908 that it had been the first doll factory in the United States. Fletcher's two patents—for a machine used in

making baseballs in 1876 (US patent 174,511) and for a doll-stuffing machine in 1887 (US patent 371,751)—are verifiable by the patent office. Later, after the unhappy termination of a brief partnership with Fletcher, Phillip Goldsmith opened a large factory at Russell and Harvey Streets. P. Goldsmith & Company made dolls, toys, and baseballs from around 1880 until the factory burned in 1890. After relocating, and following Goldsmith's accidental death, his sons concentrated on baseball items. Later, they purchased the Mac-Gregor Golf Company of Dayton, Ohio, and eventually they sold their baseball business to the Brunswick Company of Chicago, Illinois.

Hellmann Lumber

The Hellmann Lumber mill was saved during the recent widening of 12th Street (also known as Martin Luther King Jr. Boulevard), and on October 22, 2013, it was auctioned off as a historic site for $36,500. Richard Hellmann acknowledged, in an *Enquirer* article, that a house still standing across the street was the home of his grandparents, Frank and Clara Hellmann, and is where his father, Frank Jr., grew up. Richard's grandfather worked his entire life as an employee at the mill, leaving him with only "stubs for two fingers." The first joint was gone on his forefinger, and the first and second joints were gone on his middle one. Richard's uncle Lou informed him that his grandfather's finger sections had been sheared off when caught under a leather belt turning on a big steam-powered pulley.

Richard Hellmann's great-grandfather Clemens came from Oldenburg, Germany, in 1869, starting the Hellmann Lumber Company in 1877. Richard's grandfather Frank worked for Clemens's other son, George, who as the eldest son inherited the company exclusively. Don Hellmann sold the business in 2001 to David Hill and partners. Retaining the family name, the new owners moved the Hellmann Lumber Company to Walton, Kentucky.

See also: Hellmann, Richard. "My Life—Building Sold, but Memories Remain." *Cincinnati Enquirer*, Kentucky ed., 2013 Nov. 29.

BANKS AND SAVINGS & LOANS

Many banks and financial institutions have originated and operated in Covington. Through the years, these banks and savings and loan associations were the lifeblood of Covington's commerce and of its home ownership. Covington's banks invested in the community and in its long-term commercial, residential, and cultural needs. They also provided business-to-business services, such as liquid assets and ready cash for business-to-customer transactions.

The First National Bank was organized in 1864 by founders John G. Carlisle, John Fisk, Amos Shinkle, and other prominent Covington businessmen. One of Covington's largest banks during this era, it opened in 1865 in the Odd Fellows Hall on the northeast corner of Fifth Street and Madison Avenue. In 1892 the bank moved to an Italianate-style building at 515 Madison Avenue. Soon, the First National Bank merged with the Covington City National Bank. An acquisition of the Merchants National Bank of Covington in 1908, and a merger with the Farmers and Traders National Bank of Covington in 1910, resulted in the First National Bank moving its headquarters to the Farmers and Traders location on the northwest corner of Sixth Street and Madison Avenue. After the Federal Reserve Board approved a trust department for the bank, the institution's official name changed in 1926 to First National Bank and Trust Company. Suburban development of branches occurred in the 1960s and 1970s, including a merger with the First National Bank of Latonia. Kentucky Bancorporation Inc. purchased

First National Bank in 1983, operating as the Kentucky National Bank (KNB). Then, Star Banc Corp. acquired KNB, and the bank was known as Star Bank, NA. In 1999 Star Bank, NA, changed its name to Firstar. The following year, Firstar was purchased by US Bank.

Peoples-Liberty Bank and Trust Company was the result of a 1928 merger between Peoples Savings Bank and Trust Company (organized in 1903 and opening in 1904) and the Liberty National Bank (formerly German National Bank, established in 1871). The German National Bank's signage is still displayed atop a Richardsonian Romanesque-style building at 609–611 Madison Avenue. German National Bank merged with the Merchants National Bank in 1913, keeping its name until the outbreak of anti-German hysteria during World War I. It then changed its name to Liberty National Bank of Covington in 1918. Peoples-Liberty merged with the Central Savings Agency in 1933. The First National Cincinnati Corporation purchased Peoples-Liberty in 1988, which soon became Star Bank. The name changed to Firstar in 1999, and then changed its name again to US Bank when that bank took ownership in 2000.

Covington Trust Company started in 1890 when the Kentucky General Assembly passed a special act making it the first trust company in Covington. The Covington Trust headquarters were located at the northeast corner of Sixth Street and Madison Avenue for many years. Huntington Bank absorbed the Covington Trust (Commonwealth Trust Bank Corporation) in 1986.

Citizens National Bank opened on the southwest corner of Madison Avenue and Pike Street in 1890. In 1896, it built a three-story building, designed by architect Daniel Seger, located just across the street at the southeast corner of Pike Street and Madison Avenue. Central Trust Company (Central Bancorporation of Cincinnati) acquired the bank in 1986. Soon, PNC Financial Corp. (Pittsburgh, Pennsylvania) acquired Central Trust, changing the names of its banks to PNC. There is now a PNC bank branch located on West Fourth Street in downtown Covington.

Grassroots savings and loan associations sometimes operated out of saloons. Local wage earners paid weekly dues to the associations, which loaned money to their members for the acquisition of residences and businesses. At the time of their establishment, savings and loans provided loans for the working classes. In contrast, banks

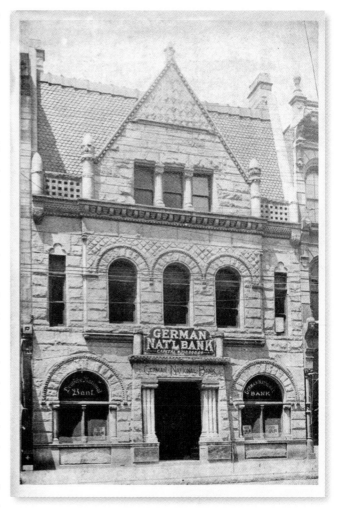

TOP: German National Bank, Madison Avenue. Source: *You'll Like Covington: Covington, Kentucky, Seen through the Camera.* Covington, KY: Industrial Club of Covington, Kentucky [1912?]. ABOVE: Western German Savings Bank, Ninth and Pike Streets. Source: *28th Annual Crowning Fest of The Deutsche Schuetzen-Gesellschaft of Covington, Ky.* Cincinnati, OH: Hennegan & Co., 1910.

usually loaned money only to wealthier residents and businesses. Hence, savings and loan associations were once referred to as building and loan associations, generally until the era of the Great Depression. In fact, German Americans in Covington called them *bauvereins,* which means "building societies." Building and loans often had their origins in ethnic neighborhoods. For the German American community, the Burnett Perpetual Building & Loan Association (incorporated in 1887) was located at 1607 Eastern Avenue in the Austinburg neighborhood. The General Savings and Loan Association was the longest-running savings and loan in Kentucky, for more than 110 years, when it merged with another company in the 1980s. Covington's African Americans developed the Progressive Building and Loan Association in 1906 to advance home ownership among its members. The Citizens Federal Savings and Loan of Covington is among the few savings and loans that remain in the region. With changes in federal laws, today's savings and loan associations now offer additional services in line with full-service banks.

INVENTORS

Long before government grants, business incubators, and enterprise zones, there were famous inventors and entrepreneurs in Covington. Their business and commercial efforts ranged from state-of-the-art technology to enterprising cutting-edge consumer products. The following list highlights noteworthy inventors associated with Covington. It is significant to note that four of these inventors have been inducted into the National Inventors Hall of Fame.

Gail Borden Jr. (1801–74), whose innovative condensing process allowed milk to be preserved before the days of refrigeration, lived in Covington during his childhood. Born in Norwich, New York, in 1801, his family moved during his youth to Kennedy's Ferry, where he assisted his father in surveying the future town of Covington in 1814. The family later moved to Indiana in 1816. Although his schooling was limited to a year of formal education, he was always eager to research and discover ways to improve daily life with his inventions. His 1856 invention (US patent 15,553), titled "improvement of concentration of milk," is a vacuum pan displayed in the Agriculture Hall at the Smithsonian's National Museum of American History. It is a copper kettle containing a heating coil that slowly warms milk, without scalding, to produce condensed milk. Borden's condensed milk process became a significant part of the dairy industry. He was inducted into the National Inventors Hall of Fame in 2006.

Granville Woods (1846–1910), known as the "Black Edison," was born in Columbus, Ohio, in 1846 and completed college courses in electrical and mechanical engineering in 1878. A genius, inventor, and businessman, Woods arrived in Cincinnati in 1880 and eventually moved in 1888 to Lynn Street in Covington. His most significant patented inventions were induction telegraphy (US patent 373,915), also known as multiplex telegraphy, and an improvement in railway telegraphy (US patent 373,383) in 1887. The induction telegraph patent was the first telegraph that operated while trains were moving, making it possible for trains to communicate while in transit. It saved countless passenger lives by averting disastrous train crashes with oncoming trains. In Cincinnati, he founded the Woods Electric Company and eventually opened a similar facility in Newport, Kentucky. Woods manufactured electrical and mechanical devices, such as switches, telegraph systems, and appliances. In 1890 he moved to New York City, where he patented additional inventions, including the third-rail technology still used today by many electric-powered transit systems. Woods received 45 US patents for his inventions, including railway induction telegraphy, electrical railways, and other technologies. Ultimately, he profited by selling major patents to General Electric and the Westinghouse Air Brake Company. Woods was inducted into the National Inventors Hall of Fame in 2006.

Covington resident James Meehan (1834–1908) worked at the Kentucky Central Railroad repair shops as a young man. Later, Meehan copatented an improvement in lubricators for locomotive steam engines in 1873, with steam valve manufacturing innovator Frederick Lunkenheimer of Cincinnati (US patent 138,169). That same year, they were granted a design patent (US patent D 6,545) for an ornamental design of a lubricating cup on steam engines and other machinery. Meehan was appointed as a master mechanic for the Cincinnati, New Orleans, & Texas Pacific Railroad in 1881, which leased the rail shops in Ludlow, Kentucky. He invented a special type of railcar brake shoe, which made him wealthy. His first patented brake shoe from 1886 (US patent

354,724) kept the thread of the wheel dressed to the proper shape to reduce channel or groove wear in the wheel tread and to improve passenger comfort. Resigning his job with the railroad in 1893, he promoted his Meehan brake shoe, manufactured by the Condon-Ross-Meehan factory in Chattanooga, Tennessee. His other patented inventions included a second brake shoe for railway brakes (US patent 720,167) in 1903, and railway car coupling (US patent 756,174) in 1904.

Born in Covington in 1893, African American Frederick McKinley Jones (1893–1961) invented the first successful mobile refrigeration devices for trucks and trains to keep fresh produce and meats from spoiling. Jones's patented invention, Air Conditioner for Vehicles (US patent 2,303,857) in 1942, replaced the less effective method of using ice and salt for transporting foods. This mobile refrigeration invention vastly expanded successful food-delivery distance, allowing fresh produce availability year-round. Jones's mother was black, but he had no memories of her. During his early childhood, Jones remembered living with his Irish father in rooming houses in Cincinnati. By the time he was ready for school, his father had left him with a Roman Catholic priest, a Reverend Ryan, who provided a strong educational foundation for him. Young Jones became a mechanical whiz. He cofounded the Thermo King Corporation to produce his mobile refrigeration devices. During World War II, Jones invented mobile refrigeration to permit blood plasma to be delivered to the war's Pacific theater. Jones was the first African American to be awarded the National Medal of Technology in 1991. He was inducted into the National Inventors Hall of Fame in 2007.

A. S. (Abraham Sidney) Behrman (1892–1988) was born in Covington and graduated from the University of Kentucky with a bachelor of science degree in industrial chemistry in 1914. Between the years 1923 and 1978, Behrman was granted more than 50 patents, mostly related to chemistry and water treatment innovations such as water

Fred McKinley Jones. Courtesy of the Minnesota Historical Society.

softening, purification, and filtering. He also published numerous scholarly articles and reports. His best-selling science book, titled *Water is Everybody's Business: The Chemistry of Water Purification* (1968), was part of the Chemistry in Action Series sponsored by the Manufacturing Chemists Association. It provided a foundation for a generation of high school and college students to pursue chemistry careers. Behrman served during both World Wars. His earlier published works included *Philippine Water Supplies* (coauthored with George W. Heise), printed by the Philippine Bureau of Science in 1918. While serving as a water supply officer in the US Army during World War I, Captain Behrman assured safe drinking water supplies as part of the Sanitary Corps for the troops on the front during the Battle of Chateau Thierry in 1918. He retired from the service with the rank of Colonel. Behrman served as vice president and chemical director at the International Filter Company (Infilco), and later as vice president and director of research at the Velsicol Corporation, both in Chicago. In his later career, he consulted. Behrman received honors from both the American Chemical Society and the University of Kentucky Alumni Association.

George Sperti (1900–91), research scientist and inventor of Preparation-H hemorrhoid relief treatment, suntanning lamps, and other consumer products, was born in Covington. In 1935, Sperti founded a scientific institute named Institutum Divi Thomae in Cincinnati, later renamed St. Thomas Institute. Finding a cure for cancer was the Institute's primary purpose. Instead, a cell derivative that stimulated healthy cell growth found a huge market as Sperti Healing Ointment (later renamed Preparation-H) for use on scars, burns, and wrinkles (US patents 2,320,479 Topical Remedy and 2,320,478 Toilet Preparation from 1943). The active ingredients in the original Preparation-H were shark liver oil and live yeast cell derivative (LYCD). After the US Food and Drug Administration discovered clinical-testing irregularities in the use of LYCD, Sperti's company removed the ingredient from products sold in the United States. However, the Canadian and European versions of Preparation-H still contain LYCD, which some claim is the special ingredient that heals skin burns and cosmetically tightened facial wrinkles. By 1970, St. Thomas Institute held approximately 127 patents. After Sperti's death in 1991, the St. Thomas Institute campus was sold and its proceeds were designated for scholarships at Thomas More College in Crestview Hills, Kentucky, and at the College of Mount St. Joseph in Cincinnati.

George Rieveschl Jr. (1916–2007) was a chemical engineer, professor, and inventor of Benadryl (generic name, diphenhydramine). While researching and teaching at the University of Cincinnati (UC) in the early 1940s, Rieveschl invented diphenhydramine, an early antihistamine. Soon he worked for pharmaceutical company Parke-Davis, where his discovery was refined, patented, and marketed (US Patents 2,421,714 and 2,427,878, both granted in 1947). Rieveschl's related chemical research resulted in dozens of pharmaceutical patents granted over the next two decades before he returned to UC as vice president of research. After retiring from UC in 1982, he moved to Riverside Terrace condominiums in Covington. Rieveschl was active in supporting local arts and educational initiatives in the region, including the Carnegie in Covington and the new science building at Northern Kentucky University.

George Rieveschl Jr. Courtesy of Lloyd Library and Museum, Cincinnati, Ohio, George Rievschl Jr. Papers, 1916–2007, Collection No. 19.

Carl Faith (1927–2014), although he did not hold any patents, was an eminent mathematician. Born in Covington, he grew up on Fifth Street, studied art at Baker Hunt, and graduated from Holmes High School in 1945. He earned his bachelor's degree in mathematics from the University of Kentucky, and his master's and doctoral degrees from Purdue University in West Lafayette, Indiana. Faith taught at Purdue, Michigan State, Pennsylvania State, and Rutgers. Well known for his publications and awards dealing with ring theory, he earned a Fulbright-NATO Postdoctoral Fellowship, as well as an NSF Postdoctoral Fellowship. He died in Princeton, New Jersey, on January 12, 2014.

Although John Roebling was not from the Northern Kentucky region, his name and presence live on in the engineering marvel named after him, the John A. Roebling Suspension Bridge. Roebling's invention for anchoring suspension chains for bridges (US patent 4,710) from 1846 is the foundation of the historic Covington and Cincinnati Suspension Bridge (later renamed the John A. Roebling Suspension Bridge), completed in 1867. Roebling was also the chief engineer for the construction of the Brooklyn Bridge in New York City. He was inducted into the National Inventors Hall of Fame in 2004.

Lastly, it is very important to acknowledge that the first documented US patent granted to a woman in Covington was granted to Jennie B. Moore for her invention of an improvement in fashion dress stays (US patent 509,480) in 1893.

POST WORLD WAR II: DECLINE AND RENAISSANCE

World War II veterans returned home to resume traditional family lives and working careers. Between the dire economic challenges of the Great Depression and the rationing and shortages of consumer goods during the Second World War, families were ready for peacetime and eager to buy new homes and consumer goods. Business opportunities abounded. The prosperity of the post–World War II era encouraged many Covington residents, employed by Covington businesses, to move south to the sprawling Kenton County suburbs. Earlier, the streetcar line to Fort Mitchell, Kentucky, in the 1910s initially drew some Covington residents to spacious lots and newer neighborhood subdivisions. Ultimately, the streetcars were replaced by modern buses that could travel beyond the limits of the streetcar tracks. Circa 1950, one such Covington streetcar barn in Covington, on Madison Avenue between 19th and 20th Streets, was transformed into a retail location known as Fashion Fair (later Twin Fair). As automobiles became increasingly common after World War II, Erlanger, Fort Mitchell, Fort Wright, and other Kenton County, Kentucky, suburbs offered midcentury ranch-style homes with modern conveniences and attached multicar garages. Covington's business employees could easily drive their own vehicles from these and other suburbs to work in Covington. In time, some Covington businesses, seeking more space, lower tax rates, and closer proximity to their workforce, also joined the migration to the suburbs.

Johnny's Toys Store was founded on Decoursey Avenue in the Latonia retail district in 1939. As the prosperity of the post–World War II era ensued, families shopped for the latest toys and amusements for their children. Customers regionwide (from as far as Dayton, Ohio) shopped at Johnny's Toys Store, as it was advertised on the *Uncle Al Show*, a longtime popular WCPO children's television program. Johnny's Toys' retail innovations included detailed

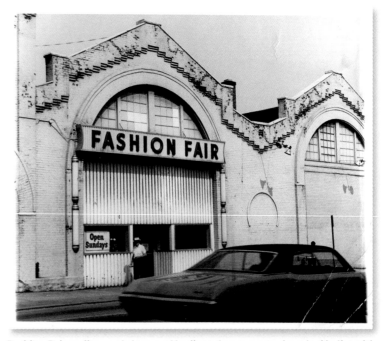

Fashion Fair, a discount store on Madison Avenue, was located in the old streetcar barn. Courtesy of the Kenton County Public Library, Covington.

newspaper advertisements featuring specifications on the latest toy trains and other products; child customers getting promotional keys in the mail to open a Birthday Castle door for a free birthday toy; and free Totter's Otterville trolley rides on an outdoor minirail line. At the firm's peak, there were multiple retail locations in the Greater Cincinnati region. The Johnny's Toys Store Covington retail site eventually closed in 2009 due to changing economic conditions and the rise of national chain stores such as Toys "R" Us and Walmart.

During the postwar period, mom-and-pop independent retail and service businesses opened in Elsmere and Erlanger, Kentucky, along the Dixie Highway. Across

ABOVE: Downtown Covington, Seventh Street and Madison Avenue, circa 1940s. From left to right: S. S. Kresge five-and-dime store, Goldsmith's Ladies' and Children's Wear, and Coppin's Department Store. Courtesy of the Kenton County Public Library, Covington. BELOW: Downtown Covington, circa 1943. From left to right: Liberty Theater, Eilerman's Men's and Boys' Wear, and Citizens National Bank. Courtesy of the Kenton County Public Library, Covington.

the Licking River from Covington, the newly built Newport Shopping Center also attracted shoppers. Newer suburban retail stores, offering plenty of free parking, began to take their toll on downtown Covington. In 1966, for instance, S. S. Kresge five-and-dime store closed its downtown location at 624 Madison Avenue. In fact, the S. S. Kresge Company closed many of its five-and-dime stores in downtowns nationwide in favor of opening newer, modern Kmart discount department stores in the suburbs. The S. S. Kresge Company officially changed its name to the Kmart Corporation in 1977. At its peak, there were four Kmart stores in the Northern Kentucky region, including Cold Spring, Edgewood, Florence, and Newport.

During the 1950s and 1960s, the Covington Retail Merchants' Association attempted to lure shoppers to downtown with Covington Dollar Days, free bus rides, and regional event sponsorships such as Covington's National Folk Festival at Devou Park in 1963 and in Florence at Latonia Race Course in 1964. Old Town Plaza (a pedestrian mall) was opened on West Pike Street between Madison Avenue and Washington Street in 1977. While the plaza seemed to slow the decline somewhat, it could not compete with further suburban retail developments such as Florence Mall.

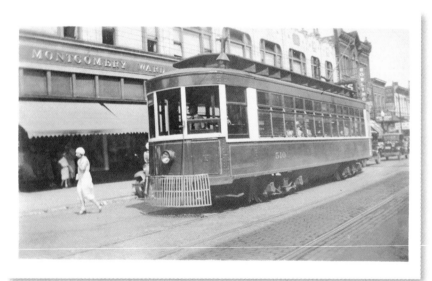

TOP: Eilerman's Men's and Boys' Wear, interior. Courtesy of Kenton County Public Library, Covington. LEFT: Montgomery Ward department store, Eighth Street and Madison Avenue. Courtesy of Paul A. Tenkotte. ABOVE: F. W. Woolworth 5-and-10 Cent Store. Colorized in Woolworth colors. Source: *Kentucky Post*, 25 Mar. 1942.

Downtown Covington merchants were not alone, as this trend of downtown retail decline occurred nationwide.

Until the 1970s Covington had the largest shopping and business district in Northern Kentucky. Coppin's Department Store was Northern Kentucky's major department store for many decades. In 1873 John Roberts Coppin founded the California Dry Goods Store at 607 Madison Avenue. Coppin moved to a larger site at 538 Madison Avenue in 1880. In 1906 Coppin purchased a lot at the northeast corner of Madison Avenue and Seventh

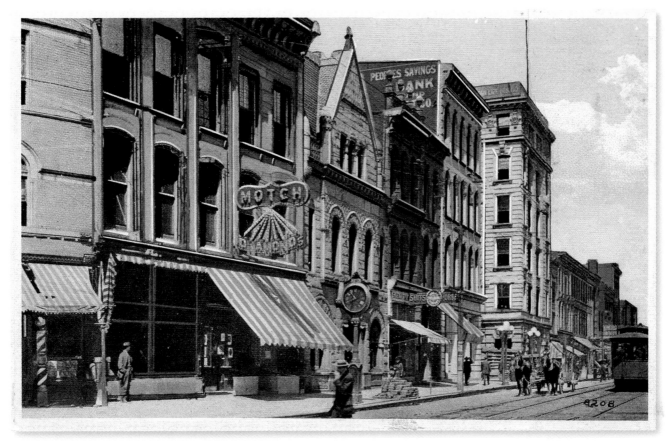

ABOVE: Motch Jewelers, circa 1910s. Courtesy of Paul A. Tenkotte. LEFT: Motch Jewelers. Photo by Dave Ivory, 2014.

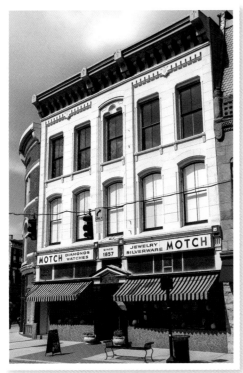

Street, where he built a seven-story building—the first reinforced steel skyscraper in Kentucky. In 1907 Coppin officially incorporated his business as the John R. Coppin Company. John Coppin passed away in 1913, but the family maintained partial management and ownership until 1923. During the mid-1960s and later the early 1970s, the store was purchased by two different Chicago retailers. In 1977 the store closed.

Many downtown retailers suffered the same fate as Coppin's, primarily due to costly and inconvenient automobile parking. Yet in its heyday, downtown Covington retailers included department stores Coppin's, JCPenney, Montgomery Ward, and Sears & Roebuck; five-and-dime stores F. W. Woolworth and S. S. Kresge; clothing stores Dalton's Women's Wear, Eilerman & Sons, Goldsmith's Ladies' and Children's Wear, and the Parisian; and furniture and appliance stores Edward P. Cooper, Louis Marx and Brothers, Modern Furniture, A. J. Ostrow, and Tillman.

Many retailers remain in the downtown area. With the creation of a wedding district and art shops, downtown is experiencing a renaissance. Motch Jewelers was founded in 1857. Family owned and operated, its 613 Madison Avenue location features a landmark sidewalk clock in front of the store. Klingenberg's and Landwehr's hardware stores have operated in several Covington locations since the 1920s. Hill Seed Company served as a prominent retailer in Covington for 135 years. On New Year's Eve in 1998, this longtime retailer closed its downtown location. Soon, Klingenberg's Hardware and Paints (founded in 1922) moved into the Hill Seed building. Klingenberg's is also located at 3916 Winston Avenue in Latonia. Fedders Feed & Seed is a similar type of retailer located in Covington at 1550

Russell Street. It has provided home and garden goods and animal foods and supplies since 1877.

Regionally based Remke Markets originated in Covington. William Remke opened a small neighborhood meat market on the northeast corner of 13th and Holman Streets in 1897. After multiple moves for larger retail space, in 1922 Remke's Markets settled in the Peaselburg neighborhood at 19th and Holman Streets, where it remained for nearly 70 years. The Covington location closed in 1991. The family opened one of the region's first self-serve grocery stores in Fort Mitchell in 1935.

INDUSTRIAL AND MANUFACTURING FACILITIES

At the beginning of the 1950s, Kelley-Koett Manufacturing employed 700 employees. This was, by far, the largest factory employer in Covington, according to *Made in Kentucky: A Handbook of Industry and Manufacturing 1951–52*. The handbook also cites the following firms employing more than 250 workers (numbers of employees listed in parentheses): Bavarian Brewing (329), Sohio Petroleum (277), Stewart Iron Works (283), Triangle Paper Bag Manufacturing (250), and Wadsworth Electric Manufacturing (286). Other notable Covington employers at this time included Blue Grass Provisional Company (now Blue Grass Quality Meats), R. A. Jones, Klaene Foundry Company, Liberty Cherry & Fruit Company, Michaels Art Bronze Company, Mosler Lock Company, and Chris A. Papas & Son Candies. Glier's Meats was established in 1946. It has been headquartered at 533 West 11th Street since 1967, in part of the former Bavarian Brewery plant. Glier's makes the German food *goetta*, and lots of it—by 2002, it had sold 1 million pounds of goetta.

Like Cincinnati, Covington has been the home of many machine tool manufacturers. Anthe Machine Works Inc., at 407 Madison Avenue, remains in business after more than 100 years, machining woodworking cutters and shapers for customers throughout the United States and Canada. In 1942 the Kratz-Wilde Machine Company was founded; about 1997, it was sold to Aviation Sales Company for $42.5 million. Started by Donald Morrison in 1953, the D. C. Morrison Company operates on Johnson Street at the Ohio River levee, making machine tools for the three big automakers, jet engine manufacturers, and others.

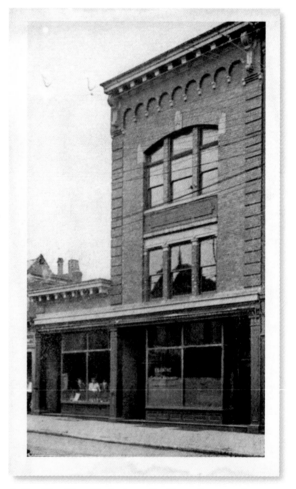

In 1969 the Internal Revenue Service (IRS) bolstered employment opportunities in Covington, as it brought hundreds of full-time jobs to the city, as well as thousands of seasonal opportunities during income tax season. Today, the IRS employs more than 4,000 workers in Covington alone. However, the IRS facilities displaced working class residents, which, in turn, decreased customer base for retailers in or near downtown Covington. For example, Kroger and Albers groceries in downtown closed during this period.

With historic preservation activities beginning in the 1960s and 1970s, Covington began to attract upper-middle-class professionals back to the city. An urban renaissance was born, as the historic Licking Riverside featured restoration of historic homes that rivaled Mount Adams across the Ohio River in Cincinnati. New trendy retail shops and restaurants soon appeared in the Westside, in the newly named MainStrasse District.

Meanwhile, areas of Covington south of downtown continued

Anthe Machine Works Inc., Madison Avenue. Source: *You'll Like Covington: Covington, Kentucky, Seen through the Camera.* Covington, KY: Industrial Club of Covington, Kentucky [1912?].

ABOVE: Arlan's discount store, Latonia Plaza. Raymond E. Hadorn photo, in the collection of Paul A. Tenkotte. RIGHT: Atkins & Pearce Manufacturing. Photo by Jeff Blakemore.

to prosper. Latonia Plaza featured Arlan's discount department store and a Ben Franklin five-and-dime store. Covington's annexation efforts resulted in territory that doubled the size of the city, and is now known as South Covington. After 1977, commercial distribution centers such as White Castle restaurants and Atkins & Pearce Manufacturing, a precision-engineered textiles company, relocated within the annexed area along Madison Pike (KY 17), with convenient access to I-275. Residential builders completed new single-family-home subdivisions as well. Now the largest neighborhood in geographic size within the city limits, South Covington features parks, rolling hills, and wooded areas.

MAINSTRASSE AND RIVERFRONT DEVELOPMENTS

In the late 1970s, the city and the state began to invest in infrastructure to develop Covington near the newly named MainStrasse district. Echoing the area's German heritage, the new 100-foot Carroll Chimes Bell Tower in Goebel Park, with its carillon and glockenspiel, was the centerpiece of restored properties with restaurants, pubs, and specialty retailers.

Additional new developments began to appear along the Ohio River. David Herriman built Riverside Terrace, a 34-unit condominium project on Riverside Drive, in 1984 at a cost of $4.4 million. Soon, 43 more condominium units were added. Recently, Roebling Row Apartments and the modernistic residential

building known as The Ascent at Roebling's Bridge have been built. In 1988, locally owned and operated real estate developer Corporex broke ground on the RiverCenter development. The first phase of the project included a 19-story office tower, RiverCenter I with a parking garage, and 7-story Embassy Suites Hotel. A 16-story office tower, RiverCenter II, was completed in 1999 as part of phase two. Prominent corporate tenants that moved their corporate headquarters to RiverCenter II included Ashland Inc. and Gibson Greeting Cards. Ashland Inc. moved its corporate headquarters from Ashland, Kentucky, to Covington while Gibson moved its headquarters from Cincinnati. Ashland sold the petroleum-refining portion of its business in 2005 to Marathon. As a Fortune 500 company, Ashland remains a major international corporation. It currently employs 85 professional workers in Covington. When it moved its headquarters to Covington, Gibson Greeting Cards Inc. was the oldest greeting card company in the United States. The company also set up a distribution facility in Pioneer Valley Industrial Park in South Covington. After losing major national chain customers, such as Walmart and Kroger, Gibson was purchased by American Greetings Corporation, based in Cleveland, Ohio. Subsequently, it closed its Covington headquarters.

A first-ever Northern Kentucky Convention Center was completed in 1998. Located next to RiverCenter, at Madison Avenue and Rivercenter Boulevard, the Northern Kentucky Convention Center and Visitors Bureau features a 204,000-square-foot facility, directly connected to the Marriott Hotel at RiverCenter. The IRS expanded its Covington presence for 2,000 IRS employees with the opening of the IRS Gateway Center on Scott Boulevard, also near the RiverCenter development. In 1994 Fidelity Investments (a mutual funds and financial services company headquartered in Boston, Massachusetts) built a 188-acre branch campus in South Covington off I-275.

RECENT REVITALIZATION

Recently, Covington has become home to a number of tech and business accelerator companies, especially along the redeveloping Pike Street zone. UpTech, located at 112 Pike Street, is a business incubator designed to attract and accelerate entrepreneurs and to create (or foster) an informatics industry in Northern Kentucky to support entrepreneurs. On Russell Street, around the corner from UpTech, is a life science biotech incubator and accelerator company known as Biologic. It has significant experience and resources available to assist life science startups during the difficult early stages of development. More than 20 professionals are on-site, along with its network of investors, attorneys, accountants, human resources, regulatory, public relations, and marketing professionals. Covington is increasingly becoming the home of a growing technology innovation corridor that includes similar like-minded companies. TiER1 Performance Solutions in RiverCenter provides training programs addressing the special needs of corporations; C-Forward tries to bring big business information technology solutions to small firms by implementing digital technology and other resources; and the Northern Kentucky ezone provides resources for entrepreneurs.

At the time of this writing, developers are planning the restoration of the historic Coppin's Department Store building into an upscale hotel or apartments. Beginning during the Christmas holiday season of 2013, downtown experimented with pop-up (that is, short-term) retail shops in the triangle formed by Madison Avenue, West Pike Street, and West Seventh Street. In 2013 the Covington branch of the Kenton County Public Library completed its newly renovated and enlarged facilities downtown. And in 2014 Gateway Community and Technical College (GCTC) began renovating a number of buildings into its new downtown campus.

Downtown Covington has lured artists as it has rebranded itself with a "Life on the Left Bank" culture. Such promotional efforts are drawing progressive artists and craftspeople to purchase their own historic studios and homes within the Renaissance Covington districts. As the Renaissance Covington zones are experiencing an urban revival, MainStrasse and Latonia have remained important retail districts in Covington at the start of the

LEFT: Downtown Covington along Madison Avenue. Photo by Dave Ivory, 2014. ABOVE: Klingenberg's Hardware, West Pike Street. Photo by Dave Ivory, 2014.

21st century. MainStrasse features many specialty shops sprinkled between popular pubs and restaurants that attract younger adults, while Latonia features family-friendly and value-conscious retail establishments. There are a few fast food restaurants conveniently located immediately off I-71/I-75 on West Fourth and Fifth Streets too.

Today, Covington businesses and employers range from small sole proprietorships to large Fortune 500 companies to the mammoth IRS processing center. Business accelerators like UpTech and an innovative technological corridor are propelling the city and the region into the advanced guard of a rapidly changing 21st-century economy.

Ronald L. Sargent

Ronald L. Sargent (1955-) was raised in Covington, and during high school worked at Kroger Supermarket in Fort Mitchell, Kentucky. In 1973, he graduated from Holmes High School. Sargent earned BA (1977) and MBA (1979) degrees at Harvard University. In 1979, he accepted an executive position at Kroger Company in Cincinnati, where he remained until 1989. Then, he joined Staples, a newly founded office-supply store chain. By 1997, he had become President of the North American Operations of Staples, then was President and Chief Operating Officer from 1998 to 2002. He has been Chief Executive Officer since 2002.

Covington's Principal Employers, 2014
(courtesy of Larry Klein, city manager)

Employer	Employees	Rank	Percentage of Total City Employment
Internal Revenue Service	4,500	1	16.79%
Fidelity Investments	4,100	2	15.30%
Covington Board of Education	925	3	3.45%
St. Elizabeth Hospital	800	4	2.98%
State of Kentucky	360	5	1.34%
Club Chef	320	6	1.19%
Rosedale Manor	310	7	1.16%
No. KY MH-MR Board	280	8	1.04%
Atkins & Pearce Mfg.	265	9	0.99%
Ashland Inc.	85	10	0.32%
Total	11,945		44.56%

Covington Centenarian Businesses–Notable Highlights
Businesses and organizations born in Covington more than 100 years ago
(including those originating in Covington that have since moved and those regionally founded and currently located in Covington).

BUSINESS/ORGANIZATION	YEAR ESTABLISHED
Allison and Rose Funeral Home Inc.	1830
Anthe Machine Works Inc.	1897
Atkins & Pearce (regional Cincinnati origins)	1817
Blue Grass Quality Meats (now located in Crescent Springs, Kentucky)	1867
Hellmann Lumber (now located in Walton, Kentucky)	1877
J. H. Fedders Feed & Seed	1875
Linnemann Funeral Homes (now located in Erlanger and Burlington, Kentucky)	1882

Michaels Art Bronze Company (acquired by a Philadelphia, Pennsylvania, company)	1870
Middendorf Funeral Home and Middendorf Bullock Funeral Homes	1860s
Motch Inc.	1857
R. A. Jones and Co. (now located in Crescent Springs, Kentucky)	1905
Remke Markets Inc. (located throughout metro NKY/Cincinnati)	1897
Rusk Heating & Cooling	1865
St. Elizabeth Healthcare	1861
Stewart Iron Works	1886
Swindler & Currin Funeral Homes	1914

SELECTED BIBLIOGRAPHY

Behrman, Abraham S. *Water is Everybody's Business: The Chemistry of Water Purification.* Garden City, NY: Doubleday & Company, 1968.

De los Reyes, Vanessa, and Kelly Carnahan Hemmert. "R. A. Jones: A Centenary Company in Northern Kentucky." *Northern Kentucky Heritage* 13 (2) (2006): 2–12.

Holian, Timothy J. *Over the Barrel: The Brewing History and Beer Culture of Cincinnati.* 2 vols. St. Joseph, MO: Sudhaus Press, 2000–01.

Lietzenmayer, Karl J. "The Fedders Family and Four Generations with the J. H. Fedders Feed Company." *Kentucky Heritage* 19 (1) (2012): 32–41.

———. "John Roberts Coppin: The Family and the Company." *Northern Kentucky Heritage* 5 (2) (1998): 1–15.

———. "M. C. Motch, Jewelers: A Kentucky Centennial Company." *Northern Kentucky Heritage* 18 (2) (2011): 65–70.

———. "Stewart Iron Works: A Kentucky Centennial Company." *Northern Kentucky Heritage* 5 (1) (1997–98): 1–14.

Made in Kentucky: A Handbook of Industry and Manufacturing, 1951–52. Frankfort and Louisville, KY: Agricultural & Industrial Development Board of Kentucky and the Kentucky Chamber of Commerce, 1952.

Neikirk, Mark, ed. *Kenton County Together: A Call to Action.* Highland Heights, KY: Kenton County Government Study Group, 2013.

Northern Kentucky Chamber of Commerce. *Northern Kentucky: Looking to the New Millennium.* Memphis, TN: Towery Publishing, 1999.

Northern Kentucky Newspaper Index. Kenton County Public Library, Covington, KY.

Pictorial and Industrial Review of Northern Kentucky. Newport, KY: Northern Kentucky Review, 1923.

Rodengen, Jeffrey L. *New Horizons: The Story of Ashland Inc.* Fort Lauderdale, FL: Write Stuff Enterprises, 1998.

Tenkotte, Paul A., and James C. Claypool, eds. *The Encyclopedia of Northern Kentucky.* Lexington, KY: University Press of Kentucky, 2009.

Thompson, Charles. *Going on 200: Century-Old Businesses in Kentucky.* Lexington, KY: Kentucky Humanities Council, 2003.

CHAPTER

FROM CHALKBOARDS TO COMPUTERS: EDUCATION AND LIBRARIES IN COVINGTON

by David E. Schroeder and Rob Haney

THE history of education in Covington mirrors that of many urban centers across America. From the early frontier settlers to the many waves of immigrant settlers, education has evolved and adapted to meet the needs of its diverse population. The early one-room log structures gave way to wooden frame facilities and finally the steel and masonry structures that are in place today. The educational content, too, has continued to develop in order to accommodate the changes in population from early German and Irish immigrants to the current influx of Hispanic and other students from around the world. The city of Covington slowly moved from segregated school services for African Americans into the desegregated population mixes, as did all public institutions after the United States Supreme Court decision of May 31, 1955. Public education in Covington has a long, successful history, which truly reflects the transformation of the city itself.

The early settlers relied on many private forms of education, supported by churches and individuals providing educational opportunities in their homes. One of the first recorded mentions of instruction was in the home of Mr. and Mrs. Gist. They advertised in-home instruction for a fee in the *Cincinnati Daily Gazette* in August 1820. These early pioneers from Virginia taught lessons in their home for males and females, ages 5–14. They offered instruction in the "rudiments of knowledge" to individuals who could afford to pay.

The first recorded effort to offer free educational opportunities to the poorer students of Covington began in 1825. A subscription school was started to provide instruction to disadvantaged children. This effort was led by Mr. John Dow and Judge Thomas. They started this movement by raising $80 and began conducting instruction in a log cabin that was rented by the trustees of the town. This system of private fundraising to provide educational opportunities continued until 1830, when the city council offered the first appropriation toward this effort. Appropriations by the city council toward the free school totaled $546.11 before they passed the first city charter that approached free public education.

Mortimer Murray Benton (1807–1885), Covington's first mayor (1834–1835), formed an educational committee that decided to divide the city into wards. These wards were the first educational boundaries drawn up to organize the delivery of instruction to the city's children. The first ward covered the area from the mouth of the Licking River west to Madison Avenue, south to Fifth Street, east back to the Licking River, and north back to the mouth of the Licking River and the Ohio River. The second ward was framed by the western part of the city limits, beginning at Madison Avenue and heading west to the outer edge of the city, Fifth Street being the southern edge of this ward. The third ward included all other portions of the city.

The city council purchased the first structure to be utilized under the new city charter in 1836. A log cabin was purchased for $150 and became the first public educational facility in Covington. It was located on the banks of the Ohio River near Garrard Street. This school officially opened to the first students in December 1836 and was attended by 25 students. An undisclosed second facility opened, and it was reported that a total of 45 students were attending the two school facilities by 1837.

At the time of Covington's early public education efforts, there was neither a standard certification for teachers nor any common understanding of educational curriculum in Kentucky. There was widespread discussion and movement toward a universal education and an ideology around a system of Common Schools. James Clark, governor of Kentucky from 1836 to 1839, addressed the General Assembly in 1836 and urged the "expediency of establishing a system of Common Schools without delay." The General Assembly first took action in 1837 and legally established a system of common schools in Kentucky. This law set up the first funding across the state for public education in Kentucky.

In 1841 the Covington City Council was approached by concerned citizens about the status of public education efforts in the city. The concerned citizenry petitioned for an accounting of all funds collected from the Kentucky General Assembly since 1837, as well as the first public school tax levied in the city. The total revenue available from all sources amounted to $896. The organized community members were seeking a principal teacher to be hired and two female teachers. The city council record referred to the concerned citizens as "the school visitors." It granted this group the right to purchase materials necessary to build a new three-room school, to be located on the public square near the jail at the intersection of Third Street and Scott Boulevard. The new school opened in October 1841, at a total cost of $2,200. The city council also granted the school visitors the authority to separate male students from female students.

The "school visitors" became known as the Board of School Visitors. The first board members noted were M. M. Benton, J. H. King, Thomas Phillips, James M. Preston, and C. W. Tarvin. The board was charged with hiring staff and keeping records sufficient to make reports to the city treasurer regarding the expenses of the educational system. This board hired the first principal in the school system, Mr. C. W. Clayton, along with two assistants, in 1841.

The common school process languished early on and was underfunded by the General Assembly. The early public educational system seemed to stall and remained relatively stagnant until the state legislature passed a 2¢ tax on $100 worth of property. This measure was overwhelmingly supported by taxpayers.

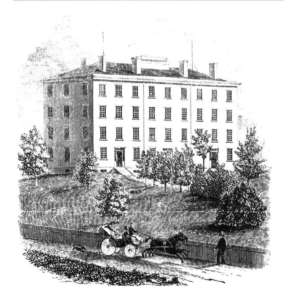

Western Baptist Theological Institute, West 11th Street. Source: Collins, Richard H. *History of Kentucky*. 2 vols. Covington, KY: Collins & Company, 1882.

Western Baptist Theological Institute

Baptists residing in the then-Western (now Midwestern) states in the 1830s and 1840s were hampered by a lack of well-trained ministers to spread the faith. In 1833 the Western Baptists gathered at Cincinnati, Ohio, for a convention. At this meeting, discussions turned toward the establishment of a seminary to train future ministers. The committee eventually decided on a site just south of Covington, Kentucky.

Three buildings constituted the Western Baptist Theological Institute's campus. The largest structure stood four stories tall and contained classrooms, a dormitory, and a chapel. The cornerstone of the building was set in place on August 3, 1840. Two other buildings used by the institute were already on the site when the property was purchased. One of these homes belonged to Alfred Sanford. Following the purchase, the Sanford home was remodeled for use as a president's residence; this house still stands at 1026 Russell Street. The other home was remodeled for use as a faculty residence.

Finally, in September 1845, the first classes at the Western Baptist Theological Institute were officially inaugurated. The institute offered a two-year program in theology and a classical program for those who were not yet ready for college work. Despite an excellent start, the Western Baptist Theological Institute proved very fragile. The institute was established to serve Western Baptists, both from the North and the South. The issue of slavery, however, divided the Western Baptists from the very founding. In 1855 the board decided to close the Western Baptist Theological Institute. The Northern and Southern factions of the board agreed to the sale of all the property, with the proceeds being divided equally. The school's campus eventually became a large residential district. Also, the trustees of the institute were responsible for the establishment of a cemetery on the property, which eventually became Linden Grove Cemetery.

Private Academies

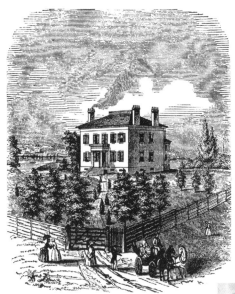

Covington was the home of many private schools and academies that were not affiliated with any religious denomination. These began circa 1820 with the operation of a coeducational school in the home of the Gist family. Throughout the 1830s and 1840s, the number of private academies in the city multiplied. In general, these academies were owned and operated by private individuals, such as Orr's Female Academy on Sandford Street, later home to the Rugby School. Private schools came and went. Some were coeducational, and others were segregated by gender. Some offered room and board, while others did not. With the steady improvement of the public school system in Covington, and the development of Catholic schools, the private schools began to lose popularity in the late 19th century.

ABOVE: Orr's Female Academy, 622 Sandford Street. Source: Collins, Richard H. *History of Kentucky*. 2 vols. Covington, KY: Collins & Company, 1882. RIGHT: The Rugby School's campus occupied the old Orr's Female Academy on Sandford Street. Originally only for boys, it later became coeducational. This photo is circa 1900. Courtesy of the Kenton County Public Library, Covington.

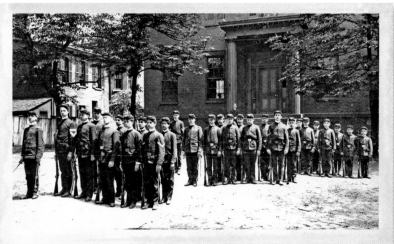

In 1846 the first school construction in the third ward took place on Greer Street between Sixth and Seventh Streets. This facility was a wooden frame structure that contained four rooms. It opened in September to 75 boys and girls and a 12-month term, which was highly unusual for the time, and even more astonishing given the limited funding available for public education.

By 1849 the Board of School Visitors was operating three common schools: First District, Second District, and one rented room. Third District was then under construction north of the graveyard on Craig Street. The report to the city council in 1849 reflected a total of 400 students attending common schools in Covington, taught by nine teachers.

In 1850 a tremendous overhaul took place within Kentucky to organize and strengthen the system of common schools. Until then, the state had little success allocating funding consistently to the various public school systems operating in the counties of Kentucky. This all changed in 1850 when the legislature adopted the first constitutional provision for funding schools, and prevented state officials from using the funds for other purposes. Prior to this provision, some schools collected tuition from those students who were able to pay, and the poorer students were admitted free of charge.

The constitutional changes in Kentucky made a profound and long-lasting impression on the formation of the public education system in Covington. These changes established the notion of school districts in Covington, which are still in use today. The area of the various school boundaries may have changed over time, but the idea of numerical school districts being used to describe the geographic area for a school is still in place today. The Covington City Council, by charter, established the first numerical districts when they divided the city into five school regions. The five districts were defined within the city corporation limits, encompassing the area bound by the Ohio and Licking Rivers and stretching south to Eighth Street. The westernmost boundary was defined by the railroad tracks near Pike Street.

By the 1850 charter, the city council also established a commitment to support and maintain a system of common schools. This commitment acknowledged the responsibility to construct and maintain facilities necessary to meet the educational need of its citizenry. This charter established school terms consistently for all district schools. This new structure also established a body of school trustees led by an elected chairman. The trustees conducted regular meetings to manage the organizational affairs of the school system. The charter also required that these meetings be attended by the city clerk. Further, it created the first permanent revenue stream, with a dedicated tax levy placed upon the valuation of taxable property. It was also supported by the annual revenue collected from the state. These funds were to be accounted for distinctly and separately from all other city funds, and were set aside for the school trustees and expended by the order of this new board, separate from the normal city council expenditures.

The city also established a formal Board of Examiners. This three-member panel was charged with examining teacher certifications, granting new certifications, and visiting the school sites at least once a month. This group also attended the annual examinations of the students and made regular reports to the city council. The panel was comprised of D. C. Benton, John Miller, and C. W. Tarvin. This group made the first public report to the community in the *Covington Journal* newspaper in 1851. It was reported that total enrollment in all five districts was 716, an increase of 316 over the previous year. The city began offering public night school classes in the First District School in 1852. Two teachers were employed to conduct the classes in bookkeeping, arithmetic, grammar, and writing.

The first public high school in Covington was established in 1853. This new school was opened at 11th Street and Scott Boulevard. The first students for the school were recruited from the advanced classes being offered in the common schools located throughout the city. Twenty students were interviewed, examined, and initially selected for the first session that began on January 8, 1853. Professor Asa Drury was hired to begin the high school program. The first courses offered in the new high school were algebra, ancient and modern history, composition, Latin, and rhetoric.

By 1869 the high school population grew to 90 students. The high school operations moved to Fourth Street and Madison Avenue in September. The students called their new school the Soup House because the building previously housed a food distribution for needy citizens.

The growth of the public education system in the early 1850s led the Board of Trustees to create the first superintendent position to manage the affairs of the school system, held by Professor A. Drury, in 1856. At that time, the student population had grown to 1,108. All of the school buildings were over capacity and many teachers were listed as teaching 80 students.

The public education system became stressed with increased enrollment and rising expenses by 1859. The tax structure was insufficient to maintain the basic operations, let alone expand to meet the increasing needs of the growing city. The Board of Trustees met in May 1859 with the intention of closing down the system. This drastic measure was avoided after concerned citizens became involved and clamored for the continuation of the public education system.

It was during this turmoil that the trustees realized that they had violated the city charter when they hired Professor A. Drury as superintendent of schools. They had set an annual salary for Professor Drury of $300, which was higher than allowed by the charter. Mr. Drury submitted his letter of resignation at the end of the 1859 school year.

The Civil War years proved to be extremely difficult for the public education system. The total school enrollment before the start of the war had swelled to 1,250 students. By 1862 it had slipped to 948. At the meeting of the school board on April 20, 1862, the board voted to close the school system. The *Covington Journal* reported the resolution as passed by the board: "Resolved: By the Board of Trustees of the Common Schools of Covington, that from and after Friday the 30th day of the month all the public schools of the city be closed and that they remain closed until otherwise ordered by the Board." The reason given for the decision was the "unsettled conditions of public affairs."

The school system was reopened in September 1862 with an enrollment of 1,220 students. Even though the war pressed on, the enrollment continued to increase. The numbers increased to 1,681 by 1866. It was during this period of rapid growth that the school system constructed its first brick school building. The new school was built on the site of the First District School and replaced the former 5-room frame building with a 12-classroom building. It is also worth noting that the board of trustees denied the reappointment of four female teachers in 1863. The teachers were refused new contracts because they were reported to have sympathized with the Confederacy.

The Covington school system did not replace the superintendent position after Professor Drury resigned in 1859. This position was eventually filled by John W. Hall Sr. in 1868 for an annual sum of $2,500. The original charter that established the annual superintendent salary of $300 was amended to allow the board of trustees to establish a sufficient compensation.

After the Civil War ended, a renewed and progressive interest in public education began across the country. The state of Kentucky sought better teachers with appropriate qualifications, uniformity of textbooks, and high-quality educational facilities. The end of the war also brought about the end to slavery; all blacks were free and citizens of the commonwealth. However, the public education system in Covington did not rush to offer educational services to African American children. The school system had been decimated by years of war and was primarily focused on restoring the opportunities for white students.

On April 17, 1866, a group of concerned citizens approached city hall about the creation of educational opportunities for African American students. One of the most notable members of this organized effort was Jacob Price. Price, who was a free man before the Civil War, owned a local lumberyard and was also an ordained minister at the Bremen Street Baptist Church, which housed

Old First District School, Scott Boulevard. Source: Collins, Richard H. *History of Kentucky.* 2 vols. Covington, KY: Collins & Company, 1882.

the first classes for black students. Miss Wolfe was the first teacher hired and was paid by the Freedmen's Aid Society. From 1866 to 1875, it was reported by Dr. Joseph Walton that two schools operated independently of the public school system for the purpose of educating black students. In addition to the Bremen Street Baptist Church, the black Methodist church opened a school for students.

Another prominent member of the Covington scene in the late 1800s was William Grant. Grant was a white attorney practicing in Covington during this time and a shrewd politician. He sought support and approval from the black community after they were granted the right to vote. Grant promised the influential members of the black community that if they supported his effort in seeking election to the state legislature in 1875, he would support an amendment to the Covington school charter providing education to black students. William Grant kept his promise. In 1876 the city charter was amended, and the Covington Public School System accepted responsibility for educating black students.

However, the newly amended charter did not provide an opportunity for black students to be educated in the same building as white students, let alone the same classroom. The Kentucky Legislative Act of 1874, as well as the "Separate but Equal" US Supreme Court ruling in 1896, would become the law of the land. The Covington Public School System adhered to this public policy and to the policy that no black school could be located any closer than 600 feet to a school for white children.

The first public school used for black students was the former school constructed for white students on Greer Street. The Second District School was vacated in 1871 when a newer school was constructed. The first black teacher, paid $30 per month, was hired to begin classes for black students. The early efforts by the public education system to educate black students were anemic and lackluster. The quantity and quality of the course offerings were less than those of white students, and the children at the all-black school received a curriculum that would support a career with domestic positions in the community.

Meanwhile, Covington's public educational system provided new facilities for white students. In 1872 a new high school facility was constructed at 12th and Russell Streets. This new 12-room school became known as the Covington High School. The first high school graduation from the Covington High School occurred on June 5, 1869. Ms. Amelia S. Orr was the first recipient of a four-year high school diploma.

There were many changes and advancements in public education in Kentucky that also affected the Covington Public School System in the late 1800s. The state pushed hard to reduce illiteracy. Even though the public education system was prospering and organizing with great integrity across the commonwealth, many students were simply not taking advantage of the free educational opportunities available. It was reported in the *Licking Valley Register* that a quarter of a million people in the commonwealth could not read and write. In 1895 the Covington School System approved a new truant officer position, created to manage the attendance efforts for each school. Visits were made to the homes of children who were reported absent.The Covington School System also organized and implemented a complete course structure, from kindergarten through high school graduation. The school district added four kindergarten classes in 1891. Curriculum and courses were added throughout the late 1800s that improved, strengthened, and enriched the educational opportunities for students. This effort paid off for the school district. In 1896 the Covington High School was honored by the state college in Lexington, Kentucky. This new accreditation by the state college enabled all graduates the opportunity to enter the college without any further examination.

On a less-than-parallel course was the beginning of high school courses for black students in Covington. The first high school courses offered for black students began within the Colored School building until a new facility was constructed. The high school was first established in 1886 and was called the William Grant High School in honor of the late Colonel William Grant. Samuel Singer (brother-in-law of Jacob Price) became the first principal of the new high school. William Grant had previously donated property located on Seventh Street for the construction of a new school for African American students. It opened in 1888 and later became known as the Seventh Street School in an attempt to drop the title Colored School. The William Grant High School continued to operate on the upper floors of

Covington High School, 12th and Russell Streets, circa 1913. Courtesy of Paul A. Tenkotte.

the Seventh Street School. In 1889 the all-black high school announced its first two graduates, Annie Price and Mary E. Allen. Price was the daughter of Jacob and Mary Price; she later became a teacher at Lincoln-Grant High School.

Old Lincoln-Grant School, East Seventh Street. Source: *Annual Report of the Board of Education of the City of Covington, Kentucky, for the Year Ending June 30, 1910.*

The course offerings between the all-white Covington High School and the William Grant High School differed significantly. The Covington High School was described as having a comprehensive program that offered three graduation courses—a commercial course, a general academic course, and a manual-training course. The William Grant High School was referred to as a standard high school, and the graduates were listed as having received a general degree.

By the start of the 1900s, the Covington Public School System enrolled 4,342 students of a city population that had grown to about 51,000. It employed 94 teachers, 6 principals, 2 specialists, and 5 substitutes, and operated a total of six school buildings.

The tax structure for public education had also grown to 35¢ per $100 valuation of property and an additional 10¢ per $100 valuation of property for sinking fund purposes. By this time, the school term had increased to 10 months. In the first decade of the 1900s, the school system added six new school facilities, including the Fifth District School, located on Holman Street, in 1902, and the Sixth District School, on Maryland Avenue, in 1906. The Sixth District School was the first school construction project that was financed by the

sale of bonds. As of the date of this publication, both of these facilities are still standing, and the Sixth District School is still in operation as an elementary school. The city of Covington annexed the city of Latonia in 1909, adding three small school buildings to the total building inventory—they became the Eighth, Ninth, and Tenth Districts. The annexation of Latonia and Rosedale also added the Latonia Colored School. This school was organized in 1890 for the black students who resided in Latonia and for those whose families were associated with the operation of the Latonia Race Track. The original school for black students was called the Milldale Colored School and was located on Kruse Avenue off Main Street. The Latonia Colored School was eventually located at 30th Street and Decoursey Avenue until it closed in 1912. Graduates of this school attended the William Grant High School located on Seventh Street.

The most significant development and impact on education in Covington also occurred in the first decade of the 1900s. In 1908 the state legislature passed a compulsory attendance law that required all children between the ages of

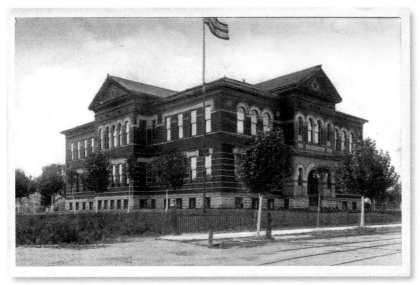

Fifth District School, Holman Street. Courtesy of Paul A. Tenkotte.

7 and 14 to attend some public or private school regularly each school year. This law established a punitive system for all responsible guardians who failed to comply with this new state provision. Any guardian found to be negligent in complying with this law was fined $25 for the first offense and $100 for the second offense.

In 1909 the school district added another new facility. The new school building, named the Seventh District School, was an eight-room facility located on Howell Street. It was at that time that the school district renamed the Seventh Street Colored School as the Lincoln Elementary School and the William Grant High School, because board members felt it would be confused with the newly constructed Seventh District school for white children. By 1912 the school name had become simply the Lincoln-Grant School.

In 1911 the Parent-Teacher Association was formed in all of the white schools. This organization met regularly to discuss child welfare and child development. It adopted such efforts as providing shoes, clothing, food, and glasses for needy students. It also worked toward maintaining lunchrooms that provided a wholesome meal at a reasonable price. This effort was essential for poor families attempting to comply with the new compulsory attendance law. Many of these families did not even have the basic needs necessary to attend free public school.

A new development took place in 1912. Homer Sluss was the superintendent of Covington Public Schools, and he implemented the first midyear promotion of students. This new concept allowed students who were struggling to complete the necessary courses for graduation to finish in the subsequent school term. This semiannual promotion allowed those students to finish their course work in the first term and graduate midyear. This change also allowed students with academic prowess to advance according to their abilities and to graduate early. This change did not affect the graduation of students from the William Grant High School until mid-1930. Mr. Sluss also established the compulsory age for enrollment in the first grade as 6 by the first day of September.

In 1914 two junior high schools were established—the John G. Carlisle Junior High School and the John W. Hall Junior High School. Both of these schools were designed to conduct instruction according to departmental disciplines,

and were housed in two of the elementary schools. This approach was set for seventh- and eighth-grade students and allowed teachers to prepare classrooms that were aligned with their instructional specialty. It promoted a deeper and more intentional subject content delivery for the students. The John G. Carlisle School began serving students at the Second District School until it moved into the former Covington High School building in 1919. The John W. Hall Junior High School started its operations in the Fourth District Elementary School.

Another new development took place in 1914 when an evening school opened for white and black students. The classes were housed in separate facilities and were entirely different. The courses offered to the white students included a two-year commercial course, a four-year academic course, and classes in mechanical drawing and shop mathematics. The evening school for black students was relegated to basic rudiments in English and arithmetic.

In December 1915 the 17-acre Holmesdale Estate was purchased for $50,000. This property had been previously owned by Daniel Henry Holmes, a wealthy merchant and department store owner in New Or-

leans, Louisiana. The site was chosen as a more central location for high school services, especially since the annexation of Latonia and Rosedale by Covington. The old Holmes family mansion, dating from the late 1860s, was used for the school. Construction began on a new building (today called the Senior Building) in 1916 and opened for students on January 6, 1919, with an enrollment of 500. The high school continued to use the former residence of Daniel Holmes as a cafeteria, band room, and bookstore, and even held dances in the former ballroom. A tunnel was constructed to

Holmes High School, circa 1928. Note the old Holmes family mansion, which was demolished in 1936. Courtesy of Paul A. Tenkotte.

connect the new school facility with the former residence. This building was commonly referred to as the Castle. By late 1919, the school was already being referred to as Holmes. At first, it had minimal athletic facilities, other than a gymnasium. All football and baseball games were played off-site. The first football game held on the Holmes campus was played in 1925 after a resourceful student (Gene May, class of 1928) constructed a field in the lake bed of the former Holmesdale estate. May borrowed equipment and secured material donations in order to construct the first football field. The current stadium is in the same location as the original field built by May.

The year 1916 ushered in several new changes for the Covington Public Schools. This was the year the district offered summer classes for the first time and provided students with a chance to make up one class before the start of the September session. This was also the year that classes were established for students with special needs. A class for boys started in February that provided extra attention for students who were struggling. The course was structured to provide hands-on manual training for students who were mentally challenged or "out of harmony with their school environment."

The city of Covington annexed West Covington in 1916 and as such, the Covington School District took over management of the West Covington Public School System that was in operation in 1917. West Covington had a public school in operation dating back to 1882. The Covington School District constructed a new school facility in 1922 at a total cost of $100,000, which opened to students in September 1923. The new Eleventh District School was located on Altamont Avenue.

In 1926 Covington Public Schools added a new junior high school to the Holmesdale campus. A bond sale was issued for $425,000 in 1926, and the new 45-room school officially opened in September 1927 with an enrollment of 900 students. The John W. Hall Junior High School was closed at the Fourth District School and moved to this new location.

The school district also initiated plans for a new school for black students. The Lincoln-Grant School was woefully inadequate for the number of students attending classes. The school district added several additional programs housed in buildings located in the downtown business district. The students were forced to change buildings during the day, depending on their course work. Two of these structures were in deplorable condition, and one was considered a firetrap. In fact, students were trained to slide down the fire escape in Kroger grocery bags to expedite their exit. The bags allowed them to glide quickly down the fire escape structure. The bustling downtown business district was also unnerved by the presence of the black school located in the middle of the thriving commercial center. Business owners were not happy with the image that the school was portraying to downtown visitors and customers. The frustration on the part of the businesses became known as "that downtown issue." Further, a new school was critical to meet the needs of a growing population. The Covington School System operated the only high school for black students in Northern Kentucky. The neighboring school districts in Boone, Campbell, and Kenton Counties paid tuition to Covington for their black students. The students outside the Covington School District rode buses, cars, or trolley cars, or they walked. In fact, the Boone County officials decided that it was much cheaper to buy the students "an old junker car" than provide bus transportation.

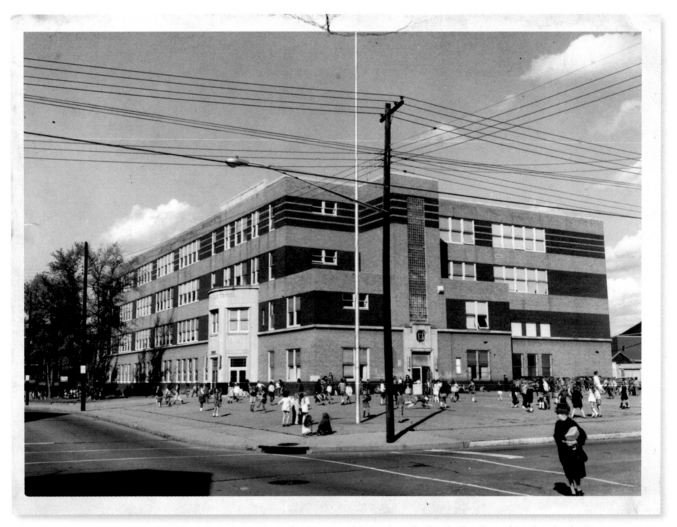

John G. Carlisle School, circa 1960s. Photo by Raymond E. Hadorn, in the Collection of Paul A. Tenkotte.

The school district authorized a bond sale for acquisition of a site and construction of a new African American school. The amount of the bond sale was $250,000, and a resolution was passed on June 29, 1928. However, it was not until 1932 that the school opened for its first students. The entire process was fraught with politics, court actions, design problems, bidding problems, and the stock market crash of 1929. Even the eventual location of the school became a political football. The new school was constructed on Greenup Street.

The 1930s were a period of substantial construction activity for the school system. The Great Depression led to the creation of the Works Progress Administration (WPA). This program aided in the funding and assistance for construction of four elementary schools, replacing the old First, Second, Third, and Fourth District Schools. This program also assisted with additions at Fifth and Sixth District Schools. A new school board administration building was constructed on Seventh Street on the former site of the Seventh Street Colored School. The WPA program also added an administration building on the Holmes campus. The new administration building was constructed in place of the former Daniel Holmes residence.

The John G. Carlisle Junior High School was again moved in 1937 when a new facility was constructed at Pike and Holman Streets. The new four-story facility housed the Second District Elementary School on the lower levels and the Junior High School on the upper floors. Each school was managed by separate administrations.

As with the entire city of Covington, the school system was significantly affected by the flood of 1937. Three schools were flooded, including Lincoln-Grant, Third District, and Sixth District. Third and Sixth District only received water in the basement and were able to serve as a shelter for local residents. It took several weeks after the floodwaters receded to clean up the facilities and to reopen for school services.

In 1941 all school centers once again were asked to serve the community for services other than education. The schools were organized and assisted with the efforts of World War II. They became registration centers for the military draft as well as locations for citizens to pick up ration stamps for gas, meat, sugar, and shoes. The most profound impact on the school system at that time was the enlistment of so many high school males. A significant number of students were drafted by the armed services or left school and enlisted to serve the nation. This interruption in the education system led to the start of the General Educational Development (GED) tests. This process was established to allow returning soldiers the opportunity to complete their high school educational requirements.

The next major wave of changes to hit the Covington School System, and all public education systems nationwide, came after the US Supreme Court ruled on May 17, 1954, that the segregation of African American students was in violation of the 14th Amendment of the US Constitution. This decision was appealed, and the courts reaffirmed the earlier court decision in 1955. The immediate impact was felt by the Lincoln-Grant School. The Covington School System took 10 years to integrate the separate Lincoln-Grant School student population into the rest of the schools. The school board and school administration carefully and cautiously approached the integration of the African American population into the formerly all-white schools. The previous 100 years were consumed with maintaining the "separate but equal" status for black and white students. The school district formed a committee to proceed with a detailed study of problems inherent with the desegregation process. Glenn O. Swing was the superintendent who led the committee work until his retirement in 1960. David Evans took over as superintendent and presided over the balance of the desegregation efforts.

The desegregation plan prepared by the Covington School Board was approved by the US Department of Health, Education, and Welfare (HEW) for the 1965–66 school year. This plan marked the end of the segregated Lincoln-Grant School, with William Grant High School graduating its last class in 1965. At that time, the school building began operation as an elementary school with a desegregated population. The school district also transferred Lincoln-Grant teachers to other assignments within the district. The progress of Covington's desegregation efforts was monitored for many years by the HEW and by civil rights groups.

In 1957 the school district constructed and opened a new Ninth District Elementary School. The old school was located at Graff and Ferry Streets; the new location was at 28th Street and Indiana Avenue. The site for the school was previously owned by the Coppin family, who owned Coppin's Department Store.

A major addition was made to the Holmes campus in 1966 when the new science building and the David M. Evans Fieldhouse were constructed. These facilities provided new science labs, a library, and a gymnasium. The new gymnasium was the largest such facility in Northern Kentucky.

In 1946, a year after World War II ended, the University of Kentucky established a limited curriculum extension course center at the Trailways bus station on Pike Street in Covington. Two years later, the university rented space at First District School in Covington and began a two-year college program, thereby establishing Northern Community College (NCC), the first community college of the University of Kentucky. Subsequently, as enrollment increased, NCC was moved in 1961 to a new two-building facility located on a hilltop above Covington, and in 1970 it was absorbed into the new Northern Kentucky State College (now Northern Kentucky University).

Several construction projects involving the Covington Public School System took place in the early 1970s. The new Glenn O. Swing Elementary School opened at 19th Street and Jefferson Avenue, thus merging the former Fifth and Seventh District Schools. The new Latonia Elementary School was constructed in 1973, combining the Eighth and Tenth District Schools.

With the opening of Glenn O. Swing School, the Fifth District Elementary School was closed in 1972, and its facility was repurposed for alternative programs. The school district began to offer programs designed to meet the diverse needs of students who were having a difficult time completing the necessary requirements for graduation through the traditional educational program. This new, comprehensive program was designed for struggling students. The approach provided pathways either back to the traditional school environment or to exploration of work experience options that suited the needs of each student. An alternative high school was established for students beginning in grade 10. The facility also began to operate as a job preparation center that provided opportunities for students both to begin planning for the job market and to remediate their required course work necessary for graduation. Additionally, it managed a program for students who were court ordered or referred by the school due to behavioral problems. The Covington Area Day Treatment Center provided a comprehensive network of options necessary to manage all types of students.

There was another change to the junior high school structure in Covington in 1971. The John G. Carlisle Junior High School was closed and replaced by the Covington Junior High School. The John G. Carlisle School then became an elementary school. The new location of the junior high school was the First District Elementary School. All elementary school students were transferred out of First District to adjacent schools, and the building was renovated for junior-high-school-age students. The Covington Junior High School remained open until 1977. At that time, all junior high students were transferred to the Holmes campus.

By 1975 HEW was still unhappy with the efforts of the Covington School System in achieving a proportionate racial balance of students and teaching staff. Superintendent Bert Bennett's contract was not renewed in 1975, and he was replaced by Gary Blade. Blade prepared a very controversial plan to change the racial balance of white and minority students, while also complying with other elements of the HEW report. In 1976 the Covington School District closed the doors forever at the Lincoln-Grant School, which was operating as the 12th District Elementary School. The school district also closed the Eleventh District School located in West Covington, the only school in the district without a black student. This move also initiated bus transportation for students in Covington for the first time.

The state of Kentucky began to expand vocational training programs throughout the commonwealth in the 1970s, providing funding for the construction and operation of new facilities. The Covington School District had a substantial student population in need of vocational training opportunities, but it was not listed as a location for one of these new centers. The Covington students interested in vocational training were transported to the Patton Vocational School, located in the Kenton County School District. The district petitioned the state for its own independent facility, and was

finally granted permission to construct and operate a facility on the Holmes campus. The Chapman Vocational School was constructed and opened to students in 1980. There was some opposition to the construction of another facility on the Holmes site due to the further elimination of precious green space from the campus.

In 1980, with declining enrollments, Covington Public Schools closed the operation of Third District. The facility was subsequently sold and repurposed into an office building at the corner of Fifth and Philadelphia Streets. During the late 1980s, the school district acquired the former Bishop Howard School from the Diocese of Covington, located at 12th Street and Scott Boulevard, as well as all adjacent parcels comprising an entire city block. The facility became James Biggs Early Childhood Center, the first district-wide preschool center, designed to provide early-childhood-age students with an opportunity to overcome any learning disadvantages and socioeconomic struggles and to make certain that they were ready for kindergarten.

By 1980 the city's annexation efforts ended, having doubled the city's size in the prior 30 years. With the annexations, the city's borders crossed over into the boundaries served by the Kenton County School District. Hence, many Covington students in South Covington attend Kenton County Public Schools, as well as those in the Kenton Hills neighborhood. In fact, two Kenton County School District facilities are located within Covington's city limits: Taylor Mill Elementary and Fort Wright Elementary.

In 1994 the John G. Carlisle Elementary School was razed and replaced by a much smaller and more modern elementary school building. The two-story cast-stone Art Deco elements from the former school were reconstructed and incorporated into the design of the new elementary school. Many residences, as well as some commercial facilities located on Pike Street, were acquired to expand the campus for the new facility. Some former streets and alleys were closed to connect all of the acquired parcels into a seamless site for the school.

The school district also undertook a major renovation and expansion of the Sixth District Elementary School, starting in 1997 and completed in 2000. The 1906 facility had never been renovated and still used a coal-fired furnace. The reconstruction of the building included a significant expansion of the school and the campus. Adjacent properties were acquired and razed to provide sufficient parking and play areas for students. The school district petitioned the city to close one block of Maryland Avenue to extend the school site across to the newly acquired parcel.

The district faced significant economic challenges in the 1990s, stemming primarily from declining enrollment. The state of Kentucky provided funding for educational purposes on a per-pupil basis. With suburbanization and a declining city population, Covington Independent Schools had been losing enrollment for decades. The district voted to close the former Fifth District Elementary School (18th and Holman Streets) that had been operating as an alternative school since 1972. The Fifth District facility was subsequently sold and converted into senior living apartments. The school system also closed the Fourth District Elementary School, but repurposed it as the Covington Academy for Renewal Education (CARE) for some of the programs that had been operating at Fifth District. In addition, some of the remaining alternative programs from Fifth District were relocated to the former Rosedale Federal Savings and Loan building at Ritte's Corner in Latonia. The CARE program only lasted three years, and the old Fourth District School reopened as the Thomas Edison Elementary School. Edison, in turn, closed at the end of the 2008–09 school year, and has since been converted into apartments.

In 2001 the school district prepared and implemented a plan for a middle school to be located at the First District Elementary School facility. The students from First District were reallocated to adjacent elementary schools with sufficient capacity, and the building was reopened as the Two Rivers Middle School. The new school opened to students in the sixth and seventh grades. The Holmes Junior High School was turned into an eighth- and ninth-grade center. In 2001 the school district opened a sixth-grade-only center in the former First District Elementary School named Two Rivers. Beginning with the 2002 school year and continuing until 2009, the "middle" concept was expanded to include sixth through eighth grades. The middle school was again returned to the Holmes Junior School building for the 2009–10 school year.

The student population of the Covington School System has been on a steady decline since its peak enrollment of 8,600 students in 1958. The enrollment fell to 6,000 30 years later in 1988, and began losing 150 to 200 students annually by the mid-1990s. As of 2013–14, the enrollment was 4,072, less than half of the 1958 peak. The school district also has a student population mired in socioeconomic hardships, as well as an increasing special needs population. In addition, students from nations around the world, with little to no previous education and with little understanding of English, have special needs. In 2013 Covington Independent Schools named Alvin Garrison as superintendent. The first African American to hold the position, Garrison was principal of John Hardin High School in Elizabethtown, Kentucky.

The school system and the city have faced many hardships over the last 200 years and are facing significant hurdles moving forward. They have proven capable of dealing with overwhelming hardships in the past, and it will be necessary to draw from this past and to utilize creative strategies to carve out a prosperous future for Covington's citizenry.

GATEWAY

The Gateway Community and Technical College purchased the former First District (also called the Two Rivers Middle School) facility in 2010, where it has been leasing space for an urban college campus. Gateway College is in the process of creating a significant college campus in downtown Covington. Many commercial buildings, as well as the former First Methodist Church, have been acquired and are in the process of being repurposed to offer collegiate courses around the core area of downtown Covington. The new campus concept blends with the architectural and historical significance of the city and complements the surrounding neighborhoods.

First District School, Scott Boulevard, became part of the new Gateway Community and Technical College. Photo by Dave Ivory, 2014.

CATHOLIC EDUCATION

When St. Mary's Church was blessed on September 21, 1834, the building included a large sacristy that served as a school classroom. Two of the earliest instructors were a Mr. Wakefield, who taught the English-speaking students, and a Mr. Dengler, who taught the German-speaking pupils. Catholic schools were established in the United States and in Northern Kentucky for several reasons. The common, or public, schools typically had a strong Protestant flavor. Bible reading (from the King James Version) and the singing of denominational hymns were unwelcome to Catholic parents. Many feared that the public schools were established in part to convert their children to other faiths. Also, many public school boards were dominated by Protestant ministers. Catholics, who primarily spoke a language other than English, also feared the public schools would turn their children away from their cultural roots. The Catholic clergy, in cooperation with the laity, made a conscious decision to support the building of Catholic schools wherever possible—this was especially true in the German-dominated Midwest. The Catholic population of Covington followed this trend, and within 50 years, a flourishing system of Catholic schools existed in the city.

In 1841 the German-speaking parishioners of St. Mary's Parish founded the new Mother of God Parish on Sixth Street. A school was founded at the same time under the direction of a lay teacher. In time, the parish established

both a boys' and a girls' school. Catholic schools taught a traditional curriculum with the addition of religion. When the Diocese of Covington was established in 1853, Reverend George Carrell, SJ, was named the first bishop. Carrell and his successor, Augustus Maria Toebbe, both supported Catholic education and encouraged every parish in the diocese to establish a school.

The dedication of the new St. Mary's Cathedral on Eighth Street took place on June 11, 1854. Bishop Carrell was determined to strengthen the cathedral's school by introducing women religious as teachers. In 1855 the bishop requested the Sisters of Charity of Nazareth in Nelson County, Kentucky, to send a group of women religious to Covington to staff the parish school for girls and to establish an academy. At that time, Esther O'Bierne was operating the parish school in a cottage adjacent to the cathedral rectory on Scott Boulevard. A boys' school was being operated in a three-room brick building on Seventh Street between Madison Avenue and Scott Boulevard and was also taught by lay teachers. By January 23, 1856, Mother Catherine Spalding agreed to send sisters to Covington to establish a parish school for the cathedral. The citizens of Covington responded immediately by raising funds for the new venture. Bishop Carrell wanted the sisters to open both a parish school for the poor children of the community and an academy for those parishioners and non-parishioners who preferred a more advanced education for their children. At first, the sisters were reluctant to begin an academy; instead, they proposed opening a common school teaching the basic branches of study. Bishop Carrell insisted that a tuition academy be established. Vicar General Butler explained the need for both a parish school, or poor school, and an academy in this way:

> *[A poor school] would alone not answer the necessities of our people, for most of them are poor, still there are many able to pay for the school of their children, and also many protestants [sic] are asking for a good school, and have promised to send their children, if we have such a school established. In fact esteemed Mother, if the school should be only a plain and simple poor school, we shall not be able to carry out our good intentions, as our poor cannot support such a school, and our better off people will not help us, unless we get them a proper school, as a pay school for their children.*

The final agreement between Bishop Carrell and the sisters called for the establishment of a parish school for the cathedral and an academy. Bishop Carrell personally named the new academy after Our Lady of La Salette.

La Salette Academy, at Seventh and Greenup Streets, is now the home of La Salette Apartments. Photo by Paul A. Tenkotte.

Using the proceeds from a fair, a small two-story brick building containing six rooms, with three additional rooms in the basement, was purchased at the corner of Seventh and Greenup Streets on the commons. Formerly the home of the McCloskey family, the building was purchased as a home for the sisters and for the proposed tuition academy. Mother Catherine Spalding and her council sent Sister Clare Gardiner and five sisters to Covington to open both the Cathedral School and La Salette Academy. Tuition at La Salette Academy those first few years was $1 per month, with many of the students paying in-kind with food and other goods. In 1886 the sisters built a new brick two-story academy building on the southeast corner of Seventh and Greenup Streets, to which they added a third floor in 1903.

In 1874 a new school for the cathedral parish was built on Seventh Street between Greenup and Scott Boulevard. This two-story brick structure, with a basement, housed both the boys' and girls' schools. This was the first time that the male and female pupils were under the same roof at the Cathedral School. The Sisters of Charity continued to teach the female students and the Brothers of the Holy Cross from South Bend, Indiana (who operated the University of Notre Dame), were brought to Covington to teach the boys. Eventually, the Brothers of the

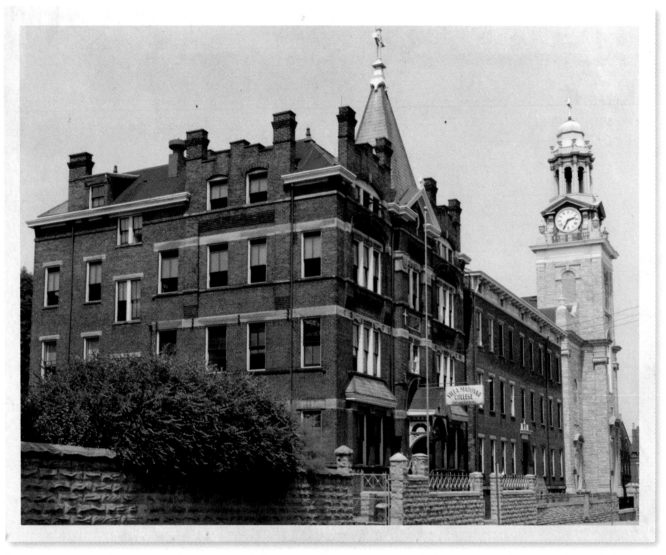

The old St. Walburg Academy on East 12th Street closed in 1931 and became part of the campus of Villa Madonna College. To the right is St. Joseph Catholic Church. All of these buildings were demolished. Raymond E. Hadorn photo in the collection of Paul A. Tenkotte.

Holy Cross left Covington, and the Sisters of Charity began teaching all of the students regardless of gender. By 1880, the school boasted an enrollment of 550 students, with a faculty of six Sisters of Charity.

St. Patrick in the Westside also sponsored a parish school. The parish initially established a school under the direction of lay teachers in 1876. This school closed in 1886. The school was reestablished in 1891 under the care of the Sisters of Charity of Nazareth. In time, the Sisters of Charity of Nazareth staffed almost all the English-speaking Catholic schools in Northern Kentucky.

The Sisters of St. Benedict arrived in Covington at the invitation of Bishop George Aloysius Carrell in 1859. Mother Alexia Lechner was appointed the first prioress. The sisters came to Covington from Erie, Pennsylvania (originally from Eichstadt, Bavaria), and were primarily recruited by Bishop Carrell to open an academy and parish schools for German-speaking Catholics. They immediately assumed operation of St. Joseph Girl's School in the Helentown (now Eastside) neighborhood. There, they constructed St. Walburg Monastery and Academy next to St. Joseph Church. The sister's services were highly sought after, and in time, they staffed dozens of schools in the diocese. St. Walburg Academy existed from 1863 until its closure in 1931 to make room for the expanding Villa Madonna College. In Covington, the Sisters of St. Benedict also staffed St. Benedict School in the Austinburg neighborhood, and Holy Cross Elementary and High School in Latonia.

The Sisters of St. Francis of Oldenburg, Indiana, had a major presence in Northern Kentucky and Covington for many years. They came to the diocese in 1861 to staff the growing number of German-Catholic parish schools sprouting up. In time, the sisters staffed six schools in the region. Four of these schools were in Covington: Mother of God, St. Aloysius, St. Ann, and St. John. After the Sisters of St. Francis withdrew from the Diocese of Covington, they were replaced in these schools by the Sisters of Notre Dame and by the Sisters of Divine Providence.

The Sisters of Notre Dame arrived in Covington in 1874. They were fleeing anti-Catholic bigotry in their native Germany during the era of the persecution known as the Kulturkampf. The sisters acquired property at the corner of Fifth and Montgomery Streets. In a small home on this property, they established their motherhouse, and in 1876, built the first wing of Notre Dame Academy. A number of additions were made to the academy over the years. In 1906 a high school curriculum was added to the program. In 1927 the motherhouse was moved to St. Joseph Heights in Park Hills, Kentucky, which allowed the entire Fifth Street building to be turned over to the academy. The sisters eventually staffed Mother of God School, St. John School, St. Augustine School, and currently Prince of Peace School in the city of Covington.

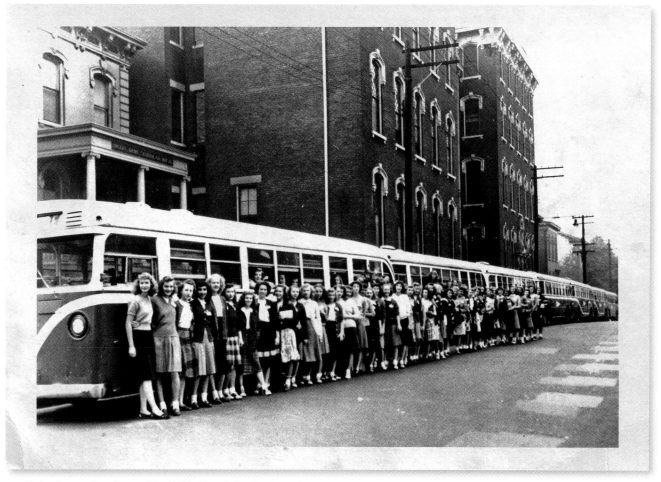

Notre Dame Academy, West Fifth Street, Covington. Photo by Raymond E. Hadorn, in the collection of Paul A. Tenkotte.

The Congregation of Divine Providence was invited to the United States and the Diocese of Covington by Bishop Camillus P. Maes in 1889. Their motherhouse was established in the old Jones mansion in Newport, Kentucky. On this site, they opened their first school, Mount St. Martin Academy. The Sisters of Divine Providence staffed schools throughout the Diocese of Covington, especially in the Appalachian Mountains region. In the city of Covington, the Sisters of Divine Providence staffed Our Savior Elementary and High School, St. Aloysius, and St. Ann in West Covington.

Catholic brothers also taught in Covington. In 1885 the Brothers of Mary of Dayton, Ohio, were invited to teach the boys at St. Joseph Elementary School and to begin a Catholic high school for boys in the city. While the young women of the community could earn a high school diploma at one of the three Covington Catholic academies, young Catholic men either went to work after finishing grade school or went to one of the Catholic schools for boys in Cincinnati. The Brothers of Mary established St. Joseph High School in 1885 on East 12th Street. They offered a two-year commercial course that focused on business classes. The school catered primarily to the middle class and prepared young men for work in area businesses. Prior to World War I, the school enrolled a small number of students. Many Catholic families needed their young sons to acquire jobs to help support the family. As a result, the school remained small in these years, with graduating classes ranging from 5 to 15 young men. Despite these small numbers, St. Joseph High School filled a critical gap in the Catholic school system in Northern Kentucky.

Catholic schools were educating a significant number of students in Covington. In 1868 the *Covington Journal* pointed out that 3,000 children were being educated in the Catholic schools of the city, and if these 3,000 pupils attended the public schools, "the school board would be compelled to build six or eight new school houses, at a cost of $100,000 and employ some 30 additional teachers at an annual expense of not less than $20,000."

These early Catholic schools were typically housed in buildings that also housed the parish church. Classes were large, and classrooms were filled to capacity. The curriculum was similar to what was being taught in the Covington public schools, with the addition of religious instruction and a strong emphasis on service to the community. In time, new, modern Catholic school buildings were constructed throughout the city. The most imposing of these structures was Mother of God Elementary School, built in 1905–06. Up until this time, Mother of God operated separate schools for boys and girls. These early school buildings were removed and replaced by a new building designed by the renowned local architectural firm of Samuel Hannaford and Sons. The building stood on the north side of Sixth

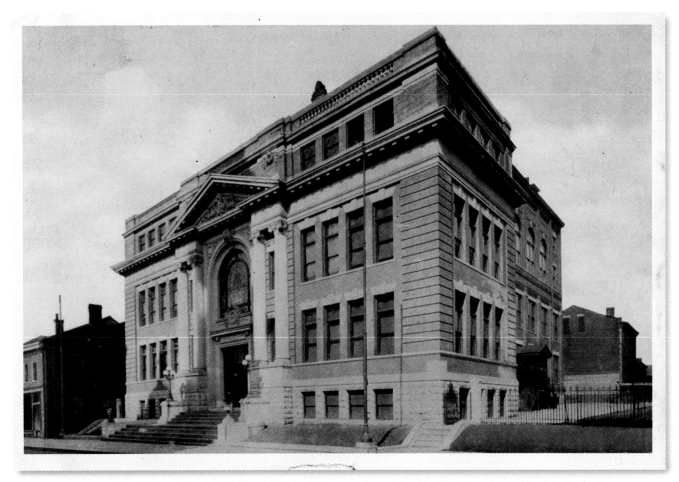

Mother of God School, West Sixth Street. This building was demolished in 1974. Courtesy of Paul A. Tenkotte.

Street directly across from the church. It was state of the art for its time, containing 10 classrooms, a teachers' conference room, a musical recital hall, a gymnasium and locker rooms, clubrooms and a billiards room for the parish, and a reading room. The new school also featured a grand auditorium with seating for 900. The auditorium included an orchestra pit, a gallery, and four boxes. At the time of the school's dedication, enrollment had reached 565 students in grades one through eight.

Holy Cross High School, Church Street. Photo by Dave Ivory, 2014.

The construction of Mother of God School encouraged the other Covington parishes to build new schools as well. These schools were modern in design and construction and were comparable to the public schools being built in Covington. In 1913 St. Patrick Parish on the Westside replaced its temporary buildings with a new brick building, which included an auditorium and gymnasium. Two new Catholic schools were dedicated in Covington in 1914, Holy Cross in Latonia and St. John in Lewisburg. St. John Church and School had originally been built on the brow of a hill at the corner of Leonard and Worth Streets. By the early years of the 20th century, the church and school were slipping down the hillside. A new piece of property was purchased on Pike Street, and funds began to be raised. When the new school was dedicated, it housed classrooms, a temporary church (which later became the school auditorium), separate living quarters for the Sisters of Notre Dame, and a rectory for the priests assigned to the parish. In 1915 the Cathedral Parish dedicated a new school on the west side of Madison Avenue, and one year later, St. Augustine Parish dedicated a large new school on West 19th Street to house its growing enrollment. St. Benedict Parish dedicated an impressive new school building in May 1923, and St. Joseph Parish in the Helentown neighborhood dedicated a new school in 1927. At that time, the St. Joseph boys and girls schools were combined under the direction of the Sisters of St. Benedict, with the Brothers of Mary focusing on their high school program. St. Aloysius Parish completed a new school building on Eighth Street in 1933. Much of the work was done by unemployed members of the parish. Our Savior Parish built a new school in 1943. The last new Catholic elementary school to be built in Covington was St. Ann School in 1957, in the West Covington neighborhood.

In the early years of the 20th century, more Catholics began to move into the ranks of the middle and upper-middle classes. The need for additional Catholic secondary schools in Northern Kentucky became apparent. In 1914 Holy Cross Parish in Latonia began a two-year commercial high school. Tuition was 5¢ a day—a rate many middle-class families could afford. In the following year, a new 12-classroom Holy Cross School was dedicated. This new building allowed for the creation of a standard four-year parish high school under the direction of the Benedictine Sisters. For many years, the parish sponsored both the commercial and academic high school programs, both of which were coeducational. A separate high school building, containing an auditorium, 13 classrooms, a library, and a gymnasium, was constructed to house the growing student population. In these early years, Holy Cross High School was primarily taught by the Benedictine Sisters and by a few lay teachers.

St. Benedict Parish also established a commercial high school in 1923, with the completion of its new elementary school. The program offered a two-year course to young women who had completed the eighth grade, and focused on business, shorthand, typing, and other useful skills needed to work in a modern office of the time. St. Benedict Commercial High School grew over the years and achieved a high standing within the business community.

When Bishop Francis W. Howard arrived in Covington in 1923, he immediately began working on improving

the schools of the diocese. Howard had been a founding member of the National Catholic Education Association and was an officer in the association for 42 years. He strongly believed that less regulation was preferable to more when it came to the schools of the diocese. Bishop Howard feared government regulation in the Catholic schools, feeling that it would be detrimental to the schools' independence. He once said, "There is need of more freedom and less legislation in the educational life of this country, education becomes stereotyped, formal and inefficient if there is no room for experiment and no incentive for initiative." Though Bishop Howard initiated annual teacher institutes and set up a board of examiners to observe schools throughout the diocese, Catholic schools in Northern Kentucky remained remarkably self-sustaining and governed locally by the clergy and religious orders.

In 1923 Bishop Howard provided the impetus for experimentation in a new secondary school for boys. While Catholic young women had many opportunities for secondary education in the academies, young men had few. In that year, Howard established the Covington Latin School in the old Shine family residence behind the Cathedral School. Covington Latin accepted gifted male students who had completed the sixth grade. These students skipped the seventh and eighth grades and entered the school as freshmen. The curriculum was based on the classics, including Greek and Latin. The school was solidly college preparatory and was taught primarily by the clergy of the diocese. It moved several times before the current facility was dedicated on December 7, 1941. Covington Latin School educated many future clergy, physicians, attorneys, and businessmen in the community.

Covington Latin School, circa 1960s. Photo by Raymond E. Hadorn in the collection of Paul A. Tenkotte.

With Covington Latin established, Bishop Howard turned his attention to establishing two central high schools for young men in Northern Kentucky—one in Covington and the other in Newport. In 1925 the Brothers of Mary agreed to phase out their St. Joseph Commercial High School and to establish Covington Catholic High School. The new Covington Catholic was housed in the Mother of God School on West Sixth Street. The first freshman class consisted of 37 pupils and drew students primarily from the parishes in Covington and neighboring Ludlow, Kentucky. The school grew quickly, adding a class level each year. In 1929 Covington Catholic marked two milestones—it was accredited by the commonwealth of Kentucky, and it graduated its first class, consisting of 17 pupils. Tuition in 1929 was $50 a year.

As the public school system in Kentucky advanced, state officials began requiring that all accredited schools be staffed by teachers with college-level degrees. The three major religious orders of women, who were staffing most

schools in the diocese, responded to this mandate by planning to open teacher-training colleges. The Sisters of St. Benedict established Villa Madonna College on their motherhouse grounds in 1921, under the direction of Sister M. Domitilla Thuener as the first dean. The school was open to members of their community and to young women who wished to receive a college education. In the meantime, the Sisters of Notre Dame and the Sisters of Divine Providence were planning colleges of their own to be established in Covington and Newport respectively. Bishop Howard quickly saw the inadvisability of sponsoring three Catholic colleges in the area. Instead, he asked the three orders of sisters to cooperate, a move that was highly innovative for its time in Catholic circles nationwide.

In 1929 the bishop appointed the mother superiors of the Benedictine Sisters, the Sisters of Divine Providence, and the Sisters of Notre Dame to a board of trustees for Villa Madonna College. A central site on a bus line was selected at St. Walburg Academy of East 12th Street, and the normal school (teacher-training college) opened in 1929 with Father Michael Leick as dean. In that same year, the Sisters of St. Benedict's Villa Madonna College graduated their first and last class, as they chose to close their college and to focus on the normal school. Since Villa Madonna College had already been accredited by the state, the diocesan normal school operated under its charter and the name Villa Madonna.

Villa Madonna College remained a small institution that primarily taught young nuns and women to become teachers. The sisters devised an ingenious plan to staff the college. Each order took charge of a group of academic programs. As an example, the Sisters of Notre Dame taught the sciences and history. This plan allowed each of the mother superiors to prepare sisters with doctorates in specific academic fields. With the end of World War II, Covington's new Bishop, William T. Mulloy, announced that the institution would become coeducational in 1945. The influx of new students on the GI Bill led to a growth in enrollment. The college began renting facilities near the administration building and cathedral to house the additional programs and students. Over the next three decades, Villa Madonna College spread to more than a dozen nearby buildings, including old homes, a vacant firehouse, the Cathedral and Mother of God Schools, and a former saloon. Eventually, the college purchased the old Knights of Columbus Hall on Madison Avenue and remodeled it into a student union, library, and faculty offices.

As enrollment at Villa Madonna College increased, so did the need for more modern facilities with sufficient off-street parking. Under the guidance of Monsignor John F. Murphy, the college constructed a new campus in suburban Crestview Hills, Kentucky, which was dedicated on September 28, 1968, with US President Lyndon B. Johnson in attendance. The name of the college was changed to Thomas More College in February 1968. In 1972 the science building was completed at the Crestview Hills campus, and all classes ceased in the city of Covington.

The last Catholic parish to be established in Covington was Our Savior on East 10th Street for African Americans in 1943. Prior to this time, the few African Americans in the community attended the Cathedral Parish. Bishop Francis

US President Lyndon Baines Johnson (left) and Reverend John F. Murphy (right) greeting visitors at the dedication of Thomas More College in suburban Crestview Hills, Kentucky, September 28, 1968. Photo by Raymond E. Hadorn in the collection of Paul A. Tenkotte.

Howard, however, wanted a more permanent arrangement. In particular, the bishop desired a school that would serve as a beacon to the African American community. In 1943 the diocese purchased two frame homes on East 10th Street in Covington for the establishment of a parish and school for African Americans. In September 1943, Our Savior School began operation in one of these buildings. Bishop Howard arranged for the Sisters of Divine Providence to take charge of the new institution. In 1946 Our Savior opened a high school. Our Savior Church was dedicated on February 11, 1944. The possibility of establishing an integrated Catholic school system at this time was impossible. In 1904, the Kentucky General Assembly passed the Day Law, forbidding the operation of integrated public or private schools within the commonwealth. The Day Law was upheld by the Kentucky Supreme Court and was in effect until 1954. By 1956 Our Savior High School had been closed, a consequence of the integration of African American students into other Catholic high schools.

In Northern Kentucky, Catholic African American children living in Covington were expected to attend Our Savior School on East 10th Street. This expectation changed with the order to desegregate the public school system by the US Supreme Court. At this time, Catholic leaders began questioning the need for separate institutions for African Americans. Our Savior School enrolled a small number of children and was housed in an inadequate building. On the other hand, many of the parishioners at Our Savior valued their school and did not wish to see it close. Bishop Richard Ackerman was faced with a decision that would please no one. If he left Our Savior School open, he would be labeled a segregationist. If the school program closed, the bishop would disappoint the parishioners of Our Savior. In the end, Bishop Ackerman felt that a stand against segregation was of utmost importance. Our Savior School was closed in 1963, and the pupils were encouraged to attend nearby parish schools. Bishop Ackerman wrote a letter to every priest in the diocese, stating that no child was "to be refused admission to any school for any reason related to race or national origin."

Another Catholic school in Covington that took integration seriously was La Salette Academy. In 1955 the school enrolled its first African American student. Initially, the Sisters of Charity feared that integration would result in the loss of many white students. The sisters, however, pushed ahead with the process out of a sense of justice. The sisters' fears were soon put to rest—only one white student withdrew.

The Catholic school network in Northern Kentucky began a transformation in the late 1940s that continues to this day. Among the most dramatic challenges to face the schools was the lack of women religious. In the years following World War II, the number of women religious in the diocese actually increased. However, these increases did not keep pace with the Catholic population, especially in the booming suburbs. During these years, the number of lay teachers employed in the Catholic schools of Covington modestly increased. As early as 1948, Bishop Mulloy found it necessary to request four urban parish schools to release sisters for other duties in the suburbs and in rural areas of the diocese. Mulloy wrote, "At my suggestion, the older parishes of the Diocese have been asked to employ the services of lay teachers, thus releasing Sisters for work in other mission fields."

During the postwar years, women had many more opportunities to acquire advanced degrees and to work outside the home. As a result, the number of young women entering religious orders dramatically declined. This meant that if Catholic schools were to survive, they would need to hire many more lay teachers. This was a very costly endeavor, since the sisters had worked for subsistence wages. Lay teachers, many of whom were supporting families, needed adequate salaries. Parishes across the country, especially those in declining urban areas, were unable to keep up with the rising costs.

Within a period of about 20 years, the number of lay teachers employed by the Catholic schools of Northern Kentucky increased dramatically. Most of these dedicated men and women had been educated in the Catholic schools of the region and were committed to their survival. Lay teachers were well trained to succeed the women religious who had spent decades in the schools. Like the sisters before them, lay teachers became the foundation of the Catholic school system in the region.

Two of Covington's largest Catholic high schools began plans to move from the city in the 1950s. Covington

Covington Catholic High School, circa 1950s, Dixie Highway in suburban Park Hills, Kentucky. Courtesy of Paul A. Tenkotte.

Catholic High School had long outgrown the facilities at Mother of God School on West Sixth Street. The school needed more modern facilities, additional classrooms, and athletic facilities to meet the needs of a quickly expanding enrollment. Property was purchased on the Dixie Highway in Park Hills, and construction began on the new school in 1953. The final portion of the building, the gymnasium, was completed in 1955. The building project was financed through an assessment on the supporting parishes, most of which were in Covington and Ludlow. Notre Dame Academy moved from its original location on West Fifth Street to its current site in Park Hills in 1963.

The city of Covington lost more than 18,000 residents between 1950 and 1975, many of whom were Catholic. Parishes were struggling with old buildings, declining membership, and the costs of teachers' salaries. The result was predictable, but unfortunate. Catholic schools began closing in Covington. In 1962 Mother of God School, with fewer than 100 students, closed. The building was used for a number of years by Villa Madonna College and by the special needs students of Good Counsel School. Eventually, the beautiful old structure was demolished in 1971.

In 1967 St. Joseph and the Cathedral Schools, located two blocks away from each other, merged to form Bishop Howard Non-Graded School in the former St. Joseph School on Scott Boulevard. That same year, St. Patrick Church and School were closed in the city's Westside.

The Covington Public Schools also experienced dramatic losses. Between 1970 and 1977, enrollment in the Covington Public Schools dropped from 8,143 to 6,308, a loss of 23%. Public school officials were forced to close several facilities due to declining enrollments and diminishing financial support. Catholic schools, however, declined even more dramatically. Between 1970 and 1977, Catholic school enrollment in the city of Covington declined from 2,770 to 1,944, a decline of 30%.

Several Covington schools were unable to weather the financial storms of the 1970s. Parishioners of St. Aloysius Parish struggled throughout the decade to keep their school alive. In the early years of the 20th century, the school enrolled more than 800 pupils and was the largest in the diocese. In 1967 enrollment stood at 265. By 1979 barely 100

pupils answered the school bell each morning. In that year, parish officials decided to close the school. Students were encouraged to enroll at St. John School in the Lewisburg neighborhood. The Sisters of Charity of Nazareth decided to close La Salette Academy in the 1970s. One of the oldest schools in the diocese, La Salette suffered from a declining enrollment and financial difficulties. Between 1970 and 1976, the sisters absorbed deficits totaling $174,000. At the same time, enrollment dropped below 200, and many of the students could not afford to pay full tuition. The last graduation occurred in 1977. The failure of the diocese to support the academies in the urban regions of Northern Kentucky left much resentment in the Catholic community. The all-male Covington Catholic and Newport Catholic received support from their feeder parish schools—the academies of the sisters did not.

The 1980s provided little relief for Catholic schools in Covington. In 1979 St. Ann School in West Covington was struggling. Talks of a school merger with nearby St. James-St. Boniface in Ludlow were initiated; however, a decision on the location of the new school proved insurmountable. In 1980 only 44 students registered at St. Ann School. At the end of the school year, parishioners voted to close the school. Bishop Howard School also did not survive the 1980s. When the school was established in 1967, it enrolled 298 students. By the mid-1980s enrollment had dipped to barely 100. Discussions began about merging Bishop Howard with nearby St. Benedict School. These talks quickly focused on race. Despite declining enrollment, Bishop Howard counted a significant number of African American students, and many feared they would not enroll at St. Benedict School. Eventually, the decision was made to merge the two schools at the former St. Benedict site. The new school was named Holy Family and opened in 1988, and many African American students enrolled.

St. John School was also struggling for survival in the 1980s. The Lewisburg neighborhood of Covington had witnessed significant population losses, and as a result, St. John School was no longer financially stable. The parishes of St. Ann, St. John, Mother of God in Covington, and St. Boniface and St. James in Ludlow decided to combine their resources and open a new school under the name Prince of Peace in the former St. John School building in 1986. More recently, Prince of Peace School has transformed into a successful pre-K through eighth-grade Montessori school, which is still sponsored by the four founding parishes and supported by the Sisters of Notre Dame.

In 1981–82 Bishop William A. Hughes conducted a study of the Catholic high schools in the diocese. One of the outcomes was a suggested merger of Covington Latin School with Villa Madonna Academy in Villa Hills. This plan was never carried out, but it did result in a renewed commitment at Covington Latin. In 1992 the school became coeducational. In 2011 Bishop Roger Foys dedicated a new $10 million expansion and renovation of the building. This new addition doubled the size of the original facility. Bishop Hughes's study also had a great impact on Holy Cross High School in Latonia, which became a district high school supported by a number of surrounding parishes. The result has been increased enrollment, expanded facilities, and new programs.

Catholic elementary schools stabilized in Covington primarily due to the establishment of the Alliance for Catholic Urban Education (ACUE) in 1997. The seven remaining elementary and three basin high schools in Northern Kentucky agreed to participate. The mission of ACUE was simple: to promote the basin schools of the diocese and to provide additional funds to ensure their continued existence. Although the diocese has contributed considerable sums to maintain the ACUE schools, the primary responsibility to fund the schools still remains with the parishes of the urban core. Since the establishment of ACUE, no Catholic schools in Covington have closed. However, the financial burden on the urban parishes has been great. Most of the parishes have declining membership and older facilities to maintain. More recent efforts to declare the urban core the mission territory of the diocese, along with an annual diocesan collection and an annual fund drive, have resulted in some relief for the urban parishes.

The Sisters of Notre Dame have remained committed to the Catholic schools of Covington. Members of the order continue to serve on the faculties of Prince of Peace and St. Augustine Schools in Covington. In 2010 the sisters also established the Notre Dame Urban Education Center. The center provides after-school programs

for children that concentrate on one-on-one tutoring, fine arts enrichment, physical education, and confidence and self-esteem building. Working with many high school and adult volunteers, the sisters' work met with great success in Covington.

Catholic schools have existed in the city of Covington for more than 175 years. While enrollment has risen and declined along with the overall population of the city, the mission of the schools has remained consistent—to offer a Catholic-based education to meet the needs of students living in the city. Today, the Catholic schools of Covington educate hundreds of Catholic and non-Catholic students in a nurturing environment.

CALVARY CHRISTIAN SCHOOL

Calvary Christian School was established in 1973 as a ministry of Calvary Baptist Church in the Latonia neighborhood. For two years, the school was housed in the church facilities in Latonia. During that time, construction was taking place on a campus on Taylor Mill Road in South Covington, which opened in 1975. The first graduating class of 17 received diplomas in 1979. In time, the curriculum included classes from preschool through the 12th grade. In 2001, the school was accredited by the Southern Association of Colleges and Secondary Schools. Today, it enrolls 360 students from various backgrounds and religious denominations.

LIBRARY

The roots of the Kenton County Public Library can be traced back to 1899, when a group of Covington citizens convened to discuss the need for a public library for their community. In 1901 a newly appointed library board passed rules that declared that every man, woman, and child in Covington would have free library service, making the Covington Library one of the first in the South to provide racially integrated service. With a $75,000

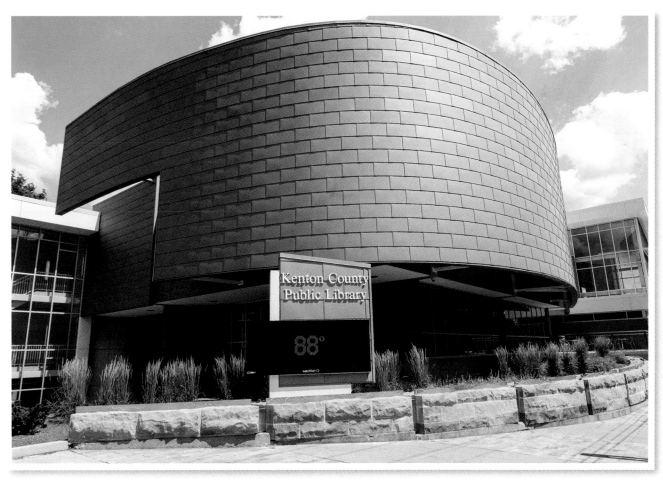

Kenton County Public Library, Fifth Street and Scott Boulevard. Photo by Dave Ivory, 2014.

contribution from philanthropist Andrew Carnegie, the new Carnegie library opened on March 16, 1904, to the citizens of Covington at the corner of Scott Boulevard and Robbins Street. By 1967 Kenton County had three independent libraries: the Covington Library, the Erlanger Library, and a bookmobile service. In order to secure reliable funding for library service for all residents of Kenton County, the people established the Kenton County Public Library Independent Taxing District in 1967.

In 1974 a new main library was constructed in Covington on Scott Boulevard, between Fifth and Sixth Streets. A new Erlanger Branch was built in 1978, followed by the Independence Branch in 1995 in rural Kenton County. In 2002 the Erlanger Branch moved to a new state-of-the-art facility and is the busiest branch library in the commonwealth of Kentucky. The Independence Branch quickly outgrew its location, and a new facility was designed and opened to the public in January 2007. The Covington Library was expanded and completely renovated in 2011–13. Immediately, the Covington branch experienced increased circulation and patron use. Some of the features of the newly renovated structure were a spacious Kentucky history and genealogy area with a temperature-controlled archive room, a much larger children's area, a drive-through window, and an expanded technology area.

Other Educational Institutions

Covington residents of all ages avail themselves of opportunities to continue their learning through museums and other educational institutions. Baker Hunt Art and Cultural Center, at 620 Greenup Street, serves more than 1,500 students of all ages annually with classes such as painting (acrylic, oil, and watercolor), drawing (manga and cartooning), ceramics, photography and film, quilting, dance, foreign languages, and yoga. It also contains the Heritage Gardens, a beautiful urban oasis in the heart of downtown Covington, tended by volunteers. The Baker Hunt was established by Margaretta Baker Hunt (1845–1930) after her death and originally included a natural history museum. Currently, it also features a house museum dedicated to the history of the Baker and Hunt families. The collection includes many items representing the fine arts and decorative arts movements of Greater Cincinnati during the 19th and early 20th centuries.

Baker Hunt shares its campus with the Covington Art Club. Established in 1877, the Covington Art Club is one of the oldest women's clubs in the Cincinnati metropolitan area. It meets at the Kate Scudder House at 604 Greenup Street. The club has been instrumental in many civic and educational programs, including its early 20th-century efforts to establish playgrounds for children, to support pasteurization of milk, to

LEFT: Ellis C. Crawford (1905–1973), first director of the William J. Behringer Museum in Devou Park. Upon his retirement in 1970, the city of Covington renamed the museum the Behringer-Crawford Museum. Courtesy of the Kenton County Public Library, Covington. RIGHT: Behringer-Crawford Museum, Devou Park. Photo by Dave Ivory, 2014.

seek abatement of pollution, and to improve jail conditions. In 1972 with the Society to Prevent Blindness, it instituted preschool visual screenings in Covington and local schools.

The Carnegie (Gallery, Education, Theater), housed in the former Covington Public Library at 1028 Scott Boulevard, offers a wealth of programs in a historically stunning facility. The Otto M. Budig Theater, built in 1904 and restored in 2006, features both theater and concert series annually. The Carnegie's galleries showcase art exhibits. In addition, it offers School Arts Integration Workshops, designed to bring drama, dance, and the visual arts to classrooms everywhere, while strengthening students' creativity, communication, and problem-solving skills.

The Behringer-Crawford Museum, housed in the historic Devou Home in Covington's massive Devou Park, opened in 1950. An addition, completed in 2007, quadrupled the size of the facility. The museum includes exhibits focusing on Northern Kentucky's cultural and natural history, as well as educational programming.

Children Inc., founded in 1977, is Northern Kentucky's largest nonprofit child-care agency, employing more than 200 staff members. Headquartered in Covington, its nationally accredited programs—including early childhood, school age, interim and summer care, and home visitation programs—serve children and families. In addition, the agency provides professional development for educators, as well as service learning opportunities for more than 26,000 students annually.

SELECTED BIBLIOGRAPHY

Cox, Robin, Wayne Onkst, Anita Carroll, and Kelly Carson. "From the Printed Page to the Technology Age, the Kenton County Public Library: A Century of Library Service, 1900–2000." *Northern Kentucky Heritage* 8 (1) (2000): 58–68.

Hampton, Jeffrey. *Leaving Children Behind: Black Education in Covington, Kentucky*. Covington, KY: Kenton County Historical Society, 2011.

Hargis, William Michael. *Covington's Sisters of Notre Dame*. Charleston, SC: Arcadia Publishing, 2011.

Harmeling, Sister Deborah, and Deborah Kohl Kremer. *Benedictine Sisters of St. Walburg Monastery*. Charleston, SC: Arcadia Publishing, 2012.

Knox, Robert. "Holy Cross High School: Eighty-Six Years of Change." *Northern Kentucky Heritage* 15 (2) (2008): 20–28.

Niklas, Sister Joan Terese, SND. "From Germany to Covington: History of the Sisters of Notre Dame." *Northern Kentucky Heritage* 16 (2) (2009): 25–33.

Nordheim, Betty Lee. *Echoes of the Past: A History of the Covington Public School System*. Covington, KY: Covington Independent Public Schools, 2002.

Northern Kentucky Newspaper Index. Kenton County Public Library, Covington, KY.

Ryan, Paul E. *History of the Diocese of Covington, Kentucky*. Covington, KY: Diocese of Covington, 1954.

Schroeder, David E. "Education and Faith." Pts. 1–4. *Kenton County Historical Society Bulletin*. Covington, KY: Kenton County Historical Society, 1996–97.

Schroeder, David E. "The Love of Christ Impels Us: A Bicentennial History of the Sisters of Charity of Nazareth in Northern Kentucky." *Northern Kentucky Heritage* 20 (1) (2013): 42–56.

Stevens, Harry R. *Six Twenty: Margaretta Hunt and the Baker-Hunt Foundation*. Covington, KY: Baker-Hunt, 1942.

Tenkotte, Paul A., and Walter E. Langsam. *A Heritage of Art and Faith: Downtown Covington Churches*. Covington, KY: Kenton County Historical Society, 1986.

Tenkotte, Paul A., and James C. Claypool, eds. *The Encyclopedia of Northern Kentucky*. Lexington, KY: University Press of Kentucky, 2009.

Walton, Joseph M. *The Life and Legacy of Lincoln-Grant School, Covington, Kentucky, 1866–1976*. Milford, OH: Little Miami Publishing, 2010.

Whitson, Frances (Fran), and Margaret Jacobs. "If These Walls Could Talk—Covington's Baker-Hunt Foundation." *Northern Kentucky Heritage* 12 (1) (2004): 2–10.

CHAPTER

FROM LANGUAGE TO LEGACY: IMMIGRATION AND MIGRATION IN COVINGTON

by David E. Schroeder, with contributions by Katie Hushebeck-Schneider

THE city of Covington is an ethnically and racially diverse city that benefited greatly from its location on the Ohio River; its proximity to Cincinnati, Ohio; and its deep cultural and economic ties with both the South and the Midwest. Covington's population has evolved over time and has been enriched by new populations and cultures.

American Indians were the first residents of what is today Covington, and evidence indicates they were present in the region as early as 12,000 years ago. By the time the explorers from the east arrived in Northern Kentucky, American Indians were using the area primarily as hunting grounds. Those remaining American Indians blended in with the other immigrants in the region.

The population of Covington began to increase in earnest during the late 18th century. Many of Northern Kentucky's earliest settlers were of English and Scots-Irish descent. In 1775 Daniel Boone and his company opened a pass through the Cumberland Gap, which brought a flood of people from Virginia's Shenandoah Valley into Kentucky. About the same time, a movement of flatboats down the Ohio River from Pittsburgh, Pennsylvania, to the current city of Maysville, Kentucky, also began. A number of these individuals eventually made their way to Northern Kentucky.

One of the early Scots-Irish migrants to settle in what is today Covington was Thomas Kennedy in 1789. Kennedy, an ardent Presbyterian, was the son of an Ulster immigrant from Northern Ireland. He migrated down the Ohio River on a flatboat and established a farm and ferry at "The Point," where the Licking and Ohio Rivers meet. Initially, he constructed a log cabin. This primitive structure was replaced in 1791 with a stone dwelling on the site of the present-day George Roger's Clark Park. A small community eventually developed around Kennedy's farm. Many of the early residents were Scots-Irish. During this era, these individuals referred to themselves as Irish and identified themselves as such on the United States census. It was only when large numbers of poor Catholic "Famine Irish" began to arrive in the mid-19th century that the term Scots-Irish became popular.

Scots-Irish and English residents made up a majority of Covington's early population. Many arrived through the Cumberland Gap or down the Ohio River. A number of these had received land grants for service in the military. Others arrived as small farmers or to work in the growing industries on the south side of the Ohio River. The founding of the First Presbyterian and Trinity Episcopal Churches were clear signs that these early Scots-Irish and English immigrants had achieved success in the community and had established deep roots.

A number of these early Covingtonians brought slaves with them from the east. African American slaves were part of the early fabric of community life and greatly contributed to breaking the land for farming. African Americans also took part in the growing river trade in the city, working to load and unload vessels. Others labored as house servants in the larger residences of the community.

African Americans contributed to the building of Covington and began establishing churches and schools in the city in the years following the Civil War. A freedman's school was established during this era, as well as the First Baptist Church (African American). Jacob Price, an African American businessman and minister, was an early leader in the community and provided stability and guidance to many. Former slaves leaving the Deep South found their way to Cincinnati and Covington in the years following the Civil War. These new arrivals added to the sense of community in the African American population. As a result of this growth in population, other Protestant and Catholic African American congregations were founded over the next century, and the African American school eventually became part of the Covington Independent School District.

Many African Americans lived on the west side of the city along Washington Street. Others formed a community on the Eastside. The Eastside community became the center of the African American community with the establishment of the Seventh Street Colored School. This school was eventually replaced by Lincoln-Grant School on Greenup Street.

The Germans were the largest immigrant group to settle in the city of Covington. They began arriving in the 1810s and their numbers increased substantially until the outbreak of World War I. The Germans were a diverse group. They came from the many German-speaking duchies and principalities of Europe with varied backgrounds, some being farmers and other skilled laborers. During the period of 1820 through 1860, Cincinnati was booming with new industries and a greatly expanding economy. Many Germans came to the region to find work and, once here, invited family and friends to join them in what is sometimes called a "chain migration" pattern. Cincinnati, and Northern Kentucky, soon became a major center of German American population and culture. The arrival of these Germans would forever change the cultural composition of the region, and Covington in particular. Covington was transformed from a frontier town populated primarily by citizens of English and Scots-Irish ancestry to a predominantly German American city. Many of these immigrants were Catholic, coming from areas like the German provinces of Oldenburg and Hanover.

Churches played a major role in the German American community. Protestants established their own churches in Covington, including the German Reformed, German Methodist, and German Baptist Churches. A number of German Reformed churches operated parochial schools in the early years. German Catholics, however, became the predominant religious group in Covington. Mother of God Parish was established in 1841 as the second parish in Northern Kentucky and the first to cater to the German American Catholic community. Over the next 50 years, six other German Catholic parishes were established in the city. The Germans also ardently supported Catholic schools in the city, resulting in the establishment of seven parish schools and two academies to serve the German American Catholic community in Covington.

One issue that drew German Protestants and Catholics together was nativism. During the 1850s, the Know-Nothing political movement took hold in Northern Kentucky. The Know-Nothings opposed immigration and the culture of the immigrants themselves. German language and customs were under attack as foreign. Much of this opposition centered on the notion of the puritanical Sunday. The English and many of the Scots-Irish found the drinking of alcohol on the Sabbath to be sinful. German Protestants and Catholics did not share in this belief. Many Germans frequented beer gardens during this time period and did so as families. These gardens offered not only beer but also food and entertainment for the entire family. Since most working-class men were employed six days per week, Sunday was their only day off. On Sundays, Germans went to church, and then many attended the beer gardens to relax and enjoy the company of others. The Know-Nothings found this unacceptable and did their best to pass laws that declared drinking alcohol on Sundays illegal. In the end, the Know-Nothings were quickly disposed of as a political movement—they were simply outnumbered in Covington.

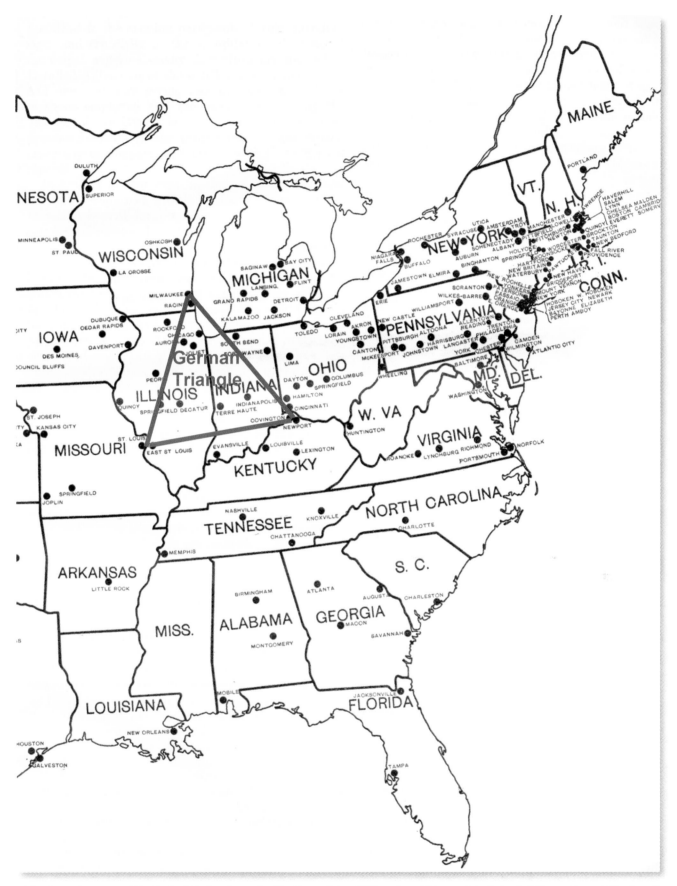

This triangular area of the United States, bounded by the points of Milwaukee (Wisconsin), St. Louis (Missouri), and Cincinnati (Ohio, with its neighboring suburbs of Covington and Newport, Kentucky), has been called the "German Triangle," for the large number of German immigrants who settled there. Map digitally transformed by Paul A. Tenkotte from a base map in US Department of Commerce, Bureau of the Census. *Special Reports: Financial Statistics of Cities Having a Population of Over 30,000: 1911.* Washington, DC: Government Printing Office, 1913.

Germans quickly climbed the political and economic ladder. They owned many small businesses in Covington and held political office from a very early time period. German butcher shops, taverns, beer gardens, breweries, grocery stores, cigar shops, and cabinetmakers were scattered throughout the city and contributed much to the economic vitality of Covington. The early breweries in Covington included the Bavarian Brewery, Covington Brewery, Heidelberg Brewery, and John Brenner Brewery—all owned by German Americans.

Germans also formed athletic, social, and business groups to retain their culture. One of the oldest was the Turners Society (*Turngemeinde*), which had been originally established in Germany in 1811. The purpose of the society was to provide physical education to its members. In 1848, the first Turners Society was established in the United States in Cincinnati. Seven years later, a number of German residents of Covington founded the Covington Turners Society. The society was officially established on September 13, 1855. Members had to agree to the following: oppose all laws calling for the prohibition of alcohol, not vote for any member of the Know-Nothing political party, and oppose the institution of slavery. In 1857 the Covington Turners acquired a building on Pike Street. These facili-

The Rademacher family was typical of the German American community at the turn of the 20th century. Henry Rademacher (1870–1933) was a cabinetmaker and German immigrant. His wife, Mary Remke Rademacher (1869–1951), was born in Covington. Her brother, William Remke, founded a local grocery store chain. The couple was married at Mother of God Church in Covington. The photo, dating from 1901, depicts their four oldest children (left to right), Marie Rademacher Bussman, Lillian Rademacher Backscheider, George Rademacher, and William Rademacher. Courtesy of David E. Schroeder.

ties included an area for exercise, a saloon, and meeting rooms. The outbreak of the Civil War, however, nearly dissolved the society. Many members joined the Union army and marched off to war. By 1864 only seven Turners remained in the organization. Following the war, membership again increased. In 1870 a new building was acquired for the society at the corner of Pike and Ninth Streets. During these years, the society sponsored singing events, gymnastic training, political debates, and rifle-shooting contests. In 1877 the society began planning for the construction of a permanent hall, which was dedicated on October 1, 1877.

German thriftiness resulted in the founding of a string of savings and loan associations throughout Northern Kentucky. One of the most well known was the Western German Savings Bank, which was established in the Westside neighborhood of Covington in February 1908. A permanent headquarters was constructed for the bank in 1908. In the following year, Edward Zeis was elected president of the bank. Zeis was reelected in each succeeding year until his death in 1946. In 1918 the officers of the bank decided to change the name of the institution. This was during the First World War, when anti-German

Turners Hall, Pike Street. The Turners still operate from this same building. Source: *28th Annual Crowning Fest of the Deutsche Schuetzen-Gesellschaft of Covington, Ky. Cincinnati, OH: Hennegan & Co., 1910.*

hysteria was at its height. At this time, the institution became known as the Security Savings Bank. Many of these savings and loans were later absorbed into the large banking institutions that exist today.

A German American group of a more social character that existed in Covington was the German Pioneer Society, established in 1877. The group decided to base its charter on that of the Cincinnati German Pioneer Society. There were 109 charter members. The purpose of the group was to "hold fast to German customs and character and to make it an heirloom for their children and grand-children, so that American materialism would not destroy the German nature."

Germania Hall, on the northeast corner of Pike and Russell Streets, featured dancing and bowling. Source: *28th Annual Crowning Fest of The Deutsche Schuetzen-Gesellschaft of Covington, Ky. Cincinnati, OH: Hennegan & Co., 1910.*

The German language was a familiar sound on Covington streets well into the 20th century. In fact, Covington Public Schools offered an elementary curriculum entirely in German at the Second District School. Other public institutions also catered to the German population. The Covington Public Library maintained a large German-language collection. In addition, the library's first printed catalog was written in both English and German. Finally, several German-language newspapers existed in Covington, including a German daily and weekly. The German Americans had made a major impact on the city.

Covington is a city of neighborhoods, and many had strong German connections. The city's Westside, especially Sixth Street and south, was heavily German. Main Street was lined with many German-owned shops and taverns. Grace Reformed, Immanuel German Reformed, Mother of God, and St. Aloysius Churches all built beautiful buildings with

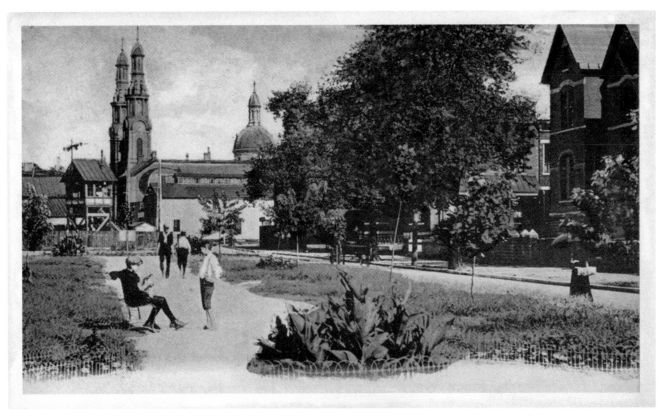

Sixth Street Park, looking toward the German American parish of Mother of God Catholic Church. Note that this postcard predates the elevated railroad tracks. Courtesy of Paul A. Tenkotte.

LEFT: The old German National Bank Building, Madison Avenue. Photo by Dave Ivory, 2014. RIGHT: Children playing on Pershing Street in Covington's Westside, circa 1940s. Before the anti-German hysteria of World War I, Pershing Street was called Bremen Street, after the German city of the same name. Photo by Cyril Von Hoene, courtesy of Greg Von Hoene.

steeples that dominated the skyline. The Lewisburg neighborhood along Pike Street was also heavily populated by Germans, especially German Catholics. This was one of the few neighborhoods in the city that never housed a public elementary school, other than a storefront public kindergarten. Instead, Lewisburg was dominated by St. John Catholic Church and School. On the Eastside, Helentown and Austinburg were home to many Germans. St. Benedict, St. Joseph, and Shinkle Methodist Churches were cornerstones in the community. In the Peaselburg neighborhood, St. Augustine Church and School predominated, and in Latonia, Holy Cross Church and School kept German culture alive.

America's entry into World War I in 1917 resulted in a significant loss of German culture. As an example, the German National Bank changed its name to Liberty National Bank in order to seem more American. The German book collection at the Covington Public Library was removed, and German language classes at the public schools were eliminated. Most Catholic schools also eliminated the teaching of the catechism in German. Many German Protestant churches quit offering sermons in German and stopped singing German hymns. Some of these congregations changed their names, removing the word German. The city of Covington also officially changed several street names to appear more patriotic. As an example, Bremen Street was renamed Pershing Street.

Despite the anti-German hysteria, Covington's German Americans embraced the war effort, sent their sons off to fight, and bought Liberty Bonds in large numbers. Many families, however, downplayed their German heritage and quit speaking German, even in their homes. While the war did not deal a deathblow to the German American community in Covington, it did damage their culture and traditions.

While Germans enjoyed a majority in Covington, they were not, by far, the only group to have an impact on the community. The Famine Irish began arriving in Covington in the late 1840s and early 1850s. English colonialism in the 18th and 19th centuries resulted in the native Irish losing ownership over much of their nation. The Irish Catholics were discriminated against with the passage of the penal laws, which forbade them from holding public office in their own country. The Irish were forced onto small lots that were capable of producing few crops that could feed a family. One crop that was successful was the potato, and the Irish relied heavily on it as their primary

source of food. In 1846 a fungus appeared on the potato crop in Ireland. The result was a devastating famine. The English response was typical laissez-faire economics. English politicians believed that the economy would regulate itself and that no government interference was required. The result was the death of more than a million Irish, due to starvation, in the years between 1846 and 1851. More than a million others chose to flee their homeland, with many coming to the United States. Some found their way to Covington.

The Famine Irish pioneered large-scale chain migration to the United States. Due to limited resources, they typically could send only one or two family members at a time. In many cases, they sent the eldest daughter, who could typically find work as a domestic servant. In these positions, young women received free room and board and were able to send money home to finance the immigration of other family members. In time, the entire family would cross the Atlantic Ocean. Once in the United States, many settled on the eastern seaboard in cities like New York City and Boston. Others traveled farther inland and made their way to the Midwest.

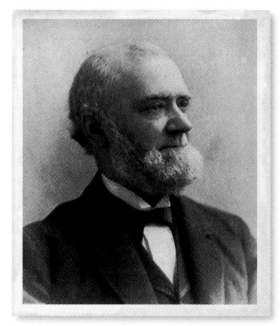

James Walsh, an Irish immigrant, became a prosperous businessman. His firm, James Walsh & Company, operated a number of distilleries in Kentucky, Indiana, and Ohio. With his son Nicholas, James Walsh was a major donor supporting the construction of Covington's Cathedral Basilica of the Assumption. Source: *The City of Cincinnati and Its Resources.* Cincinnati, OH: Cincinnati Times Star Co., 1891.

Unlike the Scots-Irish who had preceded them, the Famine Irish were from farming communities and possessed few other skills needed in an emerging industrial city like Covington. As a result, many of these early immigrants found work as unskilled laborers. They worked on the construction of canals, area roads, and the John A. Roebling Suspension Bridge. Once the railroads were complete, they found employment feeding the steam engines with coal. In time, they moved up the ladder to become engineers, mechanics, and bookkeepers. Others became day laborers. They would gather in a central part of the city and wait for employers to arrive. These employers would hire a group of men for the day with an agreed wage. On some days, work could be found for these newcomers, while on other days, no work was available.

The Famine Irish also found employment in Covington's civil service positions. The Irish soon became mainstays in the city fire and police departments. Others found work in city hall in the developing waterworks. These jobs provided on-the-job training and required little formal education. Despite some prejudice against them, the Famine Irish established strong family and community networks, and within a generation or two, many had become middle class.

The Famine Irish formed a strong local community. The ancient Order of Hibernians grew quickly and provided life insurance and other benefits to the community. Local saloon culture also was very important for the men of the community, and many bars and taverns that catered to the Irish community sprang up in Irish neighborhoods.

The Catholic Church, however, proved to be the main social and religious institution that bound the community together. When the Famine Irish arrived in Covington, they found a home at Covington's English-speaking Catholic congregation, St. Mary's Cathedral on Eighth Street, which was predominantly Irish. Many of these new arrivals joined St. Mary's and sent their

Nicholas J. Walsh, son of James Walsh, also donated large sums toward the construction of Covington's Cathedral Basilica of the Assumption. Courtesy of Paul A. Tenkotte.

Reverend Theobald Mathew (1790–1856), called the "Irish Apostle of Temperance," traveled throughout his native Ireland, as well as Great Britain and the United States, administering the Cork [Ireland] Total Abstinence Pledge. His two-and-a-half-year tour of the United States (1849–51) brought him to more than 300 US cities and towns, including Covington on Sunday, June 29, 1851. Courtesy of Paul A. Tenkotte.

children to the parish school, as well as to nearby La Salette Academy. The rhythm of Catholic life—baptisms, first Communions, weddings, and funerals—was a comforting element for the community. These familiar events had been part of their lives in Ireland and provided the community with a connection to the old country. Irish American priests and the Sisters of Charity of Nazareth also provided the community with stability and aid whenever needed. When St. Patrick Parish in Covington was established in 1870, many of its first members were Famine Irish and their children. Its longtime pastor, Father Thomas McCaffrey, led the congregation from 1913 until 1957. McCaffrey was much beloved in the community and was well known for helping all those in need.

The 1890s brought an end to mass immigration to the city of Covington. The Scots-Irish, Germans, and Famine Irish were no longer coming to the city in large numbers. However, other groups began arriving during this time in smaller numbers. One of these groups was from Italy. Although not large in number, the Italians who found their way to Covington had an impact on the city. Some became fruit peddlers, while others established their own businesses. The center of Italian American life in Northern Kentucky was in neighboring Newport, and many of the Covington Italians found life among their compatriots more appealing. Those who remained in Covington typically attended the Cathedral or St. Patrick Parishes in the city.

In the late 19th and early 20th centuries, a small number of Eastern Europeans found their way to Covington. Poles, Hungarians, and Greeks added a new element to the culture of the region. In particular, a number of these Greeks began opening chili parlors in Cincinnati and Northern Kentucky. This Cincinnati chili added to the ethnic foods in the region and became an item that was associated with the area across the United States.

The largest group of Eastern Europeans who immigrated to the region was the Russian Jews. Many of these individuals were fleeing oppression, both religious and cultural, in the Russian Empire. The Covington

Monsignor Thomas J. McCaffrey, longtime and beloved pastor of St. Patrick Catholic Church, Philadelphia Street. Courtesy of Paul A. Tenkotte.

FAR LEFT: Anthony Geisen, 6 years old and a member of St. Patrick Catholic Church in Covington, holds an American flag, 1913. Courtesy of Paul A. Tenkotte. LEFT: The son of Irish immigrants, Daniel O'Donovan (1874–1943) was a member of the Democratic Party, served in the Kentucky state House of Representatives, and was mayor of Covington (1924–27). Courtesy of the Kenton County Public Library, Covington.

Jewish community was primarily Orthodox. In 1911 Rabbi Samuel Levinson of the United Hebrew Congregation in neighboring Newport began offering religious services in the *Kentucky Post* building on Madison Avenue. A synagogue was constructed on Seventh Street between Scott Boulevard and Greenup Streets in 1915.

The Jewish community had a great impact on the business community in Covington. Jewish families owned furniture stores like Dine-Schabell, Marx Brothers, Modern Furniture, and Ostrow Furniture in the city. Other Jewish-owned businesses in the city included Abe Weinstein's Restaurant, Dan Cohen Shoes, Frank's Men's Shop, Ideal Shoes, and the Parisian clothing store, just to name a few. These Jewish-owned businesses contributed greatly to the city's economy and provided employment for many.

The major institution in the Jewish community was Temple Israel; however, Jews also were active in the public school system and other community groups. The community was small but tightly knit and did much to support community events and programs.

By the 1930s many Jewish families began an exodus from Covington to Cincinnati that lasted for another two decades. Many of the Covington Jewish families wished to live in a larger Jewish community that offered more activities and choices in worship. Another primary reason was to offer their children greater opportunities to find appropriate Jewish spouses in the larger Cincinnati community. Though a significant number of Jews left Covington, many retained their businesses in the city for decades.

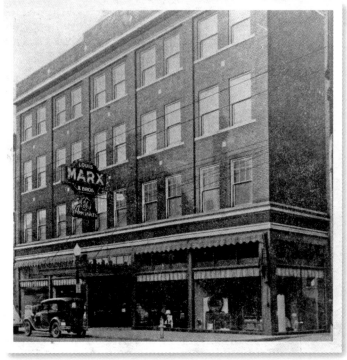

Marx Furniture, Madison Avenue, was one of many Jewish-owned businesses in downtown. Courtesy of the Kenton County Public Library, Covington.

Asian immigration to Covington began with the Chinese. Chinese first began immigrating to the United States in large numbers in the middle of the 19th century. They came primarily for economic reasons, and most of them settled in the western states, where jobs, especially in the building of railroads, were plentiful. In the latter part of the 19th century, Chinese immigrants began arriving in the Greater Cincinnati region. Many of them found homes and opened small businesses in Covington, and others settled in Newport. Covington once had the largest Chinese population in the commonwealth of Kentucky.

This close-up of a postcard from the early 20th century shows the Peping Chop Suey Restaurant, located on the northwest corner of Pike Street and Madison Avenue in downtown Covington, next to Motch Jewelers. Courtesy of Paul A. Tenkotte.

Chinese Americans faced significant racial prejudice. Their clothing, food, language, and customs set them apart. In 1882, Congress passed the Chinese Exclusion Act, preventing citizens of China from entering the country. The Chinese who were already in the country were not forced to leave; however, they were forbidden to apply for naturalization. The Chinese Exclusion Act was the first legislation in United States history that barred an entire ethnic group from immigrating to this country.

The earliest mention of Chinese in Covington appears in the *Ticket* newspaper in 1877 in an article about the marriage of a Chinese American and an African American. The Chinese population grew slowly. The US censuses for 1900 and 1910 shed much light on the lives of Chinese Americans in Covington. All were males and most were single (if they were married, their spouses were not living in Covington). The average age was between 35 and 40. A majority had been born in China; all who were natives of the United States had been born in California. A significant number were able to speak English.

Most Chinese Americans in Covington operated laundries. By 1880, one Chinese laundry had already been established on Madison Avenue. In 1897, 6 of the 11 laundries in Covington were operated by Chinese Americans. The number of Chinese laundries remained stable in the years between 1900 and 1945, ranging between five and eight. The last Chinese laundries appear in the Covington city directory in the late 1940s.

The migration of Appalachians to Northern Kentucky began in significant numbers in the 1940s. During this time period, it is estimated that more than 100,000 Appalachian residents relocated to the Greater Cincinnati area. Jobs in the Appalachian region decreased dramatically due to the decline in demand for coal and the continued mechanization of industry. The demand for blue-collar manufacturing and industrial labor drew Appalachians to the Greater Cincinnati area. Much like the European immigrants a century earlier, many Appalachians relocated to Northern Kentucky, especially Covington.

Many Appalachians found reasonable housing in Covington's Westside. This neighborhood was in transition. Once home to thousands of Irish immigrants and others, the neighborhood was becoming more industrial. Housing prices were falling, and many longtime residents had moved. The clergy assigned to St. Patrick Parish on Philadelphia Street clearly recognized the impact of shifting demographics of the neighborhood and parish. Middle-class families were moving out, and Covington's Westside was becoming increasingly Appalachian and non-Catholic. St. Patrick's pastor, Monsignor Thomas McCaffrey, described the situation: "In the area north of Fifth Street you meet a non-Catholic, even anti-Catholic population, many of whom are immigrant or first generation citizens of Covington who spring from rural and mountain areas of the state." He continued, "Convert appeals and missions do not touch these people and the Catholic Church is really something alien to their way of life, something ignored in the one case, avoided in another." Appalachian migrants had brought their own religious and cultural traditions with them. On the one hand, longtime residents felt threatened by new faces in their neighborhood, and, on the other, the Appalachians felt the sting of prejudice from their new neighbors.

The construction of I-75 through Covington's Westside also brought significant changes. The Fifth Street expressway ramps were built less than a block from St. Patrick Church and the Third District Public School. Increased

As German American and Irish American families moved to the suburbs, Covington's Westside attracted many Appalachian migrants. This photograph shows the 600 block of Bakewell Street, June 14, 1961. Photo by Cyril Von Hoene, courtesy of Greg Von Hoene.

traffic made the area less desirable for residential use and attracted a number of service-oriented businesses. The neighborhood continued to change during the 1960s. The United States government began acquiring property in the area near the intersection of Third and Johnson Streets in the early years of the decade. On this site, a large Internal Revenue Service facility was constructed. Hundreds of homes were demolished in the process. The transition of the Westside from a second- and third-generation immigrant community to a highly concentrated Appalachian neighborhood was remarkably quick and mostly peaceful. The longtime residents either sold their homes outright or rented them out as furnished apartments to the newcomers.

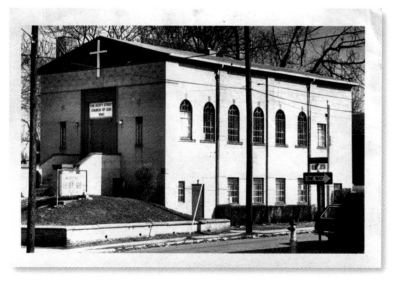

As an example of the reuse of buildings by successive ethnic groups, Covington's synagogue Temple Israel later became the Scott Street Church of God, a popular Appalachian congregation. Courtesy of the Kenton County Public Library, Covington.

While tension between the groups did exist, violence was rare. Like the European immigrants before them, Appalachians established their own churches and other institutions. The century-old St. Patrick Parish closed its doors in 1967 and was demolished. Third District School closed its doors in 1980, as the population of the city continued to decline. Appalachians eventually also settled in other Covington neighborhoods, including Lewisburg, Austinburg, Peaselburg, and Latonia. Their presence brought a new dynamic to the city, as older immigrant communities increasingly moved to the suburbs. As time passed, Appalachians assimilated into the population and made up a significant portion of the Covington Independent School District's population.

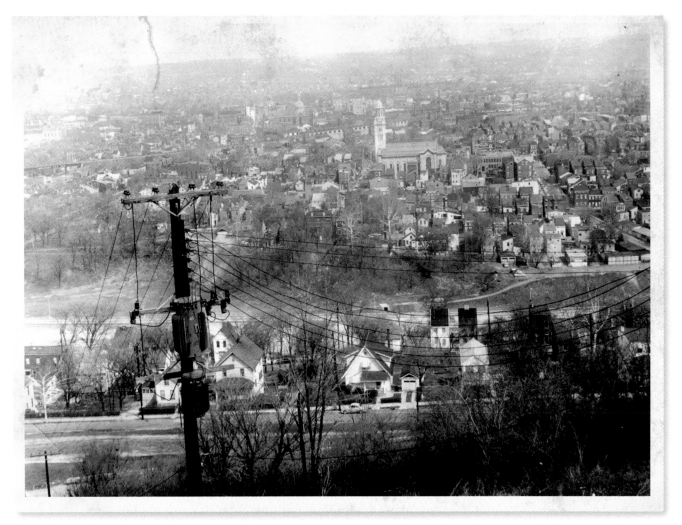

The construction of I-75/I-71 tore apart Covington's Westside. This photo was taken in 1960 or 1961 by Cyril Von Hoene. Courtesy of Greg Von Hoene.

Greek Immigrants
BY KATIE HUSHEBECK-SCHNEIDER

When one thinks of Greater Cincinnati and Covington, one of the first images is that of Cincinnati-style chili. This heavily spiced ground beef stew was invented in 1922 by the Slavic-Macedonian Kiradjieff brothers in Cincinnati's Empress Burlesque Theater. It would seem that the iconic chili was born from necessity and creativity more than anything. While the plan of the Kiradjieff brothers was to serve their native Greek cuisine, they quickly discovered that there was not much call for traditional Greek food in the area. Instead, they chose to doctor a traditional Greek meat sauce with chili powder and ground beef. They decided to serve it over noodles and call their new creation chili to promote its appeal.

Covington has a rich history of chili parlors, the great majority of which were founded, owned, and operated by proud Greek families. A longtime favorite among Covington residents, Covington Chili, has been a mainstay on Madison Avenue for more than 75 years, since its establishment in 1936. The parlor was founded by Christy and Mae Terzieff, who operated it until the 1950s, when brothers Tim and Michael Stephans (derived from the Greek name Stephanopoulos), from Kastoria, Greece, bought the restaurant from them. In the 1990s, George Stamatakos purchased Covington Chili, expanding its menu offerings to include other nonchili items, such as gyros, and freshening some of the décor and furnishings while retaining the parlor's original charm.

Another standout in the Covington chili scene, the Liberty Chili Parlor, was founded in 1940 by Macedonian immigrants Pando Golodova, Nicholas Evinoff, and Stephen Labo. It enjoyed great success because of its close proximity to the grand Liberty Theatre that stood between Sixth and Pike Streets on Madison Avenue. In 1951 Alexander Tolovich bought Liberty Chili and operated it until the 1960s, when it closed.

Like Liberty Chili, the Latonia Chili Parlor owed much of its success to the proximity of two movie theaters, the Latonia Theatre and the Kentucky Theatre. The parlor was owned by the father-and-son team of Samuel and Carl S. Gerros. Like the Empress Chili Parlor in Cincinnati, the Latonia Chili Parlor served as a training venue for fellow Greek immigrants, many of whom went on to open their own chili parlors in the surrounding area. One of the most notable of these was Lazaros Nourtsis who, in 1964, opened Price Hill Chili, which still stands today.

While Dixie Chili did not get its start in Covington, its home base, in the neighboring city of Newport, is not far away. The chain, which now includes Newport, Erlanger, and Covington, Kentucky, branches, was started by Nicholas D. Sarakatsannis in 1929, and it represented the first chili parlor in Northern Kentucky.

There were many other chili parlors that once dotted Covington's streets, including The Chili Bowl, 438 Madison Avenue, owned by Risto Vasilovh; Midtown Chili, 1922 Madison Avenue; Kentucky Chili Parlor, 339 Pike Street, owned by Ann Caldwell in 1963 and then moved to 1008 Lee Street by 1967; A1 Chili Parlor, 438 Madison Avenue, owned by James P. Kappas in the 1960s; and ABC Chili Parlor, 405 Scott Boulevard, owned in 1951 by William and Alex Chaldekas. Most of these chili parlors have since closed, but the impact that these Greek immigrants who owned them had on the Covington social and cultural fabric was and still is unmistakable.

Another area where Greek immigrants excelled was in the production and sales of candy and ice cream. There are several names that come to mind in Covington, including the Coston brothers, Soterios Droganes, and the famous Papas family. By the 1890s, Covington boasted around 40 confectionary shops, many of which not only offered candy, but also sold ice cream. The Coston Brothers, a shop situated at the northeast corner of Sixth Street and Madison Avenue, featured a charming Victorian interior and dished out both candy and ice cream to eager patrons. The Costons had replaced the Sciutti family at their Sixth Street and Madison Avenue location in 1908, but they were gone by 1915. There is another familiar sign that awaits passersby next to the Pike Street Railway Underpass. The sign, which boldly reads "Ice Cream, Sam's Candy," is a remnant of the series of stores opened by Soterio Droganes in Covington. Soterio acquired the Sixth Street and Madison Avenue location that the Costons owned, operating it for about three years. After that, he moved to Pike Street, first settling at 205 West Pike and eventually moving next door to 207 West Pike. The store closed in the late 1960s. There was another location of Sam's at 506 Madison Avenue, which operated from 1923 until the 1960s.

Coston's Ice Cream Parlor and Candy Store, Sixth Street and Madison Avenue. Courtesy of Paul A. Tenkotte.

The Papas family legacy of fine confectionary treats continues to be known and celebrated even today. Who, of those living in Northern Kentucky, could ever think about spending an Easter without biting into a rich Papas Opera Cream Egg? The Papas story begins with Christus Papas in 1909, when he immigrated to the United States from Macedonia. Learning how to make candy at an early age, Papas was operating a fully functioning business by 1935, when he and his wife, Lillian, decided to open a new store in Covington called Lily's Chocolate Shop at 830 Madison Avenue. Christus's grandson, Chris Papas, said that the idea for the rich opera crèmes came from Christus's first shop near Music Hall in Cincinnati. Two years later, the family moved the store next door to 832 Madison Avenue. Christus retired from the business in 1951, eventually leaving the chocolate shop business to his daughter Katherine Hartmann and her husband, Norbert. Their son, Alex, assumed control over the Papas candy manufacturing process on Ninth Street. Today, Chris and Carl Papas, the third generation, operate the candy plant, and the factory has the ability to produce as many as 80,000 candy eggs per day.

 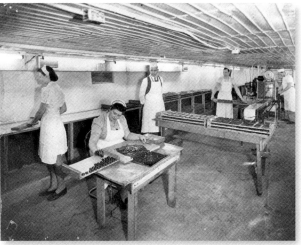

LEFT: Lily's Candy soda fountain, Ninth Street and Madison Avenue, July 1948. Courtesy of Ron Einhaus. RIGHT: Candy dipping, Lily's Candy. Courtesy of Ron Einhaus.

A Hispanic American neighborhood store on Holman Street serves the neighborhood's new Latino population. Photo by Dave Ivory, 2014.

During the 1990s, the Hispanic population in the Greater Cincinnati area began to grow and is still growing today. Prior to this time, most Hispanics came to the Northern Kentucky area only during the harvest season. This familiar pattern slowly began to break down, and by 1995, many Hispanics had moved to Northern Kentucky permanently. Between 1990 and 2000, the Hispanic population in Boone, Campbell, and Kenton Counties tripled.

Many of the Hispanic immigrants were Catholic and looked to the church for services and assistance. In the mid-1990s, Monsignor William Neuhaus, pastor of St. John Parish in Carrollton, Kentucky, began to study the Hispanic population of the region. In 1996, he presented a proposal to the mission office of the Diocese of Covington to establish a Hispanic ministry program in Northern Kentucky. Bishop Robert

Muench approved the creation of the new office under the administration of Catholic Social Services. Spanish-language liturgies were soon being celebrated at the Cathedral Basilica of the Assumption in Covington, St. John Parish in Carrollton, and St. Patrick Parish in Maysville. The Hispanic ministry program at the cathedral blossomed, and in January 2001, the parish established the Centro de Amistad, or Center of Friendship, in the old cathedral rectory on 12th Street. The center was under the direction of Juana Mendez, a Sister of Charity of Cincinnati. It was established to provide Spanish scripture classes, religious education classes for children, English as a second language classes, General Educational Development (GED) sessions, job placement services, home buyer education classes, and social programs.

During the episcopacy of Bishop Roger Foys, the Hispanic population of Northern Kentucky continued to expand. In the year 2003, average attendance at the Spanish-language Mass at the cathedral reached between 350 and 400 each Sunday. That same year, 40 Hispanic children were baptized at the cathedral. Covington, however, was no longer the center of the Spanish-speaking population in the region. Instead, many Hispanics found homes and employment in the neighboring cities of Florence in Boone County and Erlanger in Kenton County. These developments led Bishop Foys to establish Cristo Rey (Christ the King) Parish in Erlanger in 2004 to serve the Spanish-speaking residents of Boone, Campbell, and Kenton Counties. The new parish was housed at the gymnasium of the old St. Pius X Seminary. Some classes and other activities continued to be held at the cathedral in Covington to meet the needs of the Hispanics in the city.

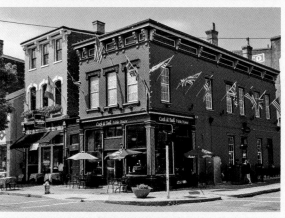

ABOVE LEFT: In the late 20th century, interest in ethnicity grew. Covington's MainStrasse district celebrates the region's German heritage, as seen in this photo of the second annual Oktoberfest in Covington, 1980. Courtesy of the Kenton County Public Library, Covington. TOP RIGHT: Jack Quinn's restaurant, now Molly Malone's Irish Pub and Restaurant, on the northwest corner of Fourth and Court Streets, celebrates Irish heritage and cuisine. In the 19th century, this building was built by Joseph Hermes, a German immigrant, who ran a saloon there. Hermes was active in German American societies in the city and even published a short-lived German newspaper, *Die Gegenwelt*. Later, the building became the home of the printing business of German immigrant Alban Wolff. BOTTOM RIGHT: MainStrasse, West Sixth and Main Streets. Photo by Dave Ivory, 2014.

As the Hispanic population of Covington grew, so did their presence in the community. A number of Protestant congregations began outreach programs. In addition, a number of Hispanic-owned businesses have opened, including restaurants and grocery stores. The Hispanic population has also brought a new influx of students into the Covington Independent School District. Administrators, principals, and teachers have all found ways to adapt to and welcome these newcomers. Although times have changed, the need to teach English to immigrants has not. Covington schools are still meeting that challenge today, as they were in the 19th century.

Most recently, in 2010, the Sisters of Divine Providence of Melbourne, Kentucky, established the Centro de la Divina Providencia in a vacant building in the 900 block of Scott Boulevard. Sister Barbara Patrick, CDP, was named director of the center, which provides English as a second language classes to the Hispanic immigrants.

Covington is a city of immigrants. From American Indians to the Scots-Irish, Germans, Irish, Jews, Appalachians, and now to the Hispanics, each group has brought its own cultures, foods, and religious traditions. All have enriched the community in their own ways, making Covington a diverse and accepting place to live and work.

SELECTED BIBLIOGRAPHY

Casebolt, Pamela Ciafardini, and Philip G. Ciafardini. *Italians of Newport and Northern Kentucky*. Charleston, SC: Arcadia Publishing, 2007.

Merriman, Scott Allen. "Ordinary People in Extraordinary Times? Defendants, Attorneys, and the Federal Government's Policy under the Espionage Acts during World War I in the Sixth Circuit Court of Appeals District." PhD diss., University of Kentucky, 2003.

Northern Kentucky Newspaper Index. Kenton County Public Library, Covington, KY.

Oral Histories, Covington's Jewish Community. Kenton County Public Library, Covington, KY, 2014.

Tenkotte, Paul A., and James C. Claypool, eds. *The Encyclopedia of Northern Kentucky*. Lexington, KY: University Press of Kentucky, 2009.

Tolzmann, Don Heinrich. *Covington's German Heritage*. Bowie, MD: Heritage Books, 1998.

Woellert, Dann. *The Authentic History of Cincinnati Chili*. Charleston, SC: American Palate, 2013.

Woellert, Dann. *Cincinnati Turner Societies: The Cradle of an American Movement*. Charleston, SC: History Press, 2012.

CHAPTER

10

FROM NOVELS TO NEWSPAPERS: THE LITERARY HERITAGE OF COVINGTON

by Robert D. Webster and Roger Auge II

COVINGTON, Kentucky, has been the birthplace, childhood home, or life-long residence of many well-known authors. From collections of poetry first published in the early 1800s to suspenseful novels later transformed into thrilling major motion pictures, the people of Covington have produced a proud literary heritage.

William Whiteman Fosdick (1825–62) was the son of Thomas R. and Julia Drake Fosdick. His mother and aunt were actresses, members of the pioneering Drake family of actors. Raised in Covington, William Fosdick practiced law in Covington and New York City, and then returned to the Cincinnati, Ohio, area, where he was editor of the *Sketch Club,* a literary journal. He wrote poetry, was considered by some the poet laureate of Cincinnati, and penned one novel, *Malmiztic.*

Forceythe Willson (1837–67) spent his childhood years in Covington where he attended the public schools. He became a journalist, a poet, and a clairvoyant. After the death of his parents, he oversaw the education of his younger brother, Augustus E. Willson, who later became governor of Kentucky (1907–11). Willson was best known for his work *The Old Sergeant, and Other Poems* (1867).

Daniel Henry Holmes Jr. (1851–1908), the third of four children of Daniel Henry Holmes Sr. (namesake of Holmes High School), tried his hand at many occupations before finding his true passion, writing music and poetry. He had managed his father's dry goods business in New Orleans, Louisiana, for a short time, had studied commercial arts abroad, and was a lawyer in Covington. Before closing his law practice, Holmes published his first book of poetry, *Under a Fool's Cap: Songs,* in 1884. Two other works, *A Pedlar's Pack* and *Hempen Home-Spun Songs,* were published in 1906. Holmes was widely considered one of Kentucky's finest lyric poets.

Daniel Carter Beard (1850–1941) was the son of artist James Henry Beard of Covington. Daniel Beard became one of the founders of the Boy Scouts of America. In addition to being a talented illustrator, especially for several of Mark Twain's books, he was also an author. He is best known for *The American Boy's Handy Book,* as well as his autobiographical account, *Hardly a Man Is Now Alive* (1939). His sisters were Lina (1852–1933) and Adelia (1857–1920) Beard. The Beard sisters were founders of a girls' organization that eventually became known as the Camp Fire Girls. They wrote several books together but are best remembered for *The American Girl's Handy Book* (1887).

St. George Henry Rathborne (1854–1938) was born in Covington to Captain Gorges Lowther and Margaret Robertson Rathborne. He attended Woodward High School in Cincinnati. In 1868 Rathborne sold his first story to the *New York Weekly,* the start of a long and prolific career. Because he wrote under at least 20 pseudonyms, no one knows for certain how many books he penned, although it clearly numbers more than 300. Rathborne was popularly

known for his books for boys and for his dime novels, inexpensive paperback novels that became popular in the late 19th century as literacy in the United States increased.

Byrd "Birdie" Spilman Dewey (1856–1942) was born in Covington to Jonathan Edwards and Eliza Sarah Taylor Spilman, a descendant of the famous Taylor family of Kentucky. Her father was a Presbyterian minister, so the family moved in 1877 to Salem, Illinois, where he accepted a new pastorate. There, Byrd Spilman met Frederick Sidney Dewey, her future husband. A veteran of the Civil War, her husband suffered from respiratory problems, so they moved to Florida in 1881, eventually settling near Lake Worth. Byrd began writing, principally for newspapers and magazines, including *Good Housekeeping* and *Vogue*. She published a number of books, including *Bruno* (1899), *The Blessed Isle and Its Happy Families* (1907), and *Pine Woods to Palm Groves* (1909). She and her husband were among the founders of Boynton, Florida.

St. George Henry Rathborne was one of the most popular dime novelists of his time. This cover is from his 1912 novel, *Canoe Mates in Canada.*

Mary Cabell Richardson (1864–1925) spent her entire life in Covington. In her early years, she worked as both a librarian and a clerk within the US circuit and district courts. Afterward, she was a valued reporter with several local newspapers. Around 1900, she published a collection of poems including "Be British," which became a war slogan in England during World War I.

Mary C. McNamara (1865–1938) spent most of her life in Covington, writing various pieces of literature. Her most famous book, *"Glory" of the Hills*, however, was penned while a resident of the Lynch Hotel, situated deep within the Appalachian Mountains at Lynch, Kentucky.

Born in Perryville, Kentucky, Elizabeth Madox Roberts (1881–1941) spent her teens and twenties in Covington. In 1915 she published *In the Great Steep's Garden*, a collection of poems that accompanied Kenneth Hartley's photographs of mountain flowers. A second book of poetry, *Under the Tree*, was published in 1922. Her highest acclaim, however, clearly came as a fiction writer. Her novels included *The Time of Man* (1926), *My Heart and My Flesh* (1927), *Jingling in the Wind* (1928), *A Buried Treasure* (1931), *The Haunted Mirror* (1932), *He Sent Forth a Raven* (1935), *Black Is My True Lover's Hair*, and her best-known work, *The Great Meadow* (1930), which depicts the early settlement of Kentucky.

Elizabeth Madox Roberts. Courtesy of Paul A. Tenkotte.

George Elliston (1883–1946) moved with her family as a child to Covington, where she graduated from the old Covington High School. In 1909 she became society editor for the *Kentucky Times-Star*. A pioneer among female journalists, she later was a reporter for the *Cincinnati Times-Star*. Also author of a number of poetry collections, she served as editor of the poetry magazine *Gypsy*. Elliston left much of her large estate to the University of Cincinnati for the establishment of the George Elliston Poetry Trust Fund.

Gertrude Orr (1891–1971) served with the American Red Cross in military hospitals during World War I. Born in Covington, she spent much of her life in California, where she wrote more than 30 scripts for Hollywood films including *Marriage* (1927), *Mother Machree* (1928), *Waterfront* (1928), *Little Men* (1935), *Country Gentlemen* (1936), and *Call of the Yukon* (1938). In 1943 she penned *Here Come the Elephants*, a book on the history and psychology of elephants.

George Dillon (1906–68) moved with his family to Covington when he was only 5 years old, spending his formative years in the city. His family

moved to Chicago in the 1920s, and he attended the University of Chicago. His first collection of poetry was *Boy in the Wind* (1927), followed by *The Flowering Stone* (1931), which won the 1932 Pulitzer Prize for poetry. Dillon was longtime editor of *Poetry* magazine.

Harriette Simpson Arnow (1907–86) was born in Wayne County, Kentucky, and spent only a few years in Covington. Those, however, were extremely productive in regard to her literary career. She discusses the trials and tribulations of Appalachian migrants to urban areas, and migrants to Covington and Cincinnati likely influenced her widely popular trilogy *Mountain Path* (1936), *Hunter's Horn* (1944), and *The Dollmaker* (1954). Arnow also wrote two books on Kentucky's Cumberland River area: *Seedtime on the Cumberland* (1960) and *Flowering of the Cumberland* (1963). In 1974 she published *The Kentucky Trace: A Novel of the American Revolution*.

Dr. Hollis Spurgeon Summers Jr. (1916–87) served as an English teacher at Holmes High School in Covington. His fame came later in his life, when he became chair of the English department at the University of Kentucky, a professor at Ohio University in Athens, and an author of seven books of poetry and five novels.

Alice Kennelly Roberts, 1965. Courtesy of the Kenton County Public Library, Covington.

Alice Kennelly Roberts (1920–) was born in Covington, attended Covington Independent Schools, and spent many decades as a teacher and administrator at Holmes High School. Roberts was a featured columnist with the *Kentucky Times-Star*, *Kentucky Enquirer*, and *Kentucky Post* during her long career. While her columns earned great praise, she is also known for her books of poetry and prose: *Bluegrass* (1949), *Bluegrass Junior* (1952), *Bluegrass Seasons* (1959), and *Shamrocks and Bluegrass* (1988), a story of her Irish heritage.

Born in Hammond, Indiana, Jean Shepherd (1921–99) worked at various radio stations in Cincinnati and Covington and lived in an apartment along Madison Avenue. In his thirties, Shepherd moved to New York City, where he had a celebrated career on WOR radio as a late-night talk show host. Jack Paar even suggested that Shepherd, not Johnny Carson, replace him on the *Tonight Show*. Shepherd's crowning achievement is the screenplay he wrote in 1983, *A Christmas Story*. His semiautobiographical story, told through a narrator, follows 9-year-old Ralphie Parker as he attempts to persuade his parents to buy him a Red Ryder BB gun for Christmas. This widely popular holiday movie classic was also the inspiration for the television series *The Wonder Years*.

Walter Stone Tevis Jr. (1928–84) was born in San Francisco, California, but moved with his family to Richmond, Kentucky, at age 10. A graduate of the University of Kentucky (UK), he served as a part-time instructor at UK's Northern Community Center in Covington (now Northern Kentucky University) in the 1950s. As a graduate student at UK, Tevis took a liking to a Lexington, Kentucky, pool hall, where he gathered material for what would become his first novel, *The Hustler* (1959). He went on to pen six additional books: *The Man Who Fell to Earth* (1963), *Mockingbird* (1980), *Far From Home* (1981), *The Queen's Gambit* (1983), *The Steps of the Sun* (1983), and *The Color of Money* (1984). So popular were Tevis's works that three were made into major motion pictures: *The Hustler*, starring Paul Newman and Jackie Gleason; *The Man Who Fell to Earth*, with David Bowie; and *The Color of Money*, starring Paul Newman and Tom Cruise.

Born in Newport, Kentucky, John A. "Jack" Kerley (1951–) is a retired advertising copywriter who took his many experiences walking the streets of Covington and Newport and transformed them into a series of suspense

thrillers, including *The Hundredth Man* (2004), *The Death Collectors* (2005), *A Garden of Vipers* (2006), *Blood Brother* (2008), *Little Girls Lost* (2009), and *Buried Alive* (2010).

Toni Blake (1965–) was Covington born but attended Grant County High School, where she served as editor of both the school yearbook and the newspaper. Since then, she has published more than 40 short stories and has entertained thousands through her contemporary romance novels, including *Hotbed Honey* (2000), *Swept Away* (2006), *Letters to a Secret Lover* (2008), *One Reckless Summer* (2009), *Holly Lane* (2011), and *Half Moon Hill* (2013).

While those authors listed above received great acclaim for their fine works of poetry and fiction, there are many from the nonfiction genre as well. Vance H. Trimble (1913–) of the Scripps-Howard News Bureau in Washington, D.C., was a 1960 winner of the Pulitzer Prize for national reporting. Three years later, he left Washington and became editor of the *Kentucky Post,* head-quartered in Covington. Trimble lived in the Kenton Hills neighborhood of Covington. He continued as *Kentucky Post* editor until 1979, and later retired to his hometown of Wewoka, Oklahoma. He is the author of a number of books, including *Sam Walton: The Inside Story of America's Richest Man* (1991).

Vance Trimble. Courtesy of the Kenton County Public Library, Covington.

Matt S. Meier (died 2003) earned his doctorate in history from the University of California–Berkeley. He earned his master's degree in Mexico and was fluent in Spanish. As a professor at Santa Clara University in California, Meier served as chair of the history department. Nationally, he was one of the pioneers of Chicano history. His extensive works include *Dictionary of Mexican American History*, *Chicanos: A History of Mexican Americans* and *Mexican American Biographies: A Historical Dictionary, 1836-1987*.

Gary S. Webb (1955–2004) was a reporter for the *Kentucky Post* in the late 1970s and the early 1980s, and lived on West 11th Street in Covington. Later, he became a reporter for other newspapers, including the San Jose (CA) *Mercury News,* where he shared a Pulitzer Prize with a team of reporters for their earthquake coverage. In 1999 he published an important book titled *Dark Alliance: The CIA, the Contras, and the Crack Cocaine Explosion.*

Kate Trimble Woolsey (circa 1858—unknown) grew up in her family's commodious home on the southeast corner of Madison Avenue and Robbins Street in Covington. A suffragette and a prominent leader for women's rights, she authored *Republics Versus Woman* in 1903. As late as 1915, the *Kentucky Post* reported that she was dividing her time between Covington, New York City, and Europe.

John E. Burns enjoyed a long teaching career at Holmes High School; his *A History of Covington, Kentucky, through 1865* was published posthumously by the Kenton County Historical Society in 2012. Other books and collections related to Covington history include Covington-born Paul A. Tenkotte's dissertation "Rival Cities to Suburbs: Covington and Newport, Kentucky, 1790–1890" (1989); Tenkotte and Walter E. Langsam's *A Heritage of Art and Faith: Downtown Covington Churches* (1986); Tenkotte and James Claypool's *The Encyclopedia of Northern Kentucky* (2009); Jim Reis's four-volume *Pieces of the Past* (1988–2011); Chester Geaslen's three-volume *Strolling Along Memory Lane* (1973–74); Allen Webb Smith's *Beginning at "the Point": A Documented History of Northern Kentucky and Environs, the Town of Covington in Particular, 1751–1834* (1977); and *The Papers of the Christopher Gist Historical Society* (8 vols., 1949–57). More than 35 years of the *Bulletin of the Kenton County Historical Society,* with articles by various authors, is now archived on the society's website. An earlier *Papers of the Kenton County Historical Society* (3 vols.) was published in 1990. *Northern Kentucky*

Heritage continues as a solidly researched, semiannual collection of articles embracing the entire 13-county region. Karl J. Lietzenmayer, a longtime editor, is a gifted local historian and frequent contributor.

Several other publications are available on specific areas, aspects, or ethnicities of Covington: Joseph Gastright's *Gentleman Farmers to City Folks: A Study of Wallace Woods, Covington, Kentucky* (1980); Don Heinrich Tolzmann's *Covington's German Heritage* (1998); Terry W. Lehmann and Earl W. Clark Jr.'s *The Green Line: The Cincinnati, Covington, and Newport Railway* (2000); and John Boh and Howard W. Boehmker's *Westside Covington* (1980). The best account of horse racing in Covington is James C. Claypool's *The Tradition Continues: The Story of Old Latonia, Latonia, and Turfway Racecourses* (1997).

Several biographies have been written on famous Covingtonians, including William E. and Pasco E. First's *Drifting and Dreaming: The Story of Songwriter Haven Gillespie* (1988) and Harry R. Stevens's *Six Twenty: Margaretta Hunt and the Baker-Hunt Foundation* (1942). William R. Alger, Lawrence Barrett, and Montrose J. Moses each wrote on the American tragedian actor Edwin Forrest. Similarly, the life of William Goebel has been detailed by several authors, including James C. Klotter, Urey Woodson, and David Livingstone.

Covington-born Robert D. Webster (1958–) has held various positions with the Kenton County Historical Society and is a frequent contributor to *Northern Kentucky Heritage Magazine*. He is known for his many books on local and regional history, including *Northern Kentucky Fires* (2006), a summary of the most memorable fires of the region; *The Balcony Is Closed* (2007), a history of Northern Kentucky's long-forgotten neighborhood movie theaters; and his most popular work to date, *The Beverly Hills Supper Club: The Untold Story behind Kentucky's Worst Tragedy* (2012).

Ben Lucien Burman

Possibly the best-known and most successful author from Covington, Ben Lucien Burman (1895–1984), penned 22 books in his long literary career. Born to Jewish immigrants, Burman graduated from the old Covington High School before attending Miami University at Oxford, Ohio, and Harvard. Back in Covington, Burman taught at Holmes High School and later worked as an editor for the *Cincinnati Times-Star*. He wrote for newspapers in Boston and New York City and served as a contributor for such publications as *Nation*, *Reader's Digest*, and the *Saturday Review*. He is far more remembered, however, for his many books about life on the Ohio and Mississippi Rivers.

Burman published his first book, *Mississippi*, in 1929 (made into a film titled *Heaven on Earth*). *Steamboat Round the Bend* (1933) followed and became humorist Will Rogers's most successful motion picture. After *Blow for a Landing* (1938) and *Big River to Cross* (1940), Burman was regarded as the "new Mark Twain" due to his love of river life in the South and the memorable characters of whom he wrote.

During World War II, Burman worked as a correspondent in France and North Africa, but quickly returned to writing after the war. *High Water at Catfish Bend* (1952) was the first of seven satirical, Aesop-like Catfish Bend stories. Burman's book sales numbered in the millions, and many of his titles were translated into several foreign languages. He won the Southern Authors Award in 1938 and was a nominee for the Pulitzer Prize.

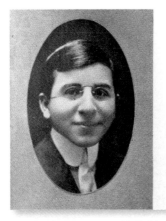

BEN LUCIEN BEHRMAN.

Literary Society, '09-'10-'11-'12-'13; Secretary of Literary Society, '10-'11; Orchestra, '11-'12-'13; Glee Club, '12-'13; Debating Society, '12-'13; Exchange Editor of *The Student*, '11-'12; Business Manager of *Student*, '12-'13; Midget Basketball Team, '10; Athletic Association, '12-'13.

"I seen my duty and I done it."

Ben Lucien Burman, 1913 high school photo. Courtesy of the Kenton County Public Library, Covington.

Robert F. Schulkers

Born in Covington, Robert F. Schulkers (1890–1972) graduated from St. Joseph High School (now Covington Catholic High School). He and his wife, Julia, lived in Latonia for a few years and then resided in various Cincinnati and Columbus, Ohio, neighborhoods.

In 1911 Schulkers became secretary to W. F. Wiley, publisher of the *Cincinnati Enquirer*, and began writing stories for young readers. In 1918 he was asked to write a weekly article for his fans. His first was titled "The Snow Fort," which became the forerunner of an extremely popular Seckatary Hawkins series of books.

Because of the popularity of the books, a Seckatary Hawkins Fair and Square Club was established and is still in existence. Anyone who promises to live up to the club's rules, such as "Always be fair and square," "Tell the truth," "Never give up," and "Try to learn something new each day," can join. The club had several million members at its peak. Seckatary Hawkins Days were popular at Cincinnati's Coney Island, and nationally there were parades, picnics, and other activities associated with the club. Schulkers's books had a great influence on author Harper Lee, who used a quote from his *The Gray Ghost* at the end of *To Kill a Mockingbird* to reinforce the moral ending of the novel.

NEWSPAPERS

One of the most nationally prominent journalists from Covington was Robert S. Allen (1900–81). Born in Latonia, Kentucky (now part of Covington), he was the son of Harry and Elizabeth Sharon Allen. Robert Allen served in World War I and in 1923–24 studied at the University of Munich while working as a correspondent for the *Christian Science Monitor*. He was one of the first American journalists to criticize Adolf Hitler. Returning to the United States, he eventually became chief of the Washington, D.C., bureau of the *Christian Science Monitor*. He and fellow journalist Drew Pearson wrote *Washington Merry-Go-Round* (1931) and *More Washington Merry-Go-Round* (1932), books about the Washington political scene that sold hundreds of thousands of copies. Allen and Pearson then started writing an investigative syndicated newspaper column titled *Washington Merry-Go-Round* (1932–41). He and Pearson wrote two books about the US Supreme Court titled *Nine Old Men* (1936) and *Nine Old Men at the Crossroads* (1937). Allen became an intelligence officer in World War II, during which he lost an arm. After the war, he published *Lucky Forward: The History of Patton's Third U.S. Army* (1947), *Our Fair City* (1947), *Our Sovereign State* (1949), and *The Truman Merry-Go-Round* (1950). He authored his own nationally syndicated newspaper column, *Inside Washington*, from 1949 until 1980.

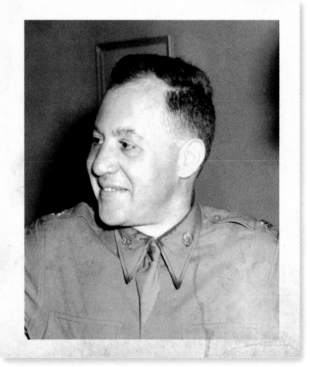

Robert S. Allen. Courtesy of the Drew Pearson Papers, Lyndon B. Johnson Presidential Library, Austin, Texas.

Covington has been home to a number of newspapers throughout its history. These have included daily, weekly, and monthly varieties, serving a host of different interests and audiences. Covington's first newspaper, the *Licking Valley Register*, came into existence in 1841. More recently, in 2013, Michael Monks unveiled the online *River City News*. Covington's 200-year history generally parallels the rise and the decline of the print news industry during the last half of the 19th century and the entire 20th century, as television's monolithic

advances spelled a slow retreat of printed daily newspapers, and the Internet brought about yet more changes in the following years.

In the years between Covington's founding in 1815 and the 1840s, printed information was the main source of news for growing populations. John E. Burns's *History of Covington, Kentucky, through 1865* lists a number of the earliest newspapers: the *Yankee Doodle Dandy,* the *Freedman's Journal,* the *Daily Covington Register,* the *Intelligence,* the *Christian Journal,* the *Covington Union,* and the *Covington Journal.* These papers came and went, and others, such as the *Ticket* and the *Daily Commonwealth,* followed in the late 19th century. Money was to be made, so they thought, in print journalism. Newspapers, then as now, tended to reflect certain viewpoints or perspectives and sometimes were the mouthpieces of particular political parties.

Orville James Wiggins (1856–96) was born in Covington but educated in Cincinnati's public schools. Wig-

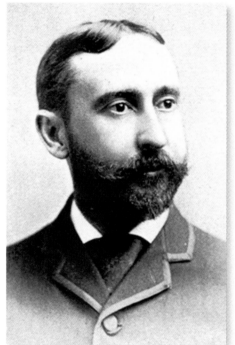

gins was the city editor of Covington's *Daily Commonwealth* and was a reporter for the *Cincinnati Enquirer* and the *Cincinnati Times-Star.* In 1884 he published a series of articles, titled *History of Covington,* in the *Daily Commonwealth.* Wiggins also served as a clerk of Kenton County courts, a clerk and later a president of the Covington Board of Education, and an insurance agent.

However, two major newspapers—the *Kentucky Enquirer,* an edition of the *Cincinnati Enquirer,* and the *Kentucky Post,* an edition of the *Cincinnati Post*—have provided the most news and commentary for a vibrant public discourse for more than 100 years. The *Enquirer* developed a Northern Kentucky staff in 1972. But the *Post* put "Kentucky" in its masthead in 1891, according to *Pieces of the Past* by Jim Reis. Later, when the *Post* merged with the *Times-Star,* the masthead carried both names for a short period.

Clay Wade Bailey (1905–74) was one of the most well-known journalists to cover Kentucky politics. He began his career with the Louisville *Courier-Journal,* then worked for the United Press, and, in 1938, became a reporter for the *Kentucky Post.* Blessed with an excellent memory and the talent to read upside down—useful when in the offices of state officials—

Orville James Wiggins. Source: Roe, George Mortimer. *Cincinnati: The Queen City of the West.* Cincinnati, OH: The Cincinnati Times-Star, 1895.

Bailey was also personable and hardworking. The Clay Wade Bailey Bridge in Covington is named for him.

For most of its history the *Enquirer* has leaned middle-to-right conservative while the *Post,* until its closure in 2007, was considered liberal or Democratic. Leanings were determined by the ownership of each. The Taft family owned the *Enquirer* for many years, while the Scripps family owned the *Post.* Brady Black (1908–91), who lived in suburban Fort Mitchell, Kentucky, served as a longtime reporter and editor for the *Enquirer* and as its editor/vice president from 1964 until 1975.

In 1982 *Kentucky Post* reporter Jim Reis began his well-known weekly *Pieces of the Past* column about Northern Kentucky's heritage, known affectionately as Reis's Pieces. By 2005 he had produced 1,100 articles in the series, some of which were reprinted in four separate volumes (1988–2011). As Reis described the importance of the printed media and its audience, people "helped newspapers rebuild after fires, propped them up when

Clay Wade Bailey (left) with Kentucky Gov. Ned Breathitt, 1965. Courtesy of the Kenton County Public Library, Covington.

Jim Reis. Courtesy of the Kenton County Public Library, Covington.

creditors beat on their doors and relied on them for local, national and international news during wars and disasters." Newspapers covered the Civil War and the Wright Brothers' first flight in 1903. Locally, they covered the 1937 flood; the 1977 Beverly Hills fire; government affairs in Covington and Frankfort, Kentucky, and in Washington, D.C.; suburban sprawl following World War II; and the Civil Rights Act of 1964, signed into law by then-president Lyndon Baines Johnson. Although it folded in 2007, the *Kentucky Post* had "the greatest staying power and influence," Reis wrote.

The *Kentucky Enquirer*, popular as a morning daily, was a wraparound of the *Cincinnati Enquirer*, which focused its attention primarily on news north of the Ohio River. With a small staff of Northern Kentucky reporters, coverage of Covington events, culture, or politics was limited until the 1970s. Editors such as Jack Hicks and Jo-Ann Albers wrote on issues involving Covington and its neighboring communities in Kenton, Boone, and Campbell Counties.

However, with major media outlets on the Ohio side of the river, the focus of news was on Cincinnati and its evolution. Further, newspapers faced increased competition from radio and television. Nevertheless, the *Post* and the *Enquirer*, the papers in nearest memory, featured some interesting and talented voices. Here are some samples.

Judy Clabes, editor of the *Kentucky Post* from 1983 to 1996, now editor of **kyforward.com** and retired president of the Scripps-Howard Foundation, states: "My happy years as editor of the *Kentucky Post* were also the years of the Renaissance for Northern Kentucky and especially Covington." Respected leaders stepped up and formed a three-county chamber of commerce, the Tri-County Economic Development (now called Tri-Ed), and Forward Quest (now known as Vision 2015). "And," Clabes wrote, "there was the *Post*, providing the glue that provided the right environment for getting the right messages out." Among the writers and editors of Clabes's time were Michelle Day, Mike Farrell, Pat Moynahan, Mark Neikirk, and Shirl Short, in addition to Dan Hassert, Peggy Kreimer, Greg Paeth, Jim Reis, Jack Schicht, and Debra Vance. Each reflected a passion for journalism and a unique voice as a writer.

Other writers and staff of the *Kentucky Post* included Alice Akin, Roger Auge II, Tom Kramer, Tom Loftus, Mike Mersch, Nancy Moncrief, Margaret Paschke, Burl Russell, Lee Stillwell, Gary Webb, Carl West, and Bert Workum. Photographers included the talents of Randy Cochran, Joe Munson, and Richard Pridemore. Pulitzer Prize winner Vance Trimble, a news reporter's editor, ran the paper ironhandedly until Clabes's time. Paul Knue was editor from December 1979 through August 1983, when he became editor of the *Cincinnati Post*. The *Kentucky Post*'s final editor was Mike Phillips. Carl West now operates the *Frankfort Journal* and is a founder of the Kentucky Book Fair. Tom Loftus reports expertly for the Louisville *Courier-Journal*. Roger Auge II reported for the *Kentucky Post*, the *Anchorage Daily News* (Alaska), and the *Voice of St. Matthews* (Louisville, Kentucky). Auge, who holds a master's degree in education, taught in Covington schools and at Gateway Community and Technical College.

Mark Neikirk, now director of the Scripps-Howard Institute for Civic Engagement at Northern Kentucky University, started as a reporter and ended up as managing editor of the *Kentucky Post* and the *Cincinnati Post*. He related a story in which the paper received a tip about a "mom in a box." It was discovered that a woman in the MainStrasse area of Covington had stored the remains of her mother in a box in her house, while dressing in public as her mother. She concocted the ruse to keep receiving her late mother's social security checks.

There is much history in Covington's 200 years of journalism—including colorful editors and reporters such as Bob Fogarty, Abe Heitzman, and Jack Hicks, as well as inside editors such as Henry Childress, Mark Neikirk, Burl

Judy Clabes. Courtesy of the Kenton County Public Library, Covington.

Russell, and Lee Stillwell who knew how to nose out news. Editors such as Judy Clabes, Clemons "Bud" Deters, Pryor C. Tarvin, and Vance Trimble truly made the newspapers staples of daily life in Covington.

On November 2, 1978, Jo-Ann Albers was welcomed to the editor's position at the *Kentucky Enquirer* in a *Kentucky Post* editorial by Vance Trimble. Albers was quoted as saying her goal was to "beat the *Kentucky Post* on all stories." But, Albers later said, "my ambition wasn't realistic." Her strongest memory was convincing the Kentucky Supreme Court to rotate release times and dates on decisions to give morning newspapers like the *Enquirer* "a fair share of news breaks." In the intervening years, newspapers like the *Enquirer* and the *Post* faced increasing competition from radio, television, and the Internet. The *Post*'s print version ended officially with its December 31, 2007, edition. The *Cincinnati Enquirer* continues to publish a daily printed edition, including the *Kentucky Enquirer*. Likewise, the Roman Catholic Diocese of Covington continues to publish a weekly print edition of the *Messenger*. Still, the future of print news media will certainly bring additional changes. As the *River City News* reported on May 1, 2014, the *Enquirer* experienced further layoffs in 2014. Perhaps the future lies with Michael Monks and his digital *River City News* and Judy Clabes with her vibrant **kyforward.com.** News is news, but technology changes.

SELECTED BIBLIOGRAPHY

Browning, Sister Mary Carmel. *Kentucky Authors: A History of Kentucky Literature*. Evansville, IN: Keller-Crescent, 1968.

Gardiner, C. Harvey. "Ben Lucien Burman (1895–1984)." *Northern Kentucky Heritage* 3 (1) (1995): 22–31.

Northern Kentucky Newspaper Index. Kenton County Public Library, Covington, KY.

Tenkotte, Paul A., and James C. Claypool, eds. *The Encyclopedia of Northern Kentucky*. Lexington, KY: University Press of Kentucky, 2009.

Ward, William S. *A Literary History of Kentucky*. Knoxville, TN: University of Tennessee Press, 1988.

CHAPTER

11

FROM LEECHES TO LASERS: MEDICINE AND SENIOR HOUSING IN COVINGTON

by Brian L. Hackett, PhD, and Luke Groeschen

WHEN the first ships carrying English colonists arrived at Virginia to establish Jamestown in 1607, they carried with them a number of noblemen, a small number of laborers, and a few skilled workers. The skilled workers included a blacksmith, a barber, a stonemason, a tailor, a drummer, carpenters, and a "surgeon." It might seem ironic that a man of medicine would be listed in the same category as men who worked with their hands in hard labor, rather than in highly delicate skilled crafts. But it is true, for medical men and indeed the medical profession itself were to be feared. Seeing the doctor or, worse, going somewhere to be treated, was an action of last resort for those suffering from illness or injury. A typical doctor's treatment might be bleeding the patient with leeches or with specially designed "bleeders" to remove the diseased "humors" that caused disease. Dating from classical Greece and still prevalent into the 19th century, humorism was the belief that four humors—black bile, yellow bile, blood, and phlegm—comprised human beings and that these humors needed to be kept in harmony. If the humors were unbalanced—for example, if a person were thought to have too much blood—disease occurred. Cures concentrated on returning balance to the humors—for example, bleeding for too much blood, and purgation for too much black bile. It is no wonder that the fear of a cure might be worse than the disease itself. The results were that many people shied away from medical treatment and instead relied on a whole unregulated cottage industry of do-it-yourself medical cures and self-help books.

By the time settlers came to what we now know as Covington, Kentucky, very little had changed. Medical training of doctors was still quite rare. Many doctors received little formal training, mostly by working with other doctors or picking up medical knowledge through on-the-job training in the military or out of necessity. Many of the earliest men of medicine who came to Northern Kentucky in the late 1700s fit this description. They were hardworking men who not only practiced medicine, but also owned farms and other businesses in order to make ends meet.

The major exception to this sweeping assessment was Dr. Thomas Hinde, the first recorded physician in the Northern Kentucky area. By the time Hinde arrived in Kentucky in 1797, he was 60 years old and was an American legend. He studied medicine and surgery at St. Thomas Hospital in London, England, receiving a license to practice surgery at age 19. He joined the Royal Navy and sailed to America to join British forces fighting the French in the French and Indian War. In 1759 he was assigned as the personal physician for General James Wolfe on his campaign to attack and capture Quebec, Canada. Wolfe was sick for much of the campaign, but preferred the battlefield to the sickbed and, despite his illness, continued to lead his men in battle. Part of Hinde's duty was to keep the general well enough to fight. On September 13, 1759, General Wolfe was mortally wounded in a battle against

French regulars and Canadian militia. He reportedly died in Hinde's arms. A famous and highly romanticized painting of the death of General Wolfe, by Anglo-American artist Benjamin West, depicts Hinde attempting to comfort the dying general. The painting was created in 1771, many years after the war, and is the property of the National Gallery of Canada in Ottawa.

After the French and Indian War, Hinde returned briefly to England before returning to America to take advantage of the new lands that England's victory over the French made available. Hinde resigned his commission in the military and set up a private practice in Virginia, where he met and became good friends with Patrick Henry, the famous American patriot. Hinde treated Henry's wife, Sarah, for mental illness. Perhaps it was Henry's influence, but Hinde quickly became sympathetic to the American Revolutionary cause and joined Henry as his personal physician and military surgeon to the Virginia militia. While attached to the militia, Hinde spent much of his personal fortune buying medicine in order to inoculate the troops against diseases such as smallpox. His actions at the time were considered controversial, since giving people shots to prevent diseases was still an unproven science. It is likely that his creative use of inoculations saved many soldiers.

As a result of his hard work on behalf of soldiers during the American Revolution, Thomas Hinde was given 1,000 acres in the newly opened lands of Kentucky. Wisely waiting until the region was stabilized after a period of American Indian and pioneer unrest, he moved his family to Clark County, Kentucky, in 1797. Two years later, he moved to Newport, Kentucky, where he found more people who needed his services. In 1808 he served the soldiers at the Newport Barracks, as well as many families in the area, often traveling great distances by horseback to see patients.

Hinde was a very devout man, serving as a strong supporter of the Methodist church in the last decades of his life. But this was not always the case. At one point in his life he was a Deist, believing that God had created the earth, established certain physical rules or mechanisms, but otherwise did not interfere with the everyday lives of humans. His beliefs reflected those of many of the founding fathers, including Thomas Jefferson, James Madison, and Ben Franklin. After coming to Northern Kentucky, Hinde's daughter and mother came under the influence of a Methodist preacher and converted to Methodism, a fact that upset him greatly. He first banished his daughter and then began to treat his wife for mental illness. His method of choice was a "blistering plaster" applied to her back, causing great pain in an attempt to coax the mental illness out of her. A blistering plaster used concentrated mustard to produce heat in the affected part of the body. To cause a blister, a mixture of mustard and other chemicals was used to produce a chemical burn on the patient's skin, thus bringing the disease-causing humors to the surface. This method of treatment failed on Mrs. Hinde, and soon Hinde himself converted to Methodism and became an outspoken supporter of religious faith for the rest of his life.

Thomas Hinde died in 1828 at the age of 92. Interestingly, Hinde's favorite son-in-law, Richard Southgate (1774–1857), was the executor of the doctor's extensive estate. His great-niece Louise Southgate (1857–1941) became one of Northern Kentucky's first female physicians, starting her practice in Covington in 1893. She was a leader in the health community for many years, as well as an advocate for women's rights.

Other doctors active in the early Covington area included Peter Abbot, John Bennett, Thomas Eubank, David Fisk, Henry Gunkel, Samuel Hopkins, A. C. Johnson, John Orr, Hugh Rachford, Nathan Burger Shaler, and Guy Wright. Of particular importance was Dr. James Andrew Averdick (1852–1931). An 1871 graduate of the College of Medicine (Cincinnati), Averdick practiced medicine in Batesville, Indiana, and moved to Covington in 1875. A popular physician, he was active in the Covington community, serving as county coroner; on the county board of health, as house physician of St. John's Orphanage (the Diocesan Catholic Children's Home); and as a member of Kentucky's House of Representatives. Among Averdick's proudest achievements was his half century of service on the Covington Board of Education, including the office of president. He was a supporter of equal education for all and worked for the passage of a bond issue to build Covington's Lincoln-Grant School, one of the state's finest African American schools.

COVINGTON'S FIRST HOSPITAL

Although doctors arrived in Covington in the early years of settlement, it would be more than 60 years before the city would see its first hospital. Like doctors, hospitals were looked on with suspicion by our 18th- and 19th-century ancestors. Hospitals meant a lot of things to our ancestors, few of them good. First, "decent" people who were sick generally stayed at home where their families could care for them. Second, people regarded hospitals as bringing sickness into a community, making it unhealthy to live there. Finally, hospitals were places of last resort where people went to die, and only when they had no place else to go.

In Covington, there was one other fact that made Northern Kentucky's first hospital unpopular. The city's first hospital was founded by Catholics. At the time, in the 1860s and the early 1870s, Catholics were considered outsiders—immigrants who brought with them religious beliefs that seemed foreign to then predominantly Protestant Northern Kentucky. Covington's first hospital, St. Elizabeth, was the remarkable collaboration of three incredible women, Henrietta Esther Scott Cleveland (1817–1907), Sarah Worthington King Peter (1800–77), and Sister Frances Schervier (1819–76),

as well as the Bishop of Covington, George Carrell. Henrietta Cleveland, a widow who had lost her husband and two children, was a devout Catholic convert with a special interest in the challenges facing the poor. She was a descendant of two prominent and wealthy pioneer families, the Scotts and the Fowlers, and was the owner of several properties in the city of Covington. Perhaps it was her personal challenges, a young widow bearing the loss of her children, that made her so concerned with the plight of others.

Henrietta Esther Scott Cleveland. Courtesy of Paul A. Tenkotte.

In 1860 Covington was a growing city, offering many opportunities for workers in manufacturing, construction, and service industries. Record numbers of immigrants and poor individuals and families moved to the community, stretching the city's resources near the breaking point. Life in overcrowded boardinghouses with improper sanitation meant that diseases could spread quickly. Sickness and serious injury were particularly hard on the poor, since they did not have the resources to nurse the sick back to health in their own homes. Of special concern were men and women who had no family ties in the area and had no one to take care of

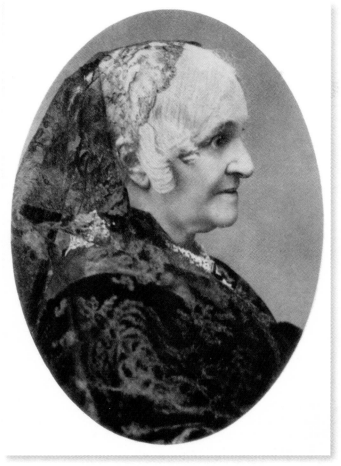

Sarah Worthington King Peter. Courtesy of Paul A. Tenkotte.

them in a time of illness. The answer was simple: Covington needed a hospital.

Henrietta Cleveland turned to her friend Sarah Worthington King Peter for help. Peter had successfully established a hospital for the poor in Cincinnati in 1858, working with a group of Catholic nuns. Peter, a fellow Catholic convert, was also the product of a wealthy pioneer family, the daughter of Thomas Worthington, the "father of Ohio Statehood." Like Cleveland, Sarah had led a life of personal tragedy and had a special feeling for the poor, especially the plight of women and children.

With the blessing of Bishop George Carrell (1803–68), Cleveland and Worthington approached Sister Frances Schervier, founder and leader of the Sisters of the Poor of St. Francis in Aachen, Germany. The order, founded in 1844, was dedicated to the poorest of the poor, to those whom others had forsaken. Although they were a new order of nuns, the sisters had a reputation for working with the severely ill and the profoundly mentally handicapped. They were determined, hardworking, and never turned away from a challenge. And establishing a hospital in Covington would be a major challenge.

Bishop Carrell agreed that a hospital was needed in Covington, but little did he know that it would delay a longtime dream of his own. The bishop had purchased an abandoned store on Seventh Street, perhaps in hopes of turning it into a seminary. The building was far from perfect. Purchased at a sheriff's sale, it had been unused for years. There was no heat, no water, an open sewer under the kitchen addition, and an infestation of bugs, including lice that lived in the wallpaper. In addition, when there was heavy rain, the basement flooded, destroying any provisions stored there. However, the building was near the center of town, and it had room for 10 beds.

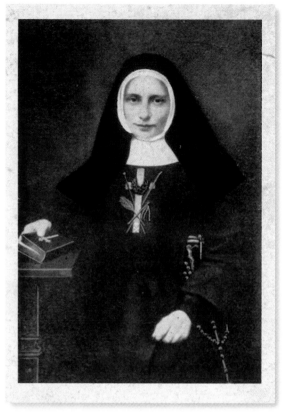

Sister Francis Schervier. Courtesy of the St. Elizabeth Healthcare Collection, Kenton County Public Library, Covington.

The first location of St. Elizabeth Hospital was on East Seventh Street. Source: *One-Hundred-Twenty-Five Years, St. Elizabeth Medical Center* (Covington, KY: St. Elizabeth Hospital, 1986).

St. Elizabeth Hospital opened in mid-January 1861, just as the United States was tearing itself apart over the issue of slavery. The hospital's first patient was Louis Myer (Meyer), a 35-year-old laborer who had a wife and three young children. As a sign of the inclusive nature of St. Elizabeth Hospital, Louis Myer was a Methodist. According to the hospital's intake records, Myer suffered from "rheumatism," which, in the 19th century, was a catchall term for any disease affecting the muscles and joints that could not be linked to a specific disease or accident. It is probable that Myer's condition had deteriorated to the point at which he could not even attend to basic needs without help. His young wife, who had three young children, must have been completely overwhelmed with the burden of taking care of her dying husband. St. Elizabeth hospital was probably her only hope. Louis Myer died there on March 11, 1861. The cause of death was "decay of the bones."

St. Elizabeth Hospital Foundling Asylum. Courtesy of the St. Elizabeth Healthcare Collection, Kenton County Public Library, Covington.

Louis Myer was one of 79 patients who stayed at the hospital that first year. Of those, only 13 died, a remarkably low number considering that most people went to hospitals to die. St. Elizabeth was open to anyone in need, regardless of religion or race. In 1863 the sisters removed a dying enslaved woman from a cruel master, bringing her to the hospital when the slave master could no longer endure her painful cries. They also took in orphans, abandoned children, and dying babies, giving everyone a chance at hope and comfort.

It is no surprise that the 10-bed hospital was soon too small to meet the growing demands of Covington. In 1868 St. Elizabeth Hospital had the opportunity to purchase the old Western Baptist Theological Seminary on West 11th Street for $50,000. The seminary went out of business when factions of the Baptist Church split over the issue of slavery before the Civil War. For a short time, the building served as a military hospital for Civil War wounded. By the time the sisters at St. Elizabeth Hospital obtained the property, wild pigs were found living on the grounds and on the first floor.

Raising the money to pay the purchase price of the building was the first challenge faced in converting the building into a hospital. This task was made more difficult when a group of citizens under the leadership of Covington businessman William Ernst filed a lawsuit against the city of Covington in an attempt to block the city from donating $5,000 toward the purchase of the building. Ernst's public argument was that the municipal government should not give money to religious organizations because it would set a bad precedent. Newspaper articles at the time hint at different reasons, including a general anti-Catholic sentiment by Ernst and his followers.

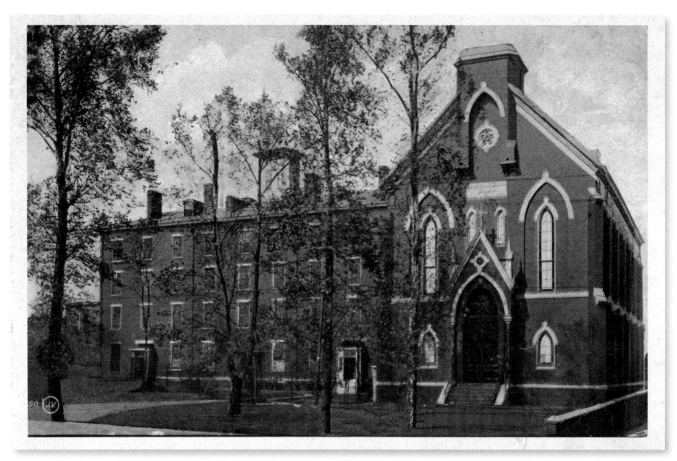

St. Elizabeth Hospital's second location was on West 11th Street. Courtesy of Paul A. Tenkotte.

Ernst and his supporters were success-
ful in preventing the city of Covington
from supporting the new hospital, not
by winning in court but by drawing out
the process to the point that the Sisters
of the Poor simply declined the city's
offer.

The new location of St. Elizabeth
Hospital opened in spring 1868, with
100 beds, running water on all four
floors, and special four-story privies
built into the corners of the rear of the
building so patients would not need to
go outside or climb stairs to use the
bathroom. Other advantages of the
new hospital included an orchard, a

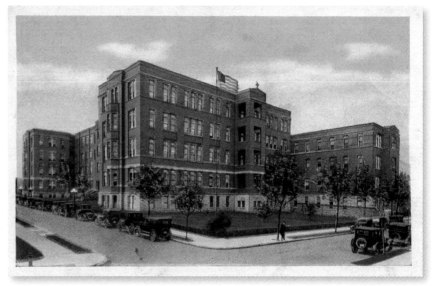

The front entrance of St. Elizabeth Hospital's third location originally faced West
21st Street. Courtesy of Paul A. Tenkotte.

large outdoor cooking area for food preparation, and a "dead house," where the deceased could be stored to
prevent body snatching and to await proper burial.

The 11th Street St. Elizabeth Hospital continued in use until it was replaced by the East 20th Street hospital,
opened in 1914. This third location was designed and built to be a hospital and boasted state-of-the-art operat-
ing rooms and X-ray facilities. Soon a nursing school was added, and during the Great Depression of the 1930s,
the hospital operated a soup kitchen for the many poor families living in and around Covington. The 20th Street

hospital became the hospital that most citizens of Covington over a certain age remember. It is where they and their children were born, and where loved ones were healed or cared for in their last days. It was the rock that the community looked to in times of need.

EPIDEMICS IN COVINGTON AND THE PESTHOUSE

Covington has battled numerous epidemics throughout its 200-year history, including cholera, smallpox, and Spanish influenza. We are a little more protected from serious outbreaks today as medicine has become much more advanced than it was when Covington was first founded. For instance, now we can pinpoint the cause of an outbreak of *E. coli* to contaminated food and stop it from spreading further. Occasionally, a new bug presents a challenge, such as the H1N1 virus, or swine flu, did in 2009, posing a major threat until a vaccination was developed. Often, during Covington's early days, causes of diseases were unknown and therefore difficult to treat and eliminate before they spiraled out of control.

Cholera, an intestinal disease with symptoms such as vomiting and diarrhea, was an annual struggle Covington residents faced. According to a *Covington Journal* report in 1849, cholera was confined almost exclusively to the German population in Covington. The disease ran its course by the beginning of August and returned again in 1850. Upon its return, cholera attacked everyone—not just certain populations; rich and poor alike were affected. It is difficult to determine the number of individuals who were taken ill by cholera, as many cases were not reported and at other times the numbers were exaggerated. Covington experienced additional bouts with cholera, including the one in 1873, which claimed a number of lives. By the end of the 1870s, doctors from Germany discovered that cholera was caused by drinking contaminated water. This connection allowed health boards to institute new sanitation standards to stamp out the disease in Covington and across Northern Kentucky.

During the latter part of the 19th century, Covington residents also faced serious outbreaks of smallpox. Smallpox is a highly contagious disease that dates back thousands of years. Covington had its fair share of outbreaks of the deadly disease during its history. One of the earliest documented smallpox outbreaks in Covington occurred in 1831, but it was quickly brought under control due to precautions established. During the 1850s and the 1860s, yearly cases of smallpox appeared in the city. In 1875 the outbreak of smallpox in Covington was blamed on African Americans. Only 10 years removed from the end of Civil War, the belief that blacks were the cause may have reflected the prejudices of the time period. Newspapers like the *Ticket* and the *Covington Journal* reported how open carts took afflicted victims to the county pesthouse, using main thoroughfares (such as Madison Avenue) and causing great concern among those living near the route. The *Ticket*, a Covington-based newspaper, accused city leaders and physicians of hiding the seriousness of the outbreak from Covington residents. The smallpox epidemic of 1875 appeared in the spring and lingered into the early days of 1876, claiming many lives.

Smallpox continued to be a nuisance in Covington for many years to come. In 1881, a major outbreak forced Covington to isolate itself. No one was allowed to leave or enter the city without a special permit. Officers were ordered to guard the bridges to ensure no one violated quarantine ordinances. Beginning slowly, this smallpox epidemic eventually claimed more than 300 lives by May 1882. At this time a vaccine for smallpox existed, but many chose not to receive it. By the 1940s, vaccination for smallpox was mandatory; however, outbreaks still occurred throughout the nation. In the early 1980s, the World Health Organization declared victory over smallpox by eradicating it from the world.

In 1918, while the sons of Covington were off to war in Europe fighting on ships and in trenches, a battle against disease was being waged in our backyards. All over the United States, the nation was in a fight against Spanish influenza. Spanish influenza began appearing in the early fall in Covington, sometime after the first of October. Health officials initially vowed that there were no confirmed cases of Spanish influenza in the city, but instead there were cases of grip and pneumonia. By October 9, 1918, the epidemic had reached Covington, according to local newspapers, which estimated 1,000 cases of Spanish influenza and claimed that the grip and the Spanish influenza

COVINGTON HAS 1,000 CASES OF SPANISH "GRIP"

On October 9, 1918, the *Cincinnati Times Star* reported that there were 1,000 cases of Spanish influenza in Covington. The previous day, health officials stated there were no cases of the illness, but that they were seeing numerous cases of grip. In the October 9 article, health officials reversed their previous statement, declaring Spanish influenza and grip to be one and the same. Source: *Cincinnati Times Star* (Kentucky edition).

were indeed one and the same. Due to the epidemic, numerous bans and restrictions were issued within the city to fight its spread. Schools, churches, public gatherings, and many other businesses were forced to close or fall in line with restrictions brought about by health officials.

By November 8, 1918, the situation was beginning slowly to improve, and health officials began lifting or loosening bans. Protestant church services were held to one hour, Catholic churches could have three masses, each one 30 minutes in length, and no Sunday school or weekday services were allowed. For a brief period, the city seemed to be getting back to normal with the lifting of restrictions. Even the Covington Library was reopened for business, promising not to fine patrons who had borrowed items before the epidemic began. Despite efforts to try to reopen schools, too many children were absent, and the decision was made to delay school reopenings again after the first of the year. By mid-December, a vaccine began to make its way into the hands of health departments and physicians in Covington and all across the nation. Covington physicians were urged to report the use of the vaccine, and citizens were urged to get the vaccine to help fight further contagion. Meanwhile, many advertisements appeared in the local newspapers, suggesting all sorts of remedies and cures for influenza. By Christmas, very few cases were being reported, and all bans had been lifted citywide. Health officials continued to urge caution, advising residents to continue healthy practices that had been adopted during the height of the epidemic.

Cases continued into the new year but not at the numbers seen during the height of the epidemic. In Covington, according to health department records, the influenza epidemic that raged from the end of September to December claimed 267 lives. It is unknown how many actual cases of Span-

ANTI-INFLUENZA MASKS IN USE

Many doctors and nurses treating patients in hospitals and offices wore gauze masks to prevent themselves from contracting the Spanish influenza virus. Dr. James P. Riffe, head of the Covington Board of Health, was said to always wear a mask when seeing patients. He was stricken with the flu in early November. Source: *Cincinnati Times Star*, Kentucky edition, 10 Oct. 1918.

ish influenza there were in the city, as many physicians often failed to report the cases that they were attending. Many of those who were stricken by Spanish influenza were admitted to St. Elizabeth Hospital. Patient records from St. Elizabeth suggest the average stay of patients was about 7–10 days. By the end of the epidemic in the city, Dr. James P. Riffe, who was at the forefront of the battle against Spanish influenza, attributed the willingness of the citizens of Covington to accept the bans and regulations as the reason that the city fared so well.

Smallpox, influenza, and other epidemics stretched the available health care resources of the community to the breaking point. Further, the contagious nature of these diseases required isolation of patients. Some patients had no choice but to be sent to the city's pesthouse. Located on Kyles Lane on what was sometimes referred to as the flats (where NorthKey and St. Charles Community are currently located), the pesthouse—sometimes called the Branch Hospital or Lazarus Hospital—was operated by the city's board of health. It cared for the contagious and suffering poor of all races. Conditions there were overcrowded. By June 1875, during the midst of a smallpox epidemic, the facility's three small rooms held 19 patients. City leaders decided to build a new building. The *Ticket* declared the facility, completed in late 1875, "the cleanest, nicest, airyest [*sic*] place of the kind in the United States." With 11 rooms, beds for 50 patients, a stable, a cistern, a dead house, and a "house for the disinfection of clothing," the new

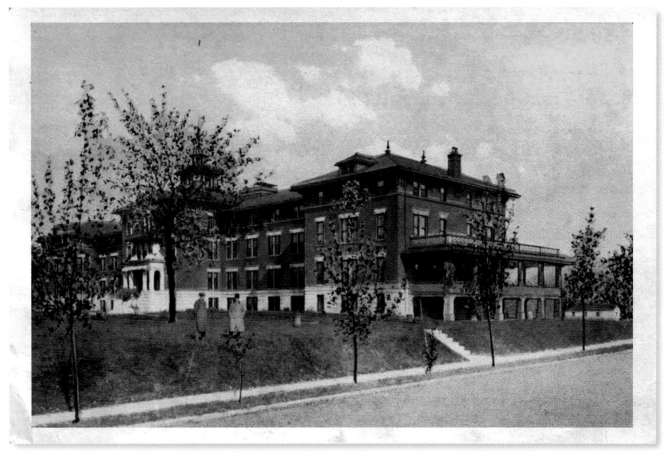

The Kenton County Infirmary in Rosedale. Courtesy of Paul A. Tenkotte.

pesthouse was an improvement—but not for long. By 1899 the *Kentucky Post* reported accusations that a nurse there abused patients and forced them "to commit immoral acts." A county judge ordered an immediate investigation. By 1903 the city had sold the 9-acre pesthouse property to the county.

By the early 20th century, new ideas were circulating nationwide about care of the poor, the ill, and the elderly. As part of this national trend, Kenton County was investigating the need to build a modern "infirmary" to care for the indigent poor. New county infirmaries, basically the predecessors of re-tirement and nursing homes, would replace the old poorhouses, such as that operated by Kenton County at Independence. Still, the pesthouse remained open for contagious cases. In 1929 Paul Garber, a *Kentucky Post* reporter, was sent to the pesthouse with smallpox. His front-page, inside investigation re-sulted in the city dedicating funds for improvement of the pesthouse.

The pesthouse's days were quickly approaching an end. In May 1907 the county opened a new state-of-the-art, four-story infirmary at Rosedale in Latonia, closing its old poorhouse. Meanwhile, the scourge of tuberculo-sis (TB) was stalking the nation. In 1937 Northern Kentucky's first tuber-

Many patients were admitted and treated at the Covington–Kenton County Tubercu-losis Sanatorium during its years of opera-tion from 1951 to 1979. This 1963 photograph shows Mrs. and Mr. Leo Tucker leaving the facility with staff members bidding them a healthy farewell: Dr. Kenneth Lockwood, Dr. Ronald G. Fragge, Dr. Charles J. Farrell, and Cecilia Perrine. Courtesy of Kenton County Public Library, Covington.

culosis sanatorium opened in the former pesthouse, overseen by Covington physician Charles J. Farrell (1901–77). Farrell successfully lobbied for a $400,000 county bond issue in 1947 to fund a new sanatorium. Opened in April 1951 and located on the grounds of the old pesthouse (now 50 Farrell Drive), the new four-story Covington–Kenton County Tuberculosis Sanatorium was overseen by Farrell. With the emergence of new drugs to treat TB, the hospital closed in 1979 as a long-stay and short-stay facility providing skilled nursing care. A year prior, it had begun sharing

its sprawling facility with a new inpatient psychiatric unit operated by the Northern Kentucky Comprehensive Care Center (now called NorthKey Community Care). Transitioning to specialized care for children and adolescents, the facility changed its name to the Children's Psychiatric Hospital and is now simply known as NorthKey.

WILLIAM BOOTH MEMORIAL HOSPITAL

St. Elizabeth Hospital and the pesthouse were not the only hospitals in Covington. There was also William Booth Memorial Hospital, founded in the old Shinkle Mansion on East Second Street. Booth Memorial Hospital was the creation of Mary Anne Hemingray Shinkle, wife of Bradford Shinkle, whose father was the power behind the building of the Roebling Bridge. Mrs. Shinkle was the daughter of Robert and Mary Hemingray, owners of the Hemingray Glass Company. After Bradford's death in 1909, she donated their house to the Women's Social Department of New York City, a branch of the Salvation Army. The Salvation Army quickly decided to convert the large mansion into a hospital and home for unwed mothers, considered social outcasts by society at that time.

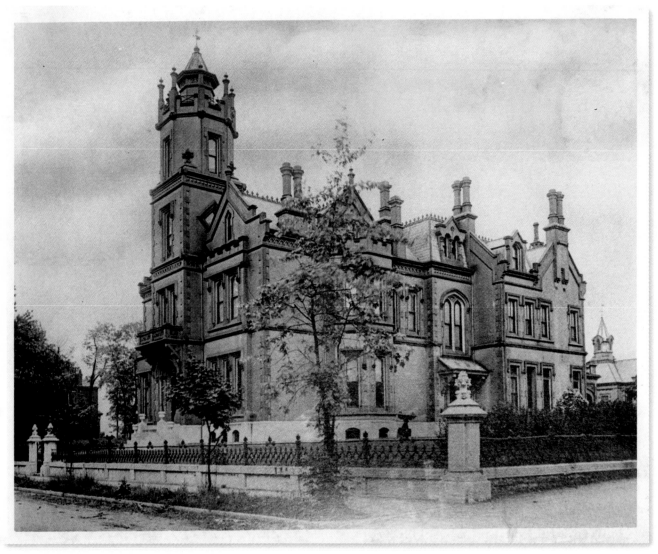

Booth Hospital was originally housed in the Shinkle Mansion on East Second Street. Courtesy of Paul A. Tenkotte.

The birthing hospital in the mansion operated until 1914, when a group of citizens in Covington approached the Women's Social Department about converting the hospital for unwed mothers to Covington's first Protestant hospital. The Salvation Army agreed, and sent May Morgan to head up the hospital, naming it after William Booth, founder of the Salvation Army. Interestingly, both of Covington's hospitals, Catholic St. Elizabeth and Protestant Booth, were led by women.

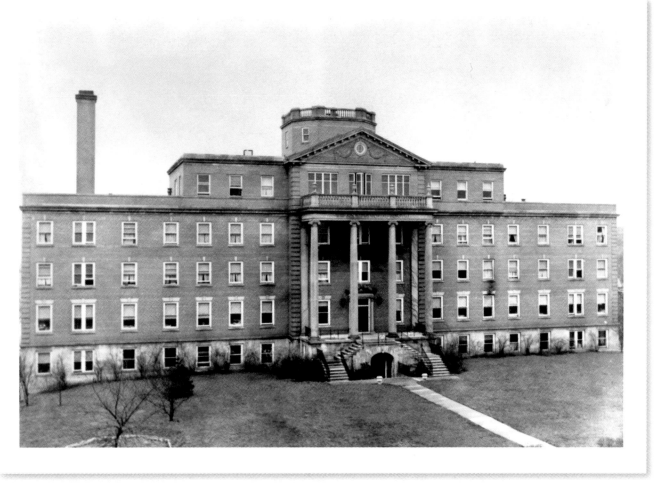

Booth Hospital, 1926. Courtesy of the St. Elizabeth Healthcare Collection, Kenton County Public Library, Covington.

As promised, the people of Covington raised $100,000 to help convert the former mansion into a hospital. Donors included the Masons, African American churches, ladies' societies, and many private individuals. The new hospital boasted two features that would always be connected with Booth Hospital, a large maternity ward and a nationally recognized nursing school.

The need for Booth Hospital was apparent from the moment it opened. Hundreds sought relief within its walls. In 1920 more than 100 babies were born in the maternity ward, and some 137 surgeries were performed in the hospital's operating room. Soon it also became obvious that the little hospital in the big mansion needed to expand. A limited number of beds and the growing needs of the community were sending patients to other hospitals, especially those across the river in Cincinnati.

In October 1926 a new Booth Hospital opened with 100 beds, two surgery rooms, an emergency room, and even a special clock in the maternity ward for accurately recording the birth times of babies. For a few years, Booth Hospital thrived, but as the nation's economy soured in the first years of the Great Depression, the hospital began to run a deficit. In June 1932 it announced the closing of its nursing school until the economy improved. Things only got worse. With the rest of America, Covington and the surrounding communities also suffered. More people, who could not pay, turned to the hospital for even the most basic of services.

On September 1, 1932, Booth Hospital discharged its last patient and closed its doors, promising to reopen when things got better. It took five years, but Booth reopened to a grateful community on January 1, 1937. Despite the celebration of the hospital's reopening, they could not have picked a more unfortunate time to open. On the very month that the hospital reopened, the worst disaster in Northern Kentucky history took place.

Floodwaters in January 1937 reached a record 79.99 feet, causing incredible damage to Northern Kentucky, Cincinnati, and anywhere else in its unforgiving path. Thousands were left homeless, and most citizens endured weeks without heat, electricity, or reliable water. When the water receded, businesses and buildings were damaged, many beyond repair. Individuals who survived the flood often found that they had lost everything. The newly reopened Booth Hospital was badly damaged. During the height of the flood, 50 people had taken refuge there, despite the fact that there was no heat or electricity. The building sustained more than $25,000 worth of damage, a considerable sum in 1937. The supporters of the hospital kicked off a campaign in May to fix the hospital and to return it to full service. By the end of the year, the hospital was back open and running at full capacity.

Booth Hospital continued to operate in Covington until 1979, when a new Booth Hospital was opened in Florence, Kentucky. The old Booth Hospital in Covington closed its doors after 65 years of service. In 1989, Booth Hospital Florence was sold to St. Luke Hospital, ending a 75-year relationship with the Salvation Army.

Meanwhile, St. Elizabeth Hospital opened a south unit in Edgewood, Kentucky, in 1978, and the Covington location became known as St. Elizabeth North. With continued suburban development in Northern Kentucky, St. Elizabeth expanded its Edgewood unit in the 1980s and 1990s, relocating various departments there. In 1980, the north unit opened St. Elizabeth Hospice, which subsequently moved to a new building in Edgewood in 2006. By 2004 St. Elizabeth officials announced plans to move most of its inpatient beds at Covington to Edgewood. However, hospital officials remained committed to maintaining a facility in Covington. In August 2009 St. Elizabeth opened a brand-new $29.2 million facility along I-75/I-71 in Covington. Called St. E. Covington, the three-story acute-care facility features an

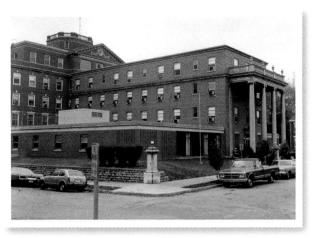

Booth Hospital. Photo by Raymond E. Hadorn, in the collection of Paul A. Tenkotte.

WM. BOOTH MEMORIAL HOSPITAL

Rates effective December 1, 1948

Six bed Wards	$6.50 per day
Four bed Wards	7.00 per day
Two bed rooms	8.25 per day
Private rooms	9.50 and
		11.00 per day

Maternity Rates

Room rates same as above. There is an additional charge of $22.50 for routine delivery service, $1.25 per day for the care of the baby and a $2.00 charge for circumcision.

Tonsillectomy Rates

Room rates same as above. There will be a flat charge of $10.00 for operating room and routine laboratory fees. There will be an extra charge for medications.

Booth Hospital, 1948 rates for services. Courtesy of the St. Elizabeth Healthcare Collection, Kenton County Public Library, Covington.

emergency room; offices for physicians and surgeons; a women's wellness center; and diagnostic/imaging, dialysis, and physical therapy services. The following year, in 2010, St. E. Covington opened the Cincinnati metropolitan area's largest diabetes center. Meanwhile, the old, sprawling 20th Street hospital was sold, and, since December 2009, has served as home to Providence Pavilion, a nursing home and rehabilitation center. By 2014 Providence Pavilion's renovated facility featured rooms for 82 residents; a cafeteria; a chapel; a beauty salon; and physical, occupational, and speech therapy services.

In addition to Providence Pavilion, Covington is also home to other nursing and retirement homes. Kenton county residents passed a 0.3% payroll tax in 1988 to fund a new building for Rosedale Manor in Covington's Latonia neighborhood. Formerly known as the Kenton County Infirmary, Rosedale Manor Nursing Home built

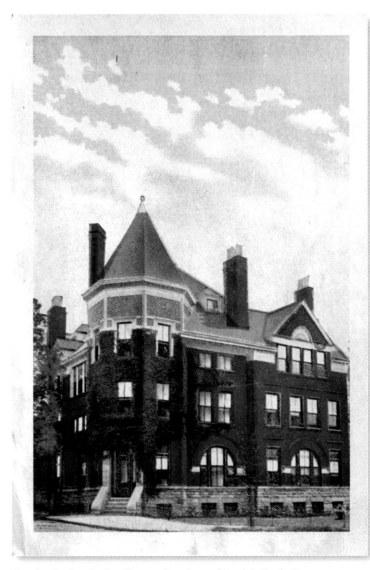

The Covington Ladies Home. Courtesy of Paul A. Tenkotte.

a new $10 million state-of-the-art facility on the same site, completed in 1992. Sold by the county in 2008 to the nonprofit Kenton Housing Inc., Rosedale Green operates today as a skilled nursing facility with both long- and short-term care.

The St. Charles Community operates at 600 Farrell Drive, off Kyles Lane in Covington. Opened in 1961 as the St. Charles Nursing Home, St. Charles Community currently operates a personal care home (St. Charles Homestead); independent living apartments (The Lodge); independent living cottages (The Village at St. Charles); adult day services (Charlie's Club); home care; and outpatient physical, occupational, and physical therapy services.

The Covington Ladies Home, founded in 1886, is located at Seventh and Garrard Streets. Its genteel Victorian building houses women in private rooms at a reasonable monthly rate. Short-term respite care is also available. This nonprofit, historic facility, overseen by a dedicated board, offers engaging activities for its residents and nutritious meals prepared on-site.

Baptist Towers, on Highland Avenue in Covington's Peaselburg neighborhood, offers independent living as well as personal care. Originally operated as Ridgeview Nursing Home by the city of Covington, the facility was hampered by financial, legal, and other problems. Eventually, the nonprofit Baptist Life Communities purchased the property, transforming it into a well-operated retirement community.

Covington has many other retirement communities, including the nonprofit Panorama Apartments (two towers, the first of which opened in 1967), the 16-story Golden Tower (operated by the Housing Authority of Covington), and Academy Flats (also operated by the Housing Authority of Covington). Other privately owned facilities offer retirement housing as well, including St. Aloysius Apartments and La Salette Gardens.

For decades, low-income residents and those lacking health insurance have relied upon the dedicated staff of the nonprofit HealthPoint Family Care of Northern Kentucky for medical and dental services. Founded in 1971 as the Covington Family Health Care Center, its first medical director was Dr. Robert Longshore, and its first dental director was Dr. Howard Hall. Expanding into other cities and counties of Northern Kentucky, the organization changed its name, first to Northern Kentucky Family Health Centers Inc. and later to HealthPoint Family Care. As of 2014, HealthPoint operates three facilities in Covington: 1401 Madison Avenue, 4307 Winston Avenue, and a special clinic for the homeless at 343 Pike Street. In addition to HealthPoint, the Northern Kentucky Independent District Health Department provides screenings, immunizations, and other services at its locations throughout the region, including the Kenton County Health Center at 2002 Madison Avenue in Covington.

While today we are able to fight disease with modern medicines, Covington and the Northern Kentucky region are facing a horrific, modern-day epidemic in heroin addiction. All across Northern Kentucky, heroin-related deaths are rising rapidly. Heroin is a highly addictive drug, and it is easy to purchase. Aside from its

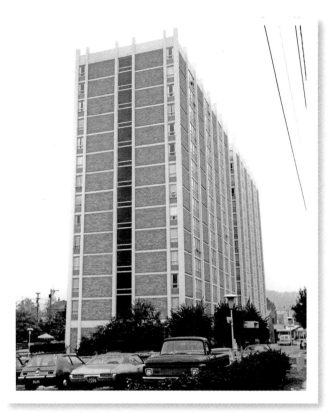
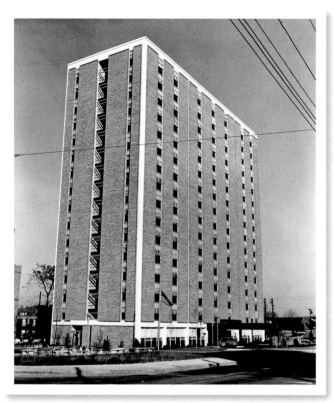

ABOVE LEFT: Panorama Apartments. Photo by Raymond E. Hadorn, in the collection of Paul A. Tenkotte. ABOVE RIGHT: Golden Tower. Photo by Raymond E. Hadorn, in the collection of Paul A. Tenkotte.

addictive nature, it poses a major health risk to the region. Used needles, which have not been properly disposed of, put others at risk of diseases such as hepatitis B and C and human immunodeficiency virus (HIV). In addition, heroin addiction sometimes leads to a rise in crime and prostitution as a means to fuel addiction. Many Northern Kentucky cities, including Covington, have held town hall meetings in order to discuss and create plans to combat the prevalence of the drug. Several treatment centers have been established in the region, including the Northern Kentucky Med Clinic in Covington, which opened in 2013. In early 2014, St. Elizabeth Hospital also announced it would be creating a treatment facility to benefit the entire region. Many groups are also advocating for state legislation to help in the fight against this new epidemic plaguing our community.

In its 200-year history, Covington has witnessed a revolution in medicine, quite literally from leeches to lasers. While many older cities nationwide are experiencing the closure of hospitals and medical facilities, Covington is home to St. E. Covington, state-of-the-art physicians' offices, Providence Pavilion, Rosedale Green, the Northern Kentucky Psychiatric Hospital, and many retirement and personal care facilities.

Milestones and Memories

Dr. Alvin C. Poweleit was a beloved doctor in Covington, known as Pepa to his friends and patients. He was an American hero, serving in the Philippines in World War II, where he was honored for his bravery for saving men trapped in a submerged troop carrier, and was a survivor of the Bataan Death March. He spent three years in Japanese POW camps, serving the medical needs of his fellow prisoners. He saved countless lives. During the war he sustained a back injury that forced him to give up doing surgery. He then enrolled at Harvard University, obtained a degree specializing in eye, ear, and throat medicine, and began a practice of that specialty in Covington lasting nearly 50 years. His trademark bow tie, crowded offices where treatment was always given and an appointment time meant nothing, and generations of grateful patients were to follow. The author of several books on his experiences and the history of the medical profession in Northern Kentucky,

Poweleit also kept his vow that if he survived the war, he would treat all veterans for free. Arguably the era's best known and most beloved physician, Alvin Poweleit, who had survived so many deprivations and hardships during the war, died in 1997 of neck injuries sustained when his taxi was involved in an accident, just one block from his home. In 2002, the Kentucky legislature approved the naming of the I-275 bridge crossing the Licking River between Campbell and Kenton Counties as the Dr. Alvin C. Poweleit Memorial Bridge.

- One of Covington's longest-serving physicians was Dr. John Redden, who practiced in the city from 1956 until 2013, a few months after he turned age 90. Growing up in New Albany, Indiana, he attended the medical school of the University of Louisville in Kentucky. Of his days in Covington, he was quoted in the *Kentucky Enquirer* of July 8, 2013, as saying, "I don't think I've had a bad day here."
- There were so many doctors' offices on Scott Boulevard (formerly called Scott Street) that the people of Covington referred to the street as Doctor's Row.
- Jeff Davis, "King of the Hoboes," a popular cultural hero of the 1920s, helped to raise money for Booth Hospital.
- The Covington Health Department once ran a "penny clinic" in local schools. A coin box was placed in each school classroom where kids would drop in pennies. Doctors, including Clifford Heisel, from the health department would stop at the schools to check the children's tonsils and to collect money for the health department.
- The Opportunity School opened in 1950 in Covington for the special needs of children with handicapping disabilities living in Northern Kentucky. It was the first of its kind in Kentucky.
- John L. Phythian Jr. was the first president of the Campbell-Kenton Medical Society in 1904. His father, John L. Phythian, was dismissed as a surgeon from the Newport Barracks during the Civil War for being a Confederate sympathizer.

ABOVE LEFT: Dr. Alvin C. Poweleit. Source: Poweleit, Alvin C., and James C. Claypool. *Kentucky's Patriot Doctor: The Life and Times of Alvin C. Poweleit.* Fort Mitchell, KY: T. I. Hayes Publishing, 1996. ABOVE RIGHT: Dr. James Averdick (1852–1931) was one of Covington's most well-known and well-beloved physicians and civic leaders. Averdick served as a Kentucky state representative, as Kenton County coroner, and as a member of the Kenton County Board of Health. For nearly 50 years, he served on the Covington School Board, helping to oversee its transition to one of the finest public school systems in the state. Courtesy of Michael R. Averdick.

- The cholera epidemic that Covington and most of the Cincinnati region suffered in 1848–49 was caused by soldiers coming home from the Mexican War (1846–48). They arrived by riverboat and took the Miami and Erie Canal on their way back to New York City, spreading the disease everywhere they traveled.
- Dr. S. J. Watkins from Alabama is considered the first African American physician in Covington. He practiced both dentistry and medicine from 1891 to 1946.
- Jacob Crittenden from Covington was the first African American student to attend the medical school of the University of Kentucky. He was a junior in 1970.
- Dr. Julia Thorpe was the first female doctor in Covington, starting her practice in 1879.

Dr. Randolph, seen here in 1979 treating one of the many patients he saw in his Covington office over his 59-year career. He treated about 3,000 patients annually. Courtesy of the Kenton County Public Library, Covington.

SELECTED BIBLIOGRAPHY

Drake, Daniel. "A Sketch of the Life and Character of Dr. Thomas Hinde." *The Western Journal of the Medical and Physical Sciences* 2 (12) (1829): 625–34.

Hackett, Brian L. *For the Centuries: St. Elizabeth Healthcare and Northern Kentucky, 1861–2011.* Edgewood, KY: St. Elizabeth Healthcare, 2011.

Northern Kentucky Newspaper Index. Kenton County Public Library, Covington, KY.

Poweleit, Alvin C. *History of Medicine in Campbell-Kenton Counties, Kentucky.* Campbell-Kenton Medical Society, 1970.

———. *Medical History of Northern Kentucky.* Northern Kentucky Medical Society, 1991.

Poweleit, Alvin C., and James C. Claypool. *Kentucky's Patriot Doctor: The Life and Times of Alvin C. Poweleit.* Fort Mitchell, KY: T. I. Hayes Publishing, 1996.

Reis, Jim. "Smallpox Terror: Life in the Late 1900s Marked by Fear of a Rampaging Killer." *Kentucky Post,* 15 Aug. 1983.

Sartwell, Melinda. "Pioneers of Progress: The Southgate Family in Northern Kentucky." Part 1. *Northern Kentucky Heritage* 19 (2) (2012): 3–9.

———. "Pioneers of Progress: The Southgate Family's Next Generation." Part 2. *Northern Kentucky Heritage* 20 (1) (2012): 28–36.

Tenkotte, Paul A., and James C. Claypool, eds. *The Encyclopedia of Northern Kentucky.* Lexington, KY: University Press of Kentucky, 2009.

CHAPTER

12

FROM RAGTIME TO RADIO: MUSIC AND ENTERTAINMENT IN COVINGTON

by John Schlipp, Karl J. Lietzenmayer, and Nathan McGee

EARLY ENTERTAINMENTS

Nineteenth-century residents of Covington, Kentucky, did not have to travel far for entertainment, as many venues were within walking distance. Early on, there were frequent visits from genuine big-top circuses, tent shows, fairs, showboats, and Sunday open-air prize fights. The pugilist events were technically illegal and were a constant concern for law enforcement officials. However, the promoters usually found a way to avoid the authorities, and these popular prize fights were held either where scheduled, or elsewhere, if discovered.

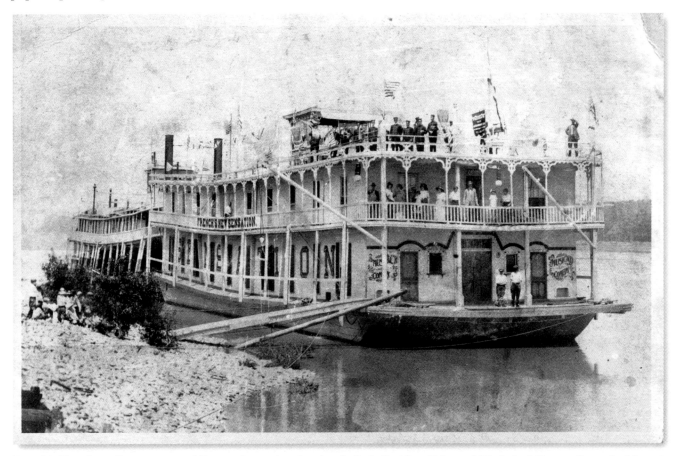

French's New Sensation was one of the most popular showboats that plied the Ohio and Mississippi River valleys, docking at towns all along the way. The tall young man standing on the bottom deck is Claude Hursong (1893–1965), who worked on the boat. Courtesy of Mrs. Robert Cullen (Claude Hursong's daughter).

When the Marquis de Lafayette returned to the United States in 1824 to bid final farewell to his officers, he traveled through Covington on his way from Louisville and Lexington, Kentucky, following the Covington and Lexington Turnpike (US 25). He was accompanied by an entourage, including a young Joseph Tosso (1803–87). Tosso, born in Mexico, resided in Louisville at the time and was part of a company of an honor guard on white steeds assembled at Louisville to march beside the marquis. A child prodigy, Tosso was the finest violinist of his day. It is not certain that he brought his violin to play for Lafayette at the reception held in Cincinnati. Nonetheless, by 1827, Tosso had moved to Cincinnati to teach and conduct music. He resided locally at his Rose Cottage in Latonia Springs, Kentucky, on the Banklick Turnpike (KY 17). He wrote and often played his most famous composition, "Arkansas Traveler," which subsequently became a popular political campaign song. In his old age, he moved to 25 Powell Street (now 15th Street) in Covington.

Joseph Tosso, circa 1880s. Courtesy of Cincinnati Museum Center–Cincinnati History Library and Archives.

ODD FELLOWS HALL

By the 1840s and 1850s, Covington had several large halls for meetings and entertainment. Cooper's Hall, on the northwest corner of Sixth Street and Madison Avenue, was the city's first large meeting space. By the late 1850s, it included a gymnasium, and by the 1870s was the center of temperance meetings opposing the use of alcohol. About 1850, Joseph Keene, a contractor and bricklayer, built the Magnolia Building on the corner of Cooper Street (now Pike Street) and Madison Avenue. Its Magnolia Hall was even larger than Cooper's Hall. For a couple of winter seasons, a Covington-based theatrical company held plays at the Magnolia. Some of the young actors involved later pursued careers in the entertainment industry, including R. E. J. Miles, who became manager and lessee of Robinson's Opera House in Cincinnati. Later, the Magnolia Building became known as the Planters House, and, by the 1870s, it had been renovated into ground-floor shops and upper-floor offices.

The Magnolia Building (highlighted in yellow) stood on the southeast corner of Cooper Street (now Pike Street) and Madison Avenue, as depicted on this 1886 Sanborn Fire Insurance Company map. Courtesy of the Kenton County Public Library, Covington.

By far, the best-known meeting space in Covington was the Odd Fellows (the Independent Order of Odd Fellows, or IOOF) Hall at the northeast corner of Fifth Street and Madison Avenue. Built in 1857, the Odd Fellows Hall hosted many traveling events on its spacious second floor. The hall, a space of 86 feet by 54 feet, unobstructed by any support posts, became the center of civic events in the city for decades. For example, a December 1876 advertisement promoted a local theatrical production at the Odd Fellows Hall. On Mondays, Thursdays, and Saturdays each week, the *Novelty Theatre* presented "pleasing specialties, sparkling minstrelsy, songs, dances, and beautiful dramas" by specialty artists and a full dramatic company. Balls and banquets used the IOOF hall frequently, such as the military ball in honor of Valentine's Day in 1861, which was said to be the "grand social event of the season."

Also that year, the famous George Christy Minstrels performed at the hall, as did a most unusual event, "Tom, the Little Blind Negro Pianist," who was scheduled for three days of concerts. Tom, who was a slave owned by James

Bethune of Columbus, Georgia, had no formal musical training; however, he could reproduce any tune he heard on the piano, eventually developing a repertoire of some 5,000 songs. However, this gift was accompanied by many other deficiencies, which prompt modern-day psychologists to suspect that he was a savant. After hearing of the firing on Fort Sumter that same week, Bethune left with Tom in great haste for the South, canceling part of the presentations.

Nineteenth-century Covington residents enjoyed the entertainment provided by traveling troupes, itinerant acting groups who visited cities throughout the region. William Shakespeare's plays were especially popular with American audiences. One of the greatest of American Shakespearean actors was Edwin Forrest (1806–72). Born and raised in Philadelphia, Forrest joined a traveling troupe that, after performing in Lebanon, Ohio, broke up. Only 17 years old at the time, Edwin Forrest walked all the way to Newport, Kentucky, where he knew Rachel Riddle, of the Riddle acting family. While in this area, he often climbed the hills west of Covington, practicing his acting. With the help of the Riddles, and of James Taylor III, Forrest's career was launched in the right direction. He soon became a celebrity in the United States and Europe. In 1839, fondly remembering his early struggling days in Covington, he purchased land from Israel Ludlow and built an 11-room house called Forrest Hill at what is today 309 Wright Street in Covington. Whenever he played to crowds in Cincinnati, he stayed at Forrest Hill. Edwin Forrest ranks among the greatest actors of the 19th-century American stage.

Edwin Forrest. Courtesy of Paul A. Tenkotte.

During Edwin Forrest's traveling road shows, he appeared onstage with an actress born in Covington named Blanche Chapman (1851–1941). She was a descendent of two well-known acting families, the Chapmans and the Drakes, who performed at English and American theaters from 1705 to 1944. Chapman could sing, dance, and play dramatic roles. She partnered with her sister, Ella; they were billed as the "Talented, Bewitching, and Beautiful" Chapman Sisters. Blanche's stage popularity peaked during the 1860s and 1870s when she also appeared on the same stage with famous actors of the 19th century, such as Edwin Booth, Joseph Jefferson, and John McCulloch. Chapman played the part onstage of Mrs. Wiggs in *Mrs. Wiggs of the Cabbage Patch* in 1903, based upon books by Louisville author Alice Hegan Rice. Rice was influential in acquiring Chapman to repeat her Mrs. Wiggs role in the first 1914 silent film adaptation of the same. Blanche Chapman married Harry Clay Ford in 1874, the manager of the Ford Theatre, where President Lincoln was assassinated in 1865. The famous rocking chair where Lincoln sat when he was shot was the personal property of Chapman's husband. He had placed it in the theater box for Lincoln's comfort. After Lincoln's death, the Ford Theatre was closed and its contents were held by the War Department as evidence during the trial of the assassination conspirators; the rocking chair was later stored at the Smithsonian Institution. In 1929 the famous rocker was returned to Blanche as heir and widow of its original owner. Ultimately, the rocking chair was purchased by Henry T. Ford and placed on display at the Henry Ford Museum in Dearborn, Michigan.

The Chapman Sisters, circa 1870. Source: The Library of Congress.

Renowned Covington thespian Frederick Henry Koch (1877–1944) was born in Covington but spent part of his youth in Cincinnati. The family eventually moved

to Peoria, Illinois, where he graduated from high school. Koch attended Caterals Methodist College in Cincinnati, traveling to small nearby towns and performing Shakespearean comedies. He eventually finished his college degree at Ohio Wesleyan with a bachelor of arts degree in 1900. Koch advanced his scholarship by graduating from Harvard in 1909 with a master of arts degree in literature. Commonly known as the "father of American folk drama," he taught dramatic art as a university professor, first at the University of North Dakota (1905–18) and last at the University of North Carolina at Chapel Hill (1918–44). Koch devised the term *folk play* based on the German word *volk* ("common people") as applied to folk subject matter that is realistic and human, as well as often imaginative and poetic. He established the noted Carolina Playmakers at the University of North Carolina at Chapel Hill.

With the arrival of large numbers of Irish and Germans came new festivals and entertainments. The Germans had their *volksfests* ("people's festivals") and *schützenfests* ("shooting festivals") as well as their popular Germania Society. The Irish celebrated St. Patrick's Day with parades

Cover of a souvenir booklet celebrating the 28th Annual Schützenfest of Covington. Source: *28th Annual Crowning Fest of The Deutsche Schuetzen-Gesellschaft of Covington, Ky.* Cincinnati: Hennegan & Co., 1910.

and established the Hibernians. Each group had its favorite neighborhood saloons, where entertainment was sometimes provided and, at other times, extemporaneous.

With the large German immigrant population in Covington and Northern Kentucky in general, the establishment of social groups such as the Turners (*Turnverein*) emphasized physical fitness. The local chapter of this national organization still operates at Pike and Main Streets. During the Civil War, they formed a regiment for the Union and were noted for their bravery and fitness.

SINGING SOCIETIES

Germans were also fond of choral singing, and by the early 20th century, several all-male singing societies (*Sängerbünde*) were meeting. The local groups in Northern Kentucky and Cincinnati were part of a national organization, formed in 1848, known as the *Nordamerikanischen Sängerbündes* ("North American Singing Societies"), based in Chicago. Initially, these groups began with a union between singing societies in Greater Cincinnati, Louisville, and Madison, Indiana, and held their first *Sängerfest* ("singing festival") in Cincinnati in June 1849. By 1867 the festival held at Cincinnati attracted almost 2,000 singers. A building was erected just for these festivals, Sängerfest Hall, 110 feet by 250 feet (on the site of the present Cincinnati Music Hall). *Sängerbünde* included the Turners in many of their festivals. These groups performed some classical music; however, their repertoire consisted mostly of secular music and drinking songs.

Covington's own Edward Strubel (1875–1964), a German immigrant who was organist since 1895 at Mother of God Church on West Sixth Street, directed several of the *Sängerbünde*. The highlight of Strubel's career directing *Männerchöre* ("men's choirs") occurred in 1924. To celebrate their diamond jubilee, the Nordamerikanischen Sängerbündes conducted a national contest for the best composition of an original American folk song. The lyrics were required to be from an American poet and a prize of $500 was offered, a sizable sum for 1924. Strubel chose a poem by James Whitcomb Riley called "When Evening Shadows Fall." He wrote a melody for the poem and won the prize. He was invited to direct his work at the 35th national assembly scheduled for June, where he conducted

it before 4,000 singers in Chicago. Strubel also formed the Mendelssohn Singing Society in 1909, an all-male chorus that centered on classical repertoire. Unlike the *Männerchöre,* the Mendelssohn Singing Society frequently combined with chamber players and guest instrumentalists. For example, a December 1910 performance featured a "promising young violinist," Adolph H. Borjes, along with the chorus and soloists. In 1911 a nationally recognized pianist, Clarence Adler, shared the stage with the chorus. The concerts were usually held at the Carnegie Library or Holmes High School auditoriums in Covington. If newspaper accounts of their performances can be believed, the Mendelssohn Society was highly regarded professionally. The group even had its own headquarters at Rowekamp's Hall, at 16th and Greenup Streets in Covington. It was short-lived, however, disbanding after the directorship passed briefly to Professor Sylvester Eifert (1880–1955), local organist at St. Aloysius Church at Seventh and Bakewell Streets.

The Mendelssohn Singing Society was resurrected in February 1932, at a meeting held at the Covington YMCA, with many of its old members in support. Daniel Fries Sr., a Covington steel manufacturer, called the group back into operation and became the president. Their first concerts were held at the Covington YMCA, Carnegie Library auditorium, or Holmes High auditorium. By 1934 Fritz Bruch (died 1956) was appointed director. He was a cellist in the Cincinnati Symphony Orchestra and conductor of the newly formed amateur Northern Kentucky Symphony.

In 1980 Dr. John Westland, who was a music professor at Northern Kentucky University, formed the Northern Kentucky Community Chorus, which gives two or three concerts each year at various venues in the region. Westland retired as director in 2012, and the chorus carries on in the capable hands of Stephanie Nash. Nash has been music director at Lakeside (Kentucky) Presbyterian Church since 2005.

PICNIC GROUNDS AND AMUSEMENT PARKS

Residents of Covington reportedly had great fun attending the growing number of area amusement parks. In 1852 the earliest Northern Kentucky park was Cole's Gardens (also known as Licking Gardens), situated near present Meinken Ball Field in Latonia, Kentucky. John Cole owned the facility, which seemed to have been mostly for picnicking and relaxing away from city pollution and not actually an amusement park, at least by today's standards. Regular steamboats took patrons from Cincinnati Public Landing to the grounds, which consisted of a house and gardens. Soon a Pittsburgh transplant, J. L. White, leased the grounds from Cole. White made "thorough renovations" according to the *Covington Journal,* and reopened it on May 1, 1852. Within two years, it was leased by an R. J. Turner, who renamed it Ingleside. During the Civil War years, the area was used to bivouac Union troops, and all traces of the picnic grounds vanished.

In the late 19th century, many Covingtonians took the streetcar to Chester Park on Spring Grove Avenue in Cincinnati, where amusement rides were the main attraction along with picnics. The finest amusement park in Northern Kentucky was located in Ludlow. The 85-acre Lagoon Amusement Park was created by damming Pleasant Run Creek to create a lake for boating. In addition to popular amusement park rides, it boasted the largest dining and dance hall west of New York City. Streetcar lines from Covington were extended to reach the park, and extra cars were needed during the summer season. The park opened in 1895 and was periodically improved until it closed in 1918 at the onset of Prohibition.

The most popular still-extant amusement is Cincinnati's Coney Island, situated upstream on the north bank of the Ohio River. Before the automobile, Northern Kentuckians were transported by several successive river steamboats, called the *Island Queen,* which docked at the Cincinnati Public Landing. Each summer, Coney Island held citywide promotions like "Covington Day at Coney," bringing out large numbers of the town who filled up the

Island Queen. The last steamer burned in 1947, but the wider ownership of automobiles after World War II had already become the preferred way to reach the park. Today, residents of Covington also drive to nearby Mason, Ohio, to experience the rides, food, and games at Kings Island.

With the development of Devou Park, picnics, outings, and tennis were popular amusements. The park was improved with the building of a 9-hole golf course in 1922 (later expanded to 18). By 1910 a wooden band shell was constructed in the natural bowl-shaped depression near the center of the park, and band concerts were occasionally held there. By 1935 summer concerts were weekly events, with Ruth Best (1900–78) as the usual mistress of ceremonies. These concerts were vaudevillian in style, including not only music, singers, and orchestras but also acrobats and comedy acts. Best was an accomplished singer and occasionally was listed as part of the entertainment as well as being emcee, usually appearing wearing rather decorative hats. A new, larger concrete band shell (still extant) was constructed in 1939 with Works Progress Administration funds, and the summer concerts with Ruth Best became a fixture into the early 1950s. These popular events attracted crowds of 20,000

at times and occasionally 30,000 or more. During the years of illegal gambling, Best would sometimes engage acts appearing at the better nightclubs to perform at the Devou Park Band Shell. Though the popularity of the Devou concerts faded in the 1950s with the advent of air-conditioned movie theaters, summer concerts in the park have resumed on an irregular basis, sometimes hosted by the Kentucky Symphony Orchestra (KSO). For example, during the World Choir Games in the summer of 2012, the KSO Symphony and Chorus combined with a group from the Ukraine to present a Devou concert during what turned out to be a very hot week.

Devou Park Bowl Concert, August 16, 1939. Courtesy of the Kenton County Public Library, Covington, and Northern Kentucky Views.

MOVIE THEATERS

After the IOOF sold their Odd Fellows Hall in 1923, entertainment continued to be housed in the building when the New Covington Theater opened, offering silent movies and vaudeville acts. The New Covington was home to its own theater troupe called the Fremont Stock Company. Before closing the upper floors in the 1970s, the final use of the Odd Fellows Hall's ballroom was as a roller-skating rink. In the 21st century, the building has been completely renovated and once again hosts balls and receptions.

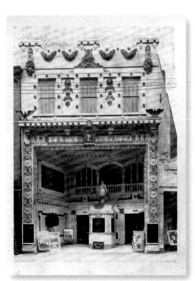

With the development of motion pictures, several theaters quickly made alterations to provide screens to project the new medium. Particularly in silent film days, live entertainment often augmented the usually short films, which were accompanied with music from piano, pipe organ, and occasionally even small orchestras.

Covington played a major role in the early movie industry. At the turn of the 20th century, Marcus Loew was visiting his penny arcade on Fountain Square, Cincinnati, one of many he owned in various cities. A carpenter working for Loew told him that he should see a new moving picture show in Covington. In 1904 a Covington house painter named Frank E. Lanius purchased a projector and the film *The Great Train Robbery*. Early the following year, he opened the

One of Covington's early theaters was the Casino on Pike Street near Madison Avenue. Source: *You'll Like Covington: Covington, Kentucky, Seen through the Camera.* Covington, KY: Industrial Club of Covington, Kentucky, [1912?].

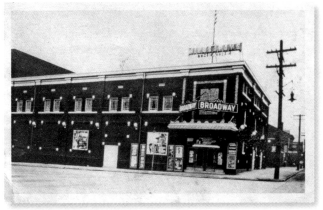

LEFT: The lobby of the Liberty Theater, Madison Avenue, featured a scale model of the Statue of Liberty. Courtesy of the Kenton County Public Library, Covington. TOP: The Hippodrome Theater, West Seventh and Washington Streets, was built circa 1912. After suffering a fire in 1917, it was rebuilt. In 1930 it was renamed the Broadway Theater. Courtesy of the Kenton County Public Library, Covington. ABOVE: The Madison Theater under renovation, 1989. Courtesy of the Kenton County Public Library, Covington.

first movie theater in Covington, located on the north side of Pike Street, west of Craig Street. Lanius charged 5¢ and showed the film on a hanging bed sheet. Marcus Loew visited Lanius and was impressed. Loew soon opened similar theaters and eventually purchased several failing movie studios to form MGM (Metro-Goldwyn-Mayer), which ultimately became one of Hollywood's major motion picture studios.

By World War I, movie theaters had proliferated in almost every neighborhood in the nation and gained increasing popularity with the advent of talkies after 1927. During this golden era, there were at least 30 movie houses of some type in Covington. Some were short-lived, but the memorable ones were the 700-seat Broadway Theater at Seventh and Washington Streets (closed in the 1950s); the 1,500-seat Liberty Theater (608 Madison Avenue; closed in the 1970s); and the 1,350-seat Madison Theater (728 Madison Avenue). The Madison closed as a movie theater in 1977. It underwent a $3 million restoration in 2001 and reopened as a live venue theater. Latonia also had several theaters, the best remembered being the 800-seat Kentucky, near Ritte's Corner.

WOMEN

By the start of the 20th century in Covington and Cincinnati, a new social and cultural seed had been planted. Women were gaining acceptance in certain community and professional roles. Henry James's novella *Daisy Miller* (1878) and other novels cultivated this acceptance and coined the term the *New Woman*. Yet career opportunities

for women were still restricted. Even so, in addition to teaching and nursing, talented women increasingly became prominent authors, visual artists, and leading singers and actresses. Some attained national recognition.

Anna Bell Ward (1897–1986), born in Covington, graduated from the College of Music at the University of Cincinnati. Already as a child, she was an accomplished singer in the Cincinnati region. As a young adult, she was nationally recognized as an assistant manager for a Central Kentucky movie theater chain in the 1920s and 1930s. She also authored short stories. Perhaps her most lasting legacy was as an actress, a costume designer, and an associate producer in a series of *Range Busters* western films during the early 1940s.

Other Covington women from this same era achieved acclaim, including opera singer Clara B. Loring (1896–unknown), songstress Elizabeth Parks (1888–1925), and songstress Katherine Hall Pook (1886–1948). Actress Patia Power (1882–1959) taught drama classes in the region and was the mother of famous Hollywood actor Tyrone Power.

SYMPHONY ORCHESTRA

The Northern Kentucky Symphony Orchestra existed as a volunteer community orchestra, performing from 1934 through 1955. This group rehearsed and performed at the Covington YMCA as well as at Covington's Carnegie Library auditorium (now Carnegie Visual & Performing Arts Center). The music director through all that time was Fritz Bruch. The April 1940 concert featured Mozart's *Symphony in G Minor* and Beethoven's *Egmont Overture*, along with two pieces written by Bruch himself, "Fantasy" and "December Serenade." The concert was part of the centennial celebration of Kenton County's establishment. After the retirement of Fritz Bruch, the Northern Kentucky Symphony dissolved.

In 1986 a group of local musicians reestablished the orchestra as the Music Society of Northern Kentucky, based at the Carnegie Center. The organization offered chamber music and ensembles, later augmented to form a full orchestra. Their director was Jack Kirstein (1921–96). Kirstein was also a cellist with the Cincinnati Symphony and a former member of the LaSalle Quartet. In 1990 after Mr. Kirstein became ill and retired, several conductors led the Music Society briefly before it dissolved in 1991.

James R. Cassidy, a fresh College Conservatory of Music (University of Cincinnati) graduate, offered to form an orchestra, and the Music Society was re-formed as the Northern Kentucky Symphony Inc., later changed to the Kentucky Symphony Orchestra. After auditioning 80 musicians, Cassidy took the Greaves Hall stage on the campus of Northern Kentucky University on November 21, 1992, with an all-Russian program. One of Cincinnati's most versatile pianists, Michael Chertock, was soloist for Rachmaninoff's *Rhapsody on a Theme of Paganini*. The orchestra's 1992–93 season included 14 paid principal chair players. Chertock was again the guest artist at the 10th anniversary concert in 2002. Today the KSO boasts a professional orchestra with 50 paid players and a number of talented charter musicians. Throughout the course of a year, the KSO and subsidiary ensembles present approximately 40 concerts.

CHURCH MUSICIANS

Some outstanding Covington church musicians contributed fine music enjoyed by regional audiences beyond the scope of their congregations alone. They included Bernard H. F. Hellebusch (1825–85). Arriving in Covington by flatboat in 1844, German-born Hellebusch became a teacher at Covington's Mother of God School. As organist at Mother of God Church, he oversaw installation of the parish's mammoth Koenhken and Grimm organ. Hellebusch is most famous for his German American hymnal *Gesang und Gebet Buch* (*Song and Prayer Book*), first published in 1858 and reprinted many times. In it, he popularized such German church hymns as "Grosser Gott" ("Holy God, We Praise Thy Name"), "O Haupt Voll Blut und Wunden" ("O Sacred Head Surrounded"), and the Christmas classic "Ihr Kindlein Kommet" ("O Come Little Children"). He lived at the southeast corner of Fifth and Russell Streets in Covington.

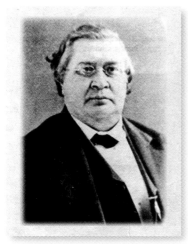

Bernard H. F. Hellebusch. Source: Hellebusch, Julianna Mattei. "B. H. F. 'Teacher' Hellebusch (1825–1885)." *Northern Kentucky Heritage* 1 (2) (1994): 14.

In 1938 Leo Grote (1902–80) formed the outstanding Choral Club stationed at Mother of God Church, Covington. The Choral Club performed sacred concerts in the school auditorium, some of which were broadcast over WZIP radio, Covington. During Holy Week of Lent, tableaus (actors formed "in place" on stage) re-created Jesus Christ's Passion, enhancing presentations like Theodore DuBois's *Seven Last Words of Christ*. The group expanded with on-location concerts, directed by Grote's successor, Karl Lietzenmayer, beginning in 1965. Mother of God's Choral Club traveled to such cities as Buffalo, New York, and Washington, D.C., as well as many Northern Kentucky churches and other venues.

The Mother of God Church Choral Club, 1948. Courtesy of the Kenton County Public Library, Covington.

Robert Schaffer (1921–2014), organist at the Cathedral Basilica of the Assumption for 60 years starting in 1949, founded the Cathedral Concert Series in the early 1980s and was music professor at Thomas More College as well as organist for the Cincinnati Symphony. A trombonist and organist, he studied under Parvin Titus at the College Conservatory of Music (University of Cincinnati), where he met his musically talented wife, Rita Avram. Robert and Rita resided in Park Hills, Kentucky, with their three children, who all became accomplished musicians and played as a family at many public functions: Robert on trombone and his children Mark on keyboard, Gregory on drums, and Rebecca on clarinet. Gregory has now assumed the position of Cathedral organist and choir director.

About the same time that Edward Strubel arrived at Mother of God Church, Cincinnati-born Albert Bollinger arrived in 1890 at Trinity Episcopal and was organist and music director for the next 57 years, until his retirement

Rita and Robert Schaffer at the Cathedral Basilica of the Assumption. Courtesy of the Schaffer family.

in 1947. His great-nephew Wilmer Hayden Welsh (1932–2008) was professor of organ at Davidson College and the major professor of Dr. John Deaver, who since 1980 has served as the organist at Trinity. In 1981 Deaver organized a free monthly noonday concert in the sanctuary, with an optional inexpensive lunch known as *Midday Musical Menu*. Some of the community's most talented musicians have presented programs over the years. This event has continued to the present. The *Midday Musical Menu* (at noon one Wednesday each month, except during the summer) and the Cathedral Concert Series are the two longest-running concert series in Covington. Deaver is also adjunct assistant professor of organ at the College Conservatory of Music of the University of Cincinnati.

RAGTIME

Ragtime is considered America's first recognized original music genre to have mass appeal, long before blues, country, or jazz. Scott Joplin's "Maple Leaf Rag" and "The Entertainer" are among the most famous examples of ragtime during its heyday between the years 1893 and 1917. Cincinnati scholarly music historian John Edward Hasse defines ragtime as a "dance-based American vernacular music, featuring a syncopated melody against an even accompaniment" (Hasse 1985, 2). African Americans of the Midwest and southeastern United States are credited with the development of ragtime. Cincinnati newspaper journalist Lafcadio Hearn (1850–1904) reported an early ragtime-roots style performed by roustabouts across the Ohio River from Covington nearly 20 years before the national phenomenon. Early ragtime pianists were often heard playing in saloons in Covington.

Ragtime pieces published by Covington musicians included "A Daisy Girl" by Louis H. Mentel in 1905, "Diplomatic Rag" by William M. Hickman in 1910, and a popular American Indian–inspired ragtime tune titled "Fire Water" by Covington-born regional band leader Justin Huber in 1911. Huber's bands transitioned to playing both jazz and symphony music during the 1920s and 1930s. Northern Kentucky composer Floyd H. Willis published many ragtime scores, including "Kentucky Rag" in 1908.

Ragtime was displaced by jazz during the Roaring Twenties. However, Fats Waller (1904–43) introduced the stride piano style (a form of ragtime) heard during his broadcast performances for WLW radio in Cincinnati in the early 1930s. During this period, Waller was known to play the piano for late-evening audiences at live venues in Covington. Ragtime resurfaced as "honky-tonk" in the 1940s and 1950s. The Academy Award–winning film score and adaptation of Scott Joplin's ragtime music in *The Sting* (1973) further revived the genre for future generations.

Fats Waller at WLW Radio, Cincinnati. Courtesy of Paul A. Tenkotte.

BLUES

The blues is an African American folk music style with its roots in 19th-century field songs, church music, and folk expressions from the South. The blues transcends a wide range of emotions and musical styles, expressed by melancholy instrumental or vocal performances. It is a musical predecessor to jazz and emerged in mainstream culture in the 1920s. Blues artists from the South migrated northward, often settling in urban settings such as Covington. W. C. Handy (known as the "Father of the Blues") had one of his early blues songs, "Memphis Blues," printed by Otto Zimmerman and Son of Cincinnati in 1912. The combination of river and railroad migration drew African Americans to Covington and Cincinnati from a varied cross section of geographical locations from the South (mostly Kentucky and eastern Virginia). Urban blues ensemble songsters and jug bands of the Northern Kentucky/Cincinnati region

(rather than traditional rural solo blues) were influenced by minstrel and folk songs, vaudeville panache, jug band music, urban hokum, barrelhouse, and snot-slinging raunchiness, as well as Southeastern, Alabama, and stomping Deep South piano traditions. This diverse musical mixture resulted in a unique blues sound, documented in audio recordings from the 1920s and 1930s, which exhibited a popularized style blending blues, ragtime, and early jazz.

Blues pianist Jesse James resided in Northern Kentucky and performed blues numbers such as "Southern Casey Jones" and "Lonesome Day Blues." Northern Kentucky also served as a performing venue for some significant blues artists, including Ed Conley, a backup jazz/blues bassist born in Covington and a studio musician at King Records in Cincinnati. Live blues performances have been heard at Covington music venues such as Chez Nora and Lucille's Blues Club. Blues music continues to influence contemporary jazz, country music, rhythm and blues, rock, and hip-hop musical styles.

JAZZ

Jazz is an original American musical art form. It began near New Orleans at the beginning of the 20th century, rooted in the mixture of African folk music and Western traditional music. Jazz has many subgenres. Ragtime and blues are antecedents of jazz, regionally cultivated and adopted in the tristate region in the 1920s because of

its proximity to both the Ohio River and railroads to the South. Other later jazz subgenres would include Dixieland, big band, bebop, and free jazz.

Covington jazz rhythm drummer Nelson Burton (1922–2010) recalls the heyday of jazz in Covington and Cincinnati in his book *Nelson Burton: My Life in Jazz*. Burton grew up on Ninth Street on Covington's Eastside. In his youth, Burton listened to famous musicians such as Thomas "Fats" Waller (1904–43) playing honky-tonk piano in local jazz clubs of Covington into the wee hours of the morning. At this time, Waller resided in Cincinnati as he performed on the "Nation's Station," WLW radio, from 1932 to 1934. At WLW, Waller played romantic pipe organ music, accompanied by dreamy poetry narrated by Peter Grant

ABOVE: Nelson Burton. Courtesy of the Kenton County Public Library, Covington. RIGHT: Mary Ellen Tanner. Courtesy of the Kenton County Public Library, Covington.

on the perennially popular late-night radio program *Moon River*. Yet his WLW performances on his *Fats Waller's Rhythm Club* were a better representative of his famous stride piano jazz style, which led to international fame. In his memoir, Nelson notes that nationally famous jazz bands like Bix Beiderbecke, Duke Ellington, Fletcher Henderson, Erskine Hawkins, and Nobble Sissle all performed in the tristate area. Nelson Burton served as a house drummer at the Cotton Club and as a studio drummer for King Records, both in Cincinnati. Burton established a musical partnership with another Covington jazz musician, Clarence "Tubby" Washington. They organized a jazz band called the Jumpin' Jacks and eventually opened their own club known as The Corner Pocket at the corner of Ninth and Greenup Streets in Covington.

Covington-born Christopher Wallace Perkins played the trumpet at the Cotton Club in Cincinnati. Other Covington jazz music personalities included Justin Huber and his many orchestras during the 1920s and 1930s, jazz singer Mary Ellen Tanner (1946–2014), and jazz drummer John Von Ohlen (1941–). Overall, however, classical jazz and big band, as mainstream music, went into decline with the rise of rock and roll in the 1950s.

RADIO

Covington's radio history is intimately tied to Cincinnati and the surrounding region. The first broadcast to initiate from Covington actually came from a station outside of the city. Station WFBE's transmitter originated in Indiana and operated as a Cincinnati station. In 1928, however, remote broadcasts originated in Covington, including many programs sponsored by the Kelley-Koett X-Ray Company (Covington). The shows highlighted local places of interest, including the suspension bridge, the cathedral in Covington, and Devou Park. The local broadcasts lasted for about a year, until an epochal shift occurred the following year.

In 1929 Covingtonians' ears first turned toward their own locally operated radio programs when station WCKY appeared on the air. Its call letters, CKY, were shorthand for "Covington, Kentucky." Efforts to establish the station were spearheaded by Wesley Berry (L. B.) Wilson (1891–1954), a wealthy citizen who seized the opportunity to broadcast when the Federal Radio Commission allowed the addition of two stations in Kentucky. The studio and offices in Covington operated out of the fourth floor of the People's Liberty Bank, on the southeast corner of Sixth Street and Madison Avenue.

Wilson served as the station's first president, a job that followed a long line of positions in the city. He was born in Covington in 1891 and attended public school in the city, where he honed his business acumen. He began practicing his skills as a showman from an early age, inviting children into the basement of his home at 15th and Greenup Streets for carnival games that cost a marble to play. Wilson later struck up a career in vaudeville with his brother, playing stages across Europe in the early 1900s before sailing back to America in April 1912. After returning to Covington, Wilson entered the film business, the newest entertainment realm offered in the city. He worked as a teenager for Orene Parker, managing the Colonial Theater on Madison Avenue. He moved from the movie business to radio with the 5,000-watt WCKY in 1929. In 1931 he turned his full-time attention to the station when he took over as general manager. In 1937 the station increased to 10,000 watts and switched affiliation from the National Broadcasting Company (NBC) to the Columbia Broadcasting System (CBS). In the late 1930s, at its peak, WCKY could reach more than half of the nation's population after dark. In 1939 the station again increased to the maximum allowance of 50,000 watts, but the increase coincided with the end of its days in Covington. The studios moved to the former Gibson Hotel in downtown Cincinnati, though the station's call letters still serve as a reminder of its origins.

WCKY's establishment coincided with the Great Migration of the 1920s and the growing popularity of early country music, or as it was actually called at the time, "hillbilly" sounds. WCKY was always in competition with other regional stations for talent, but nonetheless many stars made their way through Covington. In the 1930s Garner "Pop" Eckler joined WCKY after organizing a makeshift band, the Grant County Entertainers, and winning an amateur contest on the station. Eckler, who hailed from Dry Ridge, Kentucky, stayed at WCKY for two years

Lily May Ledford. Courtesy of Paul A. Tenkotte.

before crossing the river and spending time at WKRC and WLW. Eckler returned to WCKY for a time, as one half of the Yodeling Twins, with Roland Gaines the other, on the popular show *Happy Days in Dixie*.

Other popular musicians and radio stars also called Covington home for a time. Lily May Ledford, one of the popular Coon Creek Girls of the *Renfro Valley* programs on WLW, lived with her sister and bandmate Rosie at 502 Greenup Street while the show originated in 1937 from Music Hall in Cincinnati. She also did side work at other local studios and theaters in the area and recalled how the regional fan base crowding the studios at WCKY brought gifts and fan mail every day. The Coon Creek Girls performed at the White House on June 8, 1939, for President Franklin Delano Roosevelt and his guests, British monarchs King George VI and Queen Elizabeth. Country music stars found love in Covington too, in addition to the heartache and loss they pined about in song. Rosie Ledford married *Renfro Valley* producer Clarence "Cotton" Foley in Covington in 1937, while they were working on shows in the region.

In the early 1930s, the popular and longtime duo of Ma and Pa McCormick (Alice and Clarence respectively) lived at 2755 Dakota Avenue in Covington. During their long career in the country music industry, the duo appeared on WLW shows like the *Boone County Jamboree*, later known as the *Midwestern Hayride*. They were also one of the first acts to perform on the popular *Top O' the Morning* show on WLW, which ran from 1928 to 1933 and primarily featured old-time music.

Covington's second attempt at a station of its own occurred in 1947 when Arthur Eilerman launched WZIP. The station again had to compete with larger Cincinnati-based operations but promised to focus on Covington. WZIP located its tower near the Ohio River, where I-75 currently runs, and used the same studios formerly home to WCKY. The transmitter location allowed for the station to have one of the best signals in the area, but location and broadcast power alone were not enough to build a substantial audience. Unlike the national focus of WCKY, WZIP's programming centered on local public service, like city hall meetings, as well as interviews and the broadcasting of local musical acts. Its dramatic programs, a staple of many stations in the era around World War II, included local

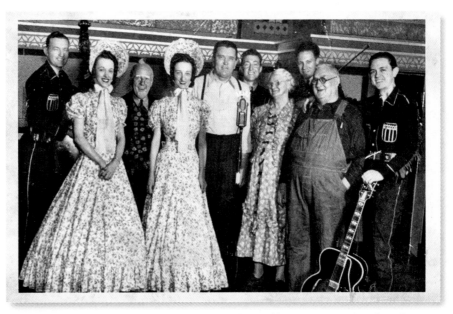

WLW Radio's Green Valley Folks, from left to right: Bill Brown, Jo Taylor, Grandpappy Doolittle, Alma Taylor, Hal O'Halloran, Walt Brown, Ma McCormick, Sleepy Marlin, Pa McCormick, and Merle Travis. Courtesy of Paul A. Tenkotte.

talent almost exclusively. In 1957 "The Voice of Northern Kentucky" followed the same fate as its predecessor when the station rights were sold to Ed Weston and Len Goorian, who moved it across the river to Cincinnati.

A third attempt has been longer lasting. WCVG was established in 1965 under the original call letters, WCLU, on 1320 AM, with its transmitter near the Latonia Plaza. Irv Swartz served as the first station president and used available local talent. The station initially specialized in modern country but has undergone myriad changes in its lifetime. During the 1980s, the station perhaps most famously became the nation's first to broadcast "all Elvis" programming, though that lasted only briefly. During the 1990s, WCVG became a gospel station and home to local sports, including live broadcasts of basketball games from Holmes High School. In 2006, the Davidson Media Group purchased the rights and transitioned to all-Spanish-language programs, making it the first station in the region to adopt this format. The setup lasted two years before switching back to gospel pro-

Carmen and Arthur Eilerman, WZIP studio. Courtesy of the Kenton County Public Library, Covington.

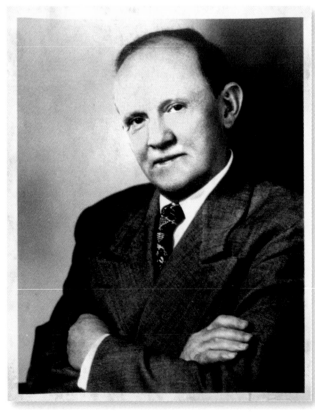

Haven Gillespie, circa 1949. Courtesy of the Kenton County Public Library, Covington.

gramming in 2008. In recent years, the gospel format has lasted, but the station has also broadcast games from the Florence Freedom baseball team, including its run to the 2012 championship series in the Frontier League.

HOLLYWOOD AND TELEVISION

The heyday of Hollywood featured five music and media megastars born and raised in Covington. These include one renowned popular music lyricist, two nationally recognized media celebrities, and two movie industry camera craftsmen.

Every Christmas holiday season, we are reminded of one of Covington's most famous music men, Haven Gillespie, as we hear and sing his lyrics to "Santa Claus Is Comin' to Town." However, this Christmas tradition is not his only lyrical claim to fame. Between 1911 and 1972, Gillespie published more than 300 tunes, from ragtime to pop standards. Gillespie's other musical gems still heard today include "You Go to My Head," "The Old Master Painter," "That Old Lucky Sun," and "Breezin' along with the Breeze."

Kathleen Myers. Courtesy of Paul A. Tenkotte.

Kathleen Myers (1899–1959) was a Covington-born actress who found success on the silver screen. She appeared in more than 20 feature movies during the peak silent film era of the 1920s. Myers performed with film superstars such as Buster Keaton in *Go West* (1925) and Tom Mix in *Dick Turpin* (1925). Silent film buffs often reminisce about Kathleen's frequent roles in Western and action settings, such as her five films with Maurice B. (Lefty) Flynn: *Heads Up* (1925), *Smilin' at Trouble* (1925), *Traffic Cop* (1926), *Sir Lumberjack* (1926), and *Mulhall's Greatest Catch* (1926).

Noteworthy popular media icons hailing from Covington include Una Merkel and Durward Kirby. Both spent their early formative years honing their talents in the region, eventually moving on to greater career opportunities. Merkel attended the First and Sixth District schools and studied acting under Patia Power (mother of movie matinee idol Tyrone Power) in Covington. She successfully performed on stage, in movies, and on radio. She began her career in silent films but gained acclaim as a wisecracking supporting film actress in many comedies and musicals at Metro-Goldwyn-Mayer (MGM), where she performed with Jimmy Stewart, Clark Gable, Jean Harlow, Maurice Chevalier, Lana Turner, and, much later, Elvis Presley. At Universal Studios she performed in a famous brawl scene with Marlene Dietrich in the classic movie *Destry Rides Again* (1939). On the air, Merkel starred as Leila's cousin, Adeline Fairchild, on

Una Merkel, 1946. Courtesy of Paul A. Tenkotte.

one of classic radio's sitcoms, *The Great Gildersleeve*. She performed on Broadway, where she won an Antoinette Perry (Tony) Award for best supporting actress in *The Ponder Heart* (1956). Merkel appeared in more than 100 theatrical films (including made-for-television programs) from the silent era through the 1960s.

Durward Kirby was enrolled at St. Benedict School in Covington. During his adolescent years, his family moved to Fort Thomas, Kentucky, where he attended high school. Kirby's broadcasting career attained national recognition when he reported news stories about the flood of 1937 at WLW radio. He also hosted big-band broadcasts for WLW from area nightclubs, such as the Lookout House in Lookout Heights (now Fort Wright), Kentucky. The National Broadcasting Company (NBC) heard his news reporting and other WLW broadcasting work, and invited him to work for them in Chicago. There, he soon met and worked for Garry Moore while collaborating on the *Club Matinee* radio program. After serving in World War II, Kirby resumed his national broadcasting career as a television pioneer on the *Garry Moore Show* through the 1960s. Kirby's roles went beyond announcer, as he often performed in comedy sketches with the cast, including new-kid-on-the-block Carol Burnett when she joined the program. Such sketches on the *Garry Moore Show* helped Burnett attain national fame. Kirby also served as a cohost with Allen Funt's popular *Candid Camera* television program of the 1960s. He continued to serve as an announcer or actor in television commercials in the 1970s, earning a Procter & Gamble Award as Outstanding Spokesperson in 1982. His other awards for broadcasting accomplishments included induction into the Greater Cincinnati Broadcasting Hall of Fame.

Behind the scenes in Hollywood's golden era, two prominent craftsmen from Covington captured the megastars on film. Avid classic movie fans know these names very well. George Hurrell was a still photographer, while Robert Surtees was a renowned cinematographer.

George Edward Hurrell (1904–92) was the photographer who invented glamour portrait photography as we know it today. Known as the Grand Seigneur of the Hollywood Portrait, his glamorized publicity stills of Hollywood's icons of the 1930s and 1940s set the standard. Beginning his career as a painter, he accidentally fell into photography, initially to capture images of his paintings. Before long, he was invited to photograph the society crowd of Los Angeles while working for the famous photographer Edward Steichen, who influenced Hurrell to practice celebrity portraiture photography. The rest is history, as he was hired to head up the publicity portraiture photo gallery for MGM in the 1930s and later for Warner Brothers through the 1940s. During Hurrell's heyday, his famous portraits included that of Humphrey Bogart, James Cagney, Joan Crawford, Bette Davis,

Durward Kirby. Courtesy of Paul A. Tenkotte.

Clark Gable, Greta Garbo, Jean Harlow, Rita Hayworth, Katharine Hepburn, Ramon Navarro, Tyrone Power, Jane Russell, Norma Shearer, Mae West, and others. One can most often spot a Hurrell celebrity portrait style by how a movable boom light is controlled, combined with key lighting at high angles. This photographic technique creates a lush and dramatic image that is sensual yet spiritual.

Robert L. Surtees was born in Covington but raised in Cincinnati. His Hollywood cinematography won him three Academy Awards, one each for the MGM films *King Solomon's Mines* (1950), *The Bad and the Beautiful* (1952), and the sound version of *Ben-Hur* (1959). Surtees was among the few classic-film-era cinematographers to transition successfully into the contemporary, more independent era of motion pictures in the 1960s. Surtees's trademark style was lavish location images captured in beautiful Technicolor and, later, expansive wide-screen film processes. He earned one of his Academy Awards for his contrasting affectionate and cynical moods, accomplished with lush, velvet black and intensely white images, in *The Bad and the Beautiful*. Surtees started out as portrait photographer, retouching photographs in Cincinnati. His career took him to Hollywood in the late 1920s to serve as an apprentice to established cinematographers such as Gregg Toland and Joseph Ruttenberg. He officially became the MGM director of photography in the early 1940s and remained at that studio for nearly 20 years. He maintained the glamorous "Hurrell look" of MGM images (high-key lighting) in the studio's total output, both still and moving images. Surtees established a realistic look in Technicolor with innovative camera filtering and lighting techniques. Film historians have implied that post-Renaissance impressionist artists inspired his work. Surtees's later contemporary works included films such as *The Graduate* (1967) and *The Sting* (1973). During his career of more than 50 years, nearly 100 feature films include his attributed screen credit. He was also nominated for 16 Academy Awards.

From the 1930s through the 1960s, Cincinnati was a regional and national media powerhouse. The region's

Mary Wood. Courtesy of the Kenton County Public Library, Covington.

radio and television programming was often aired live and syndicated nationally. Mary Wood, a longtime Covington resident, was a witty radio and television critic. Wood served as a scriptwriter at WLW radio, where she wrote stories for soap operas. Later, as a staff writer at the *Cincinnati Post* for 36 years, she reviewed and followed the careers of Bob Braun, Nick Clooney, Rosemary Clooney, Paul Dixon, Ruth Lyons, and other regional entertainment legends. Her reviews not only informed readers about local celebrity and programming happenings but also provided abundant memoirs for media historians to document our rich broadcasting and music recording history. Wood will most likely be remembered as a humorist and commentator, as documented in her book *Just Lucky I Guess* (1967).

Christmas nationwide would not be the same without Haven Gillespie or without another Covington resident, Jean Shepherd (1921–99). After serving in World War II, Shepherd moved to the Cincinnati area, living in an apartment on Madison Avenue in Covington. He worked for a variety of Cincinnati radio and television stations as a host. Later moving to broadcasting markets in Philadelphia and New York City, Shepherd wrote the famous screenplay *A Christmas Story* (1983), which has become a holiday classic. In the movie, Ralphie Parker recounts memories of himself as a 9-year-old in his Indiana hometown of Hammond, as he tries to convince his parents to buy him a Red Ryder BB gun.

BLUEGRASS AND COUNTRY MUSIC

Bluegrass music developed from traditional folk ballads and old-time music, representing the earliest Scots-Irish settlers of the Appalachian Mountains. Folklorist and music collector Alan Lomax identified it as "folk music with overdrive." Bluegrass had a significant development and fan following in Covington and the surrounding region after its genre offshoot from country music in the early 1940s. Country music has virtually the same origins as bluegrass. Hillbilly music (as it was initially labeled) was nationally recognized in the 1920s, with the advent of commercial recordings and radio broadcasts. Soon the name *country and western* was adopted during the 1940s, as the term *hillbilly music* was considered demeaning. Bluegrass music was introduced during this same period by Bill Monroe (1911–96) of Rosine, Kentucky. Monroe and his band played acoustic stringed instruments quickly, accompanied by his high-pitched, "lonesome" tenor singing. Bluegrass music features a fast tempo, often with a duple meter highlighting the offbeats, and frequently includes tight vocal harmonies. By the 1970s the country and western name changed to simply *country*. While bluegrass maintained its name and is largely associated with the commonwealth of Kentucky, there is a less stylized and more modern bluegrass derivative called newgrass. Both bluegrass and country music are part of a larger group known as American roots music. Roots music encompasses a broad range of folk music genres, including bluegrass, country music, gospel, old-time music, jug bands, Appalachian folk, blues, Cajun, and American Indian music.

During the Great Depression era of the 1930s, Covington's country and western music fans were treated to live broadcasts from WLW radio in Cincinnati, such as the *Renfro Valley Barn Dance* and the long-running *Boone County Jamboree* (later renamed *Midwestern Hayride*). Live country music programming remained a popular format at WLW radio and its later television chain through the early 1970s. Cincinnati's legendary King Records was spawned from the ample supply of country singers and musicians working at WLW in the 1940s. King Records' country and bluegrass

artists included Bonnie Lou, Jerry Boyd, Cowboy Copas, the Delmore Brothers, Pop Eckler, Hawkshaw Hawkins, Louis Innis, Tommy Jackson, Grandpa Jones, the Stanley Brothers (Carter and Ralph), Merle Travis, and Zeke and Zeb Turner. For a short period, during the early years of King Records' country-music recording era, Cincinnati and the tristate region rivaled Nashville as the bluegrass- and country-music capital of the nation.

Country music has always been popular in the region. The swell of Appalachian migration to Covington and the region after World War II further popularized bluegrass, old-time, and traditional folk music. Covington's WCKY-AM radio station is often credited for the development of our region as one of the most active bluegrass areas of the nation. From the 1940s through the early 1960s, WCKY's country music disc jockeys included Nelson King and Wayne Raney (also a singer and harmonica player for King Records). Since then, the WNKU-FM radio station at Northern Kentucky University continues the tradition of playing folk music among its blues, bluegrass, and rock format.

NATIONAL FOLK FESTIVAL

In the 1960s Covington's location between the North and the South made it a prime destination for Sarah Gertrude Knott's National Folk Festival. From May 23 to May 25, 1963, the Devou Park Band Shell hosted a variety of folk acts from around the world, including performances by American Indians, displays of immigrant folk traditions, and other American acts. The festival opened with a performance and talk by musician and folklorist John Jacob Niles playing his large Appalachian dulcimer. The festival returned to the area in 1964 at the Latonia Race Course in Florence, Kentucky (now Turfway Park), and hosted popular bands that were a part of the folk revival, including the Kingston Trio, Joan Baez, and Peter, Paul, and Mary.

GOSPEL SINGING

Gospel music is an emotional vocal genre in Protestant Christian religious music, largely originating with African American culture in the southern United States. Gospel tunes are often simple melodies influenced by the blues and folk music traditions, combined with harmony and syncopated rhythm. Besides solo vocalists, groups, or choirs, pianos and organs are typically utilized for accompaniment. Additional musical instruments include tambourines, drums, and guitars. Gospel subgenres include urban contemporary, blues, southern, and bluegrass. Gospel music was also influential in the development of soul music.

The Northern Kentucky Brotherhood Singers began their careers in gospel music singing at Covington's North Street Baptist Church. Eric Jennings, Robert Mullins, and Greg Page met in the church's choir in the 1980s and formed a gospel trio. Their a cappella musical styling is based on a mixture of traditional African American gospel singing, barbershop, and rhythm and blues music and incorporates unique close harmony singing. The a cappella nature of their music makes them unique among gospel singing groups in the state. The group has also professed and acted on their strong ties to the city. They are frequently seen at fundraisers and charity events, helping to raise money for various causes or to support churches in need of money for restorations. In the 2000s, the group worked with Covington youth at the Frank Duveneck Arts Center. The singers taught classes and worked with students on exercises to improve their singing ability. That same decade the group began international tours, which took them to most of the 50 states, as well as Europe. They participated in the World Choir Games held in Cincinnati in 2012. They can be regularly spotted at regional festivals in the Ohio Valley area as well.

The Ball Family Gospel Singing Group has also gained popularity in its 45-plus years as an institution in the Covington area. The family formed a group in 1969 based around the family patriarch, Herbert Ball, who sang gospel music on radio station WLW for a time. The group has toured nationally, including headlining for shows in Branson, Missouri. The Ball Family has also frequented festivals, churches, and prisons around the country. Herbert Ball passed away in 1981, but the family has carried on the tradition into the 21st century.

The Ball Family Singers. Front: Herbert Ball, Joyce Yeary, and Greg Warren. Rear: Ruby Williams, Peggy Arnold, Nelson Ball, and Carole Hill. Courtesy of the Kenton County Public Library, Covington.

Adrian Belew. Courtesy of Adrian Belew.

MODERN MUSIC AND MEDIA

The eclectic musician Adrian Belew resided in Covington during his nascent years. Belew was born Robert Steven in Covington in 1949. He gained national fame as a guitarist in the 1970s and toured and played with the likes of Frank Zappa, David Bowie, the Talking Heads, King Crimson, and local supergroup the Psychodots. He stayed on the cutting edge with progressive and modern rock bands through the early 2000s. In 2001 Belew received the Cincinnati Entertainment Association's Lifetime Achievement Award for his work and four years later was nominated for his first Grammy. Most recently, he joined the rock group Nine Inch Nails for a brief time in 2013, though he played with them in the late 1990s as well. Belew continues to play music and took his band Crimson ProjeKCt, an offshoot of the King Crimson lineup, on world tour in 2014.

Michael Conner of Latonia, keyboardist of the country rock band Pure Prairie League (PPL), served as a long-term member of PPL since recording its hit song "Amie" in 1972 until his passing in 2004. Conner graduated from Newport Catholic High School and attended Eastern Kentucky University in

295

Richmond, Kentucky. He also played the keyboard for a 1960s garage band known as The Vibrations. Conner's piano playing styles encompassed Delta blues, country rock, and classical.

Born and raised in Covington, Mitch English served as a nationally recognized morning television talk show host and funny weatherman on the CW network's *The Daily Buzz* during the years 2002 through 2012. In 2013, he transitioned to become executive producer of *Good Morning San Diego* at KUSI-TV. He is also known for stand-up comedy and acting.

Mitch English. Courtesy of Mitch English.

Holmes High School Marching Band

The marching band at Holmes High School dates to 1914, when Horace Ballinger served as chair of the music department and assistant principal. In the 1920s J. L. Newhall served as the bandleader. Kenneth Stanton directed the band during the 1930s and early 1940s, and Robert Bowersox took over as the head of the band when it entered interschool competitions in the mid-1940s, including the University of Kentucky's marching band festival. The Holmes marching band of the later 1950s and early 1960s began to develop under the training of directors Jack Levi (1955–57), John Larimore (1958–62), and Ray Spaulding (1962–64).

National recognition became commonplace for the band during the 1960s and 1970s when teacher and director James Copenhaver influenced hundreds of Holmes music students and led the band to national renown. Students were required to practice beyond school hours and, for the first time ever, to attend two-week summer rehearsals. Copenhaver's band was the first in the tristate area to offer unique precision-drill, military-style performances in crisscross patterns and more complex intricate geometric designs. With such stringent rehearsal standards and marching discipline, the band demonstrated its reputation for excellence with top honors in the state in 1966, 1967, and 1968. Then, in 1969, the band was honored as Grand Champion in the South at the Contest of Champions in Murfreesboro, Tennessee. The band also won the national grand championship at the Eighth Annual Virginia Beach National Music Festival in the summer of 1969. Soon, the nationally winning band appeared as guest performers on the regional WLW television network's *50-50 Club* midday broadcast. In 1970 the Holmes High School Band commercially released an LP audio recording. That same year, Copenhaver resigned to pursue his master's degree and eventually to become the director of bands at the University of South Carolina. His Holmes band assistant, Richard Faust (1970–72), fostered the same momentum as did directors Allen Couch (1972–74, also a graduate of Holmes) and Dennis Cain (1974–76).

In 1971 senior Greg Wing was selected as one of two high school marching band players from Kentucky to perform in the McDonald's All-American Band. The All-American Band played at the Macy's Thanksgiving Day Parade and the Tournament of Roses Parade. Television personality and hostess for both events Betty White interviewed Wing during one of the parade telecasts.

The Holmes High School Marching Band won the Summer National Championships of the Marching Bands of America (now Bands of America) in 1975. Subsequently, they were invited that same year to march in the First Annual Thanksgiving Day Parade in Cincinnati. Band director Ted Denman led the band with further first-place awards from 1976 to 1981. Directors Doug Johnson (1981–85), Larry Johnson (1985–86), and David Bay (1987–88) led the band to further honors at competitions. Greg Bingman (1989–95) and Frank Sloan Jr. (1996–2009) served as directors over the last few decades.

In 2012 the Holmes band returned to the spotlight when it qualified for the Kentucky Music Educators Association's (KMEA) State Marching Band Championship semifinals, placing 15th overall in the state. No Holmes band had ever qualified for the KMEA state championship since its realigned

sanctioned contests in 1986. In addition, the band has performed at local venues such as Florence Freedom and Cincinnati Cyclones games, Cincinnati's Flying Pig Marathon, and the Kentucky Derby Festival's Pegasus Parade.

Lee Roy Reams

Lee Roy Reams, a Broadway actor, dancer, singer, choreographer, and director, graduated from Holmes High School and the University of Cincinnati. While he was growing up in Covington, his mother placed him in dancing school. He performed regionally during his youth for the Newport Catholic Actors Guild, the showboat *Majestic*, and Cincinnati's Playhouse in the Park. Reams got his first big break, appearing in a minor part in the premier run of *Sweet Charity* on Broadway, in 1966. Soon, he landed major roles, starring in productions such as *Applause* with Lauren Bacall in 1970, the revival of *Hello Dolly!* with Carol Channing in 1978, and other significant musical plays. He received both Tony and Drama Desk Award nominations for Best Featured Actor in a Musical in 1981 for David Merrick's *42nd Street*.

Lee Roy Reams, 1979. Courtesy of the Kenton County Public Library, Covington.

From actors Edwin Forrest, Blanche Chapman, and Una Merkel to musicians B. H. F. Hellebusch and Adrian Belew to lyricist Haven Gillespie, photographer George Hurrell, cinematographer Robert Surtees, and screenplay writer Jean Shepherd, Covington has been the home of many talented performing artists. At the center of the expanding western frontier, Cincinnati and Covington were in the crosshairs of some of America's earliest acting families, including the Drakes and Chapmans. Immigrants and migrants to the region, from German Americans to African Americans to Appalachians, brought their own ethnic music and traditions. These enriched and enlivened the musical and entertainment heritage of Covington.

SELECTED BIBLIOGRAPHY

Alger, William Rounseville. *Life of Edwin Forrest, the American Tragedian*. 2 vols. Philadelphia: Benjamin Blom, 1877.

Barrett, Lawrence. *Edwin Forrest*. New York: Benjamin Blom, 1881.

Bogardus, Carl. "Showboats." *Northern Kentucky Heritage* 7 (1) (1999): 1–23.

Burton, Nelson. *Nelson Burton: My Life in Jazz*. Cincinnati: Clifton Hills Press, 2000.

Claypool, James C. *Kentucky's Bluegrass Music*. Charleston, SC: Arcadia Publishing, 2010.

First, William E., and Pasco E. First. *Drifting and Dreaming: The Story of Songwriter Haven Gillespie*. St. Petersburg, FL: Seaside Publishers, 1988.

Ford, George. *These Were Actors: A Story of the Chapmans and the Drakes*. New York: Library Publishers, 1955.

Fox, John Hartley. *King of the Queen City: The Story of King Records*. Urbana, IL: University of Illinois Press, 2009.

Graham, Philip. *Showboat: The History of an American Institution*. Austin, TX: University of Texas Press, 1951.

Hagan, John Patrick. "Frederick Henry Koch and the American Folk Drama." PhD diss., Indiana University, 1969.

Hasse, John Edward, ed. *Ragtime: Its History, Composers, and Music*. New York: Schirmer Books, 1985.

Hellebusch, Julianna Mattei. "B. H. F. 'Teacher' Hellebusch (1825–1885)." *Northern Kentucky Heritage* 1 (2) (1994): 13–25.

Herbert, Anne. "Sylvester Victor Eifert, Organist, Teacher (1880–1955)." *Northern Kentucky Heritage* 19 (1) (2012): 21–28.

Holmes High School. *Lest We Forget* yearbooks, Kenton County Public Library, Covington, KY.

Katchmer, George. *Biographical Dictionary of Silent Film Western Actors and Actresses*. Jefferson, NC: McFarland & Company, 2002.

Lietzenmayer, Karl J. "Lafayette: His Remarkable Life, His Love of America and His 1825 Triumphal Tour through Kentucky." *Northern Kentucky Heritage* 16 (2) (2009): 3–24.

———. "Mother of God Choral Club: A 70-Year Covington Tradition Disbanded." *Northern Kentucky Heritage* 17 (2) (2010): 41–51.

———. "A Picture History of Covington's Independent Order of Odd Fellows Hall," *Northern Kentucky Heritage* 7 (2) (1999).

———. "Professor Edward Strubel, Composer, Church Musician, Teacher (1875–1964)." *Northern Kentucky Heritage* 1 (1) (1993): 27–37.

Ludlow, N. M. *Dramatic Life As I Found It.* St. Louis: G. I. Jones and Company, 1880.

Moody, Richard. *Edwin Forrest: First Star of the American Stage.* New York: Alfred A. Knopf, 1960.

Moses, Montrose J. *The Fabulous Forrest: The Record of an American Actor.* New York: Benjamin Blom, 1929.

Nash, Francis. *Towers Over Kentucky: A History of Radio and Television in the Bluegrass State.* Lexington, KY: Host Communications, 1995.

Northern Kentucky Newspaper Index. Kenton County Public Library, Covington, KY.

Rees, James. *The Life of Edwin Forrest.* Philadelphia: T. B. Peterson & Brothers, 1874.

Rice, Joe M. *Early Cincinnati Radio, 1910–1970.* Florence, KY: J. M. Rice [1971?].

Rosenberg, Neil V. *Bluegrass: A History.* Urbana, IL: University of Illinois Press, 1985.

Shaw, Dale. *Titans of the American Stage: Edwin Forrest, the Booths, the O'Neills.* Philadelphia: Westminster Press, 1971.

Tenkotte, Paul A., and James C. Claypool, eds. *The Encyclopedia of Northern Kentucky.* Lexington, KY: University Press of Kentucky, 2009.

Tracy, Steven C. *Going to Cincinnati: A History of Blues in the Queen City.* Urbana, IL: University of Illinois Press, 1993.

Webster, Robert D. *The Balcony Is Closed: A History of Northern Kentucky's Long-Forgotten Neighborhood Movie Theaters.* Covington, KY: Kenton County Historical Society, 2007.

———. "An Incredible Era: James K. Copenhaver and His Legacy." *Northern Kentucky Heritage* 18 (2) (2011): 24–47.

Wolfe, Charles K. *Kentucky Country: Folk and Country Music of Kentucky.* Lexington, KY: University Press of Kentucky, 1982.

13

FROM PACKET BOATS TO POLLUTION: THE OHIO AND LICKING RIVERS

by Don Clare, Victor J. Canfield, and Marc F. Hult

THE OHIO RIVER: GATEWAY TO THE WEST

"The Ohio is the most beautiful river on earth. Its current gentle, waters clear, and bosom smooth and unbroken by rocks and rapids, a single instance only excepted." This is what Thomas Jefferson wrote in his only published book, *Notes on the Current State of Virginia, 1781–82*. Maybe its waters are clear if a small tumbler is dipped into the middle of the river, but to residents of Covington, it has always been "that ol' brown river," just as the song of the same title by the now-deceased Kenton County songwriter Danny Wilson so aptly says: "Just lead me down to that green, green valley, where that old brown river flows." These words actually could have been written by the very first settlers of the area we now call Covington, a city located on the banks where the Licking River, flowing northward, meets the Ohio.

Two of Covington's geographical boundaries are rivers: the Ohio and the Licking. The other two borders, western and southern, are hills, essentially making a river basin that Covington occupies generally safe from all but the worst yearly seasonal flooding occurring on both rivers. The rare but devastating floods, of course, know no boundaries. The Ohio separates the state of Ohio from the commonwealth of Kentucky. It separates Cincinnati from Covington. The Licking separates the two Kentucky counties Campbell and Kenton as well as the two cities Newport and Covington. The north-flowing Licking empties into the Ohio at what is called "The Point," which in early settlement days was a well-known, dedicated meeting spot for pioneers, settlers, and military expeditions in what was then the West.

Ever since man first appeared on the North American continent, the Ohio River has provided him with the manner and means of life's very sustenance. It has also provided him a path to follow and explore filled with unending natural beauty to inspire and fascinate him during his journey. But along with these abstract qualities it was laden with concrete dangers and destruction. How many primitive towns and villages succumbed to the river's maddening whims before the natives sought higher ground, yet still within sight of her majestic powers? How many historic towns and cities also met the same fate decades and centuries later? Is there some kind of message here? How about this: Treat me with awe and respect, and I will provide for you; treat me with disdain and irreverence, and I will swallow you.

Along with hundreds of other small towns and cities, Covington, Kentucky, called the Ohio River "mother." The town was conceived in this river's very being, presence, and location. The Ohio River was, in essence, an avenue of national expansion, which enticed adventurers, explorers, pioneers, and settlers to leave the crowded eastern seaboard colonies and embrace the unknown western reaches of this newly found and formed civilization in

the unsettled North American continent. The Ohio River was eventually to become the "course of empire" because of its strategic location across the Appalachian mountain range to the interior of the continent. If the Ohio River valley and basin could be occupied and settled, then why could not the entire continent? These thoughts and aspirations long preceded the possibility of the Louisiana Purchase (1803) and the concept of manifest destiny. And what about the American Indians, the indigenous people who were occupying this land? In times past, mountain ranges had always defined the boundaries dividing one country from another country and one civilization from another civilization, but in the case of the North American continent, mountain ranges really had no bearing at all. The mountains of North America were not natural boundaries—they were simply inconveniences that the east-to-west-flowing rivers had to negotiate. The Ohio River proved to be the major watercourse for the exploration and settlement of the first western expansion of what would become the United States. Still, leaders in England were certain that the newly formed United States of America would fail and split into separate countries, naturally divided by chains of mountains, just as they are on the European continent.

The British, the French, the Americans—none showed concern for or acknowledged the rights that the American Indian tribes had for this land in question. Just like the mountain ranges, their rights too could be circumnavigated. The mind-set of entitlement and manifest destiny was bred and rebred into the white Euro-American settlers. The name Oyo (the word derivative used to name the Ohio River) seems to be the only thing they gave the native peoples credit for, and the translated meaning of the name has been debated over and over for centuries by historians and linguists alike. Still, there is no universally accepted meaning for the name. It may possibly even have been a bastardization of the name that the natives actually used. Different tribes all had different words and meanings for the name of this mighty river. "Oyo" seems to be the common denominator in most of them. Credit must go to the French, who determined that the translation of Oyo was "La Belle Rivière" ("the beautiful river"). And although today this venerable waterway is simply called the Ohio, hardly anyone can doubt the fact that it is indeed a most beautiful river.

But how long had it existed? And why was it formed where it is and not somewhere else? To answer these and other questions about the origin of the Ohio, the sciences must be explored. Years of climatic and geological changes influenced the landscape of the earth. These were directly responsible for the present-day coordinates of the Ohio River, which in preglacial times was part of the Teays River's drainage basin. Glacial events added the finishing touches to metamorphose this ancient river into the present one. During the Illinoian Glacier stage of 200,000–250,000 years ago, the Ohio River settled into its present course in the Cincinnati/Covington vicinity, and the current "Point" was born.

The Ohio River watershed drains approximately 200,000 square miles of land and carries a larger volume of water to the Gulf of Mexico than any other river in the inland rivers system. Even though other rivers in the United States may drain larger areas of land, none of them carries more volume to the Gulf. This is because the water runoff of the Ohio is higher, and less of it is absorbed into the ground. The Ohio River is a total of 981 miles long, beginning at "The Point" in Pittsburgh, where the Allegheny and the Monongahela Rivers come together, and ending at Cairo, Illinois, where the Ohio enters the Mississippi River. Its banks serve as the official boundaries of five states: Illinois, Indiana, Kentucky, Ohio, and West Virginia. Back when the northern, or Indian, bank was still the Territory Northwest of the River Ohio, the Ohio River was part of the commonwealth of Virginia up to the low-water mark on the opposite shore, as spelled out in the Treaty of Paris in 1783, ending the Revolutionary War. When the Kentucky counties of Virginia became the commonwealth of Kentucky in 1792, the river became part of Kentucky. In 1803 Ohio (named for the river) became the first state carved out of the Northwest Territory; but the river still belonged to Kentucky.

Just as our current interstate highway system was developed primarily as a national defense project for the rapid transport of military equipment, so too did the Ohio River play a similar role for our military as the post–Revolutionary War priorities switched from fighting the British to subduing the American Indians. Pioneers

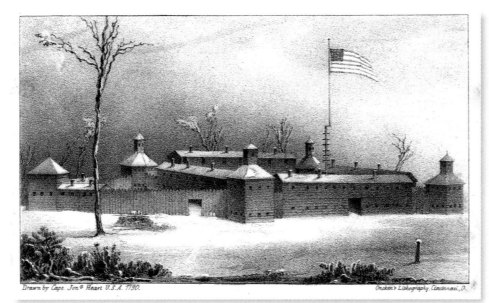

Fort Washington, Cincinnati.
Source: Cist, Charles. *Sketches and Statistics of Cincinnati in 1851.* Cincinnati: Wm. H. Moore & Co., 1851.

and settlers were going west regardless of the objections of the native peoples. Hostilities between the settlers and the American Indians grew and were nurtured, and the government had to step in to provide protection for the early settlements. George Washington himself extolled the beauty and fertility of the Ohio River valley to his fellow officers and friends and made land claims in the new West. The first three major white settlements along the Ohio were the direct result. Marietta, Ohio, where the Muskingum River meets the Ohio River, was founded by General Rufus Putnam in 1788. Point Pleasant, Ohio, where the Kanawha River joins the Ohio, was established by Major Andrew Lewis in 1774. And Cincinnati, across from the mouth of the Licking River, was settled in 1788 and fortified with the completion of Fort Washington in 1789. This town was first named Losantiville, taking the "L" from Licking and combining it with the Latin word *os,* meaning "mouth"; the Latin *anti,* meaning "opposite" (in this case "across from"); and the French word *ville,* meaning "town," thus making Losantiville "the town opposite the mouth of the Licking River." That name did not last long, however. General Josiah Harmar (1753–1813), who was the first commander of Fort Washington, changed it to Cincinnati in honor of George Washington's name for the elite group of military officers called the Society of the Cincinnati, an homage to Lucius Quinctius Cincinnatus, the legendary Roman farmer who twice dropped his plowshare in the middle of his field to take up arms to defend his country. Fort Washington was situated in what was the Northwest Territory and not in one of the original states of the Union. The northern side of the river was referred to as the Indian bank, while the southern side was called the Kentucky bank.

It is only natural to want to see what is on the other bank of any river, so it was not very long before the Kentucky side attracted settlers, and two of these, Francis and Thomas Kennedy, eventually established a cross-river ferry boat service, even before a name for the emerging settlement in Kentucky was ever considered. The building of Fort Washington in Ohio, opposite the mouth of the Licking, was to protect the new settlers coming downriver into the area, including those living in Kentucky.

THE STEAMBOAT AGE

If elbow grease was the first ingredient in the settlement of this area of the Ohio valley, then steam was the second. As early as 1785, it occurred to James Rumsey of Virginia to attempt to harness steam in order to power a vessel on the Ohio River. His idea and experiments of pumping water out the ship's stern to propel it did not pan out. But others, who believed in the extraordinary power of harnessed steam, came up with other applications until, in 1810, Robert Fulton and Nicholas Roosevelt built a steam-powered vessel, the *New Orleans,* in Pittsburgh. This famed craft was the first steamboat to travel to New Orleans under its own power in 1811, making trips from Cincinnati to Louisville, Kentucky, and back on its inaugural voyage. As improvements were realized by other engineers and boat builders along the Ohio, the steamboat brought commercial and economic prosperity to the Ohio valley. Cincinnati was one of the major benefactors of the steamboat, and due to its proximity, the city located on the Kentucky bank, which was given the name of Covington in 1815, naturally benefited as well.

The "steamboat age" saw Covington grow and prosper in manufacturing, services, and commerce, all due to its physical relationship to the Ohio River. The city witnessed an influx of Irish and German immigrants, skilled and unskilled workers, laborers, and artisans. Carpenters, boilermakers, foundry workers, and blacksmiths all found employment in the actual construction of the steam-powered packet boats. Boat owners, captains, pilots, engineers, firemen, and the myriad other crew members essential for the safe and profitable operation of these boats, both for commerce in moving produce and products and for comfortable accommodations for transportation and travel, settled in Covington too. As the city population grew, so too did the job market and employment opportunities. Beer breweries, distillers, raw and prepared food retailers and wholesalers, bakers, butchers, and grocers appeared on the scene to make provisions available to the populace. Doctors, pharmacists, tailors, cobblers, and every other imaginable service provider set up shop, and Covington grew to become the largest city in Northern Kentucky. By 1850 Covington was the second-largest city in the commonwealth of Kentucky. Around this time, and up to the Civil War, the steamboat age was peaking universally but soon would give way to the railroads as the up-and-coming, state-of-the-art form of transportation of people and goods. Railroad popularity naturally took hold first in the geographical areas devoid of inland river access. So later, even after rail transport arrived in Covington, the city's association with and dependence on the Ohio River for commerce and economy was little affected.

Though the Ohio River was the dividing line between the North and the South, and although Covington was one of the most northern cities of the geographical South, as the Civil War approached, the residents of Covington overwhelmingly supported the Union. There was, however, a very active and vocal faction of dyed-in-the-wool Confederate sympathizers in Northern Kentucky and Covington, but their resistance and Southern loyalties were easily quelled without very much bloodshed. In fact, an amazing engineering feat took place on the river itself in the summer of 1862. A pontoon bridge was built over wooden coal barges lined up side by side across the river from Cincinnati to Covington, thus allowing Union soldiers and Cincinnati militia troops quick and easy access to help defend and build fortifications in the hills south of Cincinnati and Covington, thereby warding off invasion by the Southern army.

Covington was a center for the operation of steamboats. One of Covington's most successful businessmen, Amos Shinkle (1818–92), began his ascent to wealth in the steamboat trade. Shinkle's first steamboat was the *Mary Cole,* which ferried passengers round-trip to and from Cole's Garden, an amusement and picnic grove on the Licking River. Later, in 1850–51, Shinkle built the *Champion* for the same purpose. Just about the same time, Oliver P. Shinkle, Amos Shinkle's youngest brother, moved to Covington and began his career as a boat captain. Other Shinkle steamboats proudly bore the *Champion* name. During the Civil War, Amos Shinkle sold the *Champion 3* and *Champion 5* to the federal government for use by Union troops. Later, he began to build and operate steamboats to transport coal, a business move that made him a millionaire. The Shinkle family either built or purchased a number of steamboats for their company in the late 19th century, including the *Vincent Shinkle* (620 tons; 1874), the *Golden Crown* (261 feet by 41 feet; 1877), and the *Golden Rule* (261 feet by 41 feet; 1877).

Shinkle's neighbor, Commodore Frederick A. Laidley (1841–1931), owned and operated steamboats too. Laidley was best known as the general manager and treasurer of the Louisville & Cincinnati Packet Company (also known as the White Collar Line). Laidley's beautiful home, at 404 East Second Street in Covington, still stands, a testimony to the money that could be made in the steamboat trade. The two premier boats of the White Collar Line were the *City of Cincinnati* (300-foot length; 38-foot width; 6-foot draft; licensed to carry 1,500 passengers) and the *City of Louisville* (301-foot length; 42.7-foot width; 7-foot draft; licensed to carry 1,500 passengers). The *City of Louisville* set a record run upriver from Louisville to Cincinnati in April 1894—9 hours and 42 minutes. In 1910 Laidley and business partner Lee Howell of Evansville, Indiana, purchased a steamboat line called the Louisville & Nashville Packet Company.

Three Views of Civil War Pontoon Bridges

During the Civil War, two of the most popular national weekly newspapers were *Harper's Weekly* and *Frank Leslie's Illustrated Newspaper*. The Siege of Cincinnati was an important turning point of the Civil War in the Western theater. Had Cincinnati, then the nation's seventh-largest city, fallen to the Confederates, the outcome of the war could have been much different. Note the two scenes of the pontoon bridge across the Ohio River looking toward Covington, one by moonlight (right). The pontoon bridge over the Licking River near Covington connected the line of Union defenses between Kenton and Campbell Counties. Meanwhile, gunboats patrolled the Ohio River, as seen in the moonlit view to the left.

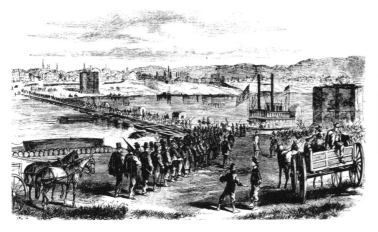 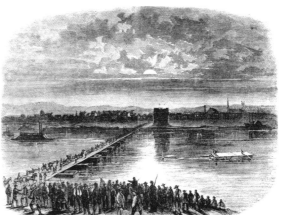

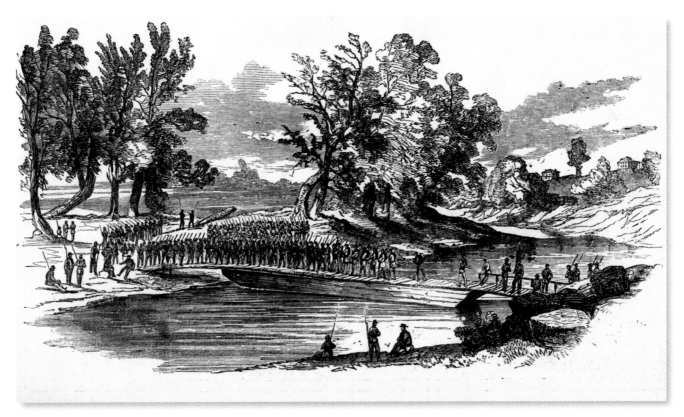

TOP LEFT: Civil War pontoon bridge across the Ohio River, looking toward Covington from the Cincinnati shore. Source: *Frank Leslie's Illustrated Newspaper*, 6 Sept. 1862. TOP RIGHT: Moonlit view of the Civil War pontoon bridge across the Ohio River, looking toward Covington from the Cincinnati shore. Source: *Harper's Weekly*, 27 Sept. 1862. ABOVE: Civil War pontoon bridge across the Licking River near Covington. Source: *Harper's Weekly*, 27 Sept. 1862.

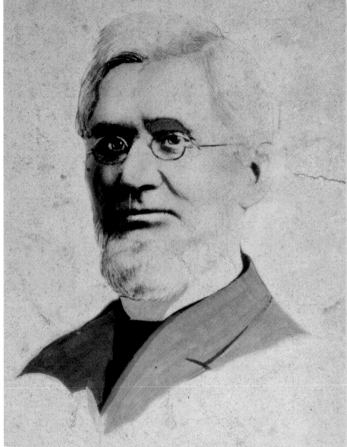

TOP LEFT: Steamboat along the Licking River. In the background is Amos Shinkle's palatial home on East Second Street. Source: Kenny, D. J. *Illustrated Cincinnati.* Cincinnati: George E. Stevens & Co., 1875. TOP RIGHT: Amos Shinkle. Courtesy of Paul A. Tenkotte. ABOVE LEFT: The Amos Shinkle Townhouse, at 215 Garrard Street in Covington, was built in 1854. It has been lovingly restored by its current owners, the Desmarais family, and by its former occupants, Bernard Moorman and Donald Nash. Photo by Dave Ivory. ABOVE RIGHT: *Champion No. 6,* one of Amos Shinkle's steamboats, docked below the Covington and Cincinnati suspension bridge in Covington, 1867. Courtesy of the collection of the Public Library of Cincinnati and Hamilton County.

Famous rivermen were born in Kentucky, including Cassius Bell Sandford (1808–71) of Covington; Kenton County-born Captain William Starke Leathers (1807–52) and his more famous brother, Thomas P. Leathers (1816–96), captain of the *Natchez*; and John W. Cannon, captain of the *Robert E. Lee*. Cassius Bell Sandford, the son of Northern Kentucky pioneer General Thomas Sandford (1762–1808), served as mayor of Covington and married Frances Leathers, sister of Thomas P. and William S. Leathers. Cassius Sandford and William S. Leathers

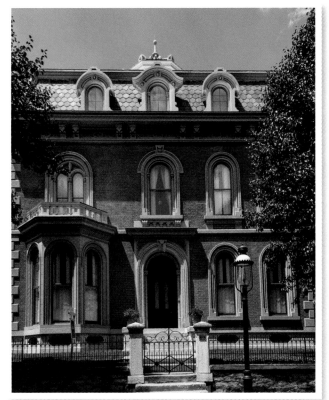

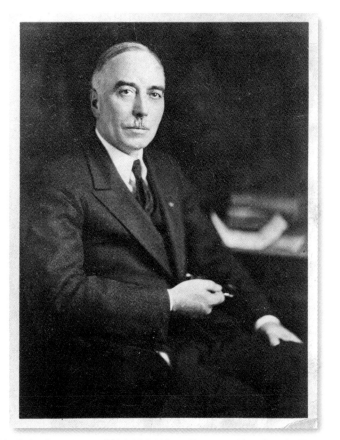

TOP LEFT: Frederick Laidley Home, East Second Street, Covington. Photo by Dave Ivory, 2014. TOP RIGHT: Steamer *City of Louisville*, owned by Laidley's Louisville & Cincinnati Packet Company, circa 1911. Courtesy of Paul A. Tenkotte. Other Covington residents owned and operated steamboats, including James Hatfield (1865–1938), founder of Hatfield Coal (Madison Avenue and Pike Street, Covington). With its affiliated companies Hickey Transportation and the Hatfield-Campbell Creek Line, Hatfield operated such famous steamboats as the *Ellen Hatfield*, the *Henry C. Yeiser Jr.*, the *J. T. Hatfield*, the *Julius Fleischmann*, and the *W. C. Mitchell*. Another coal dealer, A. Montgomery & Company (Third and Main Streets), operated boats, including one named after an influential Covington resident, *William Ernst* (1878). ABOVE LEFT: The steamer *J. T. Hatfield*. Courtesy of the Kenton County Public Library, Covington. ABOVE RIGHT: James Hatfield. Courtesy of the Kenton County Public Library, Covington.

were partners in two steamboats called the *Princess*. The Leathers family was originally from Baden in Germany and settled in Virginia. Receiving an old land grant of 1,250 acres in Northern Kentucky, they purchased hundreds of additional acres in Kenton County, owning much of present-day Fort Mitchell, Lakeside Park, and Crestview Hills. William S. and Thomas P. Leathers were the sons of Colonel John White Leathers (1782–1840), who served in the War of 1812 and had purchased much of the family's land along the Covington and Lexington Turnpike (now Dixie Highway) outside Covington. Captain Thomas Leathers moved to Natchez, Mississippi, before the Civil War. Nonetheless, he retained ties to his Northern Kentucky roots. In July 1892, he and five other business partners (Frank P. Helm, F. C. Leathers, T. P. Leathers Jr., John L. Sanford, and George Winchester) incorporated

the New Orleans and Vicksburg Packet and Navigation Company with headquarters in Covington, Kentucky. According to the *Articles of Incorporation* (book 4) at the Kenton County Courthouse in Covington, "The business of said company shall be the building, buying, selling, and outrigging of steamboats, and other vessels and watercraft; carrying passengers and freight of all kinds by such boats, vessels and watercraft, and the buying and selling of all manner of freight in cargoes or otherwise."

From our modern perspective, steamboats evoke a sense of graceful travel at a slower pace. But to people of the time, steamboats were cutting edge, a fast, efficient, and inexpensive manner of moving cargo and passengers. Steamboat owners and pilots could not resist the temptation to race their boats. Perhaps the most celebrated steamboat race of the 19th century was between the steamers *Robert E. Lee*, owned by Captain John W. Cannon, and the *Natchez (VI)*, owned by Thomas P. Leathers. In 1870 the two steamboats raced each other between New Orleans and St. Louis. One of Captain John W. Cannon's pilots aboard the *Robert E. Lee* was Covington native James Pell. The *Robert E. Lee* won. James Pell lived to the age of 87, dying in Covington in 1916.

Captain Thomas P. Leathers, 1895. Courtesy of the collections of the Louisiana State Museum, loaned by Gaspar Cusachs.

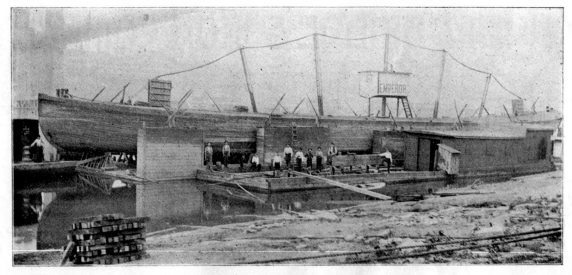

OHIO AND MISSISSIPPI RIVERS AND TRIBUTARIES.

COVINGTON DOCK CO.

B. J. DRESSEL.

DOCKYARD, FOOT OF SCOTT STREET, Near Suspension Bridge. COVINGTON, KY.

VIEW OF COVINGTON DRY DOCK.

DOCKING AND REPAIRING BARGES, BOATS, FLOATS,

AND ALL KINDS OF RIVER CRAFT.

145

Covington Dock Company. Source: *Marine Register of the Ohio and Mississippi Rivers*. Pittsburgh: R. L. Polk Co., 1899.

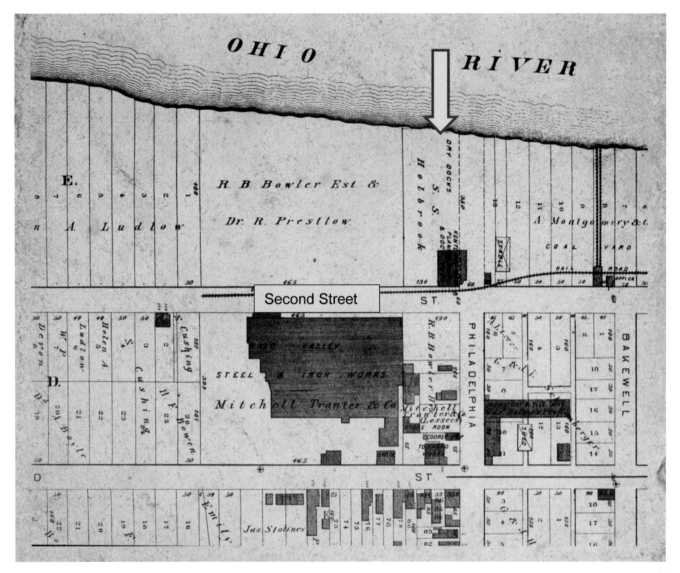

The 1877 Covington atlas shows the Covington Dock Yard at the end of Philadelphia Street. Source: Hopkins, G. M. *City Atlas of Covington, Kentucky.* Philadelphia: G. M. Hopkins, 1877.

Covington had several boatyards across the decades of the 19th century. In 1853 A. J. Alexander & Company was a lumber business located in Covington at the corner of Second Street and Scott Boulevard (formerly called Scott Street). In that year, Alexander launched a steamboat that was designed to operate between Cincinnati and New Orleans. In the same year, he built the sailing ship *Salem*, which was launched in Covington and sailed down the Ohio and Mississippi Rivers to the Gulf of Mexico, to the Atlantic, and then to New York City. From there, the *Salem* voyaged to Valparaiso in Chile. By the late 19th century, the foot of Scott Boulevard became home of the City Wharf and of the Covington Dock Company, which repaired "all kinds of river craft" (Marine Register 1899, 145).

During the late 1870s, another boatyard was located along the Ohio River at the corner of Second and Philadelphia Streets. Called the Covington Dock Yard of the Kentucky Saw and Planing Mill, an example of its handiwork included the *Kenton,* a ferryboat that operated for the Main Street Ferry between Covington and Cincinnati. In 1881 Commodore Sam Coflin purchased the Covington Dock Yard. In the early 1880s, under his guidance, the yard continued to build barges and steamboats, including the *Handy 2* (139 feet by 25 feet; 1883). Nearby, the Covington Iron Works (West Fourth Street) built the hull of the snag boat *E. A. Woodruff* (1874; lengthened in 1885 by Cincinnati Marine Ways; 226-foot length; 48-foot width; 7.6-foot draft). And, later, the Covington Machine

Works (location unknown) constructed the *Queen of St. Johns* (1885; 192.5-foot length; 363-foot width; 7.4-foot draft). Currently, Carlisle and Bray Enterprises, operating a fleet of towboats, has headquarters in Covington's RiverCenter.

CONQUERING THE RIVER?

Communication between Cincinnati and Covington had naturally been established very early on, be it social, commercial, economic, religious, or intellectual. Getting back and forth across the river was mostly a relatively easy task by johnboat or ferryboat, on horseback, by foot in the summer during low stages, or across the ice when it froze. But there were always those times and seasons that prohibited these modalities because of floodwaters or ice. From as early as 1815, there had been talk (more like dreams) of building a bridge between Cincinnati and Covington. But those dreams went nowhere except up in smoke. There just was not enough engineering knowledge—much less the finances or materials and resources—to accomplish such a feat. So the back-and-forth ferry had to suffice as far as crossing in style was concerned. In 1829 the bridging idea gained momentum when the Kentucky General Assembly chartered the Kentucky and Ohio Bridge Company, but Ohio failed to charter its own version and the idea died in the water. There was much concern among steamboat owners that bridges all along the inland rivers of America would essentially ruin the industry of river steamboat traffic because they would impede and prevent passage underneath them. Bridge designs were just not tall enough to allow the boat stacks to clear during high water. The steamboaters had a strong voice and political pull. Besides, the opponents claimed, the bridges would just make it easier for slaves to escape from Covington to the free North. There was also opposition among certain merchants and manufacturers in Ohio that a bridge would allow competitive goods from the South to interfere with Northern businesses. Finally, addressing all the issues brought forth by the various opponents, the Kentucky General Assembly proposed a new bridge charter, which, after both sides came to agreement on the various proposed amendments, the Ohio legislature approved in March of 1849. Now there was serious movement to construct a bridge that was high enough to allow steamboats, with their high fluted stacks, to pass beneath unobstructed.

The Ohio River at Cincinnati fell to 2.3 feet on October 27, 1895, matching the low-record years of 1862 and 1874, but slightly higher than the lowest recorded depth at Cincinnati, 1.9 feet in September 1881. This photo dates from October 1895. Courtesy of the Kenton County Public Library, Covington.

Despite Ohio's repeated objections, the northern boundary of Kentucky remained the low-water mark on the Ohio side. That meant that the commonwealth of Kentucky owned the entire waterway. Needless to say, the movers and shakers for the building of a bridge had to be Kentuckians, more specifically, Covingtonians, and even more specifically, Amos Shinkle, the Covington banker and philanthropist who headed the Covington and Cincinnati Bridge Company. Paced by the opening of the Covington and Cincinnati (now John A. Roebling) Suspension Bridge in 1867, there would follow more bridges connecting Covington and Cincinnati, as well as a system of dams and locks, administered by the US Army Corps of Engineers, that have both deepened the Ohio River

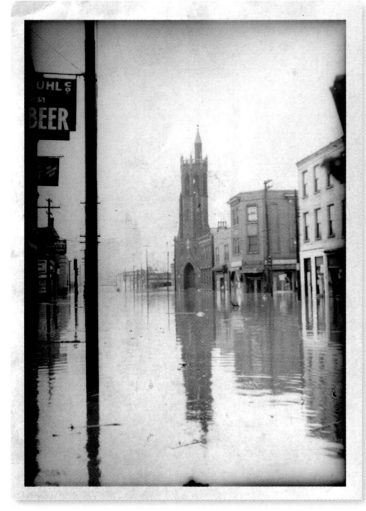

ABOVE: The 1937 flood backed up the Willow Run Creek, as seen in this photo from Western Avenue. The bell tower is that of St. John Catholic Church in the Lewisburg neighborhood. Courtesy of Paul A. Tenkotte. LEFT: The 1937 flood, looking north on Madison Avenue toward Trinity Episcopal Church. Courtesy of Paul A. Tenkotte.

and doubled its width. With these improvements, Ohio River commerce has continued to grow and prosper, and both Covington and Cincinnati have profited accordingly, ever being nurtured by "that old brown river's" enduring hold on their economies.

The Licking and Ohio Rivers flooded almost annually. But by the early 1800s, increases in flooding—due to deforestation—had begun to take their toll. Europeans settling the headwaters of the Licking River during the first half of the 1800s cleared land for farming and cut trees for charcoal to use in iron smelters. Covington native Daniel Carter Beard (1850–1941) expressed it best in his autobiography *Hardly a Man Is Now Alive.* As a consequence of removing the forests that retained water and soil, by the 1860s when it rained in the headwaters "the Licking was booming, a stream of liquid 'too thick to drink and too thin to plow'" (Beard 1939, 128).

Of course, the high-water mark of the floods varied greatly. Flood damage typically included homes, businesses, farms, and boats. For example, on August 26–27, 1848, the Licking River swelled beyond its banks. Two or three flatboats tore loose from their moorings, crashing into the abutments being constructed for the new Licking River suspension bridge at Fourth Street. The steamer *Sarah Bladen,* also on the Licking River, likewise broke loose and was rescued almost 2 miles down the Ohio River. The *Covington Journal* of September 1 found some humor in the flooding, stating that "from the fence-rails, pumpkins, and watermelons brought down by the flood in the Licking, we infer the farmers above have suffered some."

Major flooding along the Ohio and Licking Rivers occurred in 1883, twice annually in both 1907 and 1913, and the worst of all in 1937. The city of Newport, Kentucky, sitting at a lower elevation across the Licking River, typically fared worse than Covington in all of these floods. Nevertheless, Covington's susceptibility, especially through backwaters of Willow Run Creek from the Ohio—and Banklick Creek from the Licking—also placed it in a vulnerable position. Homes, businesses, and streets were submerged. Buildings were toppled from their foundations and literally floated away. Each time, the resilient people of the Ohio River valley rebuilt. The permanent solution to the problem of flooding in Covington would be found during the post–World War II years. Begun in 1948 and completed in 1955, the $8.9 million Covington floodwall and levee project now protects the city from minor and major flooding alike.

Resiliency, however, could not solve Covington's persistent concerns with pollution. Daniel Carter Beard candidly described the situation in the 1860s: "Covington had no sewers. All the ashes and garbage were dumped in the middle of the streets. The garbage was disposed of by the pigs, while the ashes were carried away by the street cleaners. Everybody in Covington drank rain water from cisterns. This water was a gray color, due to soot on the roofs, and it had a decidedly black, sooty taste" (Beard 1939, 141).

In 1869 Covington voters approved a waterworks construction project with a cost not to exceed $300,000 and to be constructed by the Holly Water Works. By 1871, 85,000 feet of water mains had been installed and connected to a well and pump system located downtown at Second and Main Streets. The well yielded water from the alluvium of the Ohio River. It was 18 feet in diameter and 71 feet deep, but was extended an additional 35 feet by driving a pointed and perforated 3-inch pipe into the gravel. It produced a purer water supply for the city. However, it was reportedly geochemically incompatible with water that was later obtained directly from the Ohio River, and ultimately the well was abandoned.

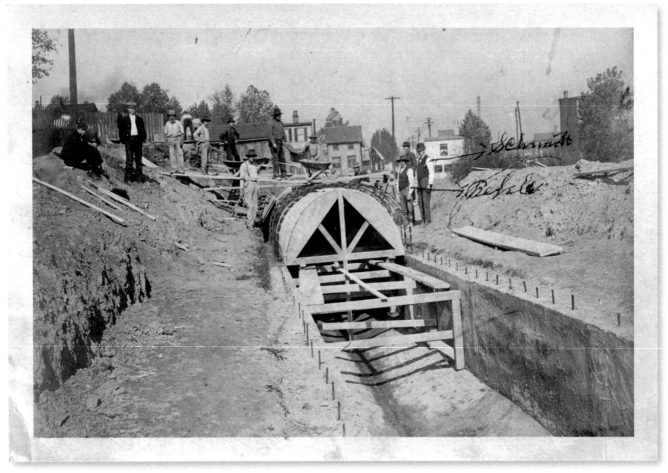

Willow Run Sewer construction, 1905–06. Courtesy of the Kenton County Public Library, Covington.

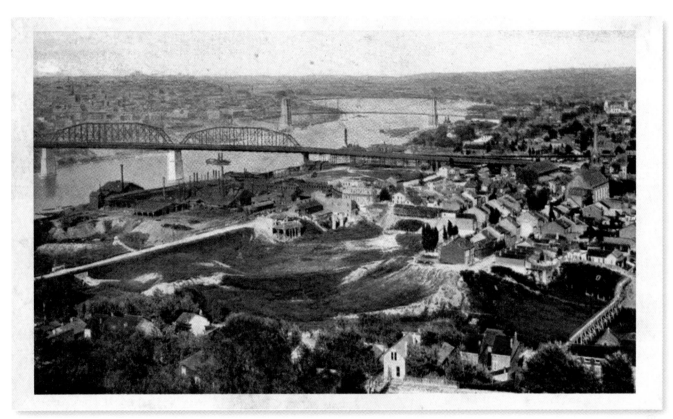

Willow Run, circa 1909. Courtesy of Paul A. Tenkotte.

Pollution in Covington increased steadily as the population grew. A large part of that pollution was owing to the lack of adequate collection and treatment of sewage. The construction of sewers was more contentious and less systematic than providing Covington with a municipal water supply. And until 1954, sewers simply dumped the wastes into the Ohio River. Early sewers built prior to the Civil War were built of wood, often from locust trees, and were prone to leakage. By 1891 the need for a half-mile-long, 10- and 12-foot-diameter masonry sewer down the stream channel known as Willow Run Creek (what is now the I-75/I-71 corridor) became apparent. Estimates of the costs ranged from $100,000 to $300,000. The issues of who would bear the costs and the need to condemn properties were controversial. The matter was litigated, and a city ordinance that had passed was ultimately found to be constitutional. Subsequently, several properties were condemned, a contract was let, and the tunnel was completed in January 1895 at a cost of about $70,000, including the purchase price of the condemned properties. Further Willow Run Sewer improvements followed in subsequent years. These still exist today, in essentially their original form, as the largest combined sewer (mixing storm runoff with human and industrial waste) overflow in Covington and Northern Kentucky.

With time, this infrastructure has aged and has become inadequate to handle increased runoff from new development and roads. What in the 19th century was a state-of-the-art system designed on the "Cincinnati Plan," in the 21st century evolved into an undersized, obsolete system that, as it was originally designed, discharges untreated human wastes into the Ohio River every time it rains. It has been the object of several green infrastructure projects by Sanitation District #1 (SD1) to minimize its impacts on Ohio River water quality. However, a final fix may require waiting for reconstruction of the Brent Spence bridge corridor, whose real estate the waste system occupies.

Compliance with federal regulations under the Clean Water Act requiring reduction in discharges from, or elimination of, "combined sewer" systems is a problem nationwide. But Covington's combined system has always been less than ideal. Within five months of the completion of the project at Willow Run Creek, the city was fined $4,000 by Kenton Circuit Court for allowing, as the *Kentucky Post* of May 14, 1895, reported, "a horrible stench caused by defective sewerage at Fourth and Scott Streets."

Sanitation District #1 was created in 1946 by amendments to the Kentucky Revised Statutes (KRS 220) that gave the SD1 broad authority to protect streams and to build and maintain a sewer system to collect sewage from 17 of the region's individual, municipally owned and managed sewer systems. The first SD1 treatment plant was opened in Bromley, Kentucky, in 1954. In 1948 the Ohio River Valley Water Sanitation Commission (OR-SANCO) was founded as an interstate compact to manage water quality on the Ohio River. The stricter standards for discharge it established required not just primary treatment of sewage (removal of solids) but also secondary treatment (biologic treatment and nutrient reduction), which the Bromley plant was not designed to do.

In 1979, largely with federal funding made available through the Clean Water Act, the Dry Creek Wastewater Treatment Plant was opened at Villa Hills, Kentucky, providing secondary treatment. Pump stations and collector sewers were constructed that ran along the Ohio and Licking Rivers to intercept sewage that would have been

This pristine scene of Banklick Creek from the 19th century contrasts greatly with the pollution problems that have beset the Banklick watershed in the 20th and 21st centuries. Source: Collins, Richard H. *History of Kentucky*. Vol. 2. Covington, KY: Collins & Company, 1882.

previously discharged directly into those water bodies, and the sewage was conveyed to the Dry Creek Plant.

In 1994 KRS 220 was again amended to increase SD1's authority, and by 1995, 28 cities, including Covington, had turned over ownership, operation, and maintenance of their sewer systems to SD1. In 2007 (in response to a lawsuit by the commonwealth of Kentucky and the federal government charging that SD1 was in violation of the 1972 and 1977 federal legislation collectively known as the Clean Water Act, CWA), SD1 entered into a consent decree that stipulates the actions it must take to comply with federal regulations by 2025 to reduce or eliminate the nearly 1 billion gallons of untreated sewage discharged into Northern Kentucky's waterways.

As of 2014, the Ohio and Licking Rivers both have water quality impairments as determined by OR-SANCO and the Division of Water of the Kentucky Environmental and Energy Cabinet. Both rivers typically have unacceptable levels of pathogens as measured by *Escherichia coli* bacteria after rainfalls that bring diluted sewage to the rivers.

The Licking River upstream from its confluence with the Ohio (river mile 0) to the confluence with Banklick Creek (river mile 4.8) partially meets Kentucky water quality standards for primary contact recreation (that is, swimming) and for warm-water aquatic habitat. This reach coincides with Covington's frontage along the Licking River. This is an improvement over previous 303(d) lists (formal documents listing streams that do not meet their intended uses under the CWA), in which the reach failed to meet standards even partially ("fully impaired"). The improvement is attributed to recent efforts by SD1 to reduce combined sewer overflows and, in the Banklick (Creek) Watershed, sanitary sewer overflows (SSOs). An SSO is a discharge, illegal under the CWA, from a failing or overloaded sewer. The pump station at SD1's headquarters was in 2002 the third largest SSO in the southeastern United States, and its illegal discharges have been significantly reduced in recent years through various updates and improvements.

In addition to water pollution, large debris drift issues remain problematic. Water in the Licking River, where it enters the confluence at The Point in Covington, is nearly always visibly more contaminated with silt and tree debris than water in the Ohio. This debris impacted a floating restaurant and nightclub complex that opened on the Ohio River at Covington Landing in 1990, which went bankrupt in 1997. The barges, upon which Covington Landing had been constructed, sank in 2006, two days after being sold by the city of Covington to a salvage company. In 2014 the historic Mike Fink Restaurant was moved from Covington, partly owing to costs associated with damage and complaints about debris that had been accumulating along the riverbank.

The debris problem has also adversely affected riverbank recreation. Covington was home to BB Riverboats, an excursion boat operation founded in 1979, offering lunch, dinner, late-night, and specialty cruises in the Cincinnati area. Ben Bernstein, the founder of BB Riverboats, also owned the Mike Fink Restaurant. BB Riverboats operated its fleet from Covington Landing at the foot of Madison Avenue. Its excursion boats included the *Betty Blake*; two different boats named the *Mark Twain*; the 350-passenger *Becky Thatcher*; the *Huck Finn*; the 90-passenger *Good Ship Lollipop*; the 180-passenger *Kon Tiki*; two separate boats named *River Queen*; the 600-passenger *FunLiner* (the old *Chaperon*, formerly owned by Johnston Party Boats); and the flagship vessel, the 1,000-passenger *Belle of Cincinnati*. Sadly, in December 2005, following the closing of Covington Landing, BB Riverboats moved to Newport, Kentucky.

Another pervasive problem along the Ohio and Licking Rivers in Covington and elsewhere is stream bank erosion and other damage to aquatic ecosystems. Construction of the Markland Dam on the Ohio River downstream from Covington was completed in 1964, raising the pool level (the normal height of water behind the dam) 22 feet. This contributed to erosion and loss of habitat for aquatic species. In Covington, the effects of erosion that are of most concern are along Riverside Drive at The Point and along the Licking River upstream from its confluence with the Ohio River. The shoreline of the Licking River, between the confluence and the Fourth Street Bridge, has retreated at least 10 feet and has lost more than a dozen large trees to erosion between 1998 and 2014.

In 2014 the Covington City Commission responded to concerns that the historic stone wall at the end of Riverside Drive was on the verge of collapsing, that there was loss of riverbank elsewhere along the waterfront, and that there was a decline in the aesthetic appeal of the city's most visible and iconic areas. The commission moved to have measures put in place to stabilize the riverbank. The action is part of a larger economic development project to rejuvenate Covington's Riverfront. These measures were designed not to interfere with the longer-term Ohio River Ecosystem Restoration Project envisioned by the US Army Corps of Engineers (USACE) and authorized, but not funded, by the US Congress in 2001. That study endeavored to identify the damage caused by the dam impoundment and other USACE activities on the Ohio River and its tributaries, including mussels habitat, shoreline erosion, and loss of spawning habitat for fish. Recreation opportunities for Covington residents have also been lost, with sand beaches along the Ohio having been drowned out by the perennially high water.

Also in 2014, with support from South Bank Partners Inc., the USACE held a four-day planning session to evaluate and design riverbank improvements in which city staff and a Covington citizen participated. The focus on ecosystem restoration was based in part on the legal authority that the Corps has to participate in such efforts. Previous efforts to develop a plan using economic development as a rationale had not gone forward. A report is due in July 2015 that will focus on long-term restoration of the riverbanks and associated ecosystems.

Covington owes its founding, its prosperity, and its future to the Ohio and Licking Rivers. While flooding has largely been controlled with the building of massive floodwalls and levees, problems of water pollution, debris, and erosion remain. As Greater Cincinnatians increasingly return to the riverbanks to enjoy the scenery and recreational opportunities they afford, we need to continue to work for sustainable solutions to ensure the viability of our rivers for future generations.

SELECTED BIBLIOGRAPHY

Beard, Daniel Carter. *Hardly a Man Is Now Alive: The Autobiography of Dan Beard*. New York: Doubleday, Doran & Company, 1939.

Cleary, Edward J. *The ORSANCO Story: Water Quality Management in the Ohio Valley under an Interstate Compact*. Baltimore: Johns Hopkins University Press, 1967.

Johnson, Leland R. *The Falls City Engineers: A History of the Louisville District, Corps of Engineers, United States Army*. Louisville, KY: US Army Corps of Engineers, 1974.

———. *The Ohio River Division, U.S. Army Corps of Engineers: The History of a Central Command*. Cincinnati: U.S. Army Corps of Engineers, Ohio River Division, 1992.

Marine Register of the Ohio and Mississippi Rivers. Pittsburgh: R. L. Polk Co., 1899.

Northern Kentucky Newspaper Index. Kenton County Public Library, Covington, KY.

Reid, Robert L. *Always a River: The Ohio River and the American Experience*. Bloomington, IN: Indiana University Press, 1991.

Robinson, Michael C. *History of Navigation in the Ohio River Basin*. Washington, DC: US Government Printing Office, 1983.

Schrage, Robert, and Donald Clare. *Along the Ohio River: Cincinnati to Louisville*. Charleston, SC: Arcadia Publishing, 2006.

Tenkotte, Paul A., and James C. Claypool, eds. *The Encyclopedia of Northern Kentucky*. Lexington, KY: University Press of Kentucky, 2009.

Way, Frederick Jr., comp. *Way's Packet Directory, 1848–1983*. Athens, OH: Ohio University Press, 1983.

Way, Frederick Jr., and Joseph W. Rutter. *Way's Steam Towboat Directory*. Athens, OH: Ohio University Press, 1990.

Welky, David. *The Thousand-Year Flood: The Ohio-Mississippi Disaster of 1937*. Chicago: University of Chicago Press, 2011.

White, John H. Jr. *Wet Britches and Muddy Boots: A History of Travel in Victorian America*. Bloomington, IN: Indiana University Press, 2013.

Williams, Geoff. *Washed Away: How the Great Flood of 1913, America's Most Widespread Natural Disaster, Terrorized a Nation and Changed It Forever*. New York: Pegasus Books, 2013.

CHAPTER

14

FROM CITY COUNCIL TO CITY MANAGER: GOVERNMENT IN COVINGTON

by Joseph Hinds and John T. Spence

COVINGTON, Kentucky, was, and still is, a city of bridges. In both a physical and an allegorical sense, Covington's politics, government, law, and judiciary have evolved with the community's bridges. As bridges were constructed and enhanced, Covington's local government also adapted to changes in the city, in the Cincinnati metropolitan area, in the commonwealth of Kentucky, and in the nation. The wedding of directional and philosophical gateways by Covington's government spans the years with a unique connectivity.

The story of Covington is also the story of politicians, lawyers, and judges bridging cultural and economic differences. Covington's political leaders were open to change in order to do the right thing for their community. It is a story that illustrates the city's great capacity to reenvision itself while maintaining a deep respect and admiration for its cultural and social history.

Covington is a city that looks forward while vigilantly protecting its heritage, innovatively connecting past to present to future. These temporal gateways are what contribute to the city's strength of character, allowing it to reposition itself in times of challenge and to reenergize itself to take advantage of opportunities. Covington, the gateway city, is poised to continue to adapt while still remaining true to its heritage.

The common thread that runs through the city's politics is a metaphorical bridge connecting Covington politicians, lawyers, and judges to the citizens. Far from perfect, many times politicians did the right thing for the community of Covington because they had a vested interest in improving their city. They lived here. Even a selfish sentiment to improve the value of their neighborhood translated into making a better community for their neighbors and friends.

You can find lists of Covington's mayors, city managers, population, and other fascinating facts and stories on the website of the Kenton County Public Library. See kentonlibrary.org/genealogy/regional-history/covington.

GATEWAY TO THE WEST: THE FORMATIVE YEARS, 1815–45

Our story begins with the early formation of a trustee government in Covington, which originally was in Campbell County, since Kenton County was not created until 1840. On February 8, 1815, the state legislature granted a charter to the Covington Company to incorporate the town of Covington, appointing five trustees to manage

the town. These trustees were prominent military officers, merchants, and social pillars. They attracted businesses, improved roads, provided very basic services, and assisted in fighting smallpox and cholera epidemics. They made Covington a better place to live because their families lived here too. These trustees, acting on behalf of the Covington Company, sold city lots and recorded land titles. The 299 lots included in the plat were aligned in a checkerboard pattern matching the street design of Cincinnati, so that Covington was, in effect, an extension of its northern neighbor.

The Covington Company promoted town lots through auctions. It advertised the young town as being well positioned among the main rivers and roads, opposite the flourishing city of Cincinnati. The trustees worked closely with the Covington Company, offering incentives for companies to move to Covington. The early lots were sold for a few hundred dollars. Clearly, these promoters were tying their Northern Kentucky investments to the market of Cincinnati. The Queen City of Cincinnati was a green welcome mat carved in the hills, attracting travelers coming down the Ohio River who found work in the area and stayed.

The local excitement around the birth of Covington was painted against the backdrop of a statewide political storm raging over economic downturns, banking growing pains, and state legislative conflicts with the court system. The national financial panic of 1819 filtered down to Covington, as real estate values plummeted.

On April 1, 1826, 38 townspeople turned out to vote in the first election of trustees. Seven trustees were elected by voice vote. About two weeks later, the first city ordinance imposed an annual tax on animal owners. The most expensive animal to own was a horse. Horse owners were taxed 50¢ per horse, while cattle and hog owners only had to pay one-fourth of that price. But on February 17, 1827, the trustees repealed the tax on milk cows. On April 17, 1826, one of the first criminal laws passed by the trustees was a fine of $10 for cockfighting. However, this law was removed from the penal code less than a year later since the trustees recognized that "Kentuckians enjoyed their cockfighting" (Harrison 1876).

On December 23, 1828, Mortimer Murray Benton was appointed city clerk by the trustees. Benton went on to become a famous local attorney and politician by working his way up the town's political ladder. Benton became a commissioner of taxes in 1831, a difficult year as smallpox ravaged the community. A house on the west side of town was designated for patients afflicted with the disease. He was selected to be tax collector in 1832, the year of the Great Flood. As the appointed census taker in August of 1832, Benton reported that there were 1,433 people in the town. Within 17 years, Covington had become a thriving community. In the fall of 1832, cholera attacked the town, and the trustees raised money to help citizens who had the disease. In June 1833 Benton was named the tax assessor, and he promptly increased taxes.

On February 24, 1834, the town of Covington became a city. The first city charter was granted by the Kentucky General Assembly, giving limited powers to a mayor and control to city councilmen. On April 5, 1834, Benton, now in the law firm of Phelps and Benton, was elected Covington's first mayor. Also, eight councilmen were elected from four wards. Though Benton was the mayor only until October 2, 1835, he continued his public service as president of the city council from 1849 to 1853. Additionally,

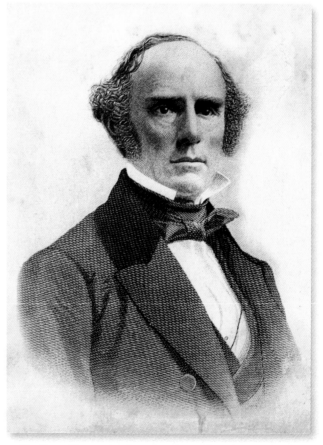

Mortimer Murray Benton. Courtesy of Paul A. Tenkotte.

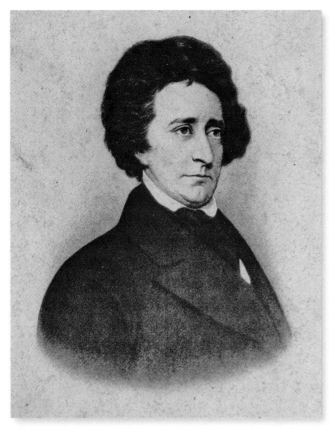

William Wright Southgate. Courtesy of the Kenton County Public Library, Covington.

he represented Kenton County in the Kentucky legislature. He also was president of the Kentucky Central Railroad Company. Benton was buried on March 6, 1885, in Highland Cemetery in Fort Mitchell, Kentucky. During his service to the community, he improved the condition of roads to and from Covington and was able to attract businesses into the area.

Benton's law partner, Jefferson Phelps, became a trustee on November 9, 1827. Phelps, the son of a county judge, represented the city's trustees in Frankfort, Kentucky. He was an advocate for state legislation that assisted the city, relating to many issues, including improving roads to Covington. Phelps was declared assistant tax assessor in May 1833. Then he was appointed Covington's first legal adviser, a position later known as city attorney.

William Wright Southgate, another attorney in Benton's law firm, was appointed mayor pro tem to replace Benton on October 2, 1835. He received $30 for handling the job until the next election. On October 17, 1835, Southgate was elected Covington's second mayor in a special election. He lived in the Gano-Southgate House on 405 East Second Street, sometimes known as the Carneal House. Southgate resigned in 1836 to run for Congress, and he was successfully elected as a Whig candidate to one term as a US representative 1837–39. He was an unsuccessful candidate for governor at the Whig convention in Louisville, Kentucky, in 1843. He returned to his practice of law, continuing to offer guidance to those in city offices. Covington businesses closed in honor of the very popular Southgate for his funeral on December 28, 1844.

Moses V. Grant served as the third mayor of Covington, elected on August 20, 1836. He was the first mayor to regard his position as more than merely honorary. In an effort to pressure the council into doing what he thought was right for the city, Grant stood up against council members for two terms. On February 6, 1845, he resigned under pressure from the city council. Frustrated with politics, he died a hero on October 5, 1846, during the Mexican-American War at Fort Laredo, Mexico.

Andrew Jackson was elected US president in 1828. The townspeople of Covington generally did not favor Jackson, who exercised strong executive power. His opponents called themselves American Whigs, identifying with the British political party who emphasized legislative power. Henry Clay, a great Kentucky statesman and orator, and known as "The Great Compromiser" for his efforts to maintain the union, was the leader of the Whigs. Clay organized the party with John C. Calhoun and Daniel Webster, creating a national movement.

The Whigs in Northern Kentucky included both wealthy slaveholders and poor nonslaveholders, who liked the Whigs' support of improved navigation along the Licking and Ohio Rivers. In Northern Kentucky, both the *Licking Valley Register* and the *Covington Journal* were Whig newspapers. On September 2, 1843, Robert Wallace from Covington was elected chairman of the Democrats, the party opposing the Whigs, at a meeting of delegates to the 10th Congressional District. Wallace led the attacks on the Whigs in Northern Kentucky. James T. Morehead, who later practiced law in Covington with John White Stevenson, was elected governor in 1834 as a Whig. He later became a Whig party US senator 1841–47.

Covington also had a sizable minority affiliated with a Democrat splinter group called Locofocos, named after "locofoco" matchsticks that they used when the traditional Democrats turned the lights out on them in 1835 at a

meeting in New York City. The Covington Locofocos, opposed to banks and monopolies, received support from the *Covington Union Democrat* newspaper.

On January 29, 1840, Kenton County was created, carved out of portions of Boone and Campbell Counties. By 1845, Covington followed the national shift toward mobilizing the masses and incorporating the values of Jacksonian Democracy. On February 10, 1845, the Kentucky General Assembly amended Covington's charter to create a managerial mayor.

GATEWAY TO THE SOUTH: 1845-92

Covington also implemented an at-large system in 1845 to elect city council members, designed to allow citizens to vote for all candidates on the ballot, and to encourage elected officials to focus on the entire community, rather than just a small district or ward. The benefit of an at-large system was to move away from parochial interests, allowing political leaders to focus on the big picture and to conduct more long-term planning. But there was a downside. It also diminished the political clout of minorities, leaving them without representatives to protect their interests. Unfortunately, this is what happened, as old-guard politicians ignored minority and ethnic interests.

The 1845 system of city government, in addition to a council elected at large, included a managerial mayor. On February 18, 1845, Bushrod W. Foley, born in Virginia, was the first mayor elected under this new form of government. Foley, a local attorney who lived at Front and Russell Streets, was appointed director of the Covington and Lexington Railroad while he was mayor. Like most Whigs, he furthered capitalistic enterprises. Foley's ability to negotiate with investors, and his position as mayor, strengthened the company's weak financial position, leading to the success of the railroad line.

As Covington grew, its rural, rustic setting evolved into an urban gateway to the South. Citizens of Cincinnati and southwest Ohio saw Covington as a fertile field for investments, for buying homes, for transportation south, or for recreation. Covington attracted assertive and talented leaders, including politicians, attorneys, and judges, who knew how to get things done. By 1850, Covington was the second-largest city in the state, with a population of 9,408. It had its own industrial base, which included tobacco companies, pork and beef packing plants, iron manufacturing plants, a brewery, cotton plants, sawmills, and flour mills. This set the stage for stronger mayors, who worked directly with these businesses.

Within less than a decade, the Whig Party collapsed under the weight of the slavery issue. The Covington election of January 1855 brought a new party onto the stage called the American Party, or more popularly, the Know-Nothings. It began nationwide as a secret group with antiforeign and anti-Catholic sentiments. Their name derived from the answer its members gave when people asked them about the inner workings of their party. Mayor Foley and 17 other politicians won office under this party's banner. However, the Know-Nothings fell apart about as quickly as they appeared, due to disagreements over the issue of slavery as well as a riot that erupted in 1856 in Covington between the German-American Turner Society and nativists. Foley was the first mayor to become an officer in the Civil War, serving as a colonel in charge of the police guard for the Kentucky Central Railroad. He served as mayor for almost 15 years, until 1860. As former mayor, he participated in a February 12, 1861, Cincinnati parade welcoming President-elect Abraham Lincoln (1860–65) to the Queen City, on his way to his inauguration in Washington, D.C.

Noticeably absent at the Cincinnati parade welcoming Lincoln, because he refused to participate, was the new Covington mayor, John A. Goodson, who served from 1860 to 1862. Goodson, a general contractor and builder, was a Jacksonian Democrat. Born in Alabama, he took a very active role in local politics, not only as mayor but also serving as president of the city council. National politics were heating up. The Republicans became the antislavery party, leaving the national Democrats split into two factions by the Mason-Dixon Line. The Civil War began soon after Abraham Lincoln came to power. Goodson was followed as mayor by Cyrus A. Preston, who served from 1862 to 1865. Both mayors attempted to keep commerce going with their northern neighbors. Meanwhile, the Civil War halted construction on the Covington and Cincinnati Suspension Bridge. In late August 1862 Confederate

General Kirby Smith took the town of Paris, Kentucky, about 65 miles south of Covington. General Lew Wallace, who later wrote the novel *Ben-Hur*, set up Union defenses around Covington, in preparation for an attack. The Confederates, who advanced as far as Vickers farmhouse near Fort Mitchel [*sic*], retreated to Perryville, Kentucky, where they fought their final major battle in Kentucky on October 8, 1862. Except for cavalry raids by John Hunt Morgan, Covington was not threatened again by Confederate forces.

Amos Shinkle, who served on the city council, was an important local politician who worked behind the scenes to better his community. Shinkle, president of the Covington and Cincinnati Bridge Company, ensured that the bridge connecting the two cities, now called the John A. Roebling Suspension Bridge, was completed after the Civil War. He also brought gaslights, water, and telephone service to Covington.

The bridges connecting Cincinnati with Covington were a symbolic and practical balm to help healing after the Civil War. Bridges brought the North and the South together for commerce and recreation. The mixing of cultures negated much of the Civil War resentment.

John White Stevenson

John White Stevenson. Courtesy of the Library of Congress.

John White Stevenson (1812–86), an attorney, served on Covington City Council in 1850. He also served 1845–49 in the Kentucky House of Representatives, and then as a US representative 1857–61. He later became the first governor of Kentucky from Covington. Elected as Kentucky lieutenant governor in 1866, just after the Civil War ended, Stevenson, a Democrat, assumed the office of governor after the premature death of Governor John L. Helm. Stevenson was governor 1867–71 and helped to heal the wounds of war by finding common ground between the former combatants. As governor, he had to call in the state militia to halt violence against blacks who were attempting to obtain the right to vote. After being governor for almost four years, he served in the US Senate for the next six years, giving him the distinction of serving in both houses of the US Congress.

Judge John William Menzies

Judge John William Menzies (1819–97) was admitted to the bar and practiced as an attorney in Covington, Kentucky. He became a member of the Kentucky House of Representatives from 1848 to 1855. He was elected as a Unionist to represent Kentucky in the US House of Representatives, serving from 1861 to 1863. Menzies resumed his legal profession in Covington and was also a delegate to the Democratic National Convention in 1864. He became judge of the chancery court in 1873 and presided over the bench until 1893. Menzies died on October 3, 1897, and was buried in Linden Grove Cemetery in Covington.

John Griffin Carlisle

John Griffin Carlisle (1834–1910), a lawyer from Covington, became the leader of conservative Kentucky Bourbon Democrats, who supported business interests. He served in the Kentucky House of Representatives (1859–61) and in the Kentucky Senate (1866–71). Carlisle was elected lieutenant governor of Kentucky from 1871 until 1875. He served in the US House of Representatives from 1877 until 1890, and was Speaker of the US House of Representatives 1883–89. Carlisle was a US senator from 1890 until 1893. He was a conservative, probusiness politician, supporting President Grover Cleveland (1885–89 and 1893–97). When Cleveland was elected president in 1892, he selected Carlisle to be

John G. Carlisle. Courtesy of the Kenton County Public Library, Covington.

secretary of the treasury. In the panic of 1893, the public made a run on the American gold supply. Carlisle put a halt to the treasury's production of silver coins, irritating agrarian Democrats. He practiced law in New York City, where he died at the age of 75 on July 31, 1910. He was buried in Linden Grove Cemetery in Covington.

The three Covington mayors serving 1865–77 were Cassius B. Sandford, 1865–68; Leander Evans Baker, 1870–74; and Robert A. Athey, 1874–90. Sandford was elected mayor in 1865, and served during the opening of the Covington and Cincinnati Suspension Bridge, a connection that significantly stimulated growth in Covington.

Covington needed a source of pure drinking water, and the city council acted to secure one. On October 19, 1867, the council approved a water contract with Cincinnati, whereby Covington would pump Cincinnati water across the river to supply Covington residents. Some Covington citizens were convinced that their council members had received bribes for their votes on this issue. A lengthy special investigation failed to prove that metropolitan "boss rule" (the name given to corrupt politicians who could be bribed) was behind the Cincinnati-Covington water contract. However, the citizens of Covington suspected that there was widespread corruption in their city government, and the water contract fell by the wayside. During Mayor Baker's tenure in 1870, the Covington city commission signed a contract with the Holly Manufacturing Company to develop a waterworks system for the city. It was completed and fully operational on February 20, 1871. Nevertheless, to many it appeared that the corruption of boss rule in Cincinnati had crossed the bridge and had permeated Covington's politics, law, and judiciary. Either way, Covington now had a functioning, albeit imperfect, water system.

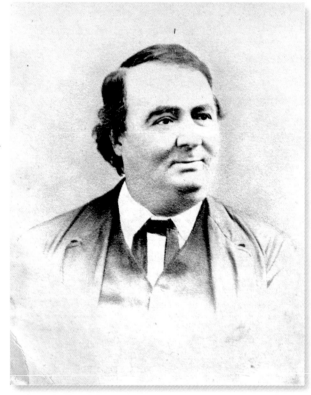

Robert A. Athey. Courtesy of the Kenton County Public Library, Covington.

Robert Athey's term as mayor extended into a period called the "New South," which was moving away from its rural roots and focusing on industry. Even though Athey was affiliated with the Union Labor Party, a forerunner of the Populist movement, he still supported industry in the area. Athey was mayor when business monopolies, including railroad companies, were availing themselves of the plentiful labor force of Covington. During his tenure, labor unions organized and became more powerful. Athey also welcomed the immigration of Germans and other nationalities to Covington.

The late 19th century witnessed an agricultural revolution in the United States. New technology and improved seeds led to greater productivity. Agriculture increasingly shifted from subsistence to commercial farming, but a transition also occurred in political affiliations. While politicians had been very attentive to the needs of industry and transportation, they often ignored the concerns of both farmers and the urban working class. Farmers began to support Granger laws at the state level, attempting to regulate the abuses of large corporate railroads and warehouse interests that squeezed them. The Grange society led to politically active alliances that became the genesis of the Populist Party.

The Populist movement gathered strength throughout the United States in the last half of the 19th century. Big businesses were growing bigger, with power in the hands of a few men, and national politics were dominated by industrial interests. Covington's politics paralleled that of the nation's, which featured special interest groups. Some

businessmen had great influence over politicians. The stage was set for a new party to enter the ring. The Populists, spinning off from the Farmers' Alliance and other groups, were determined to bring ethics back to government.

GATEWAY TO THE NORTH: POPULISM, 1891–1914

Covington and all Kentucky cities had been handcuffed by politicians in Frankfort for much of the 19th century. The Kentucky General Assembly required municipalities to obtain permission from the state for most of their actions. The Kentucky constitution was revised in 1891, granting Covington and other cities in Kentucky municipal home rule, allowing them to make basic decisions without having to run to the legislature every couple of years for approval. In Covington's case, home rule allowed it to turn its attention from the politics of the South to becoming a gateway connecting to the North.

Many voters were very dissatisfied with traditional politicians, attorneys, and judges. Corporate corruption, particularly by railroads, had dominated the ballot boxes, and citizens were disgruntled. Decades of extremist positions, ranging from late 19th-century scandals to big-business profiteering, had taken their toll. Citizens wanted their individual rights protected.

Covington, a second-class city under the new state constitution, adopted a charter creating a weak mayor with a bicameral legislature, reflecting the values of Populism by expanding the reach of democracy. The mayor again became a ceremonial position, with 10 council members elected to represent five wards, and seven aldermen elected at large, following the requirements of the new state constitution. This was an interesting bicameral approach, reflective of the Senate and House of Representatives of the US Congress. In Covington's case, the aldermen were more like senators, with special focus on the larger, overarching needs of the city. On the other hand, the councilmen were similar to representatives, representing the needs and interests of their wards.

In May 1891 the National Union Conference was held at Music Hall in Cincinnati. More than 1,400 delegates attended, setting the stage for the establishment of a new Populist party nationwide. Kentucky attendees to the conference crossed the river into Covington and established the Populist Party of Kentucky, choosing a slate of candidates for the 1891 Kentucky elections.

Joseph Rhinock. Courtesy of the Kenton County Public Library, Covington.

Joseph L. Rhinock, a Democrat and a Populist sympathizer, was elected in 1892 as Covington's mayor. Rhinock had been employed in oil refining and was president of the Covington Public Library Board. He was the organizer and first president of the Jefferson Democratic Club of Covington. He also was active in theater management in New York City and Cincinnati, and was vice president of the Shubert Theatre Corporation and Loew Theatrical Enterprises. He served two terms as mayor, until 1900. Rhinock also served three terms in the US House of Representatives, from 1905 until 1911. He died on September 20, 1926, in New Rochelle, New York.

The height of political discord in Covington came in November 1899, with a highly contested mayoral race between William A. Johnson and George Davison. The election was marked by irregularities. Johnson was named mayor (1900–03), though lengthy litigation by Davison followed.

In November 1903 the mayoral election resulted in the election of George T. Beach, 1904–07, and Covington's boss rule came to an end. He was followed as mayor

by John J. Craig, 1908–11, and George E. "Pat" Philips, 1912–15. Mayor Beach, born in 1843 in Tredegar, Wales, was the only Covington mayor born in Britain. He was also active in the community as a painter and a banker, with a strong interest in reforming municipal politics. Mayor Philips, an attorney, continued his service as the commissioner of public finance from 1916–17 and as a judge of the police court from 1926–29. Mayor Philips's term was a transition to progressive influences. He worked with the Political Equality League in Covington to obtain a larger, more professional day care nursery center, emphasizing progressive, ethical needs of the community.

William Goebel

At the end of the 19th century, William Justus Goebel (1856–1900), a Democrat from Covington, was elected governor of Kentucky. He was a law partner with Governor John Stevenson and Senator John G. Carlisle. Goebel worked behind the scenes forming political coalitions that supported African Americans' and women's rights, as well as urban progressive goals. He attacked the power of the railroads and corporations. On April 11, 1895, Goebel shot and killed John Sandford, a political opponent who was the son of Charles Sandford (the mayor of Covington in 1865). Since there was a question as to which man had drawn his pistol first, Goebel was not indicted. Some wondered if John Sandford even had a gun.

In the gubernatorial election of 1900, Goebel's Republican opponent, William S. Taylor, was certified by the election commission as the winner. But the legislature, with a Democratic majority, had the final decision. On January 30, 1900, Senator Goebel was shot as he walked to the state capitol to be sworn in as governor. The legislators declared Goebel as the new governor, and he was sworn in on his deathbed on January 31, 1900. He died on February 3, 1900. Sixteen people were indicted for his murder, but only three were convicted. Eventually, all three men received pardons. Goebel was considered by some a martyr for progressive reform. His body lay in state in Covington, where thousands of his supporters passed by his coffin to pay their final respects.

William Goebel. Courtesy of Paul A. Tenkotte.

Orie Solomon Ware

Judge Orie Solomon Ware (1882–1974), an attorney and a US Representative, was born in a log cabin in Pendleton County, Kentucky, but moved to Covington in 1888 with his parents. In 1903 he was admitted to the bar and in 1910 practiced as an attorney in Covington with his law partner and mentor, former Kenton County Circuit judge William Shaw. Ware was a member of the Democratic Party and served as the postmaster of Covington from 1914 to 1921. He was the commonwealth attorney for the 16th judicial circuit from 1922 to 1927, after which he resigned to accept election to the US House of Representatives, serving from 1927 to 1929. Later, Ware served as a Kentucky Circuit Court judge from 1957 to 1958. He died on December 16, 1974, and was buried in Highland Cemetery in Fort Mitchell.

Orie S. Ware. Source: *Pictorial and Industrial Review of Northern Kentucky.* Newport, KY: Northern Kentucky Review, 1923.

At the turn of the 20th century, a new movement was in vogue—the Progressive movement. The breakdown of honesty in government drove many voters to search for better candidates. The Progressive movement was a continuation, to a certain extent, of Populism, but gave the people even more control over their government. It championed home rule, so that Progressives achieved great changes at municipal levels.

GATEWAY TO THE MODERN INDUSTRIALIZED WORLD: PROGRESSIVISM, 1914–30

Annexation of Latonia and Rosedale, located just west of Covington, had been discussed in the early 1900s, but the impetus to take action originated from the new Populist support, emphasizing access to better municipal services. These cities had been annexed in November 1908, in hopes of improving their schools, fire departments, and tax base. The residents of West Covington followed suit and voted for annexation in November 1916. Progressivism, focusing on the many benefits that a good government could provide its citizens, became the political gateway to the modern industrialized world. Often associated with President Theodore Roosevelt (1901–09), Progressivism pushed for honesty in government and regulation of big business, always emphasizing an overall awareness of the public good. It supported economic individualism and political democracy, returning to the "good old days" of morality and civil purity.

In 1910 the Kentucky legislature granted second-class cities like Covington the authority to change their form of government. Accordingly, in 1914, Covington abolished its bicameral council and established a commission form of government, with five commissioners elected at large. This action followed the Progressive ideals of finding solutions to problems for the entire community and doing so in a professional manner devoid of elements susceptible to graft and corruption. Hence, Covington terminated ward elections, which had focused on the needs of small neighborhood wards, and which were more vulnerable to boss rule. The four commissioners became like a board of directors in a business. The mayor was largely a ceremonial position, acting as city ambassador. Covington also embraced "good government" reforms, including a civil service system, with merit employees.

In 1916 Covington Mayor John J. Craig, a Republican businessman, attempted to curb gambling and corruption in the city. However, Covington had just transitioned to a commission form of government, with four commissioners elected at large and a weak mayor. Even though the mayor wanted to make changes, he simply did not have the power. However, the commissioners were successful in pursuing beautification of the city and in enhancing education. Later, in 1919, Craig was elected Kentucky state auditor.

John J. Craig. Courtesy of the Kenton County Public Library, Covington.

Covington was able to form coalitions and unite with other Northern Kentucky municipalities in order to become more efficient. Eight cities, including Covington, united to form a Northern Kentucky fire and police service, well in advance of the current 911 emergency dispatch system. These municipalities agreed to come to the aid of each other in case of a major emergency, thereby eliminating redundant expenditures. The new Progressive paradigm was based on municipalities being more like businesses than political entities.

Covington offered enticements to bring businesses to the city during the 1920s. Mayor Thomas F. Donnelly, serving two terms (1920–23 and 1928–31), and Mayor Daniel O'Donovan, serving one term (1924–27), encouraged businesses to locate in Covington by suspending unnecessary regulations, reducing taxes, and offering subsidies. Donnelly, of Irish ancestry, was born on October 27, 1870, in Covington. His business acumen made him a natural for the role. O'Donovan,

also of Irish descent, was born on December 4, 1874, in Covington. He and his predecessor had much in common, so he continued Donnelly's policies. He was an active member of the Covington community and of St. Mary's Catholic Cathedral. As a Progressive mayor, he made house calls to visit his constituents. Citizens considered him a friend for their causes. After his term as mayor, O'Donovan became a salesman in Cincinnati, dying on June 26, 1943.

Mayor Donnelly was elected for a second term from 1928 to 1931. While he was mayor, the city imposed zoning regulations promoting the public health, safety, morals and general welfare of the city. Nationally, the stock market crashed on October 29, 1929, leading to the Great Depression, which may have been a catalyst for Covington's electorate to adopt the new city manager form of government.

Thomas Donnelly. Courtesy of the Kenton County Public Library, Covington.

GATEWAY TO MODERNITY: CITY MANAGER GOVERNMENT, 1930–

Covington's adoption of a new city manager form of government in 1930 was not without controversy. Progressive ideals led some in the community to suggest that the commission plan of government failed in many respects; for example, compared with the previously used bicameral system, the commission form relied upon the decision making of only a few elected officials and thus offered more potential for graft. Further, Progressives argued that elected officials who set policy should not also administer that policy as department managers. They maintained that policy and administration should be separated in the name of checks and balances. Finally, Progressives pointed out that the commission form relied upon full-time elected officials, costing the community more in salaries and denying the community's successful business leaders an opportunity to serve. Commission supporters, however, liked the efficiency of having only a few elected officials to make decisions. They pointed out that the former bicameral system was not an effective way to support citywide projects, as politicians serving a ward-based constituency were less likely to appreciate the need to raise taxes or to choose the city's greater needs over their localized self-interests. This, proponents of the commission system argued, had led to poorly run and ineffective city government.

At first, Progressives, like Thomas F. Donnelly, mayor since 1920, challenged the commission form of government by asking voters to reinstate the bicameral system of government, stating that the commission form was "doomed." However the election results of 1922 shattered that plan when the voters approved keeping the commission form, 6,460 votes to 5,675. Despite the setback, and as a commissioner from 1924 to 1928, Donnelly continued to work to change Covington's government. In 1927, as he campaigned for a second term as mayor, he was joined in his opposition to the commission form by Covington business leaders under the banner of the Covington Industrial Club. With his November election as mayor, and with the support of the business community, Donnelly was able to present voters a new alternative to commission government.

The city manager governmental form, which was growing more popular nationally as a model for "good government," was adopted by Cincinnati in 1924. It was able to unite disparate political interests because it integrated what was considered the good business practices of the commission form (efficient decision making and at-large elections) with the separation of political policy making from professional administration (a Progressive ideal) under a city manager acting as chief executive of the city. Under Donnelly's leadership, Covington adopted city manager government in 1930, but retained the term *commissioner* for each council member.

Donnelly and his Progressive allies also introduced city planning to Covington. In the late 1920s Ladislas Segoe, who had previously completed a comprehensive plan for Cincinnati at the behest of the city's Charterites,

was asked to develop a plan for Covington. Approved in 1932, the plan for Covington received wide exposure in the field of city planning for its visionary nature and became a model used for planning in other American cities.

Concerns about Covington's form of government did not end, however. In 1940 the Covington Voters League circulated petitions to bring back the "Councilmanic" form of government used between 1892 and 1914. This effort, though unsuccessful, was largely motivated by a continual challenge the city faced throughout most of the 20th century, debt and the need to raise taxes.

Covington, like most modern cities in the early 20th century, faced the growing pains associated with providing modern conveniences, like safe streets, clean water, a sewer system, and police and fire protection. In addition, new demands were added, such as organizing a health department and hiring a plumbing inspector to ensure proper sanitation. These conveniences could be expensive, particularly during the early half of the century, when Covington employed a large workforce providing much of the Northern Kentucky region with water and sewer services. Covington also continued a role American cities had adopted in the 19th century, providing funding to hospitals and other caregivers to ensure that the most needy in society had a social safety net, funding the public library, running its own jail, and managing weights and measures in the city. Much of the costs for these services, while somewhat offset by federal monies during the Great Depression and World War II years, were borne by the city and its taxpayers.

A popular civic leader, Theodore Kluemper (1866–1946), a Democrat, served as commissioner of public works and commissioner of public safety under Covington's new commission form of government in the early 20th century. From 1934 until 1940, he was city manager of Covington. Courtesy of Carol Rekow.

Like all politicians, Covington's elected officials sought to make services available without burdening their constituents. This meant that often the city would borrow funds to make it through a fiscal year. It would also look for operational savings, most often by reducing the workforce, and, at other times, by raising the costs for services provided to neighboring communities.

By 1933 Covington was operating with an annual budget of just over $1 million, and during the 1930s, despite the Great Depression, Covington saw an increase in commercial investment in its downtown, built two firehouses, and came to an agreement with several adjacent communities to provide firefighter assistance should the need arise. Unfortunately, by 1938, the city had more than $3.5 million in bonded indebtedness. The amount of debt fueled political conflict in the city and split the commission between competing groups. Leaders of the "Good Government League" (generally associated with Commissioner Carl Kiger) blamed the situation on the city manager, Theodore Kluemper.

Throughout the 1940s, the city sought to reduce costs by trimming the municipal payroll, particularly in the waterworks and public service departments, but also looked for ways to increase revenue. By 1942 the city had cut its employment from just over 500 to 392. As efforts to trim and augment the budget continued, city employees, including the police and fire departments, often engaged in wage disputes with the city.

Several ideas to increase revenue were explored. Two that seemed popular were having adjacent communities pay for the Covington services they used and annexation, specifically along the Dixie Highway. However, it was not long before the adjacent communities began to discuss incorporating as a way to escape annexation. Another opportunity to raise revenue came as a result of downtown merchants' concerns about parking. In 1944 the city sought bids for its first parking meters, while also giving the city manager responsibility for liquor licenses.

No matter what strategies the city employed, or which political faction controlled city hall, the budget continued to be challenging. However, despite the need to borrow to make the budget whole, the city continued to make progress on a number of fronts, including the development of a recreational program for youth and the easing of traffic congestion by creating a series of one-way streets. Meanwhile, the city was running into problems with its pension funding, and there were sewer problems due to runoff and combined-sewer overflows. These budget problems were a source of concern for competing political groups in the city. Those who supported the sitting administration largely won the 1950 election. However, an independent candidate, Robert F. Moore, was elected and his concerns eventually formulated the direction that the city would take in placing more pressure on adjacent cities that relied on Covington's infrastructure.

As Kentucky's second-largest city, with a population of 64,282 in 1950, Covington continued its annexation efforts during the early 1950s. Leading the charge was newly elected commissioner John J. Moloney, who stated that the city would eliminate all services to neighboring suburban communities if these suburbs did not increase their payments or refused to be incorporated. A *Kentucky Post* editorial on January 13, 1950, declared that this announcement was a "courageous statement of policy," as many "smaller communities have escaped debt and have tax rates lower than Covington partly . . . because they could contract with the larger and older city." However, it was prophetic that the editorial also suggested that the days when annexation could take place had probably passed. A gentleman's agreement delayed the service cut, but the suburbs were incensed at what some considered Covington's "iron hand methods" to force annexation, and Covington elected officials were denounced as "communists" by angry suburbanites.

Meanwhile, Covington still suffered from budget travails and sought a myriad of alternative revenue stimulants, including charging the Covington Independent School District a fee for collecting their tax revenues and raising property valuations through the city's board of equalization. None of these proposals met with much support in the community. However, a relatively new idea that had been recently adopted by Cincinnati, the earnings tax, did offer a realistic method for taking some of the tax burden away from residents.

Two issues appeared to be the principal points of contention between the factions seeking election in the early 1950s. The People's party, with John J. Moloney as its mayoral candidate, supported the earnings (or payroll) tax, but it also strongly suggested that Covington was being run by gambling interests who represented "greedy racketeers and political bosses" (*Kentucky Post*, 2 Nov. 1951). The opposition was the Progressive party. The People's party won three of the four commission seats, and Moloney was elected mayor. With a majority on commission, Moloney instituted policies, including scheduling regular "town meetings," prioritizing recreation, beginning a program to create a cleaner Covington, and calling for a master plan for the city that would focus on eliminating blight. Moloney failed, however, to get the majority to support adoption of a 1% payroll tax, as his three fellow People's party members voted against the issue.

At its population peak during the 1950s, Covington already faced challenges to its political, social, and economic hegemony in Northern Kentucky. While downtown merchants debated what to do to alleviate traffic congestion (settling on a one-way-street option) and to create more parking for their clients (eventually buying the Stop Shop lot at Seventh and Washington Streets), more businesses and residents were moving south along Dixie Highway, out of the city. By 1956 the migration had attracted the concerns of the business community and elected officials, resulting in calls for "no new taxes" and an increase in efforts to remove blight through the implementation

of urban renewal plans. Also in 1956, Covington city commissioners narrowly passed an earnings tax, popularly known as a payroll tax. In 1959, the courts upheld urban renewal project proposals for the city's riverfront. In 1962 the site of the Internal Revenue Service (IRS) was cleared, and the city hired a manager for its urban renewal program planning, Richard Dickman.

The 1960s were a period of increasing tension and pressure on the city as a result of the continuing migration of people and businesses out of the city, coupled with the rising costs of continuing to provide infrastructural and safety services to many suburban communities. Although in 1963 the city embraced the moniker of "Gateway to the South," Covington merchants and city hall were growing increasingly concerned about the economic stability of the city, as the interstate highway system began to take shape in the region. By 1964 city leaders were declaring that if a proposed shopping center were built along the circle freeway, it would "throttle downtown business" (*Kentucky Post*, 16 Apr. 1964). Merchants sought to develop competitive strategies and proposed an interstate highway spur through Covington along 16th Street. They also worked with city officials to create a redevelopment plan for downtown. The city applied for federal Model City program funding to bring urban renewal to an area roughly bounded by Madison Avenue and Washington Street, between Sixth and Eighth Streets. Construction of a shopping mall was proposed within this area.

To help stem the migration of residents from the city, a policy was adopted at city hall in 1965 requiring all city employees to live in Covington. Meanwhile, annexation discussions continued. The community of Kenton Hills, Kentucky, agreed to accept annexation later that year. Although the city budget reached a new high of $4.4 million, 1967 was a particularly difficult year at city hall as a budget deficit had the city turn to mortgaging municipal properties in order to insure its bonds. One cost to the city was removed from the budget, however, as the library became a countywide entity. Mayor Bernard F. Eichholz proposed that a new Kenton County Courthouse be built at Pike Street and Madison Avenue, in the city's proposed model city area. Despite optimism about the city's future, the

This downtown parking garage and shopping center would have erased many of the historic buildings along the south side of Pike Street, between Madison and Washington Streets. Courtesy of Paul A. Tenkotte.

city's population continued to decline, a trend that the Northern Kentucky Area Planning Commission (now called the Planning and Development Services of Kenton County) projected would continue well into the 1990s.

The city's attempts to gain federal funding through the Model City program was rejected in late 1967, and the effort to stimulate redevelopment shifted to enticing private investment to Covington. After taking office in 1968, Mayor Claude Hensley and the new commission removed Bernard Eichholz, the former mayor, as city manager. Richard Dickman, the city's urban development director who had overseen the development of the IRS center, Panorama Apartments, and the Franklin Street and West Side Urban Renewal projects, resigned.

After hiring Robert F. Wray as the new city manager, one of the first successful efforts of the new commission was enticing Captain John Beatty to bring his riverboat restaurant—the Mike Fink—to Riverside Drive. However, residents of the Licking Riverside neighborhood filed suit to stop the project. Meanwhile, in the downtown, merchants voted 35-5 to stop the city from implementing a plan for developing a shopping mall and underground garage that would have effectively removed every building between Seventh and Eighth Streets between Madison Avenue and Washington Street. As Adrian Greenburg, president of the merchants' group and Modern Furniture said, "we do not wish to have the heart of downtown Covington torn out" (*Kentucky Post*, 31 Jan. 1968).

The search for private investment to redevelop the city, and the laissez-faire approach of city officials to consider almost any proposal, resulted in galvanizing a sizable number of historic preservationists. They shared a concern that Covington, in its anxiety to stabilize its economics, would demolish its history and cultural heritage. This concern seemed justified, as one redevelopment project after another emanated from city hall, calling for the demolition of existing infrastructure.

One of the first historic buildings to be removed was a residence on Greenup Street near Sixth Street, replaced by a modern office building. In April, a plan was made to demolish the Liberty Theatre and adjacent buildings on Madison Avenue between Sixth and Seventh Streets for a new garage. Meanwhile, the city was experiencing a dramatic increase in building permits for gas stations, car lots, and new buildings (including hotels) in the Westside urban renewal area along the riverfront.

The "Era of the Golden Shovel" was well underway when, in July 1968, the city's planner, Fred Donsback, presented the commission with a $10 million proposal to redevelop the area between Greenup and Garrard Streets along the riverfront for a 24-story hotel with 250 motel units, and a 31-story apartment tower with a 5-story parking garage. The proposed development also included the potential to link the project area with downtown Cincinnati via a monorail across the Ohio River. The commission voted to approve the plan. By August, critics of the redevelopment plan spoke out, with George Dreyer, president of the Northern Kentucky Heritage League, taking the lead. Despite the criticism, the commission voted unanimously to approve the renewal plan, with Mayor Claude Hensley stating, "We're going to develop Riverside Drive, plain and simple" (*Kentucky Post*, 7 Aug. 1968). In response, a local landowner, Polly King, sued the mayor, arguing that his comments had cost her tenants on Riverside Drive. While the renewal plans proceeded, the commission turned to consider other issues of the day, including raising the payroll tax from 1.75% to 2%.

Throughout the fall of 1968, the city saw more heated public meetings around the proposed urban renewal project on Riverside Drive. Resident and lawyer Patrick Flannery threatened the city with a suit over the plan. Mrs. Thomas Weldon, representing the Northern Kentucky Heritage League, asked that the plan be reconsidered. Suggestions were made that the development corporation proposing the plan had, as part of its partnership, a convicted felon, and the Northern Kentucky Area Planning Commission's report on the area—a plan the city had paid for—was read, indicating that the area was historically significant. The pressure was mounting against the plan, with the original unanimity of support seemingly split (Turner and Wehrman against, and Hensley and Drahmann for), with Commissioner Vera Angel as the swing vote. At a commission meeting in early November, Mayor Hensley called for a motion to proceed on the plan. Commissioner Drahmann's motion, however, could not get a second. Mayor Hensley refused to accept the defeat and vowed that the project was not finished.

In reaction to the unfolding events over their neighborhood, residents of Licking Riverside and the Northern Kentucky Heritage League organized a public tour of 10 homes in the area, with proceeds going to maintain the George Rogers Clark Park. It was estimated that the event drew 2,000–3,000 visitors, including Kentucky Governor Louie B. Nunn's wife.

Shortly after the neighborhood tour, the Covington-Kenton-Boone Chamber of Commerce called for the complete demolition of "all homes on the Riverside Drive and the north side of Second Street from the Suspension Bridge east to the Licking River." While keeping the Mike Fink riverboat, the proposal called for developing the area with a combination of low- and high-rise buildings with approximately 800 housing units. Mayor Hensley was pleased with the support, and Commissioner Vera Angel thought the proposal sounded feasible since she felt that the area had lost its charm.

A new, "modern" Covington seemed assured when, in late November 1968, the city learned that its Model City grant application for $80,000 to study downtown redevelopment was approved. At the same time, the Citizens United Telephone Company published a glossy booklet titled "The Era of the Golden Shovel," promoting Covington's attractions. In late November plans for demolishing Riverside Drive were resubmitted to the commission for approval and included a call by the regional chamber of commerce for a heliport. Residents once again gathered to defend their neighborhood. "I now know how the pioneers felt when they had to stave off repeated attacks from the Indians," declared resident Patrick Flannery (*Kentucky Enquirer*, 21 Nov. 1968). However, plans for the riverfront were not working out, as many at city hall expected. When the motion to approve was read for a vote, only the mayor and Commissioner Drahmann supported it. Their swing vote, Vera Angel, had defected. Despite the lack of a majority, the next several weeks saw more plans presented for clearing all the land between the Ohio River and the north side of Second Street, and between Greenup and the Licking River. Well-known businesspeople in the region came out in support of the chamber's plan. The impetus, according to Carl Bankemper, project architect, was to stop the predicted blighting of the area over the next 20 years.

The fateful final votes on plans to demolish the area along Riverside Drive occurred in December, with the redevelopment proposal reintroduced at the month's first meeting. After Commissioners Wehrman and Drahmann motioned and seconded the plan, the public was allowed to speak on the proposal. Katherine Van Hoene of the Wallace Woods neighborhood rose and gave an impassioned speech against it, stalling the vote while residents in Licking Riverside were called to city hall. As she filibustered, more and more residents joined the meeting, some in their pajamas. When the chorus of voices against the plan grew, Wehrman pulled his motion. Commissioner Ron Turner used that moment to make a motion that the proposal never be raised again, but that effort was defeated as Hensley, Drahmann, and Wehrman voted against it. The next week, Wehrman reintroduced the redevelopment plan, suggesting that Commissioner Angel might change her mind. However, despite originally supporting the proposal, Angel made it clear that she would now never vote in support. The next day, the city learned that the request for federal monies counted on for leveraging the redevelopment of the neighborhood had been turned down. Mayor Hensley stated that he was undeterred by the news and suggested that the plan be scaled back to a one-block area between Greenup and Garrard Streets.

When the new one-block proposal was presented to the board of commissioners for their approval in mid-December, residents of the Licking Riverside neighborhood responded with a petition recalling the mayor. The meeting became boisterous, and the police intervened to keep order. Wehrman, perhaps seeking to reach a compromise, stated that he would vote against redevelopment efforts if no developer stepped forward by January 1969. A few days later, Harold Thornberry, owner of an adult entertainment business on Madison Avenue known as The Pad, was introduced by Wehrman as the selected developer. Simultaneously, a proposal was submitted by local businessmen Richard Combs and David Herriman. During the next week, Wehrman accused the mayor of "trying to handle the whole deal by himself" and withdrew his support for urban renewal on the riverfront ("Withdraw Resolution; Saves Riverside," *Kentucky Post*, 20 Dec. 1968).

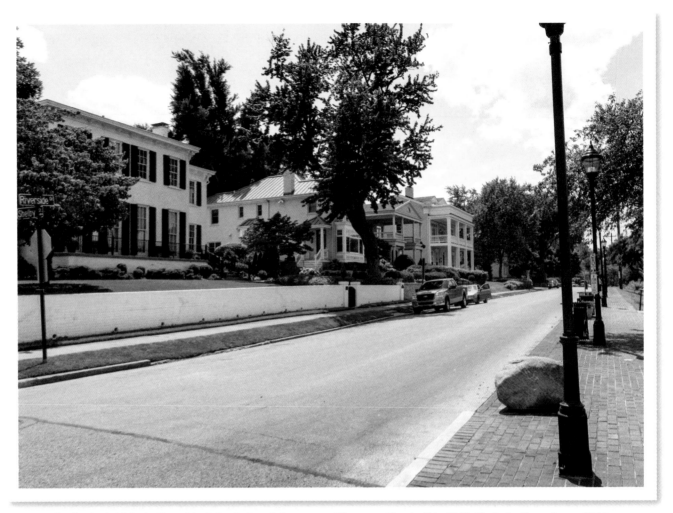

Covington's historic Riverside Drive fortunately escaped the wrecking ball in 1968. Photo by Dave Ivory, 2014.

Christmas in Covington, 1968, delivered a gift to the city in the form of a federal grant of $640,000 to expand the urban renewal area westward toward the interstate corridor. Pressure and interests for redevelopment appeared to shift westward as well. While skirmishes between supporters and opponents of the plan for redeveloping Riverside Drive took place throughout spring 1969, support for preserving the historic area grew in the city. In early 1969, the Kentucky Heritage Commission named the Riverside area a designated historic district. In a front-page banner editorial in May, the *Kentucky Post* came out solidly behind preservation, suggesting that Covington's historic assets compared with Savannah, Georgia, and envisioning a future where the city would benefit from cultural tourism as a result.

While battles over urban renewal flared throughout the year in the city's Westside neighborhood, other issues begin to capture the headlines. The city and county argued over payments for the new shared administrative building. Personnel issues also made news, as Mayor Hensley cast a vote of no confidence in the city manager over problems associated with the city's landfill. The police continued to raid gambling establishments in the city, hitting 18 cafés in September and citing them for illegal horse race betting. On a more positive note, just before the November election, the city created its first position for a real policewoman, not merely a "police matron."

Despite a plethora of diverse political issues, historic preservation conflicts continued. In 1969 the city lost Hathaway Hall in West Covington (Botany Hills) for a senior high-rise apartment building, and St. Elizabeth Hospital proposed tearing down three homes on Wallace Avenue for a surface parking lot—only one home was demolished, however. The impact was swift, as Wallace Woods residents formed a neighborhood association along the lines of the Riverside example and vowed to take action should further proposals be made. Meanwhile, an estimated 150 residents in Ida Spence Homes (now City Heights) rallied at the Ida Spence Community Center, calling for more police protection.

The September primary elections of 1969 appeared to indicate how important the historic preservation issues were politically, as Commissioners Drahmann and Wehrman both lost, and Commissioners Turner and Angel finished first and second respectively. Ralph Grieme Jr. and George Wermeling were elected commissioners. The first order of business for the new commission was rescinding all the last-minute ordinances the previous commission had passed in December, including those that threatened administrative positions. The commission's pledge did not stop controversy, however. Arguments against the fluoridation of the city's water supplies created conflict with the state, as did the state's control over charity bingo regulations. The new board was also not happy with the lack of communication between city hall and the school board as a result of the decision to replace Eighth District and Tenth District Schools with a new Latonia Elementary. Another high-profile contentious issue surrounded the city's Model City program, through which federal monies were being used to redevelop the city. Several residents on the city's Eastside claimed that decisions were being made by Model City administrators with only cursory public input.

Storm water flooding remained an ongoing challenge for the city. Since 1956, there had been concerns that storm water overflow exceeded the sanitation system's capacity. A series of flooding incidents served to keep the issue alive. The new commission attempted to put pressure on Sanitation District 1 to alleviate the problem. The city's frustrations were represented by Covington legal counsel Donald C. Wintersheimer, who wryly commented, "It cannot be candidly maintained that when the sewers work, they are the district's; but when they overflow, they are Covington's" (*Kentucky Post*, 20 June 1970).

By late 1970 the Model City program, which was limited by legislation to a five-year lifespan, was coming under increasing pressure for results, with some questioning the value of the program. In addition, city manager Wray criticized the program director for hiring employees without receiving approval from the city, since program funding went through city hall. The controversy subsided to some degree after James Clay, the Model City director, resigned in March.

The Era of the Golden Shovel reached its zenith with the demolition of the Romanesque Revival city-county building at Third and Court Streets and the construction of the second Panorama apartment building on West Fourth Street. Mayor Claude Hensley's departure from city hall at the end of 1971, however, did not relieve pressure on the city's historic resources. Through the next four decades, proposals would continue to be made calling for the demolition of both individual buildings and whole neighborhoods. Ironically, it was the Era of the Golden Shovel that awakened an organized response among citizens to those threats. Citizen pushback forced compromises that, many times, resulted in saving important elements of Covington's unique 19th-century character and in informing new leadership of the political viability of a preservation agenda. In the 21st century, the city has seen the development of a citizen-based initiative (Progress with Preservation) dedicated to raising awareness for maintaining the importance of Covington's historic resources in future development proposals. City officials and residents alike have arrived at the same destination and appreciation for the city's historic character.

Covington achieved a significant social milestone in the 1971 general elections, electing the city's first African American commissioner, James Simpson Jr. To deal with the ongoing financial crisis, the payroll tax was temporarily raised 0.5%, enabling the adoption of a $6 million budget. The payroll tax increase became permanent in 1972. Despite the increasing tax revenue, the city retained an estimated debt of $900,000. In April, Joseph Condit, who had previously been the chief accountant with the Model City program, became the city's chief accountant, thereby starting a long administrative career at city hall. Bernard Grimm was elected mayor and the new commission, with only one holdover (George Wermeling), named Paul Royster as city manager.

Redevelopment interest in Covington, the budding preservation movement, and the city's retail decline sparked a flurry of ideas intended to revitalize what some considered a dying city. In a 1971 editorial, the *Kentucky Post* called Covington "not a pretty place," while the state declared in February 1972 that Covington had a major drug problem. A proposal to adopt historical development zoning (a precursor to the city's local historic designation) failed to pass at city hall, and the struggling Model City program saw Fred Hollis, its former director of programs, named as

acting director in an attempt to keep it a viable force. Also in early 1972, Winston Park voted to merge with Taylor Mill, Kentucky.

A new effort at revitalization began with the establishment of CURE (Covington Urban Redevelopment Effort), largely stimulated by banker Ralph Haile Jr. and by local merchants. CURE's first actions were to undertake a new plan for the city's downtown, while urging the development of luxury housing in the Riverside Drive area. In October Russell Crockett, the city's finance director, released a statement saying that the budget at city hall was under control. Meanwhile, the commissioners voted four to one to end the Model City program and the short-lived directorship of June Hedrick.

The November 1973 elections saw three new faces join the commission, Carl Bowman, Bernard (Bernie) Moorman, and Mike Mangeot, who nosed out incumbent William (Bill) Sageser by four votes. Perhaps the biggest impact upon the city, however, was the continued efforts to revitalize the neighborhoods. Twelve people associated with Mother of God Catholic Church bought 17 homes on Covington Avenue

Ralph V. Haile Jr. Courtesy of Kenton County Public Library, Covington.

under the auspices of the Covington Avenue Properties Partnership, organized by Reverend William Mertes in 1974. This project exemplified America's budding "urban pioneer movement," where middle-class families were reinvesting in the historic resources of cities while renewing the community's economic and social stability. The organization of the Covington Avenue project was based upon an initial investment of $59,000 for the properties, with individual buyers then finalizing their purchases through land contracts. Investors included Bernie Moorman, Howard and Sue Hodges, Mike Averdick, Charley and Kathy Lester, Reverend Raymond Holtz, Reverend Paul Wethington, John and Catherine Nestheide, Vic Canfield, and Richard Sacksteder. While renovations were proceeding along Covington Avenue, the city was named a Bicentennial Community. Additional historic preservation efforts included the restoration of the Jesse Root Grant House and the Carnegie Library, and the unveiling of a statue of George Rogers Clark in his namesake park along Riverside Drive. Change, however, was not always met with approval, as city unions filed suit that summer against the city for its efforts to privatize waste collection. Commissioner George Wermeling joined the suit against the city, but eventually waste services in Covington were privatized, a trend taking place throughout the nation as cities worked to continue to provide services and keep the tax rate down.

To enhance downtown, a proposal was adopted in 1976 to redevelop a one-block strip of Pike Street (between Madison Avenue and Washington Street) as a pedestrian mall called Old Town Plaza. The idea of enticing shoppers back to city centers through the creation of pedestrian-friendly streets dated back to 1959, in Kalamazoo, Michigan. Both CURE and the city, under the administration of the new city manager, Joe Condit, supported the Old Town Plaza effort, which was to cost local merchants approximately $620,000 over a 15-year period. Old Town Plaza closed the one-block area to vehicular traffic, added a fountain and landscaping, and encouraged merchants to spruce up their historic buildings.

While construction commenced downtown, CURE also proposed enticing developers to the city's western riverfront by creating a Tourist Service Commercial (TSC) zone that would allow an arena and motels to be constructed. They also supported an idea for a German village in the same area. While the arena never came to fruition, the hotels—including one with a revolving restaurant—were realized, along with many automobile-oriented commercial businesses. The German village concept, largely as a result of the efforts of local businessman Jerry Deters, eventually became MainStrasse Village. MainStrasse hosts the city's trendy boutiques and restaurants, and draws hundreds of thousands of visitors each year to its many festivals. In December 1977, a plan emerged to demolish a block-sized area of Covington's downtown for the construction of a Kmart discount department store.

However, not all the news in the mid-1970s was good. City hall again faced budgetary woes, and in 1977 Coppin's Department Store downtown announced its closing, one year after the opening of the suburban Florence Mall in Florence, Kentucky. Most troubling politically, however, was the secret meeting that allegedly took place soon after the 1977 general election between Mayor George Wermeling and two commissioners to plan the removal of nine city employees, including the city manager, Joe Condit, and his replacement by attorney Robert Gettys. Following a contentious period of negotiation, Condit left city hall to become a Kenton County district judge, and Gettys was named the new city manager. Gettys remained so until April 1978. Wally Pagan, who was assistant city manager, next served as city manager.

The following year, a grand jury investigation questioned the mayor and city manager about the city's decisions regarding annexation, ambulance service, police protection, and issues surrounding the police firing range, while the Federal Bureau of Investigation (FBI) opened a gambling probe.

City Manager Wally Pagan was immediately confronted by the quandary of the "strings attached" that are associated with federal monies. While the city was counting on receiving Urban Development Action Grant (UDAG) monies to enable the proposed Kmart project, it was told that unless it hired more minorities, those funds would not be forthcoming. In response, the city developed an affirmative action plan that focused upon training minority candidates for positions in the police and fire departments. Of the 105 police officers on the force, none were African Americans, and only one African American was part of the 110-member fire department.

The next month, Booth Hospital, long a resident of the Riverside neighborhood, announced it was leaving for the suburbs, and the US Department of Housing & Urban Development (HUD) declared Covington "the most distressed" city in the United States. While the label by HUD came as a shock to many, ironically it was Covington's historic resources that contributed the most weight to that pronouncement. While it was true that Covington had lost 25% of its population since 1960, and that about 19% of the population was economically distressed, having income of less than $1,000 per year, it was the fact that Covington's housing stock was, on average, 82 years old that was the principal factor behind the ranking. It was not long before it was recognized that the moniker was, in actuality, a benefit to the city's applications for federal money.

In February 1979, in a four-to-one vote, the city hired its first African American police officer, Gayle Wilson. While HUD acknowledged the city's progress, it insisted that at least 12% of its workforce (in line with its population figures) must be minority group members, or the future of federal funding would be in doubt. In response, the Coalition of Black Organizations and Churches (COBOC) launched a campaign, under the chairmanship of Ted Harris, to have all federal funding cut unless more jobs were opened to minorities at city hall. HUD officials visited Covington that summer to inspect the city's use of federal funds and to hear a plan by city hall for the hiring of three or four African Americans, including two women.

Unfortunately for those who were excited about the Kmart proposal, it fell through in March as the developers withdrew their proposal. However, the city's historic preservation movement continued its momentum with the Ice House on Scott Boulevard (formerly Scott Street) being named to the National Register of Historic Places, joining the John A. Roebling Suspension Bridge, the Cathedral Basilica of the Assumption, Mother of God Church, the

Carnegie Library, the Carneal and Daniel Carter Beard Houses in the Riverside neighborhood, and the Hearne House in the Licking River neighborhood. In the summer of 1979, architect Peter Rafuse submitted designs for the newly proposed "Historian's Walk" along the Ohio River, and rehabbers held two open houses in the city, one sponsored by the Old Towne Civic Association (covering the MainStrasse and Mutter Gottes neighborhoods) and the other sponsored by the Old Seminary Square neighborhood. Meanwhile, a new plan for a high-rise building next to the John A. Roebling Suspension Bridge received a vote of no confidence from the Historic Licking Riverside Civic Association.

The residents of Covington elected Bernard "Bernie" Moorman their mayor in 1979. Walter "Pete" Bubenzer, Tom Beehan, Irvin "Butch" Callery, and Tom Benton joined Moorman on the city commission. This was a significant election in the city's political history as it represented the beginning of a period when city hall began to reflect a new direction in thinking about the city's future. The city became more discerning about development proposals, using a framework to identify proposals that corresponded to a vision of the city created by city hall in collaboration with the community.

Several disparate yet similar strands of thinking evolving from the political conflicts of the 1960s and 1970s coalesced to fuel the creation of a vision for Covington's future. In a number of respects, this new vision rejected the "Era of the Golden Shovel," when city hall had a rather simplistic idea about development—whatever was new was good. While it was not entirely without benefits, the city's urban renewal program had illustrated how quickly modernity could obliterate the city's cultural heritage. A simple equation had been at work: Federal monies funded demolition and the city had no money to consider alternatives. The city's historic preservation movement emerged in reaction to this conflict.

Simultaneously, efforts by downtown merchants to reinvigorate the city's commercial heart resulted in their willingness to take an approach to development that prioritized planning. Due to the support he was able to garner from downtown business groups, local banker Ralph Haile successfully championed the benefits of planning to leverage funding for a more strategic view of Covington's future. Thus, in the early 1970s, the business community undertook Covington's first planning initiatives since Ladislas Segoe in the 1930s. They did so under the banner of the Covington Urban Renewal Effort (CURE), which eventually became the Covington Business Council (CBC).

City hall had finally become sensitive to concerns for protecting and preserving Covington's cultural identity. This was a result of engaged citizens, armed with political experience from defending their neighborhoods from what they perceived as insensitive redevelopment. This force was made more potent because it melded well with the optimism for the city's future, sprouting from the city's budding urban pioneer movement. By the late 1970s, there was a sense among many political activists that change could be made, it could be guided by the community, and it could be influenced by ordinary citizens.

Covington's annexation wars finally ended with Bernie Moorman's term of mayor (1980–83), which embodied a progressive idea of the role of government. City hall's administrative capacity greatly expanded with the hiring of the city's first economic development director (Mary Jo Russio), its first historic preservation officer (Walter E. Langsam), and its first permanent staff position for planning (Robert Horine). The commission adopted the CBC vision for renewing the downtown commercial core and developed plans for the city's riverfront. The capability of city hall to attract, engage, and manage development projects depended upon the quality of the city's public administration staff, first under City Manager Wally Pagan, then Don Eppley (the city's first professionally trained city manager), followed by future member of the Kentucky House of Representatives Arnold Simpson, and finally, throughout the 1990s, by Greg Jarvis. However, hiring a talented staff would not have been possible without the financial resources that came as a result of the city's obtaining a federal Urban Development Action Grant (UDAG). Redevelopment was focused primarily on the riverfront, and soliciting development proposals for what is now RiverCenter. The property on Riverside Drive (River Place) that had been ground zero in the city's preservation/development controversy became the site of Covington's first condominium development. There, David Herriman developed Riverside Terrace in 1982 and Riverside Plaza in 1986. The commission's focus on planning and leading development efforts in the city was further prioritized as a result

Bernie Moorman ended the city's annexation wars in 1980. He served as a city commissioner (1974–79; 1984–85; 2003–04) and as mayor (1980–83). Courtesy of the Kenton County Public Library, Covington.

of local downtown businessman Sandy Cohen's joining the commission in 1984. City staff played a major role in formulating a plan for redeveloping Covington's urban core and working with the state to acquire grants to assist with development.

Tom Beehan's term as mayor (1984–86) continued the momentum of city hall and strengthened the political impact of neighborhoods. Beehan introduced a renewed populism, as reflected in his publicly fighting proposed utility increases and emphasizing reforms affecting adult entertainment and alcohol establishments in the city. As a consequence, the city established a board of adjustments to oversee zoning issues, hired its first zoning administrator, and successfully defended itself against lawsuits to overturn the city's powers to regulate business activities. Perhaps more important for the city's future development efforts, the Central Covington Development Plan (CCDP) was completed in 1984, resulting in a guide that blended a vision for rebuilding the city's central core with regulations that protected the city's architectural heritage. This plan remains the legal bedrock for most of the city's development powers.

The commission race of 1985 brought two new faces to city hall. Nyoka Johnston and James Eggemeier joined one-term commissioner Denny Bowman and three-term commissioner Butch Callery. In 1986 Mayor Beehan left office to take employment in Tennessee, and the commission tapped Turner to complete his term. In 1987, Moorman ran for a second term as mayor, but was defeated by Denny Bowman. The city's former fire chief, James Ruth, was elected to the commission, but Ron Turner failed in his bid for reelection to the commission. Meanwhile, the city staff, using the CCDP as a guide, aggressively sought developers for, in particular, riverfront investment. In the late 1980s, the city reviewed several proposals by national firms to engage in constructing an office tower near the John A. Roebling Suspension Bridge. After two failed efforts, local company Corporex, owned by Covington-born William P. Butler, was awarded the project. By the end of 1990, through a public-private partnership, Covington's riverfront was transformed from post–Civil War warehouses to an office tower complex that reflected the city's vision from the 1984 CCDP. Covington finally had a skyline.

The 1989 general elections were largely uncontested, with only five commission candidates. Voters returned all the incumbents. The next year, Nyoka Johnston resigned, and James Simpson, originally elected in 1971, was asked to complete her term. Bowman ran

Denny Bowman, the second-longest-serving mayor in Covington's history, was a city commissioner (1984–87) and mayor (1988–2000; 2009–11). Courtesy of the Kenton County Public Library, Covington.

unopposed for reelection as mayor in the 1991 elections. In the November elections, Jerry Bamberger won what had been Johnston's seat.

In 1991 the city attracted the attention of Fidelity Investments, one of the world's largest investment firms. Eventually, the company constructed its campus on a hilltop in the city south of Latonia. Fidelity, the largest private employer in the city's history, eventually brought more than 4,000 jobs to the region, and greatly enhanced the city's payroll tax receipts.

Meanwhile, in 1986, the Kentucky state constitution was amended, allowing mayors of second-class cities like Covington to serve more than two terms. Further, election dates were moved from odd years to even years, resulting in an extra year being added to the terms of the then-current officials. Assured that he would retain his commission seat as a consequence of the electoral change, Callery challenged Bowman for mayor in 1995 but lost. History was made in November 1996, however, when Pam Mullins became the first African American woman to win a seat on the commission, joining Callery, Bamberger, and Eggemeier.

After losing a run for US Congress in 1996 and an election for Kenton County judge executive in 1998, Mayor Bowman became the city's parks and recreation director in early 2000. James Eggemeier, the city's vice mayor, was named mayor (2000), and Jerry Stricker was appointed to fill Eggemeier's commission seat. The 2000 primary was one of the few with four candidates vying to be mayor. With Eggemeier's loss in the primary, there was a dramatic shift in the political dynamics on the commission, with two commission seats being vacated. Political newcomers Craig Bohman and Alex Edmondson joined incumbents Jerry Bamberger and J. T. Spence on the commission, while "Butch" Callery, who had been denied the office of mayor five years earlier and had been a commissioner for 20 years, was elected mayor over former mayor Bernie Moorman.

Urban redevelopment efforts increasingly began to involve more private-public partnerships. Corporex, for example, created and funded a strategic planning program called Covington Pride, designed to organize citizen activists in Covington, and later gave impetus to establishing Forward Quest (now Vision 2015). Forward Quest engaged in preparing development strategies for the region that included several proposals for Covington. Another organization, Southbank Partners, grew out of a proposal to build a tower (originally proposed to span the Licking River at its confluence) that would stand some 1,000 feet tall and be crowned with a large bell symbolizing world peace.

In terms of tax revenue, the 1980s and 1990s were prosperous times, with the city seeing an annual revenue increase of about $800,000 a year. The city's budget had benefited from increasing revenues generated by payroll taxes associated with new office development, and the property tax rate was able to be held constant as a plethora of subdivisions constructed in South Covington also brought in new revenues. Nevertheless, municipal expenses remained high. In 1999, city resident and corporate executive Charles "Chuck" Scheper, with a committee of business leaders, issued the Scheper Report. Containing 90 recommendations for the city, especially in regard to cost-saving measures, the report thoroughly looked at streamlining city government. Further, it emphasized the need to address infrastructural improvements and to make changes in emergency dispatch.

Nine candidates ran in the 2002 commission primary elections, and former mayor Bernie Moorman joined the three winning incumbents for a single term following the general election. In 2003, the board of commissioners adopted a Human Rights Ordinance (the third city in Kentucky to do so), expanding protections to include disability; place of birth; marital, parental, and familial status; sexual orientation; and gender identity and added employment and public accommodations to the existing housing protections.

Eleven candidates ran for commission in 2004. Rob Sanders and Jerry Stricker were elected to the commission, joining Mayor Callery, who was elected for his second term. In 2005 Greg Jarvis resigned as city manager after being with the city for 15 years and was replaced first by the city's police chief acting as city manager, and later by the city's attorney, Jay Fossett.

Budget challenges had grown so obvious that, by 2005, Mayor Callery reported at the January commission meeting that the city had "some budget problems," which he blamed on "external forces such as increased pension costs, workers' compensation, health care, etc." This recognition led to renewed discussions on merging dispatch with the county, as well as the introduction of novel policies designed to generate development downtown, including the creation of an "Arts and Technology Zone" designed to attract a "creative class" to the city. Unfortunately, the policy did not come with a strategy for implementation and after admitting the zone's failure to attract much interest, the city repealed the designation six years later.

What seemed to be working to attract downtown investment, however, was the city's slow and methodical continued investment in new infrastructure, developing synergies with other public and private entities, and assisting entrepreneurs with so-called "gap financing." A new parking garage on Scott Boulevard was completed in 2001. City hall's work with the Kentucky Council on Postsecondary Education (1999–2001) and local business groups created the impetus for locating a community college campus downtown. "Gap financing," made available to investors such as Donna and James Salyers, resulted in the renovation of several historic structures in the 1990s and the early 2000s into new and profitable businesses, attracting additional entrepreneurial activity to the city.

In an effort, some argued, to reduce competition for incumbents, the city commission modified the city's electoral process in time for the 2006 elections, creating an at-large ward system. Incumbents ran only against candidates in their ward, but were required to achieve a majority of all votes cast in the city to win. Among the arguments for adopting ward elections was that the method would enhance representativeness and allow candidates to run against each other, as the primary would reduce to two the candidates for each ward. In actuality, an incumbent could lose the vote in his or her ward and yet be elected (which actually occurred). Only two wards had primaries, and in the general election one of the incumbents, Edmondson, was beaten by Sherry Carran. In ward C, Steven Megerle won a seat on the commission. Soon after the election, the ward system was abolished and the prior system reestablished.

In November 2008 Bowman turned back Callery's effort to serve three consecutive terms as mayor, ending for Callery a string of 29 years at city hall. Joining Bowman in his comeback win were incumbent commissioners Carran, Megerle, Stricker, and newcomer Shawn Masters. With the resignation of Megerle as commissioner, the fifth-place finisher in the election, Mildred Rains (most recently the city's code enforcement director) was named to the commission.

Fifteen candidates ran in the 2010 commission primary, and in November, two political newcomers, Steve Casper and Steve Frank, joined incumbents Masters and Carran on the board of commissioners. Denny Bowman, the city's second-longest-serving mayor, resigned in September 2011.

With more than a year left on the mayor's term, the board of commissioners had to decide whom to name mayor. Chuck Scheper was approached and offered the position based upon his knowledge of the city (Scheper Report 1999), his executive business background and connections, and his willingness to serve without aspirations for subsequent terms. While much of Scheper's agenda included implementing recommendations made in the original Scheper Report (1999), soon after he took his oath of office, the city hired a management firm, funded with monies raised by the new mayor, to review the city's operational costs and organizational structure. Covington and Kenton County dispatch systems were merged with provisos made to protect the employment status of Covington employees, one of the major points of contention in past negotiations. The mayor led union negotiations as well and won major concessions resulting in significant savings. While resolving the financial crisis was the mayor's principal focus, he also pushed for creating a more business-friendly environment by calling for a reduction in the payroll tax, which he had originally sought in the 1999 Scheper Report, and which the local business community had been complaining was the highest in the region. While reducing the rate by .05% gave the commission credit for taking action, the size of the reduction had little effect at the level of the individual employee.

Commissioners Carran and Casper faced each other for mayor in the November 2012 general election. The voters of Covington made history by electing Sherry Carran the city's first female mayor. The commission race was

LEFT: Mayor Sherry Carran is a 1974 graduate of the University of Cincinnati, with a bachelor's degree in architecture. She is the city's first female mayor. Carran served three two-year terms as a Covington City Commissioner (2007–12). She has received many honors, including the Northern Kentucky Area Development District's Outstanding Volunteer Award (2006), distinction as an awardee of the Outstanding Women of Northern Kentucky (2008), and the Kentucky Society of Architects' John Russell Groves Citizens Laureate award (2010). Courtesy of Sherry Carran. RIGHT: Larry Klein has served as city manager of Covington since July 2009. From 1998 to 2008, he was city manager of Fort Wright, Kentucky. He is a founding member and past president of the Kentucky Occupational License Association. Courtesy of the City of Covington.

also highly competitive, as there were three seats open after Masters dropped out of the race. Incumbent commissioner Steve Frank was reelected and was joined on the commission by Chuck Eilerman, longtime citizen activist Mildred Rains, and political newcomer Michelle Williams.

As Covington prepares for its 200th anniversary, political history continues to be made. The 2014 elections will introduce new leaders to the city's board of commissioners, who will be charged, as were their predecessors, with guiding the city into the future. While challenges, frustrations, and crises can be expected, the people of Covington can also look forward to continuing to be engaged in democratic politics and being fortunate to have the opportunity to have a voice in their community. It is in local politics where democracy is closest to the people and most accessible. In Covington, civic engagement is possible for anyone who cares about the city's future.

Citizens have regularly looked to elected officials and business leaders to develop a vision to guide the city. While Covington continues to have a vibrant business community that champions the city for investment, since the 1970s, many more people have joined the effort. Today, those voices include an active collaboration of Covington neighborhoods engaged in numerous projects designed to improve the city's quality of life. They have been joined by new groups calling for a focus on the arts, social life, and the city's ability to continue to attract modern "urban pioneers." The "Cov 200" bicentennial initiative is an example of the synergy that is possible among the great diversity of interests and people of the city. A challenge for local politics in the future will be to focus that energy around a collective vision that prioritizes inclusion and continued collaboration among people who represent varied social, political, and economic backgrounds.

SELECTED BIBLIOGRAPHY

Burns, John E. *A History of Covington, Kentucky, through 1865.* Covington, KY: Kenton County Historical Society, 2012.

Claypool, James C. *The Tradition Continues: The Story of Old Latonia, Latonia, and Turfway Racecourses.* Fort Mitchell, KY: T. I. Hayes Publishing, 1997.

Gastright, Joseph F. *Gentleman Farmers to City Folks: A Study of Wallace Woods, Covington, Kentucky.* Cincinnati: Cincinnati Historical Society, 1980.

Harrison, John Pollard. "History of Covington, Kentucky." Paper read to Pioneer Association of Covington, Kentucky, on 8 July 1876, Kenton County Library, Covington.

Harrison, Lowell H., and James C. Klotter. *A New History of Kentucky.* Lexington, KY: University Press of Kentucky, 1997.

Lietzenmayer, Karl J. "James T. Earle: The Last Mayor of Latonia, Kentucky." *Northern Kentucky Heritage* 2 (1) (1994): 42–55.

Northern Kentucky Newspaper Index. Kenton County Public Library, Covington, KY.

Spence, J. T. "Mayoral Power and Governmental Evolution in Covington, Kentucky." *Northern Kentucky Heritage* 6 (1) (1998): 34–38.

Tenkotte, Paul A. "Adaptation to the Automobile and Imitation of the Suburb: Covington, Kentucky's 192 Plan as a Test Case of City Planning." *Journal of Kentucky Studies* 1 (1984): 155–170.

Tenkotte, Paul A. "Rival Cities to Suburbs: Covington and Newport, Kentucky, 1790–1890." PhD diss., University of Cincinnati, 1989.

Tenkotte, Paul A., and James C. Claypool, eds. *The Encyclopedia of Northern Kentucky.* Lexington, KY: University Press of Kentucky, 2009.

Wade, Richard C. *The Urban Frontier.* Chicago: University of Chicago Press, 1959.

Wiggins, O. J. "History of Covington." *Daily Commonwealth*, 5 Apr. 1884. Accessed 13 Sept. 2014. genealogy.kentonlibrary.org/archives/news/dc/1884/04-05.pdf.

CHAPTER

15

FROM BADGES TO BLAZES: POLICE, FIRE, AND PARAMEDICS IN COVINGTON

by Matthew J. Kelley and Chuck and Ruth Korzenborn

THROUGHOUT two centuries, residents of Covington, Kentucky, have counted on thousands of dedicated public servants who have protected them from the ravages of crime, fire, and health crises. Police officers, firefighters, and paramedics have risked their own lives in saving countless others. Many heroes and heroines, both sung and unsung, comprise a story that traces the evolution from 200 years ago to the origins of modern public safety. In the 19th and early 20th centuries, though, policemen and firemen had insecure work positions, which were dependent upon the political climate. The system of political patronage, whereby jobs as policemen and firemen were given to friends, family, and fellow members of one's political party, held sway.

An act of the General Assembly of the commonwealth of Kentucky formally established the town of Covington in 1815. The earliest record of law enforcement lists the appointment of Jacob Hardin as captain of the patrol in 1817. Captain Hardin was responsible for an 8-mile radius around the town—approximately 32 square miles of difficult terrain. To accomplish this task, he was allowed two patrollers to assist him. At that time, Covington was named the second district of Campbell County (Kenton County was established in 1840). The county's constable, Elijah Boileau, would also be responsible for maintaining peace in the new town.

On December 14, 1825, a new legislative amendment to Covington's charter allowed the election of trustees to govern the growing community. The new trustees quickly went about the business of passing laws to regulate the conduct of citizens of the town. The first laws addressed such issues as liquor sales, bathing in the river, the discharge of firearms, and cockfighting. People who engaged in other activities considered public disturbances—such as gambling or playing certain games on Sunday—were subject to a fine of up to $5.

When a fire occurred during this early period, it was up to the townspeople themselves to pull together to extinguish the blaze. Impromptu bucket brigades would be formed to battle and contain any fires that erupted. It was not uncommon for women, children, the elderly, and any able-bodied person to come to the assistance of a frantic neighbor and join the brigade. Dozens of buckets would change hands, sloshing their contents as they passed from person to person. In most instances, the best that could be done was to prevent the flames from igniting adjacent structures. Though every person in town was expected to turn out to battle a fire, often the losses were total.

By 1833 the population had blossomed to well over 700 citizens. With the expansion of the town came an increasing number of new ordinances. Many of these new laws addressed the conduct of youths, slaves, and servants on public streets. Some of these ordinances forbade such activities as playing ball, playing marbles, or pitching pennies on the Sabbath. It was therefore deemed necessary by town trustees, on June 20, 1833, to appoint Isaac Martin

as the first town marshal. He was to enforce the law during the daylight hours and to return home at night, ready to be summoned at a moment's notice to any disturbance in the town. In addition to enforcing the swelling number of town ordinances, Martin was also charged with collecting taxes from the town's inhabitants. This extra duty made Martin a familiar, though not always welcome, face to Covington's citizens. His salary was $70 per month. To deal with the growing number of lawbreakers, the trustees rented a merchant's cellar to be used as a jail. Martin's appointment signified the professionalization of law enforcement in Covington.

That same year (1833), the first fire engine house in Covington, located on the north side of Third Street, was established to help combat fires throughout the community. The first engine in use was dubbed the Coffee Mill and was hauled by men to the scene of a fire. The body of the engine was a long rectangular box into which the operators would pump water with a long-handled apparatus and hose. This action would allow them to throw water 30 feet. For the first time, firemen could douse flames they could not safely reach prior to using the engine. Flames on a roof or in the eaves of a structure could be put out before they spread. It is easy to imagine the commotion caused by a dozen stout men yelling, while running down the street with the sleek fire engine in tow—it surely must have been a spectacle.

The Coffee Mill was soon replaced by newer technology. The second engine purchased was the Washington, which operated on the same principle as a railroad handcar and required eight men to operate. Two subsequent engines, the Neptune and the Kenton, operated like rowboats, with long oarlike handles manned by volunteers at the ends. Each variation in engine design signified a slight improvement in performance. Firefighting in the 19th century remained dirty and backbreaking work.

As an incentive for volunteer firemen and citizens to respond to emergencies with speed, an ordinance was passed in 1834 that paid $2.50 for the first waterman on the fire scene in the evening and $1 for the first man to arrive at a daylight emergency. Although this system was well intended, it frequently led to arguments about who arrived first. These arguments rarely got physical, but often a structure would become engulfed while the debate continued. A good-natured rivalry between volunteer fire companies developed. Occasionally, when more than one company responded to a false alarm, the first to arrive would ambush the other and give them a good soaking. It was not uncommon for an all-out water battle to play out on the streets of the town.

By 1834 the nature of town government had changed. On February 24 of that year, the Kentucky General Assembly passed an act incorporating the city of Covington. It created a mayor and board of councilmen, who would be entrusted with the duty to appoint police officers and a city marshal. Less than a year after he was appointed, Isaac Martin was replaced by Edward G. Bladen as the first city marshal. Politics would have a significant influence over the development of law enforcement and firefighting for decades to come.

Over the next six years, 10 people held the office of city marshal. The 11th city marshal was Greenberry F. Laney, who would serve for 11 years. Though the duties of the city marshal were of a serious nature, the political side of the job could be somewhat lighter. For example, in the early 1850s, John Taliaferro announced his candidacy for city marshal in this advertisement:

> *"Mr. Editor. Having been solicited by all of my friends and two-thirds of my enemies to become a candidate for City Marshall in the coming elections and believing in the principle of 'Vox Populi, Vox Dei' which means, Mr. Editor, the voice of the people is the voice of God, I have concluded to consent to their wishes and will become a candidate. So clear the track for the Democrat John Taliaferro." (Flinker 1994, 15)*

One of the most colorful characters ever to be named city marshal was Clinton Butts. He was elected marshal in January 1855. With a burgeoning population and increasing traffic through the city, Covington became more difficult to police efficiently. If a large crowd were to become unruly, the marshal and his deputies would easily be overwhelmed. Such were the circumstances the night of the infamous Turners Riot of 1856. The Turners

Society was founded to preserve German culture, language, and customs, and to promote physical education. In May 1856 a regional Turners Society celebration evolved into what officials regarded as an unauthorized march in Covington. Returning from a picnic on Pentecost Sunday, the Turners, dressed in their regalia and brandishing swords, marched through the streets of Covington on their way to Newport, Kentucky. Marshal Butts, a member of the Know-Nothing Party and a nativist who thought that immigration was undesirable, assumed the worst. Butts and Deputy Harvey responded to the scene to disperse the mob of onlookers, to stop the march, and presumably to restore order. When the two lawmen confronted the Turners at Fourth Street and Scott Boulevard (formerly Scott Street), Butts ordered them to end their marching and to disperse. A melee ensued, and Marshal Butts lost his right arm as the result of a sword strike. Deputy Harvey lost part of his skull due to a blow from a sword. The Turners proceeded on their way to Newport, and agreed to turn themselves in to officials there. The Turners Riot did not go unnoticed by Covington's city council. They quickly passed an ordinance in March of the following year creating the Covington City Police. In addition to the city marshal, the ordinance called for one or two officers in each ward.

During the next four years, more changes, aimed at strengthening and regularizing law enforcement in the city, were made. In March 1857, Clinton Butts, despite the loss of his arm, was the first city marshal elected to a two-year term. He was ineligible for reelection in January 1859 because he had served two consecutive terms.

John McLaughlin was next elected marshal. However, in an attempt to undermine the efforts of McLaughlin (a Democrat), Butts's supporters petitioned city council to increase the size of the police force, which then consisted of the marshal and two deputies, and to rehire the former marshal by special appointment. Supporters even took up a collection to pay Butts's salary, but McLaughlin became city marshal. The attempt to retain Butts was evidence of the political atmosphere in Covington at the time. This event was a precursor to several battles over appointments to the police and fire departments that had strong political overtones.

The 1850s were the beginning of the heyday of horse-drawn fire engines and ladder wagons. Great rivalries arose from the pride each volunteer company took in the maintenance and upkeep of the engines, and in the grooming of the fire horses. Local parades were often the only place that the volunteer firefighters could show off their polished equipment. Crowds along the route would loudly cheer for their favorite company, as they marched by dressed in uniforms unique to each. It is rumored that some of the volunteers were so eager to prove their prowess as firefighters that they may have been responsible for setting small stable fires, just to be given the opportunity to extinguish them.

Clinton Butts was reelected as city marshal in 1860. By the time he took office in 1861, there was a great deal of unrest in Covington and throughout the country regarding the possibility of a civil war. Within the city, people were concerned with maintaining law and order. If a riot were to break out, the current police force would be woefully inadequate to handle the situation. Talk of creating a reserve for the police to call upon in times of crisis was heard in council chambers.

When the Civil War began on April 12, 1861, at Fort Sumter in South Carolina, it had a nearly instantaneous effect on every state in the Union, particularly in border states like Kentucky. Covington City Council reacted to the onset of war by passing an ordinance creating a volunteer corps of police that would be known as the "citizen guards." Each member would be required to take the oath and would be granted the authority of policemen. If called into action, they would be provided arms by the city. Though Marshal Butts had an unpaid corps of citizen guards, he continued to press for more police officers. In 1862 Butts's only deputy resigned, citing low pay as his reason for leaving. The one-armed Clinton Butts was the only paid lawman left in the city. Though there was significant public outcry, council did not appoint another deputy until the following year.

As the Civil War raged on, destroying property and claiming hundreds of thousands of lives, life in Covington remained quiet for the most part. The end of the summer of 1862 would bring the war close to home. At that time, the Confederate army was desperately searching for a winning strategy and a gateway to the North. A plan

suggesting that a force of rebels could move from the southern part of Kentucky to Covington (in order to lay siege to Cincinnati and thus gain control of the Ohio River) was put into action. As rumors of Confederate troops reaching as far north as Florence, Kentucky, spread, General Lew Wallace called for martial law in Cincinnati. Union troops scoured the city for men to build artillery emplacements in Northern Kentucky. Confederate forces had probed the area surrounding Covington, and when they saw the defenses that had been constructed in only a few days, they retreated. The great emergency was over. Covington was safe once again.

Two years later, a pivotal turning point occurred for the Covington Fire Department. On July 7, 1864, the old volunteer department passed out of existence, and a professional, paid department took its place. L. D. Croninger was named Covington's first fire chief. The department was modernizing and professionalizing simultaneously. The institution of a fire alarm telegraph system helped the department to locate fires accurately. Alarms would automatically go to the nearest firehouse, significantly cutting down response time. Within 10 years, the department had 50 alarm boxes and telephones, 279 hydrants, and 42 cisterns to do their job. It was taking the fight to the fires.

By the end of the Civil War, the police force in Covington had been increased to 11 paid officers, though control of the department remained with the city marshal. It is important to note that police work at that time consisted of foot-patrol officers who worked a beat. They were familiar faces around neighborhoods and relied on good relationships with citizens to patrol the city effectively.

The post–Civil War era was marked by a memorable act of violence that resulted in the first fatality in the line of duty for a Covington lawman. City Marshal John Thompson was serving his second term in office when, on February 6, 1869, he was alerted to a robbery. John Bentley, of Florence, was accosted by three highwaymen near Covington's Lewisburg neighborhood. The robbers took between $25 and $35 and a silver watch. Two boys followed the thieves to Covington and ran as fast as they could to tell the city marshal what they had seen. Marshal Thompson hurried to the tollbooth at the foot of the suspension bridge, where he caught up with three suspects matching the description of the thieves. Two of the men had paid and proceeded to cross, but the third man was confronted by Thompson, who placed him under arrest. The man quietly went with the marshal. When they were about 15 yards away from the tollbooth, the man drew a pistol, shot Thompson in the abdomen, and escaped. Thompson succumbed to the wound three weeks later. Despite a large reward and several arrests on suspicion, the gunman was never caught.

Marshal Thompson's funeral, and the procession following, was one of the largest the city had ever seen. After a solemn ceremony, politicians, policemen, firemen, merchants, women, and children followed the body from St. Mary's Cathedral on Eighth Street to Linden Grove Cemetery, where Thompson was laid to rest. Unfortunately, he would not be the only law enforcement officer to sacrifice his life when duty called.

During the following decade, budget concerns were the source of great political debate in the city, and the cost of fire and police protection was a hot-button topic. Despite these difficulties, a request to buy uniforms for the city's police officers was granted. The Covington gendarmes would now be outfitted as well as their counterparts in Cincinnati were. This development not only gave the officers a sense of pride, but it also made them easier to find in case of emergency. Citizens in the city were pleased with the change. Still, with more than 16,000 people living in the city, the call for more officers was frequently heard.

As the city grew in population, so too did the number of structures. Homes, businesses, and places of worship sprung up quickly, and many were of wood frame construction. This increase created new challenges in public safety, particularly for the fire department. At that time there were only four firehouses, which were centrally located.

New technology helped firefighters locate fires precisely, and the alarm/call box system was working to cut down response time. When a telegraph alarm box was activated, a signal would be sent to the nearest firehouse. The signal would tap out the number of the activated box, telling the firefighters exactly where to go.

That Shiny Red Fire Truck

Why are firefighters so meticulous about the cleanliness of their equipment, right down to washing the wheels? The tradition of maintaining equipment and polishing the vehicles actually serves several purposes. It began, in part, because of the rivalries between private fire companies, prior to the professionalization of the department. They continue this practice not only to instill confidence but also to ensure that everything is in working order. The custom of washing the wheels began with horse-drawn fire wagons. The wheels were washed frequently to swell the spokes, so they would not be dislodged while speeding down cobblestone streets.

Tobacco-Chewing Fire Horse

One of the most colorful characters ever to serve the city of Covington was not a person at all; it was Fire Chief Griffiths's tobacco-chewing horse, Tat. Part thoroughbred, the horse was extremely smart and would occasionally help himself to a pouch of tobacco kept in a hip pocket. The habit gained him such notoriety that he was featured in the *Kentucky Post* in 1911 and 1917. Tat did mind his manners and did not spit—he seemed to enjoy the juice too much.

"Big Mox" McQuery

William Thomas "Big Mox" McQuery was one of the most popular officers to ever wear a police uniform in Covington. Big Mox spent seven seasons (1894–91) playing first base in the big leagues, including with the Cincinnati Outlaw Reds, before joining the Covington Police Department. He quickly became a fixture about town and was well liked by all. McQuery was the second Covington officer to die in the line of duty, when he was shot after stopping two suspected robbers at the south end of the John A. Roebling Suspension Bridge. Big Mox was buried at Linden Grove Cemetery after a hero's funeral attended by hundreds from both sides of the river.

Another innovation changed the way that fire horses were harnessed and hooked up to engine wagons. Firemen in Covington took great pride in the care and upkeep of their prized horses, and even shared the back half of the firehouse with them. At the sound of an alarm, with the horses in their stalls directly behind the firefighters' sleeping quarters, a weighted device called a joker would drop. The dropping weight would trigger a mechanism that would lower the harnesses from the ceiling rafters onto the backs of the waiting horses, which were quickly hooked to the wagon. And off they went. It must have been quite a spectacle to witness those magnificent horses bursting out onto the street amid the hollering and clamor created by an alarm. The steeds were carefully selected and had to demonstrate good disposition as well as strength and speed. They would race fearlessly down the streets and alleys of Covington at breakneck speed, regardless of heat, icy conditions, or darkness. The horses were more than mascots; they were truly a part of the firefighting family. These were the golden years of the horse-drawn fire engines.

Many of the blazes that the department would fight were related to the growth of the city. It was a time of wood, coal, and gas fuels to heat and light homes and businesses. As structures were built more closely together, the chance of a stray spark or floating ember catching an adjoining building on fire grew exponentially.

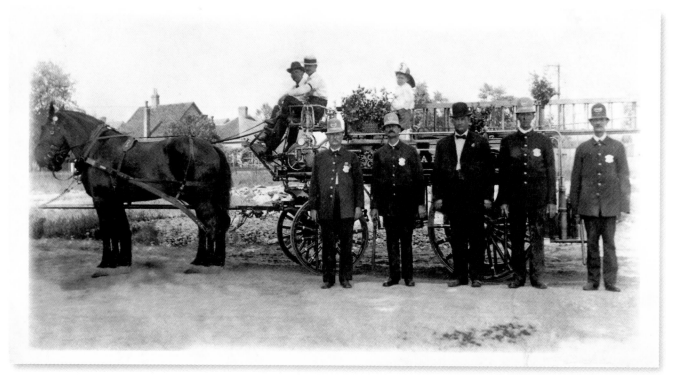

Policemen and firemen with hook and ladder wagon. Courtesy of Covington Police Department.

Such was the case when the Second Presbyterian Church (on the northeast corner of Ninth Street and Madison Avenue) caught fire in September 1880, just a few weeks after a fire at St. Aloysius Church. But it was not candles that sparked either blaze. The St. Aloysius fire was blamed on a defective chimney flue. The Presbyterian church was located next to a woodworking mill. Employees there had fed the furnace with lightwood and wood shavings. A stray ember ignited the church roof. The Covington Fire Department brought the blaze under control, but by that time the inside of the church was gutted and the roof was destroyed. This is just one example of the types of situations these firemen faced every day. They not only had to extinguish the flames but also had to concern themselves with adjacent properties to ensure their safety.

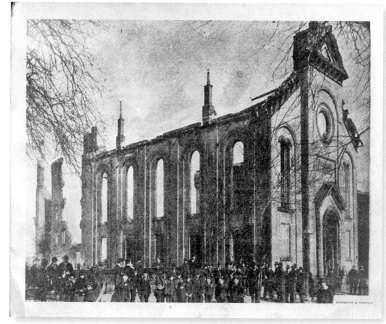

On March 5, 1893, Fred J. Meyers Manufacturing Company on Madison Avenue caught fire, which spread to a tobacco factory and then to First Christian Church (shown here) on Third Street. Courtesy of Paul A. Tenkotte.

In 1882 Kentucky governor Luke Blackburn (1879–83) signed a bill into law that had a dramatic effect on the Covington Police Department. The act called for the abolition of the city marshal and the establishment of the city police department under the supervision of a police chief. On January 4, 1883, John A. Goodson was sworn in as the first police chief of the city of Covington. Chief Goodson was presented with a 3.5-ounce gold badge with a large diamond, bought and paid for by his supporters (including the mayor, Robert Athey). Upon receiving the lavish gift, Goodson remarked that he "hoped that the brilliancy of the glittering gem would never be dimmed, but, like the star of Bethlehem, lead the wise and just to paths of virtue and peace,

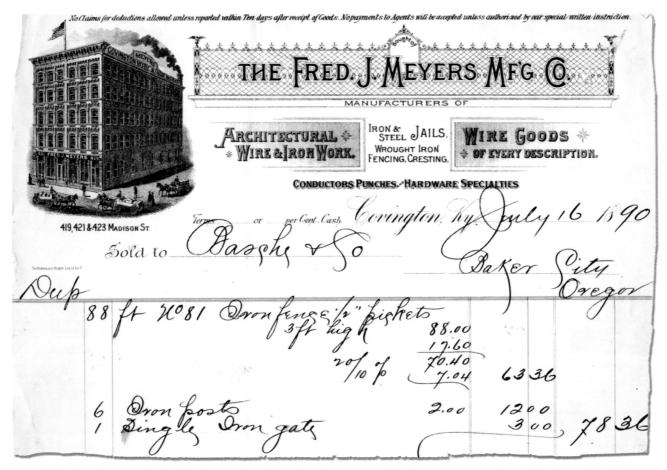

An 1890 invoice showing the Fred J. Meyers Manufacturing Company on Madison Avenue, destroyed by fire on March 5, 1893. Courtesy of Paul A. Tenkotte.

and be a beacon of light to warn wrong-doers from the sure destruction that awaits them to the Police Court of Covington" (Flinker 1994, 38).

This token was a harbinger of the political nature of the job in years to come. Shortly thereafter, the mayor was presented with a jewel-encrusted walking stick presented by his supporters, including Chief Goodson. Goodson would be directly answerable to the mayor until an act of the legislature in 1886 removed the mayor as the head of the police department and created a board of commissioners to oversee its operation. Six years later, Covington's aldermen called for the elimination of the commissioners as an unnecessary expense. The aldermen felt that the police department should be run solely by the chief of police. However, nothing came of this, as evidenced by a *Kentucky Post* article published on March 30, 1894, which exposed a scheme to influence the mayor's appointments to the commission with money collected in town by pool hall gamblers. Still, the board of commissioners did manage to pass a series of regulations designed to modernize the department.

Elections in Covington in 1895 were particularly nasty and brought electioneering by police and firemen under close scrutiny. Democratic mayoral candidate Joseph L. Rhinock openly criticized members of the police force. He accused them of threatening saloonkeepers for not supporting particular candidates and for offering favors to those who did support them. The police commissioners responded by passing two resolutions to deal with the problem of electioneering. The first specified that any member of the police or fire department caught engaging in electioneering would be dismissed. The second stated that uniforms must be worn at all times, except at special times when the chief was allowed to wear civilian clothes.

Although the election was over, Rhinock was concerned about the growing strength of the Republican Party and ordered a levy on members of the police and fire departments, as well as city officials, to contribute to the following year's campaign fund. In the wake of this unreasonable demand, Chief Goodson resigned after 17 years of faithful service.

City commissioners appointed Joseph W. Pugh to succeed Goodson as chief of police on December 3, 1895. He was instructed to address the rising problem of pool hall gambling and was encouraged to use plainclothes officers to crack down on the illegal activities taking place in such establishments. At the same time, the commissioners also authorized Pugh to purchase two bicycles to be used in the arrest of reckless wheelmen (early bicycle aficionados), another move to bring the department up to date. Pugh would oversee a growing department and ushered in several positive changes. Important arrests were made during his tenure; however, Pugh was clearly a part of the Democratic Party's machine politics of the era (see chapter 4). Pugh was arrested in 1899 and charged with federal election law violations. He and others in the department were accused of ordering challenges at voting booths and intimidating voters. An intense political battle ensued. Despite the charges pending against him and members of his department, Pugh was resolute and defended himself vigorously. The charges were eventually dismissed, and Pugh remained in office until 1903.

At the turn of the 20th century, the population of Covington was nearly 43,000. Its land mass had increased from 200 acres to more than six times that number. And the police department had grown from a single marshal to a force of 41 officers. The growth of the city created unique challenges for the fire department because parts of the city were cut off from firehouses by railroad tracks. On more than one occasion, firefighters were delayed at a crossing due to a train. People speculated that some fires could have been extin-

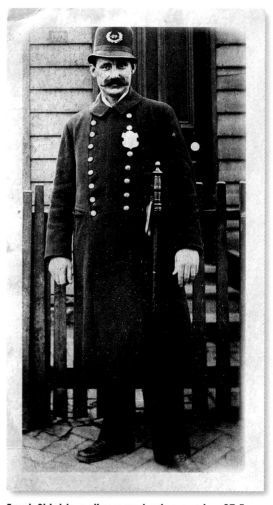

Frank Shields, policeman, badge number 27, Trevor Street, circa 1895. Courtesy of the Covington Police Department.

guished with less property damage and that a train could cause a delay of more than 10 minutes.

Some of the problems encountered by both firemen and policemen at the beginning of the 20th century were a lack of job security, pension plans, and decent wages. The idea of a pension plan was finally gaining attention, and serious discussions began. Up to that point, there were no provisions for a fireman or his family should an on-the-job injury occur, nor was there a provision for old age. This was a particularly important conversation to have at that time, because the second police officer killed in the line of duty (William McQuery) had died just a few years earlier. It would take some time before the concept of these specific benefits came to fruition, but the topic was open for debate. After 20 years with no pay raise, businessmen in the community came to the rescue of police and firemen in the city by urging city council to grant both departments pay raises. Council eventually agreed in 1906, raising monthly salaries to $70. Chiefs and lieutenants received slightly more pay.

There was also a lighter side to police work at that time. On the morning of February 5, 1909, jailer William Kranz found that he had an extra inmate in the cellar. Apparently, during the previous evening, a drunken John O'Hearn was looking for a warm place to sleep and chose to break into the building. All O'Hearn wanted to steal was a good night's sleep. The judge, however, was not amused, and ordered him to remain for an additional 30 days.

The advent of the automobile created a new challenge for the Covington Police Department. The noisy vehicles were speeding about town and had been the source of several accidents. In response, Chief Henry Schuler requested that council purchase a motorcycle for the purpose of chasing down speeding motorists. Council agreed with the chief and approved the purchase in 1912. By 1914 a commission form of government had been adopted and the successful candidate for public safety commissioner automatically became chief of police, which strengthened

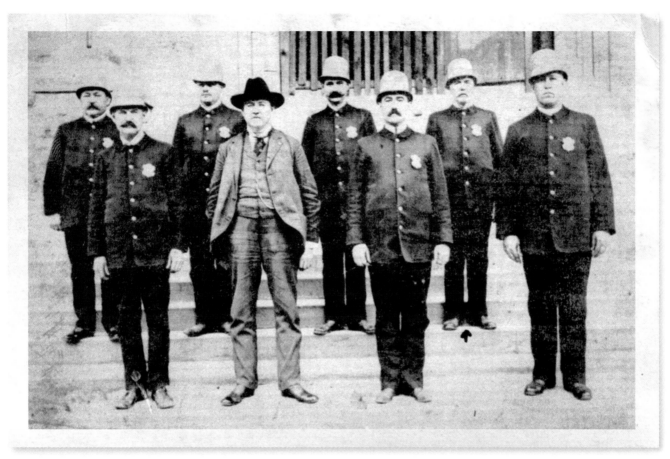

ABOVE: Covington policemen, late 19th century. Courtesy of the Covington Police Department. BELOW: Covington firemen (political appointees). Courtesy of the Kenton County Public Library, Covington.

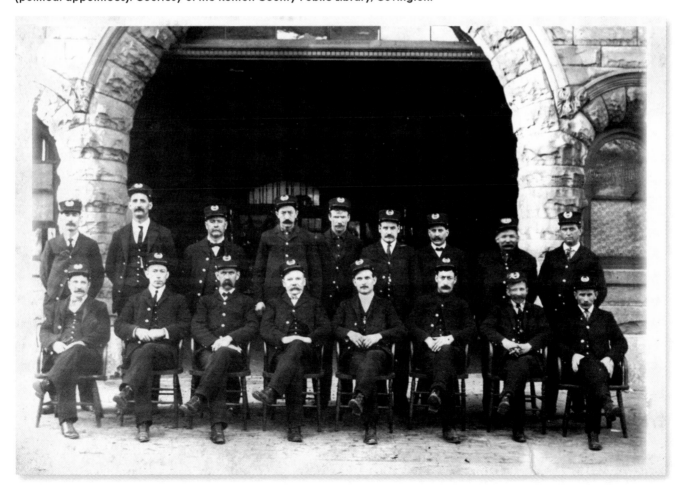

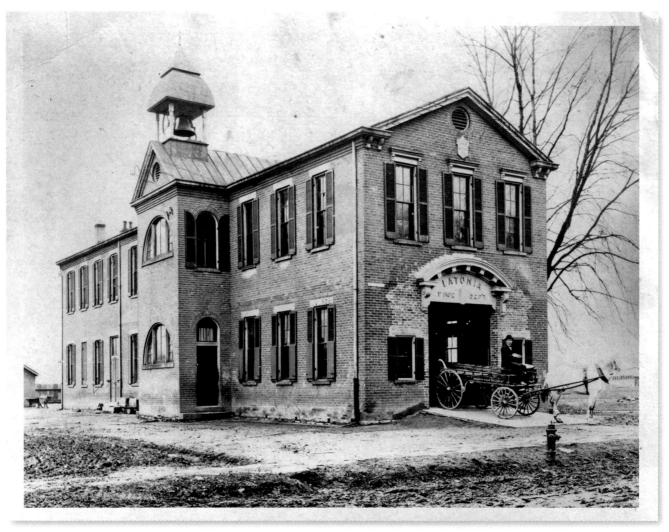

Latonia Fire Department, circa 1895–1905. Courtesy of the Kenton County Public Library, Covington.

Schuler's position concerning modernization. In addition to getting the approval for a motorcycle, the department also assigned its first traffic control officer that year.

Though the department was modernizing, race relations were still lacking. Whenever a black man answered an advertisement for a patrolman, he was informed that Covington did not have "Negro" police officers, and he was sent away. Similarly, the department did not hire policewomen. In 1915, Mrs. Alice Voohees became the first woman to hold the title of "humane matron," responsible for the city's female and juvenile prisoners.

Covington had grown substantially, and the task of fighting fires in the city grew more difficult due to the burgeoning population living in very close quarters. City council began to enter-

Covington's first motorized fire truck, circa 1914. Courtesy of the Kenton County Public Library, Covington.

tain the idea of modernizing the fire department by motorizing all of the vehicles. Talk of this had begun as early as 1904. Similar plans in Birmingham, Alabama, and New York City were underway and had cut response times in half.

Covington's main firehouse, Sixth Street at Washington Street, next to Mother of God Catholic School. Courtesy of Paul A. Tenkotte.

Undoubtedly, council also recognized that city streets would have to be repaired and brought up to date to accommodate the new vehicles.

The fire department also continued to upgrade its arsenal of firefighting weapons. At the suggestion of Chief Teddy Griffith, the purchase of a lung motor (pulmotor) was authorized in October 1916. The lifesaving apparatus was used to revive people who had been overcome by smoke or fumes. The unit would be located at the firehouse and would be available for use by doctors and the public in case of emergency. Griffith promised that there would always be a fireman who was trained in the use of the pulmotor on station at the firehouse. This would prove to be the start of emergency medical training for firefighters in Covington. That same week, Chief Griffith also investigated the use of life-protecting gear for his firefighters. Smoke helmets were issued to prevent responders entering a building from being overcome by toxic smoke. They operated by filtering air through three small cylinders that led to a tube and mouthpiece; a nose clamp had to be worn to ensure safety. The helmets later became standard equipment. The first traffic control devices to clear traffic at intersections were also put into place on Covington streets that year. The new alarm consisted of a bell and three red lights. During the day the bell would ring loudly, and at night the lights would flare.

The outbreak of World War I affected public safety in Covington unpredictably. When the call went out for able-bodied men to enlist in the military, policemen and firefighters in the city answered. By the following year, the fire department was advertising for help. Though this created a brief vacuum, the returning veterans discovered that a transition from the military to the fire or police departments would not be as difficult as moving into other careers in civilian life. Because the departments and the military had similar structures, the number of positions held by former military members would steadily increase throughout the next century.

By 1917 the Covington Police Department was ready to assume ownership of its own vehicles and communications. Prior to that time, the paddy wagon was a part of a lease (with the Merchants Police and Telegraph Company) that also included the operation of alarm boxes in the city. The wagon came with its own

driver, who would be dispatched only when needed. Officials realized that policing could be done much more efficiently if officers were in cars rather than on foot. Theodore Kluemper, the city's safety commissioner, pointed out how well the fire department had adapted to the use of motorized vehicles and that Covington was behind other cities in making the change. Still, it would take nearly a decade (1923) before the police department would have its own fleet of automobiles.

On June 20, 1920, Covington firefighters went on strike. The only people who stayed on the job were Chief Griffith and Assistant Chief Thomas Davis. The firemen stayed near their stations for the first few hours to prevent a public panic, but went fully on strike at noon. At issue were proposed cuts to the department and the need for an increase in pay. City officials took a hard line against the strikers and petitioned the governor for relief should the strike continue. The mayor called for the firefighters to be replaced. In an odd turn of events, a fire broke out at the Ohio Scroll and Lumber Company on Russell Street and at the adjacent Gatch Roofing Company on Madison Avenue. The striking firemen quickly joined the two men remaining on the force to extinguish the flames. They were assisted by numerous citizens who sympathized with the strikers. Mayor Thomas Donnelly responded by demanding that the strikers return their city-issued gear and announcing that the firemen would be replaced. In the end, the strikers capitulated and returned to work the next day, on the promise of a pay increase the following January. Public safety was restored.

One of Covington's most beloved police officers was Tommy Harris. For 15 years, he had been stationed at Fifth Street and Scott Boulevard, ushering children safely to First District School. Wagon drivers and motorists knew "Harris Corner" quite well. The jovial patrolman would hold traffic while kids scurried to and from school. In those days, a beat cop was more like a friend than a city official, and the children of First District School loved him like a family member. After a short battle with heart disease, Officer Harris died in 1926. The children of the neighborhood were devastated. His funeral at the St. Mary's Cathedral was attended by nearly all of the children from First District and by hundreds of friends and city officials. The children were so moved by the loss that they began collecting pennies to construct a memorial to their beloved protector. Within a year, they had raised enough money to purchase a bronze plaque to be placed at the intersection where he worked, with the inscription: "In loving memory of Tommy Harris, Policeman, Born 1883, Died 1926. Erected by the children he loved and protected at this corner."

In addition to performing their usual duties, members of the Covington Fire Department spent a great deal of time training in the 1920s. Occasionally, they would use downtown buildings to practice rescues. The job they were training for was continually changing. They faced the challenges of tall buildings without fire escapes and a growing number of responsibilities, including responding to automobile accidents and manning city water pumps in times of flooding. Members of the department cheerfully accepted these challenges and, by all accounts, never failed to rise to the occasion.

Patrolman Tommy Harris. Courtesy of Kenton County Public Library, Covington.

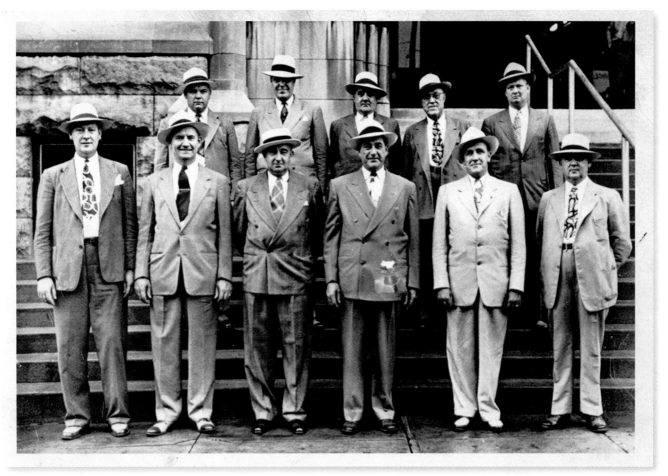

Covington detectives, June 15, 1948. Courtesy of the Covington Police Department.

One of most unusual fires in the history of the city took place at the Monte Casino Vineyards in June 1930. The vineyards had originally been cultivated by Benedictine brothers, and were a source of community pride. High winds and dry conditions caused the fire to spread rapidly, and the fire department might have lost the battle without the assistance of about 200 residents who helped beat back the blaze. Damage was limited to a few hundred dollars, but this scene of civic cooperation was priceless.

In 1930 Covington adopted a city manager form of government, whereby the city manager began to oversee police and fire department budgets. After bringing in expert Joe Fischer from the Dubuque (Iowa) Fire Department, City Manager O. A. Kratz discovered that members of the department had low morale and lacked proper training. Under these auspices, the fire department would undergo a reorganization period. Fisher was appointed as chief to oversee the proposed changes. Another of the initiatives undertaken by Kratz was to have a new alarm system installed that would permit communication between the fire and police departments and would allow both chiefs to be in constant contact with all areas of the city. The city manager also made plans to close dilapidated firehouses and to construct new ones, including a new firehouse in Latonia.

The police department was also the beneficiary of Kratz's move to modernize public safety in Covington. A new radio system was installed at police headquarters in the fall of 1931. The new set would allow them to hear broadcasts generated at station "X" in Cincinnati. The station across the river could then send a one-way announcement that could be monitored in police cars. The investment paid off less than a year later, when two officers responded to a robbery at the Kroger store at 15th Street and Maryland Avenue. The robbers were apprehended less than 5 minutes after the crime was committed.

The new radios also helped the Covington Life Squad to respond to emergencies more rapidly. Though they frequently were responsible for saving people from dire circumstances, the squad also had their fair share

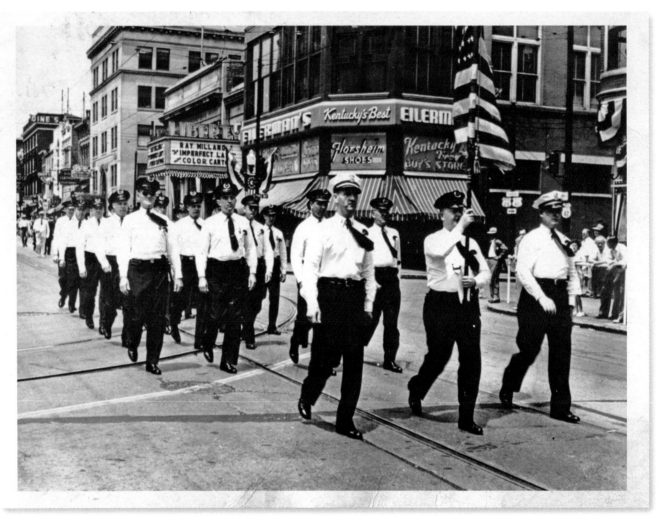

Covington police in parade on Madison Avenue, 1948. Courtesy of the Covington Police Department.

of more mundane duties within the fire department. The department, along with the squad, rescued children who had inadvertently locked themselves in bathrooms, saved kittens from tall trees, and spent long hours collecting food for Christmas baskets (along with members of the Covington Police Department) during the holidays. Firefighters and police frequently took money out of their own pockets to help the less fortunate in the community. This type of cooperation is evidenced by a small token the Life Squad gave to the police matron, Elizabeth Cohran. They presented her with a solid gold badge inscribed with her name, in appreciation of her help in their lifesaving efforts.

As World War II began, both the fire and police departments were instructed to cooperate to protect the city's infrastructure, principally the public utilities and fire equipment, including the new 75-foot ladder truck. The police department had just moved into its new headquarters, and the fire department had opened and manned its new firehouse in Latonia. Firefighters were required to become Red Cross–first-aid certified. The fire department also convinced city manager Jack Maynard to extend Covington fire protection to neighboring cities, such as Winston Park.

Although the war had depleted the workforce in the city, returning veterans in the postwar era quickly assumed public safety jobs. Both departments received more applications following the war than at any time prior. Covingtonians were ready to resume life as usual.

Several Covington churches were hit by fires over the years, but in 1947 one of the most serious blazes in the city's history took place. The United Methodist Church at Fifth and Greenup Streets had just finished services, and 250 members of the congregation had left the building, but some reported smelling smoke. An inspection of the building was conducted but found nothing unusual. Later in the day, an alarm was sounded, and within 15 minutes, the entire

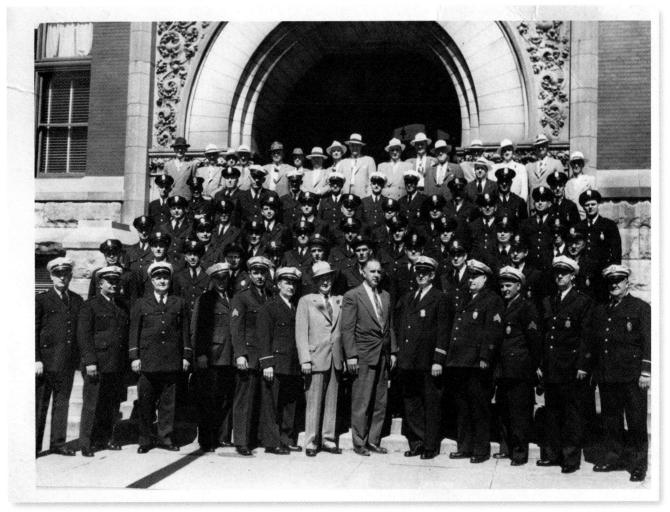

Covington Police Department in front of the old City Hall, 1950. Courtesy of the Covington Police Department.

roof was going up in flames. Soon the blaze became an eight-alarm fire. The Covington Fire Department asked for, and received assistance from, the Newport and Ludlow, Kentucky, Fire Departments. Several firefighters suffered minor injuries, but there was no loss of life. The United Methodist Church was restored and resumed services less than a year and a half later.

Another spectacular fire destroyed several buildings less than 10 years later. In the early morning hours of January 7, 1956, a fire was reported at the W. W. Welch Company. Within half an hour, flames that were estimated to have reached a height of up to 150 feet could be seen throughout the entire city. More than 200 firefighters from five departments were called to battle the inferno. Companies from Fort Mitchell, Newport, Park Hills, and Ludlow in Kentucky rushed to the scene to assist. Hundreds of people gathered at a distance to watch the fire that would end up causing $700,000 in damage. There was no loss of life, but several firemen suffered minor injuries battling the blaze.

Over the next decade, public safety in Covington would continue to evolve in much the same way as it did in other cities around the nation. By the 1960s, two-way radios were standard equipment for both the fire and police departments, and firefighting was becoming a science.

In November 1967 a 21-year-old black man named Willie Joseph Stewart was appointed by commissioners as a patrolman. He was the first African American to be hired as an officer. His appointment brought the number of members on the force to an all-time high of 96.

In 1969 James Ruth was unanimously appointed fire chief. He was a young man, only 40 years of age, but he had a vision for expanding and educating the department. Part of his plan was to send as many of his firefighters as

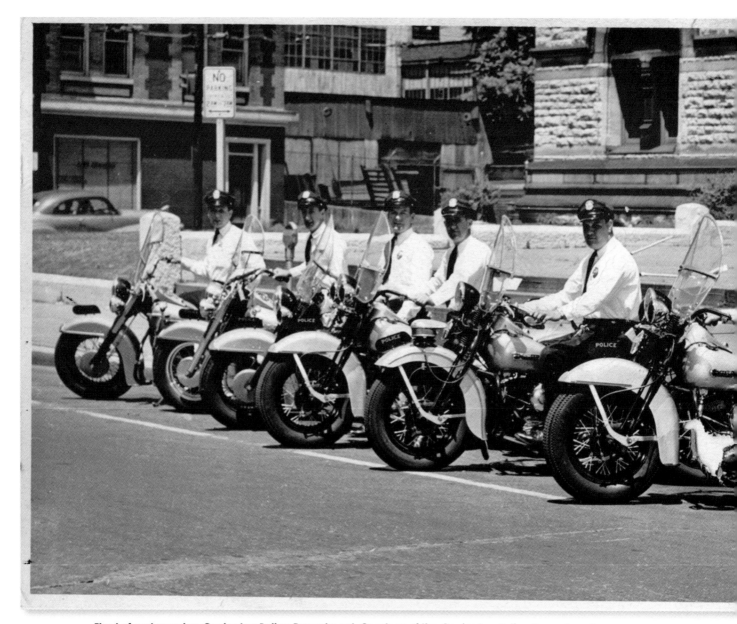

Fleet of motorcycles, Covington Police Department. Courtesy of the Covington Police Department.

possible to as many training schools as the budget would allow. They would then return and share the knowledge they had gained with their companies. He was also anxious to develop and implement plans for a new fire head-quarters.

In April 1975 Ruth's highly trained department would be tested during a massive fire at the Klaene Foundry at 16th and Russell Streets. When the first unit was rolling out their hoses, propane tanks inside the building began to explode. A call for additional alarms went out almost immediately. Soon a call for all on-duty and off-duty Covington firefighters went out. Though they brought the fire under control in less than three hours, the building was a total loss. Later that year, Ruth opened a new central fire station and headquarters on Scott Boulevard. The $1.4 million facility was dramatically different from the old one on West Sixth Street. The new station was one story with wide-open space for storage. Gone were the familiar fire poles, as the new building reflected the latest technology.

An effort to continue to modernize the Covington Police Department took a great leap forward when a group of senior staff members suggested to Chief of Police Lyle Schwartz that the city was in need of a tactical unit to address special situations. They preferred the name *tactical unit* over the SWAT (Special Weapons and Tactics) acronym because they thought it was less threatening and a more accurate description. The group devised a plan

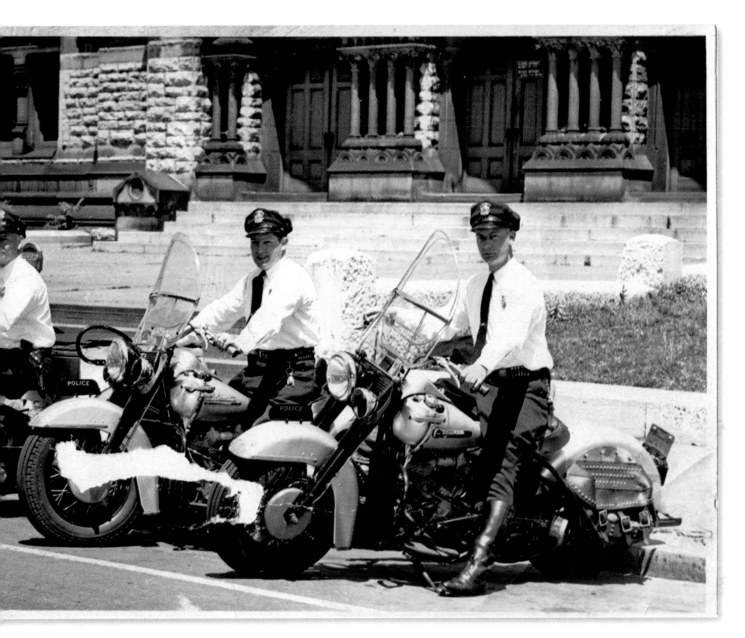

whereby they could receive proper instruction through the Ohio National Guard SWAT training program, saving the city a great deal of money. The plan was approved by Chief Schwartz, and the all-volunteer unit was formed. The officers went to a training facility aboard their large blue police van, which they nicknamed "the whale." The only additional gear they had at that time was furnished by the police department. Other equipment, such as web gear, ammo pouches, and boots, was purchased by the volunteers out of their own pockets. Most of the unit agreed to train on their days off or to use vacation time to participate in the course. Over the past 30 years, the tactical unit of the Covington Police Department has been called on dozens of times and at

Covington Tactical Unit, 1991. Courtesy of the Covington Police Department.

Smoke billows from St. Aloysius Catholic Church, Thursday evening, May 16, 1985, at about 7 p.m. Photo by Paul A. Tenkotte.

each and every occasion has served the city with valor, courage, discipline, and honor. Interestingly, Covington Fire Chief Dan Mathew currently serves as medic for the tactical unit—similar to the first Covington marshal, Isaac Martin, who became a fire warden after leaving office.

A new cooperative agreement between the Covington Police and Fire Departments consolidated their dispatch centers in 1984. The new system allowed residents to call a single number in case of emergency. And just such a number would be needed when St. Aloysius Church caught fire on May 16, 1985, more than 100 years after its first fire. More than 80 on- and off-duty firefighters responded to the call when the magnificent church was ignited by a lightning strike. This time, the result was different than in previous fires. The church suffered extensive damage, and the diocese decided to close the parish and to merge it with neighboring Mother of God Church on West Sixth Street. A year later, on September 25, 1986, Mother of God Church caught fire. During repairs to the roof from tornado damage, workers who had been soldering a part of the cupola noticed smoke coming from the roof; the ensuing conflagration would take 100 firefighters to extinguish. A $1.5 million restoration ensued, and the appreciative parishioners feted the firefighters with a dinner for saving their church.

The terrorist attacks on September 11, 2001, had a profound effect on police officers, firefighters, and paramedics across the country. The term "first responder" became a part of every American's vocabulary. Our public safety professionals felt the pain of those in New York City, Washington D.C., and a rural crash site in Pennsylvania. The devastating attacks that claimed the lives of so many brave public servants would have an unexpected effect. Ordinary people began to recognize the selfless nature of the men and women who answered the call 24 hours per day, seven days a week. There was a new sense of pride in the

community and in the ranks. Instead of just staring or looking the other way when they were met on the street or en route to an emergency, the city's residents began to smile and wave to Covington's brave men and women behind the badge. Public opinion was high, and applications for all positions grew for 10 years following the attack. People saw what happened, gained admiration for first responders, and wanted to join their ranks.

Since September 2001, both the fire and police departments have undergone continual change and development. In 2004 the fire department began its own paramedic service. Up to that time, ambulance service was run by local hospitals. Innovations such as this were a response to changing times. Both departments have to concern themselves with new technology, such as DNA evidence and a throng of new hazardous materials. But the current chiefs do not lament such changes; they embrace them. They do not want to be called heroes, but they like to be appreciated.

At an awards ceremony at the rotary club, Fire Chief Dan Mathew expressed what it means to be a Covington firefighter or paramedic, saying, "It's not a job. It's a calling." He described a simple act of kindness performed voluntarily by two of his paramedics. They were dropping off a patient at St. Elizabeth Hospital, when a woman walked into the emergency room complaining of difficulty breathing. Doctors quickly realized she was in need of a surgical airway, a procedure they could not perform at that location. The desk nurse called for an ambulance and was told it would be a long time before one could be sent due to snowy weather and bad road conditions. Without missing a beat, Matthew Archer and Sean Schlotzman responded, "We'll take her." They did not have to do it; travel was dangerous and it had been a long shift, but someone needed their help. Chief Mathew said, "It's not anything flashy, like pulling someone from a burning building, but that's what we do" (interview by Matthew Kelly, June 2014). Those humble words speak volumes.

Police Chief Michael "Spike" Jones is equally proud of his department. When he speaks about a lifetime spent in Covington, and how hard his police officers work, it is apparent that the city could not ask for a more dedicated leader. Of his department, he states, "I am so proud to be a member of what I consider to be a historically great police department. My time, and rich experience with the City of Covington, has been the fulfillment of a lifelong

Engine Company Number 5, in the South Covington neighborhood, 2014. Photo by Jeff Blackmore.

dream to serve the community in which I live. I am truly honored to work beside some of the finest police officers in the United States" (interview by Matthew Kelly, June 2014).

Residents of the city of Covington are privileged to have such a dedicated and professional group of people protecting their lives and property. Over the last 200 years, the city's public safety officers have become highly trained professionals, reflecting the modernization of municipal governmental services.

Serving and Protecting, at War and at Home

When the United States entered World War II, John Keegan enlisted in the Marine Corps. He soon became a radar man on a dive-bomber stationed on the USS *Hornet* in the South Pacific. During the Battle of the Solomon Islands, his plane was shot down, leaving Keegan adrift in the sea with a broken leg and 62 pieces of shrapnel in his back. After two days in the ocean, he was picked up by a destroyer and spent a year recuperating at a VA hospital. After the war, Keegan continued to serve his community by becoming a motor-patrol officer for the police department of the city of Covington.

John, Evelyn, and Gary Keegan. Courtesy of the Covington Police Department.

SELECTED BIBLIOGRAPHY

Burns, John E. *A History of Covington, Kentucky, through 1865.* Covington, KY: Kenton County Historical Society, 2012.

Flinker, Paul Joseph. "Development of Policing in Covington, KY: The Nineteenth Century, 1815–1900." Thesis, Union Institute, 1994.

Geaslen, Chester F. *Strolling Along Memory Lane.* Vol. 2. Newport, KY: Otto Printing, 1973.

Irwin, Graham. "History of the Covington Kentucky Police Department SWAT Team." Thesis, Union Institute, 1978.

Northern Kentucky Newspaper Index. Kenton County Public Library, Covington, KY.

Rider Charles L., ed. *History of the Covington Fire Department.* Covington, KY: n.p., 1893.

Tenkotte, Paul A., and James C. Claypool, eds. *The Encyclopedia of Northern Kentucky.* Lexington, KY: University Press of Kentucky, 2009.

Webster, Robert D. *Northern Kentucky Fires: A Summary of the Most Memorable Fires of the Region.* Covington, KY: Kenton County Historical Society, 2006.

16

FROM CHAPELS TO CATHEDRALS: RELIGION IN COVINGTON

by David E. Schroeder and Janice Mueller

PROTESTANTS

For the earliest residents of Covington, Kentucky, following their respective religious paths was of paramount importance. Throughout its 200-year history, the city has enjoyed a thriving religious life as diverse as the people who settled the area. Protestant churches were the first to be erected, beginning with the Methodists and the Disciples of Christ—both in 1827, followed by the Baptists in 1838, the Presbyterians in 1841, and the Episcopalians in 1842. Covington's African American community established two congregations by 1870: the African Methodist Church (sometimes known as the Colored Methodist Church) was established with 250 members, while the Colored Baptist Church began services with 75 members.

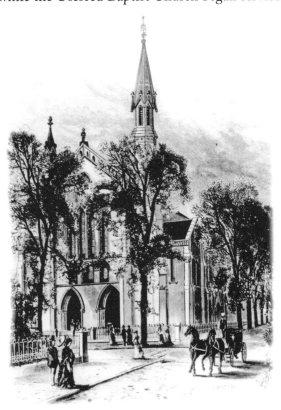

First United Methodist Church, Fifth and Greenup Streets. Courtesy of Paul A. Tenkotte.

Beginning in 1827 with just 10 members, a Methodist society was established in Covington. By 1832 this group had an expanded membership of 195, enough to finance the construction of a church at 233–235 Garrard Street. As the congregation grew, a larger structure eventually replaced the original in 1843, taking the name of the Scott Street Methodist Episcopal Church.

Throughout the United States, slavery proved to be a divisive factor among many Protestant denominations. Following the general conference of 1844, a national schism occurred, which led to the establishment of the Methodist Episcopal Church South. By 1846 members of the Scott Street ME Church joined this affiliation. A small number of dissenters formed the Union Methodist Episcopal Church, located at Fifth and Greenup Streets in Covington's Licking Riverside neighborhood. The growing congregation at Scott Street ME Church prompted the formation of a mission church in 1878. This flock would eventually construct its own church at the corner of 18th and Greenup Streets, known as St. Luke Methodist Episcopal Church South.

Members of the Scott Street Church contracted with the Cincinnati-based architectural firm Crapsey and Brown to

construct a new, larger place of worship. This Victorian Gothic structure was dedicated in May 1896. Though it sustained damage in a 1904 fire, it was restored. By 1928 the neighborhood surrounding Scott Street ME Church had been transformed into a commercial zone. Flagging membership led to talk of a merger between the congregations of Scott Street ME and St. Luke ME; however, these plans were never realized. Following the merger of the Methodist Episcopal Church and the Methodist Episcopal Church South in 1939, the members of the First Methodist Episcopal South Church and the Union Methodist Episcopal Church joined congregations, retaining the old Union ME Church at Fifth and Greenup Streets as their meeting place. In 1970 the vacant Scott Street Church was demolished to clear the area for the new Kenton County Public Library. In 2005 First United Methodist Church at Fifth and Greenup Streets closed as a chartered congregation and became an urban satellite of Immanuel United Methodist in suburban Lakeside Park, Kentucky. In 2012 it was purchased by Gateway Community College for its new urban campus.

Other Methodist congregations formed in Covington's various neighborhoods. Established in 1847, Immanuel Methodist Church served German Americans. In 1869, the congregation built a church at 10th and Russell Streets. After World War II, the Immanuel Methodist moved to a new, suburban location in Lakeside Park. Established in 1858 in Covington's Westside, Main Street Methodist's first pastor was Reverend S. S. Bellville. A frame structure on Main Street served as the first place of worship, though by 1887, enough funds had been raised to purchase land on the northeast corner of Eighth and Main Streets for the construction of a brick church. In 1986, this structure was damaged by a severe storm. Repairs were made, but the congregation continued to dwindle as inner-city residents moved to the suburbs. A proposed merger with Epworth Methodist Church never came to fruition, and Main Street Methodist closed its doors in 2004.

West Covington's Epworth Methodist Church (Union Methodist Episcopal Church) was established in 1877. First meeting places included the Main Street home of Charles Taylor and a toolshed belonging to Mr. B. Hathaway. By 1878, enough funds had been

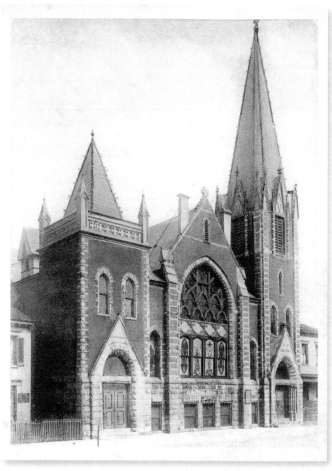

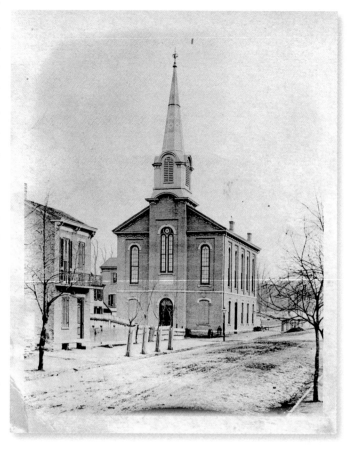

ABOVE: Scott Street Methodist Church was demolished circa 1970. Courtesy of Paul A. Tenkotte. BELOW: Immanuel Methodist Church, 10th and Russell Streets. Courtesy of Paul A. Tenkotte.

raised for the construction of a frame Gothic Revival church on Main Street, largely due to the munificence of philanthropist William P. Devou and prominent Covington entrepreneur Amos Shinkle. It was dedicated on January 30, 1879. This congregation would eventually split due to differences over practices of worship and theology. At the time of the reorganization, the church's name was changed to Union Methodist Episcopal. With the annexation of West Covington by Covington in 1916 came another name change for this congregation. Since Covington already had a Union ME Church, it was decided that, beginning in 1918, the congregation would be known as Epworth Methodist Episcopal Church. Throughout the 19th century, the church prospered, warranting the construction of a new church in 1953, located at 1229 Highway Avenue. Still in existence today, this congregation focuses on outreach to the surrounding Covington community.

In Covington's Austinburg neighborhood, another Methodist congregation eventually formed in 1867 with the establishment of a Methodist mission named for dedicated layman Amos Shinkle. The devout, wealthy businessman purchased a lot on Powell (now 15th) Street, and a church, replete with meeting rooms, was promptly constructed in 1869. By 1890 the congregation had outgrown its original structure, and again Shinkle stepped forward, matching funds for its construction. Sadly, Shinkle passed away on November 13, 1892, the same evening as the dedication ceremony for the new church. With declining membership, Shinkle Methodist and St. Luke Methodist (formerly Eleventh Street Methodist) discussed a possible merger, but this union never took place, forcing the members of Shinkle United Methodist Church to sell the building.

In the Austinburg neighborhood, a devout Christian woman named Martha Ann Taylor has been credited with organizing the St. James African Methodist Episcopal Church in 1869. When the gathering of worshipers outgrew Taylor's home, they moved to a schoolhouse. Several other moves eventually found the congregation gathering in Covington's downtown area. In 1918, while under the leadership of Reverend J. A. G. Grant, construction began on a permanent home at 120 Lynn Street, with the first phase reaching completion in 1922. From this location, St. James AME Church still serves Northern Kentucky's African American community. St. James AME Church organized St. Paul African Methodist Episcopal-Zion Church (AME-Zion), on East Robbins Street, in 1922; it closed in August 2009.

The year 1874 saw the beginning of another Methodist congregation in Austinburg. Formed from the Covington Bethel Association on October 4, 1874, this group of worshipers was originally known as Eleventh Street Methodist due to its location on Greenup Street between 11th and Bush Streets. A daughter of the Scott Street ME Church, this congregation grew rapidly. By 1912, after the construction of a larger church, the congregation embraced a new name: St. Luke Methodist Episcopal Church South. By 1928 plans to merge Scott Street ME and St. Luke ME failed. The congregation petitioned to reestablish St. Luke Methodist Episcopal, and permission was granted. It purchased St. John Episcopal Church at the corner of 18th and Scott Boulevard (formerly known as Scott Street). It has since closed.

In 1894 the Lane Chapel CME had its beginnings when a group of African American Methodists began meeting at 125 Lynn Street. This group, though affiliated with the Colored Methodist Episcopal Church, held as its namesake Isaac Lane, a former slave who, in 1873, had risen to the rank of a CME bishop. As the congregation grew throughout the 1920s, their former roofed basement structure required expansion. Funds were raised to construct an upper church, which was completed in 1945. By 1954 the denomination formerly known as the Colored Methodist Episcopal Church underwent a name change, becoming the Christian Methodist Church. Though membership has declined over this congregation's history, they are still meeting and serving the spiritual needs of their community at their original Lynn Street location.

One additional Methodist congregation formed in 1957, founded by Reverend Oyer C. Morgan, under the name Ida Spence United Methodist Church. This group of worshipers took its name from the Peaselburg neighborhood public housing complex, which is currently known as City Heights. In 1993, under the leadership of Reverend Annie Allen, this congregation worked with other Northern Kentucky Methodists on a fundraising effort to establish a City Heights clinic, which was staffed by volunteer doctors as well as a dentist.

Downtown Covington's Christian (Disciples of Christ) denomination began meeting in 1827 in a structure owned by its first elder, an educator, businessman, and politician named James Grimsley Arnold, who had moved to the area in 1818. Though this early congregation was decimated by an 1833 cholera epidemic, Arnold continued meetings in 1840 and later donated land on the south side of Third Street in 1843 for the construction of a more permanent place of worship. By 1865 the congregation had outgrown this location, and Arnold donated a larger tract located next to his home, at 14 West Fifth Street. Here, the congregation constructed a Romanesque Revival–style structure, which was dedicated on March 24, 1867. Carved above the door was the name chosen by the congregation, "Fifth Street Christian Church." This congregation thrived, though an 1875 dispute over the recalling of a minister caused a split in their ranks. This division led to the formation of the Fourth Street Christian Church, which would later become known as the Madison Avenue Christian Church. The Fifth Street congregation flourished until the church was almost entirely destroyed by a March 5, 1893, fire, which started at the nearby Fred J. Meyers Manufacturing Company.

Despite the high cost of construction materials, the congregation contracted with the Dittoe and Wisenall architectural firm to design a larger church in the Gothic Revival style, replete with stained glass windows created by the Artistic Glass Painting Company of Cincinnati. The new structure was dedicated on October 14, 1894.

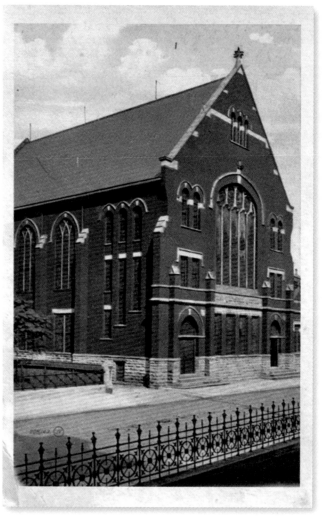

First Christian Church, circa 1914. Courtesy of Paul A. Tenkotte.

Following World War II, Covington's downtown neighborhood, and the congregation at First Christian, was impacted by urban residents relocating to suburban communities. Despite the downsizing of its congregation, First Christian joined the Interfaith Hospitality Network, offering housing to displaced families, while also participating in other charitable efforts.

After 60 members withdrew from the Fifth Street Christian Church (currently First Christian Church), the formation of a new congregation known as the Fourth Street Christian Church established a new place of worship in downtown Covington with the purchase of the old Presbyterian church on Fourth Street, newly dedicated on June 6, 1875. The congregation, though thriving, still wanted to establish themselves in a more residential area of Covington. By 1909 Central Christian Church was established, making it the third Christian Church in Covington. Still without a formal place of worship, this group began meeting at a private residence located at the corner of 15th and Greenup Streets. By 1912 representatives from Central Christian Church and Fourth Street Christian Church were holding discussions on the possibility of merging the two congregations. The successful combination of both Christian congregations prompted them to establish a new place of worship on the east side of Madison Avenue, between 15th and 16th Streets. Dedicated on November 30, 1913, this new location, in the heart of a residential neighborhood, was called the Madison Avenue Christian Church.

In nearby Milldale (now Latonia), another nondenominational Christian church was founded on February 27, 1898. The formation of this church was inspired by First Christian Church Pastor George A. Miller's revival meeting. This fledgling congregation held meetings in Bird's Hall, a rented building in Latonia. While a church

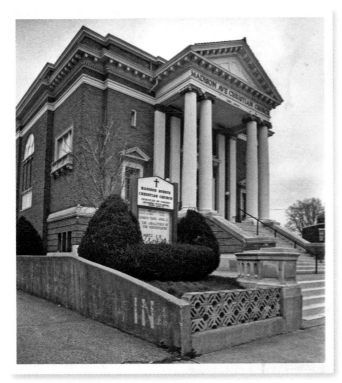

Madison Avenue Christian Church. Courtesy of the Kenton County Public Library, Covington.

was later constructed on 36th Street in 1902, the election of its first full-time pastor, Harlan C. Runyan, spurred the tremendous growth of this congregation. One expansion to the 36th Street location followed, but as worshipers continued to join Pastor Runyan's flock, it became necessary to construct an entirely new building. Located at 3900 Decoursey Avenue, the new edifice was dedicated on April 8, 1923. This thriving congregation celebrated its 100th anniversary in 1998 and is still serving the spiritual needs of its community at 39th Street and Decoursey Avenue in Latonia.

On March 10, 1838, a gathering of members from six Greater Cincinnati Baptist churches came together to discuss the establishment of Covington's First Baptist Church. Initial meetings were held in a pork-packing plant on Greenup Street. Given the dearth of Baptist ministers, the young congregation was served by several preachers during its early years. A small parcel of land was purchased by 1842 or 1843 for the construction of a church. Despite the

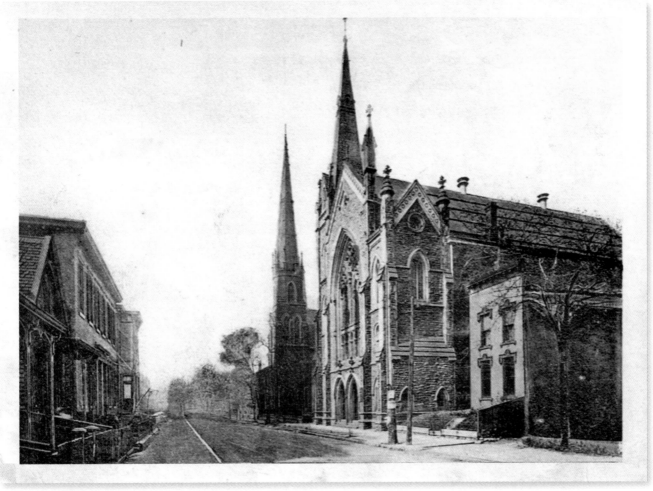

West Fourth Street, showing First Presbyterian Church (on the left; demolished in 1963) and First Baptist Church (on the right). Courtesy of Paul A. Tenkotte.

divisiveness brought on by the Civil War, First Baptist's congregation weathered the storm of differences and continued to grow. Church members, under the guidance of the Reverend W. H. Felix, demolished the old structure and began construction on a new place of worship, contracting with the Cincinnati-based architectural firm of Walter and Stewart to design the new church. Replete with stunning painted windows in lieu of stained glass, the church was dedicated in the fall of 1873. As more worshipers joined the flock, First Baptist served as the mother congregation for two mission churches: Madison Avenue Baptist, established in 1857, and Southside Baptist, established in 1889.

Southside Baptist graduated from a mission church to an independent congregation in 1907. In 1921 it purchased the old Victoria Theater at 15th and Holman Streets. The church hired architect A. W. Stewart of Cincinnati to design a new structure, but the construction was halted by lack of funds in the late 1920s and throughout much of the Great Depression. In 1939 the new building was dedicated, and in 1950 the congregation completed the second and third floors of an education building.

Forty members of the rapidly expanding First Baptist Church obtained letters of dismissal to establish a congregation in Covington's downtown area, further removed from the business district. In 1857 the congregation was formed under the name John's Baptist Church, after John S. Bush, a well-known leader in Covington's Baptist community. Until a full-time minister could be found, Pastor Asa Drury of Dry Creek Baptist Church and James A. Kirtley from Bullittsburg Baptist Church served the fledgling flock, which was meeting in the Western Baptist Theological Institute's building. Continued issues with locating a resident pastor and the sale of the Western Baptist Theological Institute to the Sisters of the Poor of St. Francis forced the congregation to find a permanent meeting location. In 1866 a parcel of land on Russell Street was purchased, which led to a name change: Russell Street Baptist Church. As pastor woes contributed to membership decline, a new lot was purchased at Madison Avenue and Robbins Street, with the congregation opting for another name change to Madison Street Baptist Church.

By 1891 some members left to form the Third Baptist Church (later Immanuel Baptist Church). Meanwhile, the congregation purchased a new lot at Madison Avenue and Robbins Streets, becoming known as the Madison Avenue Baptist by 1907. Subsequent pastors, which included Reverend T. H. Plemmons and Reverend Dr. Henry D. Allen, provided stability to the congregation. In 1911 the Robbins Street building was demolished, and another church, constructed in its place, was dedicated on June 15, 1913. By 1924 letters of dismissal were granted to an additional 40 members to establish the suburban Fort Mitchell Baptist Church. Though Madison Avenue Baptist reached a peak membership of 1,165 in 1958, throughout the 1960s and into current years membership has continued to decline. Despite this fact, Madison Avenue Baptist, no longer able to support the salary of a full-time pastor, continues to serve members residing in Covington's urban core.

In 1864 22 members in Covington's Westside neighborhood established the First Colored Baptist Church. Reverend George Dupree served as the congregation's first pastor until 1868, when Reverend Jacob Price succeeded him. Early in the church's history,

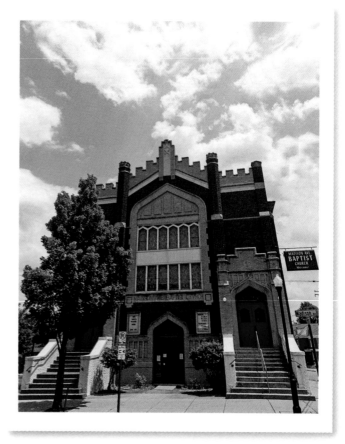

Madison Avenue Baptist Church. Photo by Dave Ivory, 2014.

a rift prompted some members of the congregation to break ties and form the Ninth Street Baptist Church. Initially, the congregation met in a structure on Bremen (Pershing) Street. Several moves later found the First Baptist Church relocating to a new, small church constructed on Robbins Street, on the city's Eastside. Continued growth of the flock required a larger place of worship, which was built on 13th Street and dedicated in 1877. Sadly, this new structure was demolished by a July 1915 tornado—though a new church was constructed by 1917 at 118 East Ninth Street in closer proximity to Covington's African American community. Covington's First Baptist Church is still operating at this same location today.

In Covington's Eastside Neighborhood, members who had left First Baptist Church formed a mission congregation in November 1869, under the leadership of Reverend H. Haggard. Early on in this congregation's history, services were held in various buildings throughout the city, including the Seventh Street Market House on Madison Avenue. By 1876 Reverend David served as pastor, until he was succeeded in 1886 by Reverend Jacob Price, who held the pastorate until 1890. In 1914 land was purchased on East Ninth Street, with the cornerstone laid into place that same year. Despite sustaining damage during the 1937 flood, Ninth Street Baptist persevered and celebrated 125 years of spiritual service to the Eastside community in 1994.

Covington's Third Baptist Church traces its history to March 15, 1891, when founding members held an organizational meeting at George W. Grizzle's Scott Boulevard home. Fifty members comprised the congregation, with Reverend S. G. Mullins serving as the first pastor. Before a permanent home was found, services were conducted in the Welch Mission, located at the corner of Greenup and Linn Streets. A lot, located at the corner of Scott Boulevard and 20th Street, was purchased, and construction began on a permanent home for the congregation. The dedication, which took place on September 18, 1892, was soon followed by the induction of a second pastor, Reverend J. A. Lee. Soon after, a mission church, which would eventually be known as the Latonia Baptist Church, was established. Third Baptist Church's congregation was eventually rededicated in August 1905, taking the name Immanuel Baptist Church. Tragically, the church was destroyed by fire on December 19, 1920. The resilient congregation made plans to construct a new church on the corner of 20th and Greenup Streets; it was dedicated in March 1922. Later dissension during the tenure of Reverend Martin Coers during the 1940s and early 1950s led to a split between Immanuel Baptist and the North Bend Baptist Association in 1957. Eventually, due to its dwindling congregation, the church was vacated and services were moved to the Garden of Hope, a facility credited to Reverend Coers that features a replica of Jesus's tomb, a chapel, and plants indigenous to the Holy Land.

Immanuel Baptist's mission church, Latonia Baptist Church, was founded by Immanuel's pastor, Reverend J. A. Lee, around 1892. Early meetings were held in residential homes until the 1896 purchase of a lot located at 38th Street and Decoursey Avenue. Some dissension caused by Latonia Baptist's bid for independence from its mother church kept the mission church from joining the Association of Baptist Churches. Some of the issues dealt with property ownership, and once these problems were resolved in autumn 1900, Latonia Baptist Church gained membership in the North Bend Baptist Association as the First Baptist Church in Latonia. Throughout its long history, Latonia Baptist had many pastors, including Reverend C. A. Earl, Reverend Jesse Warren Beagle, Reverend Thomas Clinton Crume, Reverend O. J. Steger, Reverend Black, Reverend Lewis C. Ray, Reverend Huss, Reverend Thomas Shelton, and Reverend Harold Wainscott. Despite hard times during the Depression, this congregation persevered and established many missions, including Ashland Baptist, Calvary Baptist, Decoursey Baptist, and Rosedale Baptist.

Calvary Baptist Church in Latonia is one of the largest Baptist congregations in Northern Kentucky. Fifty-two charter members founded the church in November 1922. Reverend Harry O. Fry was the first pastor, holding services in Bird's Hall at Ritte's Corner. From earliest days, the church was innovative. For example, Reverend D. B. Eastep, who began a 35-year pastorate in 1927, wrote and published small booklets for the Whole Bible Study Course. In addition, Eastep began radio broadcasts in 1938 and oversaw the building of a new church at West Southern and Tibbatts Streets in Latonia in 1939, as well as a new auditorium in 1950. Eastep died in 1962, and

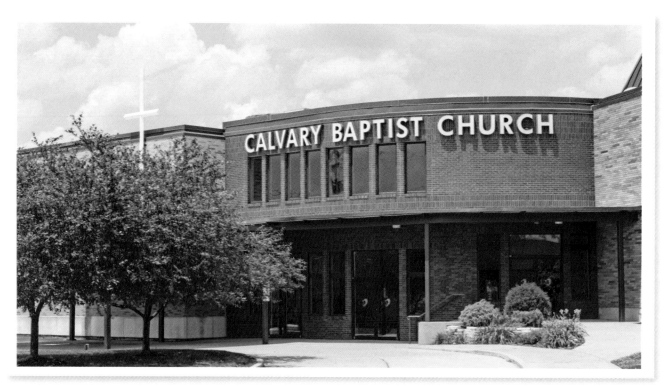

Calvary Baptist Church. Photo by Dave Ivory, 2014.

Reverend Warren Wiersbe became pastor. Wiersbe also wrote and published booklets for the Whole Bible Study Course, which were distributed internationally. He remained at Calvary until 1971, when he accepted the pastorate of the Moody Church in Chicago. In 1972, the church voted to establish Calvary Christian School, which opened in 1973 with an enrollment of 64 students. Later, the school built a sprawling campus in South Covington. In 1999, the congregation built Calvary Center adjoining the church.

By December 1927 another Baptist congregation had its beginnings in Covington's Eastside neighborhood. The Macedonia Missionary Baptist Church began meeting in the home of congregation member John Lattimore, who lived at 1209 Maryland Avenue. Worship was later held in a stable located on East 11th Street. Reverend E. Kelley, from Calvary Baptist Church, took over the helm and helped Macedonia Missionary Baptist Church to be recognized fully by April 21, 1928. The congregation continued to meet in the stable until 1939, when the property was acquired for construction of the Jacob Price Housing Complex. While a new church was being constructed at 219 East 11th Street, worship was held in an old upholstery shop. In 1965, Macedonia Missionary Baptist Church received a new pastor, Reverend Joseph R. Garr. Under Reverend Garr's leadership, construction was completed on a new place of worship, located at 323 East 11th Street, which included a junior usher board and a nursery. Reverend Garr remained as pastor until his retirement in 1995.

The Reverend William Orr is credited with organizing the first Presbyterian congregation in the city in November 1841. Though Reverend Orr came to Covington with the intent of starting a school for young women, he lent his leadership to the city's fledgling Presbyterian congregation. With 15 charter members and two elders, William Ernst and Matthew McMurtry, Reverend Orr began preaching on Madison Avenue in a rented room. Elder Ernst financed the construction of a temporary place of worship located between Fourth and Fifth Streets on Madison Avenue, though this frame structure was replaced by a brick church financed by $3,500 in funds raised by the congregation. Located west of Madison Avenue on Fourth Street, this place of worship was dedicated on December 25, 1842. Two years later, it became necessary for Reverend Orr to leave his pastoral duties to spend more of his time administering Orr's Female Academy.

Reverend Orr was followed by Reverend John Clark Bayless and then by Reverend John M. Worrall. Reverend Worrall is credited with establishing the Second Presbyterian Church, which would become known as the Madison

Avenue Presbyterian Church, in December 1854. Also under Reverend Worrall's guidance, a new home for the First Presbyterian Church was designed by Walter and Stewart, a Cincinnati-based architectural firm. This new edifice, located on West Fourth Street, was adjacent to Covington's First Baptist Church. First Presbyterian's congregation continued to expand and thrive despite the advent of World War I and the 1937 flood. Despite severe damages to the church, repairs exceeding $4,000 were completed. The centennial anniversary of the congregation was celebrated in 1941 and saw remodeling of the church and the addition of a large assembly room and four Sunday school classrooms.

Just as in World War I, the World War II era saw many members of the congregation serving their country. Urban flight began to take its toll on the congregation in the years following the 1937 flood. By 1955 most of the congregation was no longer residing within walking distance of First Presbyterian, and the establishment of Lakeside Presbyterian Church led more members to join this suburban congregation. Land was eventually acquired between the cities of Covington and Fort Wright, Kentucky, for the construction of a new church on Highland Pike, which was dedicated on September 17, 1961. The old Fourth Street church was demolished to make way for the Covington Internal Revenue Service building.

Downtown Covington's Second Presbyterian Church was established on December 25, 1854, under the guidance of Reverend John M. Worrall. Officially formed on February 28, 1855, the new congregation's 28 members had originally belonged to the city's First Presbyterian Church. Though the new congregation purchased land on the north side of Ninth Street for construction of a church, while it was being built, worship was conducted in a building located at the corner of Ninth Street and Madison Avenue. Dedicated on December 23, 1855, a church hall was added in 1861 to augment the lecture room. While the congregation continued to expand, a fire on September 21, 1880, destroyed the church. Members sold the property to a Methodist group, which rebuilt

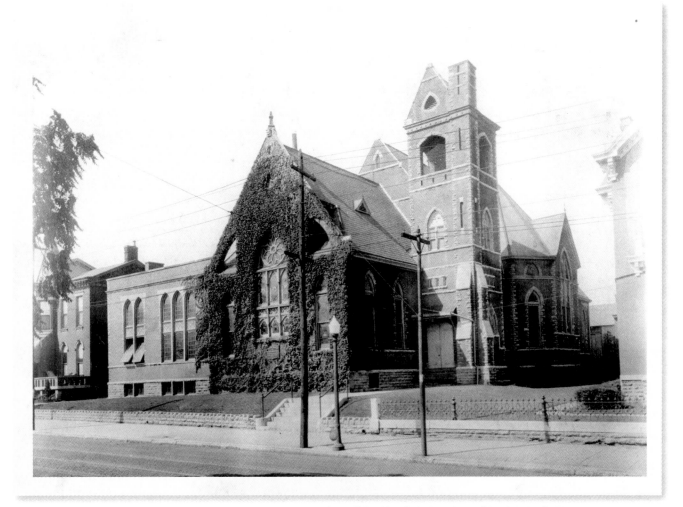

Madison Avenue Presbyterian Church was demolished in 1963. Courtesy of Paul A. Tenkotte.

the structure and established an African American congregation. Second Presbyterian's parishioners purchased property south of Ninth Street on Madison Avenue for their new church. Completed in 1882, this Gothic Revival structure would also be destroyed by fire two years later, though insurance took care of the damages. Around that time, members of the congregation adopted the name Madison Avenue Presbyterian.

Another Gothic Revival edifice, designed by the architectural firm of Crapsey and Brown, was dedicated on November 21, 1886. Prior to World War I, the congregation thrived, requiring a large addition to the church in the 1920s. The establishment of the Lakeside Presbyterian Church, located in the suburbs, along with a steady decline in membership due to the erosion of the urban core, led to a February 16, 1961, merger of Madison Avenue Presbyterian Church and the Lakeside Presbyterian Church. The Madison Avenue property was later sold, and the old church was razed.

The Episcopalian faith began its tradition in Covington on May 8, 1842, when Bishop Benjamin Bosworth Smith, the first Episcopal bishop in the Diocese of Kentucky, conducted services in a frame church located on the corner of Fifth Street and Madison Avenue. Prior to this service, Episcopalians in Northern Kentucky traveled to Cincinnati for worship. Members met on November 24, 1842, and selected Trinity Church as the name of their new parish. Accepted by the diocese on May 11, 1843, original members of the vestry included Thomas Bird, J. W. Clayton, John K. McNickle, J. L. Newby, George M. Southgate, Jackson Sparrow, John W. Stevenson, J. W. Venable, and Charles A. Withers.

Reverend Green Moore served as Trinity's first pastor. Land was purchased on Madison Avenue for the construction of a permanent place of worship. The cornerstone was laid on June 24, 1843, and just over one year later, first services were conducted on June 30, 1844. The congregation flourished and soon outgrew the Madison Avenue location, prompting the purchase of additional lots adjacent to the church's property, where a new brick church was constructed and dedicated by Bishop Smith on March 1, 1860. Two mission churches were eventually established in Milldale (Latonia) and in Ludlow, Kentucky. By February 13, 1870, a chapel had been constructed in Latonia named St. Stephen. In 1869 services were being held in Ludlow, called the Chapel of the Redeemer. The Ludlow congregation never took root, and a building was not constructed. Trinity received an 1886 addition designed by architect Louis A. Piket, who also designed the 103-foot bell tower and baptistery, which was dedicated on Thanksgiving Day 1888.

By 1890 vestry members at Trinity had purchased a tract of land located at the corner of 18th Street and Scott Boulevard, where a new mission congregation, known as St. John, was established. The first service was conducted on December 26, 1890. Interior decorations that graced the mission church were given by Cincinnati's Christ Church; they included a triple

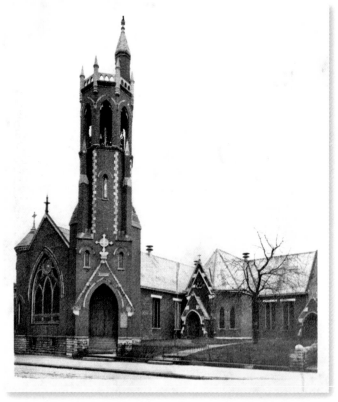

Trinity Episcopal Church, Fourth Street and Madison Avenue. Courtesy of Paul A. Tenkotte.

art-glass window, nine double art-glass windows, and 80 pews. Eight-five members of Trinity's congregation comprised St. John Mission parish, which was officially recognized on January 30, 1894. However, by the 1920s, Trinity Episcopal and its mission, St. John Episcopal, merged again. The Salvation Army eventually purchased the St. John property.

The first half of the 20th century saw continued expansion of Trinity Episcopal services and programs. Yet, like so many other inner-city parishes, membership decline following World War II, prompted by a population shift to the suburbs, caused Trinity Episcopal to reevaluate its urban scope. Rather than relocating to the suburbs, the congregation chose to continue its ministry in Covington's urban core. By 1956 members had established the Northern Kentucky Mental Health Association, followed in 1970 by the creation of the Northern Kentucky Senior Citizens Center. In 1971, Trinity Episcopal was also involved in the establishment of the Covington Community Center. This vital place of worship continues to minister to the spiritual needs of Covington's residents.

Due to the large influx of German immigrants who settled in Covington, the German Reformed Church—and the German Evangelical Church—congregations (now United Church of Christ) were popular. German Protestants residing in Covington met on May 1, 1847, to establish a congregation. Thirty families pooled their resources to purchase a lot located at the northeast corner of 11th and Banklick Streets, where a small frame building was constructed. On August 29, 1847, services were first held, with a dedication ceremony following on November 1 of the same year. By 1860 St. Paul Evangelical Church's growth warranted the construction of a new brick church on the existing lot. The main level was completed first, and contained classrooms and offices. The second level, with its large auditorium, was finished in 1867. This new place of worship was dedicated on April 28, 1868. St. Paul Evangelical Church celebrated its 25th anniversary in 1872 with the installation of a new altar, a pulpit, chandeliers, and stained glass windows. In 1875 a bell tower and clock were added to the façade.

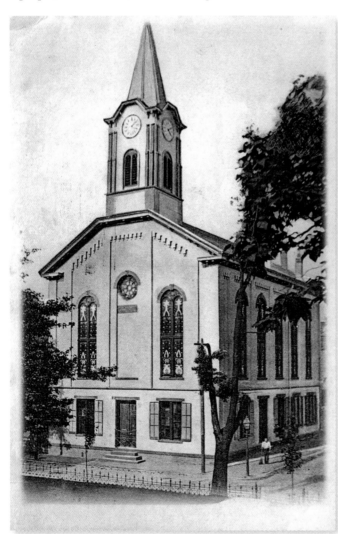

St. Paul German Reformed Church, circa 1908. The church building was destroyed by fire in 1990. Courtesy of Paul A. Tenkotte.

St. Paul Evangelical's congregation remained true to its German roots. When, in 1909, the antisaloon drive was being pushed by other Protestant denominations, St. Paul Evangelical and one other church in Kenton County refused to participate. Services were conducted in the German language until the First World War halted this practice, due to the anti-German hysteria that spread throughout the nation. Throughout the 1920s and the 1930s, the congregation continued to improve the church's facilities, removing the old tower and steeple and replacing it with a copper-crowned steeple in 1932. As a result of the 1957 merger of the Evangelical and Reformed churches with the Congregational church, St. Paul Evangelical changed its name to St. Paul United Church of Christ. As urban populations moved to the suburbs, Covington's population decreased, which affected the congregation. A building fund was started and, over the course of several years, resulted in the purchase of a 7.2-acre plot on Ft. Henry Drive in Lookout Heights (now Fort Wright), Kentucky. The services of Newport architect William F. Brown were contracted, and the new church was dedicated on February 9, 1969. Attempts to sell the old building at 11th and Banklick Streets to the All Nation Temple in 1971 failed, so the old church was used for storage, until it was destroyed by a fire on September 22, 1990.

In Covington's Westside, 18 residents met at the home of Heinrich Wilhelm Schleutker, located on the corner of Craig and Pike Streets, to plan for the establishment of a church and school in their community. Those gathered selected the name Evangelical Reformed Church. In May 1862, land was purchased at the northwest corner of Willard and Lockwood Streets. The cornerstone was laid in place on June 13, 1862, with a Palm Sunday dedication ceremony held on April 6, 1863. The two-story brick structure included classrooms on the main floor and worship space on the second floor. The congregation expanded to 300 worshipers by 1868.

In 1896 it was decided that the church should be remodeled. Additions to the façade included a steeple, along with an ornate Gothic window and stained glass windows. The dedication ceremony took place on December 7, 1896. Though some Sunday school classes and services were held in German, this practice ceased due to anti-German sentiment that accompanied World War I. The congregation voted to cease the use of the German language on April 28, 1918. Around this same time, the church took a new name, the Grace Reformed Church. With the post–World War II era move to the suburbs, Grace Reformed Church lost members of its congregation. Just as St. Paul Evangelical did in 1957, Grace Reformed joined the United Church of Christ Denomination and took a new name: Grace

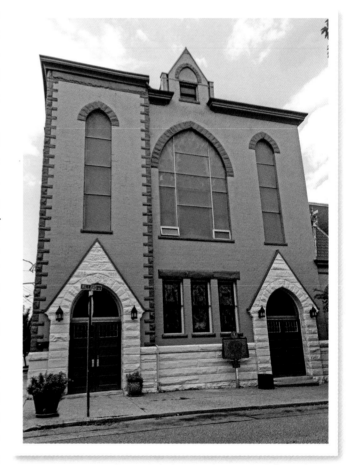

United Church of Christ. As membership continued to decline, members discussed moving to the suburbs, but a vote indicated that most preferred to remain in Covington. Finally, by the mid-1990s, with fewer than 20 members, the congregation was forced to close. The last services were held on October 29, 1995.

In Latonia, St. Mark Evangelical and Reformed Church was founded in March 1907 by Reverend William Echelmeier, who also served as its first pastor. Initial meetings were held at Bird's Hall, Latonia, as plans were made for the construction of a permanent place of worship. The cornerstone was set in place on August 16, 1908. The completed church was dedicated on January 22, 1909, with Reverend Echelmeier as minister. On July 8, 1914, Reverend John C. Klingenberger replaced Reverend Echelmeier as pastor. In October 1918 Reverend Klingenberger was succeeded by Reverend A. C. Roth.

The selection of Reverend Frank C. Scholl led to a long pastorate that lasted from 1919 until 1968. During Reverend Scholl's tenure, the church was remodeled in 1924, 1941, and 1956. It celebrated its 50th anniversary on May 28, 1958. Also during Reverend Scholl's tenure, St. Mark's experienced changes in its denominational affiliation. In 1938, the Evangelical Synod of

Grace United Church of Christ, Willard and Lockwood Streets. Photo by Dave Ivory, 2014.

North America, St. Mark's parent denomination, merged with the German Reformed Church of the United States, becoming the Evangelical and Reformed Church (E&R for short). In 1957, another change occurred when the E&R merged again, with the General Council of Congregational Churches, becoming the United Church of Christ. St. Mark's made necessary name changes and remains affiliated with the United Church of Christ. With Reverend Scholl's passing on March 8, 1969, after 49 years of faithful service to the congregation, the saddened members eventually selected Reverend Eugene Wetzel as their pastor. After Reverend Wetzel's resignation in March 1978, St. Mark's appointed Reverend George Muzny as the new pastor on March 25, 1979. In 1983, the congregation celebrated its 75th anniversary.

Though many German Protestants in West Covington attended services at St. Paul German Evangelical Church during the 1870s and 1880s, the desire to establish their own church soon led to a meeting of 16 residents on May 1, 1892. At that time, St. John German Evangelical Protestant Church was established. Property was purchased on Highway Avenue for the construction of a church. On October 2, 1892, the cornerstone was laid, with first services conducted on December 26, 1892. The new church was dedicated on April 16, 1893. In addition to conducting services in German, the parishioners also enjoyed singing and playing sacred music traditional to their homeland. However, during the First World War, German-language services were eliminated.

As the congregation flourished, it soon outgrew the facilities constructed in 1892. First-floor space was added in 1923, including an ample meeting room and classroom space. At that time, the Congregational Christian Church became the new affiliation for the church, which led the parish to change its name to St. John Evangelical Protestant Congregational Church. The congregation's 50th anniversary was celebrated in 1942, and many members fought in the armed forces during World War II. The 1950s saw the continued increase of the congregation, which led to an addition that was dedicated on March 20, 1961. One year later, the church's interior was beautified with the addition of colorized glass windows. Also in the 1950s, the merger of the Evangelical Reformed Church and the Congregation Church formed the United Church of Christ. Members of St. John remained outside this new denomination, and the congregation has long continued its independent, nondenominational role. St. John continues to serve the spiritual needs of its parishioners as well as the surrounding community.

German immigrants to Northern Kentucky included some Lutherans. In downtown Covington, Reverend J. C. Culler, from the Lutheran synod of Ohio, founded a new congregation in Kenton County. Taking the name of the First English Lutheran Church, initial meetings were held in Covington at 728 Garrard Street, at the home of Charles F. Airing. Pastoral duties were conferred upon Reverend W. H. Little until his departure from Covington in 1924. Early meetings were held at the Knights of Pythias Hall, located on Fourth Street, which the congregation purchased in 1920. In later years, church members purchased the Simrall residence, located at 1007 Madison Avenue, remodeling this 1855 home to serve as a place of worship and as classrooms. Dedication of this structure took place on June 23, 1923. By 1928, First English Lutheran Church sponsored a Pastor's Aid Society, a Sunday school, and a branch of the Luther League, but by the 1930s, the congregation was no longer viable.

In 1933, in Covington's Peaselburg neighborhood, the Bethany Lutheran Church was originally established as a mission congregation by Reverend Victor Stelle, with first services conducted on September 24, 1933. Officially organized as a congregation on April 12, 1934, initial worship services were held on the second floor of a funeral home located at 2214 Madison Avenue in Covington. By 1936, property had been purchased at 2201 Madison Avenue, with funds made available through a gift of the Lutheran Women's Missionary League and a Central District Church Extension Fund loan. The new brick church's cornerstone was laid on August 29, 1937, with official dedication ceremonies taking place on November 28, 1937. Following Reverend Stelle's departure in 1942, Reverend Carl H. Toelke assumed pastoral duties. By 1945 Reverend Gustave Schramm had been appointed as pastor, though his tenure lasted only until 1949. At that time, Reverend Albert J. Dundek was appointed pastor, and the congregation became self-sustaining.

By 1959 Reverend Alfred R. Lueders (1957–66) was appointed pastor, overseeing the congregation's celebration of its silver jubilee that same year. For the third time, a new parsonage was purchased, though this home was located in the suburbs at 505 Dudley Road. The congregation's members began moving to the suburbs, which led Bethany Lutheran to the purchase of a new parsonage with additional acreage in the early 1970s. Located at 3501 Turkeyfoot Road, the new, Erlanger, Kentucky–based church was dedicated on December 1, 1974. Faith Lutheran later closed and merged with Zion Lutheran Church in Park Hills, Kentucky. The merged congregation, Gloria Dei Lutheran Church, thrives at its suburban Crestview Hills, Kentucky, location.

In West Covington, a few other churches existed over the course of the city's 200-year history. Established in 1972, Calvary Assembly of God was located at 1279 Parkway Avenue. Two ministers served the church, Reverend

Larry Hill and Reverend Martin Wildeman, before its closure in 1977. Later that year, a conservative Catholic group established Our Lady of Fatima Parish as part of the Orthodox Roman Catholic Movement, not affiliated with the Roman Catholic Diocese of Covington. Several years after its beginning, this church closed, and the building become the permanent place of worship for a Church of God congregation.

CATHOLICS

Prior to the 1830s, no Catholic parishes existed in what is today Northern Kentucky. The few Catholics residing in the region attended services in the parishes in nearby Cincinnati. In 1833 a small group of Catholics living in Covington purchased a lot at the corner of Fifth and Montgomery Streets for the purpose of building a parish church. This property had formally been known as the White Mansion and was owned by a wealthy resident of New Orleans. The lot was situated in what was then the outskirts of the city and was surrounded by woods. The congregation was made up of American-born German and Irish Catholics. On this lot, a small church was constructed. Early accounts differ on the description of the building; some indicate a frame building, others a brick one. What is certain is that the building was small and surmounted by a slender spire and cross. This first Catholic church in Northern Kentucky was called St. Mary's and was blessed by Bishop John Baptist Purcell of Cincinnati.

St. Mary's congregation was initially cared for by the clergy of Cincinnati; however, in 1837, Father Stephen Montgomery, OP, was named the first resident pastor. Father Montgomery cared not only for the Catholics of Covington but also for a large mission territory extending as far east as Maysville, Kentucky. Under Montgomery's leadership, St. Mary's Parish was fully organized, and the first parochial school in Northern Kentucky was established. In 1849 Reverend John Baptist Lamy was appointed pastor of St. Mary's Parish. Two years later, he was appointed the first bishop of Santa Fe, New Mexico—Lamy was the inspiration for Willa Cather's 1927 novel *Death Comes for the Archbishop*. St. Mary's was honored with a visit by Father Stephen Badin in 1850. Father Badin was the first priest to be ordained in the United States and was a pioneer missionary in Kentucky.

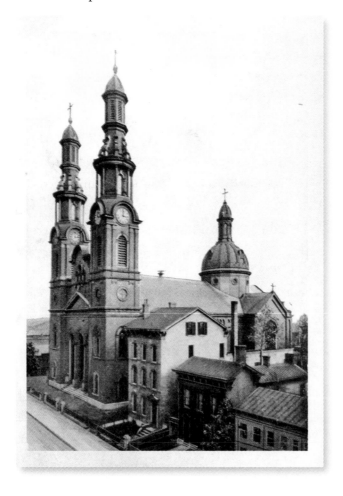

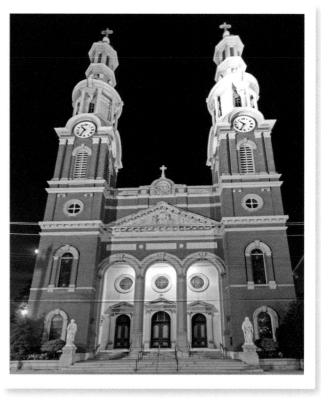

LEFT: Mother of God Catholic Church, West Sixth Street before 1915. Courtesy of Paul A. Tenkotte. ABOVE: Evening photo of Mother of God Catholic Church. Photo by Dave Ivory, 2014.

Membership at St. Mary's steadily grew as immigrants from Germany and Ireland arrived in the city. In the year 1851 alone, the parish recorded 93 baptisms and 38 marriages. Ethnic differences were initially dealt with by providing two separate Sunday Masses, one for English-speaking Catholics and another for German speakers—although the Mass itself was in Latin, the sermons were preached in English and German. The German population grew to such an extent that in 1841 they established Mother of God Parish. At that time, reports indicated that 200 German Catholics were arriving in the Greater Cincinnati area each day. Mother of God was organized by Father Ferdinand Kuhr, a native of Prussia. Initially, the congregation met at the National Hotel in Covington. During this time, a lot on Sixth Street was purchased, and a neatly designed brick building, measuring 100 feet by 50 feet, was quickly constructed. It was dedicated by Bishop Guy Chabrat, bishop coadjutor of Louisville, Kentucky, on October 10, 1842. Like St. Mary's, the people of Mother of God Parish also established a parish school. Classes were initially conducted in the church sacristy and were taught by a layman.

By 1870 the parishioners at Mother of God Parish were ready to construct a more impressive house of worship. The old church building was demolished, and ground was broken for the new Italian Renaissance Revival structure, designed by the Cincinnati architectural firm of Walter and Stewart. The cornerstone of the new church was set in place on July 3, 1870, and the building was dedicated on September 10, 1871. The new Mother of God Church sported a large portico supported by four Corinthian columns, two large bell towers, and a dome surmounted by a cupola. In 1875 a magnificent Koehnken organ was installed in the church balcony. The new church presented a splendid appearance and added greatly to the city's skyline. Father Kuhr, however, did not live to see the building completed. He passed away on November 28, 1870. Kuhr had served the German Catholics of Covington for nearly 30 years.

The German Catholic population of Covington increased so quickly that a new congregation was needed in the Lewisburg neighborhood. In 1849 the residents there gathered together and purchased a lot for a school. A building was immediately constructed at the corner of Leonard and Worth Streets, and classes began. The school was placed under the patronage of Saints Peter and Paul. In 1854 the little congregation erected a brick church near the school. As the walls of the new church were being erected, Father Ferdinand Kuhr suggested that the new parish be named St. John Parish—legend has Father Kuhr stating, "You are children of Mother of God and your new church should be placed under the protection of her adopted son, St. John."

From that time forward, the Lewisburg congregation and school were known as St. John Parish. The completed Gothic Revival building measured 60 feet by 90 feet and sported a tower with a steeple reaching 150 feet into the sky. The unfinished building (the floor had not been laid) was dedicated on December 27, 1854. Father Joseph Theresius Gezowski was appointed the first resident pastor.

German Catholics took the brunt of the Know-Nothing bigotry in Northern Kentucky during the 1840s and 1850s. They were accused of undermining American traditions by rejection of the public schools, drinking on the Sabbath, and adherence to the German language. The Irish also faced prejudice in Covington. Many had fled the Great Hunger in Ireland and came to this country with few skills. In 1855 a Covington newspaper wrote, "The flood of foreigners recently received into our country have made themselves offensive by their rude behavior, especially the lower class Irish, who seem disposed to run over Americans rough shod, and to disregard their rights in property."

Despite this opposition, German and Irish Catholics became a significant force in Northern Kentucky and specifically in Covington. In time, Catholics served in city government, played an important role in the development of the city and Kenton County, and became major business owners.

From the beginning, Catholics living in Covington were part of the Diocese of Bardstown, Kentucky. The Bardstown Diocese had been established in 1808 to care for the growing number of Catholics living in Kentucky. It was the first diocese established in English-speaking America west of the Appalachian Mountains. In 1841 the diocese was transferred from Bardstown to Louisville. Covington, however, was a considerable distance from Louisville. As a result, the bishops and clergy found it difficult to minister to the people of Northern Kentucky. In 1847 the bishops of Cincinnati and Louisville entered into an agreement that placed the cities of

Covington and Newport (including the territory 3 miles distant from them) under the care of Cincinnati. The Catholic population of Northern Kentucky was growing rapidly, and the bishop of Louisville soon regretted entering into the agreement.

In 1848 the two bishops decided to ask officials in Rome to resolve the jurisdictional matter. On July 29, 1853, Pope Pius IX settled the dispute by establishing the Diocese of Covington, Kentucky. The new diocese included 17,286 square miles and stretched from Northern Kentucky to the border of Tennessee, and from Lexington, Kentucky, to Virginia (now West Virginia). The modest St. Mary's Parish on Fifth Street was raised to the rank of a cathedral, and Jesuit Father George Aloysius Carrell, rector of St. Xavier College in Cincinnati, was named the first bishop. At that time, the Diocese of Covington contained only six parishes: two in Covington and one each in Frankfort, Lexington, Maysville, and Newport.

Old St. Mary's Cathedral, East Eighth Street. Courtesy of Paul A. Tenkotte.

When the Diocese of Covington was created, St. Mary's Parish was raised to the rank of a cathedral. The small church, however, was no longer capable of meeting the needs of the congregation. In 1847 property was purchased on the north side of Eighth Street, between Scott Boulevard and Greenup Street, as a site for a new church. Construction, however, was put off until a decision was heard from Rome. With the arrival of Bishop Carrell, plans to construct a new cathedral on the Eighth Street property were carried through. The cornerstone of the new St. Mary's Cathedral was set into place on October 2, 1853, and the building was dedicated on June 11, 1854. The modest Gothic Revival–style brick church measured 126 feet in length and 66 feet in width. A home next door to the new structure was used as a residence by the bishop and the cathedral clergy.

The 1850s witnessed a steady flow of German Catholics into Covington. Most were leaving Germany due to the lack of sufficient agricultural lands and deteriorating economic conditions. Many of these early immigrants were from Hanover and Oldenburg. The Helentown neighborhood on the east side of Covington soon became a haven for these German immigrants. A building lot was purchased at the northwest corner of 12th and Greenup Streets in November 1853. Eighty families formed the nucleus of the new congregation, which was placed under the patronage of St. Joseph. In the summer of 1854, construction began on the new church. This work, however, proved to be premature due to the lack of funds. Only the foundation was completed. Instead the congregation turned toward the construction of a combination church and school building, which was dedicated in 1855.

Initially, St. Joseph Parish was cared for by diocesan priests and priests from Cincinnati religious orders. In 1858, Bishop Carrell arranged for the Benedictine

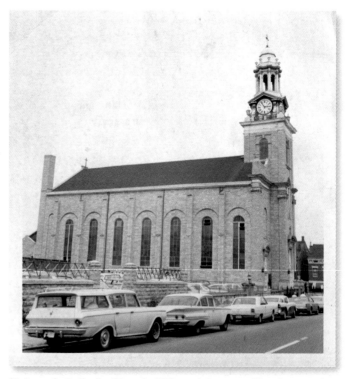

St. Joseph Catholic Church, 12th and Greenup Streets, was demolished in 1970. Photo by Raymond E. Hadorn. Courtesy of Paul A. Tenkotte.

priests of Latrobe, Pennsylvania, to establish a priory in Covington and to care for the new St. Joseph Parish. The first Benedictines to minister in Covington were Fathers Oswald Moosmueller and Romanus Hell. In 1859 the residents of Helentown completed a brick church building on the previously built foundation. The church was designed by the architectural firm of Anthony Piket. Bishop Carrell blessed the new edifice in August 1859. The early Benedictines not only were active at St. Joseph Parish but also established a large mission territory. Father Hell was the active pastor of St. Joseph Parish, while Father Moosmueller began a mission circuit that included the Northern Kentucky communities of Ashland, Augusta, Brooksville, Florence, Morningview, Verona, and the Ohio community of Ripley. Moosmueller's work eventually led to the creation of missions and parishes in these communities over the next decade.

Monte Casino's Vineyards

Named after a famous Italian monastery—Monte Cassino, founded by St. Benedict—Monte Casino in Covington was a localized misspelling. The Benedictine priests and brothers from Latrobe, Pennsylvania, purchased the old Thompson Winery property on Prospect Hill, overlooking the Peaselburg neighborhood, in 1877. There, they grew grapes for the production of altar and table wines. During Prohibition, the Benedictines were limited to producing altar wines only, making their vineyards unfeasible. In 1918, they quit the production of wine. Leased for decades to the Burkhart family, who produced grape juice there, the property was sold to Fred Riedinger in 1957. It subsequently became the Monte Casino Subdivision. A small stone chapel there, built in 1904 by Benedictine Brother Albert Soltis, was once listed in Ripley's "Believe It or Not" column as the "smallest church in the world." Riedinger donated the chapel to Thomas More College in suburban Crestview Hills, Kentucky, where it was moved and remains a symbol of the college today.

The Sorrowful Mother Chapel, better known as the Monte Casino Chapel, measures 6 feet by 9 feet. This postcard shows its original location at the Monte Casino Monastery in Covington. Courtesy of Paul A. Tenkotte.

Covington and surrounding cities developed a Catholic community that was very similar to those in the Northeast and Midwest. Parishes were created on ethnic lines; schools, academies, and other institutions were established; and a native clergy was developed. Before the Civil War, Catholics even established the first hospital in Covington, St. Elizabeth. Cincinnatian Sarah Worthington King Peter and Covington resident Henrietta Esther Scott Cleveland, both wealthy converts to Catholicism, raised the money for the new hospital. The Sisters of the Poor of St. Francis staffed it.

St. Elizabeth was open to all, regardless of race or religion. Early admittance records indicate that Catholics, Protestants, and Jews were among the patients. African Americans, both free and enslaved, were also admitted. Also during this era, St. Elizabeth Hospital cared for the needs of injured Confederate and Union soldiers. Before the close of hostilities, the sisters cared for 27 military personnel. The sisters also acquired a second building during the war years to serve as an orphanage. As many as 60 children at a time were housed at St. Elizabeth. After the Civil War, the sisters purchased the old Western Baptist Theological Institute on West 11th Street for a new 110-bed facility.

The little community of Economy, later known as West Covington, perched on the hills to the west of downtown, was developing into a village during the 1850s. In 1860 the Catholic people of the neighborhood approached Bishop Carrell for permission to establish a parish in their community. The lot selected for the church was located on Main Street (now Parkway) and was donated to the congregation by James and John Slevin of Cincinnati. Bishop Carrell set the cornerstone in place on June 1, 1860. While the church was under construction, Mass was celebrated in the home of the Burns family at the corner of High and Main Streets. The church building was constructed over a period of four years, as finances permitted. Much of the work was done by the members of the congregation. Bishop Carrell dedicated the

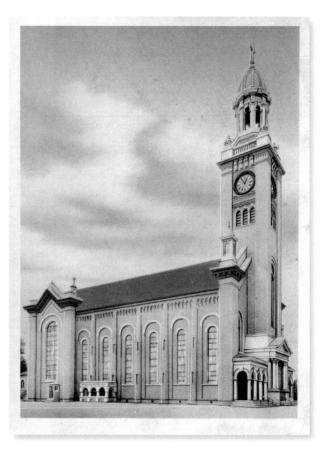

RIGHT: St. Aloysius Catholic Church, Seventh and Bakewell Streets, was struck by a major fire in May 1985 and was subsequently demolished. Courtesy of Paul A. Tenkotte. BELOW: Hand-carved statuary grouping depicting Lourdes, France, and the 1858 curing of Louis Bouriette, who was blinded in a quarry accident two years prior. Grotto, St. Aloysius Church, West Seventh Street. Raymond E. Hadorn photo in the collection of Paul A. Tenkotte.

new building on December 11, 1864. The first resident pastor, Father Adrian Egelmeers, was appointed to St. Ann Parish in 1864. During his pastorate, a two-story schoolhouse was constructed.

The population density in Covington in the post–Civil War era was on the rise. Mother of God Parish could no longer accommodate the growing number of Catholics residing in the Westside. On January 8, 1865, a number of Catholics met in a grocery store on Bakewell Street to organize a new congregation. Before the end of the month, a parcel of land was acquired at the southeast corner of Seventh and Bakewell Streets. The congregation began construction of a three-story brick building that housed the church on the first floor, a convent on the second floor, and a school on the third floor. This first St. Aloysius Church was dedicated on September 17, 1865.

St. Aloysius Parish grew very quickly. Within five months of the dedication of the first building, the congregation was already planning the construction of a permanent church. Louis A. Piket was chosen as the architect to draw the plans, which called for a Romanesque Revival structure. The new St. Aloysius Church was dedicated on November 24, 1867. Under the guidance of Father Joseph Blenke, pastor of the congregation from 1887 to 1907, a grotto to Our Lady of Lourdes was built in the undercroft of St. Aloysius Church in 1889. The grotto contained a large fieldstone wall with a niche for a statue of Mary. It also featured a miniature spring, modeled after the one found at Lourdes, France. Water from Lourdes was periodically shipped to Covington to supply the spring. The vestibule to the grotto contained several hand-carved statuary groups that had been imported from Germany. The grotto became a popular place of private prayer in the Northern Kentucky area. In 1902, Pope Leo XIII declared the grotto at St. Aloysius Church a shrine.

Though Germans were a large part of the Catholic population in Covington, they were not alone. Irish Catholics had been part of the landscape since the founding of St. Mary's in the 1830s. By the late 1860s, a large number of Irish Catholics had taken up residence in the northwestern part of the city, west of Madison Avenue and north of Sixth Street. In 1868 these Irish families requested Bishop Carrell to establish a new parish in their neighborhood. Before the project could be undertaken, however, Bishop Carrell died in September 1868.

Two years passed before Covington's second bishop, Augustus Maria Toebbe, arrived on the scene. Among Bishop Toebbe's first acts was to establish St. Patrick Parish. Father James Smith, assistant pastor at the Cathedral Parish, was appointed the first pastor. Smith, like many of his parishioners, was a native of Ireland. A site for the new parish was purchased on Philadelphia Street at Elm Street. The cornerstone of the new structure was set in place on August 28, 1870, and the building was dedicated on August 22, 1872. The church was built of brick in the Gothic Revival style and cost $40,000 to construct. Louis A. Piket was the architect.

St. Augustine Parish was established in 1870 in the city of Central Covington (now Peaselburg) and was named in honor of Covington's second bishop, Augustus Maria Toebbe. The first building, a combination church and school, was constructed on Augustine Street near Willow (now 19th) Street. The cornerstone of this structure was laid in June 1870, and the building

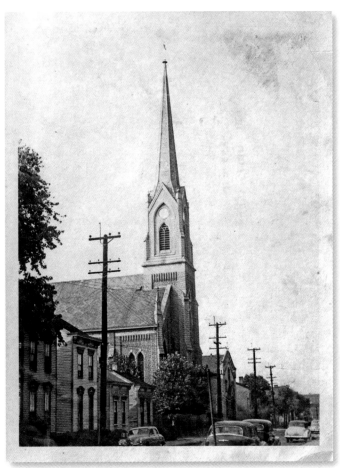

St. Patrick Church, Philadelphia and Elm Streets, circa early 1950s. The church was demolished in 1968. Photo by Cyril Von Hoene, courtesy of Greg Von Hoene.

was dedicated on October 16, 1870. Most of the early parishioners were German immigrants and first-generation Americans. Reverend L. Neumeier was appointed the first pastor of St. Augustine Parish.

Father Joseph Goebbels succeeded him in 1871. In about 1872, Father Goebbels and the parish trustees purchased a tract of land on the east side of Augustine Street between 19th and 20th Streets. On this property, they established a brickyard. Another brickyard was established by the parish on the eastside of the L&N Railroad tracks. On a European trip in 1875, Father Goebbels purchased a wire-nail manufacturing machine and shipped it to Covington. This was one of the first wire-nail machines in the United States. The machine was initially set up in a room in the saloon of parishioner Barney Meibers (northwest corner of Madison Avenue and 19th Street). Eventually, it was moved to one of the parish-owned brickyards. The profits from these concerns were intended to be used by the parish to construct a new church and school. In the late 1870s, however, the national economy experienced a downturn. The parish could no longer meet its obligations, and its creditors filed suit in 1881. All of the church property was sold at the courthouse door. Fortunately, the parishioners were able to pull together their personal funds and purchase the combination church and school.

By the 1870s the Austinburg neighborhood was become a flourishing residential district. Most of the Catholics who lived in the vicinity attended St. Joseph Parish on Greenup Street. On November 25, 1883, Father Aegidius Christoph, OSB, pastor of St. Joseph Parish, held a meeting in Austinburg to discuss a new parish and school. The residents heartily agreed, and a parcel of property was purchased on present-day East 16th Street for the new venture. Plans called for a two-story brick building, housing both a school and church. The cornerstone was set into place on October 12, 1884, by Bishop Rademacher of Nashville, Tennessee, and was dedicated by Bishop Camilius P. Maes on July 25, 1885. The initial congregation consisted of 80 families. The new St. Benedict Church was a mission parish of St. Joseph. The assistant pastor of St. Joseph, Father Cyril Rettger, OSB, attended to the needs of the Austinburgers. The parish school was opened in 1885 under the care of the Sisters of St. Benedict.

The growing city of Milldale, just south of Covington, maintained strong ties with its neighbor to the north. Eventually, the city was annexed by Covington and is today known as Latonia. Many of the early residents of this area attended St. Augustine Church and

St. Augustine Catholic Church, 19th and Euclid Avenue. Photo by Dave Ivory, 2014.

enrolled their children in the parish school. As the neighborhood grew, a number of local residents began holding meetings and collecting funds to start a new congregation as early as 1887. In 1889 Bishop Maes approved their efforts and instructed the pastor of St. Augustine's to assist in the planning of a parish, which was named Holy Cross. In 1890, a combination church and school building were constructed and were ready for occupancy in the next year. The new building was appropriately located on Church Street. The bishop assigned Reverend B. A. Baumeister as its first pastor. The year 1891 saw the opening of Holy Cross grade school under the care of the Benedictine Sisters. In 1892 a parsonage was also constructed near the church. Holy Cross Parish and School grew quickly, especially under the leadership of Reverend J. B. Reiter (1898–1932).

Covington is a community known for its beautiful and historically significant churches. Many of these were built at the end of the 19th century and the first 30 years of the 20th century. Catholics had become successful in the business community and many had achieved middle-class status. They donated generously to building funds that resulted in a number of magnificent architectural treasures. One of the first of these new church buildings was a cathedral.

In 1885 Reverend Camillus P. Maes, a native of Belgium, was appointed as the third bishop of Covington. As early as 1890, Bishop Maes began planning for the construction of a cathedral. In that year, he purchased a home and large lot at the northeast corner of Madison Avenue and 12th Street as a site for his proposed building. Two years later, Bishop Maes commissioned architect Leon Coquard of Detroit to design a Gothic-style cathedral.

Coquard based the interior on the Abbey Church of St. Dennis near Paris, France, and the exterior on the renowned Notre Dame Cathedral, also in Paris. Bishop Maes broke ground for the new cathedral in April 1894. More than a year passed before the cornerstone could be set into place on September 8, 1895,

Holy Cross Catholic Church, Church Street. Photo by Raymond E. Hadorn, courtesy of Paul A. Tenkotte.

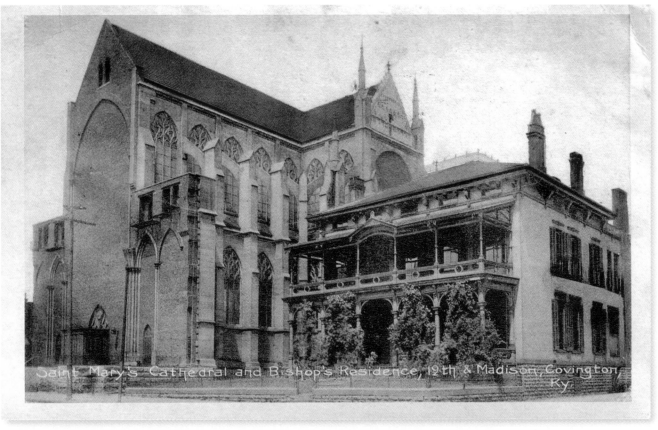

The walled-up nave of the unfinished St. Mary's Cathedral, Madison Avenue, circa 1900. Courtesy of Paul A. Tenkotte.

with a small silver trowel donated by the students of La Salette Academy in Covington. Work on the new cathedral started and stopped as funds became available. Although several large donations were received, Catholics from throughout the diocese donated most of the funds. By September 1897, the superstructure of the cathedral was ready for its tile roof. The cost of construction, however, had increased from the original estimate of $175,000 to more than $300,000. In order to raise additional funds, Bishop Maes organized a door-to-door canvas in the cities of Bellevue, Covington, Dayton, Ludlow, and Newport, Kentucky.

In 1899 construction of the building came to a complete halt when the diocese ran out of funds. Undaunted, Bishop Maes turned in his $25,000 life insurance policy to underwrite the project. The money did not last long. Just when it seemed that construction would have to be halted again, a generous gift appeared. Ignatius Droege, a Covington businessman who owned a large rolling mill in the city, presented Bishop Maes with a check for $10,000. Construction work resumed.

In 1900 the structural work on the nave and sanctuary of the cathedral was complete. Bishop Maes de-

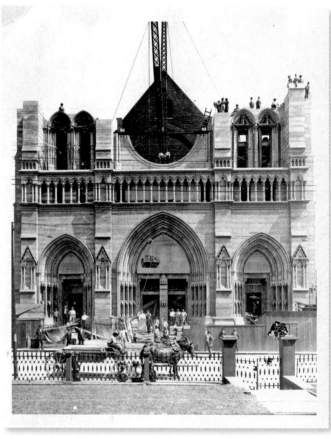

Construction of the façade of St. Mary's Cathedral, Madison Avenue, circa 1910. Courtesy of Paul A. Tenkotte.

cided to place a plain brick façade on the building and to proceed with the dedication. The first Mass to be celebrated in the church occurred on December 31, 1900, at midnight. The nave of the cathedral was dedicated with impressive ceremonies on January 27, 1901.

Like all the great cathedrals of Europe, Covington's cathedral was conceived over time. Between 1901 and 1905, funds were raised to construct the façade. Several generous financial gifts from Nicholas and James Walsh greatly encouraged Bishop Maes. The bishop called upon architect Leon Coquard and requested that he finish the plans for the façade. Coquard, however, had begun work on several other high-profile projects, including the new cathedral for the city of Denver. Coquard promised Bishop Maes that the façade's plans would be prepared; however, Coquard never produced a working draft.

Coquard's lack of cooperation led Bishop Maes to hire Newport, Kentucky, architect David Davis to complete the plans for the façade. Davis based his design on the exterior of Notre Dame in Paris, France. Construction on the façade began on September 29, 1908, and it was dedicated in 1910. At this time, the bishop decided to delay the construction of the two towers for a future date so that work on the interior of the building could be advanced. The towers were never built. The adornment of the interior of the cathedral took place as funds became available. At the time of the dedication of the nave in 1901, the window openings were filled with whitewashed glass.

In the spring of 1907, Bishop Maes traveled to Munich, Germany, to discuss plans for stained glass windows with the officials of the Mayer Studios. The first 16 windows were set into place in 1909. The enormous north transept window depicting the Council of Ephesus and the coronation of the Blessed Virgin drew the most attention. The window measures 67 feet in height and 24 feet in width and is touted as one of the largest stained glass windows in the world.

Although the cathedral was the most notable building constructed during this time period, it was by far not the only one. In 1907 St. Benedict Parish commissioned the prestigious firm of Samuel Hannaford and Sons to design a new church on East 17th Street. The Italian Renaissance Revival–style building featured

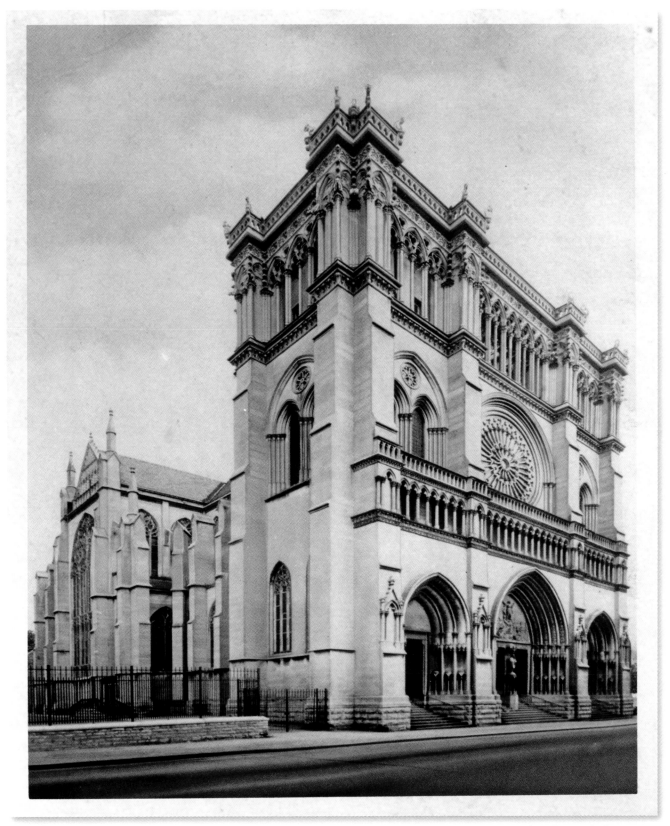

Cathedral Basilica of the Assumption, Madison Avenue. Photo by Raymond E. Hadorn, courtesy of Paul A. Tenkotte.

two asymmetrical main towers topped by cupolas. The church was dedicated in 1908. That same year, a new Holy Cross Church in the Latonia neighborhood was dedicated. Built with rough-hewn stone, the impressive building contained two tall towers and cupolas and a large rose window. The residents of Peaselburg constructed a new St. Augustine Church in 1913–14. Built on West 19th Street, it was designed by architect David Davis and soon became a landmark in the community.

The venerable St. John Parish in the Lewisburg neighborhood relocated its entire parish plant in the early years of the 20th century. The old St. John complex, located on the brow of a hill at the corner of Leonard and Worth Streets, was in a terrible state of disrepair. The hillside was slipping, and with it, the old St. John Church. In 1914 the congregation completed a new school building in Covington on Pike Street. This building housed the parish convent, the rectory, and a temporary church. By 1922 sufficient funds had been raised to begin work on a permanent St. John Church. The pastor, Reverend Anthony Goebel, was a native of Germany. He chose the architectural firm of Frank Ludewig and Henry Dreisoerner to design the edifice. The plans called for a Gothic Revival structure modeled on the rural churches of Germany. Bishop Francis Howard dedicated the magnificent new St. John Church on Thanksgiving Day in 1924.

The dedication of the new St. John Church in Covington symbolically marked the end of the immigrant era in the history of the diocese. The Lewisburg neighborhood was German and Catholic. No Protestant churches existed in the neighborhood, and the parish school was the only educational facility available, other than a storefront location for a Covington Independent Schools kindergarten. For generations, the words *Catholic* and *urban* were synonymous in Northern Kentucky.

The last major Catholic church building to be constructed in Covington was a new St. Ann in 1931–32. The old church was in disrepair and could no longer sufficiently house the congregation. The new buff-colored brick Gothic Revival edifice was dedicated on June 19, 1932.

The clergy and laity of the diocese recognized the need for additional services in the inner city during the Depression era. Counseling, the care of children, and

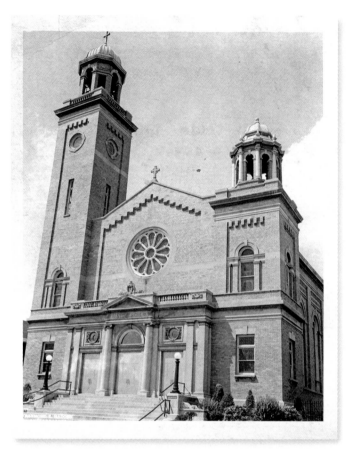

ABOVE: St. Benedict Church, East 17th Street. Photo by Raymond E. Hadorn, courtesy of Paul A. Tenkotte. BELOW: This postcard view shows the new St. John Church on Pike Street (left) and the old St. John Church at Worth and Leonard Streets (right). Courtesy of Paul A. Tenkotte.

adoption services were all necessities in an ever-changing landscape. In 1931 Monsignor Edward Klosterman, pastor of Mother of God Parish in Covington, was named the first director of the diocesan Bureau of Catholic Charities, which later took the name Catholic Social Services. With the assistance of social worker Mary Moser, the bureau began offering services to the people of the basin and the wider Northern Kentucky community.

Initially, the Bureau of Catholic Charities provided foster care and adoption services to the people of Northern Kentucky. In 1955, the bureau officially associated itself with the United Way of Cincinnati. Catholic Social Services took a giant step forward with the arrival of the Daughters of Charity of St. Vincent de Paul in Covington in 1961. Under their direction, Catholic Social Services became a full family-service agency. Eventually, Catholic Social Services moved to the old convent at Holy Cross Parish and expanded their outreach and services, primarily under lay leadership.

Mary Moser. Courtesy of Paul A. Tenkotte.

The Catholic population of Covington established an extensive network of educational facilities that eventually served children from preschool through the college level. These schools were well established and educated a large proportion of the city's population. Catholic schools were established at all the parishes in the city and drew the communities together (see also "Chapter 8, From Chalkboards to Computers: Education and Libraries in Covington").

The last Catholic congregation to be established in Covington was Our Savior Parish on East 10th Street, for African Americans, founded in 1943 by Bishop Francis W. Howard. Before that time, the few African American Catholics in Covington attended services at the cathedral. The main impetus for this congregation was the request by a number of African Americans to send their children to Catholic schools. Due to Kentucky's Day Law (1904), it was illegal to educate black and white children in the same schools. So in 1943, Our Savior School opened under the care of the Sisters of Divine Providence. The new Our Savior Church and School were housed in renovated homes. In 1948 a new Our Savior School was constructed. For most of its existence, the parish has been a mission of the cathedral. For the past several decades, the parish has been led by Divine Providence Sister Janet Bucher.

In 1945 the city of Covington teemed with Catholic life, much as it had during the previous century. Church pews were full and schools were crowded. Nearly 10,000 Catholic families claimed membership in the 21 urban parishes. These same parishes educated more than 4,700 pupils annually in their elementary schools. Multiple Catholic high schools and academies, and Villa Madonna College, were educating thousands more. However, unprecedented change was on the way. Catholics began leaving the urban core and moving to the new suburbs to the south and west. These declines in population had a significant impact on religious life in Covington. Monsignor Walter Freiberg, pastor of the Cathedral Parish, anticipated this migration when he wrote in 1946, "It seems to me that as soon as building conditions permit, we shall see a very large and extensive building program carried out in the suburbs of Covington."

The city of Covington lost more than 18,000 residents between 1950 and 1975. Catholics made up a disproportionate number of those who left. Monsignor Henry Hanses described the neighborhood around St. John Parish in 1957: "There has not been a new home built within the parish limits since the church was built thirty-five years ago and the last houses to have been built were the first ones to be torn down in favor of the new highway [I-75/I-71]." Covington was changing demographically, and this would result in changes in the Catholic community.

Parish schools were closed and merged, and parishes began experiencing declining membership. During this era, Covington lost two parishes. The neighborhood surrounding St. Patrick Parish in the city's Westside suffered greatly from periodic flooding of the Ohio River. During the catastrophic 1937 flood, the church, school, and rectory were severely damaged by high water. At this time, residents began leaving the lower Westside for more desirable neighborhoods. This exodus greatly increased during the postwar years, even though a floodwall for Covington was constructed. In addition, the construction of I-75/I-71 through Covington's Westside and Lewisburg brought significant changes to the neighborhood. The Fifth Street expressway ramps were built less than a block from St. Patrick Church. The expressway attracted nonresidential, service-oriented businesses, including a gas station and a restaurant. The neighborhood continued to change during the 1960s. The construction of the Internal Revenue Service facility at Third and Johnson Streets also resulted in the loss of many homes in the neighborhood. By the late 1960s, membership totaled 200 households at St. Patrick's, 50 of which resided outside the parish limits. St. Patrick Parish officially closed in August 1967.

Population changes in Covington's Eastside left St. Joseph Parish struggling for survival. The Catholic population of the Eastside declined as middle-class residents fled to the suburbs. As the neighborhood became increasingly African American, the old German-Catholic residents and their descendants moved to the suburbs. In 1967 St. Joseph and the Cathedral Schools merged to form Bishop Howard School. Parish membership fell below 150 households by the late 1960s. In 1969 the Benedictine fathers who staffed St. Joseph decided to withdraw from the parish. St. Joseph Parish officially closed on July 5, 1970. The church building, including its magnificent hand-carved altars, stained glass windows, and two large murals by famed Covington artist Johann Schmitt, was demolished.

On May 16, 1985, tragedy struck St. Aloysius Church in Covington. The building was hit by lightning and completely destroyed. The beautiful old church and grotto to Our Lady of Lourdes, listed on the National Register of Historic Places, was reduced to rubble. Efforts were made to preserve portions of the building, but eventually the decision was made to close the parish and merge it with nearby Mother of God Church.

Mother of God Parish had been revitalized during the 1970s under the guidance of much-loved pastor Reverend William Mertes. The parish, threatened with closure and demolition, reached out to the community and experienced a rebirth. Father Mertes and the congregation established the Parish Kitchen to serve hot meals to those in need in the community, were among the founders of Welcome House, and reached out to the deaf community in the region. As a result, Mother of God fought the trend of declining membership and experienced a substantial increase in members.

Mother of God Parish, however, experienced a significant challenge in 1985. In March of that year, a tornado (later officially determined to be a microburst) blasted through Covington, damaging the dome of the church. The high winds peeled back the tin sheathing of the dome. Plans immediately materialized to restore the dome to its original appearance. Restoration work on Mother of God Church progressed rapidly until the evening of September 25, 1986, when the building caught fire due to a worker's blowtorch. Onlookers stared in disbelief as the Covington Fire Department fought the blaze. Fortunately, the fire was confined to the dome. The water that was used to extinguish the flames proved to be a mixed blessing, causing great damage to the interior of the church. Water poured through the dome and ran across the painted ceiling and down the frescoed walls. Despite the damage, the spectacular building was completely restored at a cost of $1.5 million.

The Cathedral Parish enjoyed sustained support from Covington's ninth bishop, Robert Muench, who recognized the building's historical and architectural significance. In 1996 Bishop Muench began immediate plans to replace the deteriorating century-old tile roof. This project was completed in 1998 at a cost of $500,000. The diocese provided the funds. In October 1998 Bishop Muench began discussing the possibility of a diocese-wide fundraising campaign. Following consultation with the clergy and laity of the diocese, the Faith in Action 2000 Campaign was inaugurated in January 1999 with a goal of $10 million. The proceeds of the campaign were designated for the restoration of the cathedral building ($4.7 million), for the expansion of the Catholic Education Endowment ($3.5 million), and for the 2000 Diocesan Annual Appeal ($1.2 million). Each parish was given a goal based on annual income. Volunteers from each parish in the diocese canvased the Northern Kentucky region. The $10 million goal was not only reached but surpassed.

Bishop Muench appointed a steering committee to oversee the restoration of the cathedral. The committee included representatives from the laity, women religious, and the clergy. The committee met for the first time in May 1999. Liturgical Design Consultant Bill Brown, of Colorado Springs, Colorado, was hired to develop the restoration plans. On April 16, 2001, the cathedral building was closed to the public so that restoration work could begin. During the restoration, the parishioners of the Cathedral Parish attended St. John Church in Covington. Bishop Muench blessed the restored cathedral on the Feast of the Immaculate Conception, December 8, 2001, with imposing ceremonies.

The current bishop of Covington, Roger Foys, has made special efforts to support the parishes, and especially the Catholic schools, in Northern Kentucky's urban core. Since his installation as bishop of Covington in 2002, no parishes or schools in the city have been closed or merged. In addition, the Catholic Center was returned to the city—initially to the old St. Elizabeth Hospital on 20th Street, and in 2012, in the completely restored and rebuilt Cathedral School, which now houses the offices of the Curia.

JEWISH COMMUNITY

Cincinnati was the center for Reform Judaism under the able leadership of Rabbi Isaac Mayer Wise. While the region became known for this movement, Orthodox Jews, many of whom were immigrants from Russia and Eastern Europe, also lived in the area. In the early 1900s, there were approximately 35 Jewish families residing in Covington, most of which were of Polish or Russian descent. The Covington Jewish community longed for the establishment of a congregation. In 1911 Rabbi Samuel Levinson of United Hebrew Congregation in neighboring Newport, Kentucky, began offering religious services in the *Kentucky Post* building on Madison Avenue. Maurice Chase was one of the early organizers. Chase, a native of Odessa, Russia, was a practicing physician. In Russia, Chase had participated in a number of uprisings. Eventually, he fled to Germany and from there immigrated to New York City. By the early 1900s, Chase was living in Covington. Chase's story was not unlike that of many of the other Jews living in Covington. Most had fled religious persecution in Europe and immigrated to the United States.

Under Rabbi Levinson's leadership, the Covington congregation began plans to build a synagogue in the city in 1912. A lot was purchased on Seventh Street between Scott Boulevard and Greenup Street, and plans were commissioned. The building committee consisted of the following officers: Meyer Berman (president), Oscar Levine (vice president), Maurice Chase, J. Ginsberg, L. Gorshuny, A. Gross, H. Lipschitz, M. Meisel, I. Simon, and Max Stampil. The new synagogue was ready for occupancy in 1915. Local architect George Schofield designed the two-story brick building in the Classical Revival style. The building featured two prominent columns flanking the main doors and was topped by an imposing cupola. The first floor contained a kitchen, classrooms, and living quarters for a caretaker. The worship space was located on the second floor and contained separate areas for men and women, as was the custom in Orthodox congregations. The new structure was called Temple Israel.

Temple Israel, East Seventh Street, was demolished in 1938. Courtesy of the American Jewish Archives, Hebrew Union College, Cincinnati.

Rabbi Levinson, a Lithuanian Jew, served the Newport and Covington Synagogues from 1911 until 1923. From 1923 until his retirement in 1929, he exclusively served Temple Israel. He was succeeded in Covington by Rabbi Jacob Jacobs. The early Covington Jewish community followed Orthodox customs and worship. Many of the members of Temple Israel were leading businessmen in the community. Frank's Men Shop, Louis Marx Furniture, Modern Furniture, Ostrow Furniture, and the Parisian were only a few of the Jewish-owned businesses in Covington.

The need for a new federal building and post office in Covington led to the demolition of the original Temple Israel in 1938. Undeterred, the congregation purchased a lot at 1040 Scott Boulevard as a site for a new building. The new Temple Israel was dedicated on March 19, 1939. The simple two-story brick building cost $20,000 to construct. The only exterior adornments were several brick Stars of David on the façade. The first floor contained a kitchen, stage, and social room. The worship space was smaller than the original one and was located on the second floor. The facilities also included a three-room apartment for the caretaker.

Beginning in the late 1930s, many of the Jewish families of Covington began leaving the city. Quite a few relocated to Cincinnati. The Jewish population in Covington was small, and many parents wanted their children to be exposed to the broader Jewish community in Cincinnati as well as to have greater opportunities to marry Jewish

spouses. As a result, membership in the congregation began to fall. This trend continued throughout the 1940s and 1950s. Membership declined to such an extent that services could often no longer be conducted due to the lack of a quorum (10 male members needed to be present for worship). By the mid-1960s, Temple Israel in Covington ceased to function as an active congregation. The Temple Israel building was sold to a Church of God congregation for $9,400 in 1973. Eventually, the building was purchased by the Carnegie. Carnegie officials demolished the building in 2006 to make way for a parking lot.

SELECTED BIBLIOGRAPHY

Northern Kentucky Newspaper Index. Kenton County Public Library, Covington, KY.

Roth, George F. Jr. *The Story of Trinity Episcopal Church in Covington.* Covington, KY: Trinity Episcopal Church, 1991.

Ryan, Paul E. *History of the Diocese of Covington, Kentucky.* Covington, KY: Diocese of Covington, 1954.

Schroeder, David E. "Covington History." Covington, KY: Kenton County Public Library. Accessed June 2014. kentonlibrary.org/genealogy/regional-history/covington.

Schroeder, David E. *History of the Diocese of Covington, Kentucky.* Covington, KY: Kenton County Public Library [2001?].

Tenkotte, Paul A., and James C. Claypool, eds. *The Encyclopedia of Northern Kentucky.* Lexington, KY: University Press of Kentucky, 2009.

Tenkotte, Paul A. and Walter E. Langsam. *A Heritage of Art and Faith: Downtown Covington Churches.* Covington, KY: Kenton County Historical Society, 1986.

Weissbach, Lee Shai. *The Synagogues of Kentucky: History and Architecture.* Lexington, KY: University Press of Kentucky, 1995.

CHAPTER

17

FROM HORSE RACING TO HOOPS: SPORTS IN COVINGTON

by James C. Claypool, PhD

RESIDENTS of Covington, Kentucky, have long participated in a wide variety of sporting activities, both organized and unorganized. Unorganized sports range from lawn sports such as lawn darts, badminton, croquet, volleyball, horseshoes, and—more recently—cornhole, to pickup games of football, softball, basketball, baseball, tennis, and soccer. Other common unorganized sports include running and jogging, cycling, boating, swimming, water and snow skiing, skateboarding, billiards, roller and ice skating, table tennis, handball, racquetball, target shooting, nonleague bowling, and drag racing. For those seeking them, Covington has always provided ample opportunities for leisure sporting activities. There could be bowling at Mergards' lanes, skating at Lloyd's Roller Rink, swimming at the YMCA or Rosedale Pool, golf at Twin Oaks or Devou Park, drag racing at Thorn Hill, water activities on the Ohio or Licking River, fishing at Prisoners' Lake, pool games downtown, hoops in city parks or at private residences, pickup games on high school athletic fields, and baseball or softball games at Meinken Field. While this is not an all-inclusive list, it does represent some of the more popular sporting activities carried out within the city. For many decades, the numbers participating in these have annually been in the thousands.

BASEBALL

Organized sports are more easily traced and documented. The ethnic groups of Covington, primarily German, English, Irish, and African American, have produced many noteworthy athletes. Baseball, which was being played in Covington prior to the Civil War, began as a professional sport with the founding of the cross-river Cincinnati (Ohio) Red Stockings in 1869. Joe Sommer of Covington, a major leaguer (1880–90), played with the 1880, 1882, and 1883 Red Stockings as a pitcher, third baseman, shortstop, and outfielder. Another Covington youth, Bob Clark (1886–93), played three years with the Trolley (Brooklyn) Dodgers, three with the Brooklyn Bridegrooms, one with the Reds, and one with the Louisville (Kentucky) Colonels as a catcher, outfielder, shortstop, or first baseman. Covington's Hank Gastright (Henry Carl Gastreich) ended his seven-year career in 1896 with the Reds. The tall right-hander was a 30-game winner in 1890 with the major league American Association's Columbus Solons, and in 1893 was 15–5 with Pittsburgh and Boston, best in the league.

Howard Camnitz (1904–15) was one of seven other early major leaguers from Covington, along with Bill Niles (1895), John Farrell (1901–05), Harry Berte (1903), Bill Sweeney (1907–15), Eddie Hornhorst (1910–12), John Black (1911), and Dick Niehaus (1913–20). Camnitz, who played with the Pirates and Phillies, was a 20-game winner (1911 and 1912) and pitched on the Pirates' World Series Championship team in 1909.

Holmes High School, 50th-anniversary photo of the championship 1963 baseball team. Courtesy of Holmes High School.

The major league careers of the Heving brothers, Joe (1930–45) and Johnnie (1920–32), are commemorated by a state historical marker in Covington's MainStrasse Village. Joe, an outfielder converted to a pitcher, played with six teams; he was 76–48 with a 3.90 earned run average (ERA). Johnnie, a backup catcher for five teams, had a .265 lifetime batting average, but only hit one major league home run. From 1933 to 1950, he was a manager or player–manager in the minor leagues.

Bob Barton, who attended Covington Holmes High School, caught for the Giants, Padres, and Reds in his career, 1965–74. An outstanding high school basketball player as well, Barton was named by the *Kentucky Post* as one of the top 10 all-time Northern Kentucky players on the 2000 All-Century team. Atlanta star outfielder David Justice graduated from Covington Latin High School, where he played baseball, soccer, and basketball. He was elected National League Rookie of the Year in a career with four teams spanning 14 years, 1989–2002. His best year was 1993, when he made the first of three all-star appearances and finished third in the National League's Most Valuable Player (MVP) balloting. In 2007 Justice was inducted into the Braves Hall of Fame. Other modern-day major leaguers with Covington connections include Jeoff Long (1963–64), Leo Foster (1971–77), J. J. Tobbe (1995), Brandon Berger (2001–04), and active player Graham Taylor. One other baseballer, William Grant High School graduate Donald Johnson (1938), played from 1949 to 1952 during baseball's segregated era and was a hitting star in the Negro American League.

Several other Covington men played minor league ball. Included are Bob Curley, a 1941 Covington Latin graduate who, after serving in the Navy during World War II, pitched in the minors and was the last man cut by the Cincinnati Reds in the spring of 1952; Covington Catholic High School's Dan Neville, a pitcher in the Reds' organization who wrote a fascinating book about his minor-league experiences playing with future Reds greats such as Pete Rose, Johnny Bench, and Tony Perez; and 1964 Holmes graduate Gary Sargent, who was drafted by the Washington Senators in 1968 but never played in the majors. The many talented high school players from Covington would be too numerous to list. Of note, however, is that Holmes's baseball team, coached by current Kenton County commissioner Jon Draud, was state champion in 1963, and Covington Catholic was state 2A champion in 2002.

Perhaps the most famous Covington native involved in baseball is former major league umpire Randy Marsh, a 1967 Holmes graduate. Marsh began umpiring in the majors in 1981 and was made a crew chief in 1998. He worked

in five World Series and was part of history when he umpired the first regular season game outside of North America in 2000 in Tokyo between the Cubs and the Mets. Marsh currently is director of umpiring for Major League Baseball.

Covington has also had a rich and distinctive baseball history of its own. Professional baseball began in 1875 with the formation of the Star Baseball Team of Covington, a team founded by city politicians James Casey, William Grant, and Smith Hawes. Led by former Princeton University baseball star James C. Ernst, the Covington team played home games on a field at Madison Avenue and 17th Street that filled an entire block. Fledgling major league teams like the Boston Red Stockings played the Covington squad, and on September 21, 1875, the major league Philadelphia White Stockings defeated the Hartford Dark Blues at the Covington park, the only official major league game ever played in Covington. On seven occasions during 1875, the Covington Stars played the newly revived Cincinnati team of the National League, resulting in two wins, four losses, and one tie. This rivalry ended when the National League passed a rule prohibiting its teams to play nonleague teams located within a 5-mile radius of a league member. Financial mismanagement and competition from the Reds caused the Stars to disband in July 1876. Thirty-seven years later, in 1913, the Covington Blue Socks played 41 games in the professional Federal League before the team was moved to Kansas City. The team's bandbox-sized home field was located at Second and Scott Streets (now Scott Boulevard), and its short distances to the fences, along with proximity to the Reds, contributed to its move to Kansas. The Covington Ball Park (1895–1958), located at Ninth and Arnold Streets, became a popular sports venue for softball and baseball games. An annual program from 1949, nine years before the park was demolished to make room for I-75, featured games involving a semipro baseball league, a night baseball league, and the Northern Kentucky Major Softball League.

Covington Ball Park

Thanks to its colorful longtime manager, "Colonel" Jack Wolking, who was seeking to schedule attendance and crowd-friendly shows, the Covington Ball Park went out with a flourish. In the years immediately preceding its demolition, the park hosted "the world's greatest fast-pitch softball pitcher," Eddie "The King" Feigner (appearing as The King and his Court); the Negro Professional Baseball League's perennial pennant contender Kansas City Monarchs; and the barnstorming Indianapolis Clowns, a part-comic and part-serious baseball team that for three months in 1952 featured future Braves baseball Hall of Famer Henry Aaron as their shortstop and cleanup hitter.

 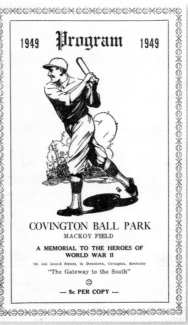

LEFT: Covington Ball Park, looking west toward Crescent Avenue. Photo by Cyril Von Hoene. Courtesy of Greg Von Hoene. RIGHT: Covington Ball park program, 1949. Courtesy of James C. Claypool.

Eeny's baseball team, Covington, circa 1950. Photo by Cyril Von Hoene, courtesy of Greg Von Hoene.

Perhaps the most interesting baseball star born in Covington is girl's professional pitcher Patricia "Pat" Scott. Raised on a farm in Burlington, Kentucky, Scott played fast-pitch softball locally, and then in 1948 was signed as a pitcher with the Springfield (Ohio) Sallies of the All-American Girls Professional Baseball League, that team's final year. In 1951 she joined the league's Fort Wayne Daisies where, pitching with finesse, she led her team to three straight pennants (1951–53), averaging 16 wins a year. Pat Scott is part of "Women in Baseball," a permanent display at the Baseball Hall of Fame in Cooperstown, New York, and a ball field in Walton, Kentucky, is named for her.

FOOTBALL

Football, like baseball, has long been a preeminent sport in Covington. Six football players with ties to Covington have played in the National Football League (NFL). Lloyd McDermott, who was born in Covington and graduated from Holmes in 1944, was a member of the Holmes team that won the unofficial 1943 Kentucky State Football Championship. After a two-year stint with the Marines during World War II, McDermott played defensive line with the 1947 Kentucky Wildcats, who won the Great Lakes Bowl. He was drafted by the Philadelphia Eagles, played one game in 1950 for the Detroit Lions, and then completed the 1950 and 1951 seasons with the Chicago Cardinals. He finished his professional career in Canada with the Ottawa Rough Riders and afterward was the defensive football coach at Holmes for many years.

Irv Goode attended Holmes before graduating from Boone County High School, where he played basketball and football. Goode played center and linebacker for the University of Kentucky and was designated by *Time* magazine a first-team all-American in 1961 and the team captain. Goode, who would play in four post-season all-star games, was a first-round draft choice of the Saint Louis Cardinals. His long and distinguished professional career, mainly as the Cardinals' starting left guard, lasted 10 seasons (1962–71). He was twice a pro-bowl player (1964 and 1967) and was an all-pro in 1970. He later played two years with the Miami Dolphins, where he was on their 1973 Super Bowl Championship team. Boone County High School's home football games are played at Irv Goode Field.

Larry Schreiber, who was born in Covington but attended Dixie Heights High School, competed for seven seasons as running back with the San Francisco 49ers and Chicago Bears between 1970 and 1976. A standout while playing for Tennessee Tech Institute, he holds several of that school's rushing records, was a football Little All American (1969), and still holds the Ohio Valley Conference (OVC) records for most career carries and yards. Initially a backup with San Francisco, in the 1970 and 1971 playoffs Schreiber scored three touchdowns. He became the 49ers' starting fullback during the 1974 and 1975 seasons, scoring eight touchdowns and gaining nearly 1,000 yards. He ended his career with 1,749 rushing yards, 982 yards as a receiver, and a total of 14 touchdowns.

Jared Lorenzen, who was born in Covington and played high school football at Highlands High School and collegiate football at Kentucky, was a backup quarterback for two years (2006 and 2007) with the New York Giants. Indisputably, at 6 feet 4 inches and weighing 315 pounds, Lorenzen was one of the largest, if not the largest, NFL quarterbacks ever. Two others from Covington played in the NFL, albeit briefly. Fred Rayhle (University of Tennessee–Chattanooga) played two games as tight end with Seattle in 1997, and Charles Bradley II (University of Kentucky) played one game as tackle with the Bengals in 1993.

Loren "Bob" White is one of Covington's many standout college football players. A "street tough" kid who later coached football at his alma mater Holmes, White was a star fullback and linebacker on the Ohio State team that won the Rose Bowl in 1958. That same year he was a first-team all-American and finished fourth in the Heisman Trophy balloting. He played one game as a pro in 1960 with the Houston Oilers during that team's successful 10–4 inaugural year in the American Football League.

Holmes High School football team, 1930. Courtesy of Holmes High School Athletic Hall of Fame.

Ron Beagle, who attended Holmes as a freshman, and Holmes's Thurman Owens also had illustrious college football careers. Beagle was a standout 60-minute player as end for Navy from 1953 to 1955, was a two-time all-American, and won the Maxwell Trophy for College Player of the Year in 1954, the only Northern Kentuckian to do so. Owens had an outstanding career as a linebacker at the University of Cincinnati (UC), captained its 1949 team, and was inducted into the UC Hall of Fame (1987). Covington Catholic's Bill Topmiller (1971) played tight end for Vanderbilt University in the 1974 Peach Bowl. Covington has also had seven or eight—dependent upon Holmes's title claim in 1943—high school state football championships: Covington Catholic at 3A (1987, 1988, 1993, 1994, 1997, and 2006) and Covington Holy Cross at 2A (2011).

BASKETBALL

Three professional basketball players, Bob Arnzen, Tom Thacker, and Dan Tieman, were born in Covington, and two others, Larry Staverman and George Stone, played college and high school basketball there respectively. Larry Staverman was raised in Covington and attended Villa Madonna (now Thomas More) College in Covington. He graduated in 1958, having established what was then his college's record for points scored (1,673) and rebounds (1,114); he remains the only player in the school's history with at least 1,000 points and 1,000 rebounds. Staverman

1930 football program, Holmes Bulldogs vs. Newport Wildcats. Courtesy of Holmes High School Athletic Hall of Fame.

was a ninth-round draft choice of the National Basketball Association's Cincinnati Royals in 1958. In 1961, he joined the American Basketball League's Kansas City Steers, and after that league disbanded in 1962, he returned to the NBA. Staverman played with the Chicago Zephyrs (1963) and during 1963–64 with the Baltimore Bullets, Cincinnati, and the Detroit Pistons. Following his retirement in 1964, he coached basketball at Notre Dame for two seasons, was the first coach (in 1967) of the American Basketball Association's (ABA) Indiana Pacers, and later coached the NBA Kansas City Kings (previously the Cincinnati Royals).

Bob Arnzen was a star basketball player at Saint Xavier High School for four years and led his team to the state finals in Ohio. He played college basketball at Notre Dame, where he was an academic all-American and was, three times, a Helms all-American. In 2005 Arnzen was named to Notre Dame's All-Century Team. He played professional ball with the ABA's New York Nets (1969) and the NBA's Cincinnati Royals (1970–71). Arnzen also pitched for four years in the Montreal Expos farm system (1969–72); in 1972 he returned to basketball with the defending ABA champion Indiana Pacers. He played a role in that team's successful title defense (1972–73) and completed the 1973–74 season with Indiana before retiring.

Dan Tieman, who was born in Covington, grew up playing basketball and baseball in Covington's Goebel Park. He played both of these sports, first at Covington Catholic High School (which had relocated to Park Hills, Kentucky, in 1955) from 1954 to 1958, and then at Villa Madonna College from 1958 to 1962. Tieman played one season, 1962–63, with the Cincinnati Royals, after which he began a long and successful coaching career. From 1963 to 1978, he was assistant basketball coach at Thomas More and then Covington Catholic; he worked his way

up the coaching ladder to become Covington Catholic's head basketball coach in 1985. Tieman's coaching career at Covington Catholic, 315 wins and 146 losses, remains a record.

Tom Thacker is perhaps Covington's most famous basketball player. After a highly acclaimed basketball career at Covington's William Grant High School, Thacker picked up a few credits to complete high school and enrolled at the University of Cincinnati in 1959. A 6-foot-2 forward, Thacker played on Cincinnati's National Collegiate Athletic Association (NCAA) championship teams in 1961 and 1962, was named an all-American (1963), and was the Cincinnati Royals' territorial selection in the 1963 draft. He played with the Royals (1963–66), the Boston Celtics (1967–68), and the ABA's Indiana Pacers (1968–71). Thacker, who was inducted into the UC Hall of Fame in 1981, remains the only basketball player to have played on NCAA championship, NBA championship, and ABA championship teams.

George Stone, a 6-foot, 7-inch forward, was a standout player at William Grant in the early 1960s and played college basketball at Marshall University. Stone elected to play professional basketball in the ABA rather than in the NBA, where he had been an eighth-round selection. He played four seasons in the ABA (1968–72), first with the Los Angeles Stars, then with the 1971 league champion Utah Stars, and concluded his career with the Carolina Cougars. Stone played in 259 games, scored 3,530 points, and had a scoring average of 13.6 points. Along with Tom Thacker and later high school and college sensation Dickey Beal, Stone remains one of the true sports heroes within Covington's African American community.

Covington has an impressive list of outstanding college basketball players. One of the earliest was Dick Maile, who lettered in golf, baseball, and basketball at Covington Catholic. A prolific jump-shot artist, Maile attended Louisiana State University (LSU), where, in 1964, he made the All-Southeastern Conference Team. He repeated that honor the following year and made the 1965 *Look* magazine All-American Team. He ended his career at LSU as the school's third-leading scorer and rebounder. Maile was an 11th-round draft choice of the Cincinnati Royals but never played in the NBA. He was inducted into the LSU Hall of Fame in 2005 and in 2006 was voted an SEC Basketball Legend.

Dickey Beal was born in Covington in 1962 and was a standout basketball player at Holmes. A lightning-quick guard who was a ball-handling wizard, Beal averaged 20 points his senior year at Holmes. Someone who might be called a gym rat, Beal could frequently be seen playing pickup basketball games at local gymnasiums. He turned down an offer to play at DePaul University in Chicago to instead play at the University of Kentucky (UK). He overcame multiple knee injuries to lead UK to the NCAA Final Four in 1984 and was a fourth-round draft choice of the NBA's Atlanta Hawks. Beal's knee problems ended his aspirations to play professionally.

Paul "Lefty" Walther (1927–2014), from Covington, was a two-time All-American basketball guard at the University of Tennessee and an NBA All-Star in 1952. He played six years (1949–1955) in the league.

A strong argument can be made that Celeste Hill-Brockett may be Covington's most noted female athlete. A star basketball player for Holmes, she graduated in 1990. The *Cincinnati Enquirer* would later name her one of the top 50 female basketball players in the region. She played her college ball at women's basketball powerhouse Old Dominion University (ODU), where, in 1991, she was named Sun Belt Conference Rookie of the Year. Hill-Brockett was conference player of the year the next three years and was named an all-American (1994). She remains the only player at her university to lead her team in scoring and rebounding all four years. She still is the leading scorer in her conference's history and was inducted into the ODU Hall of Fame in 2002. Hill-Brockett played professionally in Greece and Israel, since there was no women's professional league in the United States at the time of her graduation. In 1998 she returned to coach basketball at Holmes, first as an assistant and later as head coach. Her Lady Bulldogs made the semifinals of the Kentucky Women's Sweet 16 in 2002.

Covington has produced a plethora of great high school basketball players. The biographies of those who played for Covington Catholic alone would fill a large book. So necessarily what follows represents, at best, select samplings. There was a time when Mote Hils, who coached basketball at Covington Catholic (1963–71) and at Northern Kentucky University (NKU) (1971–80), was starting three or more players on the basketball team at NKU who had played for him at Covington Catholic. One, Richard Derkson, is in NKU's Athletic Hall

of Fame (1997). A short list of other high school basketball players connected to Covington includes Holmes High School's Bill Schwarburg (1930s), Dave Bishop (1950s), Charlie Perry (1961), Doug Schloemer (1978), Jack Jennings (1980s), and Erica Hallman (2002); Holy Cross's Jerry Rump (1950s) and Dave Hickey (1960s); and Covington Catholic's Randy Noll (1968) and Andy Listerman (1994).

COACHES

The list of outstanding coaches from Covington is impressive. The aforementioned Bill Schwarburg was a successful golf (1954–82) and basketball coach at the University of Cincinnati. Jim Brock was the legendary coach of William Grant basketball from 1955–65, and Paul Redden coached the school's football teams that won the African American Kentucky State Championships in 1929 and 1932. Ken Shields, who played basketball and baseball at Covington Catholic, coached basketball successfully at both Saint Thomas and Highlands High Schools, where he had a 460–257 cumulative record before beginning a 16-year record-setting coaching career at NKU (1988–2004); his college teams were 306–170 and played in the NCAA Division II National Championship games in 1996 and 1997. Mike Murphy, Donna Wolfe, and Ed Kennedy also had notable coaching (and in the case of Kennedy, broadcasting) careers. Murphy, a Holmes graduate, coached with great success at Holmes, Highlands, and Newport High Schools from the 1950s into the 1980s. Wolfe, a standout athlete in basketball, softball, and volleyball at Holmes in the 1950s, was a highly successful coach at Holmes in each of these sports. She and another Holmes coach, Jean Mitchell, played major roles in the inclusion of girls athletics in the Kentucky High School Athletic Association. Wolfe is also a member of the National Softball Hall of Fame and the Holmes Athletic Hall of Fame. In Kennedy's three years as Covington Catholic's head basketball coach (1947–49) his teams were 35–15. From 1961 to 1970, he was the television voice of the Reds; he also broadcast games for the Royals, the Bengals, the University of Cincinnati, and Xavier University. Another well-known sportscaster from Covington, Paul Sommerkamp, was the public address announcer for the Reds (1951–85) and did sports broadcasts on radio stations WKRC and WCKY.

All successful coaches have their own ways to inspire and motivate players. For Mote Hils it was dry, and often sarcastic, humor; for Holmes graduate Bill Aker, who coached baseball at NKU (1971–2002) and was inducted

LEFT TO RIGHT: Jim Connor, William Grieme, and Mote Hils. Courtesy of the Kenton County Public Library, Covington.

into the American Baseball Coaches Association's Hall of Fame in 2013, it was "inspirational talks" spiced with colorful language before, during, and after games; for Villa Madonna basketball player and highly successful local basketball coach Jim Connor, it was his dedication and integrity; and for Holmes's gravel-voiced football coach of the 1940s and 1950s era, Tom Ellis, it was the feared command to his players, "Hey you, come here, boy. I want to talk to you." Of such stuff legends are made!

SOFTBALL

Men's and women's fast- and slow-pitch softball games have long filled up the ballparks of Covington. Bill Cappel, a 1927 graduate of Covington Latin, is the person most associated locally with the popularity and development of softball. Always a promoter of sports, in 1935 he helped establish the Covington Major Girls League, which produced three national softball champions. Cappel captained the Nick Carr's Covington Boosters fast-pitch softball team, which won the World Amateur Championship in 1939; other Carr's stars included slugging outfielder Walt Wherry, a 1946 Holmes graduate; infielder Jackie Nie; and ace pitcher Norb "Cyclone" Warkin. Cappel served as a player, manager, umpire, and groundskeeper throughout his lifetime. In 1983 he cofounded the Northern Kentucky Umpires Association and the Northern Kentucky Sports Hall of Fame. A city sports complex in Covington's Rosedale neighborhood bears his name. Melvin Webster, a 1971 Holmes graduate, has been head softball coach at Bishop Brossart High School in Alexandria, Kentucky, for more than 15 years and has coached 18 championship teams. Webster is a member of the Northern Kentucky Hall of Fame and the Northern Kentucky Athletic Directors Hall of Fame. There were also players from Covington on the many softball teams from this area that won national men's softball championships during the 1950s.

BOXING

In the sport of boxing, three men from Covington were standouts. "Kentucky Joe" Anderson was a top-10-rated middleweight between 1927 and 1929 and defeated three champions during his 10-year career, which ended in 1931. On October 10, 1927, he was critically stabbed below the heart in an altercation involving an auto accident but survived. During the 1930s, he and his wife operated the Bluegrass Gym at Fifth Street and Madison Avenue in Covington. Rinzy Nocero was born in 1931 in Covington and during the 1950s was one of the top contenders in boxing's middleweight division. He won 19 straight fights before losing in 1954 on points in a fight staged at Madison Square Garden in New York City. His career declined after losing on a technical knockout (TKO) to highly rated Argentinean boxer Rafael Merentino in 1955. Overall, Nocero won 28 fights, eight by knockouts. Middleweight boxer Terry O'Brien, who attended Covington Catholic, turned pro in 1969 and won 16 straight fights before retiring due to injury. Later, in his 40 years as a boxing coach and promoter, O'Brien trained two Olympic boxers and 25 Golden Glove winners and, until 2011, operated Covington's Shamrock Boxing Gym. In yet another form of contact fighting, William "Bill" Dometrich, a former Covington assistant police chief, was an eighth-degree black belt in karate who in the mid-1970s founded the martial arts program at Northern Kentucky University.

Bill Dometrich

Bill Dometrich (1935–2012) had a stellar career as an officer with the Covington Police Department and as a teacher of martial arts. A practitioner of Zen Buddhism, Dometrich erected a small Buddhist temple on Martin Street in Covington that he filled with Asian artifacts and used for meditation. A US Army veteran who gained worldwide respect for his humble demeanor and commitment to advancing the principles espoused by Japanese Chito-ryu karate, Dometrich was the first American ever awarded the *hanshi*, one of traditional Japanese martial arts' highest honors.

GOLF AND SWIMMING

Golfers and swimmers connected to Covington have won several significant honors. Nate Dusing, a 1997 Covington Catholic graduate, set a national high school record in the 100-meter butterfly. He was named to the High School All-American Team (1996 and 1997) and in 1997 was named National Swimmer of the Year. He won a silver medal in Sydney, Australia, in the 4x200-meter relay and a bronze in the 4x100-meter relay in Athens. When he retired from swimming in 2004, Dusing still held four NCAA and five American records. William Scheben, from Covington, was a standout golfer for St. Henry High School in Elsmere, Kentucky, during the 1950s and later in college, where he lettered two times at University of Cincinnati and once at the University of Kentucky. A community development leader, he is the namesake of the Scheben branch of the Boone County Library in Union, Kentucky. Professional golfer Ralph Landrum, who was born in Covington, also played at St. Henry and UK. He played on the professional golf tour from 1983 to 1985, managing seven top-10 finishes. Covington Catholic golfer Steve Flesch continues his outstanding Professional Golf Association (PGA) career. The PGA Rookie of the Year in 1998, Flesch has won more than $18,000,000 and is one of the tour's all-time top-50 money winners. He has won eight tournaments worldwide, including four PGA wins.

The several other state sport titles won by Covington high schools include Holmes in basketball (2009); Covington Catholic in cross country (1982 and 1994), golf (1969 and 1984), swimming (1962, 1974, 1977, 1978, and 1993), track (2009), and basketball (2014); and Holy Cross in slow-pitch softball (2005 and 2006), women's "A" volleyball (2011), and women's "A" basketball (2012).

Another local high school, all-girls Notre Dame Academy in Park Hills (formerly located on West Fifth Street in Covington), is a perennial state athletic powerhouse. Notre Dame has 30 state high school championships and has been state runner-up 35 times, a record unsurpassed by any other local high school. In the late 1970s and during the 1980s, the school's star-studded volleyball teams, coached by Joan Mazzaro-Epping, won seven state championships and were state runners-up three times. On average, 12 Notre Dame student-athletes go on to play collegiate sports every year. One of these, professional swimmer Emily Brunemann (2005), was a champion in high school and college and has become an international long-distance swimming star. Brunemann won three state swimming titles in high school, including the 200- and 500-meter individual medleys. She was named to all-state teams all four years and in 2005 was named LaRosa's Female Athlete of the Year. After graduating high school, Emily became an all-American swimmer at the University of Michigan, after which she turned pro. Consistently ranked one of the top professional marathon swimmers in the world, in October 2013 Emily became the first American swimmer (male or female) to win the International Swimming Federation's World Cup 10K Open Water Series.

Emily Brunemann. Courtesy of Kim Dunning.

Platform diver Becky Ruehl Amann (Villa Madonna Academy, 1991–95) has the distinction of being the first Northern Kentuckian to make a US Olympic team; in 1996 she finished fourth in the 10-meter dive in Atlanta. Amann was a five-time state platform diving champion, Kentucky's 1995 Outstanding Female Athlete, and the NCAA diving champ and National Diver of the Year (1996) at the University of Cincinnati. She is the only female athlete at UC to win an NCAA title. Amann was inducted into the UC Athletic Hall of Fame (2005), LaRosa's Athletic Hall of Fame (2006), and the Northern Kentucky Athletic Directors Association Hall of Fame (2013).

HORSE RACING

Old Latonia Race Track (1883–1939), which was annexed to Covington in 1908 along with the city of Latonia, was home to the prestigious Latonia Derby (1883–1937) and was once one of America's leading racetracks. Part

of Kentucky's "3-L" racing circuit (Latonia, Lexington, and Louisville), Latonia regularly drew tens of thousands of fans to its meets until the Great Depression years. During race meets, the Latonia neighborhood was a hub of excitement and activity. Legendary jockey Eddie Arcaro cut his teeth at Latonia, working horses before moving on to greater things. Another Hall of Fame jockey, Mack Garner, married a woman from Covington and lived in Covington when he died in 1936. Hall of Fame trainer Ron McAnally, an orphan, grew up in the Covington Protestant Children's Home. Latonia native George Weaver stirred hometown emotions to a fever pitch when his horse Gowell won the local derby in 1913. The great course, which had hosted many of the nation's finest horses and equestrians, closed suddenly in 1939, and all that remains are lingering memories and a state historical marker at the corner of 38th and Winston. Internationally famous jockey Steve Cauthen, who was born in Covington, never lived there but would later ride a few races at the new Latonia track in Florence, Kentucky. Another Covington-born jockey, Matt McGee, finished next to last in the 1911 Kentucky Derby and then moved to Europe, where he won the 1914 English Derby and was a top rider in France into the 1930s. Mike Battaglia, who grew up in Covington, has had an illustrious career as a track announcer, highlighted by getting to call 18 Kentucky Derbies on network television. In yet another kind of racing, Jack Roush (NASCAR's colorful team owner nicknamed "The Cat in the Hat") was born in Covington and is in the International Motorsports Hall of Fame (2006).

For so many of us, the sounds of sports taking place in Covington conjure up nostalgic memories—the noise of children playing games in schoolyards and on city playgrounds; the crescendo of crowds cheering at high school ballgames; the crack of bats at the old Covington Ball Park or at Meinken Field; crowds pushing against the rail and cheering from the stands at the old Latonia Race Track; or the laughter and sounds on the front lawns and in the backyards of the neighborhoods of the city. And there are many more such memories that could be listed—each a recollection peculiar to one's personal experiences and age. It is therefore the sum of all of these collected memories which helps to illustrate how much sport has become a part of the fabric that defines the city of Covington in this, its 200th year.

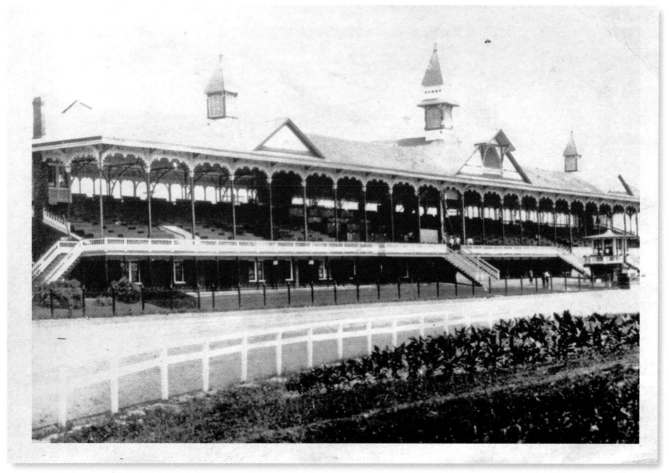

Grandstand at the old Latonia Race Track, Covington. Courtesy of James C. Claypool.

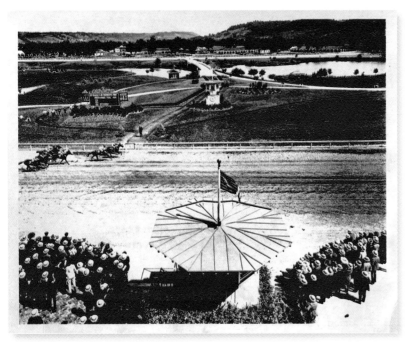

LEFT: Latonia Race Track, Covington. View from the grandstand. Courtesy of James C. Claypool. RIGHT: Mack Garner and his dog Sandy. Courtesy of Karen Schlipf and Leslee Garner.

YMCA

The YMCA (Young Men's Christian Association) was founded in England in 1844 as a Protestant organization focusing on wholesome activities for young men. The first YMCA in Covington, in 1857, was located on the third floor of a building at Fifth Street and Madison Avenue. Over the years, the organization had various locations in downtown Covington. Richard P. Ernst, while serving as president of the Covington Y, spearheaded a move to erect a permanent site on Madison Avenue (later known as the Covington Wade Branch), which opened in 1913. The facility remained in use until May 1987. The building housed a swimming pool, a gymnasium, meeting rooms, a dorm for short-term housing, and later a popular cafeteria. In 1929 the Y expanded into an adjacent building, mainly for needed women's facilities. The Y sponsored basketball, football, and baseball leagues, bicycle races, volleyball matches, rifle teams, team tournaments, marathon races, debating clubs, Hi-Y youth clubs, and teen dances. It had an exercise area; sewing classes for girls; and rooms for important civic discussions, banquets, and religious meetings. There were separate entrances for men and women. The Covington Y was

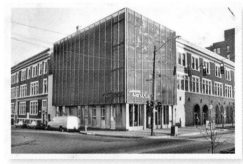

The old Wade Branch of the YMCA, Pike Street and Madison Avenue. Courtesy of the Kenton County Public Library, Covington.

replaced by newer facilities located in the suburbs, but the building constructed in 1913 on Madison Avenue remains.

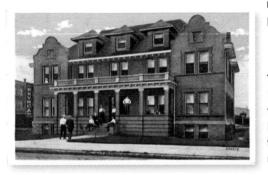

The old Railroad YMCA at 1621 Madison Avenue was dedicated in 1909, a year when the city's railroads employed more than 1,700 workers. To many rural men working in the city for the first time, the Railroad YMCA offered inexpensive rooms as well as opportunities to socialize and to attend religious services. It closed in 1958 and is now a transition care facility. Courtesy of Paul A. Tenkotte.

SELECTED BIBLIOGRAPHY

Behringer-Crawford Museum and the Northern Kentucky Sports Hall of Fame. *Reach for the Stars: Highlights of the Accomplishments of Northern Kentucky Athletes.* Covington, KY: privately printed, 2008.

Claypool, James C. *The Tradition Continues: The Story of Old Latonia, Latonia, and Turfway Racecourses.* Fort Mitchell, KY: T. I. Hayes, 1997.

Northern Kentucky Newspaper Index. Kenton County Public Library, Covington, KY.

Schneider, Bill. "Northern Kentucky Base Ball: The Early Years." *Northern Kentucky Heritage* 3 (2) (1996): 22–25.

Stem, David J., and Jan Hubbard. *The Official NBA Basketball Encyclopedia.* New York: Doubleday, 2000.

Tenkotte, Paul A., and James C. Claypool, eds. *The Encyclopedia of Northern Kentucky.* Lexington, KY: University Press of Kentucky, 2009.

Webster, Robert D. "Bowling in Northern Kentucky." *Northern Kentucky Heritage* 20 (2) (2013): 29–38.

CHAPTER

18

FROM SUFFRAGE TO SCIENCE: WOMEN IN COVINGTON

by Paul A. Tenkotte, PhD, with contributions by Deborah Kohl Kremer

BEFORE the Civil War, women in Covington began to challenge the boundaries of gender, and by the late 19th century, they were voting in municipal school board elections. As champions of education, parks, playgrounds, public libraries, and woman suffrage, they achieved a better quality of life for all residents of the city. By the 20th century, Covington women succeeded in careers as actresses, attorneys, authors, business executives, doctors, editors, inventors, musicians, nurses, politicians, scientists, and teachers.

In the 19th century, race and socioeconomic status determined the boundaries of women's roles. A black woman, for instance, contributed to her family's well-being by working as a nanny, laundress, cook, housekeeper, or field hand from the time she was old enough to hold a broom. Upper-class white women, on the other hand, could generally depend upon household servants to free them from household and child-rearing tasks in order to pursue charitable work in the community. For some, like Henrietta Cleveland, their influence would continue to reach well into the 21st century.

Henrietta Esther Scott Cleveland (1817–1907) was born in October 1817 in Covington, Kentucky, the daughter of Major Chasteen and Abigail Fowler Scott. Her grandfather was Jacob Fowler, one of the earliest settlers of Covington and Newport, Kentucky, and pioneer of a family who quickly rose in the socioeconomic ranks. In 1834 she married George P. Cleveland, scion of an old New England family. Henrietta's comfortable life, however, was visited by many tragedies. Her first child, Charles, died at age 2 in 1838. In January 1839 her young husband died at age 31, while she was pregnant with their second child, George. Then young George died at age 11 in 1851. Following her husband's death, Henrietta lived with her parents in Boone County, Kentucky. Without a husband and children to care for, an upper-class white woman, like Henrietta, often sought out other nurturing activities. Sometime before 1860, Henrietta moved back to Covington and began to involve herself in charitable work among the poor. Probably about this same time, she converted to Catholicism. Perhaps like her Cincinnati friend, Sarah Worthington King Peter (1800–77), she was attracted to the Catholic Church's dedication to helping the poor and downtrodden. As a congregant of St. Mary Church in Covington, she was a member of the parish's Martha and Mary Society, a group of women dedicated to serving the poor.

Concerned that Covington did not have a hospital, Cleveland and her friend Peter approached Bishop George Carrell of Covington about the possibility of establishing one. Cleveland and Peter raised the necessary funds, and with the staffing of the Sisters of the Poor of St. Francis, opened St. Elizabeth Hospital in 1861 in a small building on East Seventh Street in Covington. During the Civil War, St. Elizabeth Hospital cared for the children of working mothers and opened a foundling home for orphaned and abandoned infants. Both Cleveland and Peter also visited hospitalized Union soldiers in the region, as well as imprisoned Confederate soldiers. After the war, the two women spearheaded additional fundraising to buy the old Western Baptist Theological Institute on West 11th

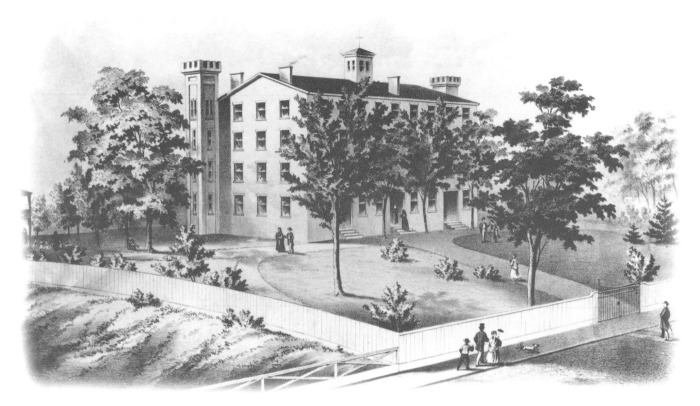

St. Elizabeth Hospital's second location on West 11th Street. Courtesy of the Kenton County Public Library, Covington.

Street—used during the Civil War as a Union Army hospital—as a new home for St. Elizabeth Hospital. Today, St. Elizabeth Healthcare is the largest employer in Northern Kentucky, and a major regional healthcare provider.

For many upper-class and middle-class women of the 19th century, the "cult of domesticity" meant that marriage, the maintenance of a pleasant and virtuous household, and the raising of children were priorities in their lives. Indeed, for all socioeconomic classes in the 19th century, the maintenance of a home was immeasurably time consuming. Before refrigeration and other household conveniences, shopping at city market houses was an almost-daily routine. Stoking stoves and furnaces with coal—and spending countless hours keeping homes clean of the ever-present coal dust—were among other daily tasks. In addition, there were numerous other chores: preserving and canning fruits and vegetables; cooking family meals; raising children; assisting sick and elderly family members; teaching Sunday school classes; and engaging in charitable and cultural activities.

For young upper-class ladies, Covington and other cities of the 19th century had finishing schools. These appeared as early as the 1840s in Covington and provided girls with classes in subjects such as art, dance, elocution, foreign languages, geography, history, literature, music, needlework, and the social graces. During the 1840s, the curriculum at the Covington Seminary for Young Ladies also included courses in astronomy, biblical antiquities, botany, chemistry, geology, and philosophy. The educated and cultured graduates of these institutions would apply their skills to the women's sphere

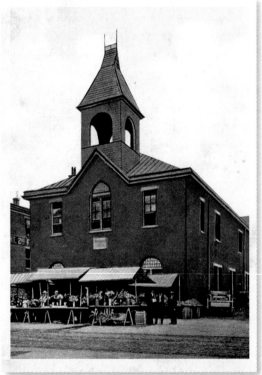

The City Market House was situated on West Seventh Street, today the site of a small parking lot. Courtesy of Paul A. Tenkotte.

of the cult of domesticity, marrying well, supervising a household, and engaging in philanthropic work. Indeed, the defined missions of such finishing schools clearly aligned with these domestic expectations. For example, in establishing the Kentucky Female College in Covington, leading citizens of Covington passed a number of resolutions in January 1855, stating that "the future prosperity and permanence of our country" depends upon "the preservation of a pure and enlightened Republicanism." Therefore, it was "of paramount importance to thoroughly educate the females of our country upon whom devolves the responsible duty of forming the character and developing the mental and moral worth of children" ("Kentucky Female College," *Covington Journal*, 27 Jan. 1855).

But what about upper- and middle-class women who did not marry? Their options were limited. If they were Catholic, they could possibly enter a convent and become a nun, although convents accepted women of all socioeconomic groups, especially middle- and working-class women. Catholic sisterhoods serving in Covington—including the Benedictines, the Sisters of Charity of Nazareth, the Sisters of Notre Dame, and the Sisters of the Poor of St. Francis—were the early career women of their time. They established and operated schools, orphanages, and St. Elizabeth Hospital, and staffed these institutions at every level, including directorships. If they were Protestant, well-educated women might teach in the public schools or finishing schools. If, however, a single woman married, she would be expected to resign from teaching in order to devote her time completely to her husband and children. Some unmarried daughters remained at home, caring for aging parents or extended family. Participating as volunteers in community charities was especially encouraged. Volunteering at churches was another social outlet. There were, of course, exceptions, but these were rare. For instance, as early as 1858, Covington had a female physician.

Catholic Sisters
BY DEBORAH KOHL KREMER

The Sisters of Notre Dame

Although the Sisters of Notre Dame can trace their beginnings to Belgium and then Germany, the Covington contingent came directly from the first American province of the Sisters of Notre Dame, established in Cleveland in 1874. Covington Bishop Augustus Maria Toebbe had a sister in that congregation and invited members to Covington that same year. Although his sibling would not arrive until the following year, the group quickly got to work on the construction of their academy and convent, which was located on West Fifth Street in Covington. The Sisters of Notre Dame also assumed control of Mother of God School and began teaching in several other diocesan schools. They expanded their ministry to include the operation of St. Joseph Orphan Asylum in Cold Spring, Kentucky, and during the next 100 years established two hospitals in Eastern Kentucky as well as the St. Charles Nursing Home in Covington.

In 1924 the Sisters of Notre Dame in Covington became a separate province of the congregation. They moved their Covington motherhouse to a new suburban location, known as St. Joseph Heights, on Dixie Highway in Park Hills, Kentucky, in 1927. In 1963, upon completion of a new school building, Notre Dame Academy for girls was also moved to this location, adjacent to the convent.

The Benedictine Sisters of St. Walburg

On June 3, 1859, three Benedictine sisters, led by German-born Mother Alexia Lechner from St. Walburg Abbey in Eichstätt, Bavaria, Germany, arrived in Covington to teach the children of German immigrants. The first member, Helen Saelinger, joined the community in 1860; she became Sister Walburga Saelinger and was the second prioress. By 1862, with 12 sisters in the community and very limited funds, they had built a monastery building on East 12th Street, between Scott and Greenup Streets. One year later, they founded St. Walburg Academy for boarders and day students. During these early years, the sisters were also called to establish, or provide staff for, many diocesan schools.

In 1903 Mother Walburga purchased acreage high atop a hill in what is now Villa Hills, Kentucky. The sisters quickly established Villa Madonna Academy for girls (now coeducational) inside a house on the

property and broke ground on a school building that opened in 1907. The sisters who taught at the academy lived with the boarding students. In 1921 Sister Domitilla Thuener began Villa Madonna College in two classrooms at the academy. She became the first dean of Villa Madonna College. St. Walburg Academy in Covington closed in 1931, and the building then became home to Villa Madonna College. By 1937 the St. Walburg Monastery building was completed, and the community moved the motherhouse from Covington.

Over the next 100 years, the sisters continued to uphold the Benedictine tradition of work, prayer, and community. In addition to the schools, the Benedictine sisters also worked to establish St. John's Orphanage in Fort Mitchell, Kentucky, two hospitals in eastern Kentucky, and two hospitals in Colorado. Besides founding Villa Madonna Academy, the sisters also established Villa Montessori School and Madonna Manor Nursing Home on their Villa Hills property.

In general, working-class women had few employment options available to them—work as domestic servants, in factories, or, in worst-case scenarios, in the vice trades. Kentucky was notorious for its lax labor laws, even into the early 20th century. The working class labored long hours, sometimes seven days per week, in dimly lit, poorly ventilated factories that required strenuous labor under unsafe working conditions. The wages of women were lower than those of men, and those of black women were lower than those of white women in comparable jobs. Poor widows or sick women might find a home at the county Widows' and Orphans' Home on Kyles Lane, at the later 20th-century Rosedale Manor in Covington, or at St. Elizabeth Hospital.

In 1886 philanthropic Covington women established the Home for Aged Women and Indigent Women (later renamed the Covington Ladies Home) as a clean, caring environment for women older than 60. Mrs. Ellen B. Dietrich led the effort, joined by Miss Sarah Breck, Miss Sue Crawford, Mrs. Henry (Eugenia B.) Farmer, Mrs. Wesley C. Hamilton, Miss Georgia Holmes, Miss Mary S. Ingram, Mrs. Q. A. Keith, Mrs. Lindsey, Mrs. D. Thomas, Mrs. Charity E. Warner, and Mrs. Frederick P. Wolcott. Some of the city's leading businessmen—A. D. Bullock, Jonathan David Hearne, Howell Lovell, and Henry Worthington—generously donated to the cause, and a house was purchased at 10th and Russell Streets. Officially incorporated in 1888, the Covington Ladies Home was supervised by a Board of Lady Managers, representing the city's Protestant churches. Men, however, served as fiscal trustees. In 1891 Charity Warner, president of the Board of Lady Managers, began a fundraising campaign to purchase land upon which to build a more spacious facility. They purchased a lot on the southeast corner of Seventh and Garrard Streets, where they built a new building capable of housing 50 women. Opened in June 1894, the facility still serves as the Covington Ladies Home today. Not surprisingly, many of the women who established the home were also involved in the women's suffrage movement, including Mrs. Henry (Eugenia B.) Farmer, Mrs. Wesley C. Hamilton, Mrs. Charity Warner, and Mrs. Frederick P. Wolcott.

Some poor, infirm men and women also found accommodations at St. Elizabeth Hospital, where the sisters generally opened their doors to all in need. In addition, the Roman Catholic Diocese of Covington was involved in many efforts to help the working class citywide. For example, in 1900, Reverend Ferdinand Brossart, rector of St. Mary's Cathedral in Covington (and later bishop), announced the opening of a free day nursery. Managed by the church's Martha and Mary Society, the nursery was intended for the children of poor working-class women. Likewise, the women of Trinity Episcopal Church (Covington) established a Girls' Friendly Society (GFS) in 1922. The GFS was part of an international movement, founded in Great Britain in 1875 by Mary Elizabeth Townsend, who was concerned for the welfare of poor working-class girls who had moved to cities in search of employment. The Covington chapter helped girls with their English, introduced them to poetry, and held plays, bazaars, and even international folk dances. Mrs. Frank A. Rothier, a prominent suffragist, spearheaded the founding of the Covington GFS, along with Mary S. Anderson Gibbons. Mary

Cabell Richardson (circa 1864–1925), a Covington reporter for the *Cincinnati Commercial Times*, a society lady, and a poet, bequeathed her East Fourth Street home to the Girls' Friendly Society, placing it on a firm financial foundation for many decades.

Clearly, the 19th century was a time of great change. Abolitionists, including many women, challenged the institution of slavery. And some of these same women abolitionists also pursued equal rights for women. In October 1853 the *Covington Journal* related how nationally renowned Lucy Stone had lectured to large audiences in Cincinnati (a "curiously made up city"), beginning with "Woman's Rights" and closing "with a thin auditory on American Slavery." While criticizing her "short hair, unfemenine [*sic*] features, and dress of the unseemly and ridiculous Bloomer cut," the reporter nonetheless admitted that she spoke with "great plausibility" and was "often truly eloquent." Three years later, in 1856, the *Covington Journal* reported, rather smugly, that a Covington lecture on "woman's rights" was poorly attended: "It is a fair inference," the writer assumed, "that the women of Covington enjoy all the 'rights' they care about, and have nothing more to ask for."

The *Covington Journal* of the 1850s could not have been more wrong. After the Civil War, women in Covington challenged gender boundaries. Jennie B. Moore, a single woman of Covington, exemplified the "new woman." She studied at the University of Cincinnati (1877–78), patented a dress-stay in 1893 (US patent 509,480), designed an emblem for the Kentucky Daughters of the American Revolution in 1898, and worked as a dressmaker and as a music and vocal teacher. She applied for clerk of the school board in 1898 (a position always held by men) and attempted to secure a position as a librarian at Covington's new library in 1899. Remaining single throughout her life, she died in November 1925 and was buried in Covington's Linden Grove Cemetery.

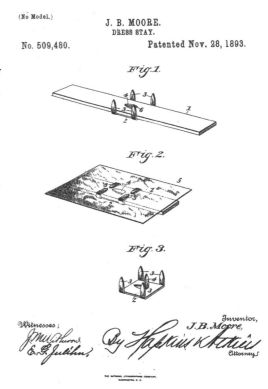

Jennie Moore's dress-stay patent. US patent 509,480.

After the Civil War, Covington women organized for equal rights with relentless momentum and achieved national and—in the case of Kate Trimble Woolsey—even international acclaim. In the 1890s, Kentucky woman-suffragists, including Eugenia B. Farmer (1835–1924) of Covington, fought for women's right to vote in school board elections and to serve as school trustees.

Eugenia Barrett grew up in Cincinnati. She attended Oberlin College in Ohio during the early 1850s, but it is unknown whether she graduated. In 1858 she married Henry C. Farmer (1830–1912). Since her husband was a railroad employee, the couple moved often. During the early part of the Civil War, they lived in a boardinghouse on Washington Avenue, a fashionable area of St. Louis, Missouri. Farmer and her husband were ardent Unionists, with little sympathy for Southern supporters. While living in St. Louis, they lost their firstborn child, Edmund B. (1859–61). As Eugenia Farmer related in a 1918 convention speech to the Minnesota Woman Suffrage Association, the loss "was crushing. I was heart-broken. My doctor sought to divert my mind by interesting me in alleviating the suffering of others. He took me to a Union hospital. There, side by side, I saw a father and his four sons. Each had lost a leg. My heart at once went out to them, and from that time on, I devoted myself to the interests of our wounded soldiers. Under the Doctor's direction, I became skillful in the making and use of bandages. Daily I brought to the hospital large quantities of magazines, books, and literature." Later during the war, Eugenia and her husband moved to Vincennes, Indiana; to Columbus, Ohio; and then to Amelia, Ohio. While at Amelia, Confederate raider John Hunt Morgan and his men approached the town. Eugenia hid "some valuable papers" of her husband's "in the back of a leather-covered chair, carefully sewing up the place" where she had stuffed them.

Eugenia B. Farmer. Source: *Kentucky Post,* 6 Aug. 1895.

During the Civil War, Farmer stated that "there was little time for suffrage work, but with the coming of peace, came further opportunity in this direction." She moved to Washington, D.C., where she met Susan B. Anthony in 1875. Anthony and Farmer became close friends, attending 12 National Suffrage Conventions in the nation's capital. Indeed, it was Anthony herself who encouraged Farmer to organize a woman suffrage organization in Covington, Kentucky, where the Farmers had moved. In Farmer's words, "I put an ad in the Cincinnati papers in September of 1888, for all those interested to meet me at Covington. Susan B. Anthony said to organize even if only three persons responded. In this case, six came, and I was elected president of this initial Covington association." The Kenton County Equal Rights Association (ERA) was born. Months earlier, in January 1888, Farmer's friend and colleague, Laura Clay of Lexington, Kentucky (the daughter of abolitionist Cassius Clay), organized the Fayette County Equal Rights Association. In November 1888 the Fayette and Kenton County ERA chapters attended the national convention of the American Woman Suffrage Association (AWSA) in Cincinnati.

The Cincinnati convention inspired Clay, Farmer, and others, who organized the Kentucky Equal Rights Association on November 22, 1888. The Kentucky ERA elected Clay as president and Farmer as corresponding secretary. Clay, Farmer, and others spearheaded a woman suffrage lecture circuit across the commonwealth of Kentucky, as well as political lobbying efforts at both the municipal and the state levels. Meanwhile, the commonwealth of Kentucky convened a constitutional convention in 1890 to write a new state constitution. The Kentucky ERA lobbied for women's rights, and Clay even spoke before the assembly. Adopted in 1891, the new constitution unfortunately did little to advance women's rights in Kentucky, except for allowing the General Assembly to pass laws giving women limited suffrage in municipal and other elections. The 1891 constitution did, however, establish limited "home rule" for cities throughout the state, including classification by population. Louisville became the state's sole first-class city, while Covington, Lexington, and Newport were the commonwealth's only second-class cities.

The Kentucky General Assembly met biennially, that is, every two years. At its 1892 session, the state legislature focused on achieving alignment between state laws and the new state constitution. Meanwhile, at a March 1893 meeting of the then all-male Covington school board, Farmer and three other women suffragists—Mrs. Wesley C. Hamilton, Mrs. Charity Warner, and Mrs. Frederick P. Wolcott (all of whom were involved with the Covington Ladies Home)—successfully convinced the board to concede the possibility of allowing Covington women both voting and trustee rights in school board elections. A month later, Farmer and Clay were in the state capital at Frankfort, Kentucky, preparing for the 1894 session of the legislature. Their plan was to lobby on behalf of legislation to permit women to vote for, and to serve on, school boards of second-class cities. Farmer personally addressed a number of sessions of the state legislature. With the help of Kentucky state senator and Covington resident William Goebel, a bill was passed by the Kentucky General Assembly in 1894, allowing women to vote in—and run as candidates for—school board elections in second-class cities only. In addition, the General Assembly also extended property rights to married women.

By 1895 Farmer began a citywide campaign in Covington, visiting churches and canvasing homes to educate women about casting their votes in the fall 1895 Covington school board elections. She also invited well-known

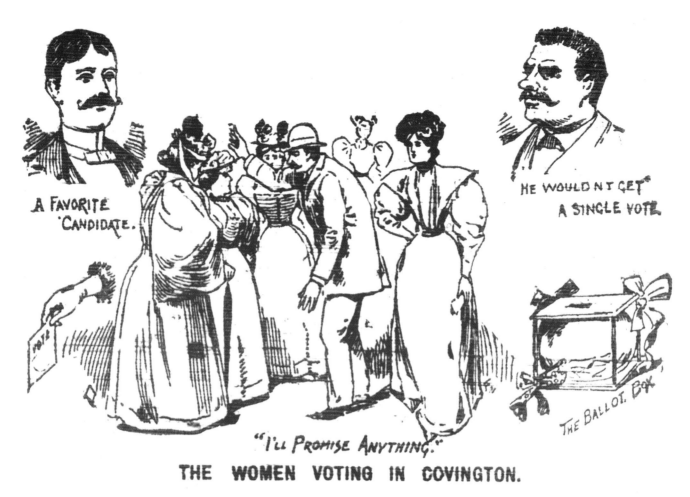

A FAVORITE CANDIDATE.

HE WOULD N'T GET A SINGLE VOTE

"I'LL PROMISE ANYTHING."

THE BALLOT BOX

THE WOMEN VOTING IN COVINGTON.

This political cartoon discounted woman suffrage by implying that they might vote for the more handsome male school board candidate. Note that the ballot box has ribbons on it. *Source: Kentucky Post, 5 Nov. 1895.*

suffrage leader Lillie Devereux Blake (1833–1913) to Covington that year to speak on the subject of "By a Jury of Her Peers." By summer of 1895, Eugenia Farmer had announced her candidacy for a seat on the Covington school board as well as the candidacy of her sister suffragists, Mary Barlow Trimble and Hester Baldridge.

The fall 1895 elections in Covington were a historic occasion. The Kenton County ERA had thoroughly canvased the city, finding a total of 7,833 Covington women eligible to vote. In addition, they had offered training sessions on voter registration and on the voting process itself. On the day of the election, white and black women alike turned out at the polls. Women were restricted to voting for the school board only, not for mayor or for any of the other municipal positions. Although the three female candidates lost election to the school board, they nonetheless made history, being the first women in Covington to run for office in the city's first election featuring partial woman suffrage. Meanwhile, in Lexington, Kentucky, the 1895 school board elections resulted in victory for four female candidates. Together, Covington, Newport, and Lexington, Kentucky, made further history statewide. They were the commonwealth's first large cities to permit partial woman suffrage, long before the state's largest city, Louisville.

In 1897 the Kentucky Equal Rights Association held its state convention in Covington at Trinity Episcopal Church's Guild Hall. Kentuckian Laura Clay presided and fellow national suffragist Emma Smith DeVoe (1848–1927) lectured. Four years later, in 1901, the Kentucky Equal Rights Association again held its state convention in Covington, also at Trinity's Guild Hall. Both the Kentucky ERA and local equal rights groups continued to work for a variety of causes, ranging from equal pay for government employees to female guardianship of children to full suffrage for women. Nationally known leaders continued to visit Covington and Northern Kentucky, including Gail Laughlin (1868–1952) in 1902.

The Kenton and Fayette chapters of the ERA had warmly embraced the registration and enfranchisement of black women in school board elections. This courageous move on their part was not necessarily popular, particularly at a time when racism was rampant. In addition, many of the woman-suffragists were also supporters of temperance, that is, of protecting society against the abuses of alcohol. At its session in 1902, the Kentucky General Assembly disenfranchised women in elections for school boards in second-class cities. Farmer claimed that "liquor interests" were "influential in the repeal," although racism and politics clearly played important roles as well. By that time, however, Eugenia Farmer was readying another move, this time to St. Paul, Minnesota. Furthermore, the Covington suffragists had seemingly fractured into two organizations, although the reasons for this are unknown. Without the leadership of Eugenia Farmer, the Kenton County ERA seemed to go into eclipse. On the other hand, the star of the Twentieth Century Club of Covington was rising.

The Twentieth Century Club of Covington, established sometime during the late 1890s, may have played a key role at the 13th Annual Convention of the Kentucky ERA at Trinity Episcopal Church in Covington, October 17–18, 1901. The following year (1902), the Kentucky ERA, expending its energies in an unsuccessful bid to prevent the General Assembly from disenfranchising women, did not hold a state convention. The next statewide convention was November 11–12, 1903, also held at the Guild Hall of Trinity Episcopal Church.

Mrs. A. C. Ellis was the founding president of the Twentieth Century Club. By 1911, however, Mrs. Mary E. Giltner (who resided in Covington at 1554 Madison Avenue) was reelected to her 11th successive term as president of the club. Other members included Elizabeth Aylward, Mrs. Ida Martin Beck, Mrs. N. S. McLaughlin (1011 Scott Boulevard), Mary Light Ogle, Mrs. Mattie Bruce Reynolds (517 Greenup Street), and Dr. Louise Southgate.

Dr. Louise Southgate (1857–1941) was a respected Covington physician and member of a wealthy and influential Northern Kentucky family. She was the great-granddaughter of Thomas Kennedy, who owned the ferry and land that later became the site of Covington. Orphaned in her early teens when her parents died of cholera, she lived with her aunt, Nancy Kennedy, at 124 Garrard Street. Southgate attended the Western Female Seminary in Oxford, Ohio, and graduated in 1893 from the Women's Medical College of Cincinnati. Traveling to Europe, she attended medical lectures in Vienna, Austria, and at the Pasteur Institute in Paris, France. Upon her return to Covington, Dr. Southgate opened her own medical practice, working until her retirement in 1930. During her long life, she volunteered with the Hindman Settlement School in Knott County, Kentucky, and was involved in woman suffrage, both in Covington and in neighboring Hamilton County, Ohio.

Mary Light Ogle, who lived on Light's Hill in what is presently the suburban community of Park Hills, was a women's rights leader and an inventor. In a *Kentucky Post* interview of November 12, 1906, she eloquently contested a commonly held belief among those opposing

Mattie Bruce Reynolds. Source: *Kentucky Post,* 25 Sept. 1916.

suffrage, namely that women would ruin government affairs: "Women deserve their just rights in city affairs when cities have such a reputation, at home and abroad, as Covington. A city of 50,000 population, that has submitted to abuse and failure . . . with streets like cess pools [*sic*], alleys like garbage holes, water like a liquid form of typhoid fever ooze, soot and poisoned vapors, called air, schools minus a superintendent, and the degrading distinction of being the only city in America of its size without a park. Would these conditions exist in any town if respectable women had a voice in city or county government?"

Covington women worked tirelessly for the betterment of their community. By the 1890s, poolrooms had become a recognized nuisance in Covington and other communities. Essentially, poolrooms were off-track betting places, where one could place a bet on horse races. Operating outside the law, poolrooms were regarded as bad influences for residents, promoting gambling, drinking, and other vices. Women were especially involved in the long struggle to rid Covington of poolrooms. Likewise, leading women of the community organized a Covington Civic League in 1896, championing "a better system of street cleaning," as well as the establishment of "a public park, a public library, and other institutions designed for the betterment of the city" (*Kentucky Post*, 18 Mar. 1896). One year later, the Covington Civic League featured 125 members. Not surprisingly, many woman suffrage leaders joined these civic efforts. Covington's African American women were also active in civic affairs, having established the Colored Woman's Club (CWC). By 1897 the CWC requested the establishment of city kindergartens for black children.

The indefatigable labor of women interested in civic improvements transformed the city. In 1901 the Covington Public Library opened to all, regardless of race. Helen B. Landsdowne was the first head librarian, and women served on the board of library trustees by 1908. Unfortunately, Kentucky state Representative Harry Meyers of Covington was a strong opponent of woman suffrage. As chairman of the house committee on suffrage and elections in 1910, he and his male counterparts prevented a bill to extend woman suffrage in school elections statewide. In the same year, Kentucky suffragists met in Carnegie Hall at the Covington Public Library. Two years later, in 1912, women statewide finally gained the right to vote in school board elections.

Margaretta Baker Hunt (1845–1930), philanthropist
BY DEBORAH KOHL KREMER

Margaretta Baker, daughter of John and Henrietta Baker, grew up in Covington at 620 Greenup Street. Her father owned an oil lamp business, and the Bakers became quite wealthy. They were well known in the community for their philanthropy. Margaretta Baker married Dr. William Hunt in 1872, and the couple lived with her parents in their Covington home. In 1888, the couple's only child, Katie, just 15, died from spinal meningitis. That same year, the Hunts, who attended Trinity Episcopal Church at 326 Madison Avenue, donated a large stained-glass window in the church to Katie's memory. Known as the Angel Window, it is still in place today. Just a few years later, Dr. Hunt also passed away, and Margaretta became a widow. For companionship, she invited her niece, Kate Scudder, to live in the mansion next door, which became known as the Scudder House.

Margaretta Baker Hunt. Source: Stevens, Harry R. *Six Twenty: Margaretta Hunt and the Baker-Hunt Foundation.* Covington, KY: Baker-Hunt, 1942.

To overcome her grief, Margaretta began inviting neighborhood children into the home and instructing them about art. She had led a privileged life full of education and travel and felt compelled to pass this on to some of her less fortunate neighbors. With no heirs to her fortune, Margaretta set up a perpetual trust in 1922, which established the Baker Hunt Foundation to benefit arts education. By 1930, the property had become known for its Covington Natural History Museum, which was open until the late 1940s. In addition, by 1932, the foundation was offering art and music classes to both children and adults. No fees were charged for children's classes.

The Baker Hunt property covers about 2 acres and consists of both homes; an auditorium, which was built around 1930; and an art studio, which was added in the 1970s. The massive trees on the grounds create a canopy over the lush, parklike setting, which is maintained by a team of 15 master gardeners who volunteer their time. Each year, the Baker Hunt Art and Cultural Center educates more than 1,500 students, both children and adults, in dozens of different classes ranging from painting to pottery to Tai Chi.

By the early years of the 20th century, the women's rights movement was experiencing a division between what might be called conservative and progressive elements. Some conservative leaders, such as Susan B. Anthony, maintained that women were different from men—that, in fact, they were more morally attuned and therefore needed the vote to ameliorate the ills of society. On the other hand, Lillie Deveureux Blake and others, like Kate Trimble Woolsey (1858–1936), argued that men and women were the same biologically and that gender roles were learned, social constructs. Thus, men and women were entitled to equal rights according to the US Constitution. Woolsey was raised in Covington, the daughter of William W. (1821–86) and Mary Barlow Trimble (1831–1912). Her mother was a noted Kentucky suffragist and one of the charter members of the Kenton County Equal Rights Association. In 1894, when Susan B. Anthony and Helen Taylor Upton attended a suffrage convention in Cincinnati, they stayed at the Trimble home at the southeast corner of Madison Avenue and Robbins Street in Covington. On the other hand, Kate Trimble Woolsey was clearly more of a Blake follower. Kate Trimble married Eugene de Roode in 1881. The couple had one son, Trimble de Roode, who became a noted inventor and retained ties to his patriarchal ancestral home in the Netherlands. Following the death of her husband Eugene, Kate Trimble married a wealthy man, Edward J. Woolsey of New York City, in 1893. Woolsey was recently divorced, and the marriage was socially shocking for the time period.

In a controversial book titled *Republics Versus Women* (1903), Kate Trimble Woolsey argued that, in the arena of women's rights, the aristocracies of Europe were more progressive than the world's republics. As a wealthy women's rights leader, Woolsey shuttled between New York City, Europe, and Covington. In addition, she visited many places then considered quite exotic, including Alaska. By July 24, 1911, the *Kentucky Post* referred to Woolsey as a "former resident of Covington." In that same front-page article, Woolsey proclaimed, "Suffrage is only one of the powerful agencies which are hurrying in the advent of the superwoman." Gender was biological only, and laws were "man-made." Scientific research into many animal species confirmed this view, she claimed, as demonstrated in the animal kingdom, where many females chose their mates. According to Woolsey, the first human societies were matriarchal, but men "stole" women's rights while women were busy caring for children. Eventually, women would regain their prominence in modern society, she believed, and would "rule the world." An attendee at many international conferences, Kate Trimble Woolsey spent her final years living at the Imperial Hotel in Manhattan, New York City. She died in Manhattan on August 10, 1936.

By March 1913 Covington suffrage leader Jessie (Mrs. Charles Frederick) Firth (1864–1950) joined 11,000 suffragists in a march in Washington, D.C. Returning to Covington, Firth finalized plans for a massive suffrage rally at the Odd Fellows Hall on the northeast corner of Fifth Street and Madison Avenue. Held on March 18, it featured noted Kentucky suffragist Madeline McDowell Breckinridge as speaker. Breckinridge championed woman suffrage, but also "dwelt most deeply and emphatically" on "the protection of young girls, the minimum wage, white slavery, the regulation of child labor, shorter hours for women workers," and the prevention of diseases

Kate Trimble Woolsey. Source: *New York Evening World,* 1 June 1912.

like tuberculosis (*Kentucky Post,* 19 Mar. 1913). In September of that same year, Covington suffrage leaders hosted a meeting at the Simrall Building (427 Madison Avenue), inviting all candidates for the upcoming Kentucky General Assembly election in November to attend. Sadly, only two candidates—a Progressive and a Socialist—accepted the invitation and pledged their support, if elected, for the equal suffrage bill to be introduced in 1914. However, the bill faced defeat that year, as well as in 1916. As late as December 1919, Representative Harry Meyers of Covington still insisted that he would not sign any woman suffrage bill in the Kentucky General Assembly. Covington women did,

however, achieve a victory in 1915. In that year, the city's commissioners hired Mrs. Alice Vorhees as the city's first "police matron." She was responsible for overseeing "female and juvenile malefactors" (*Kentucky Post*, 15 Feb. 1915).

In January 1920 Kentucky became the 23rd state of the union to ratify the Nineteenth Amendment (national woman suffrage) to the US Constitution. Thereafter, the Kentucky Equal Rights Association slowly transitioned itself to become the Kentucky League of Women Voters (KLWV). Jessie Firth was part of the executive committee involved in the KLWV reorganization effort statewide, serving as secretary. In addition, Firth had assumed two new challenges in 1919—as an appointee to a Kenton County commission to stamp out illiteracy, and as Covington Mayor John Craig's choice as the city's official representative to purchase government foodstuffs at the end of World War I. By May 1920, both the Covington Woman's Club and the Kenton County Equal Franchise Association endorsed Richard P. Ernst of Covington for the US Senate. By October 1920, 10,438 women had registered to vote in Covington. Ernst, a Republican, won. Several years later, in 1923, he supported Jessie Firth when she became the first woman in Kenton County to run for public office. Firth campaigned for the Kentucky House of Representatives for the 64th District, but lost the election. In 1925 Bernice Lockwood of Latonia became the first woman to run for city commissioner in Covington. A *Kentucky Post* editorial on June 17, 1925, praised her decision, claiming that "Covington needs a change. The city needs men or women who will announce for what they stand; who will make a fight for those things. Covington is tired of promises which have been meant nothing." Soon after, a second woman, Miss Ada Conklin, announced that she too would run for Covington City Commission. In the October election, both Lockwood and Conklin lost, but they nevertheless made history locally.

The Covington Woman's Club, one of the endorsers of Richard P. Ernst for US Senator, was established in 1914. In 1925 the club purchased the old Richardson home in Covington at 11 East 12th Street for its headquarters. It was one of the many popular and prosperous women's clubs throughout the city, attaining a membership of 214 women by 1928.

One of the oldest still-extant women's clubs in the Cincinnati region is the Covington Art Club (CAC). Founded in 1877 as the Young Ladies Art Union, it changed its name to the Covington Art Club in 1887. By 1894 it had become a charter member of the Kentucky Federation of Women's Clubs. In the 1920s the CAC moved to 604 Greenup Street, next door to Margaretta Baker Hunt (see sidebar, page 419). Over the years, the CAC expanded to include an array of civic projects, ranging from playgrounds to smoke abatement to pasteurization of milk to the Hindman Settlement School. It was also instrumental in introducing annual preschool visual screenings in area schools. Of course, Covington women did not set their sights on women's clubs alone. By 1928 they had achieved another first, when Miss C. G. Earl became the first female member of the then all-male Covington Industrial Club.

Covington resident Mary Florence Taney (1856–1936) was a member of the Covington Art Club, as well as an organizer of the Kentucky Audubon Society. Under the administration of US President Benjamin Harrison (1889–93), she served as the first female secretary to the Collector of Internal Revenue in Washington, D.C. While attending a meeting of the International Genealogical Congress at the Panama-Pacific Exposition in San Francisco in 1915, Taney established the Colonial Dames of the XVII Century. Six years later, in 1921, she founded the National Society of the Dames of the Court of Honor, an association that annually presents awards to outstanding commissioned officers graduating from the nation's four military academies.

Covington women were instrumental in the 1929 campaign to adopt a city manager form of government. Mrs. James A. Harding chaired the Women's Division of the City Manager Committee, which was organized by wards citywide. Not surprisingly, some of Covington's best-known women joined the effort, including Jessie Firth. In the November election, the city manager form passed overwhelmingly by a two-to-one margin, inaugurating a 20th-century governmental structure for Covington.

Enfranchisement and political involvement went hand in hand with the increasing entry of women into professional careers throughout the 20th century. Women attorneys and doctors slowly entered the ranks of their male counterparts. One of Covington's best-known physicians of the post–World War II era was Dr. Dorothy B. Worcester (1908–86). Born in Birmingham, Alabama, Worcester received her BS degree from the University

of Washington in Seattle and her MD from Northwestern Medical School in Evanston, Illinois. She was a staff member at both William Booth Memorial Hospital and St. Elizabeth Hospital in Covington and served as the longtime school physician for Covington Independent Schools.

Covington's Female Professionals and Leaders

Many other chapters of this book contain the stories of some of Covington's female professionals and leaders, including, but not confined to, the following:

CHAPTER 5
FROM FETTERED TO FREEDOM: AFRICAN AMERICANS IN COVINGTON

Mrs. Bessie Brean
Dr. Tracey Butler Ross
Elizabeth B. Delaney
Bessie Lacy
Mrs. H. R. Merry

Pamela E. Mullins
Alice Shimfessel
Mrs. Amanda Snowden
Michelle Williams

CHAPTER 6
FROM ART TO ARCHITECTURE: THE VISUAL ARTS IN COVINGTON

Dixie Selden
Mary M. Nourse
Mary Bruce Sharon

Aileen McCarthy
Jackie Sloan

CHAPTER 10
FROM NOVELS TO NEWSPAPERS: THE LITERARY HERITAGE OF COVINGTON

Alica Akin
Jo-Ann Albers
Harriette Simpson Arnow
Lina and Adelia Beard
Toni Blake
Judy Clabes
Michelle Day
Byrd Spilman Dewey
George Elliston
Peggy Kreimer

Mary C. McNamara
Nancy Moncrief
Gertrude Orr
Margaret Paschke
Mary Cabell Richardson
Alice Kennelly Roberts
Elizabeth Madox Roberts
Shirl Short
Debra Vance
Kate Trimble Woolsey

CHAPTER 12
FROM RAGTIME TO RADIO: MUSIC AND ENTERTAINMENT IN COVINGTON

Peggy Arnold
Blanche Chapman
Carmen Eilerman
Carole Hill
Lily May Ledford
Rosie Ledford
Clara B. Loring
Alice "Ma" McCormick
Una Merkel
Kathleen Myers

Elizabeth Parks
Katherine Hall Pook
Patia Power
Rebecca Schaffer
Rita Schaffer
Mary Ellen Tanner
Anna Bell Ward
Ruby Williams
Mary Wood
Joyce Yeary

CHAPTER 17
FROM HORSE RACING TO HOOPS: SPORTS IN COVINGTON

Becky Ruehl Amann

Emily Brunemann

Erica Hallman

Celeste Hill-Brockett

Joan Mazzaro-Epping

Pat Scott

As the home of Villa Madonna College (now Thomas More College in Crestview Hills, Kentucky), Covington had a number of female professors. These included members of the three orders of Catholic sisters who staffed the college—the Sisters of St. Benedict, the Sisters of Divine Providence, and the Sisters of Notre Dame. Too numerous to name, some examples of those deceased include historians Sister Mary Albert Murphy, SND (1896–1995), and Sister Mary Philip Trauth, SND (1923–95); linguists Sister Mary Annunciata, OSB, and Sister Hilarine, CDP; English professor Sister Mary of the Incarnation, CDP; scientists Sister Mary Casimira (Rita Marie) Mueller, SND (1918–2008), and Sister Mary Laurence Budde, SND (1929–2013). Sister Mary Laurence established the Thomas More Biology Field Station.

Sister Mary Laurence Budde, SND, working in the greenhouse of the Biology Department at Thomas More College, Crestview Hills. Courtesy of the Kenton County Public Library, Covington.

Una Merkel
BY DEBORAH KOHL KREMER

Star of stage and screen, Una Merkel (1903–86) was born and raised in Covington. In her early 20s, Merkel was chosen for bit parts in silent movies and appeared in several films by Kentucky-born director D. W. Griffith. As technology introduced talkies—motion pictures with sound—Merkel, who had a sweet Southern drawl and the ability to deliver well-placed wisecracks, was able to make the transition successfully. One of her first starring roles was in Griffith's movie *Abraham Lincoln*. Coincidentally, Merkel played Ann Rutledge, Lincoln's first love; in reality, Merkel was related to Nancy Hanks Lincoln, Abraham's mother.

In 1927 Merkel hit Broadway, playing opposite Helen Hayes in *Coquette*. Over the years, she bounced back and forth between Hollywood and the Broadway stage, starring opposite superstars like Jack Benny, Gary Cooper, Marlene Dietrich, and Ginger Rogers. She had roles in more than 90 movies and television shows. She won a Tony Award in 1956 and was nominated for a best supporting actress Oscar in 1962 for her role as Mrs. Winemiller in the movie *Summer and Smoke*. After she received her Tony Award, she was quoted as saying that the only other award she had ever won was for a role she held in her elementary school play in Covington, Kentucky. In another article, Merkel seemed surprised at her own success, saying "Back in Covington, I was an old-maidish, bookish type, and rather shy. I always felt like the girl who knew she wasn't going to be asked to the dance, and quite frequently, wasn't."

In 1932 Merkel married Donald Burla, a businessman, but they divorced in 1945. The couple had no children. During World War II, she traveled more than 23,000 miles in six weeks as part of the USO Tour, helping to entertain the troops. Her last film role was the movie *Spinout* in 1966, which starred Elvis Presley. Merkel has a star on the Hollywood Walk of Fame on Hollywood Boulevard in Los Angeles. She passed away on January 2, 1986, and was buried alongside her parents in Highland Cemetery in Fort Mitchell.

During the late 20th century, Covington women continued to lead efforts, regionally and internationally, to serve the poor. Sister Eugenia Muething (1916–2003), a native of Covington, entered the congregation of the Sisters of Charity of Nazareth, Kentucky, in 1937. She received her bachelor's degree in music from Nazareth College (now Spalding University) in Louisville, Kentucky. In 1952, she moved to Gaya, India, to teach music at a school operated by the Sisters of Charity, called Nazareth Academy. Sister Muething spent 45 years in India. The many philanthropic activities of the sisters, ranging from schools to Nazareth Hospital in Mokama, India, are detailed in Muething's *Nazareth along the Banks of the Ganges* (1997).

Helen McNeeve Theissen (1906–2005) and Rosemary McNeeve (1914–2012) were both born in Covington, the daughters of Frank and Ellen "Nellie" McNeeve and the granddaughters of Adam and Mary Grossman. The two young girls grew up in the Wallace Woods neighborhood of Covington and attended La Salette Academy at Seventh and Greenup Streets. Helen earned her degree from Sacred Heart College in the Clifton neighborhood of Cincinnati (1928) and then an additional BS in education from the University of Cincinnati (1929). She

taught for four years at a poor public school in Cincinnati's West End. Rosemary also graduated from Sacred Heart College in Cincinnati (1935), and later earned a master's degree at the University of Cincinnati. For 21 years, Rosemary served as a teacher and principal for Cincinnati Public Schools, including the rather poor Washington Park School.

During the episcopacy of Covington Bishop William T. Mulloy (bishop, 1945–59), Helen became involved in the Diocesan Council of Catholic Women (DCCW), an affiliate of the National Council of Catholic Women (NCCW). She served as president of the NCCW from 1958 until 1960, overseeing 13,000 chapters and nine million members nationwide. Working with Eileen Egan (1912–2000) of the national headquarters of Catholic Relief Services, Helen invited Mother Teresa of Calcutta, India

Helen Theissen, Reverend William Cleves, and Rosemary McNeeve. Photo by Paul A. Tenkotte.

(1910–97), to the NCCW's annual convention in 1960. Held in Las Vegas, the convention name that year was "Women in the Sixties." While internationally known now, Mother Teresa was little known in 1960. Indeed, her trip to the NCCW's convention was the first time that she had left India since her arrival there in 1929. Hence, Helen played a key role in introducing Mother Teresa to the United States, and to the larger world. Helen and Rosemary became close friends of Mother Teresa's, sponsored one of the babies whom she rescued, and even advised her before she opened a facility for AIDS patients in New York City.

From Henrietta Cleveland to Eugenia Farmer to Helen Theissen, the women of Covington have always embraced the enslaved, poor, aged, infirm, and children of the region. Hospitals; schools; art and cultural institutions; orphanages; retirement homes; playgrounds; safe milk and food; campaigns against slavery, disease, and gambling; and campaigns for good government have all benefited from the leadership of women. Covington's women were also instrumental—regionally, statewide, and even internationally—in seeking and achieving woman suffrage. Standing on the shoulders of their courageous sisters from the 19th and 20th centuries, in 2014 Covington women serve their city as mayor (Sherry Carran, the city's first female mayor), city commissioners, firefighters and police officers, attorneys, business owners, doctors, teachers, and more. Yet great challenges still remain today, as women and children comprise much of the nation's—and of the world's—poor.

Women's Crisis Center

The Women's Crisis Center was founded in 1976 as the Rape Crisis Center of Northern Kentucky, changing its name to the Women's Crisis Center (WCC) in 1979. It provides crisis intervention, housing, support, counseling, a 24-hour hot line, and advocacy for women and children who are the victims of domestic violence, rape, or sexual abuse. Now serving 13 Northern Kentucky counties with 55 professional staff members and more than 100 volunteers, the WCC maintains a number of locations, including Covington.

SELECTED BIBLIOGRAPHY

Barlage, Sarah A. *The Covington Ladies Home: The First Hundred Years*. Covington, KY: Covington Ladies Home, 1997.

Farmer, Eugenia B. "A Voice from the Civil War (1918)." Minnesota Woman Suffrage Association Records, Reel 8, Minnesota Historical Society, n.d.

Fuller, Paul E. *Laura Clay and the Woman's Rights Movement*. Lexington, KY: University Press of Kentucky, 1975.

Hargis, William Michael. *Covington's Sisters of Notre Dame*. Charleston, SC: Arcadia Publishing, 2011.

Harmeling, Sister Deborah, and Deborah Kohl Kremer. *Benedictine Sisters of St. Walburg Monastery*. Charleston, SC: Arcadia Publishing, 2012.

Hay, Melba Porter. *Madeline McDowell Breckinridge and the Battle for a New South*. Lexington, KY: University Press of Kentucky, 2009.

Irvin, Helen Deiss. *Women in Kentucky*. Lexington, KY: University Press of Kentucky, 1979.

Knott, Claudia. "The Woman Suffrage Movement in Kentucky, 1879–1920." PhD diss., University of Kentucky, 1989.

Mielech, Ronald A. *Northern Kentucky's First College: Villa Madonna—Thomas More College*. Charleston, SC: History Press, 2010.

Minutes of the Fifteenth Annual Convention of the Kentucky Equal Rights Association, Rooms of the Lexington Woman's Club of Central Kentucky, November 17–18, 1904. Newport, KY: Davies Print, 1905.

Minutes of the Fourteenth Annual Convention of the Kentucky Equal Rights Association, Held at Guild Hall, Trinity Episcopal Church, Covington, Ky., November 11–12, 1903. Newport, KY: Davies Print, 1904.

Minutes of the Thirteenth Annual Convention of the Kentucky Equal Rights Association, Held at Trinity Church, Covington, Ky., October 17–18, 1901. Lexington, KY: n.p., 1903.

Muething, Sister Eugenia. *Nazareth along the Banks of the Ganges, 1947–1990*. Louisville, KY: Harmony House, 1997.

Nibert, Debora A. "Grandma's House: A Personal History." *Northern Kentucky Heritage* 6 (2) (1999): 39–51.

Northern Kentucky Newspaper Index. Kenton County Public Library, Covington, KY.

Roth, George F. Jr. *The Story of Trinity Episcopal Church in Covington*. Covington, KY: Trinity Episcopal Church, 1991.

Sartwell, Melinda. "Pioneers of Progress: The Southgate Family in Northern Kentucky." *Northern Kentucky Heritage* 19 (2) (2012): 3–9.

Sartwell, Melinda. "Pioneers of Progress: The Southgate Family's Next Generation." *Northern Kentucky Heritage* 20 (1) (2012): 28–36.

Stevens, Harry R. *Six Twenty: Margaretta Hunt and the Baker-Hunt Foundation*. Covington, KY: Baker-Hunt, 1942.

Stuhler, Barbara. *Gentle Warriors: Clara Ueland and the Minnesota Struggle for Woman Suffrage*. St. Paul, MN: Minnesota Historical Society Press, 1995.

Tenkotte, Paul A., and James C. Claypool, eds. *The Encyclopedia of Northern Kentucky*. Lexington, KY: University Press of Kentucky, 2009.

Whitson, Frances (Fran), and Margaret Jacobs. "If These Walls Could Talk—Covington's Baker-Hunt Foundation." *Northern Kentucky Heritage* 12 (1) (2004): 2–10.

INDEX

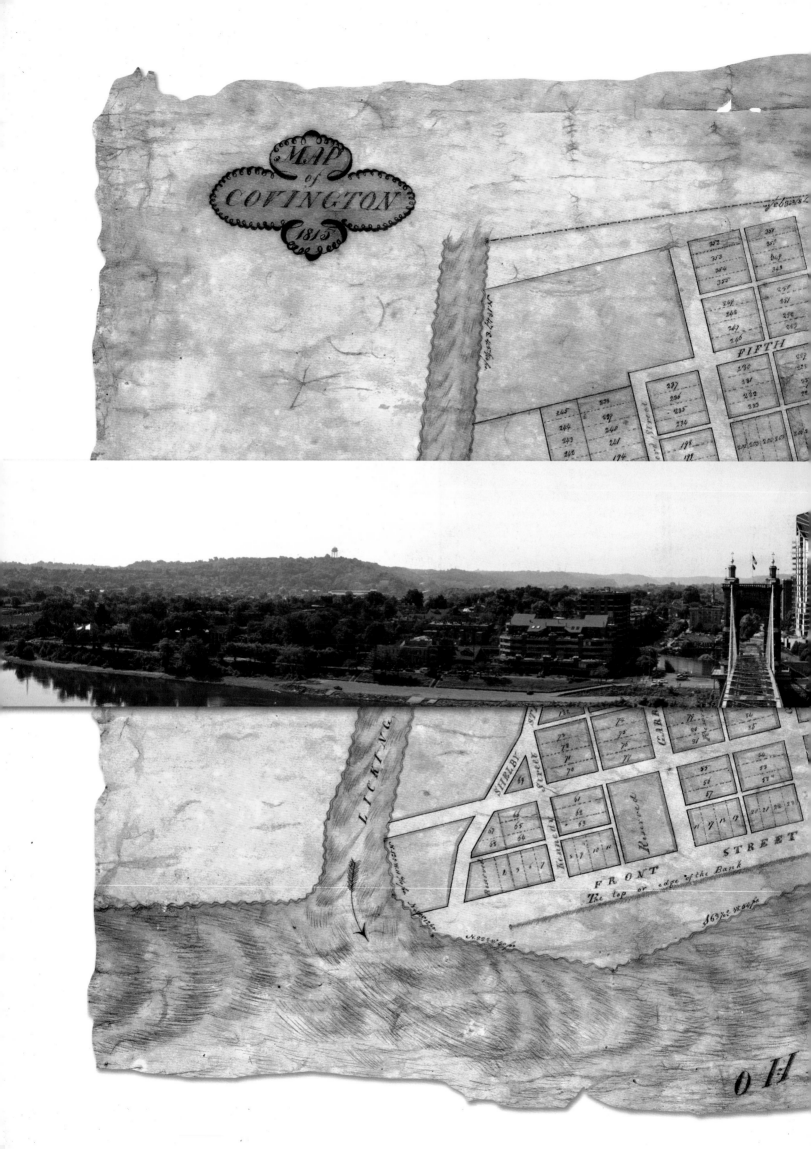